Modernism after Wagner

Modernism after Wagner

Juliet Koss

UNIVERSITY OF MINNESOTA PRESS / MINNEAPOLIS • LONDON

MM

Publication of this book has been aided by a grant from the Millard Meiss Publication Fund of the College Art Association.

An earlier version of chapter 3 was published as "On the Limits of Empathy," *Art Bulletin* 88, no. 1 (2006); reprinted courtesy of the College Art Association, and as "Über die Grenzen der Einfühlung," in *Einfühlung: Zu Geschichte und Gegenwart eines ästhetischen Konzepts,* ed. Robin Curtis and Gertrud Koch (Berlin: Fink Verlag, 2009). Portions of chapters 4 and 5 previously appeared as "Empathy and Abstraction at the Munich Artists' Theatre," in *The Built Surface,* vol. 2, *Architecture and the Pictorial Arts from Romanticism to the Twenty-first Century,* ed. Christy Anderson and Karen Koehler (London: Ashgate Press, 2002). Portions of chapter 6 were previously published in "Hooked on Kracauer," *Assemblage* 31 (Cambridge: MIT Press, 1997), and in "Reflections on the Silent Silver Screen: Advertising, Projection, Reproduction, Sound," *Kritische Berichte: Zeitschrift für Kunst und Kulturwissenschaften* 32, no. 2 (2004). Earlier versions of chapter 7 appeared as "Bauhaus Theater of Human Dolls," *Art Bulletin* 85, no. 4 (2003); reprinted courtesy of the College Art Association; and in abridged form in *Bauhaus Culture: From Weimar to the Cold War,* ed. Kathleen James-Chakraborty (Minneapolis: University of Minnesota Press, 2006). Passages throughout the book previously appeared in "Playing Politics with Estranged and Empathetic Audiences: Bertolt Brecht and Georg Fuchs," *South Atlantic Quarterly* 96, no. 4 (1998).

Published by the University of Minnesota Press
111 Third Avenue South, Suite 290
Minneapolis, MN 55401-2520
http://www.upress.umn.edu

Library of Congress Cataloging-in-Publication Data

Koss, Juliet.
 Modernism after Wagner / Juliet Koss.
 p. cm.
 Includes bibliographical references and index.
 ISBN 978-0-8166-5158-0 (hc : alk. paper) — ISBN 978-0-8166-5159-7 (pbk. : alk. paper)
 1. Modernism (Art). 2. Arts, Modern—19th century. 3. Arts, Modern—20th century.
4. Wagner, Richard, 1813–1883—Influence. I. Title.
 NX454.5.M63K67 2009
 700.9'04—dc22

 2009006979

Printed in the United States of America on acid-free paper

The University of Minnesota is an equal-opportunity educator and employer.

17 16 15 14 13 12 11 10 10 9 8 7 6 5 4 3 2 1

To the memory of my father

STEPHEN KOSS

But above all, too, nothing of the unhappy "Gesamtkunst" in the title!!! Enough of it!

 —RICHARD WAGNER, letter to Franz Liszt, 1853

I understand perfectly when a musician says today: "I hate Wagner, but I can no longer endure any other music." But I'd also understand a philosopher who would declare: "Wagner sums up modernity. There is no way out; one must first become a Wagnerian."

 —FRIEDRICH NIETZSCHE, Preface to
 The Case of Wagner, 1888

Contents

An Introduction to the
Total Work of Art

UBIQUITOUS GESAMTKUNSTWERK

References to the *Gesamtkunstwerk,* or "total work of art," abound in the discourse
of modernism in the disciplines of art and architectural history as well as in theater,
film, music, and contemporary criticism in each of these fields. The term is used
with regard to such disparate environments as the cinema palaces of Berlin in the
1920s and Andy Warhol's Factory scene in New York in the 1960s, operating as
shorthand to describe a seamless melding of a variety of art forms that overwhelms
spectators' emotions, impedes the possibility of critical thought, and molds a group
of individuals into a powerless mass. Yet as a model of artistic interrelation, the
Gesamtkunstwerk is more central and influential than its diffused presence might
lead us to believe; it both supports and inverts modernist principles as they have
been traditionally understood. Addressing a series of linked episodes in German
aesthetic discourse and artistic practice—and attending primarily to the visual arts
and architecture, particularly as their relationship played itself out in theater archi-
tecture—this book explores the history and legacy of the concept to place it, and
the idea of interdisciplinarity more generally, at the heart of modernism.

The Gesamtkunstwerk is often conflated with "Wagnerianism," as if Richard
Wagner, the composer who famously promulgated the exalted unification of the
sister arts in two essays of 1849, held a consistent theoretical view for more than
three decades until his death in 1883. Moreover, the Festival Theater built in 1876
in the town of Bayreuth to present his music dramas is often thought to represent
this view in architectural form. Within the discipline of art history more specifi-
cally, scholars regularly invoke the Gesamtkunstwerk as a countermodel for the
"advanced art" of European modernism, conveniently erasing the concept's revo-
lutionary origins.[1] Wagner's status as Adolf Hitler's favorite and Theodor Adorno's
scathing analysis of Wagner and fascism, written in the late 1930s and first published

as a whole in 1952, have encouraged critics and scholars to construct retroactive assessments of Wagner's achievements that ignore their historical and political context.[2] Such assessments invariably oppose the Gesamtkunstwerk to such basic modernist principles as artistic purity, autonomy, and medium specificity (the idea that each art form should develop and present those attributes specific to its medium). These principles remain central myths of modernism, effectively rendering the Gesamtkunstwerk "antimodernist" and, consequently, easily dismissed.

In both historical scholarship and contemporary cultural criticism, invocations and disparagements of the Gesamtkunstwerk tend to accompany a particular understanding of the role of the audience that is both present at the scene of artistic interrelation and created, it is sometimes believed, by its presence there. Loosely associated with synesthesia, phantasmagoria, and psychedelia, "Gesamtkunstwerk" often stands for an artistic environment or performance in which spectators are expertly maneuvered into dumbfounded passivity by a sinister and powerful creative force. The concept is often mistaken for a hazy mixture of art forms that intoxicates those who gather in its presence, encouraging the kind of passive aesthetic response also ascribed to the spectacle culture famously articulated by Guy Debord in 1968. Scholars and critics of German history and culture tend to treat such a manipulation of passivity, implicitly or explicitly, as fascist, protofascist, or neofascist, depending on the historical moment in which it occurs. While the modernist work is thought to aim for a bracing autonomy, forcing spectators to sit upright in their proverbial chairs to concentrate on the difficult activity of aesthetic reception, the Gesamtkunstwerk is believed to know no such vigilance. It is thought, instead, to let down the guardrails between the art forms, allowing them to intermingle in a vague interdisciplinarity that is equated with a lack of discipline.

Yet notions of artistic purity, autonomy, and medium specificity were central to Wagner's initial formulation of the Gesamtkunstwerk in 1849. In uniting the arts, Wagner argued, the Gesamtkunstwerk would allow each to achieve its full potential, to grow stronger in the struggle to define itself against the others. "By working in common," he declared, the art forms

> each attain the capacity to be and do the very thing which, of their own and inmost essences, they long to do and be. Each, where her own capacity ends, can be absorbed in the other, . . . proving her own purity, freedom, and independence as *that* which she is.[3]

The effort to unite the different art forms was thus predicated on their individual refinement and purification, with the purity of each dependent on the others' proximity; the Gesamtkunstwerk, that is, would simultaneously sustain and destroy

the autonomy of the individual arts. *Modernism after Wagner* follows this theoret-ical model to argue that modernism itself must be understood in reference to the theoretical elaboration and historical development of the Gesamtkunstwerk.

The Gesamtkunstwerk is often presumed to harbor an undifferentiated mix-ture of all forms of art, yet Wagner clearly stated in 1849 that it contained three: poetry, music, and dance. Despite today being known primarily as a composer (albeit one who wrote his own librettos), Wagner himself privileged poetry, at least initially. Calling his works "music dramas" rather than "operas," he treated music and dance as supplemental to the dramatic performance. The Gesamtkunstwerk was to dramatize narrative through the time-based medium of music. Architecture became increasingly central as Wagner worked to have a theater constructed for his music dramas, while the concept's later association with the cinema, elaborated most famously by Siegfried Kracauer in the 1920s, lingered for decades and ex-tended also to other performance venues. There have been numerous incarnations of the Gesamtkunstwerk; *Modernism after Wagner* insists on the historical specifi-city of each.

Wagner's initial focus on three primary art forms, and his particular emphasis on poetry, is significant for several reasons. Above all, the composer wished to link his works to ancient Greek drama, in which music and dance helped construct a performance that was essentially poetic in nature. The extraordinary historical reach backward in time to antiquity, a trope long present in German cultural and philosophical thought, signals a nostalgia for a mythical prelapsarian era when a unified work of art might both express and encourage sociopolitical and cultural unity among its spectators. This audience, moreover, stood symbolically for the larger democratic culture of ancient Greece. Such nostalgia was counterbalanced by the profoundly utopian nature of Wagner's project; the Gesamtkunstwerk he imagined in the mid-nineteenth century was, fundamentally, a proposal for the democratic German nation he imagined for the future, decades before the found-ing of this nation in 1871. Simultaneously artistic and political, Wagner's proposal must also be understood within the context of his own experiences in the revolu-tion of 1848–49—and of his disappointment following its failure.

Wagner's status as a composer of music dramas makes his arguments no less relevant to historians of modernism in the visual arts and architecture; his essays attend exhaustively to music's ability to help present the drama to those gathered before it as well as to questions of spectatorship more generally.[4] The Gesamtkunst-werk, in other words, describes both the work created by the interrelation of the arts and—just as significantly—its effect on an audience. It presents a model of artistic production and aesthetic reception that is active, communal, political, and fundamentally utopian. Elaborated temporally through the performance process

and using a narrative provided by the composer's own libretto, the Gesamtkunst-werk might seem to have been rendered obsolete as a model in the early twentieth century by the development of visual abstraction, with its removal of space, tem-porality, and narrative from the visual field. But for all its rhetoric of purity, the birth of abstraction was likewise an interdisciplinary effort, and the theoretical model of the Gesamtkunstwerk helps navigate that central modernist contradic-tion.[5] Many artists and art theorists in fact turned to music or to the idea of music as an abstract art form to bolster their efforts at abstraction; rather than being a framed scene—a narrative stopped in time—an abstract painting would be an object in its own right and might even be named (*Nocturne,* for example) in the manner of a musical interlude.

While discussions of the interrelation of the arts did not originate with Wagner, as we shall see, his presentation of the Gesamtkunstwerk became the central refer-ence point for later artistic practice and theory. Even during his lifetime, interest in his treatment of the concept remained far out of proportion to its status within his oeuvre, while other themes in his writings (such as communism or egoism) received far less consideration. Writing to Franz Liszt in 1853, he bemoaned the emphasis that others had placed on the Gesamtkunstwerk in his conceptual schema; misjudgments were rife, he lamented: "Otherwise it would be totally impossible that this unfortunate '*Sonderkunst*' [special or particular art] and '*Gesamtkunst*' [total art] would in the end emerge as the fruit of all my argu-ments."[6] Since then, the idea of the Gesamtkunstwerk has if anything become both more infamous and more nebulous. *Modernism after Wagner* lays out its genealogy and the historical and political context from which it emerged, tracing its development and reconfiguration through the mid-twentieth century to argue for its centrality to modernism in the visual arts and architecture.

From overarching artistic schema to conceptual foil, from bugbear to buzz-word, the Gesamtkunstwerk has stood for many things since the mid-nineteenth century. Its history, however, has not been adequately discussed; among art histo-rians it is sometimes simply overlooked. (Art historical silence may be preferable to some alternatives; in 1980 the musicologist Carl Dahlhaus called the Gesamt-kunstwerk "a pompous synonym for 'theater.'")[7] Ranging chronologically from Wagner's promulgation of the Gesamtkunstwerk in the wake of the revolution of 1848–49 to the playful figures of Bauhaus parties and performances in the 1920s, and with a final chapter on Wagner's conceptual legacy from the 1890s to the 1930s, this book explores a variety of German efforts to combine artistic disciplines, focusing particularly on the attempt to construct an audience by building a theater or mounting a performance. In the process, it links a series of proposals regard-ing the interrelation of the arts to contemporaneous theories of spectatorship:

empathy, abstraction, distraction, and estrangement, all of which emerged over the course of several decades against a background of interdisciplinary efforts.

Just as the Gesamtkunstwerk would unite a variety of art forms and blur artistic categories, so, too, would individual spectators be brought together to encounter this achievement, becoming a unified audience through their shared aesthetic experience. For Wagner—following a long line of German thinkers—the presence and the experience of an audience helped create the work of art. The emphasis on spectatorship in his early essays was elaborated more literally in his composition of thirteen music dramas (his earliest, *Die Feen* [*The Fairies*], was written in 1834; his last, *Parsifal,* premiered in 1882) as well as in his ongoing campaign to have a theater built to house his works and their audiences. Wagner's prodigious output of music dramas over the course of so many decades—as well as the centrality, throughout his working life, of theater productions, performances, and the activity of spectatorship—might suggest a consistency to his thinking and encourage the presumption that his later achievements followed logically and necessarily from his earlier ideals. *Modernism after Wagner* tells a different story. Distinguishing between the theoretical arguments of 1849 and the actual construction of Bayreuth in 1876, for example, this book questions the very possibility of rendering a utopian vision in architectural form. By emphasizing historical analyses and close readings of original texts, it seeks to trouble the straightforward association of the Gesamtkunstwerk with the aesthetics of fascism, in part by insisting on the former's revolutionary origins and emancipatory potential.

With the expansion of the modern mass audience in the late nineteenth and early twentieth centuries and with the development of new media, ideas about spectatorship underwent constant reconfiguration. Analyzing a range of attempts to create a "total work of art" from a variety of art forms and to forge a unified audience from a disparate group of individuals, this book explores the relation—both real and imagined—between the experience of the individual spectator and that of the mass audience. Broadening the modernist framework, traditionally oriented around the achievements of artists in France and the United States, it recalibrates the status of such central modernist principles as purity, autonomy, and medium specificity by placing them in an interdisciplinary context. Rather than exploring a succession of art objects or works of architecture, it discusses a select few while concentrating on the ideas that circulated around them, foregrounding the role of spectatorship in the development of modernism.

In 1911, Wassily Kandinsky offered a utopian narrative of the courageous viewer who followed the artist into the unchartered realm of abstraction, gradually gaining command of its pure, direct, and universal language. "The more abstract form is," he declared,

the more clear and direct its appeal. The more an artist uses these abstract forms, the deeper and more confidently will he advance into the kingdom of the abstract. And after him will follow the viewer [*Zuschauer*] . . . who will also have gradually acquired a greater familiarity with the language of that kingdom.[8]

Painterly abstraction—a kingdom of unknown riches—awaited discovery by the boldest artists and viewers. Those who dared navigate such territory would create truly universal works of art that would be, at least theoretically, equally accessible to all. Deepening the interaction among artist, object, and viewer, such works would bypass the limitations of linguistic difference and ignore geographic boundaries. Abstraction thus existed not only as the physical manifestation of ongoing formal developments, or as the result of a continuous effort to purify individual art forms, but also as a shared experience: a visual language for a universal audience and a fundamental component of the discourse of modern spectatorship.[9]

Kandinsky did not connect this potentially universal audience—a group of spectators who shared an experience of the visual language of abstraction—with the contemporaneous development of another art form: the cinema. Introduced in Berlin (as in Paris) in 1895, cinema initially absorbed the attention of lower- and middle-class viewers, male and female; it subsequently attracted many young middle-class women, who often went to the movies unaccompanied by men. Like other theorists and practitioners of the fine arts, Kandinsky paid scant attention to these spectators in his writings and failed to link them to those who appreciated works of fine art; art historians have likewise ignored this connection, despite such shared themes in aesthetic discourse and early film theory as near and distant vision, emotional absorption, and psychological engagement. Given that both fields developed out of nineteenth-century laboratory psychology, the theoretical overlap is unsurprising. In treating spectators both literally and theoretically, this book posits a relationship between the development of abstract painting in the early twentieth century and the fascination of the mass audience with the moving pictures that were appearing on film screens at that time.

Reverent Misunderstandings

In 1888, five years after Wagner's death, Friedrich Nietzsche described the composer as having achieved the combination of veneration and misinterpretation common among national figures and monuments. "The Germans have constructed a Wagner for themselves whom they can revere," he proclaimed, perhaps with some jealousy; "their gratitude consists in misunderstanding."[10] Such troubles have plagued Wagner's texts with particular force in an Anglophone context, as William

Ashton Ellis lamented in the preface to the publication of his own translations of the composer's writings in 1893. "In view of the curious range of theories erroneously attributed to the Bayreuth master," he declared with characteristic pomposity,

> the need for a complete English version of Wagner's Prose is obvious. A passage here and there has often been dragged from its context, maltreated, and made to point a moral with which, in the original, it had nothing whatever to do; while, on the other hand, the most valuable commentaries upon his own artistic works lie buried in the native German of Wagner's writings, because folk have been scared away from reading them by the report that his style is "impossible."[11]

While the mistreatment of Wagner's ideas is certainly long-standing, the composer's rhetorical style is, in fact, often impossible. His prose is turgid and repetitive in the original German, and his grandiose declarations frequently verge on the megalomaniacal. Ellis's English translation, still in print after more than a century, has done little to ameliorate the situation that he himself lamented, and much to sustain it; the need for a new English version of Wagner's prose remains strong.

Misunderstandings, however, are not to be dismissed. The development and reinterpretation of ideas (sometimes even by their initial authors) and the translation of these ideas into form—metaphoric operations in which theoretical claims reappear, intentionally or not, in works of art and architecture, performances, and elsewhere—are central to the history of art.[12] Theoretical claims have often helped inspire or legitimize particular artistic tactics that, in turn, offer prototypes for further conceptual developments; the notion of the Gesamtkunstwerk provides the first, and central, example in this book. Wagner's own reformulations of the concept parallel its appropriation as a foil by other theorists, practitioners, historians, and critics. Over the course of several decades, theories of spectatorship—those of *Einfühlung,* or "empathy," in particular—likewise reappeared in a variety of contexts, often so altered as to be almost unrecognizable. And, as we shall see, arguments about relief sculpture put forward at the end of the nineteenth century by Adolf Hildebrand and Aloïs Riegl reappeared in 1908 in Georg Fuchs's arguments for the shallow "relief" stage at the Munich Artists' Theater and, in 1916, in Hugo Münsterberg's analysis of film.

While such conceptual reformulations are, fundamentally, misrepresentations, over time they also come to belong to the accepted definition of a concept. Wilhelm Worringer reformulated the concept of Einfühlung when he used it as a foil for his discussion of abstraction in 1908, for example, as did Bertolt Brecht

when he used it as a foil for *Verfremdung,* or "estrangement," in the 1930s. As a result, "Einfühlung" came to signify something vastly different in the early twentieth century from what it had meant several decades earlier. The notion of the Gesamtkunstwerk was likewise transformed in this period, and one might question whether performances and festivities at the Bauhaus (combining theater, film, and music) or the political rallies of the National Socialists may be considered the more faithful enactments of Wagner's revolutionary ideas of 1849. Rather than attempting to recuperate the original version of a given concept, however—a process neither possible nor necessarily desirable—this book addresses a series of conceptual appropriations concerning the Gesamtkunstwerk and spectatorship to demonstrate that aesthetic theories themselves have a history; the meanings of concepts develop over time.

Wagner's notion of the Gesamtkunstwerk and his music dramas responded to a widespread desire for the artistic synthesis that was, according to Walter Benjamin, "precisely what is required by the allegorical way of looking at things."[13] The urge to unite the arts, he maintained, had been powerful since the seventeenth century and culminated in Wagner's creations; it remained potent in the 1920s, and it corresponded to the allegorical approach prevalent since the baroque era. Allegory framed ideas and artistic creations in order to grasp them more clearly, he wrote; it permitted the distance that fostered analysis when things were too close for comprehension. Additionally, the arts turned to one another for inspiration and theoretical sustenance. When words failed, music, "by virtue of its own essence," could help clarify the relationship of a work of art to its historical moment; like the Gesamtkunstwerk, music was "something with which the allegorical drama is infinitely familiar."[14]

Linking Wagner and the baroque was not original to Benjamin; nor was the use of musical analogy for discussing another art form. Almost four decades earlier, in "The Causes of the Change in Style," the central chapter of *Renaissance and Baroque* (*Renaissance und Barock*), Heinrich Wölfflin had likewise bolstered his arguments regarding the visual arts with a musical reference:

> One can hardly fail to recognize the affinity that our own age in particular bears to the Italian baroque. A *Richard Wagner* appeals to the same emotions. . . . His conception of art shows a complete correspondence with those of the baroque and it is not by coincidence that Wagner harks back to Palestrina.[15]

At crucial moments, art historical discourse has turned to musical analogies and examples in order to elucidate its fundamental theoretical arguments. At such

moments, Wagner has often personified the idea of the interrelation of the arts. He has also provided the theoretical framework with which to understand it.

Nationalism and Internationalism

"If one looks closely at the arts in Germany," Madame de Staël acerbically noted in 1810, "one is obliged to speak more of writers than of artists. The Germans are in all respects more adept at theorizing about art than in practicing it."[16] The remark rests on an established cliché: while France was producing paintings, Germany, land of *Dichter und Denker,* or "poets and thinkers," generated poetry and philosophy. By implication (at least for de Staël), the theorists were of less value; they merely analyzed the products of culture from a distance, instead of actually moving it forward. "The Germans would rather ponder the meaning of art, than practice it," she scoffed. "The minute they have an inkling about it, they set about drawing book loads of conclusions." Rather than endorsing such invidious comparisons between nations (or between theory and practice), this book suggests a mutual interdependence of nationalism and internationalism that parallels the relationship between the idea of purity and that of artistic interrelation. While the following chapters treat German topics—and especially efforts to express and create a form, style, or experience of art appropriate for the German nation and its people—these topics are symptomatic of developments within European modernism more generally. Occasional forays into commercial culture in the United States, seen through the eyes of a German theorist, or into postwar American art suggest, moreover, a still broader framework.

Several factors extrinsic to art history have helped determine the peculiar status of the Gesamtkunstwerk within the discipline, especially within Anglophone discourse: the concept's German origins, Wagner's convoluted prose style, and Hitler's embrace of Wagner long after the composer's death. To discuss the Gesamtkunstwerk—even to situate it historically—not only raises the specter of National Socialism and, retroactively, the messy question of protofascism but also foregrounds the overlap between socialist tendencies of the left and right wings in the decades preceding World War II. Inspired by the revolution of 1848–49 (or, more accurately, by its failure), Wagner's articulation of the Gesamtkunstwerk subsequently lent itself to manipulation in the service of fascist ideology. As we shall see in chapter 4, the "revolution in the theater" promoted by Fuchs, a politically and culturally conservative critic imprisoned in Munich in the 1920s for his activities as a Bavarian separatist, was enthusiastically taken up in the Soviet Union by Vsevolod Meyerhold, the inventor of the technique of biomechanics. The overlap of radical ideas at opposite ends of the political spectrum raises crucial questions about the relation between politics and aesthetics, and between theory and

practice, within modernism—and helps uncouple the presumed association of form and content.

Like all unfinished histories, that of modernism has in recent decades been significantly transformed. After myriad critiques, it now incorporates particular objects and entire movements that exceed the limits of the framed canvas (such as Dada, surrealism, and constructivism) or the geographic borders of France and the United States; the discussion of its canonical works has likewise been widely reconfigured to incorporate analyses of the political intentions and implications of particular artists and their creations.[17] Notably, however, such work has generally addressed the works of artists and movements considered "advanced," expanding the modernist canon to include works considered both politically and aesthetically radical. Those works thought to be politically and aesthetically regressive are meanwhile relegated to the rubric of "antimodernism" and frequently either disdained or ignored.[18] Even as Clement Greenberg's version of modernism has lost favor in recent decades, the Gesamtkunstwerk has retained its antimodernist status—where "modernism" connotes the active, heroic, and dynamic development of the most advanced art that contends with the process of modernization and the achievements of modernity.

Historians of the early-twentieth-century avant-gardes have sometimes found in Wagner's nationalist ideals a useful foil for the leftist internationalism of their chosen subjects. Whereas the composer hoped to gather people together to create a unified German audience through the experience of the Gesamtkunstwerk, the avant-garde practices of six decades later are usually characterized by an essential internationalism, in terms of the locations in which they occurred, the biographies of their participants, and their general orientation. The opposition is false, however, not only because of the disparate historical contexts of the two examples—European nationalism in the mid-nineteenth century cannot be equated with that of the early twentieth—but also because the "nationalism" of the former and the "internationalism" of the latter are mutually embedded. To call for a German nation based on cultural renewal is implicitly to wish to place Germany on the international map. Moreover, many early-twentieth-century avant-garde movements with internationalist leanings were also propelled by nationalist fervor; while oriented internationally, they were based on the rhetoric of national pride and the ideal of national strength. F. T. Marinetti's proclamation of Italian futurism on the front page of the Parisian newspaper *Le Figaro* in 1909, for example, in calling attention to the avant-garde activities of a group of Italians, served both to de-center the European art world and to reinforce the centrality of Paris.[19] Just as the idea of the exalted unification of all individual forms of art held at its core the notion of disciplinary purity and medium specificity, that of internationalism harbored intense nationalist allegiances.

The irresolvable tension between nationalism and internationalism—and its centrality within the history of modern art—is charmingly expressed by an anecdote set in Paris in late 1906 or early 1907. "When Picasso painted the *Demoiselles d'Avignon*," John Golding has written,

> those of his friends who were allowed to see it seem to have felt that in some way he had let them down. . . . Gertrude Stein writes that "Tschoukine [Shchukin] who had so much admired the painting of Picasso was at my house and he said almost in tears, what a loss for French painting."[20]

In this tale, an American writer reports the reaction of a Russian art collector to the latest work by the painter Picasso—a Spaniard. While technically incorrect (insofar as the *Demoiselles* was not, strictly speaking, French) and contradicted by later, adulatory assessments of the painting, Sergei Shchukin's comment underscores both the complexity of national allegiances and their crucial role in constructing the international identity of the art historical avant-garde.

The founding of the Festival Theater in Bayreuth in 1876—like those of the Artists' Colony in Darmstadt in 1901 and the Artists' Theater in Munich in 1908—was nationalist in orientation and rested on an ideal of cultural purity. All three were meant to demonstrate the strength of German achievements and develop audiences that were explicitly conceived of as German. But such efforts must also be seen in the context of German history: the failed revolution of 1848–49, the foundation of Wilhelmine Germany in 1871, and the developments of the subsequent decades. The first, which inspired Wagner's articulation of the Gesamtkunstwerk, was explicitly internationalist in orientation and inspired by recent events in Paris; the second united disparate cultures (Bavarian and Prussian, among others) with the hope that cultural production would solidify their union. If efforts to combine the arts in the Wilhelmine period were often intended to bolster the newly founded German nation, Bauhaus theatrics between 1919 and 1933, likewise heavily dependent on the interrelation of the arts, were internationalist in nature and helped provoke the National Socialists to close the school in Berlin in 1933. Artistic interrelation thus guarantees neither nationalist nor internationalist impulses—which are often, in any case, mutually imbricated.

MEDIUM SPECIFICITY AND INTERDISCIPLINARITY

Concurrent with the rise of interdisciplinary work in the academy in recent years, art historians have increasingly looked toward developments in neighboring fields, with the work of Aby Warburg frequently cited as the model for a new art history that simultaneously returns to the discipline's central preoccupations.[21] But while

musicologists, philosophers, classicists, and scholars of German studies and film
have addressed the topic of the Gesamtkunstwerk, art historians have generally
kept their distance.[22] Such wariness appears to derive not from the particular com-
plexity of the research the topic demands but from a lingering presumption within
the discipline of art history that such a model of artistic interrelation falls beyond
the parameters of modernism. This book, by contrast, in attending to the his-
tory and theory of the Gesamtkunstwerk following the conceptual model pro-
vided by Wagner, argues that interdisciplinarity itself derives its strength from the
achievements made within particular disciplines—and, in turn, it strengthens
these disciplines.

In the Anglo-American context, European modernism in the visual arts was
often discussed in the twentieth century in terms of a set of conditions within
painting that included opticality and the ongoing refinement and purification of
the individual art forms. From Roger Fry to Greenberg and beyond, this history
held such theoretical corollaries as pure form, the innocent eye, the universal spec-
tator, and the autonomous art object: linked phenomena at the center of mod-
ernist discourse. The intensification of the essential qualities of a form of art,
according to this argument, caused it gradually to shed those attributes not specific
to its medium; painting ceased referring to anything beyond its own limits, music
became more purely musical, and theater more purely theatrical. "The history of
avant-garde painting is that of a progressive surrender to the resistance of its
medium," Greenberg famously declared in 1940,

> which resistance consists chiefly in the flat picture plane's denial of
> efforts to "hole through" it for realistic perspectival space. In making
> this surrender, painting not only got rid of imitation—and with it, "lit-
> erature"—but also of realistic imitation's corollary confusion between
> painting and sculpture.[23]

Each individual art form followed a path of ongoing purification, a trajectory that
precluded not only the presence of narrative but also, more generally, the very pos-
sibility of artistic interrelation. Crucially, in this account, the essential nature of
painting was its flatness.

A painting by Morris Louis from 1962 is the perfect hero of such a tale. A large
acrylic work on canvas, with one dark vertical stripe bisecting the visual field and
eight adjacent stripes of different colors to its right, the painting presents a flat,
nonrepresentational pictorial expanse (Plate 1). It imitates nothing from the world
beyond its frame and shows no hint of spatial depth. Refusing narrative, realism,
and perspectival depth, it insists on its status as a painting to the exclusion of

all other art forms. Greenberg's retroactive prescription for modernist painting famously excluded as much as it permitted and provided, in the 1960s, a prehistory of the present: the teleology that offered the necessary background for the kind of contemporary art that Greenberg himself wished to endorse. The other art forms, insofar as they could exist at all within this trajectory, appeared in the act of disappearing, as unnecessary elements that were gradually removed. Perhaps equally significant is the fact that the trajectory provided was, itself, a narrative: the kind of "literature" for which, Greenberg claimed, avant-garde painting had no room.

For Greenberg and his followers, the narrative of the gradual purification of painting operated in conjunction with a larger set of ideas about medium specificity and the necessity of policing the theoretical borders of the art forms. But if such elements as narrative, imitation, and perspective were interlopers that had to be eliminated in order for painting to reveal its essential nature, the true culprit was ultimately not "literature" but theater. As Michael Fried put it in 1967: "The concepts of quality and value are meaningful . . . only within *the individual arts. What lies* between *the arts is theater.*"[24] Beyond being merely another potential intruder in the house of modernism, theater represented the idea of an incursion past the carefully policed borders of the individual art forms. Thorny questions of quality aside, "theater" would appear to be a code word for the very idea of artistic interrelation.

By such standards, Adrian Piper's *Catalysis III,* in which the artist wore a T-shirt emblazoned with the words "wet paint" on the streets of New York City in 1970, would simply be dismissed as theater (Figure I.1). Borrowing from conceptual and performance art practices, operating well outside the boundaries of the art museum, and presenting herself as a temporary painted human sculpture, Piper willfully ignores traditional artistic categories in this work to flaunt, instead, artistic miscegenation. The "theatricality" of her performance, to use Fried's term, derives also, fundamentally, from the reactions it provokes among those who encounter it. The activity of spectatorship becomes central as passersby negotiate their way around the artist. Notably, this activity—spectatorship—is also at the center of Fried's discussion of the idea of absorption.

Long after their reconfiguration as modernist myths, such concepts as artistic purification, autonomy, and medium specificity have encouraged the misunderstanding and marginalization of the Gesamtkunstwerk in the discipline of art history. Ironically, Greenberg himself acknowledged the interrelation of the arts as central to modernist practice: "[Gotthold Ephraim] Lessing, in his *Laokoon* written in the 1760s, recognized the presence of a practical as well as a theoretical confusion of the arts."[25] Only after 1848, according to Greenberg, was such confusion intentional—although it operated in the service of a notion of art that was independent

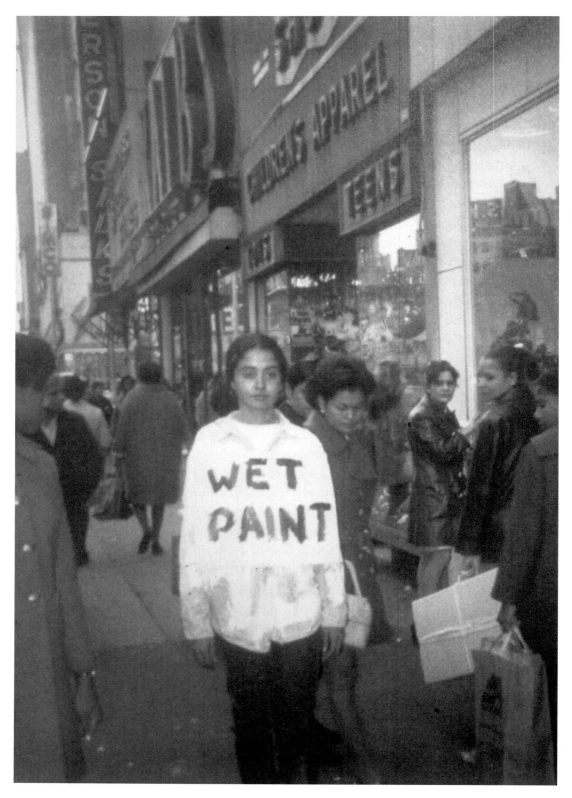

Figure I.1. Adrian Piper, *Catalysis III,* 1970. Used by permission of the artist.

of the world at large. "Each art would demonstrate its powers by capturing the effects of its sister arts or by taking a sister art for its subject," he explained, and asked, "Since art was the only validity left, what better subject was there for each art than the procedures and effects of some other art?"[26] Withdrawing into a realm of aestheticism, the individual arts sought inspiration—theoretical sustenance, as it were—in one another. Their interdependence became necessary to ensure their survival after their removal from the world. In turning to the other arts, they borrowed not only procedures but also effects, a move that focused especially on their impact on spectators.

Greenberg referred overtly to Wagner's idea of the Gesamtkunstwerk in "The State of American Writing, 1948," a contribution made to a symposium that year. While acknowledging the importance of the theme, he ascribed its practice to muddy thinking on the part of those who only vaguely understood the distinction between drama and literature:

> It must have been the unconscious realization of this difference—and the inability at the same time to determine exactly what it was—that led Proust and Joyce to borrow, as if in desperation, so many of their "structural" principles from music. And even then they did not escape from drama, for what they borrowed from most was the Wagnerian opera, that Gesamtkunstwerk, that work of "total art."[27]

Attributing the interest in the Gesamtkunstwerk to unconscious perception, intellectual weakness, and creative desperation, Greenberg here suggests that the need on the part of the two giants of literary modernism to borrow structural principles from elsewhere reflected literary impoverishment and not creative genius. His disdain for the Gesamtkunstwerk itself is palpable.

But as Greenberg himself neatly stated, "Tendencies go in opposite directions, and cross-purposes meet."[28] Greenberg articulated a notion of "pure painterly abstraction" in 1961, not coincidentally while performance-based works were dissolving traditional divisions between the arts. Relying on the presence (and, often, the active participation) of the audience to help create the work of art, the happenings and performances of such artists as Allan Kaprow in New York and Yves Klein in Paris not only aimed to dissolve traditional distinctions between the arts but also pressed on the boundaries that existed between the spectator, the artist, and the work of art. Such works may be seen to follow the model of the Gesamtkunstwerk, forging simultaneously a process of artistic interrelation and new models of spectatorship. For a contemporary reader, Wagner's arguments about the interrelation of the arts often evoke those of Greenberg. The notion of artistic

purity was central to the composer's formulation of the Gesamtkunstwerk, with each kind of art negotiating its own formal parameters and discovering its own identity only in the presence of the others. Using the concept of the Gesamtkunstwerk as its guide, this book thus situates the idea of medium specificity within a broader context, both theoretically and in the realm of artistic practice.

For Greenberg, too, the effort to achieve the ideal of medium specificity was connected to the experience of perception and the process of spectatorship. The more a form of art cast aside those features that were appropriate to other forms of art, becoming in the process more "pure," the more it attempted to achieve a physical effect on the viewer; fostering a particular aesthetic response was central to the aims of painting and sculpture. "The arts, then, have been hunted back to their mediums," he asserted,

> and there they have been isolated, concentrated and defined. It is by virtue of its medium that each art is unique and strictly itself. To restore the identity of an art the opacity of its medium must be emphasized. For the visual arts the medium is discovered to be physical; hence pure painting and pure sculpture seek above all else to affect the spectator physically.[29]

Despite these claims, there are no grounds for believing that a spectator's engagement with a work of painting or sculpture is linked more closely to bodily experience than is the engagement with such other art forms as music, film, or architecture. Yet Greenberg insisted that this was the case and that the work of pure visual art was based on bodily—and not only visual—perception. As we shall see, notions of opticality and bodily perception have been intertwined since at least the nineteenth century.

Far from offering a historical survey of the idea of artistic interrelation, this book presents Wagner's concept of the Gesamtkunstwerk as he described it in 1849 as the theoretical framework for understanding a range of subsequent modernist developments, concentrating on art and architecture with occasional forays into such other disciplines as theater, music, and film. Arranged chronologically from the mid-nineteenth century through the 1930s, it investigates particular moments in the history of the interrelation of the arts against the background of shifting models of modern spectatorship. Given the nature of the Gesamtkunstwerk and its pervasiveness in modern culture, countless relevant moments—both in Wagner's work and beyond—remain absent.[30] Often focusing on architectural history, and theater architecture in particular, each chapter describes the effort to

come to terms with—or, explicitly, to help construct—the modern audience under development in these years.

Chapter 1, "The Utopian Gesamtkunstwerk," explores Wagner's promulgation of the Gesamtkunstwerk in the wake of the revolution of 1848–49 as a radical means of encouraging audiences' active engagement. After presenting the composer's role in the revolution in Dresden in the spring of 1849 and the precursors and inspirations for his ideas concerning the interrelation of the arts, it examines the central arguments of his two important treatises of that year, *Art and Revolution* (*Die Kunst und die Revolution*) and *The Art-Work of the Future* (*Das Kunstwerk der Zukunft*), which articulate his utopian vision of the Gesamtkunstwerk, the communal experience of aesthetic engagement it would encourage, and the audiences it would both serve and create. Chapter 2, "Building Bayreuth," describes Wagner's ongoing efforts to commission a work of architecture to foster communal appreciation of his music dramas, first in the unbuilt designs of Gottfried Semper in 1865 for several sites in Munich and, later, in a structure completed in 1876 in the town of Bayreuth. Initially planned as a temporary building that would be destroyed after the performance of his *Ring* tetralogy, the Festival Theater in Bayreuth both exemplified and reworked the notion of the Gesamtkunstwerk; inaugurated just five years after the founding of the German nation, it united the arts while bringing together individual spectators in order to form a unified audience. While theoretically following Wagner's utopian vision, it also produced the kind of spectacle that Wagner himself had opposed in his early essays.

Taking up the themes of sympathy and communal feeling from Wagner's early writings, chapter 3, "Empathy Abstracted," examines the late-nineteenth-century discourse of Einfühlung, first articulated by Robert Vischer and others as an active, engaged form of spectatorship and subsequently developed within such overlapping disciplines as aesthetic philosophy, perceptual psychology, optics, and art and architecture history to describe an active, embodied aesthetic response. With reference to the ideas of such authors as Theodor Lipps, Vischer, and Heinrich Wölfflin, the chapter links the history of Einfühlung to the emergence of visual abstraction in Munich and the vast changes in the constitution of modern audiences and the new media—especially film—that demanded their attention. It ends by associating the flatness of the film screen to the "fear of space" that Worringer ascribed to visual abstraction and articulated in terms of the spectator's *Selbstentäußerung,* or "self-estrangement."

By the early twentieth century, the idea of the Gesamtkunstwerk had made its way via the writings of Nietzsche, Wagner's erstwhile disciple, to the related fields of decorative arts and architecture, which proved fertile ground for designing and promoting a "total work of art." Chapter 4, "The Nietzschean Festival," describes

the opening ceremony of the Darmstadt Artists' Colony in 1901 as a Gesamtkunstwerk—a total environment of architecture, theater, music, and the decorative arts—and as a *Fest,* or "festival," in the sense articulated by Nietzsche. Despite their rhetoric of Dionysian revelry and populist inclusiveness, however, both the ceremony and the Artists' Colony itself, with its houses and interiors designed by Peter Behrens and Joseph Maria Olbrich, were oriented toward the limited, upper-middle-class audience willing to make the artistic pilgrimage to the Mathildenhöhe, a hill at the edge of the town of Darmstadt. The chapter treats the ideas concerning the reform of theater architecture put forward by Behrens and by Fuchs, the author of the play performed at the Darmstadt opening festivities, in their effort to create a German "theater of the future"; it ends with a discussion of the Prinzregententheater, built in Munich in 1901 following Semper's designs for a theater for showcasing Wagner's music dramas in that city.

Chapter 5, "Retheatricalizing the Theater," explores the founding of the Munich Artists' Theater in 1908 by Fuchs. While promoted as an attempt to render theater purely theatrical, performances on the theater's shallow "relief stage" evoked both Hildebrand's 1893 discussion of relief sculpture (which itself relied on the tenets of Einfühlung) and the concerns of abstract art as Worringer presented them that year in his book *Abstraction and Empathy* (*Abstraktion und Einfühlung*). Fuchs's theater thus appears to conform to a modernist model of medium specificity and disciplinary purity, but its rhetoric of autonomy belies a reliance on artistic interrelation worthy of Wagner himself. The chapter sets Hildebrand's and Worringer's conflicting reactions to theater in the context of the demise of Einfühlung and the birth of visual abstraction, a shift in theoretical allegiances that Fuchs himself ignored. Fuchs's political leanings were likewise conservative; he valued theater's ability to mold a group of individual spectators into the unified audience that he considered necessary for creating a strong German state.

Linking the shallow stage at the Munich Artists' Theater to film screens, chapter 6, "The Specter of Cinema," explores a set of interrelated claims about aesthetic absorption, consumption, and distraction that were put forward with regard to film and, to a lesser extent, radio. Briefly invoking commercial culture in the United States, it examines analyses of cinema and radio that emerged from nineteenth-century German aesthetic and psychological discourse (Einfühlung in particular) and reflected political and cultural developments in Germany and the United States; it addresses, in turn, Münsterberg's discussion in 1916 of the film screen in terms that evoke Hildebrand's and Riegl's ideas about relief sculpture, Adorno's critique of the radio as inauthentic, and Kracauer's explanation of the communal experience of *Zerstreuung,* or "distraction," felt by the "little shopgirls" who watched the "Gesamtkunstwerk of effects" at Berlin movie palaces in the 1920s.

The absorption that in the late nineteenth century had described an active, engaged form of aesthetic perception was now recoded as passive and feminine, aligned with technology and the mass audience, and presented as the ultimate conduit of mindless consumption.

Chapter 7, "Bauhaus Theater of Human Dolls," explores the interrelation of the arts—united under the sign of theater and theatricality—at the most famous school of art and design of the twentieth century. It presents the experiments in stage and theater design that occurred both on and off the premises of the Bauhaus, frequently in the context of costume parties and other festivities. Such efforts re-created the human body in the shape of the doll, a creature embodying both empathy and estrangement and flourishing in the realm of photography. Anonymous and androgynous, Bauhaus dolls engaged with abstraction both individually and in groups; they blurred distinctions between performers and spectators and increasingly exemplified the bond between gender and mass culture to provide models of Weimar subjectivity and spectatorship in the context of a vision of modernism that derived strongly from the ideas of both Wagner and Nietzsche.

Finally, chapter 8, "Invisible Wagner," addresses the retroactive connection often made—or, more accurately, simply presumed—between Wagner's formulation of the Gesamtkunstwerk and fascist aesthetics. Situating the Gesamtkunstwerk within a larger aesthetic discourse, it attends particularly to accusations of dilettantism made by a range of critics, from Nietzsche to Adorno, and to related discussions of intoxication and hypnosis that circled around the composer's music, his theoretical arguments, and his personality. Both during Wagner's lifetime and for decades after his death, the idea of the Gesamtkunstwerk was linked with the kind of passivity that was deemed necessary to sustain the mass spectacle of fascism or commercial culture; this passivity, in turn, was connected to the invisibility of the conductor, insidiously controlling both the music and the audience from the darkness of the orchestra pit. But for all its affiliations with right-wing spectacle culture in 1930s Germany and beyond, this book argues, the concept of the Gesamtkunstwerk maintains the radical, emancipatory potential of its revolutionary origins: the aspiration to merge art and life, spectator and audience, the aesthetic and the political, in order to create a utopian total work of art of the future.

I

The Utopian Gesamtkunstwerk

The great Gesamtkunstwerk must contain all the branches of art in order, as it were, to use up, to destroy them for the benefit of attaining their common purpose—namely, the absolute, unconditional portrayal of perfected human nature; he [the artist] conceives of this great Gesamtkunstwerk not as the act of an individual will [*willkürlich mögliche That des Einzelnen*] but rather as the necessary collective work of the humans of the future.

—RICHARD WAGNER, *The Art-Work of the Future*, 1849

REVOLUTIONARY DRESDEN

Dresden, the royal residence of Friedrich Augustus II, the king of Saxony, was an established cultural center when Wagner arrived there in 1842. It had been home to numerous luminaries of German Romanticism, including Caspar David Friedrich, who had lived there from 1798 until his death in 1840, and Arthur Schopenhauer, who had lived there from 1814 to 1818 and who wrote there the first volume of *The World as Will and Representation* (*Die Welt als Wille und Vorstellung*). Gottfried Semper was appointed professor of architecture at the Dresden Academy in 1834 and completed the Hoftheater, or "Court Theater," in 1841 (Figure 1.1).[1] Wagner became Kapellmeister, or the resident conductor to the court, in early 1843, taking up the position that had been held by the composer Carl Maria von Weber from 1817 until his death in 1826. By the end of March 1848, Wagner had completed half a dozen operas: *Die Feen* (*The Fairies*), *Das Liebesverbot* (*The Ban on Love*), *Rienzi*, *Der fliegende Holländer* (*The Flying Dutchman*), *Tannhäuser*—the last three of which premiered in Semper's Hoftheater—and, finally, *Lohengrin*. Outside of his professional life, Wagner's interests lay also in the political debates of his day. "Now that I had finished my *Lohengrin* and had leisure to study the course of events," he later wrote, "I could no longer help myself sympathizing with the ferment aroused by the birth of German ideals and the hopes attached to their realization."[2]

Born in Leipzig in 1813, Wagner was almost thirty-six when the revolution erupted in Dresden in early May 1849. The extent of his commitment to revolutionary events, and of his political radicalism more generally in the ensuing years, has long been debated, with the composer himself often appearing to share the

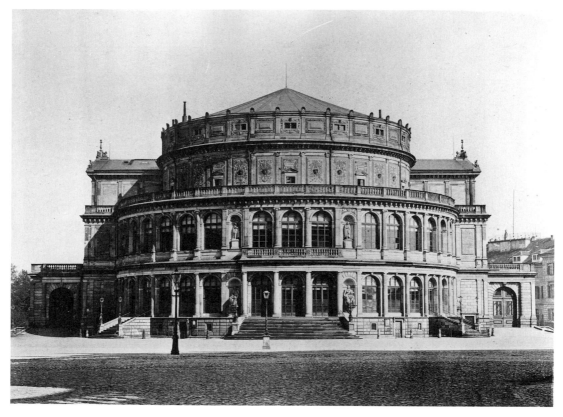

Figure 1.1. Gottfried Semper, first Dresden Hoftheater, completed 1841. Undated photograph courtesy of the Deutsches Theatermuseum, Munich (Semper 58-32-I).

political inclinations of his critics and biographers. Those who posit his youthful radicalism as naive and emphasize his manic zeal in this and other aspects of his life can certainly find reinforcement in Wagner's own later claims; his autobiography reveals embarrassment and defensiveness regarding his leftist political ideals and often ascribes his revolutionary activity to immature folly.[3] His self-deprecation and his insistence that he was merely led into revolution, rather than actively doing the leading, are matched by a suggestion that the ultimate futility of his actions proved their misguided nature. Yet the dangers of accepting such claims are many, with the unreliability of Wagner's own retrospective analyses being only the most obvious. In his "Autobiographical Sketch" of 1843, he reflected more proudly on his political leanings: "But now the July Revolution came; with one bound I became a revolutionary, and acquired the conviction that every halfway-industrious man should be occupied exclusively by politics."[4] Such fervor remained; in the autumn of 1848, the music critic Eduard Hanslick later reminisced, Wagner

was "all politics: with the victory of the revolution, he was convinced, would come a total rebirth of art, society, and religion."[5]

Wagner's revolutionary leanings, however, are often overlooked or minimized, especially those found in the most overt expression of his radical political orientation in these years, *Art and Revolution* (1849). Efforts in recent decades to minimize his radicalism, or to restrict it to the realm of art, are sometimes well intentioned, insofar as they attempt to diminish the association between Wagner and fascism that was established decades after his death. There is much within the composer's writings to suggest such an association; one need look no further than his fierce anti-Semitism in "Judaism in Music" ("Das Judenthum in der Musik"), written in 1850. The introduction to a collection of his writings published in Germany in 1935 emphasizes his rebellion against nineteenth-century liberalism and insists upon the "inner association between Wagner's artistically revolutionary and his politically revolutionary orientation," aligning him clearly with the tenets of National Socialism.[6] But neither this aspect of his thinking nor his later designation as Hitler's favorite composer should distract attention from Wagner's own historical context, or obscure the fact that both anti-Jewish feeling and nationalism were common features of radical leftist thought in mid-nineteenth-century Germany.[7]

The association of Wagner's theoretical ideas and musical works with fascism is due, in large part, to the efforts of his second wife, Cosima, and their progeny. Twenty-five years his junior, Cosima was the second daughter of Franz Liszt; when Wagner met her for the first time in October 1853, she was two months shy of her sixteenth birthday, living in Paris with her siblings and their governess, and he was accompanying her father on a rare paternal visit—the first in eight years.[8] Cosima next met Richard Wagner in 1857, in Zurich, when she had just married the conductor Hans von Bülow, with whom she had two daughters, Daniela and Blandine. Her relationship with Wagner began at the end of 1863; she gave birth to their daughter Isolde on April 10, 1865—the day that orchestral rehearsals began for Wagner's *Tristan und Isolde,* with von Bülow conducting. Another daughter, Eva, was born to Cosima von Bülow and Richard Wagner the following year; Cosima left her husband in 1868, gave birth to Siegfried in 1869, and married Wagner on August 25, 1870.[9] In the thirteen years that remained until Wagner's death, she recorded in her diary her husband's activities, accomplishments, dreams, and moods. She also took dictation for his autobiography, with many scholars noting her creative role in adapting his writing to suit the taste of King Ludwig II of Bavaria, who had commissioned the text.[10]

Some authors, while acknowledging the composer's participation in the revolution of 1848–49, have maintained that he subsequently abandoned politics to attend to artistic matters. "By the time Wagner got around to writing his treatise

on art and revolution," one writes, for example, "he seems to have changed his tune, perhaps because of his experience of Dresden and [the anarchist Mikhail] Bakunin. One year after his conversation with Hanslick [in 1848], Wagner was espousing art and not politics as the true vehicle of revolution."[11] Such a claim, however, constructs a false distinction between art and politics, implicitly presenting true artists as apolitical, or at most only naively political. It also misrepresents the nature of Wagner's arguments and activities. Like his conservatism (both aesthetic and political), his commitment to radicalism is palpable despite his defensiveness, both in the autobiographical descriptions of his activity during the revolution and in the treatises he wrote in the ensuing months. His altered political orientation in late 1849 resulted from a changed personal and historical situation—the failure of a revolution; emigration to Switzerland—after which it would have been delusional to continue clamoring for radical political change.

As a utopian socialist strongly interested in contemporary anarchism, Wagner was steeped in the revolutionary ideas circulating in Dresden, and in Europe more widely, in the autumn of 1848 and the spring of 1849. His political sympathies were influenced in part by his friendship with his assistant conductor, August Röckel, who introduced him to Bakunin, who was also then living in Dresden. Indeed, for weeks before the revolution arrived in that city, Wagner hosted meetings in his home to plan its development; by his own account, he found his discussions with fellow radicals inspiring and challenging and was prompted to seek out particular texts for further study.[12] He read Ludwig Feuerbach, most probably *The Essence of Christianity* (1841) and *Principles of the Philosophy of the Future* (1843), before the revolution. (As Friedrich Engels would write in the 1840s: "We were all, for the time being, Feuerbachians.")[13] But only in June 1849, while exiled in France, did Wagner read such works by Pierre-Joseph Proudhon as *What Is Property?* of 1840.[14]

Wagner's politics in 1848 were strong enough to inspire him to compose and circulate verses in praise of revolution. "The temper of the populace, of which there could be no question," he would later write,

> and the belief, everywhere prevalent, that it was impossible to return to
> the old conditions, could not fail to exercise its influence upon me. But
> I wanted actions instead of words, and actions which would force our
> princes to break for ever with their old traditions, which were so detri-
> mental to the cause of the German commonwealth.[15]

More than two decades before the founding of the German empire, Wagner wished the royals themselves to form the republic that would undermine their own power.

He published an anonymous article calling for a Republic of Saxony, gaining notoriety in the summer of 1848 when he gave, as he later put it, "a very spirited reading of it to about three thousand persons" at a meeting of the Vaterlands-Verein, or "Patriotic Union."[16] "I inquired whether or not it would be possible to realise all this with a king at the head," he wrote, and "pointed to the King of Saxony as being specially chosen by Fate to lead the way in the direction I had indicated." The ideals were republican; the mind-set conservative. The mixture of respect for authority and desire for radical change would prove symptomatic of his thinking.

Early in the autumn of 1848, Röckel's political activism caused him to be suspended from his job as assistant conductor, and he founded the *Volksblätter,* a socialist journal.[17] He continued to discuss politics with Wagner, who was infected by his friend's opinions. "First and foremost," Wagner wrote in his autobiography, Röckel

> had planned a drastic social reform of the middle classes—as at present constituted—by aiming at a complete alteration of the basis of their condition. He constructed a totally new moral order of things, founded on the teaching of Proudhon and other socialists regarding the annihilation of the power of capital, by immediately productive labour, dispensing with the middleman. Little by little he converted me, by most seductive arguments, to his own views, to such an extent that I began to rebuild my hopes of the realization of my ideal in art upon them.[18]

If Röckel's arguments were political in nature, Wagner's interest in them—or so he would claim two decades later—lay in their potential to help bring about his own artistic goals. Discussions with Röckel led him to believe that his cultural plans might be achieved through "a possible organization of the human race, which would correspond to my highest ideals in art."[19] His support for revolution, in other words, stemmed from its potential to sustain a revolution in the arts.

Wagner's political enthusiasms were oriented more specifically around the possibility of establishing a national theater, as articulated in such proposals as the "Plan for the Organization of a German National Theatre for the Kingdom of Saxony" of 1848. "I immediately turned my thoughts to what was close at hand, and directed my attention to the theatre," he later explained, adding,

> I now resolved . . . to suggest to the ministers that they should inform the members of parliament, that if the theatre in its present condition were not worth any sacrifice from the state, it would sink to still more

doubtful tendencies—and might even become dangerous to public morals—if deprived of that state control which had for its aim the ideal, and, at the same time, felt itself called upon to place culture and education under its beneficial protection. It was of the highest importance to me to secure an organization of the theatre, which would make the carrying out its [*sic*] lofty ideals not only a possibility but also a certainty.[20]

The establishment of a German nation was thus, in Wagner's retrospective analysis, fundamentally linked to the creation of its theater.[21] Such a call to provide individual citizens with entertainment, education, and moral development while ensuring their cultural development as a group would become increasingly louder in Germany in the coming years. Decades after the establishment of Germany as a nation in 1871, Georg Fuchs—founder of the Munich Artists' Theater in 1908—likewise demanded a German national theater.

In the spring of 1849, owing either to artistic interest or to a pressing need to escape from the police, Bakunin attended Wagner's rehearsal for a Palm Sunday performance of Ludwig van Beethoven's Ninth Symphony, which was held in Dresden's baroque opera house, designed by Matthäus Daniel Pöppelmann. The concert, it seems, inspired a significant exchange. "At its close," Wagner later wrote, Bakunin

walked unhesitatingly up to me in the orchestra, and said in a loud voice, that if all the music that had ever been written were lost in the expected world-wide conflagration, we must pledge ourselves to rescue this symphony, even at the peril of our lives. Not many weeks after this performance it really seemed as though this world-wide conflagration would actually be kindled in the streets of Dresden, and that Bakunin . . . would undertake the office of chief stoker.[22]

That the father of modern anarchism attended a symphony rehearsal in Dresden that spring and, after the performance, proffered his opinions of the composition to the conductor might now seem extraordinary. That the conductor was, in turn, actively concerned with the radical political questions of his day—and sympathetic to their revolutionary progress—should strike us as no more surprising. The friendship of Bakunin and Wagner, who regularly took walks together in Dresden, exemplifies the imbrication of revolutionary political and artistic plans in that city in 1849.

Wagner's enthusiasm for Bakunin's political ideas, however, was tempered by feelings that he would later describe as repulsion. "In this remarkable man the

purest impulses of an ideal humanity conflicted strangely with a savagery entirely inimical to all civilisation," he wrote in his autobiography, "so that my feelings during my intercourse with him fluctuated between involuntary horror and irresistible attraction."[23] Wagner shared Bakunin's interest in rethinking world politics for the benefit of all its citizens but later claimed not to have shared his wholehearted commitment to political extremism. "Democracy, republicanism, and anything else of the kind he regarded as unworthy of serious consideration," Wagner wrote, for example, whereas he himself considered each potential scenario quite worthy of discussion.[24] His sensibilities appear to have been as much personal as intellectual, and his analysis of their relationship appears perceptive. "Doubtless I, with my hopes of a future artistic remodeling of human society, appeared to him to be floating in the barren air," he wrote, "yet it soon became obvious to me that his assumptions as to the unavoidable demolition of all institutions of culture were at least equally visionary"—or, as it transpired, equally implausible.[25]

In February of that year, Karl Marx and Friedrich Engels published the *Communist Manifesto,* which they had written together in London. In France, Louis Philippe, the bourgeois king who had ruled since 1830, abdicated the throne following the February rebellions; Louis-Napoleon Bonaparte, the nephew of Napoleon, was elected president of the Second Republic in December.[26] In Berlin in early March 1849, Kaiser Friedrich Wilhelm IV—his palace surrounded by protesters inspired by recent developments in Paris—agreed to provide his subjects with a constitution but subsequently reneged on his promise. In Dresden on the last day of April, under pressure from Berlin, Friedrich Augustus II dissolved the Saxon Diet. Wagner later wrote,

> Emergency deputations, nightly mob demonstrations, stormy meetings of the various unions, and all the other signs that precede a swift decision in the streets, manifested themselves. . . . Each local deputation which petitioned for the recognition of the German constitution, which was the universal cry, was refused an audience by the government, and this with a peremptoriness which at last became startling.[27]

Finally, on May 3, 1849, when the king once again refused to meet with the democratic revolutionaries, demonstrators were fired upon and killed by Saxon troops, prompting the construction of the first barricades in Dresden.

The king and court left town the next morning and, Wagner later reported, "news arrived from all sides that, in accordance with a previous compact, the King of Prussia's troops would advance to occupy Dresden."[28] Wagner himself remained

in frequent contact with Bakunin (who, he wrote, "never moved from the town hall," from which he commanded the proceedings) and later reported being entertained, at least initially, by the revolutionary scene: "Elegant ladies with their cavaliers promenaded the barricaded streets during those beautiful spring evenings."[29] He described with amusement how at one point Semper,

> in the full uniform of a citizen guard, with a hat bedecked with the national colours . . . informed me of the extremely faulty construction of the barricades. . . . To pacify his artistic conscience as an engineer I directed him to the office of the "Military Commission for the Defence." He followed my advice with conscientious satisfaction.[30]

Wagner's charming narrative obscures his own role in assigning to the architect the task of building barricades, while also hiding the fact that for weeks, preparatory meetings for the revolution had been held at his home—with Semper, Bakunin, and Röckel, among others, in attendance (Figure 1.2). Prussian troops entered the city the following week, and Wagner left Dresden for his sister's home in

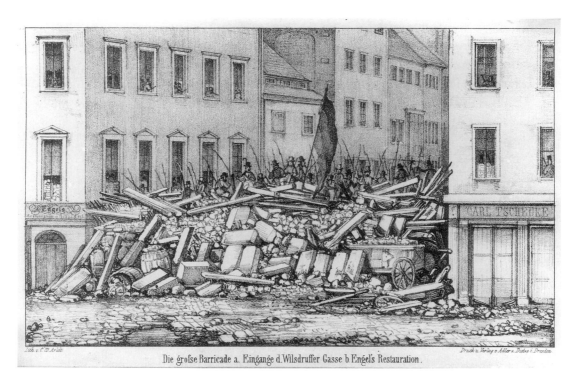

Figure 1.2. C. W. Arldt, *Die große Barricade am Eingange der Wilsdruffer Gasse bei Engel's Restauration, Dresden* (The great barricade at Wilsdruffer Gasse near Engel's Restaurant, Dresden), 1849. Lithograph. National Archives of the Richard-Wagner-Foundation, Bayreuth (N6009).

Chemnitz (with his dog, Peps; his first wife, Minna, followed with their parrot, Papo), returning the next day to check on the progress of the revolution. When, two days later, he arrived at Liszt's home in Weimar, the Dresden police had already issued a warrant for his arrest.[31] He fled to the village of Magdala, where Minna arrived on his thirty-sixth birthday, May 22. The following evening the couple met again in Jena, where it was determined that he would travel through Bavaria to Switzerland, and then to Paris. Wagner arrived in Zurich, alone, on the last day of May 1849.

"I felt so safe and protected," Wagner later wrote of his arrival in Switzerland, "whereas in my own country I had, without quite realizing it, come to be considered a criminal owing to the peculiar connection between my disgust at the public attitude towards art and the general political disturbances."[32] Disingenuously, he implies that his outlaw status had developed coincidentally, through a strange confluence of his own apolitical feelings about art and the revolutionary political fervor of his fellow Dresdeners. Zurich, he suggests, offered a refuge for him to attend to his purely artistic pursuits without the interruptions of politics. This pleasant story, however, masks a more complicated reality. Wagner's political opinions and activities had brought him to the center of the revolution and compelled his emigration. The arguments of Bakunin, Feuerbach, Proudhon, and other revolutionaries encouraged him to develop a utopian schema concerning representation that was no less political for its orientation toward the arts.[33] To paraphrase Marx: in joining forces, the individual forms of art had nothing to lose but their chains; they had an exalted world of artistic expression to win.

ORIGINS AND SOURCES

Like the status of Wagner's political leanings, questions regarding precursors and sources for his ideas—both in 1849 and later—have long provoked critical and scholarly debate. Already in 1892, Wagner's English translator, William Ashton Ellis, acknowledged that the composer's "whole scheme is Schopenhauerian from beginning to end," but he insisted that the two men had arrived independently at their ideas and, with regard to *The Art-Work of the Future,* maintained that

> an attentive perusal of this pregnant chapter cannot fail to bring home to those conversant with Schopenhauer's *"Wille und Vorstellung"* the remarkable fact that two cognate minds have developed an almost identical system of philosophy. For it must not be forgotten that R. Wagner was at the period of writing this essay, and long after, completely ignorant—as indeed was almost the whole world—of even the existence of the sage of Frankfort [*sic*].[34]

Indeed, Schopenhauer's *World as Will and Representation* first came to Wagner's attention in the autumn of 1854, through his friend the poet Georg Herwegh. Like most Germans, Wagner had remained unaware of Schopenhauer's book for three and a half decades after its publication, until it became the subject of an unsigned article in the British journal *The Westminster Review* in April 1853 and subsequently gained the notice of German readers.[35]

In 1872, Wagner himself referred to the "unspeakable benefit" of his close analysis of Schopenhauer's writings; despite such evidence, one critic insisted in 1895 that no traces of the philosopher's influence could be found in the composer's work. "Even those who want to find Schopenhauerian philosophy in the fundamental drifts" of his music dramas, Georg Fuchs asserted,

> are incorrect. Schopenhauer's theory has indeed had an effect on the textual arrangement in a purely formal manner; it has influenced the wording. But that constitutes by no means a material failure, but rather merely a formal tastelessness. The Haruspex will hardly be found who could predict Schopenhauer from the music, from the most secret entrails of the work, except for in ideas belonging to the common ground of all thinkers.[36]

Schopenhauer's ideas, in other words, were so pervasive in late-nineteenth-century Germany as to be impossible to attribute specifically to the philosopher himself. A visitor to Wagner's study in 1875, however, reported that "by the left of the door, a picture of Schopenhauer faced Wagner's large desk."[37] It is clear—and not only from Wagner's account—that the composer's encounter with the philosopher's writings in 1854 prompted a shift away from an overt and optimistic political radicalism and toward a sublation of such sympathies within his music dramas; the philosopher clearly also remained a significant source of inspiration to him.

Beyond Schopenhauer lay a range of other authors whose ideas contributed to the construction of Wagner's own arguments. While eighteenth-century theorists had cautioned against the interrelation of the arts (most famously Gotthold Ephraim Lessing, in his "Laocoon" of 1766), the theme appeared more positively in subsequent decades in the work of a range of German thinkers. Prominent among them were Franz Brentano, Georg Wilhelm Friedrich Hegel, Friedrich Hölderlin, Novalis, Friedrich Schiller, Friedrich von Schlegel, and Ludwig Tieck and Wilhelm Heinrich Wackenroder—most of whose works Wagner read in the years preceding the revolution.[38] His study of the writings of E. T. A. Hoffmann (who had been a friend of his father, Friedrich, and an acquaintance of his uncle Adolf) likewise inspired his understanding of the arts as linked both theoretically

and in practice.[39] Long before Wagner began writing, Hegel had valued tragic drama above all other arts, while Schlegel had placed the novel at the artistic pinnacle; these precursors offered inspiration and, more generally, provide evidence of the importance of the notion of artistic interrelation to early-nineteenth-century German aesthetic thought.[40] Philosophical and literary sources thus merged with political ideals to produce an orientation in Wagner's own work that was simultaneously political and aesthetic.

In a lecture of 1803, Friedrich Wilhelm Joseph Schelling endorsed Greek tragic drama as "the highest incarnation of the '*An-sich*' and the essence of all art," presenting it as the ultimate model for uniting the various art forms in a manner that strikingly prefigures Wagner's subsequent formulations.[41] "The most perfect combination of all the arts," Schelling argued,

> the unification of poetry and music through song, of poetry and painting through dance, itself brought once again to synthesis, is a theatrical manifestation in its most complete composition, equivalent to the drama of antiquity, of which has remained for us only a caricature, opera, which could be developed into a higher and more noble style from the side of poetry as well as from that of the other competing arts, to lead us back to the mode of production of ancient drama, linked with music and song.[42]

With a marvelously circuitous sense of historical development, Schelling's vision combines poetry, music, and dance to re-create the achievements of ancient drama in order to produce the hypothetical opera of the future. Precisely this mixture of nostalgia for a fictionalized Greek past and utopian yearning for an as-yet-nonexistent model of artistic interrelation would appear in Wagner's writing.

Within the musical arena, one immediate model for considering the interrelation of the arts had been provided by Weber, whose position as Kapellmeister Wagner had inherited in Dresden and whose opera *Der Freischütz* had its first performance there, with Weber conducting, in 1821.[43] In 1817, in a review of E. T. A. Hoffmann's *Undine*, Weber set out a definition of opera that appears to provide a template both for Wagner's theoretical ideas and for his music dramas. "Of course when I speak of opera," Weber explained,

> I am speaking of the German ideal, namely a self-sufficient work of art in which every feature and every contribution by the related arts are moulded together in a certain way and dissolve, to form a new world. In most cases individual numbers decide the fate of an opera. It is only

rarely that such attractive individual features, which strike the listener immediately, disappear in the final impression of the work as a whole, as should ideally occur. For ideally the listener should fall in love with the whole work and only later pick out the details of which it is composed.[44]

Such a combination of the arts, their formal distinctions dissolved to create a "new world," would prove central to Wagner's own compositions, both musical and theoretical; the emphasis on continuous music rather than distinct musical numbers would become known in the following decades as Wagner's "unending melody."

The nationalism with which Weber buttressed his argument was prompted in part by the fact that his task, as Dresden Kapellmeister, was to establish a German opera company. But such arguments rested more generally on a notion of Germanic seriousness and intensity—emotional, psychological, intellectual, and creative—that he contrasted with the shallow spectacle of French and Italian opera. "No people has been so slow and so uncertain as the German in determining its own specific art forms," he wrote several weeks later, adding,

> Both the Italians and the French have evolved a form of opera in which they move freely and naturally. This is not true of the Germans, whose particularity it has been to adopt what seems best in other schools, after much study and steady development; but the matter goes deeper with them. Whereas other nations concern themselves chiefly with the sensuous satisfaction of isolated moments, the German demands a self-sufficient work of art, in which all the parts make up a beautiful and unified whole.[45]

Weber not only ascribed particular personality traits to the inhabitants of different nations—decades before the German nation came into being—but also conflated such traits with the attributes of the art forms that each nation produced. The sensuous ease and discrete musical numbers of French and Italian opera, he believed, signaled its creators' superficiality and fully engaged the superficial audiences of France and Italy.

German audiences—slow, pensive, and unwilling to enjoy the shallow delights of French and Italian opera—demanded something more profound from their composers, Weber argued. By extension, they also deserved theatrical productions that reflected the profundity of the German soul. "The theater has become little more than a peepshow," he lamented in 1817, one "in which the noble and satisfying excitement associated with true artistic pleasure has been carefully avoided, and in its stead we have been content with the titillations of trivial jokes and

melodies and dazzled by pointless stage spectacle."[46] By implication, his task in Dresden was to recapture the sense of nobility and excitement intrinsic to opera without succumbing to the popular taste for spectacle. This same task would later fall to Wagner, as composer, theoretician, and impresario. Significantly, however, productions at Wagner's own Festival Theater in Bayreuth would themselves, decades later, be derided for their reliance on the spectacular.

The term "Gesamtkunstwerk" itself has been traced to 1827, when it appeared twice (once hyphenated, once not) in the writings of Karl Friedrich Eusebius Trahndorff, a philosopher based in Berlin. "The four arts," Trahndorff grandly declared,

> the art of wordsound [*Wortklang*], music, facial expression [*Mimik*], and the art of dance, contain within themselves the potential to join together into one presentation. But this potential is founded on a striving that pervades the entire artistic sphere; a striving toward a total work of art [*zu einem Gesamt-Kunstwerke*] on the part of all the arts; a striving that is germane to the whole artistic sphere, insofar as we recognize the unity of its inner life. This possibility will therefore comprise not only the aforementioned arts, but all of them.[47]

Citing four individual forms of art, Trahndorff maintained that their combination both represented and encouraged a wider, more diffuse expression of artistic inter-relation, one comprising a range of unnamed artistic forms and oriented, fundamentally, toward performance. Two decades later, Wagner—following Schelling—would cite just three art forms: poetry, music, and dance. But the understanding remained of a larger unified work made up of a limited set of constituent parts—as did the suggestion that the completion of the work depended on its presentation to an audience.

But if Wagner was neither the first to theorize the Gesamtkunstwerk nor the first to name it, the concept now is nevertheless associated primarily with his name.[48] This achievement may be due to the force of his personality, the vehemence of his arguments, their artistic elaboration in his own compositions, the construction of a theater in which these works could be experienced, or the receptive environment in which his ideas were expressed. Above all, it derives from the nature of his arguments. The Gesamtkunstwerk would foster a more direct artistic communication between the creative artist, the work of art, and the audience: three elements that would combine during the process of aesthetic engagement to achieve the grand unifying experience at which Wagner believed all artistic creation was ultimately aimed. Interweaving aesthetic, national, and political

aspirations, conflating production and reception, and utopian in orientation, Wagner's discussion of the communal activity of artistic production and spectatorship that helped create both the total work of art and its audience would prove central to modernism for well over a century.

THE GESAMTKUNSTWERK OF THE FUTURE

"The year 1848," George Macaulay Trevelyan famously decreed in 1922, "was the turning point at which modern history failed to turn."[49] The revolutions of that year appeared—if only briefly—to set democratic reforms in motion across Europe, and the two treatises that Wagner wrote while in exile in Zurich in the autumn of 1849, *Art and Revolution* and *The Art-Work of the Future,* reveal his fury and disappointment following this political failure. Combining fierce nostalgia and utopian longing, they formulate a revolutionary program regarding the relation of aesthetic theory to artistic practice and the sociopolitical causes and effects of each. Both also posit the complete and mutual overlap of aesthetic and political radicalism, presenting communication and representation as the highest ideals while arguing for the rights of the individual and for the potential for individuals to acquire an identity and a voice through their participation in a group. Wagner's descriptions of the interrelation of the individual forms of art and the work of art they would together produce also applied to the spectators for such a work of art, as well as to their experiences, individual and communal, within and beyond the auditorium. His ideals were utopian, but—he insisted—far less utopian than those of Christianity. They were also simultaneously revolutionary and conservative—or, as he put it, "This art will once again be *conservative.*"[50]

Both texts show Wagner adopting, from his philosophical sources, the cultural model of ancient Greece. "Before what phenomenon do we stand with more humiliating sense of the impotence of our frivolous culture," he demanded with characteristic extremism in *The Art-Work of the Future,* "than before the art of the *Hellenes?*"[51] He called for a German artistic culture that, like the one he imagined to have existed in ancient Greece, both expressed and fostered the nation's political culture; one that would also be worthy of the nation it would, in turn, help create. Indeed, while often associated with Nietzsche's *Birth of Tragedy,* the metaphoric pair of Apollo and Dionysus had already appeared in Wagner's *Art and Revolution.* "The Grecian spirit, at its zenith in state and art, found its fullest expression in the god Apollo," Wagner argued, while Dionysus was a crucial cultural catalyst who fostered creativity and caused the unification of all art forms: "Inspired by Dionysus, the tragic poet saw this glorious god [Apollo] when, to all the rich elements of spontaneous art, the harvest of the most beautiful human life . . . he joined the bond of speech, concentrating them all into one focus to bring forth the highest

conceivable art: *drama.*"[52] The cultural function of Dionysus was thus to inspire the poet to envision an Apollonian image of beauty. Under the influence of both gods, operating in tandem, the poet would create the work of art of the future, one worthy of the nation whose values it expressed.

The first of the two treatises, *Art and Revolution,* aimed, Wagner announced, "to discover art's significance as a factor in the life of the state, and to come to understand art as a social product."[53] This theoretical argument was framed by a sweeping historical narrative. Situating the origins of art in ancient Greece and celebrating tragic drama above all other forms of cultural production, Wagner attributed the downfall of the arts to their separation from one another in an artistic dissolution that had accompanied the disintegration of the Athenian state. There followed, he argued, two millennia that properly belonged "to *Philosophy* and not to Art," when the Christian thinking characteristic of Roman life replaced the artistic expression of ancient Greece.[54] Rather than helping to create and celebrate the community, art now was affiliated most strongly with commerce and industry. It aimed, in other words, at the distraction of individuals—either as "the entertainment of those who are bored" or, at the other end of the socioeconomic scale, as a safety valve to "calm the passions, absorb the excitement, and divert the threatening agitation of the heated human mind."[55] Neither role, in Wagner's mind, was an acceptable one for art.

No such tactics had been necessary in ancient Greece, where, Wagner believed, the spectator's experience was participatory rather than diversionary; the individual happily took part in the formation of the work of art by witnessing and encouraging its emergence into the public realm. "Thus the Greek was his own actor, singer, and dancer," he maintained, while "his contribution to the performance of a tragedy was to him the highest pleasure in the work of art itself."[56] This aesthetic process paralleled the creation of a larger national unity. But with the cultural and political collapse of ancient Greece came the segregation of the individual arts, a procedure felt with particular vehemence on the Athenian stage:

> Drama disintegrated into its component parts: rhetoric, sculpture, painting, music, etc., each of which forsook the ranks in which they had moved in unison, in order that each one might find its own path . . . independently but alone. And thus it was that at the rebirth [*Wiedergeburt*] of art we first met with these isolated Greek arts as they had developed out of the disintegration of tragedy.[57]

The European discovery of the arts of ancient Greece thus entailed the rebirth of each of these arts individually. Unfortunately, these art forms remained isolated

from one another; Wagner argued that their reunification would occur alongside the unification of Germany itself. "Only the great *human revolution,*" he declared, "can also win for us this work of art."[58]

Over the course of a few weeks in late 1849, while still in Zurich, Wagner expanded on his ideas to produce *The Art-Work of the Future.* This work, more than four times the length of *Art and Revolution,* invoked (both with its title and throughout the text) Feuerbach's *Principles of the Philosophy of the Future* of 1843; its first edition was dedicated to the philosopher.[59] Its language, yet more convoluted and bombastic than that of *Art and Revolution,* even led one early biographer to remark, "Unfortunately, Wagner has allowed himself to adopt the phraseology of Feuerbach, and has applied it to his own theories to such an extent that the result is very puzzling to the reader, and the work, of an animated style and a real value, is in every respect painful to read."[60] The treatise contains five chapters: "Man and Art, in General," "Artistic Man and the Art Derived Directly from Him," "Man as the Artistic Shaper of Nature's Material," "Outlines of the Work of Art of the Future," and "The Artist of the Future."[61] With these, Wagner articulated a utopian vision of the ideal work of art, elaborating on his arguments concerning the interrelation of the individual arts as well as on the spectator's role as an individual and as a member of a larger audience.

Above all, *The Art-Work of the Future* presents the overarching conceptual framework for the Gesamtkunstwerk, foregrounding its utopian nature by situating it at the crossroads of a fictionalized past and an unachievable future. Wagner conceived of three sister arts in this total work of art: poetry, music, and dance.[62] Deriving from the human faculties of speaking, listening, and looking, they formed the three central components of the lyric drama of ancient Greece and together covered the widest range of creative activity imaginable. Other art forms were introduced into the discussion as necessary; the idea of artistic interrelation suggested a multiplicity of art forms, a communal effort, with the precise number of the participants less relevant than the fact of their collaboration.

Today, the Wagnerian Gesamtkunstwerk is often considered to be a site of artistic fusion within which each individual art form discards its identity to participate in the larger group. However, Wagner himself described the concept in 1849 in terms that suggest exactly the opposite. "Not one richly developed faculty of the individual arts will remain unused in the Gesamtkunstwerk of the future," he decreed; "precisely in it will each one attain its full value for the first time."[63] Music, poetry, and dance, in other words—debased versions of their ancient Greek selves—would recapture their former glory and even surpass it. In Wagner's utopian vision of artistic interrelation, each art form discovered its own identity, as it were, in the process of contributing to something larger than itself. Without

specifying the faculties of the individual arts, Wagner argued that these would be enriched and ennobled by the process of unification. With the rhetoric and symbolism of democratic reform, he described how each art form would, by joining the effort to produce the total work of art, find its own voice and develop itself yet more fully.[64]

In this idealized scenario, artistic representation was not simply aural, verbal, or visual; it was also performative and political. In joining the Gesamtkunstwerk, each art form grew stronger in the struggle to define itself against the others and became more independent in the process. *"The solitary thing [Einsame] is unfree,* because it is fettered and dependent in un-love," Wagner explained; conjoined with others, *"the united thing [Gemeinsame] is free,* because unfettered and made independent through love."[65] On its own, for example, music vainly attempted to reproduce the attributes more properly and effortlessly achieved by its sisters, attaining the freedom to be its true self only in its association with them. The interrelation of the arts provided the necessary conditions for ensuring the autonomy of each, which he also described in terms of formal purity; each form of art would come into its own precisely to the extent that it abdicated control over its own identity. The paradox was by no means original to Wagner. "The real source of individuality was the *Volk* or the community," Fritz Stern has written of late-nineteenth-century Germany more generally, "and only by restoring it, if necessary through compulsion, could freedom and greatness be achieved."[66] The foundation of the German nation in 1871 was likewise conceived as the integration of individual states into a whole entity that would enhance, not diminish, their particularity.

Only when poetry joined "in sisterly community [*schwesterliche Gemeinschaft*] with the other arts," Wagner argued, would this art form be fully capable of exploring its own essential characteristics.[67] His rhetoric relied heavily on anthropomorphism; each individual art form was to achieve its freedom and independence by joining the Gesamtkunstwerk, losing its identity in this process by succumbing to a sisterly love that also signified a formal death. Suggestions of psychological urges and sibling rivalry masked an understanding of the art forms as spatial entities, possessing centers and peripheries. The boundaries between them remained dynamic sites of aesthetic activity, with their struggles taking place until their contours melted into those of their neighbors in what Wagner described as a process of absorption.[68] Purification occurred, metaphorically speaking, at the center of each art form. If the concept of the Gesamtkunstwerk was predicated on notions of artistic purity, on the refusal to allow one art form to become contaminated by any other, the autonomy of each form of art required the others' presence, theoretical or otherwise.

Wagner's argument was, at its core, political: "Only in communism," he maintained, "does egoism find itself completely gratified."[69] For all his revolutionary rhetoric, however, his discussion of the sister arts also exudes the conservative sentiments typical of their nineteenth-century context. Like their real-life female counterparts—women who would supposedly become more truly feminine as a result of a domestic union—the individual forms of art would discover their true nature only in connection with others. Poetry might march alongside its sisters, that is, but the autonomy and independence it thereby achieved ensured its continued association with the other arts. The Gesamtkunstwerk would operate like a traditional marriage; its success depended on a feminine sacrifice that was disguised by the rhetoric of freedom and autonomy. "Only when the defiance of all three art forms with respect to their independence breaks down to become a love for the others, only when they stop being individual arts," Wagner asserted, "will they all be capable of creating the complete [*vollendete*] work of art, and indeed their coming to an end in this sense is already in itself this work of art: their death immediately its life."[70] Poetry, music, and dance would engage in a battle to achieve their own artistic identities before, ultimately, succumbing to a love that both defined their essential femininity and signaled the demise of their autonomy.

If the various art forms were ennobled by their communal efforts to produce the Gesamtkunstwerk, so, too, were the spectator's own senses united and ennobled by the encounter with it. The experience of the individual spectator was likewise reproduced at a larger scale; in the presence of the total work of art, spectators discarded their own identities as individuals to become a unified audience. The process of entering the collectivity strengthened individuals' identity precisely to the extent that it dissolved them in a larger group. Each individual art would gain its "full value" in collaboration, an achievement measured not by some abstract ideal but, rather, by the intensity of the overall effect produced on the spectator. The combination of all art forms encouraged the purest expression of each and created a more effective Gesamtkunstwerk. As a gathering of several art forms that took place over time, a dramatic performance extended further beyond its own formal boundaries than any other form of artistic expression. And whereas a painting might exist independently of any viewer and could be described without recourse to a discussion of its audience, live performance only came into being as a result of the spectator's experience. In Wagner's words, a written drama "becomes a work of art only on entering public life; and a work of dramatic art enters life only through the theater."[71] The emphasis on the central role of spectatorship in producing the final work of art ensured that, fundamentally, performance would be valued above all other kinds of artistic production.

In helping to create the Gesamtkunstwerk, Wagner argued, individual artists would see their work improved; painters, for example, would achieve a higher standard by contributing to a stage production. "The illusion he could only hint at, could only approximate, with a brush and with the finest blend of colors," Wagner declared, "will he here achieve completely through the artistic employment of all the devices of optics, and of the art of lighting, available to him."[72] With increased exposure at the theater, where (at least theoretically) more people would gather to examine their work, painters would find their labor personally more satisfying: "The complete artwork that faces him from the *stage,* in this frame and in its fully collective public life [*Öffentlichkeit*], will satisfy him infinitely more than did his earlier work, made with more refined tools."[73] In this utopian scenario, spectator, artist, and the work of art enjoyed the mutual satisfaction of producing the Gesamtkunstwerk. Such communal efforts ennobled both the sister arts and their creators, with the spectator's own senses united and enriched by the encounter.

THE AUDIENCE OF THE FUTURE

The notion of *Öffentlichkeit*—"publicity," "public life," or "public sphere"—was central to Wagner's writing in 1849. Beyond reflecting the size of the work of art or of its audience, the term referred to the shared aesthetic experience enjoyed by the audience in the presence of the Gesamtkunstwerk. Theater performances not only made a work accessible to a larger number of people, in Wagner's estimation, but also served and produced a particular kind of group: the communal audience. Just as the work of art was produced by a combination of the individual arts, this audience was in a sense produced from the individual spectators who experienced it together. Through the notion of publicity, Wagner linked this shared aesthetic experience to public life more generally. Tragic drama, as an art form that was communally produced and communally received, represented "the entry of the people's work of art [*Volkskunstwerk*] into public political life."[74]

The total work of art thus operated equally in the political and the aesthetic realms. It had not yet been achieved in Germany, just as the German nation itself did not yet exist; in Wagner's view, both would come about simultaneously. The tragic drama created in the future German nation would counteract the prevailing tendencies of French comedy and Italian opera, which he considered to be oriented toward the spectacular and the commercial and to be ultimately individualistic in nature. Wagner wished his music dramas to emphasize psychological nuance, dialogue between individual characters, and his signature "unending melody." These works, he hoped, would overcome the divide between the grand opera then being produced by the French and the Italians—exemplified by the

works of Giacomo Meyerbeer and Gioacchino Rossini—and the instrumental cre-
ations of German composers.[75] He expressed disdain for "emotionally dissolute
Italian opera arias or naughty French cancan dance tunes," lamenting that only the
"*virtuosity of the performer* determines the audience's idea of theatrical art, as it does
in most French theaters and even in the world of Italian opera."[76] Performances
of his own music dramas, he believed, would follow the model of Greek tragedy
to gather contemporary Germans together and, ultimately, encourage a rebirth of
German culture. The strength and identity of individual spectators would be rein-
forced through participation in the communal audience, producing the idealized
German audience of the future.

Wagner linked publicity to an idea of communism—as opposed to what he
termed egoism, or individualism. The former described the public and communal
experience, simultaneously political and aesthetic, of a group of people; the latter
referred to the private experience of the solitary individual. Wagner later wrote
that he had used the term "communism" to mean "a sociopolitical ideal that I
conceived as embodied in a people [*Volk*] that connoted both the incomparable
productivity of an ancient brotherhood and the most complete and perfect [*vol-
lendetsten*] measure of the generalized essence of the future."[77] Like the notion of
the Gesamtkunstwerk itself, it was both nostalgic and utopian—conflating the
idealized past of ancient Greece and the imagined future—rather than extant. The
concept likewise reflected an emphasis on the defining function of the audience,
whether figured as the *Volk,* the ancient brotherhood, or the essence of the future.

Wagner distinguished between individual and communal spectatorship with a
metaphor of framed images. Whereas a smaller, framed painting might be viewed
by individuals and small gatherings, he argued, the grander image on a theater
stage was framed within a large proscenium arch and encountered by a group
audience:

> What the landscape painter . . . had constricted in narrow frames—
> what he had hung on the egoist's secluded chamber walls, or had aban-
> doned to the unconnected, incoherent, distorted stacks of a picture-
> storehouse—*with this* he will now fill the wide frame of the tragic stage,
> creating the whole scenic expanse as evidence of his power to re-create
> nature.[78]

By contributing to the Gesamtkunstwerk, the painter helped form this commu-
nal audience from a group of individuals—an achievement that, in Wagner's
mind, far surpassed that of placing a small painting before a solitary viewer. The
very presence of a communal audience exalted the viewing experience.

Wagner described the aesthetic activity of the individuals who formed this audience with the notion of the "sympathetic [*sympathetisch*] gaze," which was active, participatory, and fundamental to the creation of the work of art.[79] Just as the individual arts were absorbed into one another to create the work of art of the future, both individual spectators and the performers whom they faced were absorbed into the surrounding audience through a process of sympathy or emotional and psychological transference. Thus the spectator, "by looking and hearing, completely transports himself onto the stage; the performer becomes an artist only by complete absorption into the audience."[80] The ultimate achievement of an artist—whether actor or performer—lay in activating the sympathy of a group of spectators, an experience that Wagner also described in terms of *Mitfühlung,* or the activity of "feeling with." "By placing his work of art in the frame of the tragic stage," he explained, the painter "will broaden his audience from the individual whom he wishes to address to the collective of the entire public, and he will be satisfied in having extended his understanding to it, of having made it sympathetic to his joy [*ihn zum Mitfühlenden seiner Freude gemacht zu haben*]."[81] As Wagner put it two years later, the communal sympathy experienced by the group of "fellow-feeling and fellow-creating friends [*mitfühlenden und mitschöpferischen Freunde*]" would help create the total work of art of the future.[82]

Reconfigured as Einfühlung, or "feeling into," a version of this notion of sympathy would become central to German aesthetic discourse in the coming decades, as we shall see. For Wagner as for later theorists, the experience was inherently linked to that of self-estrangement, a hybrid emotion that he likened to "a thorough stepping out of oneself into unconditional sympathy [*Mitgefühl*] with the joy of the beloved, in itself."[83] Just as the art forms became more truly themselves by being absorbed into the other arts, each spectator's merging into the larger audience likewise encouraged a paradoxical autonomy in that spectator; the aesthetic response to the work of art inspired in both realms a creative generosity and a consequent loss of self. In Wagner's utopian scenario, the artist would aim his work at "those who, out of their general sympathy [*Sympathie*] for him, *can also comprehend his position* and, *by sharing in his striving* . . . can use their own creative free will *to replace the abundance of enabling operative conditions* that . . . are denied to his work of art by reality."[84]

Where individual art forms, encountered without the presence of their sister arts, might impress an individual spectator, only a unified set of art forms—each one struggling to delimit its own formal boundaries—could achieve a truly powerful effect on a larger audience. Denigrating the model of isolated spectatorship demanded by a small work of visual art, Wagner instead endorsed the shared reception of a group audience, which he conceived of as active. Like the individual

arts that were brought together to form the Gesamtkunstwerk, members of the unified audience were to be participants in its creation, not merely passive witnesses; their collective presence was central to the creative power of the work of art. "The highest shared artwork is the *Drama*," Wagner declared; "true Drama is only conceivable as emerging from the *shared urge on the part of all the arts* towards the most direct communication to a shared *public*."[85]

Such communication ultimately depended very little on language in the narrow sense. According to Wagner, the silent appreciation of a written text, an encounter enjoyed privately by an individual reader, could never approximate the full aesthetic experience that a work of art might provide when performed out loud before a gathered public. He decried the days when only mediocre poets concerned themselves with a play's performance, while superior poets confined their attentions to the written word. As a result of this deplorable situation, he exclaimed (without specifying the time period under discussion), "the unheard-of happened: *dramas written for silent reading!*"[86] Ideally, Wagner maintained—his arguments conveniently supporting the music dramas that had already made him famous—poets would orient their work toward eventual performance, incorporating such elements as sound and movement. The shared experience of this performance would unite the audience in a festival of artistic representation and communication.

In the mid-nineteenth century, the Gesamtkunstwerk could only exist as an artwork of the future, one that aimed at building future audiences. By implication, foretastes of this future could be found in Wagner's own music dramas. Wagner referred to such utopian audiences as the *Volk*, a term that represented a notion of unified German cultural strength and carried an amorphous political significance. In 1849 he defined the fellowship tautologically, as comprising those individuals who wished to be a part of such a group. "*Who is the Volk?*" he asked; who *was* the audience of the future? Such a group "is the epitome of all those *who feel a communal need*. To it belongs, then, all those who find their individual need to be based in a communal need."[87] The *Volk* thus gathered those individuals who wished to be unified by their communal experience—an experience that was both aesthetic and political. Facing a work of art, Germans would exchange their individuality for a collective identity that, for Wagner in 1849, had revolutionary potential. In later decades, the notion of the *Volk* played a more conservative role in the field of cultural criticism, and Wagner's own understanding of it likewise shifted.[88] The vagueness of this entity made it all the more easily manipulated, allowing a conceptual overlap between individual spectators and the group audience of the future that covered a range of political meanings.

If the spectator helped create the work of art, the creation of the Gesamtkunstwerk would demand the presence of a particular audience. But in Wagner's view,

the contemporary German audience was merely a "conglomeration of capricious selfishness" that paled in comparison with the Athenian spectators of the past.[89] The problem lay partly in the socioeconomic uniformity of the contemporary audience. In German theaters "loll only the affluent classes," Wagner lamented, whereas "within the ample boundaries of the Grecian amphitheatre the whole populace [*Volk*] attended the performances."[90] Brought together for a communal experience, such audiences formed a public entity that represented the nation as a whole; individual spectators gathered together to form a unified audience in a manner that paralleled the entry of the work of art, with all of its own components, into the public realm. Possessing no variations that might be overcome by the experience of the performance, the modern German audience of 1849 was constitutionally unable to undergo the cathartic experience—whether described as absorption, sympathy, or fellow feeling—that Wagner considered necessary for the creation of the total work of art of the future.

2

Building Bayreuth

God, how does either a provisional or a definitive Festival Theater [*Festspiel-haus*]—or all the building in the world—concern me?

—RICHARD WAGNER, diary entry of September 9, 1865

THEORETICAL ARCHITECTURE

While not one of Wagner's three sister arts, architecture was critical to the success of the exalted work that poetry, music, and dance would create together, and it appeared prominently in his discussion of their interrelation. The ideal construction of the stage and auditorium would allow architecture to remain silently present during the performance, fostering the most direct communication between the Gesamtkunstwerk and its audience. Like a cousin chaperoning the sister arts from a distance, its success was measured by its invisibility; as a conduit for the ideal aesthetic experience, it would be crucial but imperceptible. "In a perfect theater building," Wagner wrote, "down to the smallest details, only the necessity for art gives measure and law. This need is twofold: that of *giving* and of *receiving*, which suggestively pervade, and are mutually dependent on, each other."[1] The building was to encourage a fully reciprocal relationship between the work of art and its audience—a process of artistic exchange, of mutual absorption and emotional transport, which would occur not only between the audience and the Gesamtkunstwerk but also between the audience and the performers on stage. In this communal catharsis, "the audience, that representative of public life . . . disappears from the auditorium; it lives and breathes only in the work of art, which it takes for life itself, and on the stage, which it takes for the universe."[2]

Gottfried Semper's Hoftheater in Dresden had offered Wagner an example of how a building might gather spectators together to form an audience and house the united art forms, and the architect remained an important interlocutor. His pamphlet of 1834, *Preliminary Remarks on Polychrome Architecture,* had even referred in passing to the idea of the interrelation of the sister arts, albeit without using the term "Gesamtkunstwerk." "Under the architect's supervision," Semper wrote, "the monument became the quintessence of the arts; as a unified work of

art [*als einiges zusammenhängendes Kunstwerk*], it was defined, developed, and sustained in its details. Architecture as a separate art evolved quite naturally in relation to its sister arts."[3] While the argument is hardly unique enough to Semper to secure him as the primary source for Wagner's own opinions, it provides further evidence of the strong intellectual affinity between the two and suggests a provocative link between the idea of the Gesamtkunstwerk and contemporaneous debates over polychromy.[4] The artistic interrelation that occurred between the arts also took place within each one. As one British critic wrote, "Wagner's symphony may be likened to an omni-coloured kaleidoscope, where the same bits of painted glass incessantly appear and disappear, yielding prominence to others that have been seen before, and puzzling the eye of the examiner, as the Wagner orchestra puzzles, while it frequently enchants, the ear."[5]

If, in Wagner's conception of the Gesamtkunstwerk, the appropriate architecture helped produce the work of art, then the reverse might also be true. In the theater of the future, architecture would—like the sister arts—be transformed. "Only with the release of the egoistically separated humanistic art forms into the collective work of art of the future," he explained, "will architecture [*Baukunst*] also be released from the bonds of serfdom . . . into the most free and most indefatigably fertile artistic activity."[6] In this utopian scenario, the theater itself would not merely provide a frame through which to view a work of art; it would also combine with the art forms that appeared on stage to help create an aesthetic experience for those within its auditorium. The design of the auditorium was thus critical to Wagner's conception of the Gesamtkunstwerk, producing the optimum conditions for its reception—and, more theoretically, linking the sister arts of music, poetry, and dance to the larger theme of spectatorship.

Where it served his argument, Wagner also made use of architectural metaphors. In distinguishing between solitary and group audiences, for example, he contrasted the communal environment of a Greek amphitheater with the model of solitary confinement found within a Christian monastery. "Whereas the Greek, for his edification, gathered in the amphitheater for the space of a few short hours full of the deepest meaning," he wrote, "the Christian shut himself away in a cloister for life."[7] Ignoring the collective sanctuary offered by the Christian church, Wagner argued that the tragic drama of ancient Greece represented the highest cultural ideal and was facilitated by the spaces of the Greek amphitheater, where people convened to share the experience of spectatorship. Architecture not only helped create this experience but also expressed the spirit of its age. "We need but honestly search the content and the public effects of our art, especially that of the stage," Wagner noted, "to see the spirit of the public reflected in it as in a faithful mirror image."[8] Peering into this mirror to view the contents and the workings of contemporary German theater, however, he remained unimpressed: "Our modern

theatrical art makes manifest [*versinnlicht*] the ruling spirit of our public life . . . just as Greek tragedy marked the high point of the Greek spirit, but ours is the blossoming of the decay [*Fäulniss*] of a hollow, soulless, and unnatural order of human affairs and relations."[9]

Utopian ideals notwithstanding, Wagner also wished to have a theater constructed for productions of his own music dramas. In September 1850, he described his plans in a letter to the painter Ernst Benedikt Kietz, writing that the sum of 10,000 thalers would allow him to build a structure worthy of *Siegfried,* the music drama for which he was then composing the score.

> Then I would write out invitations to all those, everywhere, who were interested in my works, ensure a decent arrangement of the auditorium, and give three presentations—free, of course—one after another, in one week, after which the theater would be demolished and the thing would have its end. Only something like that can still appeal to me.[10]

Here Wagner articulates four crucial components of his project: the specially constructed auditorium, the sympathetic audience, the free performance, and the provisional nature of the event. All four would remain relevant to his thinking until 1876, when his Festival Theater finally opened to the public in Bayreuth.

The following week, Wagner laid out his plan in more detail in a letter to Theodor Uhlig, his successor as resident conductor of the Dresden Hoftheater. He wished his new theater to be built in Zurich, he wrote, in "a beautiful meadow near the city" with all the specifications necessary for a production of *Siegfried.* "Then I would choose the most suitable singers available anywhere and invite them to Zurich for six weeks," he wrote; "I would seek to form the chorus for the most part from volunteers here. . . . I would also gather my orchestra together that way." Wagner was motivated not only by a desire to save money but also by a fundamental belief that his works should be accessible:

> In the New Year the advertisements and invitations to all friends of musical drama would go out through all of Germany's newspapers, with the request to visit the planned festival of music drama; whoever registered and traveled to Zurich especially for it would have guaranteed entry—of course, like all entries: free! For the rest I would invite the local youth, university, singing groups, etc. to listen.[11]

Wagner imagined that this sympathetic audience would travel from all over the German lands, their journey to Zurich proving their dedication to his ideals and lending the event an aura of exclusivity. Admission would be free, but it would be

guaranteed only to those willing to make the pilgrimage. Three performances of *Siegfried* would then take place within one week; after the last, he wrote, "the theater will be pulled down and my score burned."[12] Like the flash of light that produced a nineteenth-century photograph, this sacrificial conflagration would simultaneously destroy and preserve the original production, lending it a symbolic—rather than literal—monumentality.

Two years later, in November 1852, Wagner insisted that his plan, while oriented toward the construction of an actual theater in his own lifetime, was nevertheless essentially utopian. "I can think of a performance only after the revolution," he wrote to Uhlig that year; "only the revolution can supply me with the artists and the spectators."[13] The environment he imagined was oriented, fundamentally, toward the future, and it was also decidedly German:

> I will summon what I need from the ruins; then I will find what I require. Then I will put up a theater by the Rhine, and invite [people] to a big dramatic festival; after a year's preparation I will then present my entire oeuvre over the course of four days—with it I will indicate to the people of the revolution the significance of this revolution, in its purest sense. This audience will understand me; the current one cannot.[14]

Rather than three presentations of *Siegfried* within one week, Wagner now foresaw something more elaborate. The "entire oeuvre" to be performed over the course of four days would be his *Ring* cycle, for which he had already written the librettos for the four operas (*Das Rheingold, Die Walküre, Siegfried,* and *Götterdämmerung,* or "The Twilight of the Gods"), although he would not complete the scores for all four for more than two decades.[15]

In 1862, Wagner once again expressed his hope for a theater to be constructed where he could present his *Ring,* of which he had now completed the first two music dramas and part of the third. He described his wish for a "provisional theater, as simple as possible, perhaps merely of wood, and calculated only according to the artistic effectiveness of the interior activity."[16] The ultimate goal of this theater—still posited as a temporary construction—would be to foster the aesthetic response of those it contained. Wagner famously specified two architectural features of its auditorium: the seating arrangement would be amphitheatrical, and the orchestra pit would be submerged under the stage so as to be invisible to the audience.[17] The former was intended to be democratic, as it allowed nearly equal visual and acoustic access to the performance from all seats; the latter would improve the acoustics and prevent such visual distractions as musicians and instruments from

affecting spectators during the performance. The architectural precedent for these ideas may be found at the opera house in Riga, where Wagner had been resident conductor from 1837 to 1839 and where a submerged orchestra pit and a steeply raked wooden auditorium provided the audience with impeccable acoustics.

In Wagner's theater of the future, the aesthetic experience would be facilitated by the auditorium design, which would function entirely to render this experience more direct. "In the arrangement of the *space for the spectators*," Wagner had written in 1849,

> the need for optical and acoustical understanding of the artwork will give the necessary law, which can only be observed by a union of beauty and fitness in the proportions; for the demand of the collective [*gemeinsam*] work of art is the demand of the *work of art,* to whose comprehension it must be distinctly led by everything that meets the eye.[18]

The auditorium's architecture would encourage direct visual, acoustic, and emotional absorption, providing equal access to the work of art—a notion of aesthetic immediacy in keeping with Wagner's idea of spectatorship as active and participatory. While his plans for the ideal theater building would undergo many changes before their eventual construction, both the amphitheatrical auditorium and the invisible orchestra would remain central to his vision of a building that would foster communal appreciation of a total work of art.

Gottfried Semper and Munich

Wagner's prospects for having a theater built for his works appeared to improve when, in 1864, he found an enthusiastic patron in King Ludwig II, who had recently ascended to the Bavarian throne. In early October of that year, he met with Ludwig, who had seen *Lohengrin* at the age of fifteen and had read *The Art-Work of the Future,* and who soon offered to fund construction of a theater in Munich for the composer: "I have made the decision to have a large stone theater built so that the performance of the *Ring of the Nibelungen* will be a perfect [*vollkommene*] one," Ludwig wrote to Wagner the next month; "this incomparable work must have a worthy space for its presentation; may your efforts to find capable dramatic singers be crowned by beautiful success!"[19] Wagner jumped at the opportunity to have his theater built and his debts paid off. Following the public disgrace incurred in 1858 by an adulterous affair, he had lived in Venice for a year and a half and in Paris for several months; after a ban on his presence was revoked in the summer of 1860, he had traveled through the German lands for two years vainly attempting to organize productions of his works. More recently, he had been working as

an itinerant conductor in the major concert halls of Europe. Beyond promising to bring about the construction of his long-desired theater, Ludwig's patronage seemed also to offer the possibility of personal and professional stability and the potential to establish Wagner as Europe's foremost composer.[20]

Wagner recommended his friend Semper to Ludwig and soon enlisted the architect to design a theater for him in Munich, the Bavarian capital. In a letter of December 13, 1864, the composer revealed to Semper the project's symbolic aim:

> The King of Bavaria wishes that you should build, at his commission, a large theater in Munich in the noblest style for the special purpose that I will indicate to you immediately. My young patron deeply believes in the truth of my ideal regarding a dramatic work of art, which is essentially and fundamentally different from a modern play as from an opera.[21]

The chance to build in Munich appealed greatly to Semper, who had produced several significant designs but had not constructed a theater since making his name with the Dresden Hoftheater, where Wagner had spent six years conducting. Semper had maintained a professional connection to Wagner as well, contributing a design to an architectural competition for a theater in Rio de Janeiro that was held in 1858 in connection with Wagner's own proposed visit to Brazil to produce *Tristan und Isolde*—a visit that, like Semper's theater design, never came into being (Figure 2.1).[22]

Scholars have long debated the level of initiative and enthusiasm that Wagner brought to the project for a festival theater in Munich; here, again, his own insights are unreliable. A diary entry from early September 1865, for example, reveals a perverse revulsion at the prospect of having a theater built for his works, along with a flair for melodrama:

> I'm not well. My poor nerves! A fright: Semper is here! Unfortunately, Franz [Wagner's servant] confessed to him that I wasn't out of town. I'm so far gone that Semper's visit is loathsome to me. . . . How I hate this projected theater, yes—how childish the king seems to me for insisting on this project so passionately: now I have Semper here and have to deal with him, and have to talk with him about the senseless project! I know of no greater agony than this one that stands before me—you see, that's how I am![23]

Wagner's emotional and psychological torment at the prospect of having one of the greatest architects of the nineteenth century design a building for presenting

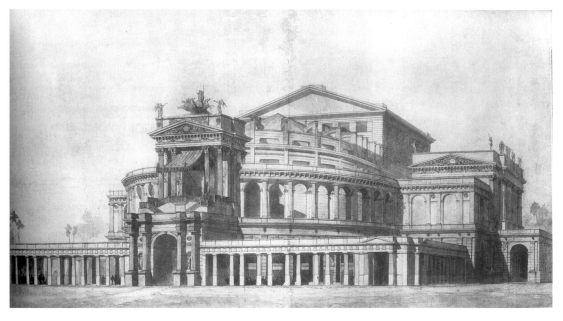

Figure 2.1. Gottfried Semper, theater, Rio de Janeiro, perspective, 1858. Copyright Brandenburgisches Landesamt für Denkmalpflege und Archäologisches Landesmuseum, Wünsdorf.

his music dramas certainly appears genuine. Had he been entirely averse to Semper's—and Ludwig's—plans, however, he might have resisted them more forcefully. This ambivalence is perhaps reflected in the fact that Semper's designs for a theater for Wagner in Munich possessed a double nature from the beginning. A permanent structure, equal in stature to the Dresden Hoftheater, would be devoted to presenting the composer's music dramas; a temporary building would also be built, ostensibly to allow Semper to test a series of architectural innovations and to have a theater ready as soon as possible.

Wagner had in 1856 set aside his projected tetralogy in favor of other works; he composed *Tristan und Isolde* between 1854 and 1860 and had been working on *Die Meistersinger* since 1861.[24] Ludwig was taken with the idea of a production of the *Ring* in Munich, however, and immediately embraced the idea of a monumental structure worthy of presenting the four linked music dramas. "After he instructed me to complete this work for a performance in the summer of 1867," Wagner wrote to Semper, Ludwig

> considered himself also obligated to be concerned about the establishment of the theater that I wish for. Lately he has become so enthusiastic for this idea that he recommended to me not to commission first a

provisional theater in wood, but rather immediately to commission the dignified version, executed in stone and noble material.[25]

For Ludwig—at least as Wagner presented the situation—the nobility of the materials with which the theater would be built would do more than reflect the status of the works performed inside. Such architectural grandeur would represent the stature of the patron who commissioned the design, funded the construction of the building and the productions it would showcase, and financially supported the composer of the works produced there.

Notwithstanding the king's enthusiasm for a monumental edifice, Wagner himself continued to insist on the creation of a temporary structure for the premiere of his *Ring*. Despite his notorious megalomania and his long-established talent for living far beyond his means, he resisted the urgings of his royal and impatient young patron.[26] It seemed to him, as he put it to Semper in a letter of December 1864, "more important and, apart from that, more practical to start first, immediately, with the construction of a provisional theater in wood and some brick."[27] Such a plan would, he explained, allow the architect

> to solve certain problems experimentally at first; finally you will gain time for the execution of the definitive building, carried out in the most noble material, that then should be left behind as a meaningful and lively monument to the German nation according to the intentions of its founder.[28]

In late 1864, such pragmatism would have been a rational basis for constructing a provisional theater in Munich. Wagner was not known for rationalism, however, especially where his own artistic plans were concerned, and it seems likely that in claiming it "more important and . . . more practical" to construct a provisional theater, he was still considering the premiere of his *Ring* in ephemeral terms.

Owing to political opposition, lack of funds, and the difficult personalities of those involved in the commission—and perhaps, as well, to an overabundance of creative fervor—reconfigurations of each proposal ensued, adapted for different locations in Munich. Semper's design for a permanent structure was reworked for several possible sites, two of which overlooked the Isar River from a vast area above the eastern riverbank, facing the center of the city to the west. "From this eminence the ideal festival theater will proudly tower," Wagner wrote to Ludwig.[29] The theater would look down on the traditional city center from a great height; perhaps more significantly, the residents of Munich would look up to it from a distance. The building's monumentality and opulence, with the central triumphal

arch on its facade flanked by more than forty smaller arches, were unmatched in Semper's oeuvre (Figure 2.2 and Figure 2.3). The front facade was to be 587 feet wide; inside would be a concert hall and an assembly hall, as well as studios for teaching and rehearsing for the school of music and acting that Wagner hoped to found. "If it had been built," Harry Francis Mallgrave has written, "it would have been not only his greatest architectural accomplishment but without question the grandest theater of the nineteenth century."[30]

Behind this extraordinary exterior lay a series of processional spaces: foyers, lobbies, and grand halls where members of the audience might circulate before performances and during intermissions. The auditorium itself was to be monumental in effect, with the capacity to seat 1,500 spectators, but democratic in its symbolism: its eighteen curved rows of seats, divided by aisles into eight sections, were arranged in an amphitheatrical design, with each seat offering more or less equal visual access to the stage. Between the auditorium and the stage lay two significant architectural features. First, the double proscenium that framed the spectators' view of the performance would destabilize their spatial perception of the stage, an effect that would be heightened by the use of technologically advanced lighting hidden between the proscenium arches. Second, Semper distanced the orchestra pit from the audience, literally and symbolically, both by an aisle and a

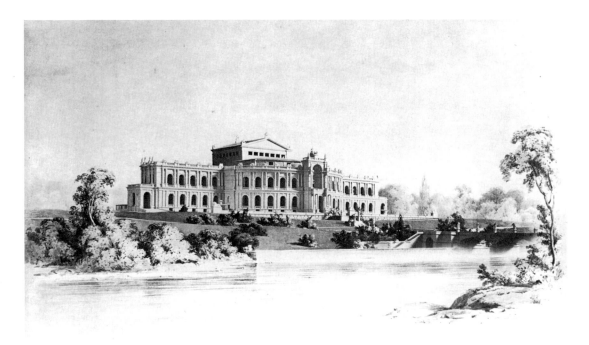

Figure 2.2. Gottfried Semper, drawing of the Wagner Festival Theater and bridge across the Isar River, Munich, 1865. GTA archives / ETH Zurich: Estate of Gottfried Semper.

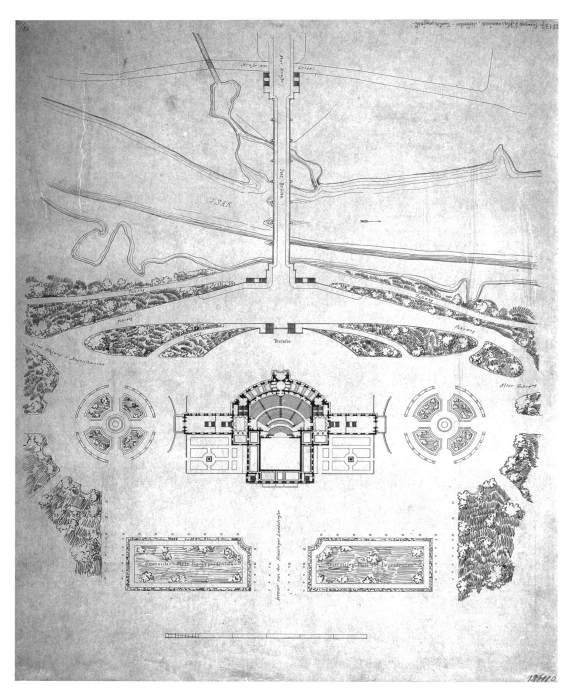

Figure 2.3. Gottfried Semper, site plan for the Wagner Festival Theater, Munich, 1864–67. Black ink on paper. Vienna, Academy of Fine Arts, Graphic Collection (HZ 21137).

barrier and by raking its floor at the same angle as the auditorium floor (Figure 2.4). Members of the orchestra would thus be removed from the audience's vision, which would more directly encounter the stage image that hovered at an uncertain distance. "It is a wonder," Wagner now wrote to Ludwig; "my idea, my instructions and requests were fully understood by Semper's genius, and—what is best of all—carried out in such a completely new and effective way that the connoisseur at once admires the sublime simplicity of this conception."[31]

For those accustomed to thinking of Wagner as the personification of megalomaniacal creativity and of his musical compositions as the epitome of the bombastic, the grandiose nature of these designs comes as no surprise. Indeed, it seems appropriate that, for a venue intended for presenting his music dramas, Semper's grand proposals conflate the achievements of architectural sites and performative events, linking the monumentality of the edifices themselves to the experience of visiting them. This achievement was to be further reinforced by extending and emphasizing the visitor's approach to the theater. A broad avenue was to be constructed, leading to the building from a corner of the Hofgarten at the city's center, while a grand new bridge would span the river; Munich audiences would thus be carefully led toward the performances of Wagner's works. Semper's third proposal for Wagner was for a site at the eastern edge of the Hofgarten itself (Figure 2.5). While the narrow streets of Paris were being demolished for the construction of the Avenue de l'Opéra, the boulevard that would lead to the opera building that Charles Garnier had begun to design, Semper proposed a processional approach of even greater grandeur to lead to a venue appropriate—or so he believed—for Wagner's music dramas.

The provisional theater, meanwhile, was to be located within the Glass Palace—itself a temporary construction that had been built ten years earlier by August von Voit in the city's botanical gardens, on the model of London's Crystal Palace of 1851.[32] The ground plan for one version of this project, made in May 1865, features an abbreviated amphitheater; a royal box is placed at the center of a row of boxes that line the auditorium's rear wall (Figure 2.6). A model for another version of this project, made the same month, shows a semicircular amphitheater and no royal box, as if to emphasize the democratic visual access to the stage provided by the auditorium (Figure 2.7). Seating 1,000 and 1,500 people, respectively, these amphitheatrical auditoriums faced proscenium stages that were visually framed and separated from the auditorium space by a grand archway.

In November 1865, Semper designed a third variation for a provisional theater in the Glass Palace, engaging further with some of Wagner's optical and acoustic concerns (Figure 2.8). Unlike in the first two designs, the orchestra pit was now steeply raked, with the conductor standing at the top of several levels, creating an

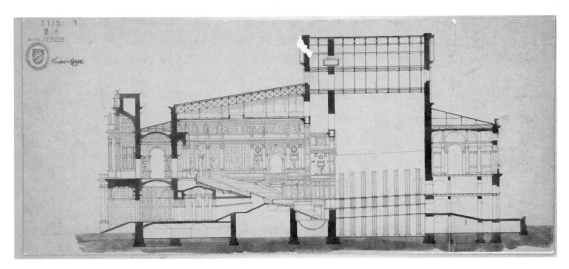

Figure 2.4. Gottfried Semper, Wagner Festival Theater, Munich, section, 1866. Photograph copyright Architekturmuseum der TU München.

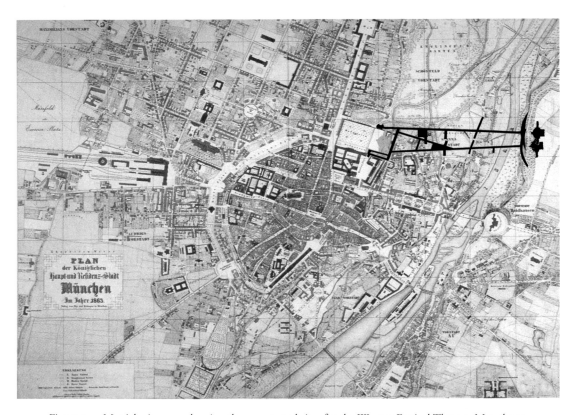

Figure 2.5. Munich city map showing three suggested sites for the Wagner Festival Theater. Münchner Stadtmuseum.

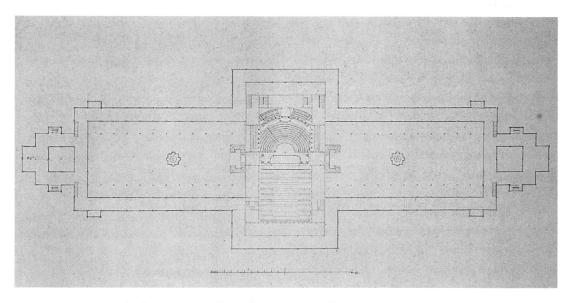

Figure 2.6. Gottfried Semper, ground plan for a provisional festival theater for Wagner in Munich, project A, 1865. Museum für Kunst und Gewerbe, Hamburg. Photograph copyright Museum für Kunst und Gewerbe, Hamburg.

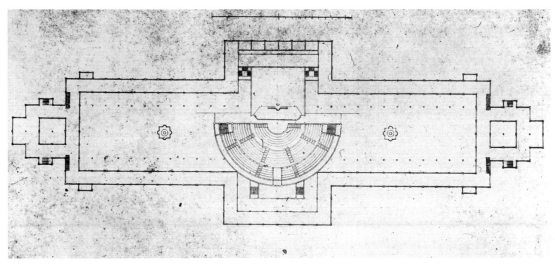

Figure 2.7. Gottfried Semper, ground plan for a provisional festival theater for Wagner in Munich, project B, 1865. Deutsches Theatermuseum, Munich (VII 3476).

angle even steeper than that of the auditorium floor. In addition, the orchestra pit was to be separated from the auditorium by a wide swath of empty space that removed the musicians and conductor from those in the audience (Figure 2.9). As a result, the activities in the orchestra pit would be rendered invisible to the spectators in the auditorium, whose visual focus would instead be concentrated on the stage image. For this project, moreover, Semper designed a double proscenium, framing the activities on stage both at the front wall of the auditorium and several feet further back. The stage image would thus remain the focus of the audience's vision and would appear to hover, magically, in the air. These features would later be taken up—and radicalized—in Bayreuth.

The permanent and the provisional, the grandiose and the ephemeral, were central to the project for a Munich theater for Wagner's music dramas and were legible in the range of designs that Semper produced for the composer.[33] Andreas Huyssen has ascribed such a mixture of opposites to the notion of the Gesamtkunstwerk itself:

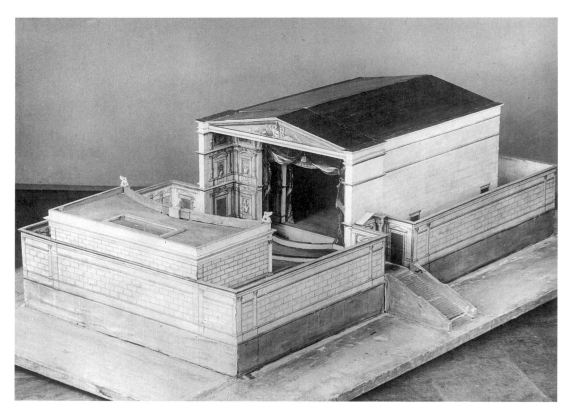

Figure 2.8. Gottfried Semper, photograph of the model for a provisional festival theater for Wagner in Munich, project C, 1865. National Archives of the Richard-Wagner-Foundation, Bayreuth (Bi 858-XV).

If the design of the Gesamtkunstwerk can be seen as a monumentalism of the future, then it is to some extent counterbalanced by Wagner's very modern sensibility of the provisionality and ephemerality of institutionalized art in modernity. Monumental desire and the consciousness of the ephemeral, the transitory, are in uneasy tension in Wagner's mind, a fact that, among other things, may explain Baudelaire's early interest in Wagner's art.[34]

The duality of preservation and destruction, central to Wagner's theoretical arguments about the Gesamtkunstwerk and reproduced in the debates over the form that the architecture worthy of his music dramas would take, was legible in Semper's designs for the composer. Yet the architect made his own wishes clear, writing to Wagner in 1867, perhaps with some exasperation, "your works . . . are too great and rich for illegitimate stages and wooden sheds."[35]

THE BAYREUTH FESTIVAL THEATER

Semper's designs for Wagner remained unbuilt, and Munich lost to the town of Bayreuth, 40 miles northeast of Nuremberg and 125 miles north of Munich, the honor of presenting the composer's music dramas.[36] Wagner visited the town—which he had last seen in 1835—with Cosima in the spring of 1871, returning in the autumn to meet with the mayor, a lawyer, and a banker; he and Cosima moved

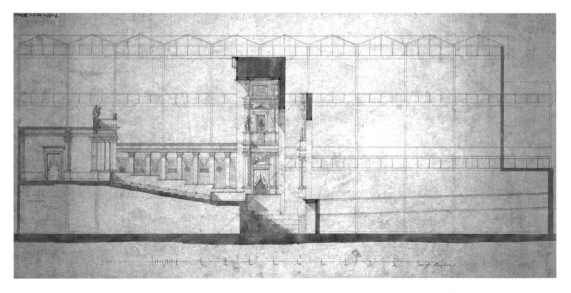

Figure 2.9. Gottfried Semper, longitudinal section for a provisional festival theater for Wagner in Munich, project C, 1865. Photograph courtesy of the Deutsches Theatermuseum, Munich (Semper 179-32-6).

there the following year with their five children. More centrally located within the German lands than Munich, Bayreuth appeared a promising site for hosting the rebirth of German (and not only Bavarian) culture; unlike the established capital city, it had the potential to become Wagner's domain. Funding from both Ludwig and Kaiser Wilhelm I of Prussia allowed him to construct there both his residence—which he named "Wahnfried," "peace from folly"—and the theater that he had been planning for more than two decades. Designed by Karl Brandt and Otto Brückwald (the former responsible for the auditorium, the latter brought in several months later to take charge of the building's exterior), the Festspielhaus, or "Festival Theater," relied heavily on the plans that Semper had drawn, which Ludwig supplied to Wagner.[37]

The theater's cornerstone was laid on Wednesday, May 22, 1876, in a ceremony preceding a performance in the town's Markgräfliches Opera House of Beethoven's Ninth Symphony, which Wagner had conducted in Dresden in the spring of 1849. Located behind a relatively plain facade in the center of town and completed in 1748, this auditorium was as ornate as any royal jewel box and laden with hierarchical subdivisions (Figure 2.10). The room's architectural focal point is the royal box in the center of the auditorium's first tier; the entire room appears to have been constructed in consideration of the view both toward and from this central point.[38] Vastly oversized in proportion to its neighbors, its extensive frame supplanting the seats in the tier above, and flanked by its own subsidiary boxes, it is approached from the orchestra stalls by means of double staircases, their bases surrounded by empty space. Three tiers of balconies form the shape of a horseshoe, its extremities oriented more toward the royal box than toward the stage. Dividing walls, since removed, ensured that each tier held a dozen individual boxes, where spectators were afforded relative privacy and a sense of property.

Wagner wanted his own theater in Bayreuth to stand in contrast to this local edifice. More generally, he wished to avoid the shallow commercialism and spectacle culture that were characteristic of French grand opera at the time—and that he associated particularly with the works of Meyerbeer, his own erstwhile supporter in Paris. In the realm of theater architecture, the spectacular was epitomized at the time by Garnier's Paris Opéra, which had opened the previous year (Figure 2.11). The grandiosity of the approach up the Avenue de l'Opéra to the building's monumental edifice was matched not only by the opulence of its interior but also by its careful choreography of its visitors, who were guided from the side entrances, where they had been deposited by their carriages, up the grand staircase and through a series of interior halls, ultimately to be brought by ushers to their seats in the auditorium. As the architect Eugène Emmanuel Viollet-le-Duc quipped in response to this processional activity, "The hall seems made for the stairway and

not the stairway for the hall."[39] From Wagner's perspective, the notion of spectacle that Weber had ascribed to French opera and its audiences in 1817 had now received, in Garnier's building, its architectural embodiment.

As with the arguments made six decades earlier by Weber, his predecessor as Kapellmeister in Dresden, Wagner's own disdain of French opera was fueled by German nationalism. The Festival Theater in Bayreuth would demonstrate the superiority of his German music dramas over the bombastic, shallow operas then being presented so ostentatiously in Paris.[40] By extension, productions of these works would likewise demonstrate and encourage the profundity and seriousness of German culture. The audiences who gathered in Bayreuth to experience Wagner's *Ring* cycle would also be recognizable, by virtue of their very presence at the performance, as superior to their counterparts in Paris. The creation of the Festival Theater for productions of Wagner's music dramas, in other words, was

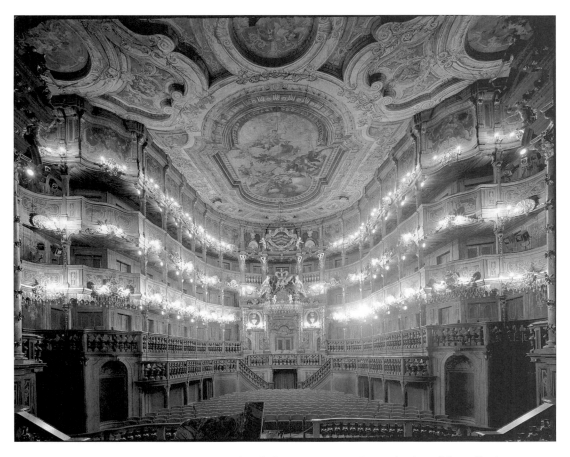

Figure 2.10. Giuseppe Galli Bibiena, Markgräfliches Opera House, Bayreuth, view of the auditorium, 1748. Photograph copyright Bayerische Schlösserverwaltung.

Figure 2.11. Charles Garnier, Paris Opéra, front facade, 1876. From *L'Opéra de Paris construit par M. Charles Garnier: Architecture, sculpture, décorative: Extérieur et intérieur,* photographs by Charles Marville (Paris: E. Bigot, ca. 1876). Photograph courtesy of the Research Library, The Getty Research Institute, Los Angeles, California.

to provide Germans, at long last, with the performance arena they deserved.[41] Equally attuned to the nationalist implications of cultural taste, Nietzsche wrote in 1888, with regard to Wagner's compositions: "The hunt for low excitement of the senses, for so-called beauty, has enervated the Italians: let us remain German!"[42] Here, too, national cultural pride was infused with a fear of infection by foreign sources.

"Remaining German" entailed, in Bayreuth, a carefully orchestrated combination of the experience of pilgrimage and, eventually, architectural seclusion. Built just north of the center of town, at the top of a small hill, the Festival Theater— like Semper's designs for Munich and Garnier's Paris Opéra—required effort for its audience to reach it. The Baedeker guidebook of 1891 shows the "Wagner-Theater" near the top of a town map, to the north of the other buildings; "Wagners Wohnhaus," or residence, is found near the town center, near the bottom of the map and not far from the Markgräfliches Opera House (Figure 2.12).[43] Even after reaching

Figure 2.12. Map of Bayreuth, 1891. From K. Baedeker, *Baedeker's Southern Germany and Austria, including Hungary, Dalmatia, and Bosnia* (London: Dulau and Company, 1891), following page 79.

the town of Bayreuth, visitors still needed to climb a hill to make their way to the Festival Theater.

One visitor to the inaugural performance of the *Ring* in 1876, Gustave J. Stoeckel, detailed the process in an essay the following spring:

> From the middle of the afternoon to the drawing of the curtain, the visitors walk or drive to the hill upon which the theater stands, about a mile and a half outside of Bayreuth. They gather in groups upon the walks in open air, or in the restaurants erected on both sides of the slope, upon which the opera-house stands about them in the middle. These groups are formed largely according to nationality, crafts, social grades in society, and occasional acquaintanceships.[44]

The processional approach toward the Festival Theater, the paved walkways and formally planted gardens at its doors, and the social activity that took place before the performances all lent the occasion of visiting the theater a sense of grandeur that was counteracted by the building's simple construction materials. Stoeckel himself had traveled to Bayreuth from New Haven, Connecticut; a musician and composer who had immigrated to the United States in 1848 after his own political activities threatened his job in Bavaria, he had been teaching at Yale University since 1855. His dedication to Wagner, already implied by his journey to Bayreuth, was further proven in his essay describing the performances he attended there.

The perseverance and the physical endurance involved in getting to—and sitting through—the first performances of the *Ring* have led Marvin Carlson to argue that the Festival Theater's "true predecessors . . . were thus not, as Wagner suggested, the theatres of Greece, but the great pilgrimage churches of the Middle Ages, supported not by a local population but by a public that considered the spiritual rewards gained there worth the labor and expense of a lengthy journey."[45] The religious metaphor suggests an asceticism on the part of the Bayreuth pilgrims that was compounded by an interior architecture that has been described as physically unforgiving. Arranged too close together in an unventilated auditorium, the unupholstered chairs could become uncomfortable during the long stretches of "unending melody" for which Wagner was famous. As we shall see, however, the mixture of the visual and the bodily—the optic and the haptic—in the auditorium design was symptomatic of late-nineteenth-century German aesthetic discourse. George Bernard Shaw even mocked the emphasis on the social and the physical in Bayreuth in 1889: "Business begins at the Wagner theater at four; but after two the stream of people up the hill is pretty constant, their immediate destination being the restaurant to the right of the theatre, and their immediate object—grub."[46]

In the 1870s, the journey to Bayreuth could be made with relative ease by train; the town's station, or *Bahnhof*, located at the north edge of the town center, appears at the center of the Baedeker map, halfway between Wagner's home and his theater. The first German railroad line had begun its operations just southwest of Bayreuth in 1835, linking Nuremberg to the town of Fürth. In 1853, train service was established between Bayreuth itself and nearby Neuenmarkt; two decades later, rail travel was common throughout Europe. Increased access to towns such as Bayreuth brought about a new conception of railroad travel as equivalent to a visit to the theater: two kinds of journey that required the purchase of tickets in advance for the use of assigned seats for a predetermined amount of time.[47] Prominently situated at the top of a small hill, Wagner's theater was visible from the square in front of the town's train station, making the processional approach to a performance especially well suited to those arriving by railway (Figure 2.13). "One goes to Bayreuth however one wishes," one French visitor explained; "on foot, on horseback, by carriage, by bicycle, by train, and the true pilgrim ought to go there on his knees. But the most practical way, at least for the French, is by railroad."[48] Such practicality was not limited to the French—or to the middle classes. The program for the ceremony for the laying of the cornerstone of the Festival Theater

Figure 2.13. Bayreuth Festival Theater seen from the train station, photograph, 1875. National Archives of the Richard-Wagner-Foundation, Bayreuth (Bi 491).

indicates that the four-day affair was officially initiated on Sunday, May 19, 1872, with a reception of the guests at the town's train station (Figure 2.14).

Indeed, the Festival Theater officially presented itself in terms of the railroad. The *Bayreuth-Album* of 1889, for example—with parallel essays in German, English, and French—introduced the theater building as follows: "About twenty minutes' walk from the Bayreuth Railway station, on a hill on the northwest side of the town, is the festival theatre built."[49] The same volume included "The Works Which Will be Represented" (that year, *Parsifal, Tristan und Isolde,* and *Die Meistersinger*) as well as biographies of the conductor Hermann Levi and some of the leading performers on stage that year. "Shorter and Longer Trips in the Environs" even listed the departure and arrival times of the four trains that ran daily to Nuremberg and the five returning each day from that town. "There is a special train going there after the performances," it noted; members of the audience were not limited to staying in the hotels of Bayreuth during the festival.[50] The journey took roughly three hours in each direction, making daily pilgrimages from Nuremberg to the performances in Bayreuth possible (if perhaps inadvisable, given the length of the music dramas).

Shaw described Bayreuth in 1889 as "a genteel little Franconian country town among the hills and fine woods of Bavaria, within two or three hours' rail from Nuremberg."[51] In another essay that year, he referred more obliquely to the link between Wagner's theater and rail travel: "Bayreuth is supported at present," he maintained, "partly because there is about the journey thither a certain romance of pilgrimage, which may be summarily dismissed as the effect of the bad middle class habit of cheap self-culture by novel reading," a habit customary among train travelers.[52] In Shaw's view, the pilgrimage to Bayreuth was a fundamentally bourgeois experience, and one he deemed worthy of gentle mockery. (But the Festival Theater was itself such an architectural success—a perfect arena for the experience of a performance—that, he maintained, its likeness should be constructed in England.) The association of Bayreuth with train travel was hardly unique to Shaw; a postcard from 1902 shows the theater facade in black and white, perfectly framed for railway passengers and impossibly parallel to the train window (Plate 2). The colorful presence in the compartment of a father and son in traditional Bavarian hiking clothes suggests that the Festival Theater had attained a place among such German cultural traditions as the day hike; a well-dressed man and woman sit across from them, presumably on their way to a Wagnerian performance; he gestures at the building's facade while she holds a rose to her blank, vaguely appreciative countenance.

Writing of his own trip to Bayreuth in 1891, Mark Twain began with a description of the crowds at the Nuremberg railway station hoping in vain to get hold of

Figure 2.14. Program for the laying of the foundation stone of the Bayreuth Festival Theater, 1872. National Archives of the Richard-Wagner-Foundation, Bayreuth (N745-6).

last-minute tickets to Wagner's theater: "It took a good half-hour to pack them and pair them into the train—and it was the longest train we have yet seen in Europe. Nuremberg had been witnessing this sort of experience a couple of times a day for about two weeks."[53] But it was not only the trip from Nuremberg that had to be taken into account, for the journeys of these "music-mad strangers" had begun much further away. Burdens were especially onerous for those who had failed to purchase tickets to Wagner's theater long in advance, Twain explained:

> They had endured from thirty to forty hours' railroading on the continent of Europe—with all which that implies of worry, fatigue, and financial impoverishment—and all they had got and all they were to get for it was handiness and accuracy in kicking themselves, acquired by practice in the back streets of the two towns when other people were in bed; for back they must go over that unspeakable journey with their pious mission unfulfilled.[54]

Such a combination of wry humor—sympathetic, yet gently mocking—along with the rhetoric of religious pilgrimage suffused Twain's essay and was reflected in its title, "At the Shrine of St. Wagner." Fortunately he, himself, had cabled for tickets and a hotel room months before, which allowed him a week of Wagnerian music drama that, he wrote, made him "feel like a heretic in heaven."[55]

Inaugurated in August 1876, the Festival Theater in Bayreuth operated for two weeks, offering three complete performances of Wagner's newly completed *Ring of the Nibelungen.* Four music dramas, consisting of roughly fifteen hours of performances, were presented over the course of five days, from August 13 to 17, with one night off in the middle. The entire cycle was then repeated from August 20 to 24 and presented for the third and final time on four consecutive nights, from August 27 to 30. The audience at these performances comprised an extraordinary range of art lovers from all over the world, as Stoeckel reported:

> Scientific men, poets, musicians, painters, sculptors, and architects; journalists and bankers, counts and princes, were all represented, coming from almost every civilized country. It seemed as if the pictures of celebrated men, which we see in art stores, had suddenly stepped out of their frames, and stood right before you. One could not walk three steps without giving elbow-room to some celebrity.[56]

Among those notables present were Kaiser Wilhelm II of Germany and Emperor Pedro II of Brazil; the kings of Bavaria and Würtemberg; the composers Anton

Bruckner, Edvard Grieg, Camille Saint-Saëns, and Pyotr Ilyich Tchaikovsky; the painters Henri Fantin-Latour, Franz von Lenbach, and Adolph Menzel; and the art historian Conrad Fiedler. "The musical representatives of all civilised nations were assembled in Bayreuth," Tchaikovsky remarked.[57] Ludwig II missed the first cycle and attended only the third presentation of the *Ring,* following Wagner's repeated entreaties; Tchaikovsky also noted the absence of Giuseppe Verdi, Charles Gounod, Johannes Brahms—and Cosima Wagner's first husband, Hans von Bülow.

Tickets for the inaugural season cost 300 thalers (an amount equivalent, in 1876, to $250) and had been put on sale several years earlier to finance the construction of the building.[58] For that price, intrepid patrons were admitted to all three complete productions of the *Ring* cycle, that is, to twelve music dramas over the course of seventeen days. Most of these tickets remained unsold, so that ultimately neither such dedication nor such expense was required. Tickets for individual performances, Shaw reported, cost the equivalent of £1, still a hefty sum in 1876. (Tickets for the dress rehearsals held earlier that month had cost much less. And of *Parsifal* in 1891, Twain quipped, "Seven hours at five dollars a ticket is

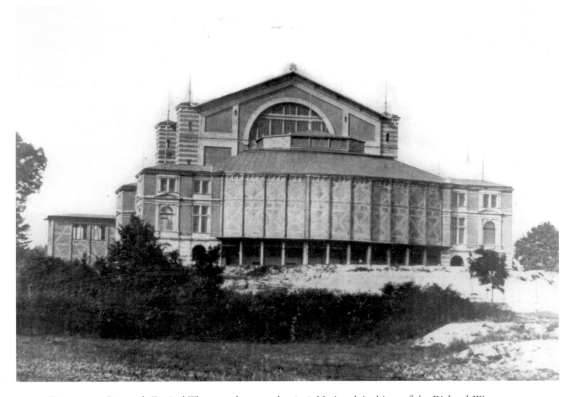

Figure 2.15. Bayreuth Festival Theater, photograph, 1876. National Archives of the Richard-Wagner-Foundation, Bayreuth (N10-246 NA).

almost too much for the money.")[59] Admission was free for fifty of the seats in the upper gallery—a fraction of the five hundred free tickets for which Wagner had wished. In 1849, he had insisted on full state subsidy—"the audience must have *unbought* admission to the theatrical presentations"—to ensure that social and economic equality among audience members would accompany the Gesamtkunst-werk of the future.[60] But entry to the theater in 1876 was not free to all, and no symbolic destruction of the building or of the score occurred after the first per-formances. Instead, the idea of the provisional was transferred to the theater's architecture: its exterior was constructed of timber with brick and stone detailing, and its auditorium was built entirely of wood (Figure 2.15).[61] Despite the modesty of the materials, the debt to Semper's own design was clear, as Wagner conceded in a letter to the architect: "Although clumsy and artless," he wrote, "the theater is executed according to your designs."[62]

The Modern Auditorium

The auditorium of Wagner's Festival Theater originally held an audience of 1,650; its interior, unlike that of the town's Markgräfliches Opera House, was remarkably plain (Figure 2.16).[63] A block of 1,345 seats fanned out from the stage to the rear wall. On each side of the room, simple transverse walls jut into the auditorium; these gradually decrease in length from the corridors near the stage, where each one ends with a freestanding Corinthian column and a Corinthian pilaster, to the rear of the auditorium, where there are only pilasters. In between the transverse walls, six plain double doors provide access to several rows of seats each. Behind a series of columns, a gallery of 100 more seats—in eleven bays, but not enclosed in private boxes—lines the auditorium's rear wall, as the ground plan shows (Figure 2.17). High above, another gallery of 205 seats is situated behind pillars that visu-ally continue the lines of those between the boxes below. As one visitor wrote, in the upper gallery "you can hear marvelously well, but you have a bad view and it is very warm," whereas seats in the loge "are reserved for Royalties and for Frau Wagner's invited guests. Although I believe that the public may sometimes get them at a price, yet officially they are not at the public disposal, which is not a matter for regret, for they are so far away that you are better off elsewhere."[64]

Folding chairs of woven wicker (not upholstered velvet, as in a traditional auditorium) appeared to cover the room from wall to wall.[65] "There are no aisles, no *Proscenium* boxes, nothing to attract the attention from the stage," Stoeckel wrote approvingly; little existed to distract the spectator. He continued,

> The auditorium is conceived in the spirit of a free arena, in the antique
> style, framed on both sides with Corinthian columns, between which

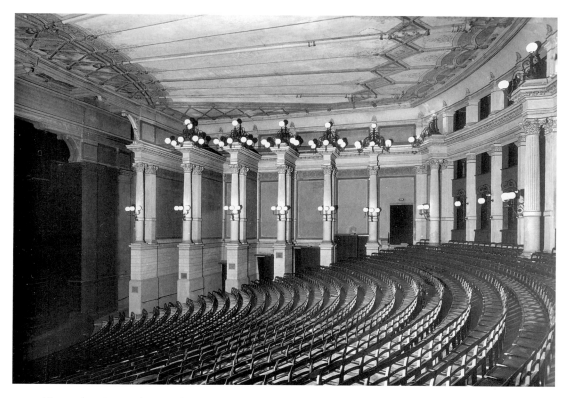

Figure 2.16. Bayreuth Festival Theater auditorium, photograph, 1958. National Archives of the Richard-Wagner-Foundation, Bayreuth (Bi 1558).

are the entrances, and on the sides of which are the chandeliers for lighting the house. The side walls reach without a break to the ceiling, which in form of a tent seems to stretch into the aether.[66]

These plain walls, sober and utilitarian, formed a provisional temple to music that reached to the sky like a more traditional house of worship. The ceiling, made of painted sailcloth, showed a simple geometric design; modern gas lamps—subsequently replaced with electric lights in glass globes—provided lighting in the room.[67] The sense of impermanence within the auditorium was echoed, Stoeckel wrote, in the materials used on the theater's exterior. "The building in its outside appearance betrays its temporary character. Its framework is of wood, bricked in; and back of the stage is an additional building for the engine, for motors and for machinery."[68] Such impermanence matched the rationalized procedures of modern machine production, and Wagner's structure provided an appropriate destination for those who had made their way to Bayreuth by rail.

After attending a performance at the Festival Theater in 1889, Shaw likewise hailed its interior design. "The difference between the Wagner Theatre at Bayreuth and an ordinary cockpit and scaffolding theatre is in the auditorium, and not in the stage," he declared, before describing this room in detail:

> From the orchestra the auditorium widens; and the floor ascends from row to row as in a lecture theater, the rows being curved, but so slightly that the room seems rectilinear. There are no balconies or galleries, the

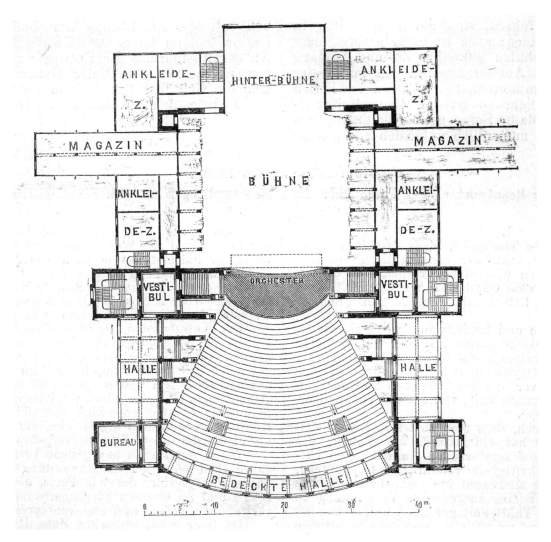

Figure 2.17. Bayreuth Festival Theater, ground plan. From Otto Brückwald, "Das Bühnenfestspielhaus zu Bayreuth," *Deutsche Bau-Zeitung,* 1875, 3. Photograph courtesy of the Canadian Centre for Architecture, Montreal.

whole audience being seated on the cross benches in numbered stalls, with hinged cane seats of comfortable size, in plain strong wooden frames without any upholstery. . . . The wall at the back contains a row of *loggie* for royal personages and others who wish to sit apart. Above these state cabins there is a crow's nest which is the nearest thing to a gallery in the theatre; but the conditions of admission are not stated.[69]

With references to a lecture hall, rectilinearity, and seats that were adequate and strong, Shaw emphasized the rationalism of the auditorium design. Even the lack of upholstery suggested a seriousness of purpose; spectators were to face forward and concentrate on the stage proceedings like well-behaved students rather than socialize, gaze at ornate decor, or indulge in naps in cushioned seats. "The prevailing colour of the house is a light dun," he continued, "as of cream colour a little the worse for smoke. There are no draperies, no cushions, no showy colours, no florid decoration of any kind. During the performance the room is darkened so that it is impossible to read except by the light from the stage." Attention was to be paid only to the stage image and to the music that issued forth from its vicinity. As Twain put it: "The interior of the building is simple—severely so; but there is no occasion for color and decoration since the people sit in the dark."[70]

The design of the auditorium, like that of its precursors in Munich, derived from the amphitheatrical model that Wagner had long championed; based on the outdoor theaters of classical Greece, it invoked Greek culture along with its democratic associations of the *Volk*.[71] Steeply raked, the rows of seats form a unified architectonic mass, their fan shape ensuring that even the seats at the ends of the rows would offer full views of the stage. (Semper's amphitheatrical designs for a provisional theater in the Glass Palace in Munich would have included some obstructed views.) In contrast to most of Semper's designs for Wagner in Munich, however, here no aisles divide the seats into separate sections, an arrangement that gives the impression of denying the existence of social stratification among them. A drawing from 1876 of an audience at the Festival Theater in Bayreuth shows spectators gathered into a well-dressed mass, with not a single empty seat in view: a convocation of equal pilgrims at the temple of Wagnerian music drama (Figure 2.18). These conditions are confirmed by Twain's assertion that, in 1891, "every seat is full in the first act; there is not a vacant one in the last. If a man would be conspicuous, let him come here and retire from the house in the midst of an act."[72]

In traditional auditoriums, such architectural delineations of space as balconies and private boxes reflected a social and economic hierarchy that was established by spectators' relative ability—and willingness—to pay for an evening's entertainment. Boxes offered relative privacy for smaller groups as well as the higher social status

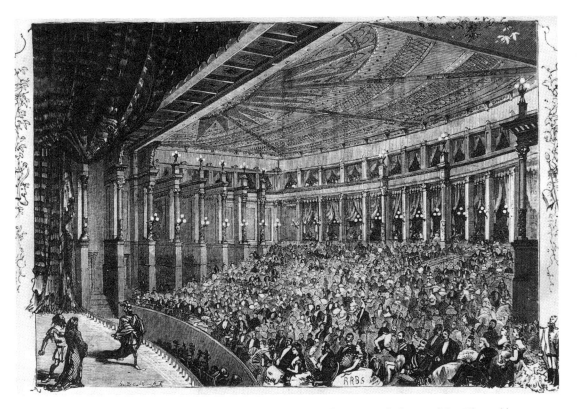

Figure 2.18. Ludwig Bechstein, Bayreuth Festival Theater auditorium with the set of *Das Rheingold*, 1876. Copyright Stadtarchiv Bayreuth.

such privacy conveyed; they also operated as architectural frames around their patrons, rendering them more noticeable from the rest of the auditorium. In the nineteenth century, Marvin Carlson has written,

> the possession of a box, especially of a box at the opera, came to be regarded as one of the more dependable signs of membership in the privileged classes, so much so that even in the democratic United States, the Metropolitan Opera was originally built not primarily to satisfy a public desire for this art, but because all the "aristocratic" boxes at the old Academy of Music were filled by immovable members of the established rich.[73]

A drawing of New York's Metropolitan Opera house published in 1883 in the *New York Daily Graphic* underscores its reliance on private boxes for many of its patrons (Figure 2.19). The scene is shown from behind the two rows of seats at the rear

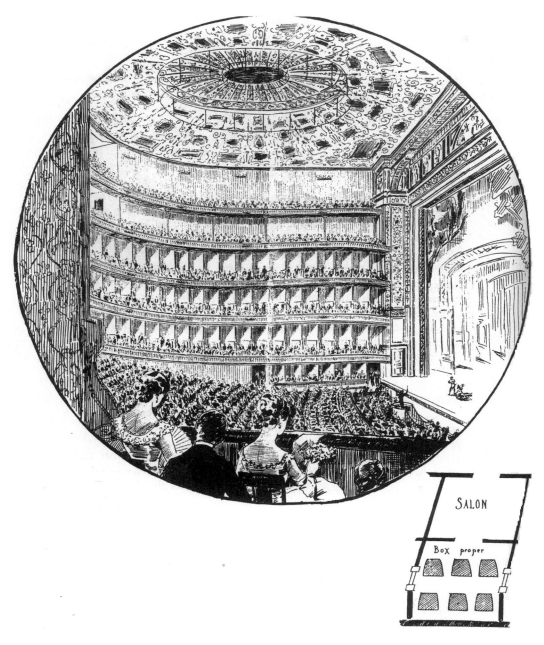

SALON

BOX proper

Figure 2.19. Boxes at the Metropolitan Opera in New York. Originally published in the *New York Daily Graphic* (1883); reprinted from Marvin Carlson, *Places of Performance: The Semiotics of Theatre Architecture* (Ithaca, N.Y.: Cornell University Press, 1989), 144. Copyright 1989 Cornell University; used by permission of the publisher, Cornell University Press.

of a box, as if from the doorway that separates the box from its anteroom, itself labeled "salon" in the floor plan that accompanies the drawing. Across the auditorium, three and a half tiers of boxes are visible below two more rows of balconies. Rather than facing the stage, they are oriented toward the other spectators in the auditorium.

The design of Wagner's auditorium in Bayreuth, by contrast, was determined by his demand for a theater that would not distract the audience's attention from the stage. "The task of the theater building of the future may in no way be considered solved by our modern theater buildings," he had declared in 1849;

> they are laid out in accordance with traditional laws and canons which have nothing in common with the requirements of pure art. Where orientation towards profit, on the one hand, and a luxurious love of splendor, on the other, have a determining effect, the absolute interests of art must be deplorably affected; and thus no architect in the world will, for example, be able to elevate our stratified and fenced-off auditoriums—dictated by the separation of our public into the most diverse classes and categories of citizenry—to a law of beauty.[74]

No such socioeconomic distinctions would be permitted within the Bayreuth Festival Theater, which would instead derive its beauty from simplicity. "It is republican to begin with," explained Shaw, who found beauty in republicanism; "the 1,500 seats are separated by no barrier, no difference in price, no advantages except those of greater or less proximity to the stage. The few state cabins at the back, for kings and millionaires, are the worst places in the house."[75] Such an inversion of the social and architectural hierarchy of the traditional auditorium impressed Shaw greatly.

Shaw commended not only the arrangement of the audience within the auditorium but also their carefully coordinated entry and departure. "The most striking architectural feature" of the auditorium, he declared,

> is the series of short transverse walls with pillars and lamps, apparently suggested by the old-fashioned stage side wing. Each of these wings extends from the side of the room to the edge of the stalls. Between the wings are the doors; and as each ticket is marked with the number not only of the seat, but of the nearest door to it, the holders find their places for themselves without the intervention of attendants.[76]

With such a rational arrangement in place, those attending Wagner's theater needed no further assistance by the time they arrived at its doors. Unlike the Paris

Opéra, with its grand processional experience, the Festival Theater in Bayreuth brought spectators to their seats as swiftly as possible. Entry was, as it were, automatized, and engagement with the performance on stage remained paramount.[77] Even the activity of program acquisition was removed from the premises, Shaw noted: "Playbills are bought for a penny in the town, or in the street on the way to the theatre."[78] The interruptions of commercial exchange had no place in Wagner's theater.

Stoeckel, too, was impressed by the circulation patterns at Bayreuth, describing how those who had arrived from all over Europe and the world were brought into the theater from its surrounding spaces. "Suddenly the conversational hum in this babel of tongues is interrupted by the call of eight trumpeters, the signal to take seats," he wrote; visitors now took up their roles as audience members:

> Everybody responds by going to that entrance, which leads him to his moveable [that is, folding] cane seat, where he waits, standing and talking until the signal is repeated within the house. From that moment until the curtain drops not a sound is heard from the audience. The lights are turned down, the seats lowered and taken, and all eyes fixed upon the curtain. The prelude begins.[79]

In this account, the Bayreuth spectators appear almost mechanized—well matched with the architecture around them. Such mechanization also impressed Twain, who declared, "It is the model theater of the world. It can be emptied while the second hand of a watch makes its circuit."[80]

Such audience behavior—silent and attentive in a darkened room—is especially noteworthy given the habits of nineteenth-century operagoers, who often socialized in a dimly lighted auditorium during performances. Twain himself contrasted the behavior of the audience in Bayreuth with that in New York:

> Here the Wagner audience dress as they please, and sit in the dark and worship in silence. At the Metropolitan in New York they sit in a glare, and wear their showiest harness; they hum airs, they squeak fans, they titter, and they gabble all the time. In some of the boxes the conversation and laughter are so loud as to divide the attention of the house with the stage.[81]

No such shenanigans took place in Bayreuth, where the sounds and images coming from the vicinity of the proscenium were paramount. Unlike New York, Twain explained to his readers, "Bayreuth is merely a large village," whose residents and visitors were not prone to mixing haute couture with their culture: "The dresses were pretty," he allowed, "but neither sex was in evening dress."[82]

In Twain's account, the efficient and seemingly mechanized system of human circulation gave way, once the performance began, to something even less alive:

> I have seen all sorts of audiences—at theaters, operas, concerts, lectures, sermons, funerals—but none which was twin to the Wagner audience of Bayreuth for fixed and reverential attention. Absolute attention and petrified retention to the end of an act of the attitude assumed at the beginning of it. You detect no movement in the solid mass of heads and shoulders. You seem to sit with the dead in the gloom of a tomb.[83]

The complete stillness of the spectators was particularly noticeable given their arrangement in the auditorium; gathered into one unified block of seats, they formed a strikingly unmoving audience. Yet they were by no means unmoved; in fact, their stillness reflected an active engagement in the music drama being performed before them. Twain continued,

> You know that they are being stirred to their profoundest depths; that there are times when they want to rise and wave handkerchiefs and shout their approbation, and times when tears are running down their faces, and it would be a relief to free their pent emotions in sobs or screams; yet you hear not one utterance till the curtain swings together and the closing strains have slowly faded out and died; then the dead rise with one impulse and shake the building with their applause.[84]

The Mystical Abyss

The architectural feature for which the Festival Theater became famous was not the series of transverse walls that captured Shaw's attention, but rather the "invisible orchestra" he was unable to see from his seat. As the section drawing shows, the orchestra pit in Bayreuth is tucked under the proscenium stage, its floor raked downward from the conductor's podium at the same angle as that of the auditorium floor (Figure 2.20). The conductor thus stands above the musicians, who are placed along large terraced steps that descend below him. This arrangement had long been a topic of discussion among architects, and other theaters had already been built with submerged orchestras. Semper, as we have seen, had experimented with a raked orchestra pit in his third design for a provisional theater for Wagner in Munich, repeating the innovation in his designs for a monumental theater in that city. Here, too, the edge of the orchestra pit was tucked slightly under the stage—albeit not nearly as far as in Bayreuth, where even the conductor remains invisible to the audience, hidden by the wall curving over his head.[85]

Reporting on his visit to Bayreuth in 1876, Saint-Saëns made a point of mentioning a French precedent for the architecture of its auditorium—one that Wagner surely did not know. The French composer described what he saw as "a theatre in a new form, a theatre with a different type of seating arrangement and with an orchestra pit closed to the eyes of the audience," coyly adding,

> Strangely enough this idea is to be found in the musical essays of [André] Grétry—here is what he was writing in 1797: "I would like to see a hall which is rather small, seating not more than a thousand persons, with only one kind of seat throughout, with no boxes, neither large nor small. I would like the orchestra to be out of sight so that neither the musicians nor the lights of the music desks can be seen by the audience. This would create a magical effect as no one would expect the orchestra to be there."[86]

Although a dedicated Wagnerian, Saint-Saëns presented his idol's achievements in terms of French precedent; deftly reconfiguring them as a German implementation

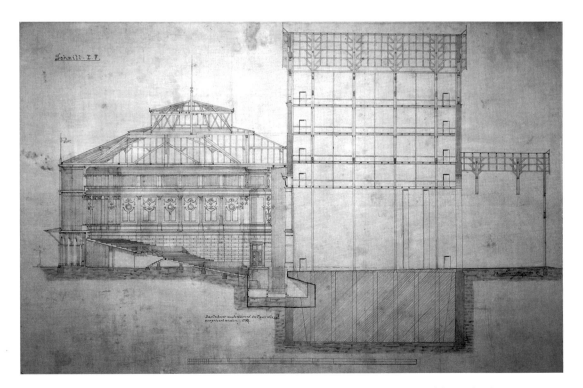

Figure 2.20. Bayreuth Festival Theater section drawing, 1874. National Archives of the Richard-Wagner-Foundation, Bayreuth (N2294).

of the ideas of a brilliant French theorist, he added, "It was left to Richard Wagner to achieve the dream of Grétry."[87] The nationalism of his remark may best be understood in light of Wagner's own well-publicized anti-French sentiments, inspired in part by his poor reception in Paris as a young composer; such nationalism was also characteristic of the uneasy cultural and political climate following the Franco-Prussian War.

From the audience's perspective, the placement of the conductor and his orchestra below the stage and behind a curved wall removes from sight much— but not all—of the activity of musical production. Spectators see the performers on stage producing music, but those in the orchestra remain invisible, their music appearing to emanate somehow from the stage area. The arrangement reflected more than an effort to improve acoustics.[88] In keeping with Wagner's arguments of almost three decades earlier about the structure of the Gesamtkunstwerk, each aspect of a production in Bayreuth was to be rendered as purely as possible, with the image, sound, and movement kept distinct from one another; the audience's experience was not to be contaminated by views of the musicians and their instruments. Without the visual distractions of musicians and conductor, members of the audience would be able to concentrate more fully on the stage image before them. As we shall see, however, while the submerged orchestra was to provide a clearer and more effective performance and encourage the audience's deep and active engagement, it later came to be·described in terms of irrationalism and passivity.

The placement of the orchestra pit in Bayreuth was also significant from the point of view of those who worked within it. A photograph taken from inside this space reveals only a wedge of the auditorium ceiling and the uppermost corners of a few short transverse walls (Plate 3). With such a limited view of the auditorium—and with no chance of being seen by the audience—the musicians could concentrate on making music. Rather than facing the spectators, they gathered around the conductor. As Shaw put it, "The instruments are not stretched in a thin horizontal line with the trombones at the extreme right of the conductor, and the drums at his extreme left: they are grouped as at an orchestral concert."[89] While not original to Bayreuth, the positioning of the conductor at the center of the orchestra was a relatively new phenomenon, one that had originated with Wagner's chief rival in Germany. "The modern arrangement of the orchestra," Carl Dahlhaus has explained,

> introduced by Mendelssohn at the Leipzig Gewandhaus in 1835, places the musicians in a semicircle about the conductor, who stands at the front of the platform with his back to the audience. As late as 1843,

however, a different arrangement was practiced in London, where the conductor stood in the midst of the musicians facing the audience.[90]

With the musicians and the conductor tucked below the Bayreuth stage, they had no need to orient themselves toward the audience. Like so much else about the design of the Festival Theater, the arrangement of members of the orchestra aimed at rationalizing and modernizing musical traditions.

Ironically, however, rationalization and modernization were easily interpreted as a kind of magic. In a darkened auditorium, even before the opening bars of the *Ring* cycle were heard, anything not immediately comprehensible was potentially the effect of sorcery. The raising of the curtain before the performance, for example, was often described in terms of awe and wonder. Rather than being pulled upward in a series of vertical tugs when the music began, for example, the curtain in Bayreuth was, as Stoeckel put it, "drawn aside and upwards so as to leave the impression that some unseen hands have moved it very gracefully out of sight."[91] The more magical the experience, however, the less it was to be trusted—and, ultimately, as we shall see, the more Wagner himself was suspected of sorcery.

Visitors to Bayreuth were not alone in remarking on the presence of magic there. Wagner himself famously referred to the "mystical abyss," or *"mystische Abgrund,"* that lay between the auditorium in Bayreuth and the idealized realm of art. "Complete separation of the ideal stage world from the reality that replaces it, by means of the circle of spectators," he wrote, corresponded to "an invisible orchestra, effective only via the ear."[92] In the darkened auditorium, the effect was like that of a séance, but the realm of art was not to be conflated with that of the spectators, who appeared as witnesses to an artistic event. Just as the individual arts, and the individual human senses, were to be kept distinct in the creation of the Gesamtkunstwerk, so, too, was the audience to be kept separate from the exalted work of art. In a letter of 1865, Semper had likewise insisted on "the necessary separation of the real world from that of the stage."[93] Critics and scholars have often emphasized the importance of the distance between the spectators and the performers in Bayreuth. Yet this distance is more figurative than literal. The submerged orchestra pit ensures that spectators there are in fact no further from the stage than in other theaters—and they remain physically much closer to the stage than in many.

The sense of auratic distance between the spectators and the stage in Bayreuth was both created and counteracted by the emotional and physical closeness achieved within the audience. Each spectator was to be made to feel like part of a larger group, and each, by joining this group, would simultaneously become stronger as

an individual. The architecture of the auditorium, from the process of admission to the arrangement of the seats, was central to producing this effect; by experiencing the work of art together, as a unified group, the audience came into being as an entity. As in the composer's discussion of the relation of the individual arts to the Gesamtkunstwerk, distance demanded proximity. With the help of the auditorium architecture, the auratic distance between the spectators and stage was to be both reinforced and constantly overcome.

Remarkably, the only thing visible to the audience in the darkened auditorium in Bayreuth—the stage image—appears to hover in the air, strangely unattached to the architecture around it. The effect is caused primarily by the presence of a double proscenium. The space of the auditorium, that is, appears to end where the transverse walls bring spectators to either side of the first few rows of seats. At some unspecified distance behind these walls (the equivalent of four rows further back, perhaps) there appears to be another set of transverse walls jutting into the stage. Behind these, another set is visible, now clearly beyond the space of the auditorium. Thus, while the darkened auditorium and the lighted stage are spatially distinct, the procession of ever-lengthening transverse walls along the sides of the auditorium seems to extend into the stage area, to be visually continued by the coulisses at each side of the stage, an effect visible in a photograph showing scenery from the inaugural production of *Parsifal* (Figure 2.21). From the spectator's perspective it remains unclear where, in the shadowy zone from which the music appears to emanate, the auditorium ends and the realm of art—or at least that of the Temple of the Holy Grail—begins.

The arrangement was directly inspired by Semper's Munich designs of a dozen years earlier, as a letter sent by the architect to Wagner on November 26, 1865, attests. "According to our agreement," Semper wrote, "I have placed two prosceniums, separated by the sunken orchestra, one behind the other. The architecture of the more narrow second proscenium is a repetition of the large anterior one, but on a smaller scale." He then elaborated on the effect of this design:

> Thus there will come about a complete displacement of scale from which will follow both an ostensible enlargement of everything happening on the stage and also the desired separation of the ideal world of the stage from the real world on the other side of the boundarylike orchestra. The latter is to be completely invisible but by no means too deeply set.[94]

The double proscenium in Bayreuth followed the precedent set by Semper, yet it lacked the monumentality of his earlier projects. The trompe l'oeil effect was to

occur in the dark, mysteriously; any surrounding architectural splendor would only overwhelm spectators and distract from the overall effect.

The double proscenium around the Bayreuth stage, one visitor wrote, "created an illusion of perspective by visually narrowing the inner frame surrounding the stage and thus making everything onstage seem larger."[95] To the audience gathered in the auditorium, those performing on stage really do appear to be larger than life. But their outsized representation may also be seen in a different way. With darkness in the auditorium and music emanating from the lighted stage, the effect during a performance conflates distant and near views; the hovering stage image appears, simultaneously and impossibly, to be both very close to and very far from the spectator. Such a conflation of near and distant vision (*Nahsicht* and *Fernsicht*) was a prevalent theme in late-nineteenth-century German visual discourse, treated perhaps most famously by the sculptor and visual theorist Adolf Hildebrand. As we shall see, this distinction was fundamentally linked to the relation of optical and embodied vision.

Hidden behind the curved wall that divides the orchestra pit from the auditorium, the conductor in Bayreuth is invisible to those in the audience, although he can be seen by those performers near the front of the stage. The emphasis on

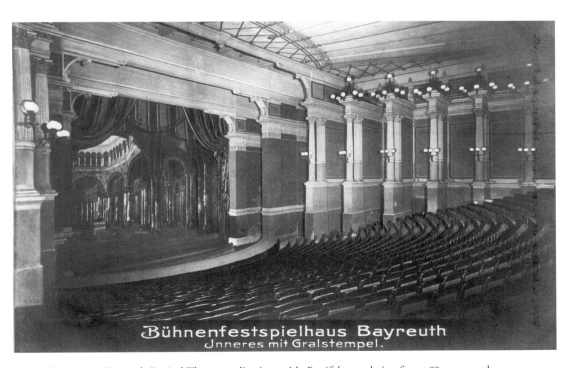

Figure 2.21. Bayreuth Festival Theater auditorium with *Parsifal* stage design from 1882, postcard, ca. 1911. National Archives of the Richard-Wagner-Foundation, Bayreuth (N3397).

display that governed the architectural arrangement at other venues—with the Paris Opéra being only the most extreme example—was thus discarded, at Bayreuth, in favor of a more rational system emphasizing sound and perceptual experience rather than spectacle. Conducting was a form of creative labor carried out, as it were, behind the scenes; members of the audience were to be neither entertained visually by the players and their instruments nor distracted by their fellow spectators, who would likewise be sitting in darkness, silently facing the stage. The musical experience occurred alongside a visual experience that itself was rendered more pure by the design of the theater. "The concentration of attention on the stage is so complete that the after-image of the lyric drama witnessed is deeply engraved in the memory, aural and visual," Shaw wrote, continuing, "The artistic success of this innovation in theatre-building is without a single drawback."[96]

Outside the building, the response was less uniformly positive. Critical assessments of the inaugural season in 1876 noted a lack of fine food in a town unprepared for quite so many (and such demanding) tourists. "I saw a woman in Bayreuth," Tchaikovsky noted, "the wife of one of Russia's most influential men, who had not eaten one meal during the whole of her sojourn in Bayreuth. Coffee was her sole succour."[97] Such remarks generally came from the bourgeois liberal establishment—for example, Eduard Hanslick, who had known the revolutionary Wagner in Dresden and who now, accustomed as he was to the comforts of Vienna, found Bayreuth rather provincial. "A little town like Bayreuth is in no way prepared for the reception of so many visitors," he wrote in his diary.

> Not only are there no luxuries; often enough there are not even the necessities. I doubt that the enjoyment of art is furthered by being uncomfortably housed for a week, sleeping badly, eating wretchedly, and after a strenuous five or six hours' performance of opera, being uncertain of securing a modest snack. Even yesterday I saw many who had arrived in the flush of enthusiasm crawling up the hot dusty street to the distant Wagner Theatre in a considerably more sober frame of mind.[98]

Not every aspect of a visit to Bayreuth pleased all of its visitors, and not all music lovers were cut out for the physical demands of a pilgrimage there. Yet clearly it would be unjust to hold Wagner personally accountable for others' disappointment with the accommodations and cuisine available in town, especially given the composer's enormous difficulties raising money for his theater.

Financially speaking, the endeavor was a fiasco, leaving Wagner with a deficit of 150,000 thalers that Ludwig finally agreed to pay only in 1878. The inaugural season of his Festival Theater appears to have overwhelmed Wagner; Cosima duly

noted in her diary in early September, "R. is very sad; says he would like to die!"[99] The composer's mood apparently had not improved five months later, when she wrote, "R. says how sad it is that he has now reached the stage of wishing to hear nothing more about the *Ring of the Nibelungen* and wishing the theater would go up in flames."[100] Such a conflagration, of course, was of a radically different nature from the fire he had envisioned, decades earlier, engulfing the score of the *Ring* and rendering his theater literally provisional and figuratively permanent. While never achieving the architectural monumentality of Semper's Munich designs, the building would become an institution, ever more solid and permanent; in 1882 a royal loge was even added to the building in the vain hope of enticing Ludwig II to the inaugural performance of Wagner's last opera, *Parsifal*.

Uniting the arts in one auditorium while bringing together individual spectators in the hope of forming a unified German audience, Wagner's theater in Bayreuth created, in some ways, the kind of spectacle that the composer himself had once opposed. Five years after the Franco-Prussian War and the founding of the German nation, the magnificence of the event was often understood in terms of a self-congratulatory German nationalism rather than in relation to the democratic impulses that had propelled the composer to delineate the characteristics of the Gesamtkunstwerk of the future in the aftermath of the failed revolution of 1848–49.[101] While forging a relation between aesthetic theory and artistic production, the construction of this "theater of the future" in Bayreuth—the concrete realization of a utopian enterprise—allowed spectators and later generations to lose sight of Wagner's earlier, revolutionary ideas. Perhaps above all, the bombastic music and occasional set pieces—with men's and women's choruses, a brotherhood duet, and a revenge trio in *Götterdämmerung* alone—meant that performances could sometimes sound strikingly similar to the Italian and French operas he had long decried.

Nevertheless, Wagner's attempts to render aesthetic principles in architectural form provided German modernists in a range of fields with a clear model, both architectural and conceptual, of the crucial link between the Gesamtkunstwerk and the theory and practice of spectatorship. One of the central achievements of the Festival Theater in Bayreuth lay in its conflation of haptic and optical concerns. The physical arrangement of the spectators within the auditorium ultimately permitted the purity of the optical arrangement. Like so many other visitors to the auditorium there, even Hanslick noted the visual clarity and democratic access it achieved. "Vision is equally good from every seat," he explained;

> one sees the proceedings on the stage without obstruction—and nothing
> else. At the beginning of a performance the auditorium is completely

darkened; the brightly lighted stage, with neither spotlights nor foot-lights in evidence, appears like a brilliantly coloured picture in a dark frame. Many of the scenes have almost the effect of transparent pictures or views in a diorama. Wagner claims that "the scenic picture should appear to the spectator with the inapproachability of an apparition in a dream."[102]

From the journey to the town, to the procession up the hill to the theater, and finally to the entry into the auditorium—and with the orchestra submerged under the stage in the darkened room, the side walls disappearing smoothly into the stage area—everything came together in Bayreuth to provide audience members with a stage image that hovered, magically, before their eyes. Simultaneously near and far, fully present yet unapproachable, this optical trick relied on physical means but appeared, simultaneously, to deny the bodily existence of those who witnessed it.

3

Empathy Abstracted

> Psychologically, the intuited form of three-dimensional space arises through
> the experiences of our sense of sight, whether or not assisted by other
> physiological factors. . . . [It] consists of the residues of sensory experience to
> which the muscular sensations of our body, the sensitivity of our skin, and the
> structure of our body all contribute.
>
> —AUGUST SCHMARSOW, *The Essence of Architectonic Creation,* 1893

AESTHETIC EMPATHY

While spectators were enjoying the inaugural presentations of Wagner's music dra-
mas in Bayreuth, a new term was being used to describe the particular combina-
tion of visual and bodily perception they experienced there. Beginning in the
1870s, researchers and theorists in the overlapping fields of philosophical aesthet-
ics, perceptual psychology, optics, and art and architectural history began to
develop the theory of Einfühlung—literally, the activity of "feeling into." In the
last quarter of the nineteenth century, Einfühlung described an embodied response
to an image, object, or spatial environment; it offered a forum for abstract discus-
sions of the spectator's active perceptual experience. Translated into English as
"empathy" (a linguistic conversion that occurred only in 1904), the concept is now
frequently conflated with sympathy or compassion and signifies a process of emo-
tional and psychological projection.[1] But the late-nineteenth-century discourse of
Einfühlung addressed, more specifically, a form of spectatorship that was simulta-
neously haptic and optic. Like the concepts of abstraction, distraction, and estrange-
ment developed in its wake—each of which relied on empathy both as a foil and
as a necessary component—it described a potentially uncomfortable destabiliza-
tion of identity along the viewer's perceptual borders, a sensation at once physical,
psychological, and emotional.[2]

Promulgated in several disciplines—none of which was either discrete or fully
formed—the concept of Einfühlung underwent divergent fates in each. A grad-
ual loss of interest among art historians (such as Heinrich Wölfflin) and psychol-
ogists (such as Theodor Lipps) preceded more forceful rejections of the concept
by Wilhelm Worringer in 1908 and by Bertolt Brecht in the 1930s; Einfühlung,
particularly amenable to discussions of spatial perception, remained for decades

within the discourse of modern architecture long after fading from the forefront of art history, its demise helping to mark the divergence of the two. Beyond offering a sequence of etymological shifts or discursive trends, its history reveals a fracturing of the disciplines around 1900; a rejection of narrative that accompanied the emergence of visual abstraction; and widespread transformations, with the birth of film, in both the objects of spectatorship and the identity and status of spectators. Having originated as a means of analyzing the aesthetic response of a solitary viewer, the concept would come to describe the absorption experienced collectively by the mass audience.

The initial theoretical statement concerning Einfühlung was made in 1873 by the philosopher Robert Vischer in the treatise *On the Optical Sense of Form: A Contribution to Aesthetics* (*Über das optische Formgefühl: Ein Beitrag zur Aesthetik*). Vischer used the term to describe a viewer's active perceptual engagement with a work of art. In this process, he wrote,

> I entrust my individual life to the lifeless form, just as I . . . do with another living person. Only ostensibly do I remain the same although the object remains an other. I seem merely to adapt and attach myself to it as one hand clasps another, and yet I am mysteriously transplanted and magically transformed into this other.[3]

This reciprocal experience of exchange and transformation—a solitary, one-on-one experience—created, as it were, both viewer and object, destabilizing the identity of the former while animating the latter. Physical, emotional, and psychological, the process placed the spectator at the center of aesthetic discourse.[4]

Devoid of spatial connotations, the German term *Einfühlung* first appeared in print in 1800 in the work of Gottfried Herder, whom late-nineteenth-century theorists cited as a precursor; the concept more generally may be traced to the writings of Aristotle.[5] The theme of sympathy evoked the work of Jean-Jacques Rousseau and Schopenhauer; one proximate influence was Nietzsche, an acquaintance of Robert Vischer's father, the philosopher of aesthetics Friedrich Theodor Vischer. Favoring the words *Mitleid* and *Miterlebnis* over *Einfühlung*, Nietzsche neither considered empathy or sympathy in spatial terms nor discussed the aesthetic response as it literally occurred on the spectator's skin. Yet his description of this response as a merger of the self into the work of art that provoked a loss of speech and the dissolution of individual identity strongly resembles the aesthetic activity that was also described as Einfühlung. In 1876, for example, he wrote that the spectator of the Wagnerian Gesamtkunstwerk is led "to a totally new understanding and empathy [*Verstehen und Miterleben*], just as though his senses had all at once

grown more spiritual and his spirit more sensual."[6] This aesthetic response also involved an element of *Selbstentäußerung*, or "self-estrangement," as we shall see.

Subsequently developed by such authors as Conrad Fiedler, Lipps, August Schmarsow, and Wölfflin, the discourse of Einfühlung treated vision and the experience of space in bodily and psychic terms.[7] Its interdisciplinary nature reflected a relative openness among the humanistic and scientific fields; viewers might "empathize into" anything from everyday objects or nonreferential markings to works of fine art, according to the interests of particular authors. Placing the perceiving eye within the viewer's body, Einfühlung described a variety of relationships between this body and the work of art, including a tendency to anthropomorphize and a notion of projection we might now associate with Sigmund Freud. The viewer, Vischer wrote, "unconsciously projects its own bodily form—and with this also the soul—into the form of the object. From this I derived the notion that I call '*Einfühlung*.'"[8] Pity, sympathy, and compassion all appeared within the discourse, and they were not always (or consistently) differentiated. Wölfflin's claim, for example, that "compassion [*Mitleiden*] . . . is psychologically the same process as aesthetic sympathy [*ästhetische Mitfühlen*]" not only had no scientific basis but also contradicted Vischer's careful distinctions between Einfühlung and *Anfühlung, Nachfühlung,* and *Zufühlung,* which may be translated as "attentive feeling," "responsive feeling," and "immediate feeling," respectively.[9]

We are aware of the power of images to elicit a visceral response; an example would be the discomfort provoked among the squeamish by depictions of physically painful events.[10] Vischer articulated this response to form in abstract terms, arguing that even simple marks could induce physical reactions. Vision itself, in fact, was not always central; the process relied heavily on a network of responses that included spatial understanding, imagination, emotion, and (in some cases) "artistic reshaping," or the creative aesthetic response. "We can often observe in ourselves," he noted, "the curious fact that a visual stimulus is experienced not so much with our eyes as with a different sense in another part of our body."[11] This sensation occurred with particular intensity along the body's surfaces, he argued, usefully providing an explanation for the mystical shivers of aesthetic transport. Along with the destabilization of identity and psychic projection, such bodily sensations on the spectator's skin produced a powerful self-awareness. Einfühlung, that is, articulated a loss of self that simultaneously reinforced a powerful, physical sense of selfhood.

Vischer primarily used as examples natural or simple forms (such as clouds, colors, and lines), a rhetorical model derived from physiology, optics, and philosophy rather than from art history, the discipline he would enter within the decade. A hazy mixture of projections and impressions, Einfühlung could also be provoked

by such three-dimensional objects as flowers and sculptures. Only in the final pages of his treatise did he attend to the perception of works of art—which, he maintained, had the capacity to prompt the purest optical feeling. In this late-nineteenth-century context, the representational nature of these objects was never questioned; his examples include Albrecht Dürer's *Four Apostles*. But in combining psychology, optics, fine art, and the notion of universal spectatorship, the discourse of Einfühlung that Vischer and others developed unwittingly helped set the terms for the theory and practice of visual abstraction. The "pure form" of the twentieth century was embedded within an idea of embodied perception.

According to Vischer, spectators feel physical discomfort while looking at a single vertical line on a blank page. "A horizontal line is pleasing because the eyes are positioned horizontally," he declared, whereas a "vertical line, by contrast, can be disturbing when perceived in isolation for . . . it contradicts the binocular structure of the perceiving eyes and forces them to function in a more complicated way."[12] Rather than positing verticality as the visual expression of the upright human body and horizontality as the representation of a landscape, Vischer discussed the pure form of a line in relation to the perceptual faculties of the individual spectator. He understood vision to be simultaneously optical and bodily and described it, crucially, as binocular. Unlike monocular vision, which perceives an image without reference to scale—the actual size of images seen through telescopes and microscopes is not apparent—binocular vision situates the body in relation to the image. As objects mediating visual experience, moreover, binoculars themselves create an image through bodily perception; held in the viewer's hands, they present a doubled image that becomes unified only within the viewer's body.[13] Turning distant views into haptic experiences, they allow the individual spectator to "empathize into" an image.

The concept of Einfühlung suffused the early work of Wölfflin, who completed his dissertation, *Prolegomena to a Psychology of Architecture* (*Prolegomena zu einer Psychologie der Architektur*), in 1886 in the Department of Philosophy at the University of Munich. "Asymmetry," Wölfflin wrote, "is often experienced as physical pain, as if a limb were missing or injured."[14] The psychological understanding of vision as embedded in the body could be most productively applied, he believed, to the interpretation of works of architecture.[15] Representations of architectural form, and architecture itself, provided opportunities for embodied vision. Wölfflin's own drawings of Romanesque and Gothic arches on a scrap of paper tucked into his copy of the *Prolegomena* allow us to test his claim that "the round arch is generally recognized as more cheerful to look at than the pointed arch. The former goes about its task quietly, content with its roundness; the latter embodies a will and effort in every line" (Figure 3.1).[16]

Figure 3.1. Heinrich Wölfflin, drawing of Romanesque and Gothic arches. Courtesy of the Research Library, The Getty Research Institute, Los Angeles, California (860448).

For Wölfflin at this time, architecture and its two-dimensional representation were equally capable of eliciting Einfühlung. Schmarsow, however, distinguished between the two. In a lecture in 1893 marking his inheritance of the art history chair at Leipzig (a position for which he was chosen over Vischer and Wölfflin), Schmarsow famously defined architecture as spatial—rather than structural, material, or formal—and unique of all the arts in its ability to provoke Einfühlung. The psychological parallel between the viewer's body and that of the work of art (in this case, a building) was mediated through vision. But while vision was crucial initially, perception ultimately proved to be a bodily phenomenon: "Every spatial creation is first and foremost the enclosing of a [human] subject; and thus architecture as a human art differs fundamentally from all endeavors in the applied arts."[17]

Schmarsow was not the first to define architecture as spatial, but his arguments were particularly significant, given his status and the context in which he spoke.[18] Like Vischer and Wölfflin, he was an art historian who placed architecture at the center of his work—standard practice in late-nineteenth-century Germany but rare today in the United States.[19] By publicly registering Einfühlung as amenable to considerations of spatial perception, Schmarsow encouraged its continuation

within the discourse of modern architecture long after it had faded from art historians' attention, a loss of interest that paralleled that of psychologists after 1900. The uneven fate of Einfühlung may thus be seen to reflect the divergence of the two disciplines of art history and architecture history.[20] Even as the spatial understanding of architecture persisted, it was often drained of the emotional content that Einfühlung had provided; indeed, the concept itself was not always named.[21]

Empathy and Relief

In 1893, however, when the sculptor Adolf Hildebrand published *The Problem of Form in the Fine Arts* (*Das Problem der Form in der bildenden Kunst*), the concept's basic principles were still considered powerful. "There is a psychology of art," Hildebrand declared in reference to Einfühlung, "a clear feeling for the effect of such stimulated movement on our sensibility as a whole. Such effects determine whether or not we breathe freely, for our general sensations are related to the spatial imagination."[22] Like Vischer, he treated the experience of aesthetic perception as temporal, spatial, and embodied. Even spectators who attended to singular, stationary works of visual art were, implicitly, mobile creatures, remaining physically present within their environment. Perception was therefore neither static nor entirely dependent on visual cues. "Since we do not view nature simply as visual beings tied to a single vantage point but, rather, with all our senses at once, in perpetual change and motion, we live and weave a spatial consciousness into the nature that surrounds us," he asserted; the awareness of space remained "even when we close our eyes."[23]

Hildebrand's treatise offered a series of conceptual dichotomies: near and distant vision (*Nahsicht* and *Fernsicht*), scanning and seeing (*Schauen* and *Sehen*), and inherent and effective form (*Daseinsform* and *Wirkungsform*). Favoring the second term in each case, he argued that the ideal work of art united these pairs; framing the effective form of the depicted object or image, it allowed the viewer to apprehend it as if from a distance, inspiring within the viewer an intense aesthetic sensation that he explained in somatic terms: "We seem, so to speak, to grow larger or smaller to fit the image."[24] He was primarily concerned with the fine (and not the applied) arts, writing, for example, that in painting, "of prime importance is not the appeal of color in itself, as in a carpet, but its capacity to denote distance."[25] Moreover, he advocated a particular kind of art, presenting relief sculpture as the ideal art form, since it spurred the spectator's visual imagination most strongly into action. His status as a relief sculptor ensured that his own artistic achievements exemplified his arguments.[26]

According to Hildebrand, the spectator's relation to the art object was essentially spatial, although it was perceived visually; his goal in *The Problem of Form*

was to theorize this aesthetic experience. "Space in general," he explained, "and the idea of form or delimited space in particular," provided the "essential content or the essential reality of things."[27] Such other features of an object as color and line were mere embellishments that helped further the viewer's apprehension of its spatial appearance. A work of art was to inspire the viewer's spatial sense as forcefully as possible; visual art represented space in two dimensions, and the artistic experience was located in the viewer's struggle to reconstruct, from these two dimensions, a full perception of the object. "The artistic representation," Hildebrand announced, "is concerned precisely with evoking [an] idea of space through the appearance it produces and only through that."[28] Art was to provoke the highest degree of kinesthetic activity within the imagination of the viewer; "the appearance must draw the imagination into depth."[29] The flattest image demanded the most intense expenditure of energy from the viewer and provoked the strongest aesthetic reaction; the flattest sculpture—or, rather, the sculpture that most explored the notion of flatness—thus offered the purest artistic experience. *→ hot/cold medium*

Following Vischer, Hildebrand distinguished two modes of perception. The distant view showed a two-dimensional, static image of an entire visual field; from a distance, the viewer saw a work whole, both literally and symbolically. By contrast, the near view offered a three-dimensional view of an object, insofar as its three dimensions could be perceived up close as a juxtaposition of surfaces at various levels. With constant kinesthetic activity, the eye created an image of a close object that was essentially mobile and temporal:

> The image received by the viewing eye at rest expresses three-dimensionality only by surface signs, through which coexisting elements are simultaneously apprehended. At the other extreme, the eye's mobility enables it to scan a three-dimensional object directly from a close vantage point and to transform the perception into a temporal sequence of images.[30]

Crucially, Hildebrand associated distant vision with the notion of flatness: a remote view appeared flat, whereas an object's three-dimensionality could not be ignored when seen up close. He labeled the viewer's production of an image from a distance "seeing" and called close vision "scanning," a conceptual distinction likewise derived from Vischer.[31] Both men considered the distant view to be static and the near view to be mobile. Constant visual activity, Hildebrand explained, gathered discrete, localized images and a host of details but never attained a coherent image of an object. Scanning was a form of scientific vision, mechanical and passive; Hildebrand described it in terms that evoke such developments in the *Seeing vs. scanning*

field of science as microscope lenses and the microtome, both of which revealed to late-nineteenth-century viewers far more of an object's details than had ever been possible. For both Vischer and Hildebrand, a complete visual image of an object actively integrated these details into a larger image; distant and static, it was by definition an "artistic image," formulated also by creative imagination and spatial understanding.[32]

Through a process of scanning, scientific vision provided the viewer with factual information about what Hildebrand termed an object's "inherent form." Taking into account also the point of view of the viewer and the viewing environment more generally produced a more complete perception of an object, which he labeled its "effective form." Inherent form had a certain abstract and rational truth, while effective form reflected the object as it was encountered in the world. "The impression of form that we acquire from the appearance and that is contained in it is always a joint product of the object, on the one hand, and of its lighting, surroundings, and our changing vantage point, on the other," Hildebrand declared; it was this joint product—the impression of an object a spectator received—that concerned him.[33] Thus the true "problem of form" was how form was perceived by artistic vision: how a spectator turned all the local and contextual impressions into a larger, static, and distant whole. "This whole exists for the eye only in the form of effects that translate all actual dimensions into relative values," he explained; "only in this way do we possess it as a visual idea."[34]

Conflating the artist's creative activity and that of the viewer, Hildebrand argued that artistic vision was by nature active, whereas the model of mechanical reception that marked scientific vision—scanning—was predominantly passive. The activity he valued was perceptual and aesthetic. Relief sculpture offered the viewer not only the possibility of the distant image, artistic seeing, and effective form but also the full range of the conceptual dichotomies to which each belonged. Presenting the viewer with the purest example of the play between near and distant vision, seeing and scanning, and inherent and effective form, it marked the pinnacle of aesthetic experience.

Hildebrand explored the topic in "The Concept of Relief," his book's fifth chapter, defining art as the "evocation of a general idea of space by means of the appearance of the object."[35] The flatter the given object, he argued, the more intensely it might provoke the viewer's spatial sense. The ideal art object, in other words, prompted the highest level of aesthetic activity by approximating two dimensions most closely; whereas freestanding sculpture and painting presented a mimetic reproduction of an object, relief sculpture could never rely on such lazy tactics. Rather, it used visual hints to convey a sense of space and provoked the viewer to merge the two-dimensional image held in the eye with a full perception

of the object. "While evoking two-dimensional effects," Hildebrand explained, relief "contains that which the eye needs in order to develop a recognizable image of the object on the surface and a coherent depth dimension for the sensation of volume."[36] The relief image best fulfilled the aim of art, and Greek relief carvings constituted the most highly developed example of the genre. Indeed, *The Problem of Form in the Fine Arts* may be seen as a rationalization for a predetermined conception of art that aimed at justifying relief sculpture.

While Hildebrand oriented his artistic interests toward ancient Greece and Rome and lived much of his life near Florence, the theories of vision he developed at the end of the nineteenth century evoke the contemporaneous pictorial concerns of impressionism. The parallel is particularly evident in his discussion of the distinction between the static, distant view of an entire visual field and the near view, which revealed an object's three-dimensional status through surface contrasts. "The closer the observer comes to the object," Hildebrand wrote,

> the less coherent will be the visual impression. Finally the field of vision becomes so confined that he will be able to focus only on one point at a time, and he will experience the spatial relationships between different points by moving his eyes. Now seeing becomes scanning, and the resulting ideas are not visual but kinesthetic; they supply the material for an abstract vision and idea of form.[37]

Close-up vision was kinesthetic; it involved the viewer's visual activity of scanning, creating an image by means of the accretion of details. At a greater distance from the work, the viewer's aesthetic activity increased, and the viewer produced a more coherent and complete visual image. While objects that were too close could not be properly apprehended, "at a certain distance from a perceived object . . . our eyes begin to see parallel and take the object in at a glance, as a coherent surface image or distant image."[38] Intentionally or not, Hildebrand's analysis of the viewing process might well describe a canvas by Claude Monet.

One persistent account of modernism in the visual arts asserts an increasing reliance on opticality, ranging chronologically from the work of Édouard Manet to the post-painterly abstraction of the 1960s. In 1967, deeply unsympathetic to the idea of embodied vision, Michael Fried celebrated the paintings of Morris Louis and others for their "continuous and entire presentness."[39] Modernism, as Clement Greenberg had explained it six years earlier, was a matter "of purely optical experience against optical experience as revised or modified by tactile associations."[40] Facing a work of art, in this account, the modernist viewer experiences an aesthetic response from the vantage point of a disembodied eye: a singular

perceiving entity that remains unencumbered by any attachment to the human body within which it is located. The conceptual opposition of bodily and optical perception paralleled another distinction between traditional representational painting and those works that Greenberg described as modernist: "The Old Masters created an illusion of space in depth that one could imagine oneself walking into," he argued, "but the analogous illusion created by the Modernist painter can only be seen into; can be traveled through . . . only with the eye."[41] The spatial concerns of traditional representational painting provided the spectator with an opportunity for an embodied perceptual experience. By contrast, modernist painting was posited as essentially flat, optical, and monocular; perceived with no awareness of the body, it was outside time and beyond narrative.

The invention of such a notion of opticality is often ascribed to Conrad Fiedler, who famously stated in 1887, "The sole aim of artistic activity is to be found in the expression of the pure visibility [*Sichtbarkeit*] of an object."[42] Fiedler's position is consequently often taken as antithetical to the concept of Einfühlung. Hildebrand, however, developed the ideas for his own book during many years' dialogue with Fiedler. Beginning in 1881, Fiedler reviewed several drafts over the course of a dozen years, a collaboration that suggests a conceptual alliance between Einfühlung and opticality. Correspondence between the two demonstrating the extent of Fiedler's influence on Hildebrand's ideas lasted from 1870 until Fiedler's death in 1895, when Hildebrand designed the bronze plaque for his friend's grave (Figure 3.2).[43] Vischer's seemingly contradictory phrase "the optical sense of form" thus captures an essential claim of Einfühlung: optical experience occurs with the entire body. For Vischer, Hildebrand, and Fiedler, opticality was not "revised or modified by tactile associations," as in Greenberg's phrase; such associations were there from the beginning.[44]

Figure 3.2. Adolf Hildebrand, bronze plaque for the grave of Conrad Adolph Fiedler, 1895. From Sigrid Esche-Braunfels, *Adolf von Hildebrand* (Berlin: Deutsche Verlag für Kunstwissenschaft, 1993), 183, Figure 228. Photograph copyright Architekturmuseum der TU München.

An acquaintance of Wagner, Fiedler had made the pilgrimage to Bayreuth to attend the inaugural production of the *Ring*; as he acknowledged in a letter to Hildebrand, "the Bayreuth productions have given me much to think about."[45] He was not entirely convinced by what he took to be the composer's theoretical arguments, however. Referring to Wagner's idea of the Gesamtkunstwerk, for example, he maintained that, "although the various human artistic faculties have a common origin in the urge to perception, they can never lead to the overall result that is manifested externally. They can only be united in idea, in consciousness."[46] While proffered in the spirit of a critique of the composer's ideas, Fiedler's argument demonstrates a peculiar solidarity with the idea of the Gesamtkunstwerk that Wagner had proposed in 1849: utopian and idealistic, the Gesamtkunstwerk was a proposal for the theater of the future and, as such, it took place "in idea, in consciousness." Not even the Festival Theater in Bayreuth could be taken as its architectural equivalent or embodiment. Yet Fiedler's enthusiasm for what he experienced at that venue was certain, and his link to the composer was further cemented when, one year after his death in 1895, his widow, Mary—daughter of the director of the Gemäldegalerie in Berlin, Julius Meyer—married Wagner's most important conductor, Hermann Levi.

In 1917, almost half a century after Vischer had described the viewer's response to a simple vertical line, the Russian suprematist artist Olga Rozanova made a small painting that consists of a green vertical stripe on a white background (Plate 4). "We propose to liberate painting from its subservience to the ready-made forms of reality," the artist declared, "and to make it first and foremost a creative, not a re-productive, art. The aesthetic value of an abstract picture lies in the completeness of its painterly content."[47] Rather than depicting three-dimensional architectural space or a narrative scene, a work of art might now demonstrate, with revolutionary clarity, the radical act of pure painting. A green vertical line, which theorists of Einfühlung in late-nineteenth-century Germany might have used to measure a viewer's embodied perception, now stood—in the Soviet Union, following the October Revolution—as a monument of modernist nonobjectivity. Vischer and his cohorts would not have recognized Rozanova's painted line as a work of art, but in positing and debating the universal response to abstract form, they theorized a perceptual response to visual abstraction decades before its actual birth.[48]

PSYCHOLOGICAL EMPATHY

While historians and theorists of art and architecture composed treatises on Einfühlung that garnered authority from psychological research—which itself depended on physiological analysis after the late 1870s—psychologists likewise attended to the topic, and with particular zeal around the turn of the twentieth

century.[49] Prominent among them was Lipps, who declared in his essay "Empathy and Aesthetic Pleasure" ("Einfühlung und ästhetischer Genuss") of 1906 that, in viewing objects, "I necessarily permeate them with . . . striving, activity, and power. Grasped by reason, they bear within them, insofar as they are 'my' objects, this piece of myself."[50] Without this active contribution on the part of a spectator, he explained, objects could not be properly considered to exist.[51] While a work of art allowed the viewer to experience Einfühlung in its purest form, this state of affairs held true for any object; psychological investigations of Einfühlung were therefore concerned with everyday objects, treating the viewer as the primary object of analysis and relying on inductive reasoning and experimentation.

Even such aesthetic theories, however, were coming to be considered useless without the support of psychological evidence. As Lipps himself argued in 1907, "Aesthetics is either psychological aesthetics or a collection of declarations of some individual who possesses a sufficiently loud voice to proclaim his private predilections or his dependence on fashion."[52] The loud proclamations of individual theorists (the reference might well have been to Schmarsow, Vischer, Wölfflin, or Hildebrand) would ideally be replaced with careful scientific analyses based on the experiences of a larger number of people. Rather than theorizing a universal aesthetic response, a psychological understanding of Einfühlung would incorporate data accumulated from numerous subjects—or at least from the same one at different moments.[53]

In testing numerous responses to forms and colors, psychological research on Einfühlung acknowledged the possibility of perceptual difference. Vischer had noted the reactions of only one pair of eyes—his own—and the role of perceptual research in his writing was minimal. Authority rested in the body of the author, who presented his experience as universal. Hildebrand's own declarations were only theoretically bolstered by laboratory research; he particularly admired the work of Hermann von Helmholtz, whose three-volume *Treatise on Physiological Optics* (*Handbuch der physiologischen Optik*) was published between 1856 and 1866. "What he says about the laws of the fine arts is completely in accordance with my thoughts," Hildebrand wrote to Fiedler, "and proves the correctness of my work— I always thought that it would find a good reader in Helmholtz in particular."[54] Hildebrand made a bust of Helmholtz in 1891, describing the commission as "a nice opportunity to get closer to this man."[55] And in 1897, three years after the scientist's death, Hildebrand designed the Helmholtz family gravesite.

Addressing individual perception at a universal level, Einfühlung offered a forum for abstract discussions of the viewer's experience, but its conception of spectatorship as individualistic also prompted its downfall. In the early twentieth century, psychologists and aesthetic theorists began losing interest in the concept,

owing partly to laboratory research that discovered perceptual differences among those tested. According to one source, the British psychologist Edward Bullough, experiments in 1905 revealed, for example, that "the same subject found oblique straight lines sometimes pleasant and sometimes unpleasant, occasionally on one and the same day."[56] The changeable nature of individuals was exacerbated by the unreliability of those in groups; universal and consistent characterizations could not be assigned even to the simplest forms. After testing one hundred viewers, Bullough himself found "four clearly distinguishable types of apperception."[57] Such discoveries called into question the accuracy of Wölfflin's universalizing statements regarding horizontal and vertical lines. "The types appear to be not merely momentary attitudes of the subject," Bullough noted, "but fundamental and permanent modes of apprehending and appreciating colour."

While only small groups were tested and while viewer categories remained vague (differences in class and gender, for example, were often disregarded), psychological research on Einfühlung established the possibility of perceptual difference. "Experimental work on large numbers," Bullough argued, "would . . . have shown that no single one of the explanations championed by different adherents of the theory [of Einfühlung] could claim the monopoly of truth."[58] Regardless of how firmly they were based in the theoretical concerns of perceptual psychology, the aesthetic theories of individual authors were seen to founder on the bedrock of scientific research. The dissolution of Einfühlung as an objective paradigm led Bullough to conclude in 1921: "The great varieties of views and the acrimonious wrangles which took place at the end of the last century between the upholders of rival doctrines arose precisely from the generalization of purely personal introspective evidence."[59] Such evidence, based on the claims of an individual theorist, could not be generalized into universal truth.

In the late nineteenth century, theorists of Einfühlung had described the aesthetic responses of a viewer whom they extrapolated from their own personal experience. They treated the spectator as an educated and cultured individual whose elite status depended on a presumed superiority to an uncultured public. Vischer's comment that Einfühlung "leaves the self in a certain solitude" meant, ostensibly, that the process of psychic projection left the viewer feeling emotionally and psychologically depleted and, as it were, theoretically solitary.[60] At the same time, it revealed a basic presumption about the kind of viewer capable of feeling Einfühlung and the environment within which it could be experienced. In articulating a universal aesthetic response to round or pointed arches, Wölfflin likewise had allowed for a particular viewer: a cultivated and sensitive individual whose soul might be transported by an exalted experience of art. While never explicitly described, the empathetic viewer was implicitly a man of property whose identity

was destabilized within the confines of a relatively private realm, carefully circum-scribed by the laws of decorum and propriety.

The capacity for aesthetic judgment presumed a level of material comfort and poise exemplified by an undated photograph of Wölfflin (Figure 3.3). The well-groomed scholar leans forward in his chair, gazing intently at a work of art. His shirt collar is crisply starched; his jacket is formal, but not uncomfortably so; and his face is bathed in a radiant light that appears to emanate from the work of art itself—or perhaps from a window at the right. We perceive the work of art in a three-quarter view: a small painting of a figure set within an ornate wooden frame.[61] Wölfflin's own attention to the work is haptic in the most literal sense; he holds it in his right hand, propped against a table, in a physical gesture that sug-gests familiarity and potential ownership. The objects on the table, meanwhile—a vase of flowers, a sculpture, a stack of books—signify further facets of his absorbed engagement: beauty, tactility, and erudition. Likewise brightly lighted (and, on closer inspection, somewhat awkwardly held), the art historian's hand appears at the center of the photograph's lower edge, holding the work of art for both him and us to see. Anchoring this representation of the trajectory of Einfühlung, it also

Figure 3.3. Heinrich Wölfflin, photograph, n.d. Courtesy of the Research Library, The Getty Research Institute, Los Angeles, California.

encourages our own gaze to travel from Wölfflin's attentive eyes down to the paint-
ing and up again to the three-dimensional figure, the flowers, and the books—and
to the radiant world beyond.

For his part, Worringer affectionately described Wölfflin as "this *bourgeois aris-
tocrat of Switzerland* (or should I say: this *aristocratic bourgeois*)," adding that "in
Wölfflin's case, the expression '*le style c'est l'homme*' is really of the most convincing
accuracy."[62] Lipps himself clearly articulated the privileged status of the empa-
thetic viewer—or, more accurately, that of the theorist of Einfühlung—when he
wrote in 1906:

> But that one should know what aesthetic contemplation means, that
> one should have had experience in this aesthetic contemplation, in
> brief: that one should know that aesthetic experience is to be absolutely
> clearly distinguished from all the experience of things that occur in
> the real world . . . All of this must first be demanded of anyone who
> speaks of *Einfühlung* and wants to join the discussion of the question
> of *Einfühlung*.[63]

Like the theorists themselves, the viewer that the concept posited was implicitly
a bourgeois man of property—one who might sit comfortably at home, holding
the object of his aesthetic pleasure in his hands. His subjectivity could be destabi-
lized within the confines of a relatively private realm; his cultural and intellectual
background (and, indeed, his gender) remained so consistent as to be taken for
granted.

With the expansion of middle-class leisure, the explosion of mass media, and
the unprecedented growth in the audience for culture in the last decades of the
nineteenth century, this cultivated individual—and the Einfühlung he theoreti-
cally experienced—was increasingly difficult to maintain as a universal model.
Introduced in Berlin in 1895, cinema gathered viewers into audiences that engaged
in a kind of spectatorship that the writings of Lipps, Vischer, and Wölfflin had not
addressed.[64] A photograph taken in Berlin in 1913 shows an audience absorbed in
this new form of spectatorship (Figure 3.4). Men, women, and children are all
together in one room, which they have been allowed to enter after paying a rela-
tively small fee. Rather than owning the work they view—or emulating this estab-
lished model of aesthetic perception, as museum visitors do—they have gained
access to it temporarily by means of a commercial transaction, and the terms of
their engagement have changed. Strangers sit among strangers, together watching
the images that flicker on the giant, flat screen before them. This screen is distant,
intangible; the spatial depth displayed on it, to use Greenberg's words, "can be

traveled through . . . only with the eye." Here, spectators cannot hold an image in their hands.

This kind of optical experience long remained outside the realm of aesthetic discourse, an omission reflecting, among other things, the popularity of cinema among lower- and middle-class spectators.[65] As Erwin Panofsky would later reminisce, movies in Berlin around 1905 were projected

> in a few small and dingy cinemas mostly frequented by the "lower classes" and a sprinkling of youngsters in quest of adventure. . . . Small wonder that the "better classes" when they slowly began to venture into these early picture theaters, did so . . . with that characteristic sensation of self-conscious condescension with which we may plunge . . . into the folkloristic depths of Coney Island.[66]

Figure 3.4. Photograph of Berlin cinema audience, U. T. Hasenheide, 1913. From Uta Berg-Ganschow and Wolfgang Jacobsen, eds., *Film . . . Stadt . . . Kino . . . Berlin* (Berlin: Argon, 1987), 44. Copyright Stiftung Deutsche Kinemathek, Berlin.

The rapid growth and rising social status of cinema audiences after 1910 made film increasingly prominent both in German society and in aesthetic debate. While they were not explicitly mentioned in analyses of the viewer's relation to the work of art, new audiences hovered in the background, challenging the narrow parameters of aesthetic discourse and prompting attention to the topic of the aesthetic experience. The immense popularity of cinema proved a particular challenge—one that, as we shall see, was felt nowhere more strongly than in the theater, where spectators already gathered as a visible community.

Psychologists' differentiation of viewer types ostensibly resulted from laboratory experimentation. The phenomenon also reflected a profound shift in the conception of spectatorship, one that was linked to a revised understanding of the status of the spectator that, in turn, reflected sociological changes among European audiences. Theorists of aesthetic Einfühlung had sought to base their claims on psychological foundations, but the emerging discipline of psychology had proved insufficient to describe a universal aesthetic response. Difficulties arose in translating individual claims into universally applicable statements, as well as in negotiating the territory between objects of fine art and mass cultural experiences. Early-twentieth-century research into psychological aesthetics demonstrated not only that a viewer could feel Einfühlung in the absence of a work of art but also that an aesthetic response might occur with no accompanying experience of Einfühlung.

Empathy and Abstraction

If the demise of Einfühlung was already under way among psychologists and aesthetic theorists at the beginning of the twentieth century, its death knell was rung in 1908, when Worringer used it as a conceptual foil in *Abstraction and Empathy: A Contribution to the Psychology of Style* (*Abstraktion und Einfühlung: Ein Beitrag zur Stilpsychologie*). Embraced as the bible of twentieth-century aesthetic theory even before its professional publication, this book catapulted its author to fame and was reprinted almost annually in subsequent decades.[67] Conflating the experiences of the artist, spectator, and historian—as well as the attributes of the work of art—Worringer argued that all aesthetic activity could be traced to a dialectical formulation comprising the two concepts in his book's title. For Worringer, following Riegl, artistic will, not ability (the *Kunstwollen,* not the *Kunstkönnen*) governed artistic creativity.[68] Borrowing a rhetorical model from *The Birth of Tragedy out of the Spirit of Music,* in which Nietzsche had divided Greek art into the duality of Apollonian and Dionysian impulses, Worringer posited empathy and abstraction as two creative urges that, together, constituted the *Kunstwollen.*[69]

Adhering to the requirements for the doctorate in his day, Worringer published copies of his dissertation in 1907, distributing them to those he thought

might prove sympathetic. One recipient was the writer Paul Ernst, who, unaware that the book had not been published professionally, reviewed it in the journal *Kunst und Künstler*. "The little book deserves to be closely heeded," he announced; "it contains nothing less than a program for a new aesthetics."[70] Providing a synopsis and an assessment of Worringer's argument, Ernst's review sparked enough interest to prompt the publication of the book the following year. A poet, dramatist, and theorist, Ernst was a central figure in the classic revival in German literature, which entailed a rejection of the theatrical naturalism that Ernst himself had embraced in the 1880s but that no longer appeared to him politically efficacious.[71] While he believed political action alone was not enough to combat the alienation of modern life, he was also disillusioned with naturalism, which he believed had come to represent social and political complacency. In such essays as "Die Möglichkeit der klassischen Tragödie" (The possibility of classical tragedy) of 1904, he advocated instead the presentation of traditional dramas to provide models of engagement—moral and social, if not always overtly political—for the audience.

Thus, in reviewing *Abstraction and Empathy* in 1908, Ernst was receptive to its rejection of naturalism and its attempt to theorize the prevalent condition of modern alienation. "For a long time in our art as well as in our art appreciation we have remained under the influence of Greek antiquity and the Renaissance," he wrote in summary of the book. "But there are people and ages who had completely different artistic feelings and expressed these in their works. As a rule, we interpret these today as achievements of a deficient ability [*Können*], when in reality they are the achievements of a differently directed will [*Wollen*]."[72] Works from beyond the borders of Renaissance Italy and ancient Greece were also worth investigating, and they required a new conceptual framework with which to be understood.

Worringer's understanding of the latest psychological research and theoretical discourse regarding Einfühlung was better than he acknowledged. His main source for empathy theory, he noted, was a dissertation completed in Munich in 1897 by Paul Stern—a student of Lipps, and Worringer's friend—and published a year later.[73] But while Worringer frequently cited the work of Hildebrand, Riegl, Schopenhauer, Semper, and Wölfflin, he generally ignored the particular claims offered by Lipps—an omission that is striking, given that his argument throughout the first of his book's three chapters revolved around a formula taken from Lipps's work. Having attended Lipps's lectures at the University of Munich in 1904–5, Worringer would have been aware of his professor's own recent shift away from the psychological understanding of Einfühlung.[74] In his book, however, he played down the importance of Lipps's major works as well as of three decades of debate on the topic of Einfühlung.

"Modern aesthetics," Worringer grandly announced in his book's opening pages, "culminates in a theory that can be described with a general and broad name as the doctrine of empathy."[75] Like the psychologists, he argued that this doctrine did not apply universally; rather, it governed only the artistic naturalism of ancient Greece and Renaissance Italy—art that was made by and for people who were at ease in their environment and who found psychic repose in aesthetic activity. Art from other eras and cultures was governed by an "urge to abstraction [*Abstraktionsdrang*]," which reflected discomfort on the part of both viewer and artist and which he associated with ornament and with the notion of style. More specifically, abstraction expressed a *horror vacui* represented on the cover of the book's ninth edition in 1916 by an ornamental motif, its abstraction mitigated by the elaborate twists of stylized snakes (Figure 3.5).

Worringer based his arguments on what he initially put forward as a condensed formula for the theory of Einfühlung: "Aesthetic enjoyment is objectified self-enjoyment" ("Aesthetischer Genuss ist objectiver Selbstgenuss"), or a pleasurable sensation rendered in the form of an object. He quoted this formula from Lipps's "Einfühlung und ästhetischer Genuss," making rhetorical use of the phrase rather than engaging more fully with a range of writings about Einfühlung. Lipps's "aesthetic system," he explained, "shall serve *pars pro toto* as a foil for the following explanations."[76] That system, in turn, was encapsulated in this one formula, which Worringer stated (without the use of quotation marks) five times in his book's first chapter, each time to slightly different effect.[77] By its fifth and final appearance, Worringer had dislodged Einfühlung from its pedestal to set a complementary theory of abstraction beside it. Even more significantly, he had placed discomfort at the heart of the aesthetic experience.

After a summary of Einfühlung that reads as an endorsement, Worringer repeated Lipps's phrase: "Aesthetic enjoyment is objectified self-enjoyment." Immediately, however, he asserted that his own book's very purpose was to demonstrate that "with this theory of empathy, we stand helpless in the face of the artistic creations of many ages and peoples."[78] While Einfühlung operated as the theoretical basis for the naturalist art of ancient Greece and the Renaissance, the happy and wholesome relation to the outside world it reflected could not be universally applied; the art of all other cultures was based on the urge to abstraction, which he posited as both a fundamental, universal urge and the result of highly developed cultures. "With primitive peoples, as it were, the instinct for the 'thing in itself' is at its strongest," he argued, positing a primitive man who was Kantian by nature.[79] Abstraction conflated a basic artistic urge on the part of primitive cultures with the modern theories produced by the most advanced intellects of western Europe: "What was once instinct is now the ultimate product of knowledge."

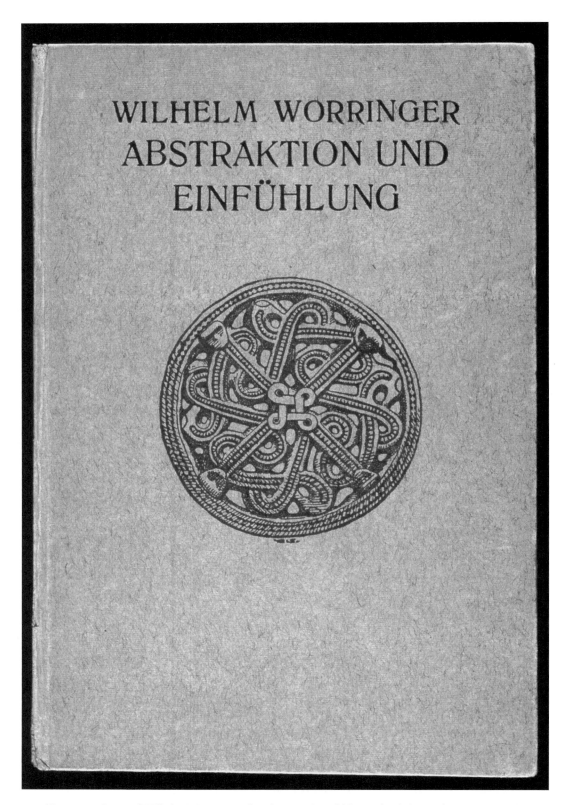

Figure 3.5. Cover of Wilhelm Worringer, *Abstraktion und Einfühlung,* 9th ed. (Munich: R. Piper, 1916).

The third appearance of Lipps's formula indicated neither agreement nor dissent. "What modern man calls beauty," Worringer explained, "is a satisfaction of that inner need for self-affirmation that Lipps sees as the prerequisite of the empathy process. In the forms of a work of art, we enjoy ourselves. Aesthetic enjoyment is objectified self-enjoyment."[80] A beautiful object was, in effect, created by the spectator's perception of it; the spectator relocated his enjoyable experience of self-affirmation within the object. The activity of aesthetic contemplation thus provided an experience of psychic repose; the aesthetic object offered a repository for the emotions it inspired.

Crucially, for Worringer aesthetic activity did not necessarily entail comfort. He first suggested as much with a passing reference to Lipps's distinction between positive and negative Einfühlung, or between a sense of freedom and one of reluctance felt in the face of the work of art.[81] But even "negative Einfühlung" did not sufficiently articulate the profound sense of unease that Worringer wished to discuss. Such a sensation could be felt, he believed, both while contemplating a particular work of art and as a general existential condition. Perhaps the true flaw of Einfühlung was its failure to account properly for psychic discomfort; what Worringer termed the "urge to abstraction"—an urge that led artists to create abstract images and led viewers to contemplate them—may be seen as an attempt to theorize this condition. Worringer proudly acknowledged the influence on his thinking of Georg Simmel, whose lectures he had attended in Berlin. In the foreword to the 1948 edition of the book, he even wrote of glimpsing the famous professor while visiting the Trocadéro Museum in Paris as an art history student and conceiving of his dissertation topic later that day.[82]

With the fourth appearance of Lipps's formula, Worringer finally stated his own position: "aesthetic enjoyment" and "objectified self-enjoyment" were not equivalent but opposed. The former described the urge to abstraction; the latter stood for empathy. Abstraction was now associated with unease: an aesthetic enjoyment encompassing the experience of its own interference. Empathy, by contrast, implied the comfortable relation between the viewer and the work of art by means of which aesthetic enjoyment was delightfully rendered in the form of an object. More important than their differences was the element of discomfort they shared: both the urge to abstraction and the urge to empathy, Worringer wrote, "are only degrees of a common need that is revealed to us as the deepest and ultimate essence of all aesthetic experience: that is the need for self-estrangement [*Selbstentäußerung*]," or a distance measured within the self.[83]

As if to emphasize the insufficiency of Lipps's formula, Worringer repeated it once more, reiterating that even Einfühlung entailed an experience of self-estrangement. In this psychic transfer, he wrote, the spectator invested the work of

art with a portion of his self, sacrificing his autonomy as an individual in order to exist, momentarily and aesthetically, within the work. "Insofar as we empathize this urge to activity into another object," he explained,

> we *exist* in the other object. We are delivered from our individual being as long as we . . . are absorbed into an external object, in an external form. We feel, as it were, our individuality flow into fixed boundaries, as opposed to the boundless differentiation of the individual conscious-ness. In this self-objectification lies a self-estrangement [*In dieser Selbst-objektivierung liegt eine Selbstentäußerung*].[84]

The empathetic spectator, letting down his emotional guard, permits himself to dissolve into the work of art. Such a process of absorption, Worringer maintained, entailed a loss of self that was felt as estrangement, not comfort.

To prove his point, Worringer quoted Lipps himself—this time, notably, from his two-volume *Aesthetics*. "In empathizing I am not the real I," Lipps had argued, "but rather am set free from this inner I; that is, I am set free from everything that I am outside of the observation of form. I am only this ideal, this observing I."[85] Even the ultimate authority on Einfühlung, it would seem, had acknowledged the viewer's bifurcated subjectivity—a distancing from the self, as it were—as central to the perceptual process. (Daily speech could likewise be mobilized to prove the existence of estrangement within the aesthetic response, Worringer maintained: "Popular usage speaks with striking accuracy of 'losing oneself' in the contempla-tion of a work of art.")[86] Abstraction and Einfühlung existed at opposite extremes along an existential continuum of emotional discomfort. The universal impulse to self-estrangement played itself out formally in one, while an individualistic urge to self-estrangement appeared in the guise of the other. Meeting at the edges of their continuum, the two perceptual experiences were not always distinguishable.

Like the theorists of Einfühlung, Worringer presented his claims in *Abstraction and Empathy* in terms of emotional sensations and psychological drives. At the same time, his book shifted the terms of aesthetic debate in several significant ways. While refusing to acknowledge that Einfühlung was abstract (insofar as it described a viewer's basic physiological response to pure form), he transposed its universalizing claims to the concept of abstraction—even though such claims had long been part of the internal critique that had crumbled the authority of Einfüh-lung. Beyond this, he reconfigured Einfühlung in his text as a general emotional identification, ignoring its spatial dimension, thus further separating the visual and applied arts from the discipline of architecture. Finally, he placed discomfort at the heart of the aesthetic response, thereby constructing a conceptual hinge

between Einfühlung and the articulations of estrangement that would describe the communal aesthetic experience of the mass audience in the 1920s and 1930s.

SELF-ESTRANGEMENT AND THE FEAR OF SPACE

The conceptual opposition of Einfühlung and abstraction in Worringer's book thus masked a more profound claim: one could trace "all aesthetic enjoyment, and perhaps the entire human sensation of happiness generally, in its deepest and ultimate essence, to the impulse of self-estrangement [*Selbstentäußerung*]."[87] The articulation of this impulse, sometimes translated as "self-distanciation" or "self-alienation," fundamentally reworked the status of comfort in the conception of the aesthetic response. If aesthetic enjoyment, at its core, entailed an experience of self-estrangement, then discomfort could be, in some essential way, pleasurable. By bringing the notion of aesthetic distance into the body of the viewer, Worringer linked the idea of an individual loss of self, fundamental to the late-nineteenth-century discourse of Einfühlung, to the idea of collective alienation, which would become central to the discourse of estrangement, or *Verfremdung*, in the work of Brecht.

Worringer's analysis of spectatorship in terms of self-estrangement derived in part from Nietzsche, who in 1876 had described the activity of spectatorship almost as a form of aesthetic schizophrenia. The spectator at a Wagnerian performance, Nietzsche had declared,

> is from time to time compelled . . . to ask himself: what would this nature have with you? To what end do *you* really exist?—Probably he will be unable to find an answer, and will then stand still, amazed [*befremdet*] and perplexed at his own being. Let him then be satisfied to have experienced even this; let him hear in the fact that he *feels alienated* [*entfremdet*] *from his own being* the answer to his question. For it is precisely with this feeling that he participates in Wagner's mightiest accomplishment, the central point of his power, the demonic *transmissibility* and self-estrangement [*Selbstentäußerung*] of his nature.[88]

For Nietzsche, aesthetic perception in its most heightened form—the engagement with Wagner's music dramas in Bayreuth, in the inaugural year of the Festival Theater there—entailed a depletion of the spectator's sense of self. The experience was both liberating and disturbing, a conflation of two sensations: a paralyzing loss of self and an active engagement in the art object. As we have seen, Wagner himself had described the aesthetic experience as a loss of ego, or "a thorough stepping out of oneself into unreserved sympathy [*Mitgefühl*] with the joy of the beloved, in

itself."[89] The simultaneous presence of detachment and absorption, estrangement and identification, defined both artistic creation and aesthetic reception.[90] But while both spectator and artist were engaged in parallel creative endeavors, each helping to create the work of art, both were emphatically singular individuals.

While the discourse of Einfühlung had, in the nineteenth century, treated the aesthetic response to spatial as well as visual form, Worringer attended primarily to two-dimensional creations in 1908. "Space is the greatest enemy of all efforts at abstraction," he asserted, "and must therefore be the first thing to be suppressed in the representation."[91] Like Hildebrand, he posited relief sculpture as the epitome of artistic creation, insofar as it transformed spatial depth into planar relations.[92] But whereas Hildebrand had associated two-dimensionality with the notion of distance on the grounds that flat images resulted, literally, from distant views, Worringer linked two-dimensionality with the emotional distance felt within the spectator's body. Describing this psychic unease as "a tremendous spiritual aversion to space [*geistige Raumscheu*]," he likened it to "physical agoraphobia [*körperlicher Platzangst*]."[93] As a result of this sensation, he argued, both artists and viewers were led to create or seek out images of abstract purity: approximations of visual planarity that soothed both eye and soul in a process reminiscent, ironically, of his initial presentation of Einfühlung.

According to Worringer, "the urge to abstraction is the result of man's great inner unease, caused by the phenomena of the outside world."[94] This "primitive fear" persisted in the modern era among "people of Oriental cultures [*orientalische Kulturvölker*]," he asserted—those who had, over the course of many centuries, managed to resist the civilizing influences of the West.[95] Abstraction, that is, was both the ultimate achievement of advanced civilizations and a basic human urge: exotic and foreign, it remained the most fundamental form of creativity. While cautioning against generalizing about "primitive" people on the grounds that the term covered disparate cultures of varying levels of artistic talent, Worringer himself privileged human instinct in a manner that today reads as Freudian. The fear of space was universal and was felt by both artists and viewers, but the "rationalistic development of mankind represses this instinctive fear, which is caused by man's lost position in the world."[96] Nonetheless, it was to be found both among "primitives" and among those contemporary Europeans who had been rendered fearful by the very process of civilization. This logic, although perverse, was prevalent in early-twentieth-century European culture, making it possible for Worringer to argue that to acknowledge the urge to abstraction was to confront human instinct on its own terms, stripped of the repressive forces of Western civilization.

Worringer characterized the urge to abstraction—both for creative artists and for those who viewed their creations—as "the attempt to rescue the single object

of the outside world from its connection with and dependence on other things, to snatch it from the course of events, to render it absolute."[97] As a process of spectatorial engagement, Einfühlung was associated, fundamentally, with temporality. Developed in an era of representational art, it was also linked to narrative; scenes might literally be depicted within a painting, or they might simply be implied, as with a portrait or a still life. Insofar as it had been used to discuss the spectator's experience of architecture, Einfühlung suggested a movement through space that necessarily occurred in time. By contrast, abstraction entailed, in Worringer's view, an effort to arrest temporality itself—to detach the "single object of the outside world" from other objects and from this world. For both artist and viewer, abstraction represented "the consummate . . . expression of emancipation from the chance and temporality of the world picture."[98] This creative urge was manifested as a universal human need to free particular objects from the existential terror of the three-dimensional and of the dimension of time itself—a fear that could be allayed only through aesthetic activity.

A passing reference made by Hildebrand to "the agonizing quality of the cubic [*das Quälende des Kubischen*]" had helped construct, in *The Problem of Form,* a theoretical justification of ancient Greek sculptural relief; Worringer appropriated the claim to justify even flatter artistic creations—as well as those from all historical eras and geographic locations.[99] All the same, relief sculpture remained central to Worringer's argument, a stance he derived from Hildebrand and Riegl. In *Problems of Style: Foundations for a History of Ornament* (*Stilfragen: Grundlegungen zu einer Geschichte der Ornamentik*), first published in 1893, Riegl had portrayed the history of world art as a grand trajectory from three-dimensional objects to two-dimensional representation:

> If we ignore concrete examples for a moment and try in a purely deductive way to reason out abstractly which of them came first in the development, then we will find ourselves forced . . . to conclude that three-dimensional sculpture is the earlier, more primitive medium, while surface decoration is the later and more refined.[100]

Like Riegl, Worringer celebrated flatness, ornament, and non-Western cultural artifacts. Unlike Riegl, he presented his arguments succinctly and polemically. Avoiding the archaeological detail that made Riegl's *Problems of Style* so intimidating, he reinforced its claims with arguments rooted in psychological discourse.[101]

Again following Riegl, Worringer held that abstraction was epitomized by the flat style of Egyptian vegetal ornament. The urge to abstraction now operated as the theoretical apparatus ushering the creations of overlooked ages and peoples

into aesthetic discourse.[102] Even while arguing for an expansion of the art historical canon, Worringer showed little interest in the expanding art audience; he described universal vision within the framework of an aesthetic discourse that had been in place since Immanuel Kant, leaving intact the conception of the spectator as a cultivated individual. Like the discourse of Einfühlung itself, Worringer's book offered, at the level of the individual viewer, a theoretical understanding of a universal, visceral response to art. Where researchers in psychology laboratories had begun to point to the possibility of larger audiences comprising varied individuals, Worringer theorized their experience within the field of aesthetics. In conflating the psychic experience of the Egyptian artist and the contemporary European spectator, and in identifying the work of art as both cause and effect of this experience, he allowed for the possibility that untrained eyes—those not belonging to cultivated Europeans, for example—might likewise be capable of undergoing an aesthetic experience.

Worringer set the duality of Einfühlung and abstraction parallel to that of naturalism and style, linking Einfühlung with naturalist depiction, and his arguments were easily understood in relation to recent cultural developments in Munich. Two decades earlier, that city's most advanced artistic creations had fallen under the rubric of naturalism, but by the early twentieth century, artists, art theorists, writers, and dramatists—his book's first reviewer, Paul Ernst, prominent among them—considered that approach to be outmoded.[103] Primarily in drama, but in other fields as well, naturalism had come to stand for an obsessive imitation of reality and the abandonment of true creativity. Rather than simply denigrating naturalism for its mimetic capacities, however, Worringer historicized it, declaring it an artistic tendency that, by 1908, was on the wane. In so doing, he distinguished it from imitation, which (like the urge to abstraction) existed, he maintained, in every era and among all cultures. "The drive to imitation, this elemental human need, stands outside aesthetics proper," he argued; "in principle its satisfaction has nothing to do with art."[104]

Despite Worringer's efforts to distinguish naturalism and imitation, the two were clearly linked in early-twentieth-century German artistic discourse; artists and designers engaged in the rejection of the former had for years been disparaging the latter. In 1900, the architect Peter Behrens had written, for example, "It's not difficult for a man with a talent for imitation to put on a mask and represent a well observed character; even if not everyone can do this, that does not make it art."[105] True art required a level of creativity beyond the simple craft of imitation; the sinuous Jugendstil tendrils that Behrens himself designed at the turn of the century did not reproduce plant forms but, rather, expressed in abstract visual terms the force of vegetal growth. By 1908, even Behrens had abandoned his Jugendstil roots.

"We have in the fine arts as in poetry reached the outermost point of Naturalism," Ernst asserted in his review of *Abstraction and Empathy* that year; "the pendulum will now swing to the other side, and it is Worringer's achievement to have explained this process historically and philosophically."[106]

As the aesthetic pendulum swung toward abstraction, naturalism and imitation came to be associated with feminine creativity. Using the terms laid out in Worringer's book, one might theoretically have assigned abstraction, and the notion of decorative ornament with which it was associated, to the province of women. But while Worringer linked ornament to the artistic creations of primitive people (*Naturvölker*) and to children's scribbles, he did not present the concept in gendered terms.[107] Those who did, meanwhile, such as the art critic Karl Scheffler, associated women not with abstraction and ornament but, instead, with empathy, naturalism, and imitation. In *Die Frau und die Kunst* (Woman and art), also published in 1908, Scheffler labeled the woman artist "the imitatrix par excellence . . . who sentimentalizes and trivializes manly art forms."[108] True creativity and aesthetic originality remained the province of men; women functioned essentially as copyists. This distinction between male and female creative impulses also held true among viewers, in Scheffler's view: "Woman looks at a work of art in terms of the nature contained within it; abstraction remains foreign to her."[109] Such an association of Einfühlung with passivity, imitation, and feminine creativity would hold sway for decades.

Artists and writers, especially in Munich, welcomed Worringer's book, which they took as support for their own rejection of artistic naturalism. While Worringer demonstrated no interest in contemporary European art, his book encouraged Wassily Kandinsky and Gabriele Münter, as well as other future members of the Blaue Reiter, to investigate painterly abstraction.[110] The flat, unmodeled planes of color in Münter's *Mädchen mit Puppe* (*Girl with Doll,* 1908–9) and its forms composed of abstracted expanses of color within heavy black outlines reflect several sources, including the paintings of Henri Matisse and the Jugendstil emphasis on planarity and flatness (Plate 5), but she acknowledged her debt to Worringer directly. "We have known each other since the beginnings of the postimpressionist development of art," the artist reminded him in a letter written on the occasion of his seventieth birthday, a development "for which you prepared the intellectual ground. I still have from those early years the original copy of your book *Abstraction and Empathy,* which had at the time such a profound effect."[111] As one critic stated that same year, there existed "hardly a single member of the avant-garde of modern art who was not deeply excited by this book."[112]

In *Concerning the Spiritual in Art* (*Über das Geistige in der Kunst*), first published in 1911, Kandinsky, too, advocated "*the rejection of the third dimension, that*

is to say, the attempt to keep the picture on a single plane."[113] His *Composition IV* of that year, an image on the threshold of abstraction, likewise demonstrates the resonance of Worringer's ideas (Plate 6). Subtitled *Battle,* the painting shows three figures standing at its center, with white robes, red caps, and two long, vertical spears. On the left, three groups of parallel black lines become the spears of advancing armies visible over the hilly horizon; on the right, two large figures lean backward in the foreground. The image requires the viewer's effort in order to become representational, evoking Kandinsky's confident assertion, already quoted in this book's introduction:

> The more abstract form is, the more clear and direct its appeal. The more an artist uses these abstract forms, the deeper and more confidently will he advance into the kingdom of the abstract. And after him will follow the viewer . . . who will also have gradually acquired a greater familiarity with the language of that kingdom.[114]

In the early twentieth century, the artist and the spectator—the former only slightly ahead of the latter—were to advance with confidence into the avant-garde. Their newly acquired familiarity with the strange forms of painterly abstraction was also, one might say, a sense of comfort with the unfamiliar; a carefully circumscribed frisson of shock that could be enjoyed within the relatively safe confines of their own artistic circles.

4

The Nietzschean Festival

A higher spirit recognized that, above all the arts, there stands one art: that of understanding and enjoying.

—PETER BEHRENS, *Ein Dokument Deutscher Kunst,* 1901

GEORG FUCHS AND THE CULT OF NIETZSCHE

At the turn of the twentieth century in Germany, the idealized vision of the unification of all art forms was almost a cultural cliché, heavily indebted to a prevailing Nietzschean sensibility that was felt with particular acuteness within the arts. No less a figure than Count Harry Kessler, patron of the arts and founder of the Darmstadt Artists' Colony in 1901, proclaimed this condition categorically: "The way in which Nietzsche influenced, or more precisely possessed, us cannot be compared with the effect of any other contemporary figure or poet."[1] While the espousal of the unification of the arts was strongly Nietzschean, the notion itself was grounded in Wagner's formulation of the Gesamtkunstwerk. As the philosopher had declared in "Richard Wagner in Bayreuth," published shortly before the inauguration of the Festival Theater, "I know of no writings on aesthetics so illuminating as Wagner's."[2] But as the nineteenth century came to an end, German aesthetes increasingly preferred Nietzsche's version of the composer's ideas. Shortly before journeying to Bayreuth for the inaugural production of the *Ring,* for example, Conrad Fiedler wrote to his friend Hildebrand, "If you want to know what art is, read 'Richard Wagner in Bayreuth' by Friedr. Nietzsche."[3]

Nietzsche's friendship with Wagner famously (and quite publicly) soured in 1876, within eight years of their first meeting, but his addiction to the composer's music—fanatical and uncontrollable, by his own account—remained strong even after his descent into madness at the end of 1888. While the young philosopher's scorn for the pomposity of the completed *Ring* cycle and for the ostentatious festivities in Bayreuth fueled the friendship's demise, the falling-out was also fundamentally personal, as biographers have long argued.[4] Nietzsche expressed his disillusionment with characteristic vehemence and offered excoriating indictments of Wagner's achievements; in 1888, five years after the composer's death, his book *The*

95

Case of Wagner essentially pathologized the enthusiasm (his own included) for Wagner's music. "We know the masses, we know the theater," he declared, his mockery dripping with elitism:

> The best among those who sit there—German youths, horned Sieg-
> frieds, and other Wagnerians—require the sublime, the profound, the
> overwhelming. And the others who also sit there—the culture *cretins,*
> the petty snobs, the eternally feminine, those with a happy digestion, in
> sum, the *people* [*Volk*]—also require the sublime, the profound, the over-
> whelming. They all have the same logic.[5]

Such snobbery with regard to all spectators, from Wagner enthusiasts to the most complacent audience members—such snobbery, even, about snobs themselves—reveals how far Nietzsche's thinking had diverged from Wagner's utopian projection of the communal work of art of the future.

According to Wagner's plan of 1849—proposed while he was exiled in Switzerland and in a spirit of profound postrevolutionary disappointment—the unification of the arts would unite spectators in communal appreciation of a performance of, for example, Wagnerian music drama; the experience would be both aesthetic and political. For Nietzsche in the 1870s, by contrast, an audience was no greater than the sum of its parts. "'Public,' after all, is a mere word," he stated; "in no sense is it a homogeneous and constant quantity."[6] The creative artist, meanwhile, whose inspiration rendered him superior to those who received his work, was under no obligation to cater to this amorphous assembly. "Why should the artist be bound to accommodate himself to a power whose strength lies solely in numbers?" Nietzsche demanded. "And if, by virtue of his endowments and aspirations, he should feel himself superior to every one of these spectators, how could he feel greater respect for the collective expression of all these subordinate capacities than for the relatively highest-endowed individual spectator?"[7] Collectivity meant nothing to Nietzsche, who valued only two figures: the artist, who bestowed the work of art from an exalted position, and the spectator capable of appreciating it.

Nietzsche described this aesthetic experience in terms of an exalted existential crisis: a self-estrangement that was not entirely negative. His presentation of the hybrid aesthetic sensation of absorption and detachment parallels his explanation of the Apollonian and Dionysian impulses in *The Birth of Tragedy out of the Spirit of Music,* first published in 1872. The similarity is partly formal; both discussions describe the dual nature of the aesthetic response. But it operates as well at the level of content: Nietzsche specifically associated Apollo with the spectator's emotional absorption in the work of art, and he linked this absorption to the notion

of pity. He also considered it to be essentially individualistic. "The Apollonian tears us out of the Dionysian universality and lets us find delight in individuals; it attaches our pity [*Mitleidserregung*] to them," he proclaimed.[8] If Apollo governed the pity felt by one person for another, Dionysus represented the sensation of universalizing passion, a loss of self within the larger crowd. Only in tandem could the two foster true creativity, both within the artist and on the part of the spectator.

In the late nineteenth century, the crowd in which an aesthete might experience such a loss of self was highly circumscribed. Wagner's audience in Bayreuth was a gathering of self-selected individuals; as Max Nordau wryly remarked, "It is useless to go to the trouble of a journey to Bayreuth if one cannot talk fluently in *leitmotifs.*"[9] For all Wagner's utopian dreams, few could afford to spend a week in Bayreuth seeing the *Ring,* and a postcard depicting the building some time after the construction of the royal loge in 1882 shows half a dozen well-heeled visitors strolling the grounds (Figure 4.1). If their shared experience depended on a sense of exclusivity that, in turn, rested on a practice of exclusion, the audience at Bayreuth was nevertheless defined by its communal experience.

Nietzsche conceived of the experience of a group of spectators rather differently. Current notions of Dionysian revelry notwithstanding, Apollonian restraint

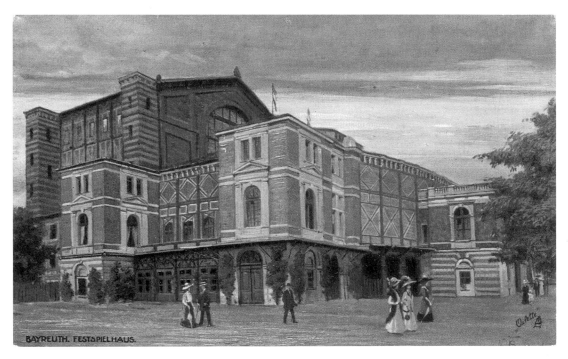

BAYREUTH. FESTSPIELHAUS.

Figure 4.1. Tucks Oilette, *Bayreuth Festival Theater,* postcard, after 1882. National Archive of the Richard-Wagner-Foundation, Bayreuth (oSig FSH-PK-Tucks-Oilette-795).

was also present in his conception of the aesthetic experience—but Wagner's democratic sympathies were not. For Nietzsche, as for the theorists of Einfühlung at the same time, surpassing the boundaries of an individual consciousness did not necessarily entail that individual's absorption into a larger group. With the growth of the mass audience in the ensuing decades, however, a question would be raised with increasing vehemence: how might the dissolution of the borders of the individual spectator form a productive theoretical basis for creating a communal audience? Reconfigured as the god of a spectatorship that was active, passionate, and communal, Nietzsche's Dionysus would haunt European—and American—aesthetic thought for decades.

In an 1895 issue of the Munich art journal *Die Kunst für Alle,* the art critic Georg Fuchs published "Richard Wagner und die moderne Malerei" (Richard Wagner and modern painting).[10] Echoing Nietzsche's early work, Fuchs celebrated Wagner's achievements as a composer of music dramas, labeling *Lohengrin,* for example, "the first great German work of art since Goethe's *Faust.*"[11] Fuchs argued that Wagner's works could "serve in certain senses as a prototype for the further development of painting," citing the works of Adolph Menzel, Arnold Böcklin, Franz von Lenbach, and Max Liebermann, among others.[12] Wagner's ideas about spectatorship, and especially his consideration of the audience as a *Volk,* would appeal increasingly to Fuchs as he turned his attention to the theater, as we shall see. Between 1895 and 1905, however, his essays operated primarily under Nietzsche's influence. "*Nietzsche* gave us the voice and the clarifying thought for all of this," Georg's brother Emil would later write. "We are the generation that listened to Nietzsche when he was still a persecuted, smilingly scorned man. We young people probably did not understand all of his ideas completely clearly."[13]

Fuchs explored his interest in Nietzsche overtly in "Friedrich Nietzsche und die bildende Kunst" (Friedrich Nietzsche and the fine arts), which appeared serially in 1895 in *Die Kunst für Alle.* He argued that the epigrammatic statements in *Thus Spoke Zarathustra,* first published in 1885, offered "the bridges by which we may reach, in Nietzsche's general teachings, the precious little island of his aesthetics."[14] Nietzsche wrote only rarely of particular artists, as Fuchs acknowledged, and his ideas on art—particularly his appreciation for the masters of the Italian Renaissance—were determined mostly by Jakob Burckhardt, his colleague at the University of Basel. Despite this seeming lack of originality, Fuchs maintained,

> a thousand artistic questions have been newly and for the first time scientifically answered by Nietzsche; I rank among them here: the formation of the arts and of the artist, the psychology of genius, the genealogy and principle of style, the purpose and the freedom of creating and

forming, on the essential and the inessential in art, the national in art, the Greeks.[15]

The central concerns of German aesthetics, in other words, were by the mid-1890s developed furthest by Nietzsche, whose scientific approach, Fuchs wrote, at last "established that which Goethe autocratically, and with the divine right of a mind so infinitely superior to his age, laid down in tightly closed sentences."[16] As the late-nineteenth-century successor of Goethe, Nietzsche had elucidated the cryptic pronouncements of this quintessential German thinker.

In keeping with prevailing aesthetic sensibilities, Fuchs bolstered his discussion of the visual arts with references to music and dance. He proposed a metaphoric use of musical terminology—for example, maintaining that perspective would more aptly be called "painterly rhythm [*malerische Rhythmik*]"[17]—and called for a synesthetic understanding of the arts with language evoking Marx:

> A motley specter is haunting the theory and criticism of painting, one that elders call "coloration," and that youngsters believe is actually the "handling of light": should this specter in great art, in the art of fulfillment, perhaps not creep at all, nor go on stilts, but rather dance, after all: a waltz, gallop and round dance? One too seldom observes images with one's ears![18]

Art criticism, Fuchs believed, could help draw the arts into a theoretical Gesamtkunstwerk—a point of view closely aligned with contemporaneous critics and practitioners of Jugendstil. The fundamental link between a synesthetic combination of all art forms into a unified whole, on the one hand, and the purity of each individual art form, on the other—a combination that derived from Wagner, via Nietzsche—would remain a central theme in Fuchs's writing for almost two decades.

Fuchs's essay on Nietzsche begins with two quotations from *Zarathustra*. The first, the prophet's declaration that "when power grows gracious and descends into view, I call such descending beauty," epitomized the Nietzschean cult of strength and grace. Beauty was not a fragile thing that needed to be carefully preserved but, rather, the miraculous appearance of power itself within the realm of daily life. The second quotation was Zarathustra's exhortation to "set good little perfect things around you, you Higher Men! Things whose golden ripeness heals the heart. Perfect things teach hope."[19] Addressing art slightly more literally, this statement is the sole reference to art objects in Nietzsche's book, and it encapsulates a paradox within his aesthetic program: such raised standards could accommodate

only a small number of aesthetes, and the beautification of quotidian reality would be achieved only for a selected few.

Nietzsche would have been the first to acknowledge such elitism, and neither he nor Fuchs would have considered it a defect. Sympathetic to the call for raised aesthetic standards, Fuchs adopted as well the philosopher's rhetoric of universal aesthetic improvement, like his fellow secessionists and the Jugendstil artists and designers. While subsequent critics—from Hermann Muthesius, in the early twentieth century, to the present—have criticized this inherent elitism, it was a cherished value in 1895, when Nietzschean precepts were offered in the pages of a journal entitled *Die Kunst für Alle,* or "Art for all," as if such ideas—and the expensive handcrafted objects they celebrated—were indeed universally accessible.[20]

To extend Nietzsche's demands from the realm of aesthetics to that of artistic practice, however, was to press on an attendant irony. The creation and marketing of objects of art and design would ideally expand the audience of aesthetes—both for Nietzsche's ideas and for the "good little perfect things" he advocated. But the boundless appreciation a group of aesthetes might experience conflicted with the socioeconomic limitations set upon them. With the growth of the middle class and drastic changes in the audience for German culture, the contradictions implicit in Nietzsche's arguments became increasingly acute, and advocates of artistic reform debated the relation of art and industry more explicitly at the founding of the Werkbund in Munich in 1907.[21] This uneasy relation would also be evident when Fuchs founded the Artists' Theater in that city the next year. Nietzsche's conception of art as a fulfillment of life, with all its contradictions, presented Fuchs and other avowed Nietzscheans with a philosophical ideal. But they took for granted the constitution of the audience for art as a group of educated, cultured individuals.[22]

In *Thus Spoke Zarathustra,* art replaced the trivial concerns of daily life with the more worthy environment of a heightened aesthetic realm, transporting the spectator to a nobler plane. Fuchs described his embrace of the idea of art "'as a completion of life,' as Nietzsche . . . already understood at a time when, still in his youthful awkwardness, he wished to represent himself as Richard Wagner's philosophical apologist."[23] Such an emphasis on what he called the "completion of life . . . through the highest artistic means" was, for Fuchs, the ultimate achievement of the philosopher's aesthetic program. The very act of viewing art elevated the spectator, endowing him with an almost religious sense of enlightenment. Artistic creativity followed a divine model: "Before God and the artist are all things equal," Fuchs would write in 1904.[24]

The Nietzschean aesthetic in Germany at the turn of the last century is illustrated by a page from the limited edition of Nietzsche's *Thus Spoke Zarathustra* designed by Henry van de Velde and published in Leipzig in 1908 (Plate 7).[25] With

a print run of 530 copies (100 bound in leather, the remainder in parchment), the edition catered to an audience seemingly oblivious to mass culture. But while the book's large size, small print run, and liberal use of gold ornament set it firmly within the tradition of the medieval manuscript, its design also invokes machine production. Across the top of its penultimate page of text, which shows the beginning of the section entitled "Das Zeichen" (The sign), two rows of fifteen gold, square ornaments repeat like factory-made items on an assembly line. On the third line, three ornaments mark the space between the edge of the text and the beginning of the margin. After the title, in capital letters, they continue in miniature; more punctuate each sentence within the body of the text. While such ornamentation had appeared in illuminated manuscripts for centuries, here a machinelike regularity places the book at the precarious convergence of a fin-de-siècle notion of art for art's sake and the machine aesthetic.

Neither Nietzsche nor the critics and artists he inspired considered the irresolvable tension between the improvement of conditions for the elite and the fate of the larger community to be a logical failing. His philosophical project, rather, celebrated an elitist appreciation that surpassed the mundane levels of existence maintained by the larger group. Those select few who enjoyed Nietzsche's publications in the form of the limited edition could pride themselves on their superiority over those who, owing to either cultural or economic deficiency, did not. But such logic was increasingly challenged at the end of the nineteenth century; partly because of the expansion of middle-class leisure and the growth of audiences, the contradictions implicit in Nietzsche's arguments became increasingly acute. As mass printings increased the accessibility of *Thus Spoke Zarathustra* and other works, the question was raised of how Nietzschean precepts might translate to larger audiences. Within the secessionist milieu, the question could remain rhetorical. But how would the celebration of elitism come to terms with the mass audience?

THE DARMSTADT ARTISTS' COLONY

In 1896, Ernst Ludwig, Grand Duke of Hessen, invited Fuchs to Darmstadt, thirty kilometers (twenty miles) south of Frankfurt, to work for the journal *Deutsche Kunst und Dekoration,* which began publication the next year.[26] There Fuchs participated in the creation of the Artists' Colony on the Mathildenhöhe, a hill rising to the east of the city that, until 1901, had been a park owned by the grand duke and open to the public on Thursdays. Fuchs described the location that year:

> Even ten years ago, the Mathildenhöhe was the most still and dreamy
> little spot in Darmstadt; and Darmstadt itself was, as the travel writer's
> joke at the time so loved to represent it, the most still and dreamy of all

still and dreamy residences in central Germany. There were many people in the city itself who had lived here for a long time and knew nothing of the park, and there were many others who only knew its name.[27]

Upon this "still and dreamy little spot," with the grand duke as its founding patron, a city would be built by artists, for art lovers; the environment would be the apotheosis of Nietzschean artistic elitism.[28] Ernst Ludwig brought to Darmstadt (in addition to Fuchs) the architects Peter Behrens and Joseph Maria Olbrich, the latter designing all the buildings at the Artists' Colony with the exception of one by Behrens.[29]

In Vienna in 1900, Olbrich had inscribed above the entrance to the secession building the motto "Der Zeit ihre Kunst; der Kunst ihre Freiheit" (To every age its art; to every art its freedom). The next year, the phrase he used over the entrance of the main building of the Darmstadt Artists' Colony, the Ernst Ludwig House, implied an altered function of art: "Seine Welt zeige der Künstler die niemals war noch jemals sein wird" (May the artist show his world, which never was nor ever will be) (Plate 8).[30] If the Viennese secessionists had raised art to the level of an anonymous and noble expression of the Zeitgeist, in Darmstadt the artist himself attained a new role: that of creative clairvoyant, artistic prophet of a realm both exalted and nonexistent. In the commemorative program book published on the occasion of the official opening of the Artists' Colony in 1901, Behrens linked these visions of artistic achievement: "Under the title 'A Document of German Art,'" he decreed, the Darmstadt exhibition "should be a manifestation of the artists' best intentions to follow the goals of their age: a first grasp at great achievements, a first word of a higher conversation, a first sound of thundering music."[31] The artistic environment would express both the spirit of the age and the potential for the exalted status of art in every arena of German culture.

The Artists' Colony would, Fuchs wrote, "fuse life and art into a unity."[32] Within its limited boundaries, existence itself would be suffused with creativity. The rallying cry to dissolve the traditional boundaries between art and life superficially resembles later efforts in the Soviet Union, evoking in particular the constructivist slogan "art into life."[33] But the differences between Darmstadt in 1901 and Moscow in 1921 remain vast. For Fuchs, art operated within a realm elevated above daily life; to fuse the two meant to raise the quotidian to the heights of aesthetic experience. Fuchs characterized the spectators as a group, but as members of the cultivated bourgeoisie they were far removed from the Soviet workers later lionized by the constructivists. In other words, Fuchs borrowed Wagner's program of cultural revolution, but not his revolutionary politics. Ultimately, his ties were to Nietzsche, and he envisioned an audience for Darmstadt who could be

imagined as, simultaneously, a multitude of thousands and the elite sector of German culture.[34]

For Fuchs, the Artists' Colony represented an effort to put cultural innovation at the service of the German empire. "The time will come," he explained, "when it will be clear *that subsidizing artistic culture is equivalent to the elevation of the nation's promotional power.*"[35] Like so much of his thinking at this time, the association of cultural achievement with political expediency came directly from Nietzsche, who had in 1873 described "culture as a unanimity of life, thought, appearance and will."[36] While German unity was primarily a cultural notion in Nietzsche's writing, it encompassed political achievements. "Let me say expressly that it is for *German unity* in that highest sense that we strive," the philosopher wrote, "and strive more ardently than we do for political reunification, *the unity of German spirit and life after the abolition of the antithesis of form and content, of inwardness and convention.*"[37] Political unity may have been presented as secondary to the cultural aspirations underlying the construction of the Artists' Colony at Darmstadt, but the concept of German cultural unity was itself deeply political.[38]

Especially after 1876, theater reform in particular encapsulated, for Nietzsche, the larger sociopolitical potential of cultural achievement. "It is quite impossible to produce the highest and purest effect of which the art of theater is capable without at the same time effecting innovations everywhere, in morality and politics, in education and society," he declared that year.[39] Rejecting prevailing notions of art for art's sake, he explained that the purpose of theater was not to provide a temporary escape route by desensitizing the audience to social ills but, rather, to present a model of social engagement. "We could not be done a greater injustice," he argued,

> than if it were assumed we were concerned only with art: as though it were a kind of cure and intoxicant with the aid of which one could rid oneself of every other sickness. What we see depicted in the tragic artwork of Bayreuth is the struggle of the individual against everything that opposes him as apparently invincible necessity, with power, law, tradition, compact and the whole prevailing order of things.[40]

Theater would force the spectator to confront the individual's relation to his environment. Taking Nietzsche as their guide, the Darmstadt art reformers viewed themselves as challenging the "prevailing order" in all fields.

If Nietzsche represented, for those in Darmstadt, a modern union of culture and politics, Goethe symbolized the achievements of traditional German culture. The very aim of the Artists' Colony, Fuchs declared, was "the aesthetic uplifting of

the whole formation of life, in short . . . all that Goethe cared to understand under the concept of 'culture.'"[41] Once again, Nietzsche's significance derived in part from his presentation of Goethe's ideas. The symbolic modernization from Goethe to Nietzsche was also made explicit at the opening ceremony of the Artists' Colony, on May 15, 1901. For this event, Fuchs rewrote his short play *Die Ankunft des Prometheus* (The arrival of Prometheus), originally named after Goethe's unfinished play *Prometheus*. His enchantment with Nietzsche prompted him to call his revised creation *Das Zeichen* (The sign), a title borrowed from the final section of *Zarathustra*.[42] The two chorus leaders were reincarnated for the occasion to become, simply, "the man" and "the woman." The sign in question was a crystal, presented at the final moment to the grand duke in gratitude for his sponsorship of the Artists' Colony.[43]

Das Zeichen was staged by Behrens on the front steps of the Ernst Ludwig House, which had been designed by Olbrich with colossal statues by the sculptor Ludwig Habich flanking the main entrance.[44] A photograph in the Darmstadt program book of the final scene of Fuchs's play documents several hundred well-dressed spectators gathered before the Ernst Ludwig House, the edges of the crowd cropped from view. The ladies' white sun parasols and extravagant flower-laden hats and the gentlemen's top hats testify to the audience's elite status within German society (Figure 4.2). Behrens himself, in the role of prophet or messenger, descends the ceremonial steps of Olbrich's building with a white-robed chorus of fifty on either side. While Behrens carries the symbolic crystal on a pillow, the chorus proclaims, "We have awaited nothing in vain; the sign radiates, the time is here!" The ceremonial, quasi-sacral nature of the performance corresponded both to its socioeconomic exclusivity and to its geographic seclusion; spectators convened in an environment specially created on the outskirts of the city to enhance aesthetic reception. The exalted experience of the beautification of life through art occurred through a shared communal experience, removed from daily life.

The ceremonial aspect of the Darmstadt performance is emblematized by a decorative vignette used to illustrate the first page of Fuchs's four-page play, which itself was printed in full in the program book (Figure 4.3). Designed by Behrens, it shows a neoclassical edifice, its architecture conveying the tone of the event: a solemn pediment coupled with the grandeur of ceremonial steps. The building is framed by the magnificent sweep of Jugendstil whiplash lines emanating from two urns perched on either side. The stately temple is adorned by a Jugendstil motif possessing its own sense of visual drama. Four pages later, another Behrens vignette marks the end of Fuchs's play (Figure 4.4). At the center is a representation of tragedy: a masklike face with fearful eyes and a gaping mouth. From its temples, lines stream to the left and right to form a perfectly symmetrical ornamental

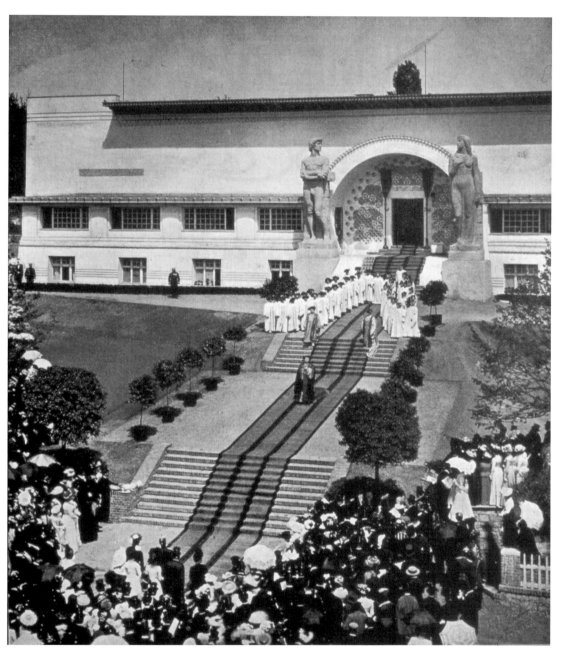

Figure 4.2. Opening ceremony of the Darmstadt Artists' Colony (Festliche Handlung zur Eröffnung der Ausstellung), May 15, 1901. From Alexander Koch, ed., *Grossherzog Ernst Ludwig und die Ausstellung der Künstler-Kolonie in Darmstadt von Mai bis Oktober 1901* (Darmstadt: A. Koch, 1901), 61. Photograph courtesy of the Research Library, The Getty Research Institute, Los Angeles, California.

„DAS ZEICHEN".

Feſtliche Dichtung von Georg Fuchs.

CHOR

Es iſt ein fremder Ruf erklungen.
Verhieße uns der erzne Ton
Des bittren Harrens Troſt und Lohn,
Um den wir heißen Blicks gerungen:
Daß wir in trunkenem Umſchlingen
Des Lebens Fülle neu empfingen,
Danach die Seele dürſtend ſchreit:
Wann kommt die Kunde? Wann kommt die Zeit?

DER MANN

O könnten wir die Glut der Träume
Im kühlen Tag doch klar erhalten.

DIE FRAU

Wird ſich das Glück uns je entfalten,
Wenn es dem Flehn der Liebe ſäume?

DER MANN

Kann es der Arm uns nicht gewinnen,
Erkauft ſich's nicht mit teurem Blut?

Figure 4.3. Peter Behrens, opening vignette for "'Das Zeichen': Festliche Dichtung von Georg Fuchs," Darmstadt program book. From *Grossherzog Ernst Ludwig und die Ausstellung der Künstler-Kolonie in Darmstadt von Mai bis Oktober 1901*, 63. Photograph courtesy of the Research Library, The Getty Research Institute, Los Angeles, California.

Figure 4.4. Peter Behrens, vignette at the end of "Das Zeichen," Darmstadt program book. Photograph from *Grossherzog Ernst Ludwig und die Ausstellung der Künstler-Kolonie in Darmstadt von Mai bis Oktober 1901, 66.* Photograph courtesy of the Research Library, The Getty Research Institute, Los Angeles, California.

design.[45] These decorative vignettes demonstrate a confluence of ancient Greek and contemporary German culture that was common at the turn of the century.

The term "whiplash line," or *Peitschenhieb,* had, in fact, been coined five years earlier by Fuchs himself; in an essay printed in the journal *Pan,* he had used it to characterize a piece of embroidery created by Hermann Obrist in Munich (Figure 4.5). Obrist's design had been carried out in golden silk thread on pale gray blue wool, but its luxurious materials did not prevent Fuchs from arguing that it conveyed an explicitly German populist aesthetic because it took a simple motif from nature, and thus from the daily life of the German people. In a strange alliance of popular culture and elite design, he proclaimed, "He who wishes for a 'national' art, and for an industry that shows popular creativity and that awakens and builds up the aesthetic drive within the people [*Volk*]—may he endeavor with

Figure 4.5. Hermann Obrist, *Alpenveilchen* (Alp violet) embroidery (example of a "whiplash line"), 1895. From *Ein Dokument Deutscher Kunst: Darmstadt, 1901–1976,* 5 vols. Mathildenhöhe Kunsthalle, Hessisches Landesmuseum exhibition catalogue (Darmstadt: Eduard Roether, 1977), 2: 67. Münchner Stadtmuseum.

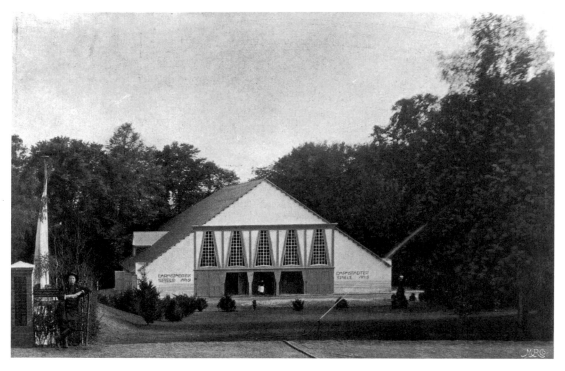

Figure 4.6. Joseph Maria Olbrich, Darmstadt playhouse. From *Grossherzog Ernst Ludwig und die Ausstellung der Künstler-Kolonie in Darmstadt von Mai bis Oktober 1901,* 80. Photograph courtesy of the Research Library, The Getty Research Institute, Los Angeles, California.

us to elevate Obrist's thought to general hegemony!"[46] The *Volk* likewise spanned the alliance of popular and elite cultures.

The opening ceremony at the Artists' Colony was only one architectural venue for spectators on the Mathildenhöhe. Among its buildings was a theater, one of the half dozen temporary structures created solely for the duration of the exhibition (Figure 4.6 and Figure 4.7). According to Karl Heinz Schreyl, this building conformed to the theater-reform ideas promulgated by both Behrens and Fuchs: "In the place of the peep-box stage, a platform advancing into the auditorium was set up that could be 'decorated' with screens and curtains."[47] Such a platform helped dissolve the distinction between stage and auditorium not only architecturally but also symbolically, linking the performance on stage to the spectators' own aesthetic experience in the way that Behrens had recently advocated in *Feste des Lebens und der Kunst* (Festivals of life and art), discussed below. In addition, spectators could rearrange their chairs, which were not attached to the floor.[48] The decor emphasized aesthetic indulgence; Schreyl writes, citing the *Kunstchronik,* that it was "entirely lined in deep violet material, without ornament, [and with] 'only the stage opening

and stage background . . . distinguished by ornamentation, naturally on a deep violet ground."[49]

Others gathered elsewhere on the Mathildenhöhe to form the audience for the latest developments in German art. At the postcard shop, likewise designed by Olbrich in 1901, they could purchase souvenirs to record their presence in Darmstadt and thus confirm their existence as art lovers (Figure 4.8). Visiting in 1901, the art historian Alfred Lichtwark observed his fellow spectators:

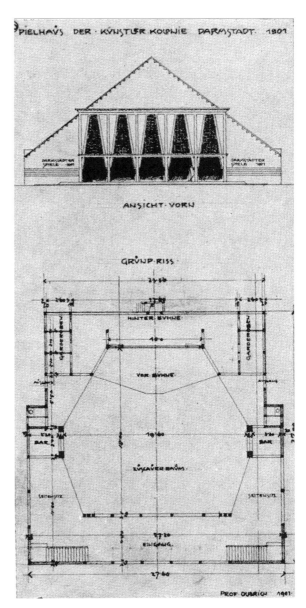

Figure 4.7. Joseph Maria Olbrich, elevation and ground plan of the Darmstadt Artists' Colony playhouse, 1901. Staatliche Museen zu Berlin, Kunstbibliothek (Hdz 10604).

In my tour, I paid especial attention to the visitors. They were from
Darmstadt and Frankfurt, belonging, on average, to the prosperous
middle class. He who knows how these and the somewhat richer class
in middle and southern Germany are made up comprehends the mood
of joyful astonishment that expresses itself mostly in admiration and
delight.[50]

As if to emphasize the aestheticism of the environment, Lichtwark noted especially
the response of female visitors: "Women, namely, were enraptured." Delighted by
the innovative architecture and design, visitors could take pleasure in the fact that
their visit to Darmstadt marked their possession of advanced aesthetic sensibilities.

Such visitors not only marked themselves as members of the German art-
loving elite but also absorbed the pervasive aura of internationalism at the Artists'
Colony. For while the artists and architects who had created the exhibition were

Figure 4.8. Joseph Maria Olbrich, Darmstadt postcard shop, 1901. From *Grossherzog Ernst Ludwig und
die Ausstellung der Künstler-Kolonie in Darmstadt von Mai bis Oktober 1901*, 98. Photograph
courtesy of the Research Library, The Getty Research Institute, Los Angeles, California.

German, their Jugendstil affiliation linked their efforts to artists and designers in Brussels, Glasgow, Paris, and other cities. Fuchs himself preferred to emphasize the German aspect of the Artists' Colony, arguing that it would operate as a preliminary step in creating a German *Volk* that encompassed the nation before a larger audience would eventually follow on the well-shod heels of the first elite visitors. The task would be to move such an event from its exclusive premises, for ultimately, Fuchs declared, "this art is *with* the *Volk,* or it is not at all. It would be simply laughable, in our democratic age, to think only of the requirements of one-sided aesthetes."[51] Again, his conception of the elite spectator as the avantgarde for German cultural rebirth derived from Nietzsche. After the founding of Bayreuth, Nietzsche shed Wagner's ideal of an immediate, nationwide rebirth to embrace instead a narrower group of spectators.[52]

In 1901, Fuchs considered the Darmstadt audience to be precisely this kind of elite group. In an essay in the Darmstadt program book, he proclaimed the performance of his play at the opening ceremony there to be "the first great festival [*Fest*] in the spirit of modern aesthetics."[53] He distinguished it from a traditional open-air theater production, labeling it instead "a festivity [*festliche Handlung*] in the new style."[54] Once again, the terminology derived from Nietzsche, who, before endorsing the "good little perfect things" of *Zarathustra,* had announced, "I want to set against the art of artworks a higher art: that of inventing festivals."[55] Unlike the small, static objects of visual art, Nietzsche's *Fest* both required and fostered the participation of an audience, producing an exalted experience for those who helped create the work of art. Enjoyed communally and occurring only once, the *Fest* would mark a particular site, forming an audience by convening a group of aesthetes and confirming those present as people capable of appreciating a form of art that surpassed that of mere objects. With the notion of the *Fest,* Nietzsche articulated the terms of a modern theatrical experience appropriate for the mass audience at the dawning of the age of middle-class leisure.

The opening ceremony of the Artists' Colony in Darmstadt sought to erase the lines between performance and spectatorship—between the physical activity on stage and the emotional activity in the audience. As Fuchs represented it, however, the spirit of modern aesthetics strictly separated performers and spectators and distinguished the art lovers attending the ceremony from those oblivious to the fervor of Nietzschean aesthetics. Another author elaborated on the importance of the event in *Deutsche Kunst und Dekoration*:

> The first great festival in the spirit of modern aesthetics: so might the opening celebration of 15 May be best characterized. It was neither a purely courtly event, nor one of those romantic "Artists' Festivals," . . .

nor a popular mass festival, and yet there was something of all three, but
in a new aesthetic union, grandly conceived.[56]

The founding of the Artists' Colony generated many such hyperbolic claims that
blur the distinction between cultural analysis and self-promotion. The conflation
of cultural criticism and publicity is significant; one of the central achievements of
the Artists' Colony was its effort at self-promotion.

Those who gathered outside the Ernst Ludwig House on May 15, 1901, wit-
nessed a unique event, and Nietzsche's influence on Fuchs's conception of it was
strong. In 1873, the philosopher had described the *Fest* as a celebration of history
registered beyond the limits of historical time; like a work of art, it existed outside
the realm of daily life. But its uniqueness meant that it also registered time in a
way that an ordinary work of art could not. "That which is celebrated at popular
festivals, at religious or military anniversaries, is really . . . an 'effect in itself,'" he
wrote.[57] The opening ceremony of the Artists' Colony was precisely that: an event
that commemorated itself. Encouraged by the event's organizers, the spectators re-
joiced in their own presence there. Steeped in Nietzschean thought, Fuchs helped
create an event that established Darmstadt's prominence in the German art world
in part by celebrating the creation of its own audience.

Fuchs's account of the audience for this event is also noteworthy, as he not
only claimed that spectators were inspired to a communal emotional response but
also inflated the numbers in attendance. In 1905, he mentioned that the "mass of
participants in the *Fest* counted in the thousands," although the actual number
must have been much smaller.[58] While the promotional photograph of the event
(Figure 4.2) was carefully cropped to suggest an audience much larger than that
in attendance, another photograph of the area, taken from the adjacent Habich
House, demonstrates that what had appeared to be the edges of a vast crowd was
really a path of onlookers only a few feet wide (Figure 4.9). The number of spec-
tators attending the ceremony—as well as their precise emotions at the time—may
be debatable, but Fuchs's high esteem for the communal emotional response that
a performance might provoke among an audience is not. This aesthetic response
entailed the audience's emotional identification not only with the messenger, or
prophet, but also with one another; each sensation was supported by and encour-
aged the other.

Ideally, the blurring of identities during the performance of *Das Zeichen*
occurred simultaneously on several levels. The spectator's emotional identification
with the messenger possessed its own complex symbolism, as the messenger was
both a fictional character in Fuchs's play and also, literally, Behrens, the architect
who had helped create the surrounding environment. In the role of the prophet,

Figure 4.9. Joseph Maria Olbrich, Christiansen House and the Ernst-Ludwig House, Artists' Colony opening ceremony site, seen from the Habich House, 1901. From *Grossherzog Ernst Ludwig und die Ausstellung der Künstler-Kolonie in Darmstadt von Mai bis Oktober 1901*, 86. Photograph courtesy of the Research Library, The Getty Research Institute, Los Angeles, California.

Behrens thus enacted a particularly Nietzschean conception of an artist's role. With Olbrich's architecture as backdrop, the conflation of the fictional character and the real architect lent the creative act of spectatorship a heightened significance; spectators were to "feel as one" with Behrens both as a fictional prophet-messenger and as a real-life artist-prophet. Another process of identification, meanwhile, was to occur among the individual spectators as their emotions merged to create a unified audience. Such sensations were, of course, permissible only within the safety of a carefully restricted crowd. Fuchs wished, he emphasized, *"to raise the aesthetic level of the circle of cultivated people,"* not to expand the parameters of that circle.[59]

While in Darmstadt, Fuchs frequently published theoretical essays on the future of German theater. In 1899, for example, he wrote three articles on the topic for the weekly journal *Wiener Rundschau,* including "Die Schaubühne—Ein Fest des Lebens" (The stage—A festival of life); the eight essays he contributed to the

Artists' Colony program book in 1901 included "Ideen zu einer festlichen Schau-Bühne" (Ideas for a festive stage). As Fuchs began to discuss more specifically the effect of the work of art on its audience, theater offered a mediating forum for his long-standing interest in Nietzschean precepts, although the term *Schaubühne* (from *schauen*, "to look"; *Bühne*, "stage") still emphasized the visual aspect of the theater experience. The transfer of attention away from art criticism might also be described as one from *Thus Spoke Zarathustra* to Nietzsche's first book, *The Birth of Tragedy out of the Spirit of Music*, a shift that prompted Fuchs to turn as well to Wagner's writings, and particularly to the notion of the Gesamtkunstwerk.

As Fuchs envisioned it in 1899, the *Fest* would remove spectators from their daily environment and transport them to an exalted realm of shared art appreciation. "Goethe's and Richard Wagner's concept, to allow all the arts to combine to arouse the celebratory mood in the viewing community, is recorded," he acknowledged.[60] But where Wagner sought to unite all the arts under the umbrella of his own music dramas, emphasizing musical composition at the expense of other forms of art, Fuchs would rely on traditional theater presentations couched in the grand event of a *Fest*. Wagner had sought to unite different forms of art on stage— a unification, as we have seen, predicated on the purification of each—to achieve the most powerful effect on the spectator. Fuchs was likewise interested in the spectator's reaction to the performance, but as a self-styled dramatist and not a composer, he wished for dramas that were not bound to music, except insofar as incidental fanfare would contribute to the overall dramatic effect.

After the opening ceremony in Darmstadt in 1901, however, Fuchs's interest in the experience of theater as festival began to wane. Still concerned with the effect of the performance on the viewer, he turned to a new topic, the architectural reform of the theater, as a means of fostering this effect. This topic, based on the notion of building as symbolic of the creation of a new culture, was no less Nietzschean in inspiration than was that of the *Fest*. As Fritz Neumeyer has written, "In the existential equation between art and life, the nub of all Nietzschean philosophy, the verb *to build* is a synonym for the fundamental human activity of creating form."[61] Fuchs took Nietzsche's summons to build literally, arguing for creating the new audience by constructing an authentic German theater. "They are destroyed in the German lands and are still not entirely conscious of their inner unity, as their *center* is missing," he declared. "Creating this center, that is the problem that concerns us: *the stage of the future*."[62]

Increasingly, Fuchs described the effect of the performance in terms of alterations to the physical design of the stage and auditorium. In an essay entitled "Zur künstlerischen Neugestaltung der Schau-Bühne" (On the artistic redesigning of the stage), published in *Deutsche Kunst und Dekoration* in 1901, he lamented the

condition of the German theater. "If we now and then take home with us an ele-vating impression" from the theater, he complained, it "develops *despite* being cooped up with neighbors devoid of understanding, *despite* the disrespectful atti-tude of the crowd, *despite* the obtrusive decorations and the banality of the stage images, *despite the theater!*"[63] Fuchs was disturbed not only by the current theater repertoire and the manner in which it was presented, but also by the mediocrity of contemporary audiences—all factors that harmed the spectator's experience of the performance. He called for "a festive house in which . . . all impressions unite ceremonially through our elevated senses into a great, and *redeemed,* happiness of the spirit." This theater would provide spectators with a collective sense of spiritual redemption based on their aesthetic experience. It would house, in other words, the sense of ceremony represented by the opening performance of the Darmstadt Artists' Colony.

PETER BEHRENS, THEATER REFORMER

One local cause for Fuchs's turn toward the consideration of theater architecture may well have been the presence of Behrens in Darmstadt, where both men lived between 1899 and 1903. Like Fuchs, Behrens was interested in the notion of theater as festival; he elaborated this vision in his first published essay, "Die Dekoration der Bühne" (The decoration of the stage), which was included in a special issue of *Deutsche Kunst und Dekoration* in May 1900 that was devoted to the Darmstadt Artists' Colony. "The theater has in our day become more and more a place of entertainment," Behrens lamented. Like most forms of art, he argued, it was be-coming increasingly stuck in the mire of naturalism, obsessively imitating reality and, consequently, abandoning its allegiance to true creativity. Happily, however, vestiges of successful art still existed in Germany: "Owing to the fact that music can never be truly naturalistic," he explained, "opera has more than any other form of theater remained in the realm of art, and so we experience the best that our age is capable of showing in Bayreuth."[64] It was not opera per se that signified artistic success, nor even Wagner's music dramas specifically. Rather, it was the experience of attending Bayreuth—the pilgrimage to a secluded site in a German town, the spectator's sense of participation within an audience, and the unification of the arts in a great and glorious Gesamtkunstwerk—that represented, for Behrens as for Fuchs, an artistic ideal. The stated goal was to raise theater to this exalted level, "that we may experience on the stage the overwhelming image of the highest har-mony through the combination of all the beautiful arts."[65]

In June 1900, one month after publishing his essay, Behrens produced a twenty-five-page booklet entitled *Feste des Lebens und der Kunst: Eine Betrachtung des Theaters als Höchsten Kultursymbols* (Festivals of life and art: A reflection on the

theater as the highest symbol of culture). Its title page, designed by Behrens, shows two figures of indiscernible gender, each holding a crystal the size of its own head (Figure 4.10). Their faces are reduced to masks, their hair is indicated by two sets of parallel lines, and their bodies are pared down to linear indications of drapery. Set among contemporaneous Jugendstil creatures, these figures would have appeared still more abstract at the time than they do today. They also register as Egyptian, a style legible as well in the ornamental designs around them: their faces seem like those of two sphinxes, stripped of individuality.[66] Behrens dedicated his book to the Artists' Colony at Darmstadt and discussed within its pages the same crystalline symbolism that would be one of the unifying themes of its opening ceremony the next year.

Within the text of *Feste des Lebens und der Kunst,* the debt to Nietzsche is clear, both at the level of the description of the spectator's aesthetic experience and at that of the larger cultural and national significance of the work of art. "Everything opens our soul to its second, eternal life" in witnessing the work of art, Behrens wrote, with words Zarathustra might have used. "We have become greater, more complete, more clear; we have forgotten the inadequacies of life; we have forgotten the shortcomings of the soul; we have forgotten that many things are ugly through our own fault."[67] His words likewise evoke Nietzsche in describing the parallels between visual style and a unified national culture: "Style is the symbol of the general feeling, of an age's whole attitude to life, and appears only in the universe of all the arts. The harmony of all art is the beautiful symbol of a strong people."[68] The harmony of the artistic whole paralleled, and equaled, the harmony of its parts; by means of its visual style, art expressed the spirit of its age and represented the nation's strength—both cultural and, by implication, political.

In the contemporary theater, Behrens lamented, a collection of individuals watched the false perspective of naturalist illusionism. Here, as in all forms of art, naturalism signaled degeneration, a decline in the creative powers exercised by both artist and viewer.[69] Advocating a theater that, with the occasional assistance of illusionistic hints, would encourage the audience to help create the work, he conceived of spectatorship as a form of participation in the performance, a communal act, rather than something witnessed from the outside by individuals who remained emotionally discrete despite their physical proximity. To counteract this sense of isolation within the audience, he called for increasing the space between seats in order to encourage social circulation among spectators. The new kind of theater he proposed would dissolve the traditional distinction between active performer and passive spectator. "Through our enthusiasm we, too, have become artists," he explained; "we are no longer waiting spectators; we are on the threshold of being participants in a revelation of life."[70]

Figure 4.10. Peter Behrens, title page of *Feste des Lebens und der Kunst: Eine Betrachtung des Theaters als höchsten Kultursymbols* (Leipzig: Diederichs, 1900).

Architecturally as well, Behrens believed, the theater should help forge a link between audience and performance. "We do not want to separate ourselves from our art," he maintained. "The proscenium, the most important part of our stage, is in structural thinking completely united with the hall. The stage follows behind it, in greater breadth than depth."[71] This shallow stage would be further unified with the auditorium by means of what Behrens termed a "rising terrace [*ansteigende Terrasse*]," mechanically adjustable.[72] Such a configuration, he explained, would help dissolve the distinction between the performance and the audience. Just as crucially, it would alter the audience's perception of the stage, flattening the visual image of the performance to create an impression of sculptural relief. The concept of relief, central to the thinking of both Behrens and Fuchs at this time, would reappear several years later in the design of the Munich Artists' Theater; for Fuchs, too, it would appear architecturally in the form of a shallow stage.[73]

Behrens's ideas about theater "as the highest symbol of culture," as his book's subtitle put it—as a Nietzschean unification of the arts presented on a shallow stage—surely resonated with Fuchs's own ideas. The title of Fuchs's 1899 essay "Die Schaubühne—Ein Fest des Lebens" foreshadowed that of Behrens's pamphlet. One indication of the conjunction of their ideas at this time is the use of Behrens's illustrative vignettes to accompany both Behrens's essay "Die Dekoration der Bühne" (published in May 1900) and Fuchs's play *Das Zeichen* (published in the Darmstadt exhibition program book in 1902); the drawings would subsequently reappear in Fuchs's book of 1905. Who was mentor and who apprentice in this relationship, a distinction numerous scholars have attempted to make, is less relevant here than the fact that influence between the two men in Darmstadt was probably mutual, with Nietzsche's ideas operating as the link between them.[74] From symbolic crystals to expressive rhythm, the central components of the Artists' Colony derived from Nietzsche, with Wagner's ideas filtered through him.

The Stage of the Future

In 1904, one year after Behrens left Darmstadt to become the director of the Kunst-gewerbeschule, or School of the Applied Arts, in Düsseldorf, Fuchs returned to Munich, leaving behind both *Deutsche Kunst und Dekoration* and the attempt to press Nietzschean ideals into the service of art criticism. Having published dozens of articles—mostly in *Allgemeine Kunst-Chronik, Deutsche Kunst und Dekoration, Die Kunst für Alle,* and *Wiener Rundschau*—as well as several plays, he now focused increasingly on the site of spectators' greatest visibility as a group: the theater.[75] While still heavily indebted to Nietzsche, he now tried to reconcile the philosopher's ideas with the growing presence of the middle class. Increasingly, he wrote of theater's role as a unifying cultural force in Germany, starting a propaganda

campaign to create a German theater in a city large enough to attract the audience he envisioned. His political affiliations at this time appear most clearly in *Der Kaiser, die Kultur, und die Kunst: Betrachtungen über die Zukunft des Deutschen Volkes aus den Papieren eines Unverantwortlichen* (The Kaiser, culture, and art: Considerations of the future of the German people from the papers of an irresponsible person), published anonymously in 1904. Here, Fuchs emphasized theater's role in forming the conservative political collectivity that he wished for in Germany. With such chapters as "Culture and the Position of World Power," "Race and Rhythm," and "On the Psychology of the Degenerate," he added his voice to German debates on culture, already politically loaded and increasingly so in subsequent decades. *"Every culture is bought with blood,"* he announced, *"for it is nothing other than the most reckless infiltration in all things of the rhythm of its own national tradition."*[76]

Fuchs justified his nationalism by underlining Germany's need to compete with other countries for cultural and political supremacy. This need, he explained, had been rendered urgent in part by recent increases in emigration. Millions of Germans had departed for America, Africa, Asia, Australia, and Russia, he warned; rather than retaining their identity as Germans, they tended to sever all ties to their nation. People all over the world, meanwhile, looked to Britain as their cultural homeland—even those who had been born elsewhere. Despite experiencing a depletion of population similar to that of Germany, the British Empire retained its reputation as a cultural authority. Its status, Fuchs argued, could be traced to the fact that "everything British has a British style," including "English childcare, English sport, English thoroughbreds, English statesmanship, the English residential building, the English household."[77] The examples reveal an upper-class emphasis on good breeding and sportsmanship as well as a valuing of interior design and management at both domestic and national levels. Much in the manner of Hermann Muthesius's book *The English House,* Fuchs argued for the need to improve German standards in these areas by following the English model.[78]

In the face of British achievements, Fuchs noted, "We Germans have only our music and our art of warfare to set against this, while the French have only their cuisine and their charm."[79] Its national standing at stake, Germany needed more than music and the "art of warfare" to establish its supremacy. But the British Empire, now in decline, was not the real threat, he argued; that came from the Anglo-American and Russo-Asiatic empires, and particularly from the United States. Fuchs recorded with approval, for example, that President Theodore Roosevelt "again and again emphasizes that a process of *cultural* concentration must precede that of political expansionism."[80] Fearing that the United States would replace Britain as the preeminent world power, Fuchs set down two linked goals for his

own nation. The first was to strengthen the navy so that Germany (together with its partners in Austria, Italy, and France) might operate as an international power. The second goal, equally important, was to improve German cultural standards "so that the other continental powers, with *France* at their head, would no longer fear a cultural step backwards in forming a closer relationship to us."[81] Both military and cultural advances were to participate in a limited European internationalism. The amorphous notion of culture was central to the notion of nation building; Fuchs ominously declared, "The price of the culture of the future is the *intercontinental war.*"[82]

Fuchs acknowledged the cultural function of the theater within the pages of *Der Kaiser, die Kultur, und die Kunst,* writing, for example, "The stage of the future will be of immense significance for the corporeal development and refinement of the race, of the same significance held by other sports for the Anglo-Saxon race."[83] But even as he clarified his political ideas in this anonymous publication, he began to modulate (if not entirely conceal) them in his writings explicitly on the topic of theater. This is especially true of the collection of essays he published the following year, *Die Schaubühne der Zukunft* (The stage of the future), which brought him fame in Germany and helped establish his international reputation in the theater. The same two vignettes by Behrens again illustrated his ideas, appearing at the beginning and the end of the book, but the notion of the *Fest* had faded in significance. Fuchs now concentrated on analyzing the elements of the new theater; such chapter titles as "The House," "The Stage," "The Actors," and "Directing" exemplify an almost willfully apolitical formalism. Other chapters, such as "On the Purpose and Style of the Theater" and "The New Culture's Bourgeois [*bürgerlich*] Theater," indicate only slightly more about the desired sociocultural functions of the new stage.

The restricted Nietzschean elite that visited the Darmstadt Artists' Colony no longer sufficed for Fuchs, who now referred to the proposed new audience as the "cultural 'superior ten thousand.'"[84] Such a number most likely derived from the writings of Nietzsche, who two decades earlier had lamented the division of German audiences into two camps, high and low:

> on the one hand a host of ten thousand with ever higher, more refined demands, listening ever more intently for the "meaning," and on the other the enormous majority growing every year more and more incapable of comprehending the meaningful even in the form of the sensually ugly and therefore learning to seize with greater and greater contentment the ugly and disgusting in itself, that is to say the basely sensual in music.[85]

But where Nietzsche showed concern over such a separation, Fuchs was happy to direct his hopes and energy toward the ten thousand whose "refined demands" and cultural superiority would allow them to understand the artistic goals of Fuchs and others. Such an audience size was, perhaps, more in keeping with Wagner's hopes, yet Fuchs also distinguished his aims from those of the composer: "Richard Wagner, in the era *before* the general cultural rebirth, built a festival theater for a public that he first had to create. We, on the contrary, plan a drama, and a festival house, for the ten thousand that already await it."[86] Where Wagner, according to Fuchs, had hoped to create an audience through its experience of the performance of his music dramas, contemporary sociopolitical conditions required new cultural tactics. The previous fifty years had created a critical mass of potential theater-goers, a dormant *Volk* that needed merely to be amassed in an appropriate setting and alerted to its cultural and political function.[87]

Fuchs claimed to have discarded the Wagnerian model by 1905, yet the title of the collection of essays he published that year suggests otherwise: *Die Schaubühne der Zukunft* clearly invoked Wagner's treatise *The Art-Work of the Future*.[88] "The stage [*Schaubühne*] can never be the 'Gesamtkunstwerk,'" Fuchs now declared. "It comes to completeness not through a cooperation of all the arts, valued equally, but instead is an *art for itself*. It therefore has a different purpose and a different origin, with laws and freedoms different from all other arts."[89] Instead of aiming to unify all the arts, Fuchs sought to purify the discipline of theater. He wished to gather the different art forms only in theory, considering the potential function of each one in order to determine that it might be discarded in creating the performance. Just as Wagner had celebrated drama as "the highest conceivable art," Fuchs believed that the ultimate achievement of the theater was the creation of pure drama. And, it transpired, only one element was essential on stage: "Drama is possible without word, sound, scenery and wall," he wrote; it could exist "purely as the rhythmic movement of the human body."[90] If performance aimed to transport the spectator to the exalted realm of art, then the traditional stage apparatus was increasingly unnecessary.[91]

Acknowledging that Wagner's Festival Theater in Bayreuth had served its purpose, Fuchs argued that in the early years of the twentieth century a new vision was needed. "The rising economic and cultural development of our *Volk*," he wrote,

> must also bring an understanding of a different, greater plan of realiza-
> tion. Goethe tells us: "Schiller had the good idea to build a house proper
> for tragedy." Since then the yearning for a national theater festival has
> always remained awake, as little forgotten by the German *Volk* as the
> hope for reestablishing the empire.[92]

Five decades after Wagner had written *The Art-Work of the Future,* Fuchs hoped for a cultural rebirth without the revolutionary politics that had pervaded Wagner's essays in 1849.[93] The communal emotional transport that would occur at the *Fest* as Fuchs envisioned it would reinscribe the audience within a cultural community that harbored implications of nationalist political strength.

The *Volk* that Fuchs wished to create through its experience of a performance was an amorphous entity, one that he linked to ancient Greek audiences by way of the potential for active spectatorship. "The *Volk,* when it is collected into a viewing community, wants not only to receive, but also to *give,*" he declared; as explanation, he reminded his readers of "how the Athenians sat in the theater, as *judges* as well," deciding the fate of the plays they watched.[94] But while invoking the Athenian spirit, Fuchs neither advocated such competitions nor called for the audience to participate in the performance in any literal way, invoking instead the festive atmosphere of ancient performances. The play itself could be one of his own, or it might come from the classical dramatic repertory, with an emphasis on Greek and German works. Each German spectator would be made active within the performance by virtue of his own emotional response, not through any kind of physical participation.

Fuchs occasionally hinted at the *Volk*'s potential to gain influence throughout Europe. "As the most gifted, discriminating, and superior men and women," he wrote in 1905, its constituents "are the European future; at the very least the *German* future. That which will be founded upon them forms the basis from which all the creative powers of the following races must henceforth shoot: that much is *certain.*"[95] The position might be characterized as one of German cultural nationalism with pan-European pretensions, as opposed to an avant-garde internationalism. While other nations were welcome to join, cultural rebirth would be German at its core. Again, the model for unifying German politics and culture originated in ancient Greece. Fuchs wrote with admiration of "the old Aristotle, whose notion of catharsis is . . . to be taken literally, as a purification, an anchoring, of the urge for life through a restless and reckless realization in a higher chorus. We want to congregate, to *feel* together [zusammen*fühlen*], with as many others as possible in *one* large, intoxicating, elevating experience."[96]

Fuchs offered several clues within his book as to the composition of the new audience. First, he distinguished it from the contemporary "bourgeois 'great public'" who, by his definition, lacked aesthetic taste.[97] He argued that "today, next to this similiculture of the 'great public,' a 'new society' is again crystallizing from the personalities of the young generation which has become too strong to be worn out and crushed by the wheels of the leveling machine civilization."[98] This "new society" was distinct both from the general bourgeois mass and from that elite

group, isolated from the rest of German culture, to which the Artists' Colony at Darmstadt had catered. But it also possessed the advantages of each: the strength of numbers and the elite's discriminating taste. It could therefore act as the vanguard of cultural change, setting an example to the rest of society and, ultimately, inspiring all of Germany to join its ranks. Fuchs wrote, "It is an old story: one needs only to explain something as exclusive, as the right of an elite, in order immediately to experience a mass rush. Ultimately everyone wants to be a member of the elite."[99]

The crucial element that would inspire the "mass rush" was the construction of an accessible venue. If the new theater were positioned "in a place of international traffic: in Munich, in Berlin, on the Rhine," for example, then more Germans would be able to attend; Fuchs explained, "Then one shouldn't think that the numbers for such a stage would remain limited to only those 'superior ten thousand.'"[100] Implicit in his argument was a critique of the model of theater as a pilgrimage site, a model exemplified by Wagner's Festival Theater in Bayreuth and by the Artists' Colony in Darmstadt. Fuchs now sought to build a theater in a major city, accessible to larger numbers. The siting of the Festival Theater was not its only shortcoming, according to Fuchs, who also decried the design of its stage. "Wagner held on to the peep-box stage with its ramp lights and stage machinery," he wrote, "and in this way prevented the painter's intervention in the true and artistically respectable sense of the word."[101] Only the restructuring of the stage itself would allow all the elements on it to come together as equals; such an architectural reconfiguration would, in turn, allow the audience to participate more fully in the performance.[102]

In addition to the vignettes drawn by Behrens and a photograph of the opening ceremony of the Darmstadt Artists' Colony, *Die Schaubühne der Zukunft* included three architectural drawings of theaters by the Munich architect Max Littmann. The first, "a schematic section drawing of a theater following the suggestions of Georg Fuchs," shows a double structure united by a glass ceiling, allowing the use of natural light to illuminate the stage (Figure 4.11). At the left, under one roof, the auditorium is divided into three levels of seating, each one raked less than the last. The stage, under a separate roof structure, is likewise divided into three sections— a proscenium area, a slightly elevated middle stage, and a more elevated area at the rear. In between the auditorium and the stage lies an orchestra pit. Submerged below the proscenium, it is invisible to the audience, following the model of Semper's theater for Wagner that was copied in Wagner's Festival Theater in Bayreuth.

Two other drawings by Littmann included in the book reveal the ground plans for "a new form of theater," and likewise follow Fuchs's suggestions; one shows the ground floor while another, divided down the center, shows the two floors above

Figure 4.11. Max Littmann, theater designed for Fuchs, section. From Georg Fuchs, *Die Schaubühne der Zukunft* (Berlin: Schüster und Löffler, 1905), following page 48. Photograph courtesy of the Canadian Centre for Architecture, Montreal.

(Figure 4.12 and Figure 4.13). Much of the design echoes those of the festival theaters for Wagner in Munich and Bayreuth. On the exterior, a curved bay at the front of the building is flanked by two rectangular rooms, doubling the length of the facade; inside the auditorium, an amphitheater laid out in a fan shape contains rows accessible from the doors at either end rather than from interior aisles. Here, too, the orchestra pit is submerged under the stage, invisible to the audience. But several crucial differences from these models remain. Littmann's theater building is entered from the side wing, not from the center of the curved facade; within the auditorium, the seating is arranged in three levels, each raked at an angle, rather than in one continuous block. At the back of the lower two levels are private boxes: a large one in the center with eight smaller ones on each side. Finally, in place of the deep stage that Wagner had demanded in order to emphasize the auratic distance between audience and performance, a shallow one appears at the focal point of the fan-shaped auditorium. Appearing in these two drawings for the first time in Fuchs's work, this shallow stage would prove to be the most significant achievement of the Artists' Theater that he would have Littmann build in Munich in 1908.

The reliance on naturalism pervasive in the conventional theater and prevalent in Munich, Fuchs believed, was inexcusably deceptive and fundamentally misguided; it would never create a realistic optical experience for the spectator. The more naturalistic the performance, the more jarring its particular flaws would be; spectators lulled into the comfort of a realistic performance would be especially

Figure 4.12. Max Littmann, ground plan of a theater designed for Fuchs. From *Die Schaubühne der Zukunft,* following page 80. Photograph courtesy of the Canadian Centre for Architecture, Montreal.

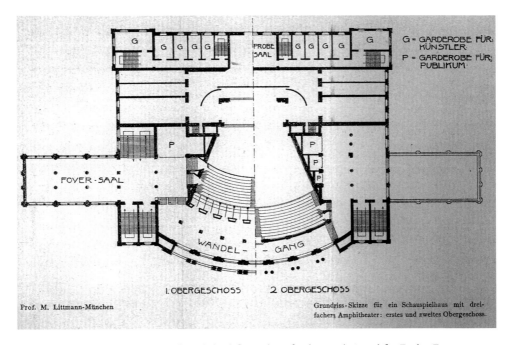

Figure 4.13. Max Littmann, second- and third-floor plan of a theater designed for Fuchs. From *Die Schaubühne der Zukunft,* following page 64. Photograph courtesy of the Canadian Centre for Architecture, Montreal.

shocked by the spatial arrangement of the traditional deep stage.[103] This deep naturalist stage strained the capabilities of the performers and directors, creating perspectival distortions that could be corrected only by bringing the rear wall of the stage forward. As Fuchs explained it, actors retreating from the audience decreased in size while their environment remained constant, thereby destroying the carefully constructed stage naturalism. "The conventional peep-box stage feigns spatial and scenic depth to us," he lamented, "but without being at all capable of making the human figure appear smaller in correspondence with this depth. And despite this it makes the claim of being 'true to nature!'"[104]

Fuchs's description of the shrinking actor was easily invoked to symbolize the inadequacies of the naturalist stage; it was quoted, for example, by the Russian director Vsevolod Meyerhold in an essay the following year.[105] For both authors, the disparagement of traditional stage architecture was inseparable from the distaste for the naturalist drama that had been popular—especially in Munich, but across Europe as well—and the production style that accompanied it. "The current maximum development of the stage machinery, and with it the consequent naturalism, have led the peep-box stage to absurdity," Fuchs declared, before working himself into a rhetorical lather: "Away with the flies! Away with the footlights! Away with the settings, the prospects, the soffits, the scenery flats and quilted leotards! Away with the peep-box stage! Away with the Loge theater! This whole sham world of cardboard, wire, burlap and sequins is ripe for downfall!"[106]

Such arguments linked naturalist dramas (such as those of Henrik Ibsen, who had lived and worked in Munich from 1875 to 1891) with the theaters then presenting them. One of the city's most famous theaters, the Schauspielhaus, built in 1901 to showcase naturalist drama, exemplifies Fuchs's association of theater architecture and the dramas presented within it. Richard Riemerschmid designed the interiors, while Littmann was responsible for the plans, nestling the structure within the interior courtyard of a block of residential buildings (Figure 4.14 and Figure 4.15). Possessing neither its own architectural facade nor a centralized entrance, the theater is approached through one of two nondescript passages accessible from the fashionable Maximilianstrasse. Through them, one proceeds from the public space of the city street into either end of a foyer, its central skylight allowing some natural illumination of its Jugendstil design (Figure 4.16). Entering this environment almost feels like walking into the aestheticized interior of a body. As Peter Jelavich has written, "One would fully conform to the spirit of Jugendstil if one compared it to a womb—hidden, vitalizing, and, above all, the source of *Jugend*," or "youth."[107]

Behind the foyer lies the Schauspielhaus auditorium itself, its proscenium stage facing just over seven hundred seats arranged on two levels: some in a horseshoe-shaped balcony, others in a gently raked orchestra section below, devoid of aisles

Figure 4.14. Max Littmann, Schauspielhaus site plan. Photograph from Max Littmann, *Das Münchener Schauspielhaus: Denkschrift zur Feier der Eröffnung,* ed. Jakob Heilmann and Max Littmann (Munich: E. Mühlthaler's Buch- und Kunstdruckerei, 1901), 3.

(Figure 4.17). The auditorium's small size, softly glittering lights, rich materials, and deep red color all form an atmosphere of intimate opulence. This atmosphere, and the fact that seats at one end of the balcony directly face those at the other, allowed the audience to turn in on itself both literally and figuratively, creating ideal viewing conditions for the emotional interiority Munich dramatists were exploring.[108] While no record exists of Fuchs's opinion of the Schauspielhaus, it cannot have been favorable. Four years after it was built, he stated unequivocally that "all men of conscious culture are united in the knowledge that within the Baroque loge theater and the flea-pit peep-box stage a general aesthetic effect will never, ever, be achieved."[109] A true aesthetic response would occur only in the appropriate architectural setting, which, he maintained, would comprise an amphitheatrical auditorium—without aisles or boxes—opposite a shallow stage.

"We wish not for the peep-box, not the panorama," Fuchs wrote, "but for a spatial formation favorable to moving human bodies, uniting them in a rhythmic unity and at the same time facilitating the movement of the soundwaves toward the spectator. Therefore, not the perspectival, deep painting, but the flat *relief* must be the model."[110] The relief stage would not be entirely flat; some depth was necessary to accommodate small crowds of actors on occasion and to facilitate

rapid scene changes. Fuchs described this stage in some detail, dividing its shallow structure into three parts: the foreground, the middle ground, and the background. Owing to its proximity to the spectator, he explained, "the *foreground* was the true performance space"; the latter two areas served subsidiary purposes, lending depth to the stage and presenting the audience with a painted image, respectively.[111] The rear wall of the theater, he decreed, was "the only surface in the scenic formation on which the painter's art can intervene."[112] Fuchs said little of

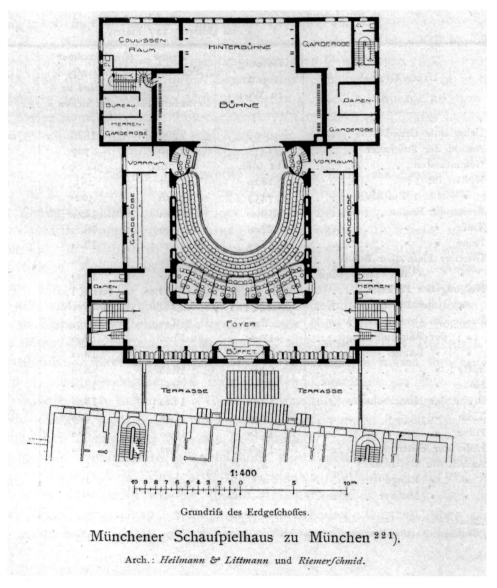

Figure 4.15. Max Littmann, Schauspielhaus plan. From *Das Münchener Schauspielhaus*, 7.

Figure 4.16. Richard Riemerschmid, Schauspielhaus foyer. Photograph by Juliet Koss, 1997.

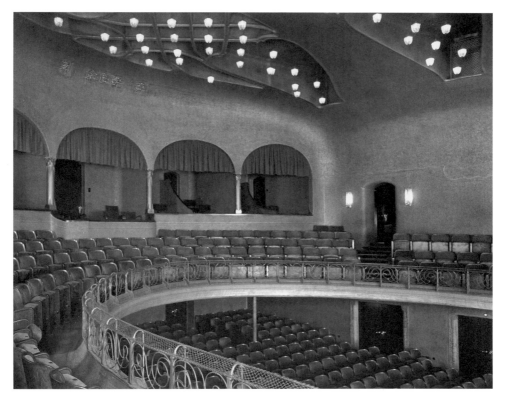

Figure 4.17. Richard Riemerschmid, Schauspielhaus auditorium, Munich. Photograph copyright Architekturmuseum der TU München.

a programmatic nature about the style of painting appropriate for this rear wall, announcing only his approval of four painters: Pierre-Cécile Puvis de Chavannes, Anselm Feuerbach, Hans von Marées, and Giovanni Battista Tiepolo. He did not remark on the internationalism of this list.

Criticism of the contemporary stage was linked to that of the drama presented on it. Fuchs decried contemporary plays, arguing that dramatists' powers had waned "since the decline of the old, primitive stage culture," and he condemned the overdependence on stage machinery.[113] The emphasis on technical details deflected attention from such genuinely theatrical effects as the actors' talent for pure performance. The fault lay in the structural properties of the theater stage; remaking the stage would therefore serve to unleash creativity among playwrights. Worthy dramas "will again come into being," he predicted, "as soon as a stage is there on which they can be apprehended as constructive unities. The stage creates the literature, and not the other way around."[114] In this scenario, architecture itself would inspire the necessary cultural rebirth. At his book's conclusion, Fuchs personified his argument: "The man who builds us the new stage," he declared, "will be regarded by us and for all to come as worthy of the highest praise."[115]

Following Wagner, Fuchs frequently used metaphors derived from the fine arts, treating the stage image with a vocabulary that derived from painting. While his discussion of the tripartite division of the stage image evoked his earlier work as an art critic, Fuchs denied that his arguments derived from any symbolic link between stage and painting. The consideration of the stage in terms of a foreground, middle ground, and background, he wrote, arose not from the connotations of "perspectival 'depth,' or the naturalistic effect of the illusion of distance, but rather simply out of consideration for practical concerns."[116] Among these concerns lay the need for rapid scene changes; overburdened with realistic details, the naturalist stage was incapable of shifting from one setting to another without long pauses. No such problems would occur on the shallow stage, where the absence of spatial depth would demand the elimination of excess props and sets. The shallow stage was thus a natural result of modern efforts toward perceptual efficiency.[117]

Beyond metaphoric comparisons, Fuchs associated the new stage with developments in the fine arts, as if the genre of theater competed with that of painting. Despite theater's status as the true art form, it still looked to the fine arts for stylistic guidance. "The 'literary drama' that is still dominant," he stated,

> considered culturally, exists on a par with anecdotal painting and with the problem- and genre-scenes of a historical, social, lyrical, erotic, humorous, psychological kind, which in the course of the last decade have been overcome by the onslaught of real painterly art.[118]

Now that painting had advanced beyond naturalism, theater would follow suit. Max Reinhardt, director of the Neues Theater (now the Theater am Schiffbauerdamm) in Berlin from 1903 to 1906 and director of the Deutsches Theater in that city from 1905 to 1930, had provided a crucial step in furthering theatrical progress by demonstrating "cubic installation" on the Berlin stage—a kind of scenic design, Fuchs wrote, "that can be set parallel to the impressionist style."[119] The relief stage was the logical successor to the illogical stage then in use.

THE PRINZREGENTENTHEATER IN MUNICH

In *Die Schaubühne der Zukunft,* Fuchs mentioned only one contemporary German theater with approval: the Prinzregententheater, built in Munich in 1901. Its architect was Max Littmann, whom he labeled "one of the most successful master theater builders."[120] As a member of the firm Heilmann and Littmann, Littmann had already built several major buildings in Munich, including the Hofbräuhaus beer hall (1896–97); a new structure for the city's largest daily newspaper, the *Münchener Neueste Nachrichten* (1904–5); and the Anatomy Building for the university (1905–8). He was best known for his theater buildings, which included (in addition to the Schauspielhaus and the Prinzregententheater in Munich) the Schillertheater in Berlin (1905–6) and the Weimar Hoftheater (1906–8).[121] Fuchs commended the architect for only one building, however, indicating no awareness of the rest of Littmann's oeuvre: "A reliable example of the theater of the future is already available. We have to thank for it *Littmann,* who, following [Karl Friedrich] *Schinkel* and Bayreuth, has created the Prinzregententheater in Munich with festive halls, amphitheater and garden."[122]

The Prinzregententheater is widely recognized as Wagner's theater incarnated, finally, in Munich.[123] Littmann himself, in the book published by his firm on the occasion of the theater's opening, emphasized the origins of his designs in Semper's "reformatory—indeed 'revolutionary'—thoughts."[124] He described the cultural and architectural lineage of his building again in an essay of 1912:

> King Ludwig II's intent to build a festival theater for the works of Richard Wagner had to be abandoned, although plans and models of the unique design had been completed by Gottfried Semper . . . because petty minds had laid seemingly insurmountable obstacles in the path of the great plans. But the triumphal advance of Wagner's art did not let the ingenious idea rest, and at the turn of the century the former Hoftheater Intendant Ernst von Boffart managed to take up the plans of Ludwig II again and to put them into effect in a short time, albeit in simpler form. Following the plans of Max Littmann, a house should rise

as the master himself had wished and planned for the presentation of his works.[125]

With this self-glorifying narrative of architectural history, Littmann recounted his vision of the Prinzregententheater. Deftly ignoring Wagner's Festival Theater in Bayreuth, he presented his work as fulfilling Semper's intentions.

A postcard with a drawing of the Prinzregententheater shows the theater's explicitly Wagnerian self-presentation (Figure 4.18). Next to the building hovers a portrait of the composer himself, who had died eight years before the theater's construction. Below are two unlabeled bars of music, identifiable to musically literate members of Wagner's audience as the Valhalla theme from the *Ring*. As the home of the gods completed at the beginning of *Das Rheingold* and destroyed by fire in the last bars of *Götterdämmerung*, Valhalla was no arbitrarily chosen Wagnerian leitmotif. In conjunction with the composer's portrait, it indicates the status of the Prinzregententheater as the home of Wagnerian music drama: the Munich theater for which the composer had always wished.

Figure 4.18. Prinzregententheater postcard, 1901. Courtesy of the Research Library, The Getty Research Institute, Los Angeles, California (970039).

Like the Festival Theater in Bayreuth, the Prinzregententheater relied heavily on Semper's designs in the 1860s for Munich. Altering the proportions and the detailing of Semper's building, Littmann retained the long, flat facade on one side of the building (covering a large reception hall for use during intermissions) as well as the pitched roof perched over a curved entry section (Figure 4.19). The building's pediment, inscribed with a dedication "to German art [*der deutschen Kunst*]," announced its cultural purpose. The Prinzregententheater was likewise located on the west bank of the Isar River, away from the city center. But where Semper's theater had appeared on a prominent bluff overlooking the river, Littmann's was set further back several streets behind the Friedensäule, or "Peace Monument," of 1899, on an avenue that extended from the Prinzregentenstrasse (Figure 4.20). While more modest than Wagner had originally desired, it was nevertheless imposing, situated on a small square at the end of a boulevard. The debt to Semper was equally clear inside the theater, as its ground plan suggests (Figure 4.21). Photographs of the entryways to the auditorium and of the auditorium itself under

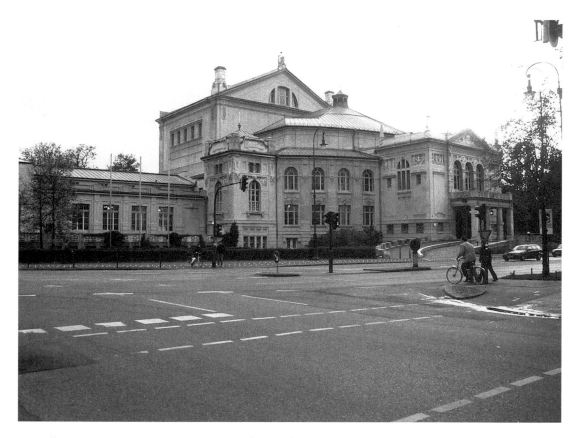

Figure 4.19. Max Littmann, Prinzregententheater. Photograph by Juliet Koss, 1997.

Figure 4.20. Max Littmann, Prinzregententheater site plan, 1900–1901. From Max Littmann, ed., *Das Prinzregenten-Theater in München, erbaut vom Baugeschäft Heilmann & Littmann, G.m.b.H.: Denkschrift zur Feier der Eröffnung* (Munich: L. Werner, 1901), 10.

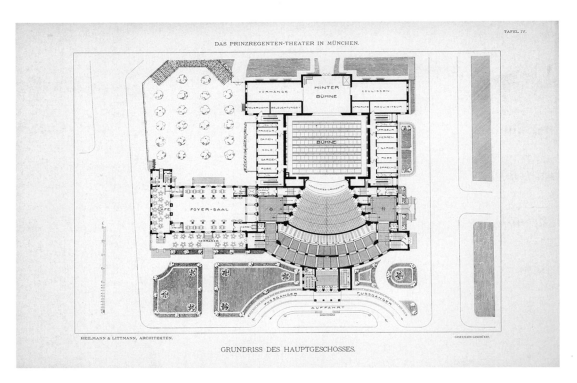

Figure 4.21. Max Littmann, Prinzregententheater ground plan, 1901. From *Das Prinzregenten-Theater in München, erbaut vom Baugeschäft Heilmann & Littmann, G.m.b.H.*, plate 4. Photograph courtesy of the Canadian Centre for Architecture, Montreal.

construction likewise evoke Semper's Munich designs and the corresponding areas in the theater in Bayreuth; shadowy figures of workers are barely visible where the unbroken rows of seats would go, and a raked amphitheatrical auditorium offers each seat a relatively identical view of the stage (Figure 4.22 and Figure 4.23).

When the theater opened with a production of Wagner's *Die Meistersinger,* the appropriation was so blatant as to provoke a public letter of protest from Cosima Wagner, the composer's widow. "It was the master's definitive will that his theater would stand only in Bayreuth," she declared, adding,

> But now that . . . the name of the master is taken for that which he expressly rejected, for a stock enterprise, I would place myself under an irredeemable burden of guilt were I not to declare that the new theater building presses the seal on the treatment that the master once was subjected to in Munich, and that it will be a serious injustice to the legacy of Richard Wagner.[126]

Figure 4.22. Max Littmann, Prinzregententheater west foyer, 1901. From *Das Prinzregenten-Theater in München, erbaut vom Baugeschäft Heilmann & Littmann, G.m.b.H.,* plate 16.

Her words had no effect in Munich, and Cosima Wagner returned to protecting her husband's legacy in Bayreuth itself. She would remain in charge of the summer festivals there until 1908, when her son, Siegfried, took over.

The egalitarian view of the stage at the Prinzregententheater, and the sense of communal spectatorship it fostered, precisely fit Fuchs's demands for the theater of the future. But if the auditorium Fuchs advocated already existed, then why did he call for a new one? First, the theater lacked the shallow stage that, he believed, would encourage an abstracted performance style for those who acted on it and would produce a flat visual field for those who faced it. Beyond this, he had played no role in the building's creation; the very process of summoning the theater of the future was as important to him as the structure's actual existence. *Die Schaubühne der Zukunft* was an impassioned call for more than simply a theater that would encourage a new German audience, drama, and culture—and the architect who

Figure 4.23. Max Littmann, Prinzregententheater auditorium under construction, November 1899. Photograph copyright Architekturmuseum der TU München.

would build such a theater. It was a call for cultural rebirth, a manifesto for the construction of a strong German culture. In writing this manifesto, Fuchs inscribed himself in his vision of a future Germany where cultural advances would help form a strong nation. "The young ladies and gentlemen" involved in the new theater both in the audience and on the stage, he explained, "will not learn Greek dances, but rather that the principle of movement and beauty of our modern *German* race shall be won through form."[127]

5

Retheatricalizing the Theater

"I mean when a stage is completely full of 2 or 3 German people who are quite large size, they really cannot help it if they seem to get in each other's ways."

—ANITA LOOS, *Gentlemen Prefer Blondes,* 1925

AUSSTELLUNG MÜNCHEN 1908

In the 1907 edition of his guidebook to southern Germany, Karl Baedeker offered his readers the following abbreviated remarks concerning Munich and its environs: "The *October Festival,* founded in 1810 by King Ludwig I. and celebrated on the Theresienwiese from the end of Sept. to the middle of Oct., attracts large crowds of peasants from Upper Bavaria; it includes an agricultural show, horse-races, etc."[1] By implication, the area was not an appropriate destination for cultured travelers, the book's target audience. Worse yet, according to Baedeker, the site had "recently been much diminished by the construction of new streets." No mention was made of the Theresienhöhe, the hill rising to the west of the field and best known as the base for the colossal statue of the allegorical figure of Bavaria. Modeled by the sculptor Ludwig von Schwantaler and constructed posthumously in 1850, this statue stood in front of the Ruhmeshalle, or "Hall of Fame," completed in 1853, a semicircular structure designed by Leo von Klenze and punctuated by the busts of eighty famous Bavarians.

The following year, this hill was the site of Ausstellung München 1908, the exhibition officially held to commemorate the 750th anniversary of the founding of the city of Munich. The exhibition comprised six main halls and roughly forty subsidiary structures; together with an amusement park, these buildings encircled a small meadow at the top of the Theresienhöhe. The ground plan was designed by Wilhelm Bertsch of the city planning department, with the assistance of several others, including Richard Riemerschmid; Bertsch was also responsible for some of the exhibition halls. Opening seven months after the founding, also in Munich, of the Deutsche Werkbund, the exhibition received almost three million visitors over the course of the summer.[2] In 1909, Baedeker repeated the patronizing assessment of the Oktoberfest but now considered the area worth a detour. The guide singled

out "the buildings of the 1908 exhibition, with the Artists' Theater built by Max Littmann, the artistically simplified stage arrangement of which is noteworthy."[3]

The Darmstadt Artists' Colony had catered predominantly to an upper-middle-class audience when it opened in 1901; visitors retreated to the city's bucolic outskirts, ascending the Mathildenhöhe to celebrate their own presence within the heightened aesthetic realm that aimed to provide the apotheosis of Nietzschean artistic elitism. Seven years later, Ausstellung München 1908 appeared to rely on the same aesthetic model. As a period photograph of the exhibition attests, the *bürgerlich* residents of Munich could stroll around the Theresienhöhe and explore the offerings of various exhibition halls (Figure 5.1). But if the Artists' Colony in Darmstadt had intended to "fuse life and art into a unity," as Fuchs had written, the Munich exhibition fostered the same goal while defining life and art more

Figure 5.1. Wilhelm Bertsch, Ausstellung München 1908, entrance to Hall I. From Bayerischen Architekten- und Ingenieur-Verein, ed., *München und seine Bauten* (Munich: F. Bruckmann, 1912), 727.

along the lines of the daily existence of the middle class. Through the united advances of art and industry and the dissemination of well-designed objects, the daily life of the German middle class would be steadily improved, materially and aesthetically.

The distinction between the two exhibitions was not lost on one of Germany's most important cultural critics. "In contrast to the exhibition in Darmstadt," Hermann Muthesius wrote in the Berlin journal *Kunst und Künstler,* "Ausstellung München 1908 offers an absolutely consistent sight, unified also in its achievements."[4] Both its contents and its form were to be admired, he explained:

> What Munich demonstrates here represents a decisive step forward in the development of art, even a milestone in the nature of exhibitions. Mind you, in Munich we are dealing with an entirely general exhibition, an exhibition embracing art, science, and industry—and in which, by the way, industry occupies the broadest area. Here a principle of exhibition technique is resolved, one that until now has been struggled with everywhere, with more or less—mostly with less—success. It is the principle of both effective and tasteful installation.[5]

The Munich exhibition demonstrated the high quality of the products of German industry, all of which—from the largest objects on display down to the postcards and other souvenirs available for purchase—Muthesius called "irreproachable as far as taste was concerned." It also revealed recent advances in German exhibition design. Perhaps its greatest success, Muthesius wrote, lay in its effectiveness as cultural propaganda. "The foreigner who saw nothing of Germany other than the Ausstellung München 1908," he declared, "would arrive at the opinion that German taste stands at an enviable level."[6]

The Munich exhibition has received little attention in the scholarly literature of the last century, yet its importance was widely acknowledged at the time.[7] As one critic wrote with admiration: "Here is a city of 500,000 inhabitants which, with its own resources, organizes a *strictly local* exhibition and which manages to fill six large halls and four hundred rooms with the products of its own activity alone."[8] L. Deubner, writing in *The International Studio,* New York's "Illustrated Magazine of Fine and Applied Art," remarked on the exhibition's wide scope, encompassing the fields of "art, commerce, trade, manufactures, education, public works, sport of all kinds, and so forth."[9] The central aim of the exhibition, Deubner explained, was to showcase the latest achievements of the applied arts in Munich and thus to demonstrate the city's good taste. Local designers whose work was on view included Bruno Paul and Riemerschmid; Emanuel von Seidl built a hall to house individual

rooms designed by Munich firms, as well as the main restaurant building at the center of the semicircular arrangement of exhibition buildings.[10] In addition to more than a hundred interiors on view in the first main hall, the exhibition also contained a picture gallery, a sculpture room, displays of works by the city's furniture makers and of pieces owned by its antique dealers, and examples of regional peasant art; local metalworkers and ceramicists also showed their creations. Deubner's essay ignored the Artists' Theater, but it mentioned the presence of "a Catholic Church with side chapels, sacristies, and niches," complete with adjacent cemetery.[11] The review was mostly positive, commending "a good average of achievement" in an exhibition "both abundant and varied."[12] While admitting that "not a few things have found their way into the exhibition which do not accord with the programme," including a hall designed by von Seidl in the style of "Old Munich," Deubner was pleased to find that the exhibition demonstrated works linking art and industry along the lines that had been laid out the previous October at the founding of the Werkbund.[13]

Not surprisingly, the Munich press that summer attended carefully to the exhibition. In a review essay in *Dekorative Kunst,* the Munich journal of applied arts, Wilhelm Michel declared that "the meaning and significance of the exhibition are of a propagandistic nature," putting on view the German people themselves by showcasing the objects they had created: "The people are exhibited outside; their taste, their cultural level, their ability to judge." Ultimately, he wrote, the city itself was "the subject of the exhibition."[14] Michel was generally unimpressed by the cultural level of the residents of Munich, however, and found little on view in the exhibition to be worthy of mention. He decried the conservatism of the Munich public, for whom "the beautiful is that which pleases, and the pleasant is that which is known" ("Schön ist, was gefällt, und gefällig ist das Bekannte"; notably, he cited with approval Wagner's understanding of this maxim), and he endorsed the work of only two designers: Paul and Riemerschmid.[15] Both designed objects in a Munich style while also successfully integrating foreign sources, balancing internationalism with a specifically local achievement. "The 'mark of Munich' in the applied arts is mainly their creation," he wrote, "and their connections go perhaps back toward England, not toward Upper Bavaria. To cause to arise from foreign stimulation an applied arts [*Kunstgewerbe*] that is native to Munich, that above all is the task solved by RIEMERSCHMID and PAUL."[16]

Three months earlier in the same journal, Günther von Pechmann had delineated several reasons for the exhibition's importance. First, and most clearly, it registered Munich as a center for the latest developments in the applied arts. "The entire exhibition has the character of a local exhibition," he wrote approvingly; "products from elsewhere are found only if the same thing is not produced in

Munich, or if the designs for them derive from Munich artists."[17] More signifi-
cantly, Ausstellung München 1908 radically reconfigured traditional exhibition
methods. While world's fairs had long arranged some objects as they would be
encountered in daily life—"the oven in the corner, the book in the bookcase, the
plate on the table," as von Pechmann put it—such arrangements undermined an
exhibition's true purpose, which was, he wrote, "to present the objects to the visi-
tor in effective disorder."[18] In Munich, by contrast, industry and trade groups were
accorded subdivisions of larger exhibition halls for presenting their wares. The
exhibition was thus oriented toward industry, with objects exhibited primarily
according to their manufacturers. "In this field the Munich exhibition signifies a
decisive reform of the essence of an exhibition," von Pechmann declared.[19] Visitors
discarded their role as aesthetes-in-training to act instead as model consumers:
"Thus in the end the consumer decides. And in fact just as much through his buy-
ing power as through his formation of good taste."[20]

According to its program booklet, von Pechmann wrote, the Munich exhibi-
tion aimed to prepare a place "not for handicrafts, nor for pure art, but rather for
life; freely for a life that, in its thousand expressions of striving after truth and
beauty, should be accompanied by matter and form."[21] Given this aim, the exhi-
bition would be evaluated neither by the responses of journal reviews nor by the
number of visitors it received but, rather, by its effect on industrial production.
"Are there, already today in Germany," he queried, "economic interest groups that
can take up the artistic tendencies represented in this exhibition and can implement
them, thoroughly understood, according to their own interests?"[22] Incursions into
industry, particularly at the level of design for international export, would mark
the exhibition's true success; merely inducing the public to appreciate recent devel-
opments in aesthetics was not enough.

Or, as von Pechmann wrote, "What does it help if we build festival rooms
and then fill them with the whole dreariness of the official festival atmosphere; if
we reform the clothing and neglect the body?"[23] The reference to clothing reform
was more than metaphoric; it evoked a central debate of early-twentieth-century
German design; it implied a critique of the *Reformkleidung,* or "reform clothing,"
movement and of related attempts to transform German daily life by redesigning
the objects that furnished that life. Like the rhetoric surrounding the reform move-
ments themselves, such critique was couched in terms of daily habits, as a treat-
ment of sensibilities and cultural attitudes, rather than focusing exclusively on the
appearance of particular designed objects. Notions of standardization, rationaliza-
tion, and efficiency—the cultural values of the expanding middle class—were in-
creasingly embraced and were opposed rhetorically to the purportedly self-indulgent
efforts of such Jugendstil designers as van de Velde and Obrist.

The critique of Jugendstil, well under way in the cultural press, provided a useful trope for those negotiating the emerging values of the industrializing German nation. Jugendstil design was characterized as overly individualistic: more suitable for aristocratic tastes than for the emerging middle-class market. Friedrich Naumann, for example, a prominent Werkbund spokesman, referred in 1906 to the work of van de Velde as "an art for the aristocrats," which happily, he wrote, "is regressing, while standardization and formalization of life are in control."[24] The aristocratic Jugendstil aesthetic was seen as a lingering effect of Romanticism, now rendered outmoded and unsuitable for the democratizing principles occupying the German nation. "*Sturm und Drang* is over," Naumann announced; "we most likely are witnessing the coming of a new high point in German domestic culture [*Haus- und Wohnkultur*]."[25]

The concept of *Sachlichkeit*—variously translated as "objectivity," "practicality," and "rationality"—associated elevated design standards with design standardization. The term had appeared in architectural discourse in 1896 in the writings of Richard Streiter, who linked it to the simplicity and good taste of the *bürgerlich* mentality.[26] As the embodiment of the *sachlich* ideal, he cited the work of the Munich architect von Seidl, who in 1908 would design some of the main exhibition halls of the Munich exhibition. By this time, *Sachlichkeit* pervaded German cultural discourse, with Muthesius one of its most prominent advocates. Indeed, Muthesius expressed approval of the structures built by von Seidl and others for the exhibition: "The extensive exhibition buildings demonstrate, above all, simplicity and *Sachlichkeit*."[27] And while the theater reformer Edward Gordon Craig declared that the Artists' Theater was "beautiful in appearance," he paid it an even higher compliment by adding that "its beauty is of secondary importance, what is paramount being its practicalness and its usefulness."[28]

Chief among those discarding the Jugendstil past to forge the new aesthetic was Behrens, who, having played a prominent role in creating the Darmstadt Artists' Colony, was now embraced as the foremost designer of the new sober style, within which *Sachlichkeit* was central. As Joseph August Lux put it in 1908:

> On the path to abstraction, Peter Behrens has emerged from his chaotic beginnings to a certain refined regularity [*Gesetzmäsigkeit*] in which glows the shimmer of an Apollonian artistic ideal. This artist, who as a result of his thinking is strong, logical and consistent, has in the relatively short time of ten years traveled an impressive path.[29]

While Nietzsche still set the terms of the discussion, the symbolic status of these terms had shifted. No longer the necessary and vital antidote to an overreliance on

static, classical beauty, the Dionysian impulse now seemed merely irrational and superfluous beside the sober harmony that, for Lux, Behrens's work represented.

Simplicity and logic described the recent efforts of Behrens, who in 1907 had been hired by the Allgemeine Elektricitäts-Gesellschaft (AEG), or "General Electric Company," to oversee all aspects of company design.[30] In his new position, he was responsible for creating a wide variety of products, from the registered trademarks of 1908 to the Turbine Factory, constructed in Berlin in 1909 (Figure 5.2). Behrens's shift to a more industrial design style was not taken as evidence of inconsistency on his part or of the whimsical nature of creative fashions more generally. Rather, it placed him at the peak of modern German cultural achievement. Already established as a designer as a result of his Jugendstil efforts, he came to represent a new ideal. Indeed, Behrens had already promoted the shift to aesthetic sobriety in 1900, declaring in his book *Feste des Lebens und der Kunst,* "We have become serious; we take our life in earnest; work stands high in value for us."[31]

Like many other cultural critics, Fuchs also tempered his Nietzschean ideals in accordance with the prevailing turn to classical principles. His respect for simplicity is revealed in a passage from his book of 1907, *Deutsche Form: Betrachtungen über die Berliner Jahrhundertausstellung und die Münchener Retrospektive* (German form: Reflections on the Berlin centennial exhibition and the Munich retrospective). Fuchs now emphasized moderation in design, calling for

> just the most simple, everyday things, those that evoke beauty with their moderate motifs. A Weltanschauung that wants to shape value from the "everyday," and for which the "everyday" appears more holy than the festival day [*Festtag*]—is this not a new, moral consciousness? And an art that makes it possible to foster moral elevation, that really achieves this suggestion—is that not a great sensuous [*sinnliche*] power?[32]

The "new, moral consciousness" represented by the sober design of everyday objects would surpass all previous efforts. Quotidian values were replacing the celebration of the *Festtag,* the festival day embraced by Nietzsche and his followers and created in Darmstadt in 1901.

Where the Darmstadt Artists' Colony had sought to celebrate the highest German artistic achievements, the Munich exhibition in 1908 aimed to display the industrial and artistic achievements of the modern German nation. Visitors again gathered at the top of a hill on a city's edge, but now they examined bathroom fixtures as well as paintings, kitchen objects as well as contemporary furniture. The antiques they viewed represented the commercial offerings of local dealers as much as the historical achievements of German art and design. Interweaving a

Figure 5.2. Peter Behrens, AEG Turbine Factory, Berlin, 1909. Photograph by Sandy Isenstadt, 2005.

complex elaboration of aesthetic, political, and socioeconomic themes, the exhibition embodied the ideals of the recently established Werkbund, which aimed to unify German art and industry through the formation of a consistent style for the applied arts. As Muthesius had written of the Third German Exhibition of Applied Arts, held in 1906 in Dresden and marking the birth of the Werkbund, "What every viewer . . . must have noticed first of all, was that everything that was exhibited, from the small art embroidery to the furnished room, spoke the same artistic language."[33]

If the Werkbund attempted to teach the objects of art and industry to speak the same language, who was expected to listen? Supporters of the *Kunstgewerbe,* or "applied arts," movement—who included Fuchs in their ranks—"presumed to be addressing all of Germany," Mark Jarzombek has written, but not everyone was paying attention; "their audience in fact was restricted to a narrow stratum of German society known as the *Bildungsbürgertum,*" or "educated upper middle class."[34] Oriented toward an industrial aesthetic, sober design was not literally intended for the wider audience to which industrial objects catered. In 1908, Lux himself elaborated on the distinction between art and industry:

> Industry provides for the masses. It arises from the masses, and is justified only through them. According to an incomprehensible falsehood [*Lebenslüge*], the masses would also like to have art. In other words, that which they have never understood and never will understand. The result is that they accept a worthless surrogate and that the industry produces this kind of art for the masses. Art industry [*Kunstindustrie*]. But in reality industry can never produce art. Art industry is a non-thing [*Unding*].[35]

Much as critics might celebrate the union of art and industry, Lux argued, the two categories were actually polar opposites that could never be reconciled.[36] Designers might struggle with representing the notion of accessibility, but they were not necessarily concerned with creating objects that would be accessible to the masses. As Lux wrote eagerly, "Already a new, huge exhibition undertaking stands at the door: Munich 1908, which will showcase especially Bavarian achievements in all areas of craft and industry open to artistic creation."[37]

THE MUNICH ARTISTS' THEATER

In her satirical novel *Gentlemen Prefer Blondes,* first published in 1925, Anita Loos describes the grand tour of Europe taken by two young American women. After visiting London, Paris, and Vienna, they travel to Munich, where, in keeping with

their efforts to witness the cultural high points of every important European city, they attend a performance at the Künstlertheater, or Munich "Artists' Theater." During the performance, they note the auditorium's dusty walls and shaky foundations and they fear the small stage will not support the actors' weight; they see no sign of the genteel atmosphere they had expected from the cultural jewel of the *Kunststadt* Munich. As the narrator puts it, the auditorium

> seems to be decorated with quite a lot of what tripe would look like if it was pasted on the wall and gilded. Only you could not really see the gilding because it was covered with quite a lot of dust. So Dorothy looked around and Dorothy said, if this is "kunst," the art center of the world is Union Hill New Jersey.[38]

Mocking the theater's insistence on its own artistic superiority and less impressed with the architecture than with the refreshments available in the lobby, they abandon the play halfway through. "You can say what you want about the Germans being full of 'kunst,'" quips one, "but what they are really full of is delicatessen."[39]

Built in 1908 by Max Littmann on the grounds of Ausstellung München 1908—and destroyed in World War II—the Artists' Theater was founded and supervised that summer by Fuchs. It soon became famous throughout Europe and in the United States for its "relief stage," a shallow performance area inspired by the ideas of Behrens and, more literally, by those of Hildebrand, whose theories exemplified aesthetic conservatism but helped initiate a discourse of flatness that proved highly productive for the theory and practice of art and architecture. Like the exhibition that surrounded it—but more literally, given its architectural function—the Artists' Theater gathered an audience into a structure that attempted to produce a particular model of spectatorship. As he had seven years earlier at the Prinzregententheater, Littmann arranged the seats into an amphitheater, eliminating aisles and boxes in an effort to dissolve social stratification within the audience. Extending this idea, he now straightened the curved rows of seats to create a perfect rectangle of spectators. This visually unified audience faced the unusually shallow stage for which the theater became famous.

In *Die Schaubühne der Zukunft*, Fuchs had published the plans for a theater drawn by Littmann in which a shallow performance area was the focal point for a large amphitheater with three levels of fan-shaped seating. At the Artists' Theater, Fuchs at last realized his plan for a shallow stage, justifying it explicitly with the model of sculptural relief that Hildebrand had advocated in *The Problem of Form*. The entire structure, in fact, was oriented around an aesthetic of flatness. The theater's facade and interiors conformed to the Jugendstil reliance on planarity, albeit

a dozen years after the movement's heyday in Munich. Fuchs presented the Artists' Theater simultaneously as a unification of all the arts under the protective umbrella of performance and as a "retheatricalization of the theater" that liberated this art form from the dominance of other art forms, especially literature. Through both its architectural form and its dramatic repertoire, the theater participated in the rejection of naturalism then current in Munich. In appropriating the discourse of relief sculpture and in presenting abstracted imagery on its stage, it also evoked the shallow stages being constructed in cities all over Germany for the display of film screens; its auditorium may likewise be viewed in relation to the mass audiences that the cinema was beginning to attract.

Two decades after it was built, the Artists' Theater was sufficiently famous to achieve a stature in Loos's novel equal to that of London's Ritz Hotel, the Eiffel Tower, and Vienna's "Dr. Froyd." Numerous remarks by dazzled critics and historians attest to its reputation, with its founder cited along with Adolphe Appia and Max Reinhardt as one of the great innovators of early-twentieth-century European theater. In 1912, for example, the British author Huntly Carter exclaimed in *The New Spirit in Drama and Art,* "I would like to see this small, beautiful, practical and complete theatre repeated in every town and city of the United Kingdom."[40] The lack of appreciation for the Artists' Theater on the part of the heroines of *Gentlemen Prefer Blondes* might appear to stem from their own cultural deficiencies, yet their judgment in fact approaches that of one important German critic in 1908: Wilhelm Worringer, whose scathing review of the theater appeared in Munich that year, the same year as his first and most famous book, *Abstraction and Empathy.*

Despite having endorsed "the most simple, everyday things" in 1907 in his book *Deutsche Form,* Fuchs remained fully committed to a Nietzschean aesthetic: a grand, communal response predicated on elitist limitations. Wagner's Festival Theater in Bayreuth was also prominent in Fuchs's mind when he invited Littmann, the architect of the Prinzregententheater, to construct the Artists' Theater.[41] A visit there would entail a pilgrimage similar to the model used in Bayreuth and Darmstadt, but at the edge of a larger city. As one American critic would note with admiration, "The Germans aren't afraid to put their theaters in pleasing surroundings and then spend a little time to get to them."[42] This extra effort, intended to imbue the experience of attending the theater with a sense of ceremony and importance, relied on a model of spectatorship that was somewhat incongruous with the exhibition's goal of fostering middle-class culture by showcasing industrial products.

Heading southwest from the center of the city of Munich, spectators would ascend the Theresienhöhe and enter the exhibition area through its main portal,

designed by the Rank brothers, Munich architects. They would then find them-
selves in a wide but relatively shallow area bordered on the left by trees and extend-
ing to the right with a view of a larger courtyard between two exhibition halls,
as seen on the exhibition's site plan on the lower right (Figure 5.3). Crossing this
shallow area, they would find themselves at the center of a larger courtyard. "If
we go only a few steps further from the entrance, in the same direction, a new
and much more festive [*viel festlichere*] group of buildings surrounds us," a critic
wrote in *Dekorative Kunst*. "To the left, MAX LITTMANN's Artists' Theater, between
the bazaar [*Verkaufshalle*] and the café, and to the right the large Hall III by the
city planner WILHELM BERTSCH. The hall and the café are drawn together by a
one-story connecting passageway."[43] The overall appearance of this architectural
group, this critic noted, again invoking Nietzschean terminology, was "more court
than square. . . . The feeling of being enclosed governs us with all elegant festivity
[*Festlichkeit*]."[44]

Only three images remain of the facade of the Artists' Theater; the most
famous is a retouched photograph taken in 1908 and used for promotional pur-
poses (Figure 5.4).[45] It appeared, for example, in Littmann's booklet on the theater,
which also contained five photographs of its interior, three ground plans, and a
section drawing. The photograph shows a modest two-story structure, symmetri-
cal and flat, between two sets of cypress trees. The facade consists of three layers:
the first, approached by six steps, is square, topped by a curved pediment on which
a plaque announces "Münchner Künstler Theater." It is divided into three bays;
within each, a double door, surmounted by a window, is framed by simple geo-
metric lines; above, three decorative panels, each curving slightly inward as if
carved from the facade, sit below a trio of more windows. The facade's second
layer, slightly recessed and several feet wider, frames the first while a third layer, the
width of the building itself, is set further back; along its center a ledge is supported
by square columns to form a simple overhang. A single band of square ornaments
across the top of the building visually stitches the three layers together: this flat
Jugendstil facade is tempered by a sedate classicism.

Upon entering the lobby, visitors faced four double doors with a small box
office between them (Figure 5.5). Above the doors, directions were provided by
inscriptions that Craig described admiringly, and with the implication that their
rationalism was somehow Germanic: "You enter the building and straight in front
of you is the Box Office. On each side are steps leading to your seats, the words
indicating the direction you are to take being made part of the decoration, not, as
in England, a sort of label on the wall."[46] Behind the lobby lay the inner foyer,
with six cloakroom openings on its interior wall, while staircases at either side of
the lobby ascended to another foyer directly above, their first steps flanked by

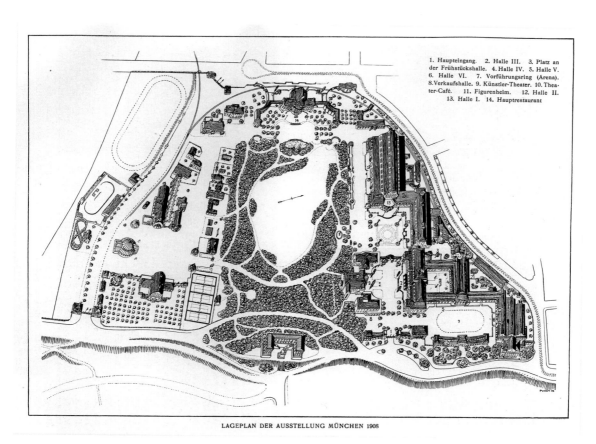

1. Haupteingang. 2. Halle III. 3. Platz an der Frühstückshalle. 4. Halle IV. 5. Halle V. 6. Halle VI. 7. Vorführungsring (Arena). 8. Verkaufshalle. 9. Künstler-Theater. 10. Theater-Café. 11. Figurenheim. 12. Halle II. 13. Halle I. 14. Hauptrestaurant

LAGEPLAN DER AUSSTELLUNG MÜNCHEN 1908

Figure 5.3. Ausstellung München 1908, site plan. From *Die Kunst* 18 (1907–8): 429.

Figure 5.4. Max Littmann, Munich Artists' Theater, main facade, 1908. From Max Littmann, *Das Münchner Künstlertheater* (Munich: L. Werner, 1908), 6.

Figure 5.5. Max Littmann, Munich Artists' Theater, lobby photograph, 1908. From *Das Münchner Künstlertheater*, 30.

columns. With a marble floor below and a plain barrel vault above, the lobby itself conveyed an air of balanced geometry: material opulence tempered by neoclassical simplicity.

A photograph of the east hallway on the ground floor shows four doors into the auditorium at the right, two of them accessible by stairs (Figure 5.6); each door offers access to two or three rows of seats within the auditorium, as the building's ground plan reveals (Figure 5.7). Such a configuration of entryways echoed Littmann's own Prinzregententheater, which itself had relied on the model used in Bayreuth—and which, in turn, had made use of Semper's plan for a Munich theater for Wagner. Before reaching these doors, in other words, visitors to the Artists' Theater encountered a small, original theater, modest in size and decor. Yet from this point onward, architectural references to these earlier theaters abounded.

Only two photographs of the auditorium remain, one taken from the side of the stage looking out at the seats and the other showing the reverse image, a view of the stage curtain from the rear corner (Figure 5.8 and Figure 5.9). Included in Littmann's 1908 booklet on the theater, they were reprinted frequently in the ensuing years. Together, they reveal a small wood-paneled auditorium with a solid mass

Figure 5.6. Max Littman, Munich Artists' Theater, side hall photograph. From *Das Münchner Künstlertheater*, 32.

ERDGESCHOSS

Figure 5.7. Max Littmann, Munich Artists' Theater, ground plan. From *Das Münchner Künstlertheater,* 21.

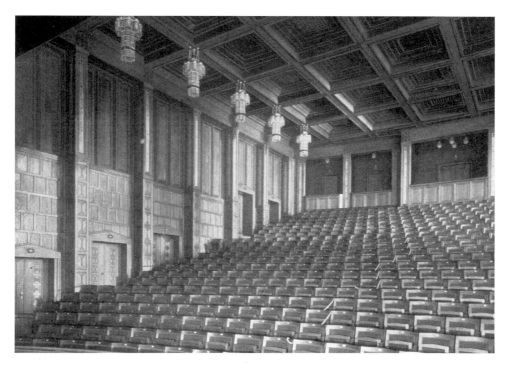

Figure 5.8. Max Littmann, Munich Artists' Theater, auditorium photograph taken from the stage, 1908. From *Das Münchner Künstlertheater,* 28.

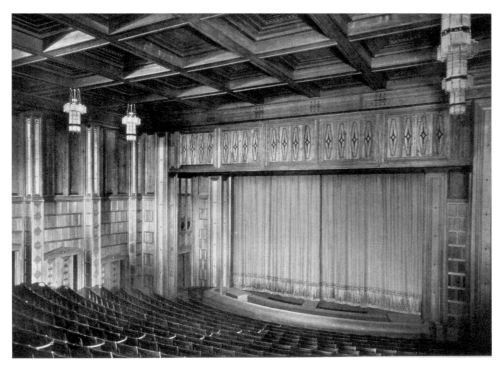

Figure 5.9. Max Littmann, Munich Artists' Theater, auditorium photograph, 1908. From *Das Münchner Künstlertheater,* 26.

of seats: twenty-two identical rows curving slightly toward the stage. Plain door-ways at either side replace the customary private boxes, while the windows of relatively plain boxes are visible along the auditorium's rear wall: a larger box at the center with two smaller ones at one side. The floor plan confirms what may already be presumed, given the formal regularity visible in the photographs: the two smaller boxes are echoed on the other side of the auditorium. The ceiling also adheres to this formal regularity; a line of seven recessed concentric squares across the width of the ceiling is repeated to form a large grid pattern above the grid of seats, while rows of electric lights descend from the ceiling on either side of the auditorium.

Each row within the auditorium contained thirty seats, except for the last, where the central box jutted into the auditorium. As at the Prinzregententheater, Littmann arranged the seats in the form of an amphitheater, rejecting the horse-shoe shape that he had used at the Schauspielhaus and that an article in *American Architect: The Architectural Review* in 1922 would label "impractical and out of fashion."[47] The article endorsed instead the amphitheatrical model, which it described as follows: "Its earmarks are that it has no aisles—one enters from the end of the row,—the entire auditorium is a solid bank of seats, there are no bal-conies, and the auditorium is the safest, most practical and most comfortable ever devised."[48] These words not only provide an accurate description of the Artists' Theater auditorium but also indicate how it was seen to express the *sachlich* ideals of practicality and functionalism. Indeed, the critic in *Dekorative Kunst* declared, "The architectural significance of Max LITTMANN's *Munich Artists' Theater* lies more on the interior than on the exterior. . . . The *interior* will further broaden LITTMANN's fame as a theater builder."[49]

Littmann himself explained the advantages of an amphitheatrical arrangement over the traditional, horseshoe-shaped auditorium, where loges and private boxes allowed spectators to see and be seen by one another but not to gain a good view of the stage itself. In such theaters, he wrote,

> the relationship of one visitor to the others is the main thing, and the spectator's relationship to the stage, from which the elevating effect derives, is so disturbed by the aforementioned defects that it is impos-sible for any serious, solemn mood, capable of producing the finest feelings of the human soul, to be achieved by the music and by the sung and spoken word.[50]

No such troubles would plague the new theater, where all seats offered more or less the same stage view; no private boxes were oriented toward the auditorium from

the sides, all seats faced the stage, and the rows of seats were raked at a steep angle to improve sight lines. Some differentiation remained, however, as the result of a system of assigned seating that enforced a hierarchy of admission prices. This system had been introduced to European concert halls and theaters only eighty years earlier, replacing the prevailing use of tickets for general admission.[51] By the early twentieth century, it was standard practice in Europe to charge more for better seats. Ticket prices at the Artists' Theater in 1914 varied widely according to seats' distance from the stage, as seen on a seating plan reproduced on a flyer advertising the summer season that year (Figure 5.10). Seats in the first two rows were the most expensive, at seven and half marks apiece; those in the last four rows cost only two and a half marks. No indication is given of the prices for seats in the boxes.

In his promotional booklet for the Artists' Theater, Littmann cited an impressive list of precursors from the history of German theater architecture to support his auditorium design. Both Schinkel and Semper, he reminded his readers, had endorsed the amphitheatrical form. Schinkel had used it in his initial sketches for the National Theater in Berlin in 1817, Littmann proudly asserted, adding, *"There lies the origin of the German amphitheater."*[52] If Schinkel provided a point of origin, Semper's design for a Munich festival theater for Wagner constituted the historical apotheosis of the amphitheatrical design in modern Germany. Other examples of the form provided by Littmann—besides the Festival Theater in Bayreuth—included the festival theater built in the city of Worms in 1887 as well as, more recently, his own Prinzregententheater and his Schauspielhaus, both constructed in Munich in 1901.

The Artists' Theater auditorium might be seen as a cross between those of Littmann's two earlier Munich theaters. Once again, the architect relied on the steeply raked amphitheatrical model he had used at the Prinzregententheater, but rather than creating a fan shape, he now made each row of seats the same width. The auditorium's footprint thus echoed the rectangular frame of the stage. He also used the modest proportions of the Schauspielhaus for a more intimate auditorium, while abandoning its flat floor and horseshoe shape. But to consider the auditorium of the Artists' Theater as a hybrid of the earlier two runs the danger of ignoring its creators' intentions. In fact, the theater's size was mostly determined by the authorities of the Munich exhibition. Fuchs had hoped for an amphitheater that would hold a much larger audience, but the auditorium was reduced, in the final design, from 1,500 seats to 642.[53]

ABSTRACTION ON A SHALLOW STAGE

The stage at the Artists' Theater, likewise compromised in construction, achieved notoriety at the time, and some fame in the annals of theater history, on account

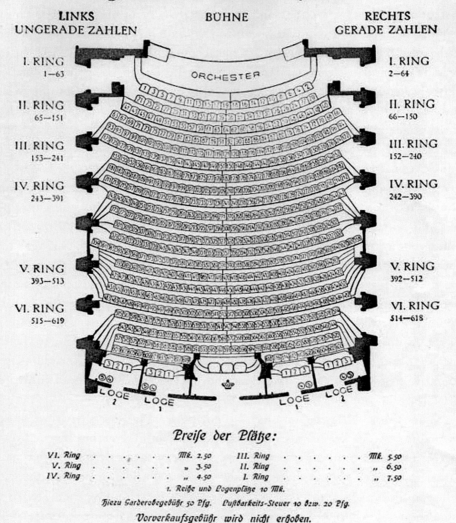

Figure 5.10. Munich Artists' Theater seating plan, flyer, 1914. Photograph courtesy of the New York Public Library for the Performing Arts. Billy Rose Theatre Division, The New York Public Library for the Performing Arts, Astor, Lenox, and Tilden Foundations.

of its shallowness. The theater historian Mordecai Gorelik wrote of the opening performance, "First surprise was the fact that the stage itself was scarcely twenty-six feet deep, the merest shelf compared with the capacious depths of older theaters."[54] But Fuchs had wished for a stage with the proportions of ten measures wide by six deep in order to present to spectators an image that was practically flat. The stage Littmann built was, in the end, not much wider than it was deep, and Fuchs was forced to rely on the judicious use of lighting and backdrops to achieve the desired stage image. But if, in 1908, his intentions were only partially realized, the Artists' Theater as it was constructed nevertheless embodied a particular understanding of theater—and, especially, of the spectator's position in relation both to the action on stage and to the rest of the audience. Here, the flat wall of spectators faced a shallow stage stripped of traditional accessories; an aesthetic of flatness ruled on either side of the curtain.

This flatness was reinforced by the absence of an intermediary zone between the seats and the stage. In the photograph taken from the rear of the Artists' Theater auditorium, no orchestra pit is visible, and a section drawing reveals that Littmann here, again, looked to Bayreuth and the Prinzregententheater (Figure 5.11).

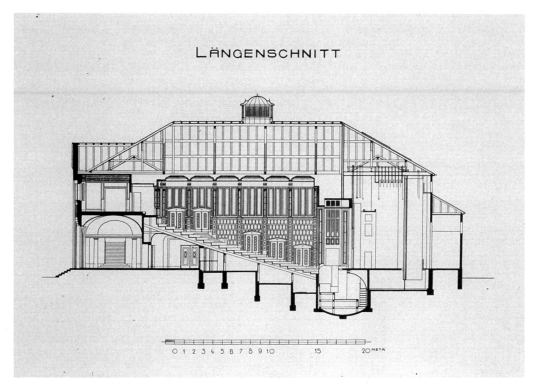

Figure 5.11. Max Littmann, Munich Artists' Theater, section. From *Das Münchner Künstlertheater*, 24.

Following these models, as well as his own section and plans, which Fuchs had included in *Die Schaubühne der Zukunft,* he tucked the orchestra pit under the stage, thus causing the music to appear to emanate from the stage itself and bringing the stage image closer to the audience. But where such proximity had in Bayreuth been counteracted by the use of a deep stage to distance the audience from the realm of art—creating a hovering stage image just beyond Wagner's "mystical abyss"—the shallow stage at the Artists' Theater brought the performance closer to the audience. Like the building's facade, productions made literal on stage the theme of flatness epitomized by Jugendstil design. Fuchs himself drew a parallel between his own attempts at theater reform and the secessionists when he exclaimed hopefully, "Now we will have a *'secession in the dramatic arts'* as well."[55]

Fuchs's concern with the notion of flatness was in keeping with Jugendstil tendencies; his rejection of theatrical naturalism also paralleled the secessionists' rejection of naturalism in the visual arts. As we have seen, the naturalist theater had enjoyed great success in Munich in the 1880s and 1890s, partly as a result of the presence of Wagner and Ibsen in that city in 1864–65 and 1875–91, respectively.[56] At the center of the Munich naturalist movement lay the journal *Die Gesellschaft* (The society), founded in 1884 by Michael Georg Conrad. When, six years later, Conrad founded the Gesellschaft für modernes Leben, or "Society for Modern Life," a central aim was to establish an independent theater for presenting naturalist drama. State censorship meant that naturalist dramas by such authors as Gerhard Hauptmann, Ibsen, and Conrad himself were presented either in censored form or in the private performances of such closed theatrical societies as the Verein "Freie Bühne," or "Free Stage Association," founded in 1891 by Conrad and others. After 1901, such dramas also appeared at the Schauspielhaus, built explicitly to showcase them. There, a deep stage accommodated illusionistic sets, perspectival scenery receded into depth as if to convince spectators of the reality of the interiors seen on stage, and the curtain represented the removable fourth wall of the room behind it. But productions were increasingly undermined by their own illusionistic efforts, particularly as late-nineteenth-century technical innovations permitted increasingly complicated stage arrangements. While the introduction of electric stage lighting at the end of the nineteenth century allowed for a more realistic stage image than had gas footlights, for example, increased brightness often called attention to the falsity of stage illusionism.

The Artists' Theater, by contrast, used electricity not to attain a more naturalistic image but, rather, to present abstracted tableaux dynamized by the lighting effects that electricity had recently made possible. Gorelik described the initial moments of the first performance there:

> As the house lights dimmed, a glow of electric light sprang up from the recessed footlights, from behind the portals, and below the upper frame of the proscenium opening. Shafts of light, their sources discreetly hidden, outlined the portal opening. Noiselessly, the curtain rose on the first *Symbolist* production of Goethe's *Faust*.[57]

The production of *Faust* used light as an abstract element in the stage composition, not merely as an advanced form of stage technology.[58] Gorelik noted the avoidance of naturalist illusionism in one other element of the stage design as well: "Surprising beyond belief, the scenery," he wrote. "Not so much scenery as a kaleidoscope made up of simple prisms."[59]

In addition to Goethe's *Faust* (part one), Shakespeare's *Twelfth Night,* and Aristophanes' *The Birds,* five other plays were included in that year's repertoire, with performances held on four evenings each week: *Herr Peter Squenz,* a comedy by Andreas Gryphius; *Das Wundertheater* (The miracle theater), a translation of the comedy *Retablo de las maravillas* by Cervantes; *Die deutschen Kleinstädter* (The German small-towners), a comedy by August von Kotzebue; *Die Maienkönigin* (The May Queen), a *Schäferspiel,* or "shepherd's play," with music by Christoph Willibald Gluck; and *Das Tanzlegendchen* (The dance legend), a *Tanzspiel,* or "play with dancing," based on a story by Gottfried Keller, with music by Hermann Bischoff. "These eight works," Fuchs wrote, "have been arranged in a cycle of six evenings of theater and will be performed during the period of Ausstellung München 1908 in the special theater building built according to the designs of Prof. Max Littmann."[60]

The Artists' Theater thus favored the classics; its repertory predominantly comprised established works of German drama, with Aristophanes, Cervantes, and Shakespeare providing only a slight flavor of internationalism. The rejection of naturalist performance, in other words, implied a rejection of the naturalist dramas prevailing in Munich, which Fuchs decried for their emphasis on literariness at the expense of theatricality. "These days," he had complained in 1901, the emphasis on the literary component of contemporary drama meant that "we absolutely understand *more* of a good theater play . . . if we read it than if we see it."[61] Performances at the Artists' Theater would avoid the works of Hauptmann and Ibsen and the visual and narrative verisimilitude that accompanied them, relying instead on the classical canon with productions exploring the use of mime and dance. The productions, rather than the repertoire, aligned the theater with theatrical reinvention; "both classicism and naturalism were unsuitable" for the "peculiarly modern style of drama which Goethe gave us in *Faust*," Fuchs explained, and a new theatrical style had to be created.[62] "The task of a truthful artistic staging of

an old master play," he insisted, was "to awaken in *the contemporary* spectator images, moods, and sensations as *identical* as possible to those that the old poet in *his* public in *his own* time wanted to arouse and also probably did arouse."[63]

For Fuchs, the perspectival scenery and "lifelike" acting characteristic of the naturalist theater spoon-fed spectators' imaginations, indulging a bourgeois appetite for entertainment. "The conventional theater counts on the inability of the audience to retain visual impressions," he explained.[64] Productions at the Artists' Theater, in contrast, would challenge spectators' perceptual habits. Stylized images and visual hints would prod their imaginations, inducing an active and creative reception of the performance. Because, Fuchs argued, drama "occurs in the mind and spirit of the spectator in response to the happenings upon the stage," theaters should "be so constructed that these optical and acoustical impressions may be communicated to the spectator as directly and as forcefully as possible."[65] Stage depth and such customary accessories as props and sets were extraneous. An actor's raised eyebrow and whispered word were more noticeable on the simplified stage that encouraged, visually and acoustically, a more direct aesthetic experience.

Fuchs argued that a theater performance occurred within the spectator's body and was merely facilitated by such elements as actors, costumes, props, sets, and lighting: "It is in the audience that the dramatic work of art is actually born; a work of art has value only insofar as it calls forth . . . a reaction and only so long as that reaction is in effect."[66] The more intense the dramatic experience, the more successful the performance. The goal was reenchantment; Fuchs's motto was "retheatricalize the theater." If art was located in the spectator's subjective experience, a performance could never be reduced to a single, definable essence. But while sanctioning an infinite variety of experiences of a work of art, Fuchs allowed only a narrow conception of its purpose: to stimulate the emotions and carry the perceptually altered spectator "into a cosmos in which the world . . . is suddenly revealed . . . as a complete and perfect pattern."[67] Successful drama provided an intensity of emotion and a vantage point from which to survey the earthly reality that provided its inspiration and material.

Two photographs remain of performances in the Artists' Theater's first season.[68] A scene from Shakespeare's *Twelfth Night,* "newly reworked by Georg Fuchs for the German stage," represents Viola's room with only three objects: a birdcage, a footstool, and a small sofa (Figure 5.12).[69] The four actors seem almost as puppet-like as the fake caged bird; their stilted poses articulate an aura of artificiality that seems unnatural even in a photograph. On either side of the stage stand two towers, flattened to abstraction. Each contains doors below and blind balconies above, providing points of entry to the scene and marking the edge of a raised platform upstage that is accessible by two wide steps. On the rear wall, a painted backdrop

Figure 5.12. Munich Artists' Theater, performance of William Shakespeare's *Twelfth Night,* 1908. From Georg Fuchs, "Das Münchener Künstler-Theater," *Dekorative Kunst* 14 (December 1910): 140.

depicts a herd of deer in a forest; its tripartite structure, the geometric frame around it, and the six delineated panels below it suggest that it represents a window, but the painting itself makes no pretension to realism. The second photograph shows a scene from Aristophanes' *The Birds* (Figure 5.13).[70] Here, the use of puppetlike figures is more blatant—and more appropriate, given the play's theme. The seven actors on stage in the photograph are essentially large stuffed birds with human legs. Dispersed across the stage, they stand, sit, and crouch upon and in front of one large rock and several smaller rocks beside it. Their overstuffed bodies, boldly patterned and presumably brightly colored, are topped by large bird heads, each of a different design; their beaks shadow the human actors' faces. The creatures' spindly legs are the only visible parts of the actors' bodies. The same abstracted towers flank the stage, connecting the same raised platform, and the backdrop behind the scene is blank; there is no pretence of naturalist illusionism.

According to Fuchs, the naturalist theater, by offering illusionistic stage images and realistic narratives, overemphasized drama's literary component at the expense of the purely dramatic, so that art forms were not able "to fulfill their independent functions but only to advertise literature as effectively as possible."[71] Such a "dictatorship of literature" forced true drama to languish at the service of this other form of art.[72] Ideally, all forms of art would work together, thereby fulfilling their

independent functions in the manner that Wagner had described. If the invasion of one art form into the realm of another was a familiar trope of cultural criticism, theoretical distinctions between art and literature were particularly acute at the Artists' Theater, which with its very name associated itself with the former. Where art symbolized the essential creative force of German culture in this theoretical dichotomy, literature represented a less imaginative and more technical kind of inventiveness.[73] At the Artists' Theater, Fuchs proudly asserted, "the dramatist is no longer required to use the theater as a mere makeshift device for the promulgation of literature. He is free to be theatrical—if he can be."[74]

Fuchs had already discussed the relationship between painting and theater in *Die Schaubühne der Zukunft,* acknowledging the common complaint that the prevailing Munich style was more suitable for the decorative arts. The problem would be solved, he argued, if painters in that city were to apply their creative efforts to the theater:

> It has long been proven that above all the *Munich* painting is governed by decorative traits; indeed its leading masters are often accused of being too "theatrical." Perhaps—no, surely—this reproach will turn into high

Figure 5.13. Munich Artists' Theater, performance of Aristophanes' *The Birds,* 1908. From "Das Münchener Künstler-Theater," 143.

praise if our Munich [artists] with their wonderfully decorative tem-
perament finally find a field of effectiveness on the new stage. . . . Many
of them will be "in their element" only there.[75]

To encourage Munich painters to work in the theater would put their talent to bet-
ter use and counteract the prevailing literary emphasis that Fuchs bemoaned. The
integration of all forms of art would allow each to achieve its highest potential.

Fuchs was certainly inspired by Wagner's ideas of the Gesamtkunstwerk, par-
ticularly as Nietzsche had represented them, and his discussion of the "strange
intoxication which overcomes us when, as part of a crowd, we feel ourselves emo-
tionally stirred" evokes the Dionysian spirit.[76] For Fuchs as well, the will to artistic
fusion required formal purification: a refusal to permit one art form to contami-
nate another. He distinguished his aesthetic and cultural aims from those of his
precursors, however. Whereas Wagner had sought to combine the arts under the
umbrella of his own music dramas, Fuchs intended to "retheatricalize the theater"
by minimizing other art forms. And, he argued, whereas Wagner had wanted to cre-
ate an audience through its experience of the performance, the German *Volk* now
only needed to be united by a cultural experience and alerted to their social and
political function. In a propagandistic book on the Artists' Theater published in
1936 and relying heavily on Fuchs's own claims, one author made the following dis-
tinction: "As opposed to Richard Wagner, who had first to create his public, Fuchs
reckoned with a public that consisted of 'tens of thousands,' that 'already wait for
something,' namely 'the drama and the festival house that we are planning.'"[77]

A program booklet, *Münchener Künstler-Theater, Ausstellung München 1908,*
was published in the summer of 1908 by the Artists' Theater Association to coin-
cide with the opening of the theater. Unlike Littmann's booklet, which described
and illustrated the architecture of the building and its theoretical precursors, this
one contained no illustrations and provided a list of productions presented that
summer, a bibliography, a few pages promoting several books by Fuchs, and three
short essays by members of the Munich Artists' Theater Association.[78] Fuchs pub-
lished other material promoting the theater, most significantly *Die Revolution des
Theaters: Ergebnisse aus der Münchener Künstler-Theater* (published in an abridged
version as *Revolution in the Theater: Conclusions Concerning the Munich Artists'
Theater*), which appeared in 1909. With liberal citations of Goethe, Nietzsche, and
other German cultural giants, the book proclaimed the theater's significance. With
such chapters as "The Theater and Culture," "The Function and Style of the
Stage," and "The New Art of the Stage and the Commercial Theater," it seemed
to be an important programmatic statement of Fuchs's ideas, but much of its text
consists of sentences rearranged from earlier publications. His central source for

self-plagiarism was *Die Schaubühne der Zukunft,* the essay collection that itself had included his own earlier writings without acknowledging the repetition. The book ends with excerpts from the more favorable reviews of the Artists' Theater's first season.

Hildebrand and Relief Sculpture

If the Artists' Theater aimed to present abstracted stage imagery and a performance style more typical of the emerging theatrical avant-garde, Fuchs himself was inspired by established ideas regarding vision and spectatorship. Historians might link his theater's shallow stage to the ideas on stage construction that he had shared with Behrens in Darmstadt, but Fuchs himself cited a different source of inspiration: *The Problem of Form in the Fine Arts,* published in 1893 by Hildebrand, a central figure in Munich's cultural world whose house was a meeting place for the city's artistic and literary establishment. As we have seen, an interest in relief sculpture, and in sculptural shallowness and visual flatness more generally, pervaded the theory and practice of the visual arts in Germany at the turn of the twentieth century.[79] Taking Hildebrand's arguments literally, and expanding them to the level of stage architecture, Fuchs commissioned Littmann to build a shallow stage for his new theater and called it the *Reliefbühne,* or "relief stage."[80] In using Hildebrand's ideas, Fuchs appropriated the theory of Einfühlung and its general presumptions about the activity of spectatorship; facing the relief stage, spectators would engage in an aesthetic activity that approximated Einfühlung. Beyond providing inspiration and theoretical justification, Hildebrand also helped promote the theater; his essay "Münchener Künstler-Theater" appeared both in *Münchener Neueste Nachrichten* and in the theater's program booklet. At the threshold between Einfühlung and abstraction, the Artists' Theater was thus an architectural emblem of a shift in German aesthetics that occurred as the nineteenth-century spectator began to metamorphose into the mass audience of the 1920s.

When Hildebrand published *The Problem of Form,* he had been working as a sculptor for two decades, living much of that time near Florence. He had established his artistic reputation in 1873 in part by designing a cycle of frescoes for the German Zoological Station in Naples with Hans von Marées, and had contributed work to a dozen exhibitions across Europe.[81] Much of his output comprised small figural sculptures; he also worked on many larger projects, specializing in the design of fountains, graveyard sculpture and mausoleums, and larger architectural creations.[82] His attempts at sculptural relief began in 1870 with a terra-cotta panel to commemorate his sister's engagement; his efforts in this medium continued until 1916, five years before his death. Typical of his output is the *Dionysus* of 1890, originally intended for his home in Munich (Figure 5.14). The sculpture depicts a

Figure 5.14. Adolf Hildebrand, *Dionysus,* relief sculpture, stone, 1890. From Sigrid Esche-Braunfels, *Adolf von Hildebrand* (Berlin: Deutsche Verlag für Kunstwissenschaft, 1993), 172, fig. 207. Photograph copyright Architekturmuseum der TU München.

drunken Dionysus, seated and asleep, with an empty cup in his hand; he is supported by a satyr while a servant holding a jug stands by, ready to pour more wine should he stir. Hildebrand frequently depicted classical Greek themes in his sculptures; hanging in his Florence studio was a row of plaster casts of the Parthenon metopes, which he had visited in London in 1877.[83]

Hildebrand mentioned theater only once in *The Problem of Form,* in a metaphor intended to elucidate the process of artistic vision. Just as peripheral vision blurred the edges of a perceived image, he argued, so, too, did near vision blur the appearance of an object. In his words, "what lies directly on the near side of the

distant plane—that is, in front of the stage—is perceived as being in transition."[84] If an actor stepped forward through the proscenium arch to approach the audience, that is, the moment was transitional, and not truly a part of the work of art produced at the theater. Both on stage and in a painting, Hildebrand wrote, "the actual space is beyond this distant plane or only begins with it." The frame of the stage was like that of a painting, marking the difference between the real space the spectator inhabited and the imaginary space depicted within the work of art. But the "real space" within his metaphor remains far behind the proscenium; the stage that Hildebrand imagined was clearly not a shallow one.

Following the publication of *The Problem of Form,* Hildebrand attended more literally to theater architecture; well aware of Semper's designs for a festival theater for Wagner in Munich, which had been published in 1893, he helped design a theater for that city in the mid-1890s.[85] While his early plans for a Munich theater no longer exist, traces of later efforts remain, including plaster models for a Munich theater from 1907–8 (Figure 5.15). In the spring of 1908, he collaborated on another design with two architects, Carl Sattler and August Zeh, under the name "Trio," entering a competition to build a replacement for the Stuttgart Hoftheater, which

Figure 5.15. Adolf Hildebrand, plaster model for a theater facade for Theresienstrasse, Munich, 1907–8. From *Adolf von Hildebrand,* 505, fig. 845. Copyright Bayerische Staatsgemäldesammlungen, Munich.

had burned down in 1902. Their design, drawn by Hildebrand himself, consisted of two attached theaters, a larger one in the front and a smaller one behind it; together these formed a monumental and imposing structure (Figure 5.16). The auditorium of the larger theater, which could hold 1,070 spectators, relied on a conventional arrangement of seats (Figure 5.17). In two crucial respects this theater followed the design of the Festival Theater in Bayreuth and the Prinzregententheater: its orchestra was sunk below the level of the auditorium, and its stage— far from looking to Hildebrand's own theories of sculptural relief—was as deep as any traditional theater stage. By contrast, the smaller theater in the back was essentially amphitheatrical; all the seats at the orchestra level faced the stage, with a row of private boxes at the back underneath two balconies (Figure 5.18).

All told, there were twenty-three entries in the competition for the new Stuttgart Hoftheater, and the winning design, built between 1908 and 1912, was by Max Littmann (Figure 5.19) Working within the firm Heilmann and Littmann, Littmann had been responsible for an initial design for the site in 1902, the year the previous theater had been destroyed, and his project had prompted the competition.[86] Six years later, his winning proposal resembled that of the Trio group, with a larger theater in front and a smaller one in back occupying a similar footprint. Here, however, the front entrance of both theaters faced the same direction, placing the smaller theater at the end of a wing of the larger one and rendering the design more like that of his own Prinzregententheater. A contemporary photograph of the main facade of the larger theater reveals the similarity between the two, both of which evoke the front of Wagner's Festival Theater in Bayreuth (Figure 5.20). The curved facade is again topped by a pitched roof, but here the building is given yet more of a sense of monumentality by the use of stone and by such

Figure 5.16. Trio (Adolf Hildebrand, Carl Sattler, and August Zeh; drawing by Hildebrand), design for Stuttgart Hoftheater, 1908. From *Adolf von Hildebrand*, 501, fig. 837.

Figure 5.17. Trio (Adolf Hildebrand, Carl Sattler, and August Zeh; drawing by Hildebrand), ground plan for larger Stuttgart Hoftheater, 1908. From *Adolf von Hildebrand*, 502, fig. 840. Photograph copyright Gabor Ferencz, Kunsthistorisches Institut der Universität München.

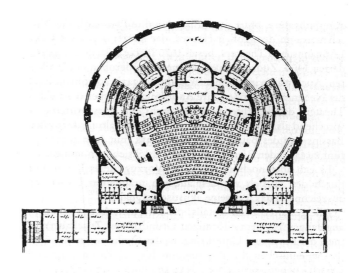

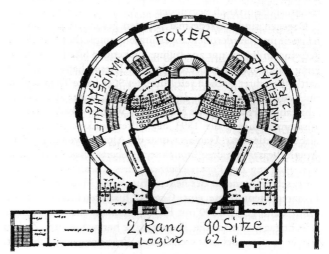

Figure 5.18. Trio (Adolf
Hildebrand, Carl Sattler, and
August Zeh; drawing by
Hildebrand), ground plan for
smaller Stuttgart Hoftheater,
1908. From *Adolf von
Hildebrand,* 503, fig. 842.
Photograph copyright Gabor
Ferencz, Kunsthistorisches
Institut der Universität
München.

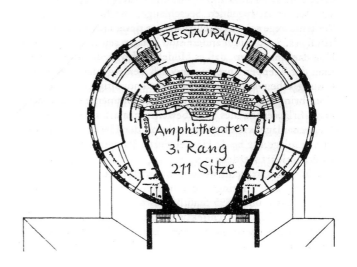

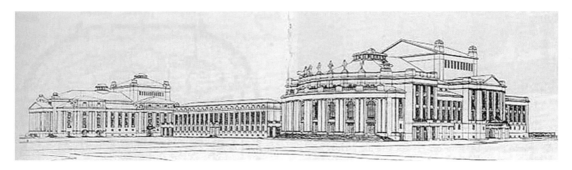

Figure 5.19. Max Littmann, design for Stuttgart Hoftheater, 1908. From *Adolf von Hildebrand,* 501, fig. 836. Photograph copyright Gabor Ferencz, Kunsthistorisches Institut der Universität München.

additions as six pairs of massive ionic columns, a balustrade, and a set of ten statues standing guard above.

While *The Problem of Form* aimed to justify relief sculpture, Hildebrand's analysis of the viewer's experience of the work of art was easily adapted for the stage—indeed, his attention to artistic vision and to the kinds of objects that might facilitate such vision almost seemed to encourage such extrapolation. The neglect of the playwright and the theater director in *The Problem of Form* did not deter Fuchs from appropriating the book to justify his own ideas; reference to Hildebrand allowed him to tie theatrical practice to aesthetic theory in a grand knot, ennobling the former, demonstrating the practical application of the latter, and allowing each to justify the other. In *Revolution in the Theater,* Fuchs claimed both that the architectural innovations he promoted were supported by the formulations of contemporary aesthetic theory and that the link between visual and dramatic theory was entirely natural. "The laws of the spatial effectiveness of art which Hildebrand set forth in his treatise *The Problem of Form,*" he announced, "here were developed and realized organically from the essence of drama."[87]

Where it helped Fuchs to prove his argument, he was not averse to transcribing extensive quotations from Hildebrand's book. But he emphasized the theoretical distinction between theater and the visual arts: "If to explain our intentions we often refer to works of visual art, it is always with the reservation that the fundamental dramatic principle of movement really excludes an inner correspondence."[88] He also emphasized that theatrical developments were based fundamentally on the efforts of talented practical men, not on theoretical claims: "The average director certainly does not torment himself . . . because he may have read Hildebrand's *Problem of Form*—he knows nothing of Hildebrand—but because his practical experience tells him that the situation otherwise will be neither understood nor

Figure 5.20. Max Littmann, Hoftheater, Stuttgart, photograph, 1908–12. From Georg Jacob Wolf, *Max Littmann, 1862–1931* (Munich: Knorr and Hirth, 1931), n.p.

effective."[89] Hildebrand provided a theoretical backdrop in front of which Fuchs could perform his explanations, and other writers likewise linked the Artists' Theater's artistic principles to those found in *The Problem of Form.* Clearly rehearsed by Fuchs, for example, the reviewer in *Le Figaro* of two of the theater's performances cited Hildebrand as theoretically analogous and quoted him to prove it.[90]

As we have seen, Fuchs was not alone in developing the idea of a relief stage; Behrens, his colleague in Darmstadt, had also done so, in 1900, without referring to Hildebrand. "The greater extension into breadth causes the relief-like arrangement and the relief-like movement of the figures and of the scenes," he wrote; "relief is the most striking expression of the line, of the moving line, of the movement that is everything, in the drama."[91] Behrens equated relief, line, and movement with drama itself, creating a tautological package that Fuchs would find equally useful. But where Behrens emphasized the visual process that caused an impression of relief, Fuchs approached the model more literally, advocating the shallow stage that simply mimicked a work of relief sculpture at a larger scale.[92] In an essay of 1910, Behrens again endorsed the relief stage:

> If they are to make a strong impression, all movements on stage must be essentially lateral, for movement which occurs in the direction of the audience is, optically speaking, without effect. All theater depends by its very nature on this relief effect. This principle has proved its validity since the days of the Greek theater, though the tendency to employ movement in depth has at times prevailed.[93]

Relying on the double authority of Greek drama and visual logic, Behrens presented the shallow stage as both historically established and fully appropriate for the contemporary German stage. "Only relief offers the possibility for rhythm, the primal element of all art, to achieve its full and palpable effect," he declared.[94] At the historical moment when the theatrical avant-garde in Europe was experimenting with the abstracted forms created by shadow puppets, tableaux vivants, and other formulations of shallow and static imagery reminiscent of the visual arts, both Fuchs and Behrens applied the visual principles of relief sculpture to the theater stage.

In his essay on the Artists' Theater in 1908, Hildebrand emphasized the importance of emotional inspiration in the spectator's experience. Rather than encouraging passive enjoyment among the spectators, he explained, theater was to present "the purely dramatic point of view, from which the poet puts the audience into a state of compassion [*Mitleidenschaft*]."[95] Discussions of sympathy and compassion, as we have seen, were closely allied with the discourse of Einfühlung, which

likewise conceived of spectatorship as the viewer's active engagement with the art object. This spectatorial engagement was emotional and physical, as opposed to purely optical; both the work of art and the spectator were in a sense constituted by this process. This conception of vision as embedded in the body, as a temporal and spatial experience of the viewer's surroundings, derived from the theoretical elaborations of Einfühlung, through which, Hildebrand explained, "we are able to relate everything to ourselves and to infuse it with our own bodily feeling."[96]

Fuchs provided no explicit evidence in *Revolution in the Theater* of his interest in Einfühlung, but his arguments suggest an affinity with its tenets. "A 'work of art' only exists if and insofar as it produces such movement, so long as it is 'experienced,'" he explained; it "is newly created every moment in which it is 'experienced.'"[97] The theatrical activity took place within the body of the spectator, an experience he described in terms that evoked the words of Nietzsche as much as those of Vischer: "There is a strange intoxication that overcomes us when we feel ourselves within a crowd, within a crowd uniformly moved."[98] A successful performance, Fuchs argued, brought the spectator to such a level of intoxication within a gathered audience and, in so doing, constructed a unified group from a collection of individuals. But "on the stage itself," he argued, "this unity, this artistic effectiveness, does not exist—nothing at all of what the spectator goes through exists."[99] Successful drama was to provoke such emotional intensity within the audience; the more intense the dramatic experience, the more successful the performance. Fuchs described this potential experience explicitly in terms of the physical properties of the stage, justifying the reform of the physical structure of the performance area by arguing that the shallow stage intensified the spectator's aesthetic experience.

Hildebrand's description of the effect of the work of art on the spectator was easily reversed to describe how altering the form of a work of art would change the spectator's emotional experience. "If we take into account," Hildebrand explained, "that every effect depends on the arrangement and opposition of individual factors and receives its value and scope only through them, then we can begin to realize how much imaginative resonance is conveyed by every change in the apparent structure of the view."[100] If viewing a work of art could affect spectators physically, then by implication the manipulation of form could encourage an empathetic response. Theater provided an ideal forum for exploring such questions; the notion of a physical response to architecture was made literal on the Artists' Theater stage, confined within the temporal limits of a performance. While theorists of Einfühlung had not set out to discuss theater reform, Fuchs readily adopted their perceptual models in his attempt to bolster a rejection of naturalism and justify the innovations at his theater.[101]

CRITICAL RESPONSES

"In the mingled light of the dying sun and the flare of great torches extending in an alleyway from the entrance to the park, the facade of this charming building stood forth from the trees," wrote Oliver M. Sayler, an American journalist, of his visit to the Artists' Theater in 1914. "There was something truly festive," he continued,

> something almost Greek, in the sense of freedom and space and the expansiveness that makes life worth living in the city that hung about the structure. Once inside the portals, the same sense of space prevailed. No crowded lobby, no corner coatrooms. Inside the auditorium, an auditorium which has never been surpassed for simple, effective beauty and harmony . . . , you looked down from a comfortable chair placed at an angle where no one in front of you broke the view of the stage. The side walls and ceiling were soft and quiet in paneled wood—an interior finish which has been found most effective acoustically by long experiment. A single row of boxes at the rear was the only concession to the theater of other days.[102]

Several clues suggest that Sayler was assisted by Fuchs or Littmann in forming his impressions: the reference to the festive, "almost Greek" nature of the building's exterior, the emphasis on the clear view of the stage from all seats, and (above all) the tone of the description, lying comfortably between elegy and propaganda. Sayler had in fact been guided through the theater by Fuchs himself; owing to the lack of a shared language between them, the English mother of one of the actors interpreted. And Sayler was hardly the theater's only positive reviewer. "In a very pleasant building by Littmann," Hermann Muthesius wrote in 1908, "a storm is under way against the overproduction of our contemporary stage performances, and the very happy attempt is made to return to simplicity, with a strong emphasis on the effects of silhouettes and relief."[103]

The most extensive endorsement of the theater was Hildebrand's essay "Münchener Künstler-Theater," first published in February 1908, three months before its opening night. "The goals pursued by the Artists' Theater," Hildebrand thus proclaimed well in advance of their realization, "are based above all on a clarification of the relationship between the dramatic and the visual arts, insofar as the latter has a place on the stage."[104] The two art forms were united in the service of aesthetic experience but operated according to different rules; the stage image, framed by the proscenium, provided the ultimate formal expression of their theoretical relationship. Theater presented a work of art enlarged to life size, enlivened by actors,

and witnessed communally. Gathered together in the auditorium, the audience watched this framed image in unison; ideally, performances would unite emotional engagement and the aesthetic detachment that Hildebrand associated with the visual arts. While he neither mentioned Wagner nor showed any concern for musical performance, his discussion of the relationship of the individual arts on stage was inflected by the composer's idea of the Gesamtkunstwerk.

Hildebrand associated the visual arts with emotional distance, with a calmness and self-control that allowed the artist to apprehend an event and turn it into a work of art. Drama, by contrast, represented an emotional immediacy and a loss of control. The distinction held true both for the reception of a work of art and for its creation; only a visual artist, he believed, could attain a true—which is to say, complete and detached—vision of an object or an event. As an example Hildebrand wrote, referring to the burning of Girolamo Savonarola on the Piazza Signoria in Florence, that "the pure appearance of the phenomenon could be observed only by an artist, who stood apart from the inner dramatic experience," while other witnesses of the scene were too engaged to achieve such aesthetic distance; for these spectators, he argued, "the inner excitement and the impassioned witnessing of what happened there did not allow for the contemplation of the piazza as a phenomenon."[105] Unlike Nietzsche's Dionysian and Apollonian impulses, contemplation and passion—expressed most purely in the visual and the dramatic arts, respectively—were theoretically irreconcilable.

Implicitly, Hildebrand associated the visual arts with the solitary individual, who observed from a distance—whether physical, emotional, or psychic—in order to be capable of rendering an object as a work of art. "He who has time and tranquillity to separate the visual image from the event," he explained, "is already beyond the purely dramatic context; the chain is broken and he is a visual artist."[106] He associated drama, by contrast, with the crowd of people who were swept away by their experience of an event and were unable to maintain an emotional distance from it. By extension, Hildebrand implied, while the experience of the individual spectator could be described in terms of the visual arts, drama by its very nature had to be discussed with reference to a larger audience. In the process of this communal experience, the group was transported emotionally; each individual within the group witnessed an event through a combination of senses that mirrored the combination of art forms within the performance.

In theorizing the relationship between visual and dramatic art, Hildebrand also attended to this relationship literally, describing—much as Wagner had in 1849—how visual artists might help prepare theatrical performances. Specifically, he advocated "the simplification of the means, in order to attain a more compelling effect," declaring

the experience of the fine artist is capable of doing infinitely much here. To create with a pair of trees, properly placed, the impression of an entire forest; to prompt with a street corner the image of a whole city in the imagination: these are the tasks that are the most interesting and important for the stage.[107]

The tasks to be completed on the theater stage by painters were subsidiary, but they were crucial to the creation of a convincing performance. In *The Problem of Form,* Hildebrand had emphasized the use of suggestion and visual hints in relief sculpture in order to convey a sense of space without relying on reproduction. He now presented this objective in relation to the painter's work on stage. As he exclaimed, "Every addition subtracts from the dramatic experience!"[108]

According to Hildebrand, illusionism in painting and naturalism in the theater, by relying on visual calculations and diversionary tactics, only encouraged passivity among spectators. He decried the existence of "plays possessing no actual, unified dramatic power, which wish to fill their gaps by keeping the eyes occupied—plays that thus calculate, in this way, right from the start."[109] Such trickery attempted to fool spectators' vision rather than inspiring their imaginations, and visual stimulation at the theater was only valuable if it caused emotional reverberation. The argument was consistent with the ideas that he had expressed in *The Problem of Form.* For Hildebrand, the artistic value of a work of art depended on the intensity of the aesthetic response it provoked, and not on its power to deceive the eye; both on stage and off, art was not to indulge in trompe l'oeil effects but, rather, to make the spectator intensely aware of the spatial character of the depicted object. The power of an aesthetic impression was thus based on the intensity of the energy the spectator expended.

Hildebrand never questioned the dependence of the visual arts on realism. Drama, however, more reliant on emotional intensity than on psychic detachment, could engage more freely in experimentation; it aimed at an experiential truth that could affect the spectator more profoundly. Performances were to provide a communal stimulation of spectators' imaginations; sets were therefore to hint at reality but not attempt illusionistic realism. Both in the visual arts and at the theater, naturalism was fundamentally misguided and doomed to fail, an argument Hildebrand illustrated with a metaphor explicitly linking a theater play to child's play:

> For it is with the spectator as with the child. Give him a doll that is too realistic and too detailed, and the imagination has nothing more to add; the doll spoils the child's imaginary world with its excessive realism and

the child has no use for it. It is exactly so with the stage that does not aim to set the imagination moving, but instead sets out with a completely opposing intention, to fool the eye by simulating real nature.[110]

The audience Hildebrand described was a gathering of naive spectators who attended a theater play in order to exercise their aesthetic imaginations. Theatrical naturalism—in the stage decor or the performance style—only served to quell this potential, destroying what was truly theatrical. "Real drama wants the spectator to experience purely dramatically," he declared; "where it occurs genuinely, the dramatic power drives away all other interests."[111]

Bühnenkunst, or "the art of the stage," was a popular subject in Munich cultural circles at the beginning of the twentieth century, spawning numerous publications.[112] One of these, by Karl Scheffler, included extensive excerpts from the writings of Behrens and such noted innovators in the theater as Appia and Craig. Published in the middle of March 1907—more than a year before the Artists' Theater opened—the essay explicitly advocated the use of Hildebrand's ideas to further the cause of theater reform. "Every director should know Hildebrand's *Problem of Form* and should study the laws of conceptions of surface and depth," Scheffler proclaimed.[113] These laws, he believed, would help the director create a stage setting and a performance that surpassed mere illusionistic replication. "Even though the consciousness of the public demands the perspectival deception," he argued, "the instinct always also requires the satisfaction of an inborn feeling for space." For a performance to enter the realm of art, and not merely to reproduce reality, it needed to offer the audience a visual play between the deep space of the stage and the shallow proscenium area. Scheffler likened this spatial relationship both to that between sculpture and architecture and that between the melody and the bass line in music. The spectator's aesthetic sense would be activated by the full use of near and distant vision as Hildebrand had described these faculties in *The Problem of Form.*

Hildebrand's endorsement of the Artists' Theater in 1908 can hardly be considered surprising; the "relief" stage was based, after all, on his own theories of sculptural relief, and his essay was easily absorbed into the theater's promotional material. By contrast, an essay by Worringer that same year dismissed Fuchs's efforts. Hildebrand had willingly accepted Fuchs's literal enactment of his theories and wholeheartedly endorsed the relief stage, but Worringer scorned the extremism of its productions and mocked the stringent rejection of pleasure on the part of the theater reformers who, he wrote, "appeal with doctrinaire pathos to the logical creativity of the eye. That is the salient point of the new program: instead of enjoying sensually, the eye should work logically."[114]

Like the two protagonists of *Gentlemen Prefer Blondes,* Worringer disliked the shallow stage and flimsy architecture at the Artists' Theater. While his essay reads like a curmudgeon's grumblings, it represents more than the biting remarks of a disgruntled theatergoer. It shows the reaction of a central figure in German culture in 1908 and a major theorist in the history of twentieth-century art—a reaction that must be seen in the context of his understanding of spectatorship at the time. Several months before publishing his essay on the Artists' Theater, Worringer had been catapulted to fame in Munich art circles by the publication of *Abstraction and Empathy.* The rejection of naturalism in favor of a stylized modernism on the stage of the Artists' Theater might appear to participate in the contemporaneous development of abstraction in the arts; Fuchs's innovations could well have been fortified by the theoretical distinction between naturalism and style that Worringer set out in his book. But while Worringer found the explanations for Fuchs's innovations perfectly logical, as a member of the audience he was unimpressed.

Worringer's essay "Das Münchener Künstlertheater" appeared in the highbrow periodical *Die Neue Rundschau* in the autumn of 1908. Worringer had no positive words for the theater, and he allowed only that its limited achievements were the result of compromise, of the incomplete fulfillment of its own intentions. With extensive use of irony, he derided its reliance on the tenets of visual theory as well as its overly literal appropriation of these theoretical ideas. Where the traditional theater ideally provided emotional and aesthetic pleasure, the Artists' Theater, in his view, was based on a principle of denial; its modernizations, he complained, "aim chiefly at rationalizing all the irrational elements currently found in the theater."[115] Taken to a logical extreme, in other words, this rationalization would dismantle the institution of theater entirely; despite Fuchs's belief that the reform stage facilitated emotional transport, the Artists' Theater ultimately destroyed the theatrical experience.

"These reform stage Protestants," Worringer wrote, winking at his predominantly Catholic readership in Munich, "perceive it as an unworthy situation that the good old peep-box stage, with its . . . absurdities and contradictions, appeals so strongly to the sensuality of the eye." Led by Fuchs, the reform theater wished to eliminate the pleasures of the traditional theater, replacing them with a literalization of aesthetic theory and, in so doing, enforcing a "paralysis of fantasy" among the spectators. Throughout his essay, Worringer compared these efforts at theater reform to the Protestant Reformation. Unadorned by traditional theatrical accoutrements, the relief stage reminded him of the "distraction-shunning sobriety of Protestant churches with their unbroken surfaces and naked walls, although this Puritan impression fortunately is somewhat tempered by the southern German color-joyousness of those Munich artists assigned to the decorative design of

the stage."[116] Luckily, painters had brought pleasure into the theater, tempering the drab starkness on stage with color. The term "decorative" might have been derisory in Munich artistic circles, but Worringer welcomed such material at the Artists' Theater. "While the choice of these artists indeed contradicts the principle" according to which the theater operated, he stated, "one has cause to rejoice at the inconsistency."[117] The colorful sets they provided for the stage at least brightened the drab views of actors "gesticulating in an airless room."[118]

Worringer was particularly displeased with the theater's most famous attribute, the relief stage. "It is only a few meters deep," he wrote, "and is terminated by a straight vertical wall, its fresco background painting giving the necessary hints for the spectator's image of a room without any illusionistic intention."[119] Such hints operated precisely in the manner that Hildebrand had delineated in *The Problem of Form* as the ideal aesthetic operation, exemplified by sculptural relief; they were intended to prompt the spectator to create the complete visual image of the work of art. For Worringer, however, Fuchs had intellectualized what rightly ought to be a sensual experience of aesthetic pleasure. At the Artists' Theater, he wrote, the spectator "literally sits before a wall that . . . unmercifully directs back the gaze, with its depth-needing sensuality." Craving spatial depth, the eye was cruelly confronted by the wall at the rear of the relief stage.

Particularly egregious, Worringer argued, were the towers that flanked the stage, "neutral but assimilated to the architectural attitude of the rest of the theater and therefore stylized in a discreetly modern way." By a neat coincidence, these side towers (visible in Figures 5.12 and 5.13) perfectly enact the theoretical distinction that Hildebrand had articulated in *The Problem of Form* between an object's inherent form and its effective form; whereas the former remained constant, the latter changed according to its context. Hildebrand had illustrated this distinction in his book with the following example: "The very same tower . . . that impresses us as being slender when it rises as an isolated object above the houses may suddenly become thick and clumsy when it is placed alongside slim factory smokestacks."[120] Altering such elements on the stage as sets and lighting would thus reshape the towers beyond recognition from scene to scene and from one production to the next.

But Worringer had no interest in such an argument. "It should be noted," he grumbled, "that these modern, stylized towers remain the same in all plays and scenes."[121] Despite changes in lighting and scenery, he continued, this fact was unavoidable:

> Again and again they emerge, like two admonishing index fingers which
> ceaselessly refer the eye, used to the beautiful illusion of the old stage

décor, to those theoretical explications of the program booklet that
attempt to convince the baffled reader, on countless pages, of the deeper
meaning of this meaninglessness and, in case of disbelief, to rub his
backwardness energetically under his nose.

For Worringer, the ideas promulgated by Hildebrand and Fuchs were pedantic
and dull, overly theoretical, and thoroughly out of place at the theater. No amount
of theoretical text in the program booklet could make up for the lack of theatri-
cality on stage. The "admonishing index fingers" on stage operated, for him, like
warning signs against an overly intellectualized understanding of art. In this opin-
ion he followed Wagner, who, sixty years earlier, had likewise lamented the over-
reliance on theoretical ideas at the theater, deriding the performance that "sees
itself compelled to the ignominious expedient of acquainting the spectators with
its particular intention by means of an *explanatory program*!"[122]

Worringer mocked not only Fuchs's aims at the Artists' Theater but also his
inability to fulfill them. Theater reformers, he wrote with patronizing mockery,
"striving for the alleged golden mean between reason and instinct . . . are satisfied
with compromise, and for now reform only the stage décor."[123] His inspection of
the auditorium clearly failed to reveal Littmann's adoption of an amphitheatrical
seating arrangement. Fuchs's self-proclaimed "revolution in the theater" was thus
reduced to the level of a minor and misguided insurrection conceived by a hesitant
group of reformers who were guided mostly by their own fears of sinful aesthetic
pleasure. While Worringer had no interest in the actual architecture of the Artists'
Theater, his baroque sentences evoked the ornate architecture of Munich's Cath-
olic churches. Allying himself rhetorically with pre-Reformation theatricalism, he
presented the reformers' disapproval of theatrical sin as a fear of the irrational, of
emotion, of creativity: a fear of theater itself.

Such fear, according to Worringer, was manifested at the Artists' Theater not
only in a generally censorious attitude to cultural pleasures but also in a devotion
to the twin idols of visuality and logic. The relief stage aligned visual and cognitive
truth, with the eye offered clues to be processed according to the dictates of logic.
At the Artists' Theater, he wrote,

> every attempt at illusionistic deception is stringently avoided. Only
> hints are given, and it is left to the eye to work these hints logically into
> a whole. It appears that, as a concession to the sensuality of the eye, this
> merely intimated stage décor is simultaneously formed into an artistic
> whole through a finely calculated distribution of colors and lines.[124]

All work and no pleasure, Worringer implied, made for a dull evening at the theater. The only successful elements at the Artists' Theater were those that had infiltrated the building despite the efforts of the stage reformers. The "artistic whole" that Worringer desired could happen only by accident.

At the same time, Worringer acknowledged that the traditional stage image could cause visual confusion. "While the stage design strives to create an impression of depth from a scenic arrangement of details," he wrote, "its perspectival layout is contradicted by the actor's consistent size in each position on stage."[125] While the stage set remained immobile, an actor approaching the audience existed only occasionally in correct proportion to the surrounding set; the spectator's spatial understanding was undermined by this continually shifting disparity. "It must be admitted," he wrote, that in the traditional theater "this perspectival attempt to simulate depth is betrayed and destroyed again and again for the logical gaze by the actor, who steps back into the simulated stage depth but becomes no smaller." The correction of this flaw was "the great achievement of the relief stage," but this achievement was in fact so minor as to be almost irrelevant; it was "probably noticed only occasionally, by one of 500 spectators." The advantages achieved at the Artists' Theater were thus outweighed by the annoyance its productions provoked among the 499 spectators whose ocular logic failed to determine the visual inconsistency of actor and set.

Worringer was no more pleased with the situation of the actors than with the architecture of the stage. "Placed before a painted screen like silhouettes," he wrote, these unfortunate people "lose all the dynamic possibilities of their art."[126] They were reduced to being mere objects, rendered lifeless and inert on stage by the stultifying emphasis on visual theory. Performing for the flat wall of spectators in the auditorium, they seemed mechanomorphic. But Worringer was uninterested in the possibilities of modernist abstraction on stage. Rather than embracing the developments on stage as those of the avant-garde, for example, he demonstrated his own absolute lack of interest in such work by deriding Fuchs's ideas. Proceeding logically, he continued with scorn, "one should therefore be consistent and work with marionettes or even just silhouettes," as if such objects were unworthy components of the true art of theater. "For, as it is, the contradiction between the actor's style and the style of the scenic arrangement is intolerable."

At his essay's conclusion, Worringer returned to the extended metaphors of the Catholic religion. "After one has seen the Artists' Theater," he declared, "one begs forgiveness of the old theater that one has so heartily slandered. One grows fond of it anew and becomes attached to it, with every *predilection d'artiste* with which one loves Catholicism."[127] The spectator's experience at the Artists' Theater,

in other words, led Worringer to regret his earlier cultural sin: that of complaining about the state of the theater. Unable to tolerate Fuchs's theatrical modernism, Worringer declared reform entirely irrelevant and unnecessary. "The much discussed problem of the theater," he wrote, was in fact "ridiculously simple. How strange—faced with the stage decor reform of the Artists' Theater it hits you like a revelation: put good actors on the stage and the problem of the theater is solved."[128]

Worringer's disdain for the relief stage sprang from many sources, only one of which was his own boredom. Fuchs had relied too heavily on the theoretical arguments of the visual arts in order to develop his reform theater; in the process he had burdened his spectators with explications. Additionally, his use of a discussion of sculptural relief and the visual theory supporting this form of art was too literal; it assumed that sculpture, architecture, and theater provided interchangeable visual experiences. Perhaps most egregiously, Fuchs had made use of an outmoded theoretical discourse in order to justify the construction of the stage of the Artists' Theater. He had relied on Hildebrand's ideas, in other words, precisely when Worringer had already begun to advocate abstraction and when Munich artists were beginning to explore this newly theorized artistic impulse. Fuchs had become interested in developing the theoretical possibilities of sculptural relief for use on the theater stage while working in Darmstadt with Behrens; Hildebrand's arguments, however out of step they were in 1908 with some members of the Munich art world, had encouraged this interest.

6

The Specter of Cinema

Of course, a photoplay is not a piece of music. But the photoplay is not music
in the same sense in which it is not drama and not pictures. It shares
something with all of them.

—HUGO MÜNSTERBERG, *The Photoplay,* 1916

PROJECTIONS IN MUNICH

In the early twentieth century, while Georg Fuchs was analyzing the separation
and integration of different forms of art on the theater stage, a new art form was
rapidly establishing a significant presence in Germany. While neither Fuchs nor
any other commentators at the time linked the construction of the Artists' Theater
to the invention of film, his theater may usefully be viewed in relation to the
tremendous rise in popularity of cinemagoing. From the architecture of its audi-
torium and stage to the model of spectatorship this architecture encouraged,
cinema provided an important unspoken referent for the Artists' Theater. When
Fuchs wrote about the role of the audience that he hoped to entice and create with
its performances, he derived his ideas from Wagner and Nietzsche; at the same
time, his writings reflect the rapidly growing mass audience in Germany as it was
being configured at the cinema.

The first public presentation of a film for a paying audience occurred in Berlin
on November 1, 1895; in the following decade film presentations appeared more and
more frequently in cities across Germany. At first, as Miriam Hansen has written,

> films were primarily shown in the *Wanderkino* (travelling shows); around
> 1904 the establishment of permanent facilities gained momentum and
> the *Laden*—and/or *Vorstadtkino* (comparable to the nickelodeon) became
> the most popular locale of exhibition. In the years following 1910, the
> theatres designed specially for motion picture shows were going up in
> Berlin and elsewhere.[1]

Thus, while the Artists' Theater was being constructed, cinema was rapidly gain-
ing popularity across Germany, but theaters were not yet being designed explicitly

as permanent homes for presenting films. The reform theater being developed on the Artists' Theater stage paralleled the early development of the *Reformkino,* or "cinema-reform," movement, which after 1907 attended to the moral implications of the new medium through censorship laws and public debate.[2]

Film as a medium began to be discussed in relation to other art forms very slowly, in the first decade of the twentieth century; even then, it was not treated as a form of art in its own right. According to Anton Kaes, only in 1909, "with the establishment of permanent motion-picture theaters and with the improvement of recording and projection techniques did cinema edge into a competitive relationship with mainstream literature . . . and with theater (which lost famous directors and actors to the new medium)."[3] The field of literature in particular harbored legitimate fears that cinema might steal both its most creative producers and its public; according to Kaes, "heated discussions erupted over the perceived danger presented by cinema to the continued existence of literature; at the same time, a number of dissenting voices in the discussion pointed to the potential benefits that cinema might have on the non-reading lower classes."[4] Analyses of the relationship between theater and film were developed only after the founding of the Artists' Theater, with the construction of more cinemas.

One of the most famous of such analyses in these years was offered by Emilie Altenloh, who had received a doctorate in sociology based on a study of film audiences in the city of Mannheim and who published her findings in 1914 in *Zur Soziologie des Kino: Die Kino-Unternehmung und die soziale Schicht ihrer Besucher* (*On the Sociology of the Cinema: The Cinema Business and the Social Strata of Its Audience*). Film, she announced, offered "something completely new that lies between stage drama and the novel."[5] The rejection of narrative on the theater stage might best be considered within the context of this triangulated relationship, with film as the unmentioned third term threatening to steal both audiences and ideas from the theater. Altenloh addressed the relationship between film and theater explicitly in the final pages of her book. "It would be false," she wrote, "to describe the cinema as the heir to the theater. Cinema would indeed have administered this inheritance badly, but it certainly has attracted all the masses that have always gone only to the theater to give themselves a good evening's entertainment."[6] Even if a straightforward formal similarity could not be established between the two, in other words, audiences chose between theater and cinema (as well as such other kinds of performance as musical concerts), rendering them competitors in the growing urban markets for evening entertainment.

Venues for cinematic presentations proliferated at a remarkable pace. "The development in Berlin is typical," Altenloh wrote; "to the 34 variety theaters that existed there in 1908, 300 more cinematographs were added over the next few

years."[7] The same statistics were repeated in Mannheim, she added; presumably they hold more or less true for Munich as well. Theater, cinema, and music concerts all vied for the increasing leisure time of the expanding middle classes, but because film tickets were less expensive than were tickets for these other kinds of performances—and because they could be arranged at the last moment—cinema began to steal theater audiences. According to Altenloh, 1908 was the last moment at which theater was still able to ignore the growing presence of film. That year, as she put it, was the "turning point after which the decline first made itself noticeable. Since then, theater directors have had to watch their houses becoming more and more deserted from year to year, and watch the deserters flocking in throngs to the cinemas [*Lichtspieltheatern*]."[8]

Paul Ernst, whose review of Worringer's *Abstraction and Empathy* had prompted its publication as a book in 1908, also addressed the relationship between cinema and the stage in 1913 in his essay "Die Möglichkeiten einer Kinokunst" (The possibilities of a film art). The art form most closely connected to film—at that time silent, presented with live musical accompaniment—was stage pantomime, he explained; both offered wordless stories to a live audience, but only live theater could create a relationship with its audience. "Film," by contrast, "gives us a pantomime without that spiritual bond between actor and spectator, but with certain possibilities of its own of a grotesque and fantastic kind."[9] Fuchs's own arguments about the spiritual connection produced at the theater between spectators and those on stage may profitably be seen in light of such an argument. Cinema, mechanically produced, might be the quintessential form of art to represent its age, which, according to Ernst, "overall puts, in place of human work, the work of the machine."[10] Film could never hope to achieve the real spiritual connection with its audience that could be created by the experience of live theater.

The Artists' Theater was built at a pivotal moment not only in the history of cinema construction—only two years after the international standardization of the film screen format—but also in the history of film itself. Writing primarily in reference to the United States, Tom Gunning has characterized the period in film history "until about 1906–07" as offering a "cinema of attractions," which he defines as "a cinema that displays its visibility, willing to rupture a self-enclosed fictional world for a chance to solicit the attention of the spectator."[11] The term "cinema of attractions," Gunning writes, refers both to the later avant-garde film theory of Sergei Eisenstein and to the fairground culture to which Eisenstein's theory of the "montage of attractions" itself referred. Despite focusing its attention solely on the classic theater repertoire, the Artists' Theater may be aligned with these early cinematic efforts insofar as the performances it presented participated in the rejection of narrative, literariness, and other trappings of theatrical naturalism.

In addition to the Artists' Theater, two other theaters were built for Ausstellung München 1908, both on the other side of the central meadow on the Theresienhöhe. One was for marionette shows; designed by the Munich architects Fritz Klee and Peter Danzer, it is visible on the right side of a photograph printed in *Dekorative Kunst* in 1908 (Figure 6.1). The structure stands like a parody of a temple: a simple triangular pediment is carried, visually if not physically, by four straight columns, while a central set of steps cuts through the plain plinth underneath the building. As at the Artists' Theater, the building's function is announced on its facade; here, a large semicircular sign bears the words "Marionetten Theater Münchener Künstler" in traditional German lettering. The sign conveys an element of advertising inversely proportionate to any emphasis on architectural design on the facade. As objects of mass cultural entertainment, the marionettes required fewer of the trappings of high art than did performances at the Artists' Theater.

The other theater was a cinema, or *Kinematographentheater,* designed by the Munich architect Orlando Kurz (Figure 6.2). Notably, the structure created to house the technologically advanced medium of film was built in a style typical of turn-of-the-century Munich architecture, its traditional forms tempered by large, flat areas of Jugendstil decoration. As Wilhelm Michel put it, "Orlando Kurz has also shown much architectonic inventiveness in his cinematographic theater. Here, too, it is a pronounced painterly spirit, which is the striving for amusing spatial and shadow effects, that governs the whole."[12] Inside, these effects were reproduced on

Figure 6.1. Fritz Klee and Peter Danzer, Marionette Theater, Munich, 1908. From Wilhelm Michel, "Wohn- und Wirtschaftsbauten auf der Ausstellung München 1908," *Dekorative Kunst* 11 (August 1908): 475.

the film screen. As with cinema palaces in the following decades, the more advanced technology was housed in more traditional architecture. While the classic dramas presented at the Artists' Theater contrasted starkly with the offerings of the two other theaters at the exhibition, the three theaters may in retrospect be seen as precursors of the avant-garde film culture of Eisenstein and others that evoked the presentations of exhibitions and fairgrounds with a "cinema of attractions."

"A screen is quite a different thing to a stage," explained P. Morton Shand in 1930 in his book on cinema and theater architecture.[13] He continued, "The first requires only a very modest area: width and height without depth; while the second calls for considerable three-dimensional space, besides a platform and roof, provided with a certain amount of fixed equipment." The statement reflects fundamental assumptions about theatrical performances: that they are necessarily naturalistic, and that they attempt to replicate reality using illusionistic sets and props. The distinction set out by Shand also illustrates the unusual status of the

Figure 6.2. Orlando Kurz, Kinematographentheater, Munich, 1908. From "Wohn- und Wirtschaftsbauten auf der Ausstellung München 1908," 478.

stage at the Artists' Theater, hovering in between stage and screen in the minds of contemporary viewers. While Fuchs emphasized the audience's experience of the performances at the Artists' Theater, the stylized rejection of naturalism enacted in its productions corresponded more to the category of cinema.

Like its stage, the amphitheatrical auditorium at the Artists' Theater may also be aligned with the theaters that would soon be built for showing films. The flat square of seats mimicked the shape of the shallow stage the audience faced. Inspired by Semper's designs for a theater for Wagner and by the Festival Theater in Bayreuth that copied these designs, the auditorium also repeated aspects of Littmann's earlier theater projects. At the same time, the configuration foreshadows the seating arrangements of Weimar cinemas, which increased in size in proportion to the rapidly growing audiences they attracted. The auditorium of the Capitol Cinema, built in Breslau in the 1920s by the architect Friedrich Lipp, provides a revealing comparison (Figure 6.3). The auditorium was far larger and far more ornate than that of the Artists' Theater; in addition to the seats at the orchestra level, it also contained a balcony that was divided into several sections of seats. But as at the Artists' Theater, most of the audience occupied a solid block of seats to which they gained access from either side of the auditorium, rather than by

Figure 6.3. Friedrich Lipp, Capitol Cinema, Breslau, 1920s. From Morton Shand, *Modern Picture-Houses and Theatres* (Philadelphia: J. B. Lippincott, 1930), 23.

passing through central aisles. The stage itself was surrounded by a series of frames of decreasing size receding backward from the proscenium area to the screen.

In 1940, thirty-two years after attending the first performance of the Artists' Theater, Mordecai Gorelik offered the following assessment of its significance:

> Let the audience know that theatre is something better than life, that it is an insight into life. The theatre is not a vulgar peep-show. No longer must the audience watch costumed actors moving inside a gilt picture-frame. The dramatic action goes half-way to meet its public. The actors work far out on that ledge of the forestage, so that their bodies loom up in relief against the setting behind them. This "relief stage" will replace existing stages.[14]

The oddly retrospective cast of these words, of course, contradicts the very nature of a prediction. But Gorelik's claim holds true, insofar as the "relief stage" at the Artists' Theater may be seen in relation to the development of other venues for housing, entertaining, and fostering the growing mass audience in Germany. Its stage and auditorium responded to the development of cinema—both as a cultural medium and as the creator of the mass audience.

Until the end of the nineteenth century, the notion of flatness had held predominantly negative connotations. In 1873, for example, when Nietzsche wrote that modern man "lets himself be emptied until he is no more than an objective sheet of plate glass," there was no need to add that such emptiness, objectivity, and transparency were lamentable aspects of the modern personality.[15] But even though the notion of cultural and personal flatness was fully at odds with the idea of the cultivated and educated individual formed by the nineteenth-century concept of *Bildung,* such flatness soon came to seem advantageous. In the visual discourse of early-twentieth-century Germany, flatness increasingly came to represent such valued modern qualities as efficiency and objectivity. Flatness linked such disparate artistic phenomena as Jugendstil design, for which the unmodeled planar surface provided the background for the whiplash line; the development of abstract painting, imminent in Munich in 1908; and the film screens of the increasingly popular cinemas. The discourse of flatness, meanwhile, helped set the terms for theories of modernist subjectivity, extending into discussions of the mass audience in the 1920s.

Within the auditorium at the Artists' Theater, flatness operated more figuratively, through the arrangement of spectators in identical rows. Facing the shallow stage, spectators would be transported to an exalted realm of art that had no need for complicated props, illusionistic sets, and such elaborate equipment as the

revolving stage (introduced in Munich a decade earlier), all of which only detracted from the pure theatrical experience as Fuchs envisioned it. Despite the avowed centrality of rhythm, this experience was to be primarily visual, and the visual theory on which it was based was likewise oriented around the notion of flatness. In 1905, Fuchs had written of "the surface, the fundamental principle of painterly creation," lamenting that on the stage it might be "eliminated to feign a three-dimensional reality" and vowing that "we will have to bring painting, as the true art of the graphically and coloristically lively surface, back to its place of honor on the stage."[16] Only by allowing the visual arts to express their true nature on the stage, in other words, would the emphasis on surfaces be allowed to take its rightful place at the theater.

At the turn of the twentieth century, the concept of flatness appeared in discussions of subjectivity as much as in those about the visual arts. If painterly perspective, presenting the canvas as a window onto deep space, had reflected humanist presumptions, the theme of flatness prepared the ground for a new spectator for whom individuality was less significant than membership within a group. Georg Simmel referred to "the resistance of the individual to being levelled" in his essay "Metropolis and Mental Life" in 1903, but individualism soon lost its appeal for theorists of modern spectatorship.[17] From discussions of the abstract model of relief sculpture to those of the mass audience in the 1920s, the ideals and contradictions of modernist vision surfaced, both formally and rhetorically, in the theory and practice of flatness. Along with other markers of visual abstraction, the flatness of the pictorial plane denoted an accessibility shared by all viewers. The celebrated "untutored eye" to whom abstraction was deemed accessible in 1908, however, invariably belonged to a highly tutored European gentleman. Given his Nietzschean bent, Fuchs thus struggled with a conundrum: how to create an audience of Nietzschean individuals without rendering each one shallow, a duplicate of the next?

ADVERTISING AND CONSUMPTION

Such a question—and the ongoing negotiations between the individual spectator and the mass audience to which he or she might belong—reverberated far beyond Germany's national borders. In 1922, a full-page advertisement appeared in *Printers' Ink Monthly*, an American trade journal, aiming to elicit advertisers for the magazine *Photoplay* (Figure 6.4). Four drawn images in the guise of film stills illustrate how, as the slogan spanning the page insists, "Every Woman Lives *Herself* on the Screen." The images tell a story conflating film spectatorship, advertising, and satisfied consumerism: after watching an actress on-screen play a record, and after reading a magazine, a woman purchases a gramophone to play music for her own

Every Woman Lives *Herself* on the Screen

ONE secret of the far-flung fascination of the motion picture is that not only are pictures of the actors thrown on the screen, but there is also projected the *personalities of the spectators*. Hopes, dreams, desires—life made to the moulding of her most precious ambition —all these appear, in the mind of the woman behind the actual scenes portrayed.

And with the spell of remembered scenes still strong upon her, she finds in the pages of her favorite screen magazine, PHOTOPLAY, a welcome guide to the goal of her desires.

It is this unique opportunity to come so closely upon the heels of favorable impressions that has made the pages of PHOTOPLAY MAGAZINE the accepted medium for the stories of so many higher quality products.

Every woman lives herself on the screen, finding there material for the surroundings of the home she longs to build. If your product in any way enters into the making of the American Home, no better background for its message may be found than PHOTOPLAY.

Picturize your appeal
In the layout of this advertisement, PHOTO-PLAY has followed the principle of *continuity*, so ingeniously exemplified by producers of better class motion pictures. PHOTOPLAY believes that a great new field is opening up in the closer study of motion picture technique by leaders in latter-day advertising.

PHOTOPLAY

James R. Quirk, *Publisher*
C. W. Fuller, *Advertising Manager*

25 W. 45th St., New York 350 N. Clark St., Chicago

Figure 6.4. "Every Woman Lives *Herself* on the Screen." Advertisement for *Photoplay* from *Printers' Ink Monthly* 4, no. 5 (April 1922): 51.

guests. A column of text, imitating a newspaper layout, presents a series of diluted Freudian claims and the clichés of 1920s American advertising copy. Spectators project their own personalities onto the film screen, it reads, with the female viewer especially prone to sensing her "hopes, dreams, desires . . . behind the actual scenes portrayed." An obscure but optimistic mirror, the screen reflects her aspirations for a rosy future; prompted by what she sees, she turns to traditional forms of advertising in an effort to channel her emotions. In this world of illustrated celluloid, one is what one purchases—especially if one is a modern woman. "With the spell of remembered scenes still strong upon her," the text explains, "she finds in the pages of her favorite screen magazine, PHOTOPLAY, a welcome guide to the goal of her desires."

A monthly journal established in 1911, *Photoplay* covered the glamorous side of the movie industry under the guidance of the delightfully named James R. Quirk, its editor after 1915. While not the first fan magazine (an honor accorded to *Motion Picture Stories,* founded in 1909 and later renamed *Motion Picture Magazine*), *Photoplay* was by 1922 the genre's leading light, billing itself proudly as "the news magazine of the screen." That year, in its July issue, it awarded its prestigious Photoplay Medal of Honor to Douglas Fairbanks's *Robin Hood* and published numerous stories on the private lives of cinema's public figures, including one presenting "Harold Lloyd's New Home." Both in the age of silent film and for several subsequent decades, the journal provided news, reviews, photographs, and gossip to legions of fans of the new form of mass cultural entertainment. Extending the visit to the cinema to the arena of the printed page, it offered a promising venue for advertisers hoping to influence the purchasing habits of American movie audiences, whose rapid expansion and rising social status were accompanied, at a time of postwar prosperity, by an impressive increase in disposable income.[18] The pages of *Photoplay* held particular promise for those hoping to turn spellbound female cinemagoers into consumers, and the advertisement in *Printers' Ink* concluded its sales pitch with the confident claim, "Every woman lives herself on the screen, finding there material of the surroundings of the home she longs to build. If your product in any way enters into the making of the American Home, no better background for its message may be found than PHOTOPLAY."

The four drawings in the *Photoplay* advertisement allegorize the replacement of live music with recorded sound, an aural loop that parallels the film within a film. The first and largest, labeled "reel 1," occupies the top quarter of the page; it shows a woman at the cinema, her husband seated beside her, watching a stylishly dressed woman who holds a gramophone record to play for her guests while elegant figures dance in pairs in the grand, high-ceilinged room. The bright film screen, receding into depth at the center of the room in the upper right corner of

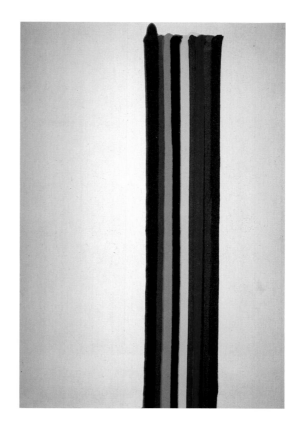

Plate 1. Morris Louis, *133,* 1962. Acrylic on canvas. Gift of Mr. and Mrs. Burton Tremaine. Image courtesy of the Board of Trustees, National Gallery of Art, Washington, D.C.

Plate 2. Bayreuth Festival Theater seen from a train compartment, postcard, 1902. National Archives of the Richard-Wagner-Foundation, Bayreuth (N3771).

Plate 3. Bayreuth Festival Theater auditorium seen from the orchestra pit. Photograph by Juliet Koss, 2008.

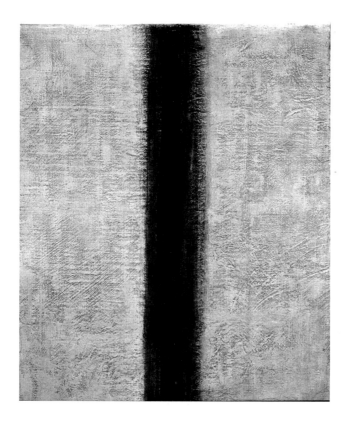

Plate 4. Olga Rozanova, *Green Stripe (Color Painting),* 1917. Rostov Kremlin State Museum Preserve.

Plate 5. Gabriele Münter, *Mädchen mit Puppe* (Girl with doll), 1908–9. Oil on cardboard, 27.5 × 19 inches. Milwaukee Art Museum. Gift of Mrs. Harry Lynde Bradley, M1966.165. Copyright 2008 Artists Rights Society (ARS), New York / VG-Bild-Kunst, Bonn.

Plate 6. Wassily Kandinsky, *Composition IV,* 1911. Oil on canvas. Kunstsammlung Nordrhein-Westfalen, Düsseldorf. Photograph by Walter Klein, Düsseldorf. Copyright 2008 Artists Rights Society (ARS), New York / ADAGP, Paris.

DAS ZEICHEN

Des Morgens aber nach dieser Nacht sprang Zarathustra von seinem Lager auf, gürtete sich die Lenden und kam heraus aus seiner Höhle, glühend und stark, wie eine Morgensonne, die aus dunklen Bergen kommt. „Du großes Gestirn, sprach er, wie er einstmals gesprochen hatte, du tiefes Glücks-Auge, was wäre all dein Glück, wenn du nicht Die hättest, welchen du leuchtest! Und wenn sie in ihren Kammern blieben, während du schon wach bist und kommst und schenkst und austheilst: wie würde darob deine stolze Scham zürnen! Wohlan! sie schlafen noch, diese höheren Menschen, während ich wach bin: das sind nicht meine rechten Gefährten! Nicht auf sie warte ich hier in meinen Bergen. Zu meinem Werke will ich, zu meinem Tage: aber sie verstehen nicht, was die Zeichen meines Morgens sind, mein Schritt – ist für sie kein Weckruf. Sie schlafen noch in meiner Höhle, ihr Traum trinkt noch an meinen trunkenen Liedern. Das Ohr doch, das nach mir horcht, – das gehorchende Ohr fehlt in ihren Gliedern." – Dieß hatte Zarathustra zu seinem Herzen gesprochen, als die Sonne aufgieng: da blickte er fragend in die Höhe, denn er hörte über sich den scharfen Ruf seines Adlers. „Wohlan! rief er hinauf, so gefällt und gebührt es mir. Meine Thiere sind wach, denn ich bin wach. Mein Adler ist wach und ehrt gleich mir die Sonne. Mit Adlers-Klauen greift er nach dem neuen Lichte. Ihr seid meine rechten Thiere; ich liebe euch. Aber noch fehlen mir meine rechten Menschen!" – ALSO SPRACH ZARATHUSTRA; da aber geschah es, daß er sich plötzlich wie von unzähligen Vögeln umschwärmt und umflattert hörte, – das Geschwirr so vieler Flügel aber und das Gedräng um sein Haupt war so groß, daß er die Augen schloß. Und wahrlich, einer Wolke gleich fiel es über ihn her, einer Wolke von Pfeilen gleich, welche sich über einen neuen Feind ausschüttet. Aber siehe, hier war es eine Wolke der Liebe, und über einen neuen Freund. „Was geschieht mir?" dachte Zarathustra in seinem erstaunten Herzen und ließ sich langsam auf dem großen Steine nieder, der neben dem Ausgange seiner Höhle lag. Aber, indem er mit den Händen um sich und unter sich griff und den zärtlichen Vögeln wehrte, siehe, da geschah ihm etwas noch Seltsameres: er griff nämlich dabei unvermerkt in ein dichtes warmes Haar-Gezottel hinein; zugleich aber erscholl vor ihm ein Gebrüll, – ein sanftes langes Löwen-Brüllen. „Das Zeichen kommt", sprach Zarathustra, und sein Herz verwandelte sich. Und in Wahrheit, als es helle vor ihm wurde, da lag ihm ein gelbes mächtiges Gethier zu Füßen und schmiegte das Haupt an seine Knie und wollte nicht von ihm lassen vor Liebe, und that einem Hunde gleich, welcher seinen alten Herrn wiederfindet. Die Tauben aber waren mit ihrer Liebe nicht minder eifrig als der Löwe; und jedes Mal, wenn eine Taube über die Nase des Löwen huschte, schüttelte der Löwe das Haupt und wunderte sich und lachte dazu. Zu dem Allen sprach Zarathustra nur Ein Wort: „meine Kinder sind nahe, meine Kinder" –, dann wurde er ganz stumm. Sein Herz aber war gelöst, und aus seinen Augen tropften Thränen herab und fielen auf seine Hände. Und er achtete keines Dings mehr und saß da, unbeweglich und ohne daß er sich noch gegen die Thiere wehrte. Da flogen die Tauben ab und zu und setzten sich ihm auf die Schulter und liebkosten sein weißes Haar und wurden nicht müde mit Zärtlichkeit und Frohlocken. Der starke Löwe aber leckte immer die Thränen, welche auf die Hände Zarathustra's herabfielen und brüllte schüchtern dazu. Also trieben es diese Thiere. – Dieß Alles dauerte eine lange Zeit, oder eine kurze Zeit: denn, recht gesprochen, giebt es für dergleichen Dinge auf Erden keine Zeit –. Inzwischen aber waren die höheren Menschen in der Höhle Zarathustra's wach geworden und ordneten sich mit einander zu

160

Plate 7. Henry van de Velde, design for Friedrich Nietzsche, *Thus Spoke Zarathustra*, 1908. Photograph courtesy of the Research Library, The Getty Research Institute, Los Angeles, California (91-B8347).

Plate 8. Joseph Maria Olbrich, Ernst Ludwig House, Darmstadt, front portal 1901. Photograph by Karen Lang, 2006.

Plate 9. Hannah Höch, *Dompteuse (Tamer),* ca. 1930. Photomontage with collage, original leather frame. Kunsthaus Zürich, Graphische Sammlung. Copyright 2008 Artists Rights Society (ARS), New York / VG-Bild-Kunst, Bonn.

Plate 10: Oskar Schlemmer, *Pastel für einen Wettbewerb,* design for the congress hall in the Deutsches Museum, Munich, 1934 (detail). Colored chalk on writing paper. Munich, Deutsches Museum, private collection. Photograph copyright 2010 Bühnen Archiv Oskar Schlemmer / The Oskar Schlemmer Theatre Estate, IT-28824 Oggebbio (VB), Italy and estate Oskar Schlemmer, Munich. Photograph from Archive C. Raman Schlemmer, IT-28824 Oggebbio (VB), Italy.

Plate 11. Paul Klee, *Matchbox Genie,* 1924. Matchboxes, feather. Klee Museum, Bern, Switzerland. Copyright 2008 Artists Rights Society (ARS), New York / VG-Bild-Kunst, Bonn.

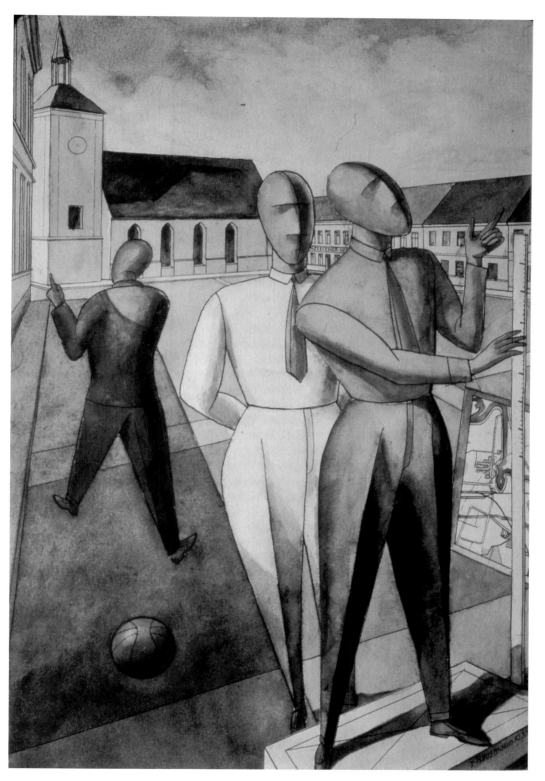

Plate 12. Raoul Hausmann, *The Engineers,* 1920. Watercolor. Arturo Schwartz Collection, Milan. Copyright 2008 Artists Rights Society (ARS), New York / ADAGP, Paris.

Plate 13. Joost Schmidt, *Der Läufer* (The runner), ca. 1932. Courtesy of the Research Library, The Getty Research Institute, Los Angeles, California (800972).

Plate 14: Oskar Schlemmer, costume designs for *The Triadic Ballet*, 1926. Black ink, gouache, metallic powder, graphite, and typewritten collage elements on cream wove paper, mounted to cream card. Harvard University Art Museums, Busch-Reisinger Museum, Museum Purchase, BR50.428. Photograph copyright 2010 Bühnen Archiv Oskar Schlemmer / The Oskar Schlemmer Theatre Estate, IT-28824 Oggebbio (VB), Italy and estate Oskar Schlemmer, Munich. Photograph from Imaging Department, Harvard University; copyright President and Fellows of Harvard College.

the page, provides the advertisement's focal point. Our heroine's absorption is un-surprising: the popularity of cinema is compounded by the presence on the screen of a gramophone, the most advanced technology of sound reproduction in 1922.[19] In "reel 2," she appears in a domestic scene, reading a magazine as her husband reads the newspaper nearby, sharing the lamplight. The magazine is *Photoplay*; she is looking at an advertisement for a gramophone. She next appears as a potential consumer, unaccompanied, sitting elegantly in a comfortable, overstuffed chair listening to a record played to her by a salesman. Significantly, a grand piano stands in the background, unused, with no piano bench beside it. Its lid is raised uselessly, as if in silent visual protest against the lid of the gramophone cabinet that is open on the salesman's other side; together these planes of wood form a triangle with the salesman's head at its apex. In the fourth and final scene, she adopts the role of the actress she had been watching and plays a record for her own guests. The process is complete: having watched the film, read the magazine, and purchased the magic object, she has become her own screen heroine.

At first glance, the advertisement appears to promote cinema attendance as much as any kind of consumer activity; neither the text nor the images entirely make sense without the other's presence, and each requires prolonged attention to decipher. A cacophony of written and visual information, pseudo-psychological claims, cinema theory, and traditional drawings representing a series of film stills, the advertisement brings together central themes in the history of modern spec-tatorship. Prominently displayed, in large boldface type at the center of the bot-tom of the page, is the *Photoplay* logo. Representations of gender, consumption, aesthetic reception, and identity formation thus ultimately serve both to promote *Photoplay* as a magazine—suggesting the publication as a venue for reaching poten-tial consumers—and to advertise the very idea of advertising itself. A closed circuit of commercial endorsement, a hall of marketing mirrors, it presents to the adver-tising directors who scan the pages of *Printers' Ink Monthly* in 1922 (a male audience) an idealized world where the "hopes, dreams, desires" of female moviegoers might be harnessed for financial gain. Through a combination of psychological insight and commercial savvy, the advertisement explains, the vague female desires that lurk "behind the actual scenes portrayed" could be replaced with desires for partic-ular commodities that might contribute to "the making of the American Home."

In an advertisement published three decades after photography became wide-spread in American print advertising, the use of drawing seems a perverse return to the old-fashioned visual forms of the late nineteenth century.[20] Furthermore, the images are incorrectly labeled as numbered "reels" rather than frames, and instead of appearing in neat descending order, as in a film strip, they vary in size and shape, sometimes overlap, and once are even aligned at one edge. Thus the

- The Specter of Cinema

idea of film is represented, but the representation itself resists the signifying features of this mass cultural form. Such a combination of film and drawing, with photography made conspicuous by its absence, reflects a significant shift under way at the time in American advertising. Women were now making most of the purchasing decisions in the domestic arena, including those concerning such expensive objects as washing machines and gramophone cabinets, and new research revealed (or perhaps researchers were willing to acknowledge, now that they studied female consumers) that purchases were often based as much on emotional as on rational factors.[21] Advertisers used photography in the early 1920s to sell products bought by men—table saws and adding machines, for example—because it represented the authority of facts and figures. But when targeting the emotional responses of female consumers, they relied increasingly on drawings to suggest the promised fantasy realm. The advertisement for *Photoplay* that ran in *Printers' Ink Monthly* courted a male audience with film stills, but it evoked a female audience with drawings.

The structural logic of the sequence of images in the *Photoplay* advertisement is itself described by a text, framed by a decorative border and vignette near its lower left corner. "Picturize your appeal," the words enjoin. "In the layout of this advertisement, PHOTOPLAY has followed the principle of *continuity*, so ingeniously exemplified by producers of better class motion pictures. PHOTOPLAY believes that a great new field is opening up in the closer study of motion picture technique by leaders in latter-day advertising." Would-be practitioners of the modern science of advertising were well advised to study film technique, and particularly that of the "better class of motion pictures," which approached cinema as an art and not merely as a form of mass cultural entertainment or a shallow imitation of theatrical performance. Analysis of film technique would not only improve the layout of print advertisements (the sequence of events illustrated by a series of images could be based on film's "principle of continuity," for example) but would also further the understanding of the psychological effects of visual imagery—an achievement that could only benefit the business of advertising. If to "picturize" literally meant to turn the indefinable appeal of a particular product into an image on the printed page, and into an advertisement for potential consumers to examine, it also suggested something more abstract and potentially more effective: the association of a product with the glamour of the moving pictures. By implication, both of these goals might be achieved by placing an advertisement in *Photoplay*.

Hugo Münsterberg and the Photoplay

The advertising copywriter at *Photoplay* was not the first to advocate a study of film technique from the point of view of both aesthetics and psychology; Hugo

Münsterberg, a professor of experimental psychology at Harvard University, had in 1916 published *The Photoplay: A Psychological Study.* Trained in Wilhelm Wundt's psychology laboratory in Leipzig and well versed in the psychological theory of Einfühlung, Münsterberg had emigrated at the turn of the twentieth century to the United States, where he soon became director of the experimental psychology laboratory at Harvard University. (This he did at the invitation of William James, then a professor of physiological psychology at Harvard who had studied under Helmholtz.) "To picture emotions must be the central aim of the photoplay," Münsterberg declared in 1916; film theory itself, one might argue, emerged from the discourse of Einfühlung.[22]

Münsterberg had established his reputation in his native Germany with his four-volume *Beiträge zur experimentellen Psychologie* (Contributions to experimental psychology, 1889–92); in the United States, he helped develop the emerging field of applied psychology with such works as *American Traits from the Point of View of a German* (1901) and *On the Witness Stand: Essays on Psychology and Crime* (1908). Until 1914, he had never been to the cinema, as he noted the following year in the *Cosmopolitan* with a strange mixture of bashfulness and pride:

> I may confess frankly that I was one of those snobbish late-comers. Although I was always a passionate lover of the theater, I should have felt it as undignified for a Harvard Professor to attend a moving-picture show, just as I should not have gone to a vaudeville performance or to a museum of wax figures or to a phonograph concert.

Vaudeville was merely live theater for lower-class audiences, while wax figures and, especially, phonograph recordings represented another kind of aesthetic fakery: what Walter Benjamin would describe two decades later as the work of art in the age of mechanical reproducibility. "Last year," Münsterberg continued, however, "I and a friend risked seeing *Neptune's Daughter,* and my conversion was rapid. Surely I am now under the spell of the 'movies' and, while my case may be worse than the average, all the world is somewhat under this spell."[23] Rather than reading a fan magazine in this spellbound state—as so many women did—he wrote a book prompted by his experience. In *The Photoplay,* he distinguished film from such other art forms as theater and music, argued that it should "be classed as an art in itself under entirely new mental life conditions," and analyzed the nature of its engagement with its audience.[24]

Like the 1922 advertisement for *Photoplay,* Münsterberg's book of the same name emphasized the role of psychological projection and suggestibility in spectators' experience of film. "The spellbound audience in a theater or in a picture

house is certainly in a state of heightened suggestibility," he explained, but whereas a dependence on realism ultimately rendered live theater "extremely limited in its means," film could produce a stronger aesthetic effect.[25] The physical shallowness of its screen proved advantageous. By calling attention to the artifice of its images, it demanded a greater effort from its spectators, who were forced to confront flatness and depth simultaneously. "That idea of space which forces on us most strongly the idea of heaviness, solidity and substantiality must be replaced by the light flitting immateriality," Münsterberg wrote; this perceptual alteration helped create the work of art.[26] While the logic seems directly inspired by Hildebrand's analysis of *The Problem of Form,* Münsterberg explained the phenomenon metaphorically:

> If we stand three feet from a large mirror on the wall, we see our reflection three feet from our eyes in the plate glass, and we see it at the same time six feet from our eye behind the glass. Both localizations take hold of our mind and produce a peculiar interference. We all have learned to ignore it, but characteristic illusions remain which indicate the reality of this doubleness. In the case of the picture on the screen this conflict is much stronger. *We certainly see the depth, and yet we cannot accept it.*[27]

Like a mirror, the film screen simultaneously presented a stationary, flat surface and a moving image of the activity that appeared to exist in the deep space beyond this surface. Its spectators were constantly aware of this spatial doubling—especially, one imagines, those unused to the new visual experience.

Film also reflected the feelings of its audience. "In the photoplay," Münsterberg wrote with deceptive simplicity, "our imagination is projected on the screen."[28] Crucially, spectators were actively involved in producing an emotional experience, rather than passively receiving impressions and sensations from the images and activities they watched. "If we start from the emotions of the audience," he explained, "we can say that the pain and the joy which the spectator feels are really projected to the screen, projected both into the portraits of the persons and into the pictures of the scenery and background into which the personal emotions radiate."[29] In terms that evoke the discourse of Einfühlung, Münsterberg legitimized film spectatorship as an aesthetic activity. To be spellbound at the cinema was not only to be in "a state of heightened suggestibility" but also to radiate one's own emotions. The *Photoplay* advertisement from 1922 likewise emphasized projection—as opposed to reception—while shifting attention to the nebulous and symbolic "every woman" who saw herself on the screen. Despite the claims of its slogan, however, the advertisement's heroine did not so much live *herself* on the

screen as absorb the life she watched into her own. Merging the psychological process of identification, passive suggestibility, and the apparently feminine activity of consumption, the advertisement showed her efforts to become a film character: to "picturize" her own life, as it were. Like Münsterberg's book, its slogan emphasized the agency of those targeted by advertising, adding a veneer of self-control to their spellbound state.

In his attempt to legitimize film as an art form, Münsterberg insisted on its separation from daily life, and consequently from all traces of commerce. Spectators who actively projected their emotions onto the screen did so to a realm that remained as isolated from the real world as any traditional painting. "A good photoplay must be isolated and complete in itself like a beautiful melody," he maintained. "It is not an advertisement for the newest fashions."[30] The argument is surprising, given Münsterberg's work on the relation of psychology to advertising—in 1913, for example, he had devoted a chapter of his book *Psychology and Industrial Efficiency* to "Experiments on the Effects of Advertisements," likewise attending to the psychological aspects of spectatorship.[31] Yet such distinctions between "art" and "life" were typical of the nineteenth-century German perceptual theory in which he had been trained—and, moreover, they provided useful support for his legitimization of film as an art form. In *The Photoplay* in 1916, he denied the possibility of a link between film and commerce, distinguishing the aesthetic arena from that of practical life.

REPRODUCING SOUND

Perhaps the most striking feature of the *Photoplay* advertisement, given its publication date several years before the release of the first talking picture, is its reliance on sound as a unifying theme. Impressed by a gramophone record played on the cinema screen, a woman listens to a record played for her by a salesman and then plays music for her guests. But the film she watches is a silent film; the advertisement itself, as printed matter, likewise makes no sound. In fact, its only possible representation of a silent moment appears in its second image, when its heroine reads a copy of *Photoplay*. The other three drawings visually represent the prerecorded sounds provided by gramophone records. In 1922, a visit to the cinema was not a silent occasion, but a musical one, and the music on offer was live.[32] If every woman lived *herself* on the screen, her experience was accompanied by the music of a piano, an organ, or a full orchestra. The *Photoplay* advertisement thus conflated not only drawing and film but also the live music heard in public at the cinema and the recordings played privately at home.

"The transformation of the piano from a musical instrument into a piece of bourgeois furniture," Theodor Adorno declared in 1928 with regard to his German

context, "is recurring in the case of the gramophone but in an extraordinarily more rapid fashion."[33] The nineteenth-century bourgeois family had owned a piano, and well-brought-up young ladies especially were expected to be proficient at its keyboard, but the music heard in the 1920s home was more likely to be recorded, with the gramophone the new cultural marker of bourgeois domesticity. This transformation, as Adorno described it, was visible even in gramophone design; "in better social circles," for example, projection horns "were quickly muffled into colored masses or wood chalices. But they proceeded to make their way into private apartments," where they served as "loudspeakers and shrouds of the emptiness that people usually prefer to enshroud within themselves." Such designs reflected a move to the bourgeois interior, and the objects themselves mirrored bourgeois subjectivity more metaphorically, in Adorno's view: their presentation of prerecorded sound confirmed the unoriginal existence of their owners and operators. "What the gramophone listener actually wants to hear is himself," he argued,

> and the artist merely offers him a substitute for the sounding image of his own person, which he would like to safeguard as a possession. The only reason that he accords the record such value is because he himself could also be just as well preserved. Most of the time records are virtual photographs of their owners, flattering photographs—ideologies.[34]

Like photographic likenesses, sound recordings were not legitimate works of art but shallow facsimiles: prerecorded music for predetermined lives. Their reflective tendency prompted Adorno—his modernist longing for a lost "authenticity" fully in evidence—to conclude, "The mirror function of the gramophone arises out of its technology."

Music suffused Münsterberg's book on film as well, but his embrace of recorded images did not extend to recorded sound, allowing him to argue that film failed when treated as a substitute rather than as an art form in its own right. "When the gramophone repeats a Beethoven symphony," he wrote, "the voluminousness of the orchestra is reduced to a thin feeble surface sound, and no one would accept this . . . as a full substitute for the performance of the real orchestra."[35] Live music appeared frequently in the book: good film was "complete in itself like a beautiful melody," for example, and three successive scenes produced an effect of "three tones blended into one chord."[36] More seriously, he argued that, as an art form, film most closely approximated music:

> Musical tones have overcome the outer world and the social world entirely, they unfurl our inner life, our mental play, with its feelings and

emotions, its memories and fancies, in a material which seems exempt from the laws of the world of substance and material, tones which are fluttering and fleeting like our own mental states.[37]

As music was essentially abstract, it provided a parallel context for understanding film's status as a site for emotional projection and reception. Münsterberg hoped to legitimize film by treating it in relation to a range of art forms. "Of painting, of drama, and of music, we had to speak," he declared, "because with them the photoplay does share certain important conditions and, accordingly, certain essential forms of rendering the world."[38] Film was allied with other forms of art by virtue of its distinction from them, and it could best be understood through its effect on its spellbound audience.

By the mid-1920s, broadcast sound was challenging gramophones' status in bourgeois homes, in the United States as in Germany. Radios offered higher sound quality than scratchy records could, and they also permitted continuous enjoyment without the bother of changing disks every few minutes or the expense of purchasing new recordings. Using a highly traditional form of visual representation to depict the most technologically advanced form of art, the *Photoplay* advertisement presents the consumer activity of a modern woman as a Gesamtkunstwerk; it offers a narrative of what might be called "the total work of shopping." In keeping with the "principle of continuity" that it posits as central to both film and advertising design, its story appears sequentially, from initial inspiration to final purchase. The experience is unified by the intoxicating presence of music, silent but central, whether implied at the cinema or played on a gramophone. "The task of music," Adorno would soon argue with regard to Wagner, "is to warm up the alienated and reified relations of men and make them sound as if they were still human. This technological hostility to consciousness is the very foundation of the music drama. It combines the arts in order to produce an intoxicated brew."[39]

By the early 1920s in the United States—if not already in mid-nineteenth-century Germany, as Adorno claimed—the Gesamtkunstwerk relied not only on technology but also on commercialism. Elegantly attired and affiliated with a man, but capable of some independence, our heroine established her credentials as a modern subject through a combination of spectatorship, passive suggestibility, and consumer will. Made spellbound by the movies, where she has seen a reflection of the self she hopes to become, she looks in the pages of her favorite film magazine, *Photoplay,* and finds an advertisement that guides her to the gramophone, the instrument of modern technology that, in turn, prolongs her intoxication with the cinema.

ABSORPTION AND DISTRACTION

In 1925, the art critic Franz Roh identified "the art of the nineteenth century, including impressionism," as "an era of Einfühlung," one that had since been replaced—first by abstraction, in the early twentieth century, and subsequently by what he hesitantly termed "magic realism."[40] In associating the demise of Einfühlung with the birth of a new form of visual art, Roh conflated a theory of aesthetic perception—a form of spectatorship—with the visual style of the art objects with which its theoretical spectator engaged. The conflation reveals, above all, the impossibility of disengaging aesthetic discourse from the kinds of objects it describes. Both the birth of abstract painting and the reconfiguration of architecture as a spatial art around the turn of the last century appeared to detach narrative, spatial depth, and temporality from the realm of the visual arts. The emergence of film, meanwhile, with its emphasis on narrative and its extraordinary ability to conjure three-dimensional space—which Worringer had called the greatest enemy of all efforts at visual abstraction—challenged the status of Einfühlung as a dominant theory of aesthetic perception. So, too, did the growing presence of crowds in cinemas and the interest of particular historians and critics in watching movies.

The reign of Einfühlung was, indeed, over. Yet, Roh's decree notwithstanding, the concept remained central to the understanding of spectatorship throughout the twentieth century and was merely reworked to accommodate shifts in the status of spectators and the objects to which they attended. It continued to surface as a conceptual foil, a feminine weakness, and—especially in the United States— the ingredient of a populist art history.[41] Given the concept's reconfiguration, it is particularly striking that three of the most important theorists of Einfühlung in the 1920s were women: Vernon Lee, Clementine Anstruther-Thomson, and Edith Stein, a student of Edmund Husserl.[42] The intense experience of absorbed spectatorship that had been discussed in terms of Einfühlung also took on other terminological guises and was ascribed to other forms of cultural production. Siegfried Kracauer asserted in 1929, for example, that films "drug the populace with the pseudo-glamour of counterfeit social heights, just as hypnotists use glittering objects to put their subjects to sleep."[43] Visiting the new picture palaces, moviegoers diverted their attention from the dull routine of daily employment by becoming absorbed by the images and narratives depicted on the silver screen. Kracauer distinguished this visual, psychological, and emotional absorption from that described by Wölfflin and his cohorts, however; at the movies, spectators' loss of self and emotional projection was reconfigured as feminine, passive, and communal. Women—or, as Kracauer put it, the "little shopgirls" on their evenings off—were thought to be particularly prone to this form of spectatorship.[44]

But while the intense absorption of nineteenth-century spectators had been called Einfühlung, Kracauer named that of the Weimar mass audience *Zerstreuung,* or "distraction," and treated it as shallow and passive. The distinction reveals more than just a conceptual shift from the solitary spectator to a mass audience, or from a bourgeois male individual to a middle-class group that contained women; it also reflects the introduction of technology into the cultural arena, following which the authentic aesthetic experience of Einfühlung was, many believed, no longer possible. It was inconceivable that the absorption of the "little shopgirls" who watched mechanically reproduced images projected onto cinema screens could be equivalent to the aesthetic experience involved in appreciating, for example, a painting. The aesthetic and the technological belonged to separate realms, with film clearly in the latter category. "The minimum achievement of the artistic entity" was, as Kracauer explained it, "to construct a whole out of the blindly scattered elements of a disintegrated world."[45]

At the cinema, where live performance revues preceded film screenings in the Weimar era, the integration of separate elements into a work of art essentially created a technological Gesamtkunstwerk. "Like the program sheets which have expanded into fan magazines," Kracauer wrote in 1926,

> the shows have grown into a structured profusion of production numbers and presentations. A glittering, revue-like creature has crawled out of the movies: a *Gesamtkunstwerk* of effects. This Gesamtkunstwerk of effects assaults all the senses using every possible means . . . until finally the white surface descends and the events of the three-dimensional stage blend imperceptibly into two-dimensional illusions.[46]

Flatness and depth coexisted with uncanny effectiveness on the film screen, offering spectators a total work of art that subsequently overflowed onto the pages of movie magazines like *Photoplay.* As in Wagner's schema, the audience's experience of the Gesamtkunstwerk was paramount. And, like Münsterberg a decade earlier, Kracauer described this experience in terms of psychological and emotional intoxication.

Unlike Wagner, however, Kracauer aligned the Gesamtkunstwerk with commercial culture, passivity, and spectacle; his analysis reveals, in addition to his own enjoyment of the distraction available to Weimar cinema audiences, his discomfort over the political implications of such activity. By taking spectators' minds off their daily lives, an evening's entertainment at the cinema prevented them from having to reflect—either on their own lot or on the world outside more generally. "The production and mindless consumption of the ornamental patterns divert

them [spectators] from the imperative to change the reigning order," he lamented.[47] By implication, neither the aesthetic engagement with the visual arts nor the enjoyment of more highbrow forms of entertainment (an evening at the opera, for example) held any such danger. The experience of cinema was understood to be passive, albeit quite pleasant. This passivity—aligned variously with the rise of the mass audience, the presence of female spectators, and the use of technology—had come to be understood as a central element of the Gesamtkunstwerk.

Never one to shy from conceptual contradiction—or the performance of passivity, or gender bending, for that matter—Andy Warhol can serve to personify these theoretical concerns and to demonstrate the extraordinary reach of these two theoretical models. A photograph from 1970 shows Warhol and other spectators engaged in rapt absorption at the Invisible Cinema, constructed that year by the

Figure 6.5. Andy Warhol at Peter Kubelka's Invisible Cinema, New York. Photograph by M. Chikiris, 1970. Copyright Anthology Film Archives.

avant-garde filmmaker Peter Kubelka for the Anthology Film Archives in New York (Figure 6.5). Permitting a form of spectatorship simultaneously individual and communal, the construction allowed each spectator to see the movie screen but not the other spectators. Dismantled owing to difficulties with air circulation in the room (heating and air conditioning proved impossible), it combined the private activity of individual spectatorship with the communal activity of movie-going. Here, a solitary spectator could attend to a film in a manner that approximated the individualistic experience of Einfühlung, as it had been described almost a century earlier with regard to representational works of art, objects in nature, and abstract forms. And who could say if these spectators felt empathy or estrangement, sitting separately, together, within a communal audience?

7

Bauhaus Theater of Human Dolls

But when I attempt to survey my task, it is clear to me that I should speak to
you not of people, but of things.

—RAINER MARIA RILKE, *Auguste Rodin,* 1907

THEATER AT THE BAUHAUS

In 1961, Walter Gropius grandly declared that "the Bauhaus embraced the whole
range of visual arts: architecture, planning, painting, sculpture, industrial design,
and stage work."[1] While the statement is not inaccurate, the straightforward inclu-
sion of theater as one of six fundamental components of the visual arts belies
the field's more complicated status at the Bauhaus. Gropius had not mentioned
theater in the initial manifesto and program of the State Bauhaus in Weimar, the
four-page pamphlet published in April 1919 that proclaimed, "Architects, painters,
sculptors, we must all return to the crafts!"[2] But stage work soon became central,
and theater proved to be a form of art that unified all the others; already in 1922,
a drawing by Paul Klee of the idea and structure of the Bauhaus shows *"Bau und
Bühne,"* or "building and stage," firmly united at its core (Figure 7.1). The Bauhaus
held performances frequently and sponsored many in other venues, causing
delight and, intermittently, disturbing the neighbors. The theater workshop, cre-
ated in the summer of 1921 and overseen initially by Lothar Schreyer, is associated
most closely with Oskar Schlemmer—who ran it from early 1923 until his depar-
ture in 1929—and particularly with his *Triadic Ballet,* first performed in full in
1922.[3] Theater was also the subject of the fourth of the fourteen Bauhaus books,
Die Bühne im Bauhaus (The stage at the Bauhaus), which appeared in 1925.[4] When
the Dessau Bauhaus was built that year, the auditorium was located near the center
of the building's triadic pinwheel, between the entrance hall and the canteen, as if
to indicate theater's pivotal status within the school's social and professional life.

The study of theater is often impeded by the nature of the medium: notoriously
difficult to document and theoretically unruly, it falls easily between disciplines
while claiming to incorporate them all. This amorphous quality gained particular
significance at the Bauhaus, where experiments in stage and theater design took

207

Figure 7.1. Paul Klee, *The Idea and Structure of the Bauhaus,* 1922. Drawing. Bauhaus-Archiv, Berlin. Copyright 2008 Artists Rights Society (ARS), New York / VG-Bild-Kunst, Bonn.

place both on and off the premises, frequently in the context of costume parties and other festivities. In all its incarnations, Bauhaus performances re-created the human body—literally and symbolically, on stage and off—in the shape of the doll, its childlike simplicity combining a comforting and seemingly animate charm with an unnerving absence of human personality. Bauhaus dolls of various kinds maintained a playful ambivalence in the face of shifting models of subjectivity, toying with gender ambiguity and engaging with the notion of abstraction both at the level of the individual subject and as a unified group of creatures, delightfully difficult to differentiate. Vessels of empathy and estrangement, they expressed and encouraged a reciprocal relationship between performers and spectators, increasingly exemplifying the bond between gender and mass culture, to provide models of mass spectatorship for the Weimar Republic.

"The history of the theater is the history of the transfiguration of human form," Schlemmer asserted in 1925, with "the human being as the actor of physical and spiritual events, alternating between naïveté and reflection, naturalness and artificiality."[5] Such contradictory attributes often appeared simultaneously on the Bauhaus stage, where performances combined human subjectivity and its deadpan absence, as seen in a black-and-white photograph taken by Erich Consemüller of Schlemmer's *Space Dance* in 1926 (Figure 7.2). Three figures pose on an otherwise bare stage in padded monochrome unitards indistinguishable in everything but (presumably) color; their feet, in standard-issue dance slippers, appear dainty and petite below their stuffed bodies; and identical masks encase their heads in shiny metallic ovoids painted with wide-eyed expressions of mock surprise. Three hands near the center of the image seem to mark the only areas of visible human flesh, but even these look so rigid as to evoke those of shop window mannequins (and one appears to be gloved); the calculated angles of the dancers' arms and legs likewise suggest synthetic limbs. Facing frontally or in profile, the perfectly poised figures lack all trace of individuality, any sense of flesh and blood, or any hint of human skeletons at their core; they seem devoid even of a generic human personality. Their padded bodies, particularly at the hips and crotch, appear female. Underneath the costumes, however, lurk Schlemmer himself (in front, on the left) and the dancers Werner Siedhoff and Walter Kaminsky. Conflating "naïveté and reflection, naturalness and artificiality"—to use Schlemmer's terms—they playfully embody a model of human subjectivity that reflects the instability of their era.

The unitards and masks resemble the protective gear of fencers; the poses call to mind the fencing ring or dance studio.[6] But despite the initial impression they give of active athleticism, the figures also seem like passive objects. They hold static, almost timeless postures, like modern parodies of the statues of ancient Greece that Johann Joachim Winckelmann had famously characterized as having

Figure 7.2. Oskar Schlemmer, *Space Dance,* performed by Schlemmer, Werner Siedhoff, and Walter Kaminsky, Dessau Bauhaus, 1926. Photograph by Erich Consemüller. Courtesy of private collection, Nachlass Erich Consemüller, Cologne. Photograph copyright 2010 Bühnen Archiv Oskar Schlemmer / The Oskar Schlemmer Theatre Estate, IT-28824 Oggebbio (VB), Italy and estate Oskar Schlemmer, Munich. From Wulf Herzogenrath and Stefan Kraus, eds., *Erich Consemüller: Fotographien Bauhaus-Dessau* (Munich: Schirmer/Mosel, 1989), plate 123.

a "noble simplicity and a calm greatness, as much in the pose as in the expression."[7] The figure on the right especially, with its simplified form, its arms tucked invisibly behind its back, evokes a ruin with missing limbs and weathered features. "The artificial figure permits any movement, any position for any desired duration," Schlemmer explained; "it permits—an artistic device from the periods of the greatest art—the variable scale of the figures: significant large, insignificant small."[8] Without human faces or individualized bodies, the figures in *Space Dance* are easily read as miniature humans, although the padding enlarges their forms. Comforting and disturbing in equal measure, they simultaneously resemble children's toys expanded to adult size and oddly overstuffed little people, in keeping with Schlemmer's declaration in 1930 that representations of the human figure belonged "in the realm of the doll-like."[9] The photograph's uncertainty of scale is

meanwhile intensified by the absence of anything else on stage with which to compare the figures, effectively rendering each one an unreliable standard for judging the other two. Receding upstage from left to right, they become smaller, but their heads remain at the same height.

Within the image, the choreography leaves no doubt that the intended spectator is in fact the camera lens; Schlemmer's careful arrangement of the figures on stage coincides precisely with Consemüller's photographic composition. Symmetrically arranged within the frame, shining out from the center of the surrounding darkness, the three heads divide the photograph vertically into four equal areas and horizontally into three, with the dark space behind them—the blank backdrop behind the stage—comprising the top two-thirds of the picture. The bodies are arranged in space, but the image reads as flat; only the straight, deep shadows linking Schlemmer's feet to the center of the horizon line (and the shorter, parallel shadows behind the other figures' feet) suggest recession into depth. The three vertical bodies—and the limbs attached to them—likewise divide the image like the lines of a geometry diagram, despite the figures' apparent difference in size and arbitrary poses. A painted line down the center of the stage floor also bisects the photograph vertically; interrupted by the feet of the central figure (Siedhoff), it continues along his body and through Schlemmer's outstretched hand to end at Siedhoff's artificial head. But Siedhoff's head is also Schlemmer's; identical to that worn by the director, it is made according to his design.

These representations of the human figure in the late 1920s—both the stage image and the photograph—test the limits of recent art historical scholarship in the United States on Weimar subjectivity. Scholarship in this field has concentrated on Dada imagery, robots, and other technological creatures, frequently emphasizing disjuncture of various kinds—from the aesthetics of montage to the prevalence of dismembered bodies in the wake of World War I.[10] Following the arguments of the artists themselves, formal disjuncture is often aligned with the politics of resistance, with the visible montage fragment treated as a marker of the "real" that questions the logic of representation and thus acts as a destabilizing force in the political, cultural, and social realms.[11] Such an equation of aesthetic and political radicalism is often convincing—as, for example, in Hannah Höch's photomontage *Dompteuse* (*Tamer*), of about 1930, a willfully uncertain depiction of the Weimar New Woman (Plate 9). A collation of partial, mismatched, roughly torn images from contemporary magazines, *Dompteuse* shows various accoutrements of control from the circus arena and public life, challenging prevailing notions of idealized feminine beauty and troubling the relationship between tamer and tamed.[12] The equation's inverse—that an aesthetic "return to order" signifies political conservatism—is often equally powerful, with positive images of physical wholeness

and the healthy body produced as National Socialist propaganda, as in Leni Rief-
enstahl's two-part film *Olympia* of 1938.[13]

Particularly in contrast to the gritty photomontages of John Heartfield and
Höch or the political theater of Brecht and Erwin Piscator, it may be tempting to
read Schlemmer's creatures, Consemüller's photograph, and Bauhaus dolls gener-
ally as ominous harbingers of the National Socialist obsession with physical cul-
ture and rationalized subjectivity. Whether openly celebratory of such tendencies
or simply blind to political reality, the dolls (by this line of thinking) are, at
best, liable to co-optation by right-wing forces; at worst their physical amplitude
and seemingly apolitical posturing prove their guilt. Insistently whole—more
than whole—they seem optimistically to embrace the mounting mechanization
of Weimar Germany; their robotic poses softened, literally, by their costumes,
they stave off the threat of dismemberment with a denial both charming and dis-
quieting. Three more figures, standing proudly with linked arms in Consemüller's
photograph of Schlemmer's *Gesture Dance III* in 1927, might be cited as fur-
ther evidence (Figure 7.3). Like a trio of padded fops, Schlemmer, Siedhoff, and

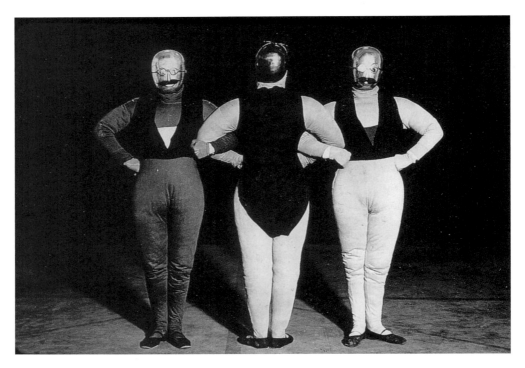

Figure 7.3. Oskar Schlemmer, *Gesture Dance III (Bauhaustänze: Gestentanz)*, 1927. Photograph by
Erich Consemüller. Bühnen Archiv Oskar Schlemmer. Photograph copyright 2010 Bühnen Archiv
Oskar Schlemmer / The Oskar Schlemmer Theatre Estate, IT-28824 Oggebbio (VB), Italy and estate
Oskar Schlemmer, Munich.

Kaminsky are buried in costumes resembling tuxedos, ostensibly useless spectacles appended to their identical masked heads. They seem blind, deaf, and dumb in the face of the escalating troubles of the Weimar Republic; Siedhoff even faces upstage, turning his back to spectators and camera lens alike—without suffering an ensuing reduction in personality.

In fact, no amount of padding could protect the inhabitants of the Bauhaus from continuous charges of communist leanings, with their festivities cited as evidence of political radicalism. The Ministry of Culture in Weimar responded to allegations in 1920, for example, that the school was "spartacistic and bolshevistic," noting that "a complaint has been made that the neighborhood of the Bauhaus . . . is often disturbed by noise during the night hours."[14] While right-wing harassment is no proof of its victims' leftist tendencies, Bauhaus activities certainly undermined authority and threatened conservative local governments.[15] Funding in Weimar was canceled in the autumn of 1924, prompting the school's dissolution the following spring; its Dessau incarnation, begun in 1925, was closed by a bill put forward by the National Socialists in September 1932; and in Berlin the school was shut down by the Nazis after only six months, in April 1933. But despite such ongoing victimization, ample connections exist between the Bauhaus and National Socialism, as recent scholarship attests.[16] Schlemmer's approving citation of Joseph Goebbels in a letter of June 1933 reveals both his own political bent and his sense of the convergence of his life and work: "I consider myself pure, and my art strong," he declared, "in keeping with nat. soc. principles—namely 'heroic, steely-romantic, unsentimental, hard, sharp, clear, creative of new types,' etc."[17] And one need look no further than Schlemmer's design, the next year, for a mural for the congress hall in the Deutsches Museum, Munich, to witness the chilling off-spring of his earlier dolls (Plate 10). Roughly sketched in blue and purple chalk, an orderly litter of identical, dark blond women stand in profile, their right arms raised in a Nazi salute. Hailing a greater power that lies beyond our sight, they are unified in a grid of support—although the feminine silhouette of their flowing, floor-length skirts suggests a return to Jugendstil ideals following the androgynous padding of their 1920s forebears.

But while such textual and visual evidence reveals much about Schlemmer in 1933 and 1934, it proves little about the figures he designed in the 1920s. Creative work never merely illustrates a political orientation that has been fully worked through years in advance, and the dolls at the Bauhaus were neither Nazi sympathizers nor leftist troublemakers, neither wholly celebratory nor entirely critical of their environment.[18] The figures in *Space Dance* and *Gesture Dance III* demonstrate the danger of applying preconceived equations to works of art in retroactive assessment of protofascist potential. Insistently refusing to postulate a firm stance

of any kind, the dolls seem instead to express the position of profound patience described by Siegfried Kracauer in 1922:

> Perhaps the only remaining attitude is one of *waiting*. By committing oneself to waiting, one neither blocks one's path toward faith (like those who defiantly affirm the void) nor besieges this faith. . . . One waits, and one's waiting is a *hesitant openness,* albeit of a sort that is difficult to explain.[19]

In light of these words, one might view the extraordinary static poses of Schlemmer's theater dolls—their noble simplicity and calm greatness—as uncertain, expectant, and hopeful. Seriously playful creatures, construction sites of modern subjectivity, they might even be seen to embody the synthesis of "the most extreme fantasy with the most extreme sobriety" with which Franz Roh characterized the technique of photomontage itself in 1925.[20]

AUTOMATA, MARIONETTES, AND DOLLS

Waxworks, dolls, marionettes, and puppets had long substituted for humans in the German literary imagination, famously appearing in the work of E. T. A. Hoffmann and Heinrich von Kleist in the early nineteenth century. "Grace," Kleist decreed in 1810, "appears purest simultaneously in the human body that has either none at all or else infinite consciousness—that is, in the puppet or god."[21] Artificial creatures gravitated easily to the stage. In late-nineteenth-century France, for example, Léo Delibes' ballet *Coppélia* (1870) and Jacques Offenbach's opera *The Tales of Hoffmann* (1881) took up these literary precursors, their leading characters melding mechanization and the performance of femininity as if testing a new model of female subjectivity. Replica humans—and female dolls in particular—pervaded the visual arts of early-twentieth-century Germany, from the paintings of the Blaue Reiter to Hans Bellmer's creations and photographs. Such treatments of the relation between subjectivity and objectification occurred with particular fervor after the birth of visual abstraction, as they permitted the continued investigation of human subjectivity despite the demise of figurative painting. "At a certain point in time," as Walter Benjamin declared in the allusive, telegraphic prose characteristic of his *Arcades Project,* "the motif of the doll acquires a sociocritical significance."[22]

At the Bauhaus, dolls of a traditional size were created as well, such as the marionettes designed by Kurt Schmidt for *The Adventures of the Little Hunchback* and pictured in *Die Bühne im Bauhaus* in 1925 (Figure 7.4).[23] They performed in private and in public, acting as scale models for theater costumes and as miniature

people, manipulated by human hands and enjoyed by human spectators. Between 1916 and 1925, Paul Klee created a puppet theater with fifty marionettes, including a self-portrait and a matchbox genie (Plate 11), for his son, Felix. As Felix later reminisced with regard to these creatures, "Some hilarious performances were held at the Weimar Bauhaus, during which various confidential matters were aired in an unsparing and sarcastic way, vexing to those concerned and highly amusing to the others."[24] Blending child's play with serious adult activity, performances could serve both as entertainment and as psychological ventilation along the model of Sigmund Freud's "talking cure." The playfulness of the dolls made by Klee and others in this period suggests a determination to reenchant the world, in keeping with Schlemmer's lament that, outside the Bauhaus, "the materialistic-practical age has certainly lost the genuine feeling for play and wonder. The utilitarian frame of mind is well on the way to killing it."[25] Proudly bearing the marks of their makers' hands, dolls embodied the drive to unify art and craft that governed the Bauhaus in its early years.

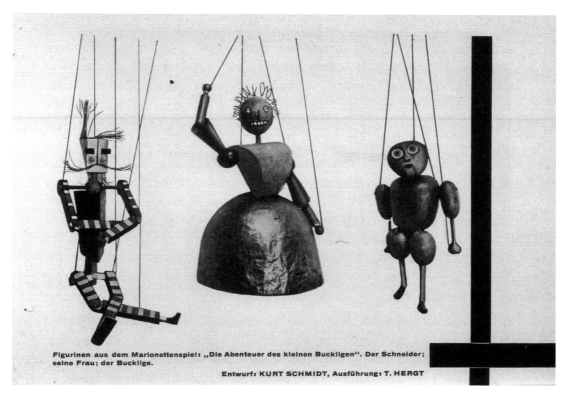

Figurinen aus dem Marionettenspiel: „Die Abenteuer des kleinen Buckligen". Der Schneider; seine Frau; der Bucklige.

Entwurf: KURT SCHMIDT, Ausführung: T. HERGT

Figure 7.4. Kurt Schmidt, design, and T. Hergt, three marionettes (the tailor, his wife, and the hunchback), for *The Adventures of the Little Hunchback*. From Oskar Schlemmer, László Moholy-Nagy, and Farkas Molnár, *Die Bühne im Bauhaus* (Munich: Albert Langen, 1925), 80.

After 1923, however, with the arrival at the school of Laszló Moholy-Nagy—and increasingly after the move to Dessau—technology became the guiding force of Bauhaus creativity, and theater provided an ideal showcase for contending with the body's increasing reification, mechanization, and androgyny.[26] "The integration of humans into stage production must not be burdened by the tendency to moralize, nor by any . . . INDIVIDUAL PROBLEMATIC," Moholy-Nagy argued.[27] As if in response, the small playful objects at the Bauhaus—toys, essentially—grew to human size; their transformation accompanied a change in status, transforming Bauhäuslers into their counterparts on stage. Despite borrowing conceptual authority from their Romantic-era antecedents, Bauhaus dolls—after the school's initial years—were not marionettes controlled by someone who, as Kleist had written, ideally "imagines himself at the puppet's center of gravity" to create *the path of the dancer's soul*" in the movement of its limbs.[28] The Bauhaus director was now more likely to perform as a doll than to hold its strings behind the scenes. Creator and performer became theoretically interchangeable, dissolving the fundamental distinction between them that the traditional theater maintained both physically and conceptually. And, as performers took on the guise of passive objects, spectators—implicitly—were increasingly rendered their equals.

Unlike the puppet and marionette, the automaton—a machine figure operating as if human, without need of human assistance—more closely approximates the model of the Bauhaus doll. From the Renaissance to the late nineteenth century, automatons had enchanted audiences throughout Europe with mechanical ingenuity and magical performances, demonstrating the wondrous qualities of the modern machine while confirming the mechanistic nature of the human body.[29] A Swiss writing automaton from 1773, capable of reproducing a short sentence on a sheet of paper, may be taken as representative (Figure 7.5). An astounding replica of human capabilities, it embodies a humanist conception of individuality: civilized, educated, and unique. In his book *Machine Man* of 1747, Julien Offrey de La Mettrie described the activity of spectatorship as a physical reflex. "We take everything—gestures, accents, etc.—from those we live with," he wrote, "in the same way as the eyelid blinks under the threat of a blow that is foreseen, or as the body of the spectator imitates mechanically, and despite himself, all the movements of a good mime."[30] Immersed in the performance, a spectator cannot resist imitating a performer's movements, even those of an inanimate automaton. Figuratively speaking, the relationship is reciprocal. Just as a spectator mimics the actions of the performer, the latter imitates its spectators, reflecting contemporaneous conceptions of what it means to be human.

"Automata represent the dream, the ideal form, the utopia of the machine," Jean-Claude Beaune has argued; "the gauge of their absolute perfection is their

independence, which endows them from the first with an anthropomorphic or living quality."[31] Like the human model on which it was based, the automaton was essentially individualistic. A suggestion of technical replication combined with the magic of irreproduceability; both as a mechanical invention and as a human substitute, the measure of its success was its uniqueness. "It is often possible to discern some temptation toward group activity" within an automaton, Beaune allows, "but not yet to such an extent as to affect its insularity."[32] Individual performers in *Space Dance* and *Gesture Dance III,* stiff and machinelike, almost pass for overgrown, padded automatons. But despite the morphological resemblance, the model of subjectivity they embody is very different: they belong implicitly within a group of identical creatures. Individual automatons continued to captivate the Weimar cultural imagination—exemplified, perhaps, by the character Maria in Fritz Lang's film *Metropolis,* released in early 1927. Yet, as a prototype for later replicas ("We will put one in every factory!"), even Maria represented the wondrous potentials

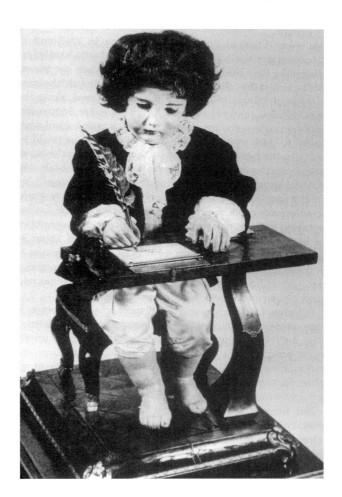

Figure 7.5. Pierre-Jaquet Droze and Jean-Frédéric Leschot, writing automaton, 1773. Musée d'Art et d'Histoire, Neuchâtel, Switzerland.

of serial production. So, too, does the *Steel R.U.R. Automaton* (Figure 7.6). The letters emblazoned across his chest stand for "Rossum's Universal Robots," referring to the 1921 play of that title by Karel Čapek, who introduced the term "robot" in its pages.

By the 1920s, German stages were well prepared for such creatures. The weakened authority of narrative, the disappearance of bourgeois characters on view in the privacy of their own drawing rooms, and the dismantling of the invisible "fourth wall" dividing the stage and auditorium—all provided evidence of the demise of naturalism in the theater, as in literature and the visual arts.[33] In Germany and Russia, in particular, performances increasingly emphasized nonrepresentational movement; Schlemmer's *Gesture Dance III* may thus be seen to stand at the intersection of modern dance and theater as both art forms sought to abandon naturalism, and its attendant psychologist impulses, in favor of abstraction.[34] "The theater, the world of appearances, is digging its own grave when it tries for verisimilitude," Schlemmer asserted in 1922, citing Hoffmann and Kleist with

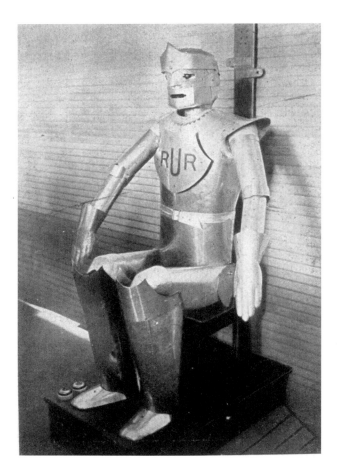

Figure 7.6. *Steel R.U.R. Automaton,* from *Variétés* 1, no. 9 (1928), following page 480. Photograph courtesy of the Research Library, The Getty Research Institute, Los Angeles, California (84-S723).

approbation.[35] Moholy-Nagy also embraced theatrical abstraction. While commending the futurists, the expressionists, and the Dadaists for helping theater overturn naturalism's "predominance of values based exclusively on logic and ideas," he criticized their reliance on figures based on subjective emotional effects and literary models, demanding instead that a new abstract human be developed for the stage.[36] Rather than resting at the top of the theatrical hierarchy, central to the activities on stage, this new model would remain, as he put it, "OF EQUAL VALUE TO THE OTHER CREATIVE MEANS."[37] Performers at the Bauhaus were to be rendered abstract both at the level of the individual figure and in groups; such traditional versions of the mechanized body as the automaton would be replaced with a new model, infinitely replicable and potentially universal.

Bauhaus dolls echoed the radical transfiguration of the human subject in early-twentieth-century Germany, when an emphasis on *Sachlichkeit* joined the potentially universal "urge to abstraction" that Worringer had described in 1908. Following World War I, *neue Sachlichkeit,* or "new objectivity," delivered a new creature, one that has been termed posthumanist; drained of psychological autonomy, this Weimar subject—visible in such works as Raoul Hausmann's *Engineers* of 1920—retained only a lingering pretense of humanist individuality (Plate 12).[38] With standardized clothing, bodies, and faces, the engineers present an image of studied efficiency and anonymous uniformity, an effect reinforced by the presence of a ruler and an urban plan, as well as by the surrounding urban environment. Simultaneously spontaneous and mechanized, playful and unsettling, their forms increasingly abstract, Bauhaus dolls of this period likewise pass for posthumanist. "The sign of our times is *abstraction,*" Schlemmer himself declared in 1925, "which, on the one hand, functions to disconnect components from an existing whole, leading them individually *ad absurdum* or elevating them to their greatest potential, and, on the other, results in generalization and summation to create a new whole in bold outline."[39] Abstraction, in other words, helped dismantle a given object—such as the human body—into its constituent elements, rendering each one essentially useless or making it more purely and forcefully itself. At the same time, it provided a new standard in keeping with the new age.

Schlemmer's *Highly Simplified Head Construction (Profile)* from the late 1920s indicates the extent of his fervor for pictorial abstraction (Figure 7.7). Reducing the head to two abstract components—a flat circle and a rectangle expanded to three dimensions—the drawing seems to calculate their structural relation. It also posits a "new whole in bold outline," a radically new model of human subjectivity: devoid of psychology and emotion, lacking all signs of individual identity, it can be measured with the instruments of geometry and, in theory, infinitely reproduced by machine. For Schlemmer, this achievement was only to be admired. "Because

Figure 7.7. Oskar Schlemmer, *Einfache Kopfkonstruktion (Profil) aus dem Bauhauskurs "Der Mensch"* (Highly simplified head construction [profile]), 1928. Pencil and ink. Bühnen Archiv Oskar Schlemmer, Collection U. Jaïna Schlemmer. Photograph copyright 2010 Bühnen Archiv Oskar Schlemmer / The Oskar Schlemmer Theatre Estate, IT-28824 Oggebbio (VB), Italy and estate Oskar Schlemmer, Munich. Photograph from Archive C. Raman Schlemmer, IT-28824 Oggebbio (VB), Italy.

the *abstraction* of the human form . . . creates an image in a higher sense," he maintained in 1930, "it does *not* create a *natural human being,* but an *artificial* one; it creates a *metaphor,* a *symbol* of human form."[40] This symbolic figure surpassed the limits of naturalism, providing an abstract, artificial model prepared for the challenges and delights of the posthumanist era. A drawing from about 1932 by Joost Schmidt, who was attached to the Bauhaus throughout its years in Weimar and Dessau (initially as Schlemmer's student and subsequently as a master), shows the active potential of this new artificial human (Plate 13). Its head is a blank oval, its body a set of abstract forms joined by circular pivots. Unlike the more traditional body that tumbles uncontrollably in a circle at the left in the drawing, this figure is shown by means of a bold arrow to proceed directly forward into the future. One suspects that some human dolls designed at the Bauhaus were inspired by the wooden figures that were used in drawing classes in place of traditional nude models, as seen in a contemporaneous photograph by Alfred Eisenstaedt of a Bauhaus drawing class (Figure 7.8). Looming over the five students gathered attentively below, the artificial figure appears, as it were, larger than life. Cause and effect are inextricable; given this image, it is little wonder the human doll would set the standard for human subjectivity.

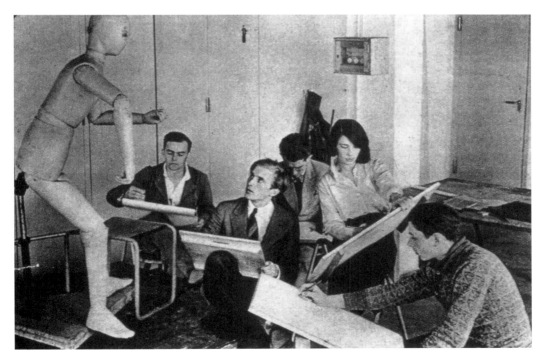

Figure 7.8. Alfred Eisenstaedt, "Drawing Class Using a Movable Model," ca. 1932. Bauhaus-Archiv, Berlin.

A photograph by Consemüller from 1925–26 presents this new figure, the human doll, and exemplifies the impossibility of distinguishing Bauhaus life from performance, identity from anonymity (Figure 7.9). Stylishly dressed in the fashion of the day, a woman reclines in a tubular steel armchair designed by Marcel Breuer. The surrounding room is empty, with the floor beneath her and the wall behind her cleared of other objects as if she were placed on a bare stage in preparation for the photographic performance. Her dress, designed without curves, was made by Lis Beyer in the Bauhaus weaving workshop; her shoes epitomize elegance. Her head a Schlemmer mask, she gazes benignly, blankly, and directly at the camera. Her upper torso and head face the camera, but with her right elbow casually resting on the arm of the chair and her right leg crossed over the left—a strikingly modern pose—visual access to her body is impeded. Her Bauhaus environment has encased and absorbed her: chair, dress, head. She is clearly female, but her slim body and ovoid head, and the pared-down fashions of the Weimar New Woman, all suggest androgyny, reproducing the effect of Schlemmer's padded dolls from the other side of the gender divide. She is in fact anonymous, currently

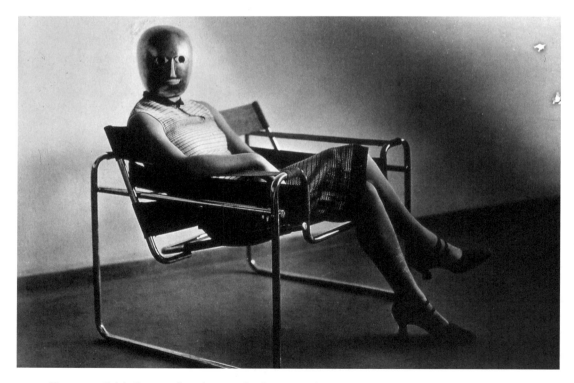

Figure 7.9. Erich Consemüller, photograph of a woman (Lis Beyer or Ise Gropius) at the Dessau Bauhaus, 1925–26. Courtesy of private collection, Nachlass Erich Consemüller, Cologne. From *Erich Consemüller*, plate 1. Photograph copyright Bauhaus-Archiv, Berlin.

documented only as either Beyer herself or Ise Gropius, who is known to have possessed the dress.[41] That the figure cannot be identified, rather than detracting from the documentary value of the photograph, certifies a central feature of Bauhaus life: the defining presence of the doll, seemingly female, and certainly anonymous.

Three photographs taken in the late 1920s illustrate the pronounced interest in androgyny at the Bauhaus. In one, two students—one male, one female—sport similar haircuts and spectacles; photographed from above, they are lying down with their heads angled toward each other, the tips of their cigarettes meeting in an ashy kiss (Figure 7.10). Boy and girl are almost identical; the modern habit of smoking links them physically and symbolically, marking the sexual spark between them like the "equal" sign in a mathematical equation. Another photograph, taken by Umbo (Otto Umbehr), shows a row of four seated women, equally stylish from their haircuts to their shoes, posed almost identically (Figure 7.11). With their heads slightly tilted and their hands almost on their hearts, they parody a cliché of maidenly sentimentality. Three of them cross their legs, but one does not—and the disparity, intentional or not, threatens to break down the machine of modern femininity. The third photograph is a self-conscious self-portrait of pensive solitude (Figure 7.12).

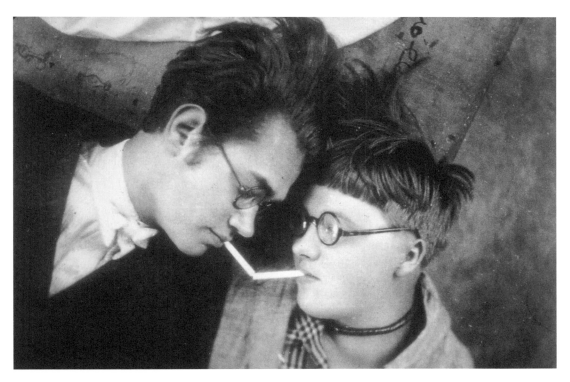

Figure 7.10. Photograph of Gerhard Kadow and Else Franke, 1929. The J. Paul Getty Museum, Los Angeles.

Figure 7.11. Umbo (Otto Umbehr), "Posierende Mädchen" (Girls posing), 1927. Copyright Phyllis Umbehr / Gallery Kicken Berlin.

Figure 7.12. Ise Gropius, "Self Portrait," 1927. Bauhaus-Archiv, Berlin.

Her hair also in a fashionable, mannish bob, Ise Gropius has used the reflections of a mirror to repeat her own image infinitely, as if internalizing the serial construction of the posing women. At the Bauhaus as elsewhere in the Weimar Republic, the New Woman embraced *neue Sachlichkeit*.[42] Drained of psychological autonomy and individualism, she allowed the trappings of androgyny to transfer her from the realm of sexual reproduction to that of serial production.

The advent of *neue Sachlichkeit* and the birth of the posthumanist subject intensified the attention to doll figures while shifting the focus from individual replicas to figural groups. With the rise of the mass audience, and in conjunction with the emerging machine aesthetic, the individual body lost its value as the privileged site of human identity. It was replaced in the Weimar cultural imagination by the corporate body, a group entity comprising a set of identical forms operating mechanistically, in unison. The mechanical woman of the late nineteenth century had transmogrified into a larger performing machine, an elaborate configuration composed of mechanized female bodies. The urge to abstraction thus inspired the mass ornamental designs—chorus lines of identical creatures, almost always female—that Kracauer described as "indissoluble girl clusters whose movements are demonstrations of mathematics."[43] The new human dolls acquired their significance in groups, gaining identity by association; those who "consider themselves to be unique personalities with their own individual souls," Kracauer added, "fail when it comes to forming these new patterns."[44] Chorus lines sometimes provided a literal model for Bauhaus high jinks, as in a photograph taken by Irene Bayer in the mid-1920s (Figure 7.13). Fourteen male figures—all slender and boyish, all wearing bathing costumes, some with hats, the first (Xanti Schawinsky) holding aloft a woman's sun parasol—kick back their heels in an impressive, messy row. "One need only glance" at a chorus line, Kracauer believed, "to learn that the ornaments are composed of thousands of bodies, sexless bodies in bathing suits. The regularity of their patterns is cheered by the masses, themselves arranged by the stands in tier upon ordered tier."[45] Here, the spirited conflation of participation and performance faces the camera lens, that singular mechanical spectator standing in for the expanded photographic audience.

If the camera's presence could gather a group of people into a chorus line, photography as a medium likewise structured Bauhaus activities, inspiring a wide variety of experimental activity. Dolls cavorted on the exterior architecture of the Dessau Bauhaus as often as they appeared in its indoor theater. They perched on several levels of the building in *The Building as Stage,* for example, a photograph taken by Lux Feininger in 1927 (Figure 7.14). Generally reproduced (as here) with the lowermost figure cropped from the image, the original photograph contains five human dolls, each one standing on its own architectural platform, while a

sculpted head gazes blindly from the building's penultimate story.[46] Each figure, enclosed in its costume and holding aloft at least one large and unwieldy prop, seems simultaneously expressive and speechless, communicative and dumb. Both on and off the stage, Bauhaus dolls proved remarkably photogenic, as seen in an image commemorating a performance of Schlemmer's *Triadic Ballet* at the Metropol Theater in Berlin in 1926 (Figure 7.15). A visual cacophony of bulbous forms and geometric shapes encases the bodies of nine performers, suppressing their individual identities and personalities. Their limbs and torsos are held at awkward angles; their gestures seem to have been inspired by the movements of modern machinery. But the sense of functionalism is undermined by both their whimsical costumes and their careful arrangement before the camera, rather than in relation to one another. Compositionally attractive as a group, they are unconvincing as robots or as a potential machine. Overall, the effect is one of uncontrollable exuberance, not rationalized efficiency.

The existential groundwork for these new figures had already been laid a decade earlier, in 1914, when Rainer Maria Rilke articulated the viewer's ambivalent relation to the figure of the doll. "At a time when everyone still tried hard to answer us quickly and soothingly," Rilke wrote,

Figure 7.13. Irene Bayer, "On the Beach at Mulde," 1926–27. Bauhaus-Archiv, Berlin.

Figure 7.14. Lux Feininger, *Der Bau als Bühne* (The building as stage), 1927. Bühnen Archiv Oskar Schlemmer. Photograph copyright 2010 Bühnen Archiv Oskar Schlemmer / The Oskar Schlemmer Theatre Estate, IT-28824 Oggebbio (VB), Italy and estate Oskar Schlemmer, Munich. Photograph from Archive C. Raman Schlemmer, 28824 Oggebbio (VB), Italy.

it, the doll, was the first to inflict on us that larger-than-life silence that later wafted over us again and again from space when somewhere we approached the frontiers of our existence. Across from it, while it stared at us, we first experienced (or am I mistaken?) that hollowness of feeling, that heart pause, in which one would perish if the whole of gently persistent nature did not lift one, like a lifeless thing, over abysses.[47]

Owing to its extraordinary capacity to absorb empathy, Rilke writes, the doll is the first figure to impose on a child the experience of estrangement. Staring blankly, it offers a comforting presence while cruelly inflicting a silence both uncomprehending and incomprehensible. A pivotal figure in human development, the doll prefigures relationships with others and, subsequently and metaphorically, with the spaces of architecture and the world. Its Bauhaus incarnations were similarly passive but capable of provoking intense emotional responses. Their padded bodies and masked heads simultaneously endearing and alienating, they provided a sentimental education for their audience, encouraging both emotional engagement and the absence of feeling.

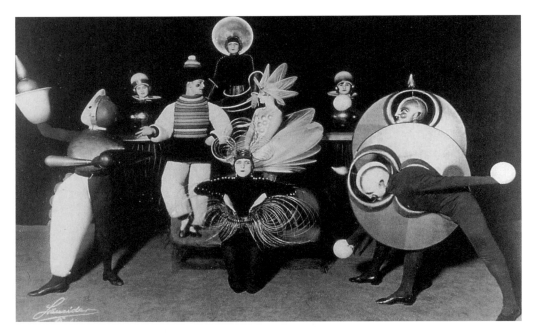

Figure 7.15. *The Triadic Ballet* as part of the revue *Metropolis Again* (*Das Triadische Ballett als Teil der Revue "Wieder Metropol"*), Metropol Theater, Berlin, 1926. Bühnen Archiv Oskar Schlemmer. Photograph copyright 2010 Bühnen Archiv Oskar Schlemmer / The Oskar Schlemmer Theater Estate, IT-28824 Oggebbio (VB), Italy and estate Oskar Schlemmer, Munich. Photograph from Archive C. Raman Schlemmer, IT-28824 Oggebbio (VB), Italy.

Spectators and Estrangement

As we have seen, Worringer had in 1908 posited self-estrangement, or *Selbstentäußerung,* as the basis of "all aesthetic enjoyment, and perhaps the entire human sensation of happiness generally."[48] Rather than describing opposing models of subjectivity among spectators and the objects of their attention, empathy and estrangement may be seen to exist on a theoretical continuum, each implying the other's presence. Afforded their historical specificity, they connote more than generic attraction and repulsion and are embedded within decades of discussion concerning the nature and function of the work of art and the aesthetic response it elicited. In 1961, Gropius evoked the discourse of Einfühlung and its description of the perception of space and form. Claiming that Schlemmer "experienced space not only through mere vision but with the whole body, with the sense of touch, of the dancer and the actor," Gropius explained that "with empathy, he would sense the directions and dynamics of a given space and make them integral parts of his mural compositions—as, for instance, in the Bauhaus buildings in Weimar."[49]

But the process of Einfühlung undergone by Weimar audiences differed from that of the nineteenth-century spectator, whom theorists had treated as a solitary male viewer, his cultivated soul transported by a unique work of art within a tranquil environment. With the emergence of the modern mass audience and the newly developed media it enjoyed—in particular the cinema, which absorbed the attention of women as well as men—ideas about spectatorship and the construction of modern subjectivity underwent continual reconfiguration. By the early twentieth century, Einfühlung had fallen from favor among psychologists and aesthetic theorists alike, owing partly to experimental research that found perceptual differences among its subjects. The concept was soon recoded as passive, describing an uncreative process of identification to which weak-willed audiences easily and happily succumbed. If the fully empathetic individual spectator of the nineteenth century had proven his profundity by "losing himself," as it were, in the privacy of his own home, the mass audience was now sometimes accused of empathizing too much. Benjamin would claim in 1936, "He who concentrates before the work of art becomes absorbed within it; he enters into this work. By contrast, the distracted mass absorbs the work of art into itself."[50] The absorption of the isolated individual, requiring time and erudition, was thought to lift the viewer to the nobler plane of art appreciation, while that of the masses—an undifferentiated group whose proletarian tastes inspired an aesthetic of reproducible objects—lowered the work of art to their own cultural level.

It was this model of spectatorship—shallow, passive, weak-willed—that Brecht opposed with such vehemence when, in 1936, he promulgated the theory of *Verfremdung,* variously translated as "estrangement" or "alienation," after many years'

work with the unnamed concept. This technique, he explained, could be used to combat the "empathy theater [*einfühlungstheater*]" that relied on the suspension of disbelief.[51] The use of Einfühlung, according to Brecht, existed only for bourgeois entertainment: it encompassed an experience of psychological and emotional identification that encouraged spectators to lose control of their own identities and prevent the possibility of critical thought. In Brecht's writings, the concept had little to do with the active experience of embodied spatial perception that the theorists of Einfühlung had debated in the last quarter of the nineteenth century. Psychological and emotional, it was devoid even of the element of self-estrangement that Worringer—following Simmel—had placed within its shallow domain. For Brecht, Einfühlung provided a useful foil for estrangement, the conceptual tool that was to reinstate spectators' self-control, critical awareness, and political engagement, both within the auditorium and, potentially, beyond its walls.

Despite his public condemnations of the concept, Brecht confided to his journal that Einfühlung could be useful as "a rehearsal measure"; in performances, he wrote, ideally "two different methods are used: the technique of empathy and the technique of estrangement [*die einfühlungstechnik und die verfremdungstechnik*]."[52] This alternation of distancing and absorption was in fact necessary, he explained, insofar as neither technique could exist without the intermittent presence of the other. In a journal entry of 1940, Brecht (with characteristic disregard for capital letters) elaborated on their theoretical relation:

> in this new method of practicing art empathy would lose its dominant role, against that the alienation effect (a-effect) will need to be introduced, which is an artistic effect too and also leads to a theatrical experience. it consists in the reproduction of real-life incidents on the stage in such a way as to underline their causality and bring it to the spectator's attention. this type of art also generates emotions; such performances facilitate the mastering of reality; and this it is that moves the spectator.[53]

Here again, theoretical techniques were conflated with the art forms that were to produce them, much as Roh had linked the realism of nineteenth-century visual art to "an era of Einfühlung"—a perceptual experience that, according to both Lipps and Worringer, involved a bifurcated sense of self. Contrary to his own highly publicized claims on the subject, the theatrical realism Brecht hoped to create in the 1930s required the occasional use of Einfühlung. At different historical moments—and with regard to radically different model subjects—both Einfühlung and estrangement described the viewer's potentially uncomfortable destabilization of identity.

Concurrent with the advent of *neue Sachlichkeit* in the 1920s, the aesthetic experience of the mass audience came to be described more positively—to be valued, that is, as much for its capacity to induce critical thinking as for its radical political potential. Brecht developed the concept of *Verfremdung* (both theoretically and theatrically) to interrupt sustained absorption in order to render the familiar strange and, in the process, to construct a spectator—a member of a mass audience—who was actively engaged intellectually. In Brecht's schema, Einfühlung directly opposed the concept of *Verfremdung* and represented a traditional, passive model of bourgeois spectatorship. The former encouraged emotional transport; the latter prevented such passivity, maintaining the audience's critical awareness of its distance from the work of art. The intermittent use of *Verfremdung,* Brecht argued, was "necessary to avoid the intoxicating effects of illusion," to prevent the audience from becoming too absorbed by the aesthetic experience.[54] However, as he acknowledged in his journals, both techniques were necessary to achieve theatrical success.[55] Estrangement was impossible without the intermittent presence of empathy—as the dolls at the Bauhaus, of course, were well aware.

Moholy-Nagy's discussion of the mechanical stage figures of futurism, expressionism, and Dada reveals the extent to which the intertwined models of empathy and estrangement—identification and shock—were expressed and encouraged by the performing bodies of the 1920s. "The effect of this bodily mechanics," he wrote, "essentially lies in the spectator being astonished or startled by the possibilities of his own organism as demonstrated to him by others."[56] Reproducing the machine in human form, such robots replaced the bourgeois characters of the naturalist stage with mechanical creatures. Yet as literal representations of modern mechanization, he believed, they still relied on the traditional technique of empathy. Spectators would identify their own bodies with those on stage, recognizing their differences with a pleasant frisson of shock. By contrast, the figures he demanded (and that Schlemmer and others would design) represented posthumanism at a symbolic level. Rather than simply reflecting modern machines literally, through their forms, Bauhaus dolls absorbed them into their structures. They did so both individually, through gesture, and—more crucially—at the level of the group. Individual dolls could be invested with personality by empathetic viewers; gathered together in photographs or on the stage, they formed the quintessential objects of estrangement. Trained by dolls to understand their own posthuman potential, spectators learned to discard their individuality and join the mass audience.

Surrogates of human *Sachlichkeit* on stage faced the *sachlich* humans in the audience: mirror images so interchangeable as to render the orchestra pit almost obsolete. Benjamin, expert equally in allegorical drama and children's toys, went so far as to claim that in the auditoriums of the Weimar Republic, "the abyss that

separates the players from the audience like the dead from the living . . . has become functionless."[57] Kracauer, too, noted the trend, writing in 1926 that "the surface glamour of the stars, films, revues, and spectacular shows" in Berlin mirrored its viewers' shallow collective consciousness. "Here, in pure externality," he explained, "the audience encounters itself; its own reality is revealed in the fragmented sequence of splendid sense impressions."[58] Like Benjamin—but with an ambivalence that stemmed from his own appreciation of the movies—Kracauer opposed such effortless viewing habits to the intense absorption of the traditional spectator. He ascribed the change in spectatorship to a change in spectators themselves, citing especially the increased number of salaried workers, the growing presence of women in the workforce, and the exacerbation of capitalism's rationalizing impulses.[59] In Kracauer's view, women visiting the cinema on their evenings off work were particularly prone to the shallow pleasures and perils of distraction. "Furtively," he wrote with a combination of sympathy, snobbery, and sexism, "the little shopgirls wipe their eyes and quickly powder their noses before the lights go up" at the end of each film.[60] His opinions were prompted not only by actual changes in the composition of audiences but also by the widespread tendency, in the Weimar Republic as elsewhere, to treat mass culture as female—in its models of spectatorship no less than in the objects of its attention.[61]

The *Triadic Ballet*

Bauhaus performances occurred in a remarkable variety of venues, from the experimental stage of the Dessau building to its balconies and roofs, where students and masters cavorted before the camera both in and out of costume—or from the German National Theater in Weimar, where the *Triadic Ballet* appeared as the culminating event of the celebrations of Bauhaus week in August 1923, to the unbuilt designs for theaters for mass audiences. The *Triadic Ballet* nevertheless remains the production most often associated with the school; begun by Schlemmer in 1912 and first presented in full at the Landestheater in Stuttgart ten years later, the project was reincarnated several times over the course of the following decade to critical and popular acclaim. In addition to the Stuttgart and Weimar productions, others took place in Dresden, Donaueschingen, Berlin, Frankfurt, and Paris, some as full-length performances and others within larger revues.[62] Delighted by the favorable response, Schlemmer transcribed some reviews into his diary for further analysis.[63] "The Triadic Ballet," he explained in an essay of 1926, "which avoids being actually mechanical or actually grotesque and which avoids actual pathos and heroism by keeping to a certain harmonious mean, is part of a larger entity—a 'metaphysical revue'—to which the theoretical investigations and the actual work of the Bauhaus stage at Dessau are also related."[64] The absence at the Bauhaus of

any strict demarcation between traditional theater performances and more general theatrical experimentation helps explain the presence of the work's costumes in a range of photographs unconnected to particular productions, with *The Building as Stage* offering only one of many examples.

Schlemmer laid out one version of the play's structure in a drawing of 1926, arranging the acts into columns, each divided horizontally into numbered scenes (Plate 14). The tripartite structure of the *Triadic Ballet*—performed by three dancers, two men and a woman—contained three acts with five, three, and four scenes, respectively. (This structure was variable; the three acts of the Weimar production in 1923, for example, contained six, three, and three scenes, respectively.) The three features of the ballet, according to Schlemmer, were "the costumes which are of a colored, three-dimensional design, the human figure which is an environment of basic mathematical shapes, and the corresponding movements of that figure in space."[65] He also considered the "fusion of the dance, the costumes, and the music" to operate triadically, an association perhaps more wisely ascribed to his own tendency to think in threes. In his plan, the characters appear either frontally or in profile, equal in height to the rectangles that contain them, which are painted yellow, white, and black according to the dominant color of each act. The fanciful, brightly colored costumes are composed of circles, spheres, triangles, and spirals; the padded forms with masks and hats appear inflatable. The symmetrical bodies seem no less abstract; stilted postures render limbs unlimber. Whimsical and awkward, the figures evoke marionettes, circus clowns, and the ultimate machine creatures of the 1920s.

Overall, the performance described the trajectory of dance history, leading from a relatively traditional dance in the first scene of act 1 to a dance of pure movement in the last scene of act 3. It traveled, in other words, from naturalism to abstraction, its sequence of costumes proceeding from almost human to thoroughly artificial. The first scene was performed by a female dancer wearing a modified ballerina's tutu; the third-act finale by a solitary creature with a spiral for a chest, a face composed of three nonrepresentational forms (all sharing one eye), and outstretched arms that brandished the tip of a spear and a rounded stick. This latter figure—whom Schlemmer labeled "the abstract"—exceeds the boundaries of its rectangle, as if breaking through the realm of representation at the end of the performance, into the world beyond.[66] An entire production of the *Triadic Ballet* thus appears within a grid; each row depicts, at a glance, the characters, costumes, and background color of each scene, with intermissions occurring, as it were, between the columns.

Beyond its utilitarian function, the design of the drawing is doubly significant at the level of its structure. First, rather than providing traditional diagrams of

stage blocking—aerial views of the characters on stage—the rectangular images present frontal views in a vertical sequence; individual scenes are legible from top to bottom. Using traditional artistic media (ink and watercolor on paper, among others), in other words, the depiction operates like three reels of film, evoking what was at the time the most technically advanced form of visual representation. The affinity of Bauhaus dolls for photography is here set in motion; if these abstracted figures were to feel at home in any context, it might well be that of the cinema, the exalted medium of the age of mechanical reproducibility. Shadow puppets of the machine age, they embody the existential shallowness of celluloid modernity. At the same time, they appear fundamentally incapable of feeling "at home" anywhere, exuding instead a sense of the uncanny as it was articulated by Freud in 1919. "The uncanny [*Unheimlich*] is that class of the frightening which leads back to what is known of old and long familiar," Freud argued, describing the double sensation of familiarity and strangeness.[67] Adorably animistic and un-comfortably inhuman, eerily charming, the dancing Weimar bodies of Schlemmer's drawing offer, simultaneously, the familiar playfulness of dolls and the sinister hol-lowness of mechanical creatures.

The logic of the film strip operates in tandem with a second structural feature of Schlemmer's drawing, which not only re-creates human bodies as dolls in the individual depictions but also reproduces this new creature at another scale. The first and third acts form larger figures, their bodies outlined by the colored back-grounds of the individual scenes. A yellow figure at the left, the height of the page itself, stands to attention with its arms at its sides: its head consists of the dancer in the first scene, its torso a perfect rectangle of four figures, and its legs the two soloists of the act's final scenes. The black figure at the right, meanwhile, four rectangles high, possesses a head and feet of equal size and a triangular body in between, with two identical dancers surmounting three more standing symmetri-cally below. Read in this way, the ballet's first and third acts form the bodies of, respectively, a man and a woman. He stands like a rectangular robot. She has breasts formed by the halos behind the upper bodies of the two dancers in scene 2; the metal winding in spirals around the female dancer at the center of scene 3—the "wire figure"—suggests pubic hair above the dotted lines that delineate, simul-taneously, her legs and the crotch of the larger figure. Viewed in this context, the little dolls in each scene may be considered ideal participants in the mass orna-mental forms that, as Kracauer wrote, "are never performed by the fully preserved bodies, whose contortions are the smallest component parts of the composition."[68] Between the yellow man and the black woman, meanwhile, the scenes of the sec-ond act (with one, two, and three dancers, respectively) together form an equilateral triangle, a visual triad symbolizing the ballet's overall schema. Below this platonic

shape are glued two paragraphs of typed text: notes on the ballet's formal components and performance history.[69]

In Stuttgart in 1922, Schlemmer played one of the parts of the *Triadic Ballet*; Albert Burger and Elsa Hötzel, partners in dance as in marriage who had appeared together in the ballet before, filled the two main roles. A photograph shows the two performing the third dance in the first act, a duet accompanied by the music of Marco Enrico Bossi (Figure 7.16). Their feet turned out in classic ballet position, their expressions stark like those of pantomime figures, and their arms gesticulating woodenly, Burger and Hötzel are formally linked but do not seem to interact.

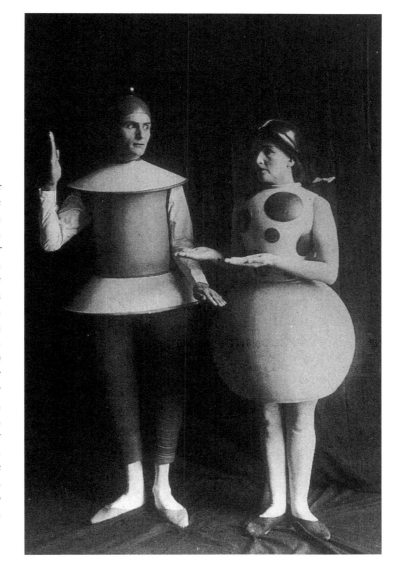

Figure 7.16. *The Triadic Ballet,* two figures from the yellow row, act I, scene 3 duet (*Das Triadische Ballett, zwei Figurinen aus der Gelben Reihe, 3. Auftritt, Zweitanz*), performed by Albert Burger and Elsa Hötzel, Landestheater, Stuttgart, 1922. Bühnen Archiv Oskar Schlemmer. Photograph copyright 2010 Bühnen Archiv Oskar Schlemmer / The Oskar Schlemmer Theatre Estate, IT-28824 Oggebbio (VB), Italy and estate Oskar Schlemmer, Munich. Photograph from Archive C. Raman Schlemmer, IT-28824 Oggebbio (VB), Italy.

In their polka-dotted, bulbous, or cylindrical costumes, they are uncanny but appealing, human yet mechanical; they are simultaneously dolls reconceived in human size and humans re-created as dolls. A confusion over gender parallels that of scale: if it is initially unclear in Schlemmer's diagram that the cylindrical figure is male and the spherical one female (their genders are reversed from the previous scene), the photograph is easily legible, yet the male dancer wears something akin to a tutu both around his waist and around his neck. The gender ambiguity is significant; in his diary that year Schlemmer registered his approval of the use of masks and his nostalgia for the use of men to represent women on stage: "Dates that historians consider high points," he wrote, "should rather be called declines: 1681, the first appearance of female dancers—until then female roles had been performed by men. 1772, the abolition of face masks."[70]

COSTUME PARTIES AND THE GESAMTKUNSTWERK

"Today the arts exist in isolation," Gropius proclaimed in 1919 in the initial Bauhaus program; he found this a regrettable condition, "from which they can be rescued only through the conscious, cooperative effort of all craftsmen."[71] To idealize the unification of all the arts in early-twentieth-century Germany was almost a cultural cliché, heavily indebted to Wagner's formulation of the Gesamtkunstwerk. One might draw a parallel between the Wagnerian notion of the unification of the arts and the way in which the umbrella structure of the general introductory course at the Bauhaus sheltered the specialized training of students within particular workshops.[72] "Together, let us desire, conceive, and create the new structure of the future," Gropius entreated, echoing the composer's formulation of "the artwork of the future" from his essay of that title.[73]

Wagnerian echoes overlapped with those of Nietzsche, whose importance for artistic thinking in Germany in the early twentieth century (and particularly in Weimar, where his archives were located) was unrivaled. By 1919, the creative, internationalist idol of prewar Germany had become a cult figure of right-wing nationalism, but pan-Nietzschean sentiments continued to captivate Germans across the political spectrum. A romantic Nietzscheanism lurked at the Weimar Bauhaus, inhabiting the souls of its artistically inclined idealists.[74] Gropius, no exception to this tendency, advocated the "mutual planning of extensive, Utopian structural designs—public buildings and buildings for worship—aimed at the future" in his "Program for the Staatliche Bauhaus in Weimar," but he posited churches, not theaters, as the communally constructed buildings that would incorporate all forms of art. Omitting both theater architecture and such subsidiary arts as costume and set design, stage decor painting, and the making of props, the program mentioned performance only in the context of extracurricular entertainment:

"Encouragement of friendly relations between masters and students outside of work; therefore plays, lectures, poetry, music, costume parties."

Exactly as Gropius decreed, theatrical events ranging from plays to costume parties, from organized fetes to spontaneous festivities, operated as essential binding agents for social life at the Bauhaus. "We worked on them as if obsessed," Felix Klee later recalled; "Oskar Schlemmer presented his stage plays especially for them. On May 18 we celebrated Walter Gropius's birthday. Every year was the traditional lantern party."[75] Wassily Kandinsky's acquisition of German citizenship in early 1928 provided another occasion for a celebration, which he attended wearing traditional German lederhosen. Parties dissolved the boundaries between spectators and performers, with all in attendance taking part in the larger spectacle. At a professional level, they provided innumerable opportunities for the design of invitations, posters, costumes, and room interiors, as well as for performances by various Bauhaus groups.[76] One of the most famous of these was the Beard, Nose, and Heart Party, organized by the Bauhaus band and held in Berlin on March 31, 1928—coincidentally, Gropius's last day as director—with invitations designed by Herbert Bayer. As a fund-raiser for the Bauhaus with an entrance fee of ten marks (half price for art students), the event featured performances by the Bauhaus Theater group.

A photograph by Umbo is thought to depict two revelers at this Bauhaus party: two identical clowns wearing jackets and ties and sporting dark, painted mustaches; metallic beards, eyebrows, and noses; and thick, curly hair (Figure 7.17). While one stares intently at the viewer, the other, identical save for the addition of a pair of spectacles, appears in profile, gazing with equal seriousness to the left; together they present the front and side views of the same party specimen.[77] The funnels perched upside down on their heads seem to bear a functional relation to the long tubes, held in their mouths like straws, that cross each other before disappearing over what appears to be the figures' shared shoulder—possibly to reappear at the tops of their funnels. Their heads held close, their bodies appear to merge, while the tubes and funnels share a delightful mechanical uselessness. Despite an absence of background detail, one senses the event's overlapping sounds, swirling movements, and multitude of other guests; emerging from the darkness with the blurred clarity of an alcoholic gaze, the two revelers embody a deadpan glee. Bodily interference—the clown tripping over his feet, the prankster falling from his chair—infused Bauhaus parties, accompanied by musical bands, dancing, recitations, and general merriment.[78] Under their funnels, the two revelers seem prime candidates for the happy irritation produced by their own bodies; nothing would appear to please them more than the prospect of tripping over their own feet.

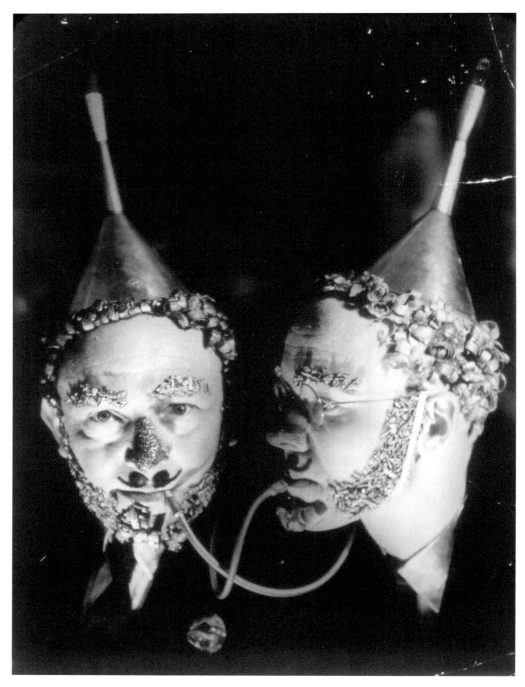

Figure 7.17. Umbo, "Two Revelers at the Beard, Nose, and Heart Party," Berlin, 1928. Courtesy of the Research Library, The Getty Research Institute, Los Angeles, California (850514).

Except, perhaps, for the possibility of tripping over each other's feet—and, the photograph suggests, these two revelers might not even register the difference. Identically dressed and decorated, they are mimetically twinned like mirror images in a carnival funhouse, their doubled presence destroying any sense of individuality. Encrustations of face paint render their faces as masks, devoid of the outward manifestations of human personality. With identical poise, they mirror each other on either side of the photograph; the crossed tubes emanating from their mouths mark a hinge between them. While the figure on the left stares directly at the camera, and at the viewer, his twin presents a more ambiguous gaze. If he is staring into the distance, then the two look past each other, peering at cross-purposes: a face and profile exemplifying serious silliness. If, however, he stares at his partner, then the viewer is incorporated into a triangular *mis-en-abîme* of clown vision, a construction of gazes interrupted only by the viewer's doubling back to return the gaze of the figure on the left. The viewer—perhaps on the verge of sensing an inverted funnel atop his or her own head—might well suppose that the crowd of partygoers outside the frame contains more copies from the same mold: an assembly line of identical clowns in formal attire, purposefully sipping from useless straws. Here as elsewhere, theatrical exuberance at the Bauhaus is undermined by uncanny repetition.

Although probably taken in 1928, the photograph might instead depict the infamous Metallic Party held in Dessau early the following year. Originally entitled the Church Bells, Doorbells, and Other Bells Party, this event was renamed, it is said, in an effort to keep the noise level down. Guests came attired in metallic objects of all kinds, from tinfoil to frying pans. They entered the party by sliding down a large chute that deposited them in the first of several rooms decorated for the occasion. An anonymous report printed in a local newspaper several days later described the event's delightful confusion. "And then there was music in the air everywhere," it read,

> and everything was glitter wherever one turned. The rooms and studios of two floors, which normally are used for serious work, had been decorated with the greatest variety of forms placed together all over the walls, shinily metallic and fairy-like, the ceilings hung with bizarre paper configurations. . . . In addition music, bells, tinkling cymbals everywhere, in every room, in the stairways, wherever one went.[79]

With breathless syntax, the text reproduces the sense of exhilaration fostered by the party's carnival atmosphere, as bands played in competition with one another while other musical sounds, less easily categorized, wafted through the Bauhaus

air. The Metallic Party also featured more traditional performances in the build-
ing's auditorium, where, the newspaper reported, "a gay farrago of film pictures
alternated with various stage presentations."[80]

Such theatricality manifested itself both in formal performances and in the
guise of general exuberance. "One does not want simply to see the play on the stage,
but to perform the play oneself," Karl Friedrich Schinkel—perhaps Germany's
most famous theater architect—had declared in 1821.[81] Reciprocity between spec-
tator and performance, a trope of theater discourse increasingly prevalent after
1900, was explored explicitly at the Bauhaus. Bemoaning the structural and sym-
bolic "isolation of the stage," for example, Moholy-Nagy stated that

> in today's theater, STAGE AND SPECTATOR are separated too much from
> each other, divided too much into active and passive, for creative rela-
> tionships and tensions to be produced between them. An activity must
> be developed that does not let the masses watch silently, that does not
> simply excite them inwardly, but that instead lets them take hold of,
> participate in, and—at the highest level of a redemptive ecstasy—merge
> with the action on stage.[82]

The aesthetic response was not meant to occur too far beyond the limits of spec-
tators' bodies; rather, performances would inspire a seated audience to a cathartic
communal surge of emotion, an active but relatively contained experience. These
efforts would be especially encouraged by the designs for three Bauhaus theaters:
Farkas Molnár's U-Theater, seating 1,590; the Spherical Theater of Andreas Wein-
inger, and Gropius's Total Theater of 1926, a 2,000-seat amphitheater intended for
the productions of Piscator.[83] This last structure was to contain neither private
boxes nor other architectural subdivisions, such as aisles, to divide the audience
hierarchically.

Within the Dessau auditorium, 164 chairs, designed by Breuer, with tubular-
steel frames and folding canvas seats, formed a unified block of spectators: eight
identical rows of nineteen chairs preceded a back row comprising twelve chairs
that flanked the room's wide entryway. Designed to present both lectures and more
elaborate stage performances, and raked very gently to improve sight lines, the
room expressed the *sachlich* ideals of practicality and functionalism.[84] A photograph
taken by Consemüller in 1928 of the block of seats prompts an image of a block of
identical spectators (Figure 7.18). As in Gropius's Total Theater, designed the
same year, the unity of the audience is emphasized. No spatial or architectural ele-
ments divide the spectators, whose group identity—and reciprocal relationship
with the posthumanist performers—is thereby encouraged. Another photograph

Figure 7.18. Erich Consemüller, Bauhaus Auditorium, Dessau, 1928. Courtesy of a private collection, Nachlass Erich Consemüller, Cologne. From *Erich Consemüller,* plate 28.

by Consemüller, taken one year earlier from the back of this auditorium, appears to show a rehearsal in progress on stage (Figure 7.19). At the center, Schlemmer perches in profile on a set of three steps. With his right hand, he gestures at the dancer Siedhoff, who stands on a wooden platform at left in a Schlemmer doll outfit, mask in hand, and leans against another structure. The relationship of the audience to the stage is thus reproduced within the photograph, as Schlemmer observes Siedhoff's performance and the two Breuer stools between them evoke the more comfortable seats in the auditorium. Andreas Weininger plays the grand piano in the auditorium at right; an unidentified man in worker's coveralls on the right directs a movie camera out the window, toward the building's terrace; and another man another stands at the center, watching the scene from the canteen behind the stage, its floor level with the stage. Finally, a sixth figure lurks at the left: its body a padded Schlemmer costume hung from a giant ladder, its head resting on the steps below. Hardly a spontaneous rehearsal image, the photograph presents the Bauhaus theater as Gesamtkunstwerk: music, dance, film, stage direction, spectatorship, and a decapitated Bauhaus doll gather together onstage, poised equally for the camera.

Creatures simultaneously without affect and fully invested with personality performed on a range of Bauhaus stages, occupied its auditoriums, celebrated at its costume parties, and clambered over its architecture to be captured by its cameras. Seven decades earlier, Wagner had imagined an ideal scene at the theater in which the spectator,

> by looking and hearing, completely transports himself onto the stage; the performer becomes an artist only by complete absorption into the audience. Everything that breathes and moves on the stage breathes and moves through an expressive urge to communicate, to be seen and heard in that space which, although comparatively small, seems from the actor's perspective to contain all of mankind. And the audience, that representative of public life, likewise disappears from the auditorium; it lives and breathes only in the work of art, which it takes for life itself, and on the stage, which it takes for the universe.[85]

In the 1920s, the Bauhaus theater aimed at something similar. Complete identification would transpire between performers and spectators; the auditorium walls

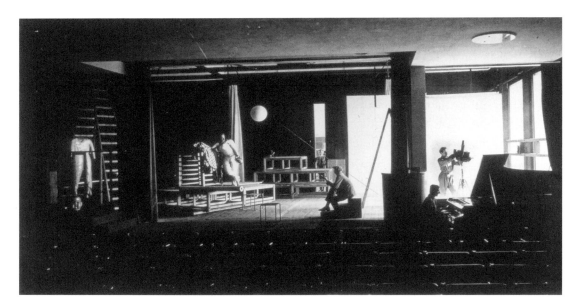

Figure 7.19. Erich Consemüller, photograph of Werner Siedhoff, Oskar Schlemmer, and Andreas Weininger on the Dessau Bauhaus stage, 1927. Courtesy of private collection, Nachlass Erich Consemüller, Cologne. Photograph copyright 2010 Bühnen Archiv Oskar Schlemmer / The Oskar Schlemmer Theatre Estate, IT-28824 Oggebbio (VB), Italy and estate Oskar Schlemmer, Munich. From *Erich Consemüller*, plate 118.

would fall away to reveal the entire world as the ultimate Bauhaus stage. But such developments ultimately depended on the receptivity of its audience, in Schlemmer's eyes: "It begins with building the new house of the stage out of glass, metal and tomorrow's inventions," he maintained in 1925. "But it also begins with the spectator's inner transformation."[86] Recognizing themselves in the Bauhaus dolls, Weimar spectators experienced a communal heart pause worthy of Rilke as all of nature lifted them, like lifeless things, across the abyss of modernity itself.

8

Invisible Wagner

In fact the atavistic moments in Wagner are always ones in which progressive
forces are set free.

—THEODOR ADORNO, *In Search of Wagner,* 1937–38

INTOXICATION AND ADDICTION

"Few puzzle any more in the way generations of Wagner lovers and Wagner fear-
ers did, about what Wagner's operas mean. Now Wagner is just enjoyed as a
drug," Susan Sontag asserted in 1987.[1] In fact, Wagner's works have been firmly
associated with themes of intoxication and addiction for well over a century, at
least since Nietzsche complained that Wagner manipulated the passions of those
in his audience rather than appealing to their intellects. Calling the composer
"the modern artist par excellence," Nietzsche argued that Wagner exemplified the
late-nineteenth-century European disease of decadence, which included among its
attributes the dangers of addiction.[2] Nietzsche had not been immune; his enthu-
siasm had prompted him in 1872 to dedicate his first book, *The Birth of Tragedy
out of the Spirit of Music,* to Wagner. By 1888—a dozen years after the founding
of the Bayreuth Festival Theater and five years after the composer's death—he
wrote as one who had recognized and overcome an addiction: "I am, no less than
Wagner, a child of this time; that is, a decadent: but I comprehended this; I resis-
ted it. The philosopher in me resisted."[3]

Nietzsche presented the experience of listening to Wagner's music as a constant
need for further intoxication, a craving for a drug, and he argued that one could
overcome this need only by remaining conscious of its powers; self-awareness thus
mitigated against potentially overwhelming enthusiasm. "By apparently succumb-
ing to Wagner's overflowing nature," he asserted, the spectator "who reflects upon
it has in fact participated in its energy and has thus as it were *through him* acquired
power *against him*; and whoever examines himself closely knows that even mere
contemplation involves a secret antagonism, the antagonism of *reflection* [*Entge-
genshauens*]."[4] One might risk losing one's autonomy by enjoying Wagner's music
dramas, but danger could be averted by engaging in the activity of reflection. The

logic appears self-serving: the philosopher recommends contemplation as a form of inoculation against his own disease. But the combination of critical distance and emotional absorption was central to German aesthetic discourse in the late nineteenth century and would remain so for many decades.

Reflection, contemplation, and careful self-examination were thus necessary elements of the spectator's engagement with Wagner's work; the effort to maintain critical distance would counteract the potentially dangerous loss of self-awareness that Nietzsche associated with the experience of succumbing to, or merely enjoying, the work of art. The philosopher described the proper manner of attending to Wagner's work as a kind of experiential doubling:

> If his [Wagner's] art allows us to experience all that a soul encounters when it goes on a journey—participation in other souls and their destiny, acquisition of the ability to look at the world through many eyes—we are, then, through such alienation and remoteness [*Entfremdung und Entlegenheit*], also made capable of seeing him himself after having experienced him himself.[5]

Such a mention of the experience of alienation appears, to a contemporary reader, almost Brechtian.[6] So, too, does the particular combination of this experience (whether described as alienation, critical distance, reflection, or self-awareness) with what is generally presumed to be its opposite: a loss of autonomy that is figured as a process of psychological identification or, as here, a "participation in other souls." Scholars have long linked the ideas of Nietzsche with those of Brecht; one might also argue that the admixture of estrangement and empathy, of critical distance and an identificatory loss of self, has been central to the discourse of modern spectatorship.[7]

The decadent soul overwhelmed by decadent music in an age of decadence was soon an established cliché—so much so, in fact, that in the late 1930s Theodor Adorno could blithely assert that "the very form of the music drama is a permanent invitation to intoxication."[8] In his novel *The Man without Qualities,* first published in 1930 and set in Vienna in 1913, Robert Musil caricatured this modernist victim with the character Walter, who could "speak convincingly of the immorality of ornament, of the hygiene of simple shapes, and of the beery fumes of Wagnerian music, as was in keeping with the new artistic taste."[9] Capable of quoting Adolf Loos and Nietzsche with equal verve, Walter had embraced modernity but now bemoaned its cultural degeneracy. "He would draw a line somewhere," Musil explains—for instance, "in painting at Ingres"—and explain that everything that came later was florid, degenerate, over-sophisticated and on the downward

path."[10] Having absorbed the relevant philosophical texts of his day, Walter despises all that Wagner stands for; as a weaker philosopher than Nietzsche, however, he cannot resist the musical narcotic by tempering his intoxication with the necessary element of contemplation.

Sometimes the addiction to Wagner's music extended beyond spectatorship. As an amateur pianist in tune with the decadence of his age, Musil writes, Walter succumbs in the privacy of his own room like a solitary alcoholic driven to drink:

> With or without his will, [the music] turned into improvisations on themes from Wagner operas, and in the splashes of this dissolutely swelling substance, which he had denied himself in the days of his pride, his fingers waded and wallowed, gurgling through the flood of sound. Let them hear it far and wide! His spinal cord was paralyzed by the narcotic influence of this music, and his lot grew lighter.[11]

Despite his own revulsion, the music's intoxicating powers defy Walter's resistance. The focus is ostensibly on Wagner, yet (as the phrase "with or without his will" reveals) Musil directs his parody most pointedly at Nietzsche's own acknowledged addiction.

The philosopher had not been alone in his predicament. In 1885, a French music critic had described the physical effects of Wagner's music in terms that suggest personal experience: "I know well that the abuse of excessive sonorities, altered harmonies, chromatic progressions and interrupted cadences imposes over time a painful shaking of the brain, and by constantly waiting for delayed resolutions, tenses up the ears and forces the nerves to shatter."[12] Such physical disturbances were enumerated not in a spirit of criticism but, rather, as evidence of a new kind of music, one rooted in physicality—and, specifically, in its physical effect on an audience. While descriptions of the responses of individual listeners (and not only those of Nietzsche or of Musil's fictional Walter) were common, this audience was usually conceived of as communal—and never more so than during a performance in Bayreuth.[13] A tension thus remained between the extraordinary individualism of the cultured listener, whose appreciation for Wagner verged on addiction, and this erudite individual's participation in a community of the similarly intoxicated. Intoxication, addiction, and shattered nerves were the physical evidence of the spectator's engagement with an advanced musical modernism that was as jarring in its way as the clang and the clatter of the modern world.

It was this modern world, according to Max Nordau, that inspired the creation of the Gesamtkunstwerk, which Nordau described in his book *Degeneration* in 1892—with admiration, disdain, and gentle mockery—as a combination of art

forms that provided the sensory overload necessary for those who appreciated or were addicted to high culture. Shifting the terms of cultural discourse from objective categories of particular forms of artistic production to the subjective experience of those who enjoyed these various art forms, Nordau explained that

> art exhibitions, concerts, plays and books, however extraordinary, do not suffice for the aesthetic needs of elegant society. Novel sensations alone can satisfy it. It demands more intense stimulus, and hopes for it in spectacles, where different arts strive in new combinations to affect all the senses at once. Poets and artists strain every nerve incessantly to satisfy this craving. A painter . . . paints a picture indifferently well of the dying Mozart working at his *Requiem,* and exhibits it of an evening in a darkened room, while a dazzling array of skillfully directed electric lights falls on the painting, and an invisible orchestra softly plays the *Requiem.*[14]

Thus artists, like spectators, had to contend with the strained nerves caused by the demands of modern life. Nordau's parable of how one such artist negotiated this situation at first seems arbitrarily chosen, yet his broader reference to the staging of Wagner's music dramas in Bayreuth soon becomes clear in an explanation verging on parody: "A musician goes one step further. Developing to the utmost a Bayreuth usage, he arranges a concert in a totally darkened hall, and thus delights those of the audience who find opportunity, by happily chosen juxtapositions, to augment their musical sensations by hidden enjoyment of another sort." The scene encompassed all the elements of Wagner's Gesamtkunstwerk: image, sound, and movement carefully deployed in a "totally darkened hall" to delight the audience with both the work of art and something more mysterious and, possibly, risqué.

Wagnerian intoxication and addiction were also easily framed in terms of illness—hysteria, neurosis—that was ascribed not only to members of the Bayreuth audience but also to the works they witnessed there and, ultimately, to the composer himself. Here, again, the terms had been set by Nietzsche. "Wagner's art is sick," he proclaimed in *The Case of Wagner,* adding,

> The problems he presents on the stage—all of them problems of hysterics—the convulsive nature of his affects, his overexcited sensibility, his taste that required ever stronger spices, his instability which he dressed up as principles, not least of all the choice of his heroes and heroines . . . all of this taken together represents a profile of sickness that permits no further doubt. *Wagner est une névrose* [Wagner is a neurosis].[15]

In an extraordinary conflation of a composer's entire oeuvre, lifetime of theoretical writing, and ailing psyche, Nietzsche offered an assessment of Wagner and "Wagnerianism" that later authors, from Nordau to Sontag, would accept almost wholesale. Such a melding of the artistic, theatrical, theoretical, and psychosomatic realms is unsurprising, given the all-encompassing nature of the Gesamtkunstwerk, yet Nietzsche's claims emerged fundamentally from his own enthusiasm for the composer and his work—and equally, from the falling out that took place between the two men in 1876.

Following Wagner's death, the discussion of addiction to his music dramas could shift to a consideration of the less pleasant aftereffects of the intoxication that this addiction had caused. "At Bayreuth," George Bernard Shaw wrote in 1889 after his first visit there, "where the Master's widow, it is said, sits in the wing as the jealous guardian of the traditions of his own personal direction, there is already a perceptible numbness—the symptom of paralysis."[16] Wagner had been dead for six years, and rigor mortis had apparently extended from the composer's body to the atmosphere in Bayreuth more generally. The mourning over his death, one might say, was experienced as a collective hangover among Wagner enthusiasts, one that appeared to preclude, for the moment, any chance of recovery from the exuberance once fed by addiction. "The conclusion that the Bayreuth theatre cannot remain the true Wagner Theatre is obvious," Shaw explained. "The whole place reeks of tradition—boasts of it—bases its claims to fitness upon it. Frau Cosima Wagner, who has no function to perform except the illegitimate one of chief remembrancer, sits on guard there."[17]

Shaw's assertion that the stench of death at Bayreuth prevented it from remaining "the true Wagner Theatre" implied, of course, that the theater had been true to the composer's original vision during his lifetime—and that this vision itself had been consistent. In fact, any attempt to build a modern theater building to house the total work of art of the future was doomed to failure, or at least destined to cause profound disappointment; Wagner's utopian wish to bring art into life for a carefully selected (and self-selecting) group of art lovers was logically impossible, given that it could not be realized until the audience of the future itself existed. By 1876, Wagner had long since disavowed his youthful radicalism, and the theater completed in Bayreuth reflected a model of aesthetic experience that differed greatly from the one he had put forward with such enthusiasm in his essays of 1849. For all its considerable success, the Festival Theater presented Wagner's works in such a way as to displease even the most dedicated Wagnerians. These included the composer himself, who purportedly exclaimed in 1878, "Oh! I am seized with horror at the idea of all these costumed, stuffed creatures; after creating the invisible orchestra, I would like also to invent the invisible theater! And the inaudible orchestra."[18]

Sorcery, Conducting, and Hypnosis

Much like the simplified and rationalized architecture around it, Wagner's "mystical abyss," the submerged pit where the orchestra played, often flummoxed those who sat in the Bayreuth auditorium. So, too, did the stage image that hovered before them in that darkened space. Although the Bayreuth Festival Theater had been constructed to provide a more effective performance and to encourage the audience's active perceptual engagement, it was for decades described in terms of sorcery and magic, and these associations were also conferred on Wagner. Nietzsche's vociferous and well-documented disillusionment with the composer in 1876 matched nothing so much as the intensity of the enthusiasm it had supplanted. "And yet I was one of the most corrupted Wagnerians," the philosopher himself lamented; "I was capable of taking Wagner seriously.—Ah, this old magician, how much he imposed on us!"[19]

In the 1890s, Nordau linked the powerful effects of the striking visual imagery on stage in Bayreuth to the productions that were seen there and also, specifically, to the composer himself: "Every action embodies itself for him in a series of most imposing pictures, which, when they are composed as Wagner has seen them with his inner eye, must overwhelm and enrapture the beholder."[20] This visual sorcery was in some mysterious manner transferred from the "inner eye" of the composer (whose death, here, remains strangely unacknowledged) to the eyes of his spectators. The magical process of transference that rendered Wagner's imagined or virtual images visible to Bayreuth audiences was matched by the extraordinary power of the images themselves, according to Nordau, for whom Wagner's achievements were (among other things) emphatically visual: "These are images [Bilder] to which nothing hitherto in art approaches."[21]

As we have seen, the magic of the stage images in Bayreuth was sustained by a range of features that included a double proscenium framing the view of the performance at an uncertain distance and an indeterminate scale, a submerged orchestra pit rendering the orchestra and its conductor invisible to those in the audience, the careful use of stage lighting, and a darkened auditorium. Visitors who found these innovations incomprehensible and therefore potentially suspect, particularly in combination with the extraordinary auditory effects of Wagner's music, often turned to the rhetoric of sorcery to describe their experiences. In his own description of the opening moments of *Parsifal,* for example, Mark Twain reported the following magical scene:

> Finally, out of darkness and distance and mystery soft rich notes rose
> upon the stillness, and from his grave the dean magician began to weave

his spells about his disciples and steep their souls in his enchantments. There was something strangely impressive in the fancy which kept intruding itself that the composer was conscious in his grave of what was going on here, and that these divine souls were the clothing of thoughts which were at this moment passing through his brain, and not recognized and familiar ones which had issued from it some other time.[22]

For Twain, visiting Bayreuth in 1891, the magic of the performance was personified in the figure of Wagner himself and compounded by the impossible sensation of time travel. While fully aware of the fanciful nature of his sensations, he nevertheless felt convinced of their veracity.

Magical performances require magicians, and conductors in Bayreuth (including, first and foremost, Wagner himself) were as celebrated as the soloists on stage; postcards printed each year provide visual evidence of their fame. As one cartoon from 1876 attests, Wagner's persona, his music, and his status as a conductor were easily elided (Figure 8.1). With his intense glare, wildly unkempt hair, outstretched arms, and conductor's baton—this last evoking a policeman's stick—the composer not only knocks the hats off passersby but also knocks these hapless listeners to the ground. Wagner was not the first composer to conduct his own work, as we have seen; Hector Berlioz and Carl Maria von Weber were notable precursors, as was Felix Mendelssohn, who is generally credited with introducing the use of the baton. Yet Wagner became famous for combining the activities of composing and conducting, owing partly to the existence of the orchestra pit, auditorium, and theater that he had commissioned for performances of his works. The elision of composer, conductor, and architecture at Bayreuth had long been established in the critical literature when Adorno labeled Wagner—making no effort to justify his claim—"the first composer to write conductor's music in the grand style" and presented the composer-conductor's baton as the symbolic object that stood in for Wagner's goals and achievements.[23]

The particular terms with which Adorno discussed Wagner's character, his musical achievements, and his work as a conductor are worth noting, both for how they meld these realms and for their strange conflation of passivity and agency. All of Wagner's compositions, Adorno argued, were

> conceived in terms of the gesture of striking a blow and . . . the whole idea of beating is fundamental to it. As the striker of blows [*Schlagender*], the composer-conductor gives the audience's claims a terrorist emphasis. Democratic considerateness towards the listener is transformed into connivance with the powers of discipline."[24]

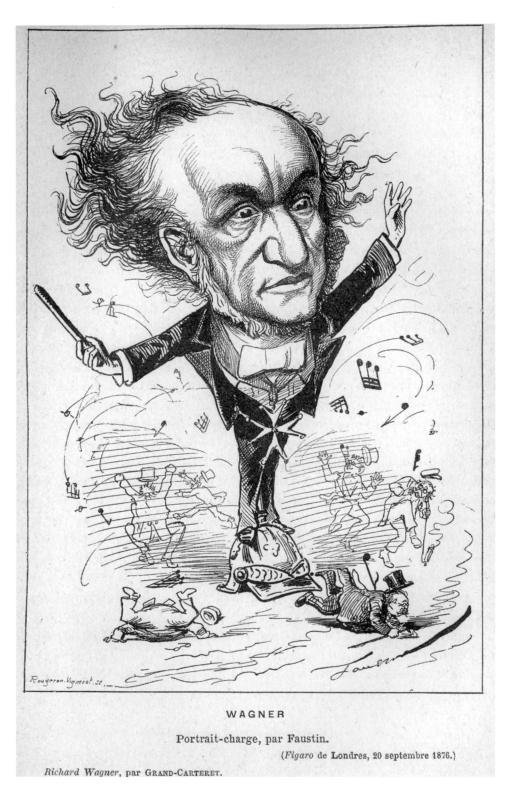

WAGNER

Portrait-charge, par Faustin.

(*Figaro* de Londres, 20 septembre 1876.)

Richard Wagner, par GRAND-CARTERET.

Figure 8.1. Faustin, cartoon of Wagner conducting in 1876, from John Grand-Carteret, *Richard Wagner en caricatures* (Paris: Larousse, [1892]), 95.

Standing in the orchestra pit, the conductor cruelly controlled his musicians as if using physical force, according to Adorno, yet his power merely represented that of those gathered in the auditorium. What initially appeared in positive terms as democratic soon devolved to become something sinister. Or, more accurately, the contradiction was simultaneous: "The conductor-composer both represents and suppresses the bourgeois individual's demand to be heard. He is the spokesman for all and so encourages an attitude of speechless obedience in all."[25] Wagner was thus seen to be sadistic and impotent, both personally and professionally; and Wagnerianism was embodied in him, symbolized by his conductor's baton, and encapsulated in the concept of the Gesamtkunstwerk, which Adorno discussed as if it had been fully realized in Bayreuth both in 1876 and in the ensuing half century.

For Adorno, the essential authoritarianism of Wagner's project, understood equally in terms of sadism and impotency, was reinforced by the architecture in Bayreuth, where the mystical abyss allowed the orchestral music to flood the auditorium without the audience catching sight of its source. By hiding the conductor and his orchestra under the stage and by eliminating social and architectural distractions, Adorno maintained, Wagner prevented spectators from seeing—and, therefore, from understanding—how the Gesamtkunstwerk was being constructed. "The flawed nature of the whole conception of music drama is nowhere more evident than . . . in the concealment of the process of production," he stated; with sound emanating from an unseen source, the music drama appeared automatized.[26] With the exception of occasional offstage vocalizing, however, singers perform at Bayreuth in full view of the audience, their mouths clearly moving; only the orchestral music is produced invisibly. This logical inconsistency did not seem to trouble Adorno, who argued that the Gesamtkunstwerk forced spectators to substitute emotional, psychological, and aesthetic absorption for critical thinking, which itself had been rendered impossible.

Adorno based his arguments primarily on the auditorium architecture of the Bayreuth theater, a building he appears never actually to have visited.[27] He also extended them to include Wagner's music. "The idea that governs his orchestration," he declared, was "that of sound from which the traces of its production have been removed, sound made absolute."[28] It was therefore impossible for those in the audience to comprehend how even one aspect of the music drama—the music itself—had been created, let alone for them to fathom the structural interrelation of the various art forms. Even the simple combination of two wind instruments was presented as obfuscatory: "The simultaneous combination of flute and clarinet prevents the listener from perceiving how they were produced; their specific character is obscured and they vanish in an enchanted sound that appears unrelated to any instrumental grouping."[29] Hypnotized by the baton of an unseen conductor,

Wagner's audiences were lulled into mindless, uncritical enjoyment. To put it in Nietzsche's terms, they were unable to counteract the experience of intoxication with that of reflection—and Adorno's own language was itself remarkably Nietzschean: "In the Gesamtkunstwerk, intoxication, ecstasy, is an inescapable principle of style; a moment of reflection would suffice to shatter its illusion of ideal unity."[30]

In Adorno's view, the encouragement of passivity in Bayreuth was compounded by the plots of the music dramas performed there, which invariably conjured a mythical past rather than directly engaging contemporary reality. These works took place beyond the boundaries of historical time; their unending melodies, incremental chromatic shifts, and unusual length stretched temporal parameters and emphasized, at all times, slowness. "The eternity of Wagnerian music," Adorno maintained, "like that of the poem of the *Ring,* is one which proclaims that nothing has happened; it is a state of immutability that refutes all history by confronting it with the silence of nature."[31] Both thematically and structurally, in other words, Bayreuth productions transported spectators unwittingly (and even against their will) into another realm, one in which sound emerged from the vicinity of the hovering stage image for hours at a time. Hiding the means of musical production from view, Adorno further argued, rendered spectators the passive recipients of an overwhelming performance, lulling them into appreciation beyond the limits of time itself. The arrangement established a profoundly paradoxical relation between authority and invisibility; as composer and conductor, Wagner deployed his powers behind the scenes, controlling orchestra and audience in a manner that Adorno described as hypnotic. The magic in Bayreuth, as well as the psychological and emotional transport that occurred there, could thus be seen as a more sinister form of sorcery: a manipulation of the hapless mass audience.

In his notes to *Rise and Fall of the City of Mahagonny,* the opera written in 1930 in collaboration with the composer Kurt Weill, Bertolt Brecht likewise stridently derided the concept of the Gesamtkunstwerk, which he, too, associated with passivity and intoxication. "So long as the expression 'Gesamtkunstwerk' (or 'integrated work of art') means that the integration is a muddle," he declared—as if no other definition for the term had become available in the previous eight decades— "so long as the arts are supposed to be 'fused' together, the various elements will all be equally degraded, and each will act as a mere 'feed' for the rest."[32] Such a state not only was theoretically unacceptable, insofar as it prevented the various forms of art from retaining their individual identities, but also had a detrimental effect on the spectator:

> The process of fusion extends to the spectator, who gets thrown into the
> melting pot too and becomes a passive (suffering) part of the total work

of art. Witchcraft of this sort must of course be fought against. Whatever is intended to produce hypnosis, is likely to induce sordid intoxication, or creates fog, has got to be given up.

The interrelation of the arts on stage was thus, for Brecht, naturally reciprocated within the audience, where individual spectators became entangled in a morass of intermingled art forms. His fear was not that spectators would be incited to lose their individual identities but, rather, that in encountering the Gesamtkunstwerk they would experience emotional hypnosis: wholly in sympathy with the dramatic activity, they would tumble into a foggy cauldron of emotionalism and passivity. Equating an extraordinary series of terms with the Gesamtkunstwerk—"fusion," "passivity," "emotional suffering," "intoxication," and "hypnosis"—Brecht positioned his own theatrical technique of *Verfremdung* in opposition to the threat he believed the Gesamtkunstwerk harbored.

But the distinction between passive and active spectatorship, or between observation and participation, is not always so clear. While Brecht was developing the theory of *Verfremdung,* it was becoming increasingly difficult, in Germany and elsewhere, to distinguish the role of the individual spectator within the communal audience. Brecht was concerned less with the passive aesthetic response per se than with the potential political ramifications of such passivity in the audiences of the 1930s. His concerns may be represented with two contemporaneous photographs (Figure 8.2 and Figure 8.3). The first, taken by Heinrich Hoffmann, shows an audience attending to Adolf Hitler and others on a theater stage. Crowded into three tiers of an auditorium, men and women appear fully absorbed in the performance they are watching; the camera, positioned just above the speakers to emphasize Hitler's bowed head in the lower left corner of the image, faces the attentive crowd and centers on the banner hung from the royal box: a flat canvas that displays a swastika. Brecht's mistrust of Einfühlung stemmed from a horror of passive, communal spectatorship and a fear of the uncritical acceptance of Nazi claims that was already widespread. Without mentioning Vischer, Lipps, or Worringer (his own reference point was Aristotle), he criticized the kind of spectatorship that entailed a loss of self and an overidentification with the object of attention. The swastika at the center of the image suggests, too, that National Socialist visual language might be associated as much with abstraction as with Einfühlung—or that the Einfühlung Brecht decried had little to do with the concept as it was discussed in the nineteenth century.[33]

A second photograph shows Hitler and his cohorts sitting in the balcony at the cinema, attending a film premiere at the Ufa-Palace in Berlin in 1933. As if absorbed in the performance, they stare out beyond the space of the image—all

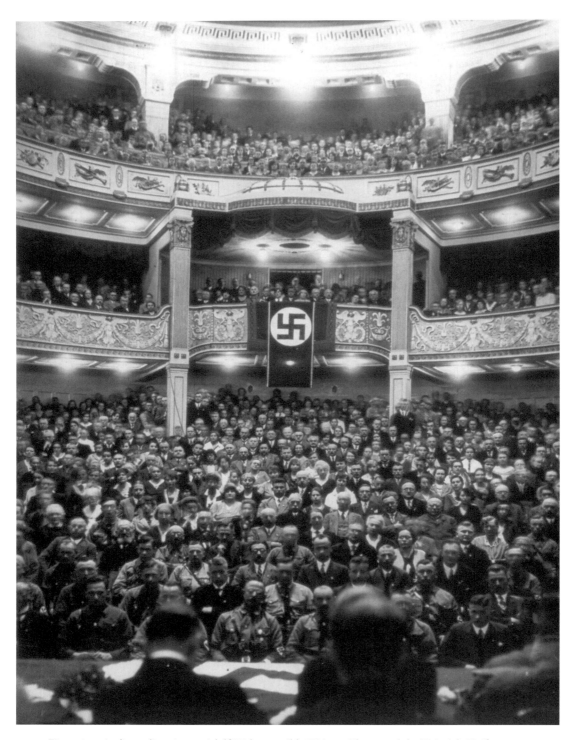

Figure 8.2. Audience listening to Adolf Hitler; possibly Weimar. Photograph by Heinrich Hoffmann.
Courtesy of the Research Library, The Getty Research Institute, Los Angeles, California (920024).

but one, who looks directly, and quizzically, at the camera lens. The generic gesture of a disembodied hand, at the right, indicates the existence of an empty seat at the bottom of the photograph, complete with a program booklet laid out on the balustrade before it. The real actors, here, would seem to be the political figures on view within the photograph, and not those whom they are watching on the silver screen. Hitler himself, his arms crossed and his head turned slightly toward the camera, appears as aware of the photographer who is taking his picture as of the film he is meant to be watching. In Germany in the 1930s, the mass audience seemed to be absorbed equally by the movies and the political rallies of National Socialism; Brecht described their absorption as passive, and he labeled such passivity Einfühlung.

As we have seen, the effort to discuss Wagner's music dramas, his theoretical writings, and his persona as a unified, ahistorical entity and the tendency to link "Wagnerianism" with themes of intoxication, hypnosis, and passivity were not original to the 1930s. Like so much of the discourse on Wagner and his music dramas

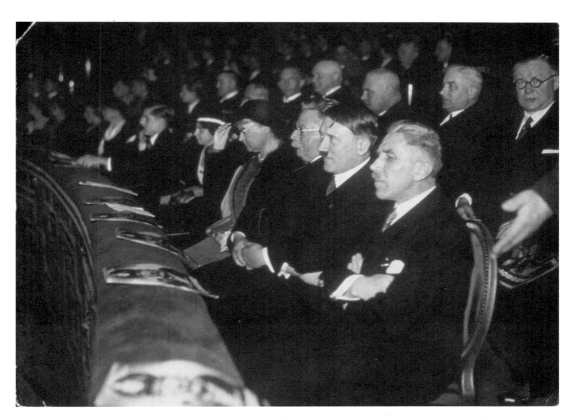

Figure 8.3. Hitler at the premiere of *Morgenrot,* Ufa-Palast, photograph, 1933. Courtesy of the Research Library, The Getty Research Institute, Los Angeles, California (920024).

in the twentieth century, it derived from Nietzsche, who declared in 1888, "The *Lohengrin* prelude furnished the first example, only too insidious, only too successful, of hypnotism by means of music."[34] The philosopher's backhanded compliment was further complicated by the parenthetical assertion that followed: "I do not like whatever music has no ambition beyond persuasion of the nerves." This particular score epitomized, for Nietzsche, musical pandering and self-indulgence; at the same time, it surpassed the works of other composers. Its very success proved its failure as a serious work, an assessment that Nietzsche believed held true for all of Wagner's achievements, musical and otherwise.

With the exodus of European writers and critics to the United States, both the association of Wagner's music dramas with intoxication and magic and the conviction that even the composer himself was not immune to the disease of "Wagnerianism" came to extend beyond Europe's geographic boundaries. In an essay of 1937, the year he immigrated to the United States, Thomas Mann declared that

> the *Tristan* score is a *Wunderwerke* [sic]. Especially when we consider the baffling, psychologically almost incredible fact that it was composed along with the *Meistersinger,* and that both were thought of as a relaxation from the strain of the mental effort needed to build up in all its minute details the giant structure of the *Ring.* It is the product of a perfectly unique eruption of talent and genius; the work, both immensely serious and immensely enchanting, of a magician possessed by his emotions and intoxicated by his own cleverness.[35]

These words, with their underlying associations of enchantments and intoxications so strong that they affected Wagner himself in the act of musical composition, subsequently appeared in English translation in 1942 in *Decision,* a journal edited in New York by Mann's son Klaus. They call into question the novelty of Sontag's announcement, half a century later in the same city, that "now Wagner is just enjoyed as a drug."

THEODOR ADORNO, PHANTASMAGORICAL HISTORY, FAILURE

Writing in Germany in the late 1930s, Adorno treated the Gesamtkunstwerk as an ahistorical entity—or, more precisely, he presented this mid-nineteenth-century concept anachronistically, as if it had emerged from his own sociopolitical context. A decade later, he would insist that "Wagner, as a human being, crystallized to an amazing extent the Fascist character long before Fascism was ever dreamed of."[36] (Responding to this text, Thomas Mann duly noted in his diary that spring, "It is

ghastly how W. as a person anticipated Hitler.")[37] This same impulse toward historical compression determined the arguments of *In Search of Wagner*. Situating the composer's personal traits in the context of larger, later political developments, Adorno presented him as a narcissist who personified the authoritarian principle; as the focal point of the music and the performance, Wagner led members of the orchestra in Bayreuth through his music dramas like a musical dictator.[38] And while acknowledging in passing that Wagner had shown "a good deal of critical insight in the years separating *Lohengrin* from *Rhinegold*," Adorno revealed little interest in historical distinctions—and it remains unclear which years he intended these brackets to indicate: *Lohengrin,* completed in 1848, premiered in Weimar in 1850; *Das Rheingold,* completed in early 1854, was not performed until 1869, in Munich.

Rather than approaching his material chronologically, Adorno divided his book on Wagner into ten thematic chapters: "Social Character," "Gesture," "Motiv," "Sonority," "Colour," "Phantasmagoria," "Music Drama," "Myth," "God and Beggar," and "Chimera." Such an arrangement freed him from the obligation to force Wagner's oeuvre into an overarching narrative arc; it also allowed him to conflate the composer's music dramas, theoretical arguments, personal life, and the political situation in Germany more than half a century after the composer's death and to make pronouncements such as the following: "The glorious blood-brotherhood of *Parsifal* is the prototype of the sworn confraternities of the secret societies and *Führer*-orders of later years, which had so much in common with the Wahnfried circle—that clique held together by a sinister eroticism and its fear of the tyrant, with a hypersensitivity that bordered on terrorism towards everyone who did not belong."[39] Here and in countless similar proclamations, Adorno circled back and forth in time, careening from fiction and myth to psychobiography and from art to politics, to place foreshadowing, suggestibility, and association at the heart of critical theory as if he, too, were a magician. The contradictions in his arguments send warning flares; his seemingly reluctant and often patronizing praise is either tempered or fully undermined by the powerful criticism that immediately follows. The frequency and tone of his attacks make it clear that more than the composer and his music dramas are at stake.

That Adorno would have linked Wagner to fascism in the 1930s and that he conceived of "Wagnerianism" in terms of musical dictatorship are hardly surprising. With politically conservative figures in the Weimar period citing Nietzsche and Wagner as their heroes, leftists tended to keep their distance; Hitler's enthusiasm for Wagner, carefully cultivated by the composer's family in the early twentieth century, likewise helped distort the understanding of his historical context. Adorno's assessment of Wagner in the 1930s—an explicit attempt to trace the origins of

fascism to an ideological and artistic package known alternatively as Wagnerianism and the Gesamtkunstwerk—would also have been buttressed by reports of current productions in Bayreuth, at the time a notorious bastion of political and aesthetic conservatism.[40] Yet, however insightful, the polemic has had a price: the image of Wagner as proto-fascistic has served to obscure the composer's actual politics as well as tamper with the significance of his achievements. Such decontextualization also conflates the active model of communal spectatorship that the composer demanded in 1849 and the passive spectatorship required of a mass audience under German fascism. Aligning the block of spectators in the amphitheatrical auditorium in Bayreuth with the fascist audience rather than with the democratic audiences of ancient Greece that Wagner himself hoped to re-create, Adorno likewise ignored the significance of the mass audience in Germany in 1876, both for Wagner and generally.

Despite its historical inaccuracies, logical inconsistencies, bile, and bluster, Adorno's treatment of Wagner cannot be dismissed; indeed, it should be attended to with particular care. For many reasons—not least of which is its immense rhetorical power—it became highly influential among later generations of scholars, critics, and theorists in a range of humanities disciplines after World War II both in Europe and the United States, and it remained so for many decades, establishing a pervasive and durable consensus regarding the composer's place in relation to German political history and to European cultural history more generally. Simply put, Adorno helped bring a discussion of Wagner's life and work into postwar cultural discourse. Hostile, anachronistic, and intensely personalized, Adorno's arguments nevertheless usefully link cultural and intellectual history to historical and political events. They assign blame to a historical figure for developments that occurred long after his death, but in doing so they raise crucial questions of historical responsibility. Following Nietzsche, Adorno maintained that in order to assess modernism one must come to terms with Wagner; in the postwar context, in order to understand Wagner's status in relation to modernism one must come to terms, first and foremost, with Adorno.

Adorno ascribed particular (and uniformly pathetic) motivations to Wagner, who appeared in his text as a talented yet immature schoolboy, one whose innovations were merely desperate attempts to cover insecurities and weaknesses. "In Wagner," he maintained, for example, "the radical process of integration, which assiduously draws attention to itself, is already no more than a cover for the underlying fragmentation."[41] Here, "Wagner" stands not only for the composer, his music dramas, and his productions in Bayreuth but also for productions that took place decades after the composer's death. According to Adorno, the unconscious and unconvincing compensatory gestures of a weak personality attempted to disguise

weaknesses with bombast, both at the personal and the artistic level. Notably, fragmentation here is presented as wholly negative, devoid of the politically and aesthetically avant-garde attributes of, say, a photomontage by John Heartfield or Hannah Höch. Moreover, given that such a notion of "integration" misrepresents Wagner's theoretical arguments concerning the Gesamtkunstwerk, the analysis is entirely moot.

Adorno also objected to what he considered to be the essential individualism of the concept of the Gesamtkunstwerk—or, more accurately, to the way in which Wagner himself put it into practice. "A valid *Gesamtkunstwerk,* purged of its false identity," he explained, "would have required a collective of specialist planners. . . . However, collective labor is ruled out for Wagner, not simply by the social situation in the middle of the nineteenth century, but even more radically by the substance of his work, the metaphysics of yearning, rapture and redemption."[42] The interrelation of the arts on the Bayreuth stage, Adorno argued, was unmatched by any real collaboration among those who had produced it; in the absence of any truly collective approach to artistic production, the Gesamtkunstwerk offered only an unconvincing pretense of collectivity. Perhaps more crucially, Wagner's power remained too great. In Adorno's blistering words, "The different arts which are now alienated from each other and cannot be reconciled by any meaning, are yoked together at the arbitrary fiat of the isolated artist."[43] The suggestion of aesthetic dictatorship is overt, and the resentment at such an arrangement palpable. Notably, Adorno's critique of the centralized approach to creativity precisely inverts Max Nordau's complaint that Wagner's "inner visions were embodied by others—the decorative painters, machinists, and actors—without requiring him to exert himself."[44] Wagner could be vilified equally for megalomania and laziness.

Throughout Adorno's book, the notion of the borders between the art forms—their existence, their preservation, and their potential disruption or dissolution—remains highly charged. Yet Adorno insisted that his real objection to the Gesamtkunstwerk was "not that it violates the allegedly absolute autonomy of the individual arts. This autonomy is in reality a fetish of the disciplines formed by the division of labour."[45] Given the impossibility of artistic autonomy in the modern world, one could not on principle bemoan the idea of the interrelation of the arts. Instead, Adorno lamented that the Gesamtkunstwerk attempted to obscure its structure of amalgamation, in part by concealing the process of its own creation. Thus, chastising Wagner for creating the total work of art on his own, he also complained that the Gesamtkunstwerk represented the division of labor in its very structure.[46] It was as if he wanted Wagner to observe the rules of the division of labor, the ultimate signifier of bourgeois work, yet also wanted to vilify the composer for his bourgeois tendencies.

Using the terms "Gesamtkunstwerk" and "Bayreuth" interchangeably, Adorno treated as identical the ideas and tendencies that he believed these terms represented. Evidence of this approach is found in his reference to the Gesamtkunstwerk as an "analogue to the methods of the Impressionist painters," whose first exhibition actually took place in Paris in 1874, and whose German incarnation emerged two decades later.[47] Ostensibly making a specifically musical claim about the relation of individual phrases to larger compositions—arguing, that is, for "the potential impressionism of his [Wagner's] technique of the motiv"—Adorno constructed a comparison that extended beyond the limits of particular music dramas to describe the Gesamtkunstwerk more generally. Just as the brushstrokes on an impressionist canvas combine to form a unified visual image, he implied, so, too, did the individual arts come together to create the ultimate Wagnerian work of art. They did so in a reciprocal arrangement, and one in which the notion of the "fragment" maintained its pejorative connotation: "The disintegration of the fragments sheds light on the fragmentariness of the whole."[48] While compelling, the comparison also contradicts Adorno's own claims: in both an impressionist painting and in Wagner's utopian Gesamtkunstwerk, the distinctiveness of the individual elements is, in fact, laid bare.

Determined to present Wagner as the personification of fascism and to link his work to National Socialism, Adorno suppressed the historical context of that work. He refused to acknowledge, for example, that the idea of the Gesamtkunstwerk emerged from early-nineteenth-century intellectual thought, as if situating the composer in relation to historical antecedents might somehow weaken Wagner's status as a prototypical figure and undermine the responsibility for later developments that Adorno wished him to hold. Despite all evidence to the contrary, Adorno insisted that "even though the experience of synaesthesia is one of the cornerstones of Romanticism, the *Gesamtkunstwerk* is actually unrelated to the Romantic theories of fifty years earlier."[49] Perhaps inevitably, the explanation for this assertion reveals a remarkable unfamiliarity with Wagner's writings on the topic:

> For in seeking an aesthetic interchangeability, and by striving for an artifice so perfect that it conceals all the sutures in the final artefact and even blurs the difference between it and nature itself, it [the Gesamtkunstwerk] presupposes the same radical alienation from anything natural that its attempt to establish itself as a unified "second nature" sets out to obscure.

This statement, of course, attributes to Wagner a set of intentions that the composer himself had never espoused. "Aesthetic interchangeability" and the erasure

of borders between art forms were not merely foreign to Wagner's goals in articulating the Gesamtkunstwerk; they were precisely what he had claimed to be working against.

Adorno's perspective on Wagner's achievements was not uniformly anachronistic, however. One recurring theme in his text is the connection between the composer's music dramas and contemporaneous consumer culture, presumably that of *bürgerlich* Germany and, by implication, all of Europe:

> Wagner's oeuvre comes close to the consumer goods of the nineteenth century which knew no greater ambition than to conceal every sign of the work that went into them, perhaps because any such traces reminded people too vehemently of the labor of others, of an injustice that could still be felt.[50]

Again, Adorno emphasizes Wagner's determination to erase the traces of the production of the work of art while failing to indicate any familiarity either with the composer's theoretical writings or with Bayreuth. As with the analogy with impressionism, the accuracy of his assessment may be questioned and the motivations attributed to Wagner for concealing his efforts may be doubted. In addressing the thematic constellation of Wagnerianism, Bayreuth, and sorcery, Adorno both absorbed and surpassed the claims of Nietzsche, Nordau, Twain, Mann, and countless others to articulate a particular modernist dialectic, one with Wagner and his Festival Theater in Bayreuth at its center: "The magic work of art dreams its complete antithesis, the mechanical work of art."[51] His declaration of the mutual imbrication of the magical and the mechanical not only sheds light on Wagner's achievements in Bayreuth but also—and against Adorno's wishes, perhaps—allows the placement of these achievements within a broader historical lineage.[52]

Adorno's declaration clearly reveals as much about his own concerns (regarding, for example, notions of authenticity, the relationship of art and commerce, and dialectical thinking) as it does about Wagner and his works. Taken at face value, and compounded by the insistence on Wagner's role as the progenitor of fascist aesthetics, it allows Adorno to posit a direct causal link between Bayreuth productions and Weimar cinema and, furthermore, to assign personal responsibility to Wagner for the development of the culture industry:

> The technological intoxication is generated from the fear of a sobriety that is all too close at hand. Thus we see that the evolution of the opera, and in particular the emergence of the autonomous sovereignty of the artist, is intertwined with the origins of the culture industry. Nietzsche,

in his youthful enthusiasm, failed to recognize the artwork of the future
in which we witness the birth of film out of the spirit of music.[53]

Unlike the musical intoxication that Musil described as "splashes of this dis-
solutely swelling substance" or that Nietzsche likened to a "participation in other
souls and their destiny," inebriation here is caused by an overdependence on tech-
nology. Adorno borrowed heavily from Nietzsche, yet chided him for failing to
link the Gesamtkunstwerk to film—even though the latter was invented after the
philosopher had succumbed to madness.

In tracing a musical connection between the Gesamtkunstwerk and cinema,
Adorno emphasized specifically the leitmotifs embedded both in Wagner's music
dramas and in contemporary film music for—as he insisted—the delectation of
hapless audiences. "The degeneration of the leitmotiv" in Wagner's work, he con-
tended, "leads directly to cinema music where the sole function of the leitmotiv is
to announce heroes or situations so as to help the audience to orientate itself more
easily."[54] In Bayreuth, as at the movies, memorable sound phrases evoking partic-
ular themes or characters pandered to and, in effect, helped create passive audi-
ences. A visual and architectural connection also existed, Adorno argued: in both,
a flat, vertically oriented rectangle appeared to hover impossibly in front of a mass
audience, presenting an image while concealing the depth of the activity it depicted
as well as the means of its construction. Perhaps above all, both encouraged a par-
ticular form of modern spectatorship: a passive audience that encountered sound
invisibly emanating from the stage image. This parallel encouraged Adorno to con-
sider Wagner's Bayreuth theater proto-cinematic, an assessment now often regarded
as fact by cultural historians and by critics in a range of disciplines.[55] That Wagner
himself intended the Bayreuth auditorium to combat distraction and that the
space actually promotes an intense, active form of attention during performances
were of no interest to Adorno.[56]

For Adorno, both the Gesamtkunstwerk and film were fundamentally phan-
tasmagorical, or forms of "magic delusion."[57] He located the sorcery not only in
Wagner's efforts to obscure the process of producing the work of art but also in the
attempt to remove the experience of the work from the realm of temporality,
through the use of technology and through Wagner's famous unending melodies.
"The standing-still of time and the complete occultation of nature by means of
phantasmagoria are thus brought together in the memory of a pristine age where
time is guaranteed only by the stars," he insisted. "Time is the all-important ele-
ment of production that phantasmagoria, the mirage of eternity, obscures."[58] The
nostalgic and utopian yearnings of the Gesamtkunstwerk thus effectively removed

it from real-world temporality; gathered in the Bayreuth auditorium, spectators lost track of time while losing themselves in the music. Ironically, however, the thematic structure of Adorno's book on Wagner and the arguments within it elide and obscure the composer's own historical context; they erase all signs of the process of Wagner's own development in order to create what might itself be termed phantasmagorical history.

Despite insistent anachronisms, one central theme in Adorno's book on Wagner effectively links the composer's ideas and achievements to the historical moment at which he had formulated the idea of artistic interrelation: the aftermath of the failed revolution of 1848–49. "The Wagnerian totality, the *Gesamtkunstwerk,* is doomed to failure," Adorno asserted. "To disguise this is not the least of Wagner's tasks in running all the different elements into each other."[59] Indeed, the more effectively the composer appeared to realize his goals, the more his achievements seemed to Adorno to be failures. The success of the Gesamtkunstwerk also marked its failure, he explained; it combined the art forms primarily in order to disguise the fact that it did so, with failure embedded in the very promise of the phantasmagoria: "With the anathematizing of the very pleasure it puts on display, the phantasmagoria is infected from the outset with the seeds of its own destruction. Inside the illusion dwells disillusionment."[60]

Yet what could it mean for a utopian theory—one that had explicitly been posited in relation to the work of art of the future, to be created for an audience that did not yet exist—to fail? If the founding of Bayreuth may be declared a travesty of Wagner's original theoretical aims as he set them out in his early writings on the Gesamtkunstwerk, then how might we judge this failure; how might we situate it historically? Given Wagner's own reaction to the first season in Bayreuth, it might seem misguided (or, perhaps more accurately, disingenuous) to accuse him of not having achieved at this theater the goals he had set out almost three decades earlier. One might certainly note, assess, and historicize the particular combination of nostalgia and utopian fervor in Wagner's arguments, trace the development of his ideas, investigate his efforts to implement them, or analyze their effects on other figures, works, and disciplines—as well as their ongoing appropriation in subsequent decades. *Modernism after Wagner* has itself attempted some of these approaches. But if "failure" might at first glance seem out of place as an evaluative notion, it is also apposite, insofar as the Gesamtkunstwerk aims to remake the world, to unify art and life, but never can. The concept also leads directly to the historical origins of Wagner's idea of the Gesamtkunstwerk: the failure at its center is that of the revolution of 1848–49, a political failure that led to the composer's own disillusionment, his exile, and his determination to remake the world on his own utopian terms.[61]

Dilettantism

Certainly the vagaries of Wagner's reputation did not begin with the rise of fascism or its analysis. Both during his life and for decades after his death, an impressive range of critics labeled him a dilettante and derided him for trying his hand at too many art forms. Adorno described him as an "outsider-cum-dilettante," while Thomas Mann noted "something peculiarly dilettantish" about the Gesamtkunstwerk.[62] In 1892, Max Nordau referred to Wagner's operas as "patchwork and dilettantism," arguing that their borrowed plots and characters and recycled musical motifs signaled both degeneracy and laziness on the part of the composer.[63] Such comments were directed not only at Wagner's personality but also at his music dramas, at the very idea of the Gesamtkunstwerk, and at the model of spectatorship it encouraged. Accusations of dilettantism, along with such corollaries as shallowness and amateurism, reveal a range of claims and presumptions about the interrelation of the arts, with regard both to artistic production and reception—often conflating the two in the person of Wagner himself.

"Wagner remained faithful all his life to the costume-fantasies of the amateur stage," Adorno declared, with patronizing force. "Even his boldest masterstrokes were unable to overcome the fundamental stance of the amateur, that of enthusiastic respect. The path of his development is that of the enthusiastic flight from the dilettantism of enthusiasts into the transcendental realm beyond the footlights."[64] Dilettantes, here, are mere devotees, unable themselves to produce a work of art; the stage is reserved for professionals, who fully appreciate (and actively participate in) the transcendental experience of art. According to Adorno, Wagner began his life as a dilettante in the auditorium, among the spectators; he subsequently attempted to make his way to the stage but, despite his enthusiasm, managed to make his way only as far as the conductor's podium. Unable to overcome his amateurish origins, he produced a form of music drama that relied on the conductor's baton to regulate both the music and the emotions of its audience. Even as a conductor, then, Wagner was essentially a dilettante:

> The conductor can do as an expert what the amateur in the auditorium would like to achieve. . . . The dilettantish features in Wagner's character are inseparable from those of . . . his resolute collusion with the public. Enthroned as conductor, he is able to enforce this collusion whilst maintaining the appearance of strongly individual opposition.[65]

Wagner here is a bourgeois, enthroned like a monarch and in "collusion with the public." These almost mutually contradictory descriptions are offered as if equal—and equally pejorative. A shallow dilettante, the composer belongs among the

spectators; aiming for the stage, he only reaches as far as the conductor's podium, where he demonstrates his authoritarian tendencies.

In trying to master so many different forms of art, Adorno argued, Wagner always remained an amateur at each one—poetry, for example—merely disguising his amateurism with genius. While the composer was for the most part able to get away with this approach, years later its essential dilettantism became clear. To bolster this claim, Adorno cited Thomas Mann, who in 1933 had stated,

> Wagner's art is the product of dilettantism, albeit one monumentalized
> by the highest exertions of will-power and intelligence and raised to the
> level of genius. The idea of uniting all the arts is itself dilettantish and,
> in the absence of the supreme effort entailed in subjecting them all to
> his overwhelming genius for expression, it would have remained at the
> level of dilettantism.[66]

Here, again, accusations of dilettantism slip slyly from Wagner's character to the idea of the Gesamtkunstwerk, as if the work of art (or, perhaps more accurately, its theoretical underpinnings) embodies the personality of its creator. Remarkably, willpower, intelligence, supreme effort, and even "overwhelming genius" are shown to demonstrate only the composer's own shallowness and inability to engage seriously with any one form of art.

Mann's own source for such accusations was, ostensibly, Nietzsche's essay "Richard Wagner in Bayreuth" of 1876, published only months before the inauguration of the Festival Theater. Embedded in Mann's text, and subsequently cited also by Adorno, was Nietzsche's own claim that Wagner's "youth was that of a versatile dilettante," a characterization that, at least initially, appears to carry neither approval nor disapproval: "He was not subjected to the strict discipline of any artistic traditions in the family or elsewhere. Painting, poetry, acting, music were all as close to him as a scholarly education and future; a superficial viewer might draw the conclusion that he was a born dilettante."[67] In keeping with the prevailing attitudes of his day, Nietzsche did not present dilettantism as wholly negative. Rather, he linked the concept to the notion of *Bildung,* the seemingly untranslatable term that combined a bourgeois upbringing, education, and cultivation to produce the well-rounded Germans of the nineteenth century. In this more positive sense, dilettantism entailed a dedication to the arts that existed regardless of financial reward or professional obligation.[68] The failure to impose discipline upon Wagner as a child allowed his creativity within a range of artistic practices, yet this advantageous versatility—at least in Nietzsche's account—was not entirely admirable. Deftly ascribing the characterization of Wagner as a dilettante to "a

superficial viewer," the philosopher appears to defend his subject from outside accusations that, in fact, he himself puts forward. For Nietzsche writing in 1876, then, Wagner and his achievements epitomized dilettantism in both its positive and negative senses.

Conservative German cultural critics in the final years of the nineteenth century explicitly promoted the practice of dilettantism. "Unfortunately the word 'dilettante' has become linked to a negative secondary meaning," Paul Schultze-Naumburg lamented in 1898, for example; the term had become the "dumping ground for all the triteness and tastelessness that old and young ladies and gentlemen aimed to introduce into the sitting room in the supposed 'atelier' style."[69] It was time, he believed, to restore to the term its rightful definition as the activity of the well-bred, aesthetically astute, and properly cultivated. Indeed, he continued, "Lichtwark has admirably traced in his 'Organization of Dilettantism' what, by contrast, dilettantes can achieve through correct education [*bei rechter Bildung*]."[70] First published in the art journal *Pan*, Lichtwark's essay was subsequently expanded to a little book, published in 1897 with an epigraph from Wagner himself. Here, Lichtwark celebrated a variety of art forms perfect for amateurs' creative experiments, from woodcuts and lithography to flower arranging, with special emphasis on photography. In promoting dilettantism, or "amateurism"—in the sense of doing something for love—his arguments followed Nietzschean precepts about the beautification of daily life. His ideas not only sparked Schultze-Naumburg's enthusiasm but also became central to the *Lebensreform,* or "life reform," movement in the early twentieth century.

The "negative secondary meaning" of dilettantism, however, had already been linked to Wagner's work as well as to his personality. In *Degeneration,* first published in 1892 and enormously popular in Germany and across Europe for the next two decades, Nordau had written that Wagner,

> as is the case with all the degenerates . . . did not understand his natural impulses. Perhaps also . . . he dreaded the heavy labour of drawing and painting, and . . . his instinct sought vent in the theatre, where his inner visions were embodied by others—the decorative painters, machinists, and actors—without requiring him to exert himself.[71]

The Gesamtkunstwerk appears here as the product of laziness: a desire to delegate responsibility for the creative process. Whereas Nietzsche had linked Wagner's dilettantish youth, upbringing, and education to his later formulation of the Gesamtkunstwerk, Nordau situates this laziness squarely within the composer's adulthood. Wagner's "unending melody," he wrote, was "the form in which incapacity for

attention shows itself in music," indicating a shallowness of character on the part of both the composer and his audiences.[72]

Attempting to reconcile prevailing addictions to Wagner's music and their own resistance to it, critics often categorized his music dramas as essentially unmusical, sometimes by implicitly accusing the composer himself of dilettantism. In his own adulatory essay on the composer, Charles Baudelaire noted this tendency: "I have heard many people deducing from the very range of his [Wagner's] faculties, and from his high critical intelligence, a reason for mistrust concerning his musical genius."[73] Genius and failure were thus implicitly linked. Baudelaire's explanation of this phenomenon was straightforward: such accusations were produced, quite simply, by envy. Indeed, the description of the aesthetic experience of Wagner's music as a kind of intoxication may have begun with Nietzsche, but it relied heavily on Baudelaire's own aesthetic program as expressed in his prose poem "Enivrez-vous" of 1864. Even Mark Twain, not generally susceptible to clichés, described the performance of *Tannhäuser* he heard in Bayreuth almost three decades later as "music, just music—music to make one drunk with pleasure."[74]

HAUNTING MODERNISM

Founded two years before the fall of the Berlin Wall and decades in the planning and making, the German Historical Museum opened in May 2006 in the Zeughaus, or "Arsenal," the oldest building on Berlin's Unter den Linden. With a permanent display officially entitled German History in Images and Testimonials from Two Millennia (an unfortunate invocation and doubling of Hitler's "thousand-year Reich"), the exhibition covers two floors, leading visitors from 100 BC to the present. The installation of more than eight thousand objects is divided into two parts: material pertaining to the bulk of this chronological span is arranged on the *piano nobile,* reached by ascending one of two grand staircases on either side of the entry hall, while the entry to the area devoted to German history since World War I is tucked into a corner on the ground floor behind one of these staircases; its exit is at the corresponding point on the opposite side of the hall, near the cloakroom and toilets. The decor for the ground-floor installation, which presents German history from the Weimar Republic to the nation's reunification after 1989, is likewise less inviting than its upstairs counterpart: the ceilings are lower, the impressive views outside to Unter den Linden blocked off, and the walls a dreary pale putty color evoking those of an old-fashioned schoolroom.

In a section of the installation downstairs devoted to the culture of the Nazi era, near a scale model of the Degenerate Art exhibition of 1937, a poster advertising the exhibition, and a poster advertising the Bayreuth festival of the same year, hangs an oil portrait of Richard Wagner made by Franz von Lenbach about a year

before the composer's death (Figure 8.4). Thinly painted in muted browns and grays, Wagner gazes up to the left in three-quarter view; the painting offers the two-dimensional equivalent of a portrait bust, darkly radiating eminence and stolidity. Rather than being placed in the hallowed halls upstairs with other nineteenth-century paintings of important German figures, the composer is situated within the context of National Socialism: "Hitler admired Richard Wagner," the information label announces; "the portrait of the composer painted by Franz von Lenbach was chosen for the *Art Museum Linz* along with countless other works of art from all over Europe." Hitler's admiration for Wagner's music—he attended every summer festival in Bayreuth from 1933 to 1939—and for the composer's politics has been cemented, at the German Historical Museum no less than in the popular imagination, into a symbolic association between the two men that remains powerful enough to dissolve any need for historical responsibility.

The notion of historical responsibility and questions regarding Wagner's placement within the narrative of German (and, by extension, European) cultural, intellectual, and political history have been central to the present study. Given the

Figure 8.4. German Historical Museum, Berlin. Photograph by Juliet Koss, 2008.

installation at the German Historical Museum, it would appear that Hitler's em-
brace of Wagner's achievements obliterated any trace of the revolutionary beliefs
the composer had held so fervently almost a century earlier. As we have seen, the
groundwork for this shift had been laid by Wagner's own careful efforts to distance
himself from his revolutionary leanings and activities in his autobiography, dic-
tated to Cosima and produced for Ludwig II in the hopes of securing funding
to construct a theater in which to present his music dramas. In the preface to
the third and fourth volumes of his collected writings, published immediately after
the Franco-Prussian War, in 1872, he made clear his disdain for the politics of
his youth:

> When, in the feverish excitement of the year 1849, I gave vent to an
> appeal such as that contained in . . . "Art and Revolution," I believed in
> the Revolution, and in its unrestrainable necessity. . . . Far though it was
> from my intent to define the new, which should grow from the ruins of
> a sham-filled world, as a fresh political ordering: I felt rather animated
> to draw the outlines of the work of art which should rise from the ruins
> of a sham-bred art.[75]

Wagner's reformulation of his youthful radicalism was easily adopted, and his fam-
ily helped link National Socialism to Bayreuth for almost half a century after his
death. His widow, Cosima, ran the Festival Theater from 1883 until 1908, when she
handed the position to Siegfried, who remained in charge until his death in
1930—the year, also, of her own death. From then until the end of World War II,
it was overseen by Winifred Wagner, Siegfried's British-born wife, who met Hitler
in 1923 and supported him enthusiastically until her own death in 1980; thus,
Hitler may have called Wagner his favorite composer, but it was the composer's
family members who welcomed Hitler to Bayreuth.[76] Nietzsche's youthful endorse-
ment of Wagner, and Elisabeth Förster-Nietzsche's support of Hitler following her
brother's death, likewise helped perpetuate Wagner's status as the quintessential
protofascist: the composer who provided the soundtrack, as it were, for National
Socialism in Germany.[77]

The treatment of Wagner's politics as protofascist, protocinematic, or proto-
spectacular tends to inspire one of two responses: either an insistence on separating
musical compositions from political ideas (with Wagner's theoretical ideas down-
played) or a claim that his music in some way helps explain, and must therefore be
interpreted through, his politics. Thomas Mann offered the former response in 1911,
dismissing Wagner's theoretical ideas as "so completely secondary, so wholly a ret-
rospective and superfluous glorification of his own talent."[78] Clement Greenberg

followed suit in 1959, arguing for the irrelevance of the composer's politics in order to maintain the exalted status of his art: "That Wagner's music became associated with German ultranationalism, and that Wagner was Hitler's favorite composer, still doesn't detract from its sheer quality as music."[79] Thorny notions of "sheer quality" aside, such claims ignore the composer's own politics and the political uses to which his ideas and his music were subsequently put—and willfully so.

One may also interpret the effort to uncouple Wagner's music from political meanings of all kinds more positively, as an attempt to correct another interpretive fallacy: the easy conflation of Wagner's art and his politics, often supported by either eliding Wagner's politics and those of Hitler or by critiquing the composer's music and his other writings in order, ultimately, to attack National Socialism both directly and indirectly. This conflation of art and politics, and of composer and dictator, was the tactic Adorno employed in his book on Wagner, in which he held Wagner personally responsible for Hitler's "final solution": "Wagner's anti-Semitism assembles all the ingredients of subsequent varieties. He had even conceived the notion of the annihilation of the Jews. He differs from his ideological descendants only in that he equates annihilation with salvation."[80] By implication, Hitler's enthusiasm for Wagner's music, and perhaps for Bayreuth more generally, necessarily led to his discovery of the composer's careful assembly of "all the ingredients" that directly inspired the extermination of the Jews. Distinctions between the two men's ideas are played down. In transposing the composer's nineteenth-century opinions into the 1930s, Adorno tells us more about his own era than about his ostensible subject. Yet his arguments have remained central to the understanding of Wagner.

The effort to trace the prehistory of the present often leads to the formulation of past events as the necessary and sufficient basis for later developments.[81] Greenberg himself described the methodological problem inherent in such an approach: "It is indisputable that Romanticism is the single most important source of Nazi doctrine," he wrote in 1941.

> But there was nothing in Romanticism that made this doctrine inevitable, nothing that made Romanticism *responsible* for it. . . . What then is the filial relationship of Nazism to Romanticism? Any one who tries to answer this question must take into account the inextricable and ambiguous connections that exist between ideas and the milieux in which and the material circumstances under whose pressure they arose.[82]

Whether teleological or simply anachronistic, accounts of Wagner as the necessary and sufficient cause of later developments can be usefully provocative. Yet

they cannot prove the historical inevitability of fascism, or fascist aesthetics, after Wagner; nor should they operate as substitutes for our understanding of the revolutionary origins and complex formation of his ideas.

These ideas have persisted for more than a century and a half, and well beyond Germany's own geographic borders; while the extent of their influence in the interrelated realms of politics and aesthetics may be debated, their centrality to the theory and practice of modernism cannot be questioned. Their tenacity is demonstrated in an essay published in 1991 by Annette Michelson on the work of Andy Warhol. In describing the artist's New York Factory as "the site of Warhol's recasting of the *Gesamtkunstwerk,*" Michelson refers not only to the interrelation of the arts effected within this space but also to the integration of artistic production and daily life that characterized the Factory scene more broadly.[83] Distinguishing Warhol's approach from that of Wagner, Michelson uses the term "Gesamtkunstwerk" to suggest a mixture of radically revolutionary and deeply conservative impulses in the realm of artistic production that incorporate the activity of spectatorship into the story of modernism. The "recasting of the *Gesamtkunstwerk*" at Warhol's Factory was apparently so complete as to render the original almost invisible; remarkably, Michelson's essay barely mentions Wagner by name. It should, perhaps, come as no surprise that her definition of the "Wagnerian dream of the *Gesamtkunstwerk*—the fusion of all the arts in one work" derives from Adorno and Max Horkheimer, rather than from the composer himself.[84]

Despite borrowing an abbreviated definition of the concept from a willfully unreliable secondary source, Michelson offers a richly suggestive description of Wagner's Gesamtkunstwerk, referring obliquely to the postrevolutionary context of its initial promulgation. "A specter haunts the theory and practice of the arts throughout our [the twentieth] century," her essay begins, "the specter of the *Gesamtkunstwerk,* a notion born of late romanticism, nurtured and matured within the modernist moment, and never wholly exorcised in the era of postmodernism and of electronic reproduction."[85] The words slyly paraphrase the opening gambit of the *Communist Manifesto*: "A specter is haunting Europe, the specter of Communism." The revolutionary fervor of 1848, the disillusionment following the revolution's failure, the utopian desire to remake the world, Wagner's radical vision of the interrelation of the arts, and the effort to develop a new form of engaged, communal spectatorship—all these elements magically combined to produce the Gesamtkunstwerk, that invisible specter that haunted modernism.

Acknowledgments

"A book about the Gesamtkunstwerk, how wonderful! Everything you do is tax deductible!" This witty conflation of intellectual labor, extracurricular tastes, and fiscal responsibility was made by a fellow art historian at a time when this project seemed to function partly to rationalize my own interdisciplinary interests or to justify the range of my own enthusiasms, and it came to mind again when I learned that Richard Wagner, his music, and the concept of the Gesamtkunstwerk had all been accused of dilettantism, as if even a concept could somehow spread itself too thin. Might the history of modernism have turned out differently had Wagner received better financial counseling?

The idea for a project on the history and legacy of the Gesamtkunstwerk emerged from (among other things) a doctoral dissertation on the Munich Artists' Theater (the subject of chapter 5 of this book), completed in the History, Theory, and Criticism of Art and Architecture section in the Department of Architecture at the Massachusetts Institute of Technology in 2000. Thanks are due to my professors at MIT, especially Benjamin H. D. Buchloh (my trenchant, irreplaceable *Doktor-Vater*), Leila Kinney, and Ákos Moravánszky, as well as to Stanford Anderson and Mark Jarzombek, my kind dissertation readers. I learned much (and with pleasure) from my fellow graduate students in Cambridge, Massachusetts, both at MIT and across town; I wish Kristen Finnegan and Ernest Pascucci, remarkably different yet equally appreciated denizens of the HTC kennel, were each still alive for me to thank along with the others.

Numerous organizations deserve my boundless gratitude for funding my work on this project over the course of many years, beginning with the Department of Architecture at MIT and the American Association of University Women. A two-year predoctoral fellowship at the Getty Research Institute for the History of Art and the Humanities brought me in 1998 to Los Angeles, where I was both inspired

and whipped into art historical shape in the glorious sunshine by my fellow participants in the Getty Scholars and Seminars Program, particularly Francesco de Angelis, Horst Bredekamp, Elspeth Brown, T. J. Clark, Georges Didi-Huberman, Heinrich Dilly, Lydia Goehr, Stefan Jonsson, Thomas DaCosta Kaufmann, Michael Lobel, Maria Loh, Richard Meyer, Reinhart Meyer-Kalkus, Robert S. Nelson, Margaret Olin, Ernst Osterkamp, Adrian Piper, and Alastair Wright. I thank them all, along with official Getty employees, including Thomas Crow, Michael S. Roth, Sabine Schlosser, Mark Vevle, Sanya Visessiri (without whom I would not have finished either my dissertation or this book), Joan Weinstein, and Wim de Wit.

At Scripps College, I am grateful for several faculty research grants and for permission to take the leaves of absence during which I wrote this book. My deepest thanks to Michael Deane Lamkin, dean of the faculty, for recognizing the importance of research at a liberal arts college and for allowing me periodically to abandon Southern California to attend to things Wagnerian; and to my colleagues at Scripps (in particular Bruce Coats, Marc Katz, Mary MacNaughton, Susan Rankaitis, and David Roselli) and in the Joint Program in Art History of the Claremont Colleges. My students deserve special mention for making teaching an ongoing pleasure. A fellowship from the Humboldt Foundation brought me to Berlin, where I was affiliated with the Kunstgeschichtliches Seminar at Humboldt University for two delightful years. I am also grateful for a summer grant from the National Endowment for the Humanities, a Scott Opler Fellowship for New Scholars from the Society of Architecture Historians, and a Millard Meiss Publication Grant awarded by the College Art Association.

Like its author, this book owes vast debts to my parents, Elaine and Stephen Koss, who introduced me to what Wagner termed "the sister arts," took me to the opera when I was still too small to see the stage, played Teresa Stratas's *Unknown Kurt Weill* almost daily for several crucial years, and taught me (mostly by example) to write, to edit, and to think about history, culture, and politics. None of this would have been worthwhile without the accompaniment of my brother, Richard, whose good sense led him to announce so impressively in third grade—or was it second?—that while he enjoyed many other kinds of cultural outings, he didn't really like watching ballet. *Schau Dir an, was aus mir geworden ist!*

For hospitality and opera tickets, I thank Donald Gellert, Elaine Koss, Bridget Gellert Lyons, and Bob Lyons in New York; Max Gellert in Seattle; Michael and Olga Leapman in London; Markus and Simone Frank (and Nathan, Jasper, and Xenia) and Helga Kurzchalia in Berlin; the Bergemänner in Nuremberg; and Kristor Hustad, my *Heldentenor* in Bayreuth. I deeply appreciate the encouragement, advice, and general good cheer received from many scholarly friends along the

way, including Tim Barringer, Barry Bergdoll, Vittoria Di Palma, Jesús Escobar, Devin Fore, the late Rona Goffen, Maria Gough, Uta Grund, Christopher Heuer, Sandy Isenstadt, Matthew Jesse Jackson, David Joselit, Lauren Kogod, Miwon Kwon, Karen Lang, Helga Lutz, Wallis Miller, Steven Nelson, Alona Nitzan-Shiftan, Frederic J. Schwartz, Charity Scribner, Alexis Sornin, Frances Taliaferro, and Claire Zimmerman (and, at critical moments, Kathleen James-Chakraborty, Paul Jaskot, Elizabeth Otto, Emmanuel Petit, Todd Presner, and Despina Stratigakos). Pamela Lee and Sarah Whiting each improved this book—and my life—immeasurably, and I thank them hugely for it.

For assistance and kindnesses I am grateful to the staff of many libraries and archives, above all the good folks at the Kunstbibliothek, Staatliche Museen zu Berlin, and the Getty Research Institute Special Collections, Los Angeles. I thank everyone (in Austria, Canada, Germany, Italy, Russia, Switzerland, and the United States) who helped me procure images and publication rights for this book, especially those who provided these images and rights for free or for a greatly reduced fee. For assistance with translations, research, and the index, my thanks to Lev Bratishenko, Frank Döring, Yolande Korb, Steven Lindberg, and Jürgen von Rutenberg. My arguments throughout this book were sharpened by the responses to my work at many conferences, symposia, and public lectures; I thank all those who invited me to speak and my audiences and interlocutors at each event.

I appreciate the guidance of Pieter Martin and others at the University of Minnesota Press, as well as every copyediting mark and query I received from Kathy Delfosse. Versions of (and passages from) several chapters of this book appeared previously in the *Art Bulletin* (2003 and 2006); *Assemblage* (1997); *Bauhaus Culture: From Weimar to the Cold War,* edited by Kathleen James-Chakraborty (Minneapolis: University of Minnesota Press, 2006); *Einfühlung: Zu Geschichte und Gegenwart eines ästhetischen Konzepts,* edited by Robin Curtis and Gertrud Koch (Berlin: Fink Verlag, 2009); *Kritische Berichte* (2004); the *South Atlantic Quarterly* (1998); and *The Built Surface,* volume 2, *Architecture and the Pictorial Arts from Romanticism to the Twenty-first Century* (London: Ashgate Press, 2002), edited by Christy Anderson and Karen Koehler. My thanks to the editors and copy editors of these publications, especially Perry Chapman, Marc Gotlieb, and Lory Frankel.

Finally, I take full responsibility for any omissions, errors of fact or judgment, and redundancies in these pages, and I proudly acknowledge the utopian (and dilettantish, in the best sense of the term) incompleteness of this volume. The very nature of the Gesamtkunstwerk—the total work of art *of the future*—demands that the only way to complete a book on the topic is to leave it unfinished. Infinite sources large and small, primary and secondary, in German and in every other

conceivable and inconceivable language, remain untapped. As Albert Lavignac, professor of harmony at the Paris Conservatory, wrote at the end of the nineteenth century in the preface to his own book *The Music Dramas of Richard Wagner and His Festival Theatre in Bayreuth*: "Of course, I have not read all that has been written about Wagner,—one human life would not suffice for that, and one would have to be a polyglot."

Notes

1. Without mentioning the Gesamtkunstwerk, for example, Jonathan Crary has contrasted Wagner's achievements in general to those of Georges Seurat, which he labels more "advanced." Seurat's *Parade de Cirque* of 1888, he writes, "can be read as a ruthless dismantling of the Wagnerian model of spectacle, a bitter parody and unmasking of its attempt, incarnated in the central figure, to combine myth and music as a social rite, and valorize the artwork as a figuration of a unified community in the making." Here, according to Crary, Seurat ruthlessly dismantles, unmasks, demythologizes, and bitterly parodies modern spectacle culture—a nebulous entity for which Wagner metonymically stands. Crary, *Suspensions of Perception,* 256. In this context, see also Welchman, "After the Wagnerian Bouillabaisse."

2. See Adorno, *Versuch über Wagner* [Essay on Wagner], published in English as *In Search of Wagner.*

3. Wagner, *The Art-Work of the Future,* 189 (translation modified; here and throughout this book, translations are mine unless otherwise indicated, and I have retained the original emphases in all quotations); Wagner, *Das Kunstwerk der Zukunft,* 3: 156.

4. Throughout this book, I have used the term "spectator" (rather than "viewer," "observer," or "beholder") to signify a subject whose experience of a work—whether a painting, a work of architecture, a theater play, or a film—is as haptic as it is optic, as bodily as it is visual.

5. The reference here is to Cheetham, *The Rhetoric of Purity.*

6. Wagner to Franz Liszt, August 16, 1853, in *Richard Wagner: Sämtliche Briefe,* 5: 401.

7. Dahlhaus, *Nineteenth-Century Music,* 195.

8. Kandinsky, *Concerning the Spiritual in Art,* 32; Kandinsky, *Über das Geistige in der Kunst,* 75–76. Although the first edition of Kandinsky's book is dated 1912, it was published in December 1911.

9. This path to abstraction has generally been treated either as a purification of the genre of painting (a story told within the history of that art form) or as an expression of the artist's cultural milieu (a cultural history with visual art at its center). In American scholarship, the former approach is exemplified by the arguments of Clement Greenberg; for the latter, see Weiss, *Kandinsky in Munich.*

10. Nietzsche, *The Case of Wagner,* 165.

11. Ellis, translator's preface to Wagner, *The Art-Work of the Future and Other Works,* vi.

12. My thoughts in this context have been inspired by Bois, *Painting as Model,* 245–57.

13. Benjamin, *The Origin of German Tragic Drama,* 181. He continues: "Winckelmann makes the connection abundantly clear when, with polemical overstatement, he remarks: 'Vain . . . is the hope of those who believe that allegory should be taken so far that one should be able to paint an ode.'"

14. Ibid., 213. On the role of music as philosophy, particularly with regard to Wagner, see Goehr, *The Quest for Voice.*

15. Wölfflin, *Renaissance and Baroque,* 87.

16. Madame de Staël, chapter 32 of *De l'Allemagne,* cited in Belting, *The Germans and Their Art,* 8.

17. Exemplary in this regard has been the work of Rosalind E. Krauss. See, for example, her *The Originality of the Avant-Garde and Other Modernist Myths;* and Krauss and Bois, *Formless.*

18. The effect, ultimately, is both to erase some works from the history of art and to conflate modernist and avant-garde practices. Recent examples include Buchloh, Foster, and Krauss, *Art after 1900.* The notion of antimodernism divides the cultural developments of the modern period into two camps: advanced and forward-looking or backward and retrograde, as if works from the former category engaged fully with modernity while those in the latter tried only to avoid the modern world. In the field of music history, Walter Frisch offers such an argument with regard to Wagner, for whom, he asserts, "'modern' is an ideological category that is incompatible with true *Deutschtum* or Germanness, which resides in the language and especially in the *Volk.*" Wagner's own writings, the author contends, reveal "the dark underside of modernism." Frisch, *German Modernism,* 12.

19. One recent exploration of the relationship between nationalism and internationalism in the history of modern European art may be found in Sandqvist, *Dada East.*

20. Golding, *Cubism,* 47. Golding cites Gertrude Stein, *Picasso* (Paris, 1938; English edition New York and London, 1939), 18, noting: "This statement of Gertrude Stein's is, however, slightly puzzling as Barr writes that it was not until 1908 that Matisse took Tschoukine to Picasso's studio (*Matisse, His Art, and His Public,* Museum of Modern Art, New York, 1941), 85. At any rate, if Tschoukine did not say this to Gertrude Stein, someone else probably did."

21. See, for example, Bredekamp, "A Neglected Tradition?"; Didi-Huberman, *L'image survivante;* and Diers, "Warburg and the Warburgian Tradition of Cultural History"; as well as Michael S. Roth, "Why Warburg Now?" presentation at the College Art Association Conference, New York, February 2000.

22. Notable among recent exceptions to this tendency in the field of art history is Lista, *L'oeuvre d'art totale à la naissance des avant-gardes, 1908–1914.* On the significance of Wagner's music dramas in the work of such artists as Anselm Kiefer, Edward Kienholz, Max Klinger, and Odilon Redon, with mention of late-nineteenth-century French discussions of the Gesamtkunstwerk, see Metken, "Wagner and the Visual Arts"; on the role of the Gesamtkunstwerk in the work of Julius Meier-Graefe, author of the first major history of modern art, *Entwickelungsgeschichte der modernen Kunst* (1904; translated as *Modern Art* in 1908), see Anger, "Modernism at Home." On the work of Philipp Otto Runge, Moritz von Schwind, and (especially) Max Klinger in relation to the Gesamtkunstwerk, see Frisch, *German Modernism,* 92–106. "Clearly,"

Frisch writes, the Gesamtkunstwerk "is a big-tent concept." Ibid., 92. See also Dömling, "Reuniting the Arts."

23. Greenberg, "Towards a Newer Laocoon," 1: 34.

24. Fried, "Art and Objecthood," 164. Despite this sentence, the "theatricality" Fried describes (and opposes to a notion of absorption) is not identical to theater per se. For Fried, "absorption" describes the bodily perception of the spectator, or "beholder." "The 'purity' that Fried thus surrenders with one hand," Stephen Melville has argued, "is (almost) silently recovered with the other (and for those concerned with tracing the genealogy of a new allegorism it is far from irrelevant that the recuperating hand here is one concerned to fence the high and serious art of Morris Louis off from the degenerate and theatrical flatbed tableaux of Robert Rauschenberg)." Melville, "Notes on the Reemergence of Allegorism, the Forgetting of Modernism, the Necessity of Rhetoric, and the Conditions of Publicity in Art and Criticism," 63. On medium specificity, new media, and "the foundational status of time in the discussion of theatricality" in Fried's essay, see Pamela M. Lee, *Chronophobia,* 43 and passim. Notably, in the late 1930s, Adorno had referred to "Wagnerian 'theatricality,' that repellent aspect of his composition," in his own attack on the idea of the Gesamtkunstwerk. Adorno, *In Search of Wagner,* 34.

25. Greenberg, "Towards a Newer Laocoon," 1: 25. "But he saw its ill effects exclusively in terms of literature, and his opinions on plastic art only exemplify the typical misconceptions of his age," he continued. Ibid.

26. Ibid., 1: 30.

27. Greenberg, "The State of American Writing, 1948," 2: 257.

28. Greenberg, "Towards a Newer Laocoon," 1: 30.

29. Ibid., 1: 32–33.

30. A more thorough treatment of the concept's history in Wagner's writings would include a discussion of *Opera and Drama,* for example.

1. THE UTOPIAN GESAMTKUNSTWERK

1. Destroyed in 1869 by an electrical fire, the building was replaced by a second Hoftheater, completed in 1878. On the cultural renaissance in Dresden in the early nineteenth century, see Mallgrave, *Gottfried Semper,* 69–72 and 76–78; see also Herrmann, *Gottfried Semper,* 3–8; and Joachim Köhler, *Richard Wagner,* 212–33.

2. Wagner, *My Life,* 438.

3. "Everything seemed to depend on making the Saxon battalions in Dresden understand the paramount importance of their action," he wrote of one revolutionary moment, for example; "as this seemed to me the only hope of an honourable peace in this senseless chaos, I confess that, on this one occasion, I did allow myself to be led astray so far as to organize a demonstration which, however, proved futile." Ibid., 478. Wagner's revisionism was due at least in part to the intended audience for his autobiography, which he wrote in the late 1860s: his patron Ludwig II. As John Deathridge writes: "It is less Wagner's flights of fantasy per se than his theatrical talent for weaving fiction with sometimes astonishingly accurate accounts of his life that has caused most of the trouble." Deathridge, "A Brief History of Wagner Research," 203.

4. Wagner, "Autobiographical Sketch," 6 (translation modified); Wagner, "Autobiographische Skizze," 1: 7. A useful corrective to Wagner's misrepresentations of his revolutionary

activities is found in Joachim Köhler, *Richard Wagner,* 223–33; in Krohn, "The Revolutionary of 1848–49"; and in Opelt, *Richard Wagner,* 112–25. For an insistent and highly entertaining description of Wagner as a socialist, see Shaw, "Wagner as Revolutionist," 22–23.

5. Eduard Hanslick, *Aus Meinem Leben,* 2 vols. (Berlin: Allgemeiner Verein für Deutsche Literatur, 1894), 1: 134–35, quoted in Joachim Köhler, *Richard Wagner,* 220. See also Kunze, *Der Kunstbegriff Richard Wagners,* 129–32.

6. Gustav Steinbömer, introduction to Wagner, *Kunst und Revolution,* 7.

7. "Unlike traditional anti-Jewish feeling, which was as widespread in the nineteenth century in radical democratic and socialist circles as it was elsewhere in society, modern anti-Semitism [after 1871 in Germany] was reactionary in its racial ideology, and could find acceptance among the middle classes only when they turned their collective back on the liberalism of the revolutionary years, a change of attitude manifest in their identification with the Second Reich, which owed its existence to authoritarian intervention rather than to democratic means." Borchmeyer, "The Question of Anti-Semitism," 172. On the influence on Wagner of such French anti-Semitic authors as Pierre-Joseph Proudhon, see ibid., 177–79; on Wagner's anti-Semitism more generally, see Deathridge, "A Brief History of Wagner Research," 220–23; Joachim Köhler, *Richard Wagner,* 277–88; Weiner, "Reading the Ideal"; Levin, "Reading Beckmesser Reading"; and Steinberg, "Music Drama and the End of History."

8. See Carr, *The Wagner Clan,* 30ff.; as well as Hilmes, *Herrin des Hügels,* 55ff.

9. See Joachim Köhler, *Richard Wagner,* 459–65 and passim. "In marrying again," Adolphe Jullien coyly put it in 1900, Cosima "retained the charge of the four charming young daughters of her first marriage." Jullien, *Richard Wagner,* 248. Two of these daughters were actually Wagner's.

10. "Wagner spoke, and Cosima added the emphases." Joachim Köhler, *Richard Wagner,* 470. Köhler ascribes to Cosima much of the blame for her husband's deficiencies (and all the blame for their institutionalization), referring, for example, to the composer's "lifelong hatred of the Jews, a hatred that Liszt's daughter elevated to the status of the central dogma of the Bayreuth faith." Ibid., 574. On Cosima Wagner's contribution to her husband's arguments, see also Gutman, *Richard Wagner,* 371–72 and passim.

11. Jones, *Dionysos Rising,* 24. Or, as Bryan Magee writes, "Wagner certainly ceased to be a revolutionary, or a socialist, or anything other than a spasmodic and atavistic devotee of the residual values of failed leftism in the later part of his life, without becoming conservative or right-wing or reactionary." Magee, *The Tristan Chord,* 3.

12. See Joachim Köhler, *Richard Wagner,* 225.

13. Engels, quoted in Magee, *The Tristan Chord,* 50. For an overview of Wagner's political thinking at this time, see Paul Rose, *Wagner,* 23–39. On Wagner's debt to Feuerbach, and on the development of Wagner's thinking more generally, see Williamson, "Richard Wagner and Revolutionary Humanism," chapter 5 of *The Longing for Myth in Germany,* 180–210.

14. Wagner refers in his autobiography to running into "a certain Menzdorff, a German Catholic priest," in the midst of the revolution in early May 1848, adding, "It was he who . . . had first induced me to read Feuerbach." Wagner, *My Life,* 494. On his reading of Proudhon, see ibid., 509.

15. Ibid., 438. "Once the insurgent populace of Paris had demonstrated in radical political action the fragility of all traditional social boundaries," Glenn W. Most has written, "it was difficult, for a moment at least, for some German intellectuals not to try to apply the very same

lesson in radical aesthetic theory to the artistic systems which had been intrinsically linked to them." Most, "Nietzsche, Wagner, et la nostalgie de l'oeuvre d'art totale," 17–18 (English translation kindly provided by Most).

16. Wagner, *My Life,* 442.

17. Wagner briefly took over the editorship of the paper in early May 1849, when Röckel was forced to leave Dresden.

18. Wagner, *My Life,* 452.

19. Ibid., 453.

20. Ibid., 453–54. See also Joachim Köhler, *Richard Wagner,* 214.

21. Or as Heinrich Habel has argued: "Theater reform was, for Wagner, equivalent with social reform." Habel, introduction to *Festspielhaus und Wahnfried,* 15.

22. Wagner, *My Life,* 466.

23. Ibid., 470.

24. Ibid., 468.

25. Ibid., 471.

26. Instability and civil war lasted for three years; in a coup d'état in December 1851, Louis-Napoleon extended his presidential term and proclaimed himself Emperor Napoleon III, which he officially became the following December.

27. Wagner, *My Life,* 473. "I felt a sudden strange longing to play with something hitherto regarded as dangerous and important," Wagner wrote of the days leading up to the revolution; "I recollect quite clearly that from that moment I was attracted by surprise and interest in the drama, without feeling any desire to join the ranks of the combatants." Ibid., 475 and 476.

28. Ibid., 477.

29. Ibid., 482 and 480.

30. Ibid., 479.

31. "The state of dreamy rapture in which I found myself at this time," he would write in his autobiography, "I can no better explain than by indicating the apparent seriousness with which, on meeting Liszt again, I at once began to discuss what seemed to be the sole topic of any real interest to him in connection with me—the forthcoming revival of *Tannhäuser* at Weimar. I found it very difficult to confess to this friend that I had not left Dresden in the regular way for a conductor of the royal opera. To tell the truth, I had a very hazy conception of the relation in which I stood to the law of my country (in the narrow sense). . . . Although it was not very evident to onlookers, I had been, and still was, shaken to the very depths of my being by my recent experiences." Wagner, *My Life,* 500 (translation modified); Wagner, *Mein Leben,* 425.

32. Wagner, *My Life,* 505–6. Presumably the dog and the parrot stayed behind with Minna in Dresden.

33. On the idea that utopia is "most authentic when we cannot imagine it," see Jameson, "The Politics of Utopia," 46. "Its function lies not in helping us to imagine a better future but rather in demonstrating our utter incapacity to imagine such a future—our imprisonment in a non-utopian present without historicity or futurity—so as to reveal the ideological closure of the system in which we are somehow trapped and confined." Ibid.

34. William Ashton Ellis, translator's note to Wagner, *The Art-Work of the Future,* 69n. Ellis elsewhere refers to the "unconscious identity of Wagner's thought with that of Schopenhauer." Ellis, translator's note to Wagner, "A Communication to My Friends," 286n.

35. On Wagner's interest in Schopenhauer, see Magee, *The Tristan Chord,* 149; Dahlhaus, *Nineteenth-Century Music,* 360–61; Dahlhaus, *Wagners Konzeption des musikalischen Dramas,* 116–17; and Reinhart, "Wagner and Schopenhauer," 287–96.

36. Fuchs, "Richard Wagner und die moderne Malerei," 114. Having long been chastised for his youthful misunderstandings of Schopenhauer's terms, Wagner offered something of an apology in 1872: "Only those who have learnt from *Schopenhauer* the true meaning and significance of the *Will* can thoroughly appreciate the abuse that had resulted from this mixing up of words." Wagner, "Introduction to *Art and Revolution,*" 26; Wagner, "Einleitung zum dritten und vierten Bände," 4.

37. Lilli Lehmann, excerpt from her memoirs, *Mein Weg* (Leipzig, 1913), reprinted in Hartford, *Bayreuth,* 45.

38. In his autobiography, Wagner described his attempts to read Hegel and Friedrich Wilhelm Joseph Schelling as the unsuccessful precursor to his discovery of Schopenhauer; see Wagner, *My Life,* 508, cited in Magee, *The Tristan Chord,* 134. On Wagner's reading of Wackenroder and Tieck's *Outpourings of an Art-Loving Friar,* see Goehr, *The Quest for Voice,* 84. See also Zugazagoitia, "Archéologie d'une notion, persistance d'une passion," 67. On the eighteenth-century debates over the relation of the arts, see Neubauer, *The Emancipation of Music from Language,* esp. "The Sister Arts," 132–48.

39. See Joachim Köhler, *Richard Wagner,* 74–76 and passim.

40. See Kremer, "Ästhetische Konzepte der 'Mythopoetik' um 1800," 15–16; and Hegel, *Vorlesungen über die Ästhetik,* 3: 474. Kremer traces Hegel's philosophical system, in turn, to Novalis's "fantasy of a *'Gesamtphilosophieren.'"* "Ästhetische Konzepte der 'Mythopoetik' um 1800," 19. On the German celebration of tragic drama as both the ultimate artistic achievement and the focal point for creating an audience as a *Volk,* with particular reference to Schiller, see Chytry, *The Aesthetic State,* 95–97. As Kremer argues, Wagner's idea of the Gesamtkunstwerk of the future is "certainly unthinkable without the idealism of Romanticist aesthetics, but in general it is much more strongly bound to a nationalistically oriented cultural politics." Kremer, "Ästhetische Konzepte der 'Mythopoetik' um 1800," 11.

41. Schelling, quoted in Kremer, "Ästhetische Konzepte der 'Mythopoetik' um 1800," 13.

42. Schelling, *Philosophie der Kunst,* 379–80. "When the highest totality is attained in drama," he wrote, "spoken art can strive to return once again to images, but cannot develop further on its own. Poetry returns to music in song, to painting in dance (insofar as it is ballet or pantomime), and to the plastic arts in theater, a living plastic art." Schelling, quoted in Kremer, "Ästhetische Konzepte der 'Mythopoetik' um 1800," 13.

43. On Wagner's relationship to and reverence for Weber, see Joachim Köhler, *Richard Wagner,* 32–40.

44. Weber, review of Hoffmann, *Undine,* in *Writings on Music,* 201. When Weber inserted this passage into the manuscript of a novel two years later, he wrote instead of "the German and French ideal." Weber, *Tonkünstlers Leben,* in *Writings on Music,* 335. An earlier draft of the novel asserts: "Malicious people (especially German composers) are always ready to say nasty things about Italian opera." Ibid., 363.

45. Weber, "To the Art-Loving Citizens of Dresden," in *Writings on Music,* 206–7.

46. Weber, review of Hoffmann, *Undine,* 202.

47. Karl Friedrich Eusebius Trahndorff, *Aesthetik oder Lehre von der Weltanschauung und Kunst* (Berlin: Maurer, 1827), 2: 312, quoted in Neumann, "The Earliest Use of the Term

'Gesamtkunstwerk,'" 192–93 (my translation). See also Dieckmann, "Vom Gesamtkunstwerk," 298–99.

48. The appellation "music drama" was likewise not original to Wagner. Dahlhaus writes: "The name 'music drama,' which may be traced to 1833 as a synonym for 'opera,' appears in the 1860s to have been put forward as a term for the specific Wagnerian works that could not be classified as opera—whether for polemic or apologetic reasons. However, the term was ironically glossed and rejected by Wagner in 1872 in the essay 'On the Term "Music Drama."'" Dahlhaus, *Wagners Konzeption des musikalischen Dramas,* 9. Dahlhaus here cites Thomas Mundt, *Kritische Wälder* (Leipzig, 1833), 90.

49. Trevelyan, *British History in the Nineteenth Century,* 292. I am grateful to Richard Koss for providing the correct attribution for this quotation.

50. Wagner, *Art and Revolution,* 59 (translation modified); Wagner, *Die Kunst und die Revolution,* 3: 35.

51. Wagner, *The Art-Work of the Future,* 89; Wagner, *Das Kunstwerk der Zukunft,* 3: 62. On the importance of Greek cultural symbolism for German thought, see Butler, *The Tyranny of Greece over Germany,* 46. See also Ulrich Müller, "Wagner and Antiquity," 227–35.

52. Wagner, *Art and Revolution,* 32 and 33 (translation modified); Wagner, *Die Kunst und die Revolution,* 3: 9–10 and 11. Perhaps encouraged by Nietzsche, later scholars have overlooked the appearance of Dionysus in Wagner's work. "The idea of 'the death of tragedy' goes back to Nietzsche," Walter Kaufmann argued; for example: "In the first half of the twentieth century, it was Nietzsche's discussion of the *birth* of tragedy, and of what he called the Apollinian and the Dionysian, that established the fame of his first book." Kaufmann, *Tragedy and Philosophy,* 163. Chytry likewise refers to Nietzsche's "discovery of the 'Dionysian.'" Chytry, *The Aesthetic State,* 326 and 350.

53. Wagner, *Art and Revolution,* 31 (translation modified); Wagner, *Die Kunst und die Revolution,* 3: 9–10.

54. Wagner, *Art and Revolution,* 35; Wagner, *Die Kunst und die Revolution,* 3: 13.

55. Wagner, *Art and Revolution,* 42 and 46 (translation modified); Wagner, *Die Kunst und die Revolution,* 3: 19 and 23.

56. Wagner, *Art and Revolution,* 48 (translation modified); Wagner, *Die Kunst und die Revolution,* 3: 24.

57. Wagner, *Art and Revolution,* 52; Wagner, *Die Kunst und die Revolution,* 3: 29.

58. Wagner, *Art and Revolution,* 53 (translation modified); Wagner, *Die Kunst und die Revolution,* 3: 29.

59. Wagner wrote Feuerbach an admiring letter in August 1850 and received a reply the following month; see Ellis, translator's preface to Wagner, *The Art-Work of the Future,* x. Ellis's English translation of the dedication to Feuerbach is found in *Richard Wagner: Prose Works,* 1: 394–95.

60. Jullien, *Richard Wagner,* 125. Jullien unfavorably compares the "politics and pseudo-philosophy" of these essays to Wagner's subsequent and "most important theoretical work," *Opera and Drama.* Ibid., 130. Here, Wagner elaborated on the characters of the individual arts, as the chapter titles indicate: "Opera and the Nature of Music," "The Play and the Nature of Dramatic Poetry," and "The Arts of Poetry and Tone [*Dichtkunst und Tonkunst*] in the Drama of the Future." A summary of this text may be found in Kühnel, "The Prose Writings," 589–96.

61. The titles in German: "Der Mensch und die Kunst im Allgemeinen," "Der künstlerische Mensch und die von ihm unmittelbar abgeleitete Kunst," "Der Mensch als künstlerischer Bildner aus natürlichen Stoffen," "Grundzüge des Kunstwerkes der Zukunft," and "Der Künstler der Zukunft."

62. In German, *Poesie, Ton,* and *Tanz.* Ellis remarks, regarding the use of the last of these, "It is the grace of gesture and of motion which Wagner sums up in this terse and comprehensive term." Ellis, translator's note to Wagner, *The Art-Work of the Future,* 95n.

63. Wagner, *The Art-Work of the Future,* 190 (translation modified); Wagner, *Das Kunstwerk der Zukunft,* 3: 156.

64. The same argument also appeared in reverse: "The art of dance, in her separation from true music and especially from poetry, not only gave up her highest attributes, but also lost some of her *individuality.*" Wagner, *The Art-Work of the Future,* 107 (translation modified); Wagner, *Das Kunstwerk der Zukunft,* 3: 78.

65. Wagner, *The Art-Work of the Future,* 96 (translation modified); Wagner, *Das Kunstwerk der Zukunft,* 3: 68.

66. Fritz Stern, *The Politics of Cultural Despair,* 180. Antoine Compagnon has argued along similar lines that "the Romantic dream of the total work, of the Wagnerian Gesamtkunstwerk, also demanded that each art approach the purity of its medium and attain its essence." Compagnon, "L'hypertexte Proustein," 94.

67. Wagner, *The Art-Work of the Future,* 139; Wagner, *Das Kunstwerk der Zukunft,* 3: 108.

68. "In order to will to be the whole thing which of and in himself he is, the individual must learn to be absolutely not the thing he is not; but . . . only in the fullest of communion with that which is apart from him, in the completest absorption into the commonalty of those who differ from him, can he ever be completely *what* he is by nature, what he must be, and as a reasonable being, can but will to be." Wagner, *The Art-Work of the Future,* 98; Wagner, *Das Kunstwerk der Zukunft,* 3: 70.

69. Wagner, *The Art-Work of the Future,* 99 (translation modified); Wagner, *Das Kunstwerk der Zukunft,* 3: 70.

70. Wagner, *The Art-Work of the Future,* 155 (translation modified); Wagner, *Das Kunstwerk der Zukunft,* 3: 122.

71. Wagner, *Art and Revolution,* 61 (translation modified); Wagner, *Die Kunst und die Revolution,* 3: 37.

72. Wagner, *The Art-Work of the Future,* 186–87; Wagner, *Das Kunstwerk der Zukunft,* 3: 153.

73. Wagner, *The Art-Work of the Future,* 187 (translation modified); Wagner, *Das Kunstwerk der Zukunft,* 3: 153.

74. Wagner, *The Art-Work of the Future,* 135 (translation modified); Wagner, *Das Kunstwerk der Zukunft,* 3: 104.

75. Dahlhaus labeled this dichotomy the "twin cultures of music" of the early nineteenth century. Dahlhaus, *Nineteenth-Century Music,* 13. "By 1830, grand opera had come to refer to an operatic genre that shifted the focus from arias to large choral and ensemble scenes and discarded stories from ancient history and mythology in favor of plots taken from 'romantic' history—from the Middle Ages or the early modern period. The principle of this species of opera was to switch abruptly between mass scenes and touching romances or prayers, between coloratura and outbursts of passion, between instrumental solos and violent orchestral devices." Ibid., 125.

76. Wagner, *The Art-Work of the Future,* 131 and 146 (translation modified); Wagner, *Das Kunstwerk der Zukunft,* 3: 101 and 114.

77. Wagner, "Introduction to *Art and Revolution,*" 28 (translation modified slightly); Wagner, "Einleitung zum dritten und vierten Bände," 3: 6. "I avoided this word 'Communism'" in that essay, he explained, "from fear of gross misunderstanding on the part of our French brothers . . . whereas I forthwith used it without scruple in my later writings on art, designed expressly for Germany." Wagner, "Introduction to *Art and Revolution,*" 28 (translation modified); Wagner, "Einleitung zum dritten und vierten Bände," 3: 5–6.

78. Wagner, *The Art-Work of the Future,* 186 (translation modified); Wagner, *Das Kunstwerk der Zukunft,* 3: 153.

79. Wagner, *The Art-Work of the Future,* 80; Wagner, *Das Kunstwerk der Zukunft,* 3: 52.

80. Wagner, *The Art-Work of the Future,* 185 (translation modified); Wagner, *Das Kunstwerk der Zukunft,* 3: 151.

81. Wagner, *The Art-Work of the Future,* 187 (translation modified); Wagner, *Das Kunstwerk der Zukunft,* 3: 154.

82. Wagner, "A Communication to My Friends," 283; Wagner, "Eine Mittheilung an meine Freunde," 4: 244.

83. Wagner, *The Art-Work of the Future,* 168 (translation modified); Wagner, *Das Kunstwerk der Zukunft,* 3: 135.

84. Wagner, "A Communication to My Friends," 283 (translation modified); Wagner, "Eine Mittheilung an meine Freunde," 4: 243–44.

85. Wagner, *The Art-Work of the Future,* 184 (translation modified); Wagner, *Das Kunstwerk der Zukunft,* 3: 150.

86. Wagner, *The Art-Work of the Future,* 143 (translation modified); Wagner, *Das Kunstwerk der Zukunft,* 3: 111.

87. Wagner, *The Art-Work of the Future,* 74 and 75 (translation modified); Wagner, *Das Kunstwerk der Zukunft,* 3: 47 and 48.

88. "The link between art and politics was the *Volk,* that mythical repository of character and strength, of which every conservative German dreamed." Fritz Stern, *The Politics of Cultural Despair,* 179. Stern notes the distinction between "the genuine *Volk* that are always right and the democratic collection of individuals, of egoists, that was almost always inimical to the *Volk.*" Ibid., 120. On the parallel between European Hellenism and the interest in folk culture, see Chytry, *The Aesthetic State,* 6.

89. Wagner, *The Art-Work of the Future,* 88 (translation modified); Wagner, *Das Kunstwerk der Zukunft,* 3: 60.

90. Wagner, *Art and Revolution,* 47 (translation modified); Wagner, *Die Kunst und die Revolution,* 3: 24.

2. BUILDING BAYREUTH

1. Wagner, *The Art-Work of the Future,* 184 (translation modified); Wagner, *Das Kunstwerk der Zukunft,* 3: 151.

2. Wagner, *The Art-Work of the Future,* 185 (translation modified); Wagner, *Das Kunstwerk der Zukunft,* 3: 151–52.

3. Gottfried Semper, *The Four Elements of Architecture and Other Writings,* 52. Mallgrave claims a direct line of influence from Semper to Wagner; the Gesamtkunstwerk "is a theatrical

conception already articulated by Semper in *Preliminary Remarks on Polychrome Architecture,*" he writes, adding, "Various passages from their writings, in fact, are so close in subject and outlook that they could have been penned by the same person." Mallgrave, *Gottfried Semper,* 126 and 128. Wagner in 1849, he argues, "certainly knew Semper's earlier pamphlet on polychromy, but the monograph on the theater [*Das Königliche Hoftheater zu Dresden*] had yet to appear. It is quite possible, however, that Wagner read the text in August 1849 when he visited Semper in Paris, just as the architect was completing the final drawings for the work. In any case, Wagner paid a second visit to Semper . . . in February 1850, during which time Wagner asked Semper to read his essay and comment on it." Ibid., 129. See also Eggert, "Der Begriff des Gesamtkunstwerks in Sempers Theorie."

4. On the enthusiasm for polychromy (both literal and theoretical) in the 1840s, see Mallgrave, *Gottfried Semper,* 182–85.

5. James William Davison, "The Wagner Festival at Bayreuth," *Times* (London), August 9–29, 1876, reprinted in Hartford, *Bayreuth,* 100.

6. Wagner, *The Art-Work of the Future,* 162 (translation modified); Wagner, *Das Kunstwerk der Zukunft,* 3: 129. "But *landscape painting,* as last and perfected conclusion of all the fine arts, will become the actual, life-giving soul of architecture; she will teach us to construct the *stage* for the dramatic work of art of the future." Wagner, *The Art-Work of the Future,* 181 (translation modified); Wagner, *Das Kunstwerk der Zukunft,* 3: 147–48.

7. Wagner, *The Art-Work of the Future,* 38–39 (translation modified); Wagner, *Das Kunstwerk der Zukunft,* 3: 16.

8. Wagner, *The Art-Work of the Future,* 43 (translation modified); Wagner, *Das Kunstwerk der Zukunft,* 3: 20.

9. Ibid. (translation modified).

10. Wagner to Kietz, September 14, 1850, in *Richard Wagner: Sämtliche Briefe,* 3: 404ff., quoted in Habel, *Festspielhaus und Wahnfried,* 13. Habel also mentions Wagner's suggestion of the idea of the *Festspiel* in a letter of 1834, citing Lucas, *Die Festspiel-Idee Richard Wagners,* 2: 38. See also Joachim Köhler, *Richard Wagner,* 534–35.

11. Wagner to Uhlig, September 20, 1850, in *Briefe an Theodor Uhlig, Wilhelm Fischer, Ferdinand Heine* (Leipzig, 1888), 58ff., quoted in Habel, *Festspielhaus und Wahnfried,* 13. See also *Richard Wagner: Sämtliche Briefe,* 3: 425ff.

12. Wagner to Uhlig, September 20, 1850. Wagner acknowledged the excessive nature of his proposal: "To the people pleased by the thing, I will then say, 'so, do the same!' But if they also want to hear something new from me once more, I'll say, '*you* get the money together!'— So, do I seem totally insane to you? Could be, but I assure you, to attain this is the hope of my life, the prospect—that alone can appeal to me, to tackle a work of art." Ibid.

13. Wagner to Uhlig, November 12, 1852, in *Briefe an Theodor Uhlig, Wilhelm Fischer, Ferdinand Heine,* 118ff., quoted in Habel, *Festspielhaus und Wahnfried,* 13. He continues: "The next revolution must necessarily bring our entire theater industry to an end; it must and will destroy everything; that much is certain."

14. Ibid.

15. Wagner had fifty copies of the *Ring* librettos privately printed, and in February 1853 he sent one to Semper in London. See Habel, *Festspielhaus und Wahnfried,* 24.

16. Wagner, quoted in Habel, *Festspielhaus und Wahnfried,* 23. "As late as 1854," Köhler writes, "Wagner was still stressing the uniqueness of this performance, after which 'house and

work may be destroyed as far as I am concerned.'" Köhler cites Carl Friedrich Glasenapp, *Das Leben Richard Wagners,* 6 vols. (Leipzig, 1905–11), 3: 467, adding, "Wagner apparently made this remark to August Lesimple in Zurich." Joachim Köhler, *Richard Wagner,* 535 and 668 n. 151.

17. See Habel, *Festspielhaus und Wahnfried,* 24.

18. Wagner, *The Art-Work of the Future,* 185 (translation modified); Wagner, *Das Kunstwerk der Zukunft,* 3: 151.

19. Ludwig II to Wagner, November 26, 1864, quoted in Habel, *Festspielhaus und Wahnfried,* 23; Habel cites Otto Strobel, ed., *König Ludwig II und Richard Wagner: Briefwechsel* (Karlsruhe: B. G. Braun, 1936–39), 1: 39. Habel calls Wagner's desire for a provisional wood theater more "realistic" than Ludwig's idea of building it in stone, but this seems inappropriate given Wagner's plan for destroying this wood theater after one performance.

20. Wagner's immediate rivals were Giacomo Meyerbeer and Felix Mendelssohn, both of whom he targeted in his essay "Das Judenthum in der Musik," which appeared in the *Neue Zeitschrift für Musik* in 1850. See Joachim Köhler, *Richard Wagner,* 126–34 and 188–92.

21. Wagner to Semper, December 13, 1864, quoted in Habel, *Festspielhaus und Wahnfried,* 25. See also Manfred Semper, *Das Münchener Festspielhaus.*

22. See Mallgrave, *Gottfried Semper,* 251–52.

23. Wagner, diary entry of September 9, 1865, *The Diary of Richard Wagner, 1865–1882,* 71 (translation modified); Wagner, diary entry of September 9, 1865, *Das Braune Buch,* 83. According to Manfred Eger, "Ludwig himself had been the first to suggest the Festival Theater," whereas "Wagner was unimpressed by the plan. . . . Secretly opposed to the idea, he had nonetheless recommended Gottfried Semper as architect." Eger, "The Patronage of King Ludwig II," 319–20.

24. Wagner would finish *Die Meistersinger* and return to *Siegfried* in 1867, completing *Siegfried* and beginning *Götterdämmerung* two years later. The premieres of *Tristan* and *Die Meistersinger* took place in 1865 and 1868, respectively.

25. Wagner to Semper, December 13, 1864, quoted in Habel, "Die Idee eines Festspielhauses," 299.

26. For a compelling argument against the generally accepted belief that Wagner "shamelessly exploited the king" and his money, see Eger, "The Patronage of King Ludwig II," 325.

27. Wagner to Semper, December 13, 1864, quoted in Habel, "Die Idee eines Festspielhauses," 299.

28. Ibid.

29. Wagner to Ludwig II, September 13, 1865, quoted in Gobran, "The Munich Festival Theater Letters," 58.

30. Mallgrave, *Gottfried Semper,* 260. Facade measurements are taken from Izenour, *Theater Design,* 155, n. 37.

31. Wagner to Ludwig II, January 2, 1867, quoted in Habel, *Festspielhaus und Wahnfried,* 61.

32. On the design for the interior of the Glass Palace, see Roth, *Der Glaspalast in München,* 31–33; as well as Nerdinger and Oechslin, *Gottfried Semper, 1803–1879,* 409–13.

33. See also Habel, *Festspielhaus und Wahnfried,* 23.

34. Huyssen, "Monumental Seduction," 188. Thorough analysis of Baudelaire's interest, with particular attention to his essay "Richard Wagner et *Tannhäuser* à Paris" of 1861, is found in Miner, *Resonant Gaps.*

35. Semper to Wagner, February 3, 1867, quoted in Gobran, "The Munich Festival Theater Letters," 64.

36. Among the reasons for the change in architect, Gobran cites the "fundamental differences" between Wagner and Semper "with regard to architecture's status in a *Gesamtkunstwerk*," for the composer's idea was "broader in theory than it was realistic in practice." Gobran, "The Munich Festival Theater Letters," 64.

37. Brandt had been working as the *Bühnenmeister,* or "stage manager," at the Darmstadt court theater when Wagner brought him to Bayreuth to supervise the design and construction of his theater. They had worked together previously in Munich; see Izenour, *Theater Design,* 156 n. 47; as well as Kaiser, *Der Bühnenmeister Carl Brandt und Richard Wagner.* "It is important to note that the Wagner-Brandt collaboration, beginning where the Wagner-Semper association ended, had run for some months before the Wagner–Brandt–[Wilhelm] Neumann–Brückwald association began, and it was Brandt who was given the final responsibility by Wagner to ensure that his explicit demands were turned into theater architecture and stage machinery." Izenour, *Theater Design,* 76. See also Mallgrave, *Gottfried Semper,* 266; Habel, "Die Idee eines Festspielhauses," 314; and Spotts, *Bayreuth.*

38. Renovations at the Markgräfliches Opera House have removed the forestage; performers no longer stand in front of the proscenium. See Mackintosh, *Architecture, Actor, and Audience,* 143. Further discussion of this theater is found in Schrader, *Architektur der barocken Hoftheater in Deutschland,* 162–73; and in Wyss, "*Ragnarök* of Illusion," 73–74.

39. Eugène Emmanuel Viollet-le-Duc, quoted in Wyss, "Ragnarök of Illusion," 67; no citation given.

40. Wagner's disdain for those composers whose works were celebrated there was also laced with (and in his mind justified by) anti-Semitism. Giacomo Meyerbeer, for example, born Jakob Liebmann Meyer Beer in 1791 to an assimilated German Jewish family, changed his name at twenty before moving to Paris and becoming enormously popular in both France and Italy.

41. Wagner had similarly contrasted German music with that of Italy and France while campaigning for the construction of a music school as part of Semper's planned theater for him in Munich. See Wagner, "A Music-School for Munich," esp. 174–77.

42. Nietzsche, *The Case of Wagner,* 169.

43. According to Nike Wagner, Wagner wanted the Festival Theater to be built in the town center, close to where Wahnfried was eventually constructed, but "the ground there proved too damp for building, and construction of the theatre was moved to a hill overlooking the town." Nike Wagner, *The Wagners,* 173.

44. Stoeckel, "The Wagner Festival at Bayreuth," 267.

45. Carlson, *Places of Performance,* 88.

46. Shaw (under the pseudonym "Reuter"), untitled essay, in the *Hawk* of August 13, 1889, reprinted in Hartford, *Bayreuth,* 141.

47. See Schivelbusch, *The Railway Journey,* 39.

48. Albert Lavignac, "Voyage artistique à Bayreuth," quoted in Miner, *Resonant Gaps,* 22.

49. "Das Bühnenfestspielhaus / Le théâtre (La salle des représentations scéniques) / Wagner's Festival-Theatre," in *Bayreuth-Album, 1889,* 11. A copy of this album signed by Melchior Lechter is in Melchior Lechter Papers, Special Collections, Getty Research Institute, Los Angeles.

50. "Ausflüge in die nähere und weiter Umgegend / Excursions dans les environs immédiats et au loin / Shorter and Longer Trips in the Environs," in *Bayreuth-Album, 1889*, 53.

51. Shaw (as "Reuter"), untitled essay, 140.

52. Shaw, "Wagner in Bayreuth," in Mander and Mitchenson, *The Wagner Companion*, 207. An abridged version of the essay appears in Hartford, *Bayreuth*, 143–46. Mander and Mitchenson give as their source the September issue of the *English Illustrated Magazine*; Hartford correctly cites the October issue, where the essay is found on pages 49–57.

53. Twain, "At the Shrine of St. Wagner," 209.

54. Ibid., 210.

55. Ibid., 226.

56. Stoeckel, "The Wagner Festival at Bayreuth," 267.

57. Peter Ilyich Tchaikovsky to Modeste Tchaikovsky, August 14, 1876, reprinted in Hartford, *Bayreuth*, 53–54. My knowledge of the inaugural performances is indebted to Gregor-Dellin, *Richard Wagner*, 716–27; as well as to Eger, "The Bayreuth Festival and the Wagner Family," 491–93.

58. On the financing of the patronage scheme, see Eger, "The Bayreuth Festival and the Wagner Family," 490–91; as well as Hartford, introduction to Hartford, *Bayreuth*, 37–38.

59. Twain, "At the Shrine of St. Wagner," 215.

60. Wagner, *Art and Revolution*, 64 (translation modified); Wagner, *Die Kunst und die Revolution*, 3: 40.

61. Water towers were constructed on either side of the building's main facade to assist in case of fire; the current building, rebuilt after World War II, simulates the original wood-and-brick construction.

62. Wagner to Semper, June 13, 1877, quoted in Habel, *Festspielhaus und Wahnfried*, 93; also quoted with date provided in Habel, "Die Idee eines Festspielhauses," 314, which in turn cites Manfred Semper, *Das Münchener Festspielhaus*, 105ff.

63. The *Bayreuth-Album* of 1889 recorded the following figures: "The house holds on the whole 1650 persons, in comparison to which we observe that the Opera house in Berlin can hold 1800 persons, the Victoria theatre in that town 1600, the royal theatre in Dresden 1730, the Hamburg town theatre 2000, the royal theatre in Hanover 1800, the Cologne town theatre 1700, the New theatre in Leipzig 2000, the royal theatre in Munich 2500, the Hofburg in Vienna 1600, and the royal opera there 2500." "Das Bühnenfestspielhaus / Le théâtre (La salle des représentations scéniques) / Wagner's Festival-Theatre," in *Bayreuth-Album*, 12.

64. Lavignac, *The Music Dramas of Richard Wagner and His Festival Theatre in Bayreuth*, 63. An intermediary balcony was added in 1930 for members of the press.

65. A sign now posted on the wall outside the auditorium notes that the total number of seats has been expanded to 1,974: 1,481 in the orchestra, 142 in the loge, 156 in the added balcony, and 195 in the upper gallery. Nike Wagner writes that the woven wicker folding chairs "were replaced in 1968; the new wooden seats were no more comfortable, but at least eighty-three additional spaces were created to boost the box-office takings." Nike Wagner, *The Wagners*, 267. These wooden chairs are now covered in corduroy. On the architectural additions made to the building since 1876, see Hartford, introduction to Hartford, *Bayreuth*, 35–36; according to Hartford, the auditorium holds 1,925 spectators.

66. Stoeckel, "The Wagner Festival at Bayreuth," 265.

67. "In 1876, gas lighting had been installed at the very last minute; electric arc lamps were also used for spots and magic lantern projections. In 1888 full electric lighting was introduced, and a generator set up in a shed behind the theatre (it took several teams of horses to drag it up the hill); when in operation it could be heard for miles around." Hartford, introduction to Hartford, *Bayreuth,* 35.

68. Ibid., 266. The reliance on mechanical means continued inside the building, as an article in the *Manchester Guardian* noted: "The bowels of the stage have a depth of 40 ft., a descent to which discovered a most distressing labyrinth of ropes and traps and awkward elbow joists that resembled a section of some universal motor. There were, in addition, two immense long wooden drums for working the machinery by means of steam, a steam pump, and other requisites for the production of vapour, which in some portions of the Nibelungen drama covers the scene from sight." Anonymous review in the *Manchester Guardian,* August 9, 1876, reprinted in Hartford, *Bayreuth,* 96.

69. Shaw, "Wagner in Bayreuth," 208.

70. Twain, "At the Shrine of St. Wagner," 211.

71. A historical treatment of this topic is found in Jochen Meyer, *Theaterbautheorien zwischen Kunst und Wissenschaft,* esp. 226–32; see also Carlson, *Places of Performance,* 128–57.

72. Twain, "At the Shrine of St. Wagner," 225.

73. Carlson, *Places of Performance,* 142–43.

74. Wagner, *The Art-Work of the Future,* 185n (translation modified); Wagner, *Das Kunstwerk der Zukunft,* 3: 151.

75. "All this is pleasant," Shaw continued, "for if you are an aristocrat, you say 'Good—a man can be no more than a gentleman' and if a democrat, you simply snort and say, 'Aha!'" Shaw (as "Reuter"), untitled essay, 141–42.

76. Shaw, "Wagner in Bayreuth," 208.

77. Shaw even noted the rational circulation of air within the room: "The ventilation is excellent; and the place is free from the peculiar odour inseparable from draped and upholstered theatres. The seats between the last doors and the back do not empty rapidly; but in case of fire the occupants could easily step over into the sections which empty at once, and so get out in time to escape suffocation or burning." Ibid., 209.

78. Ibid., 208. Or, as he wrote the previous month, "You have already bought your playbill in the street for a penny, and you will have to find your own seat among the fifteen hundred in the auditorium. However, this is easy enough, as your ticket directs you to, say, Door No 2 Left Side. That door delivers you close to the end of the row in which your seat is, and as each corner seat is marked with the highest and lowest number contained in the row, you can, by a little resolute brainwork, find your place for yourself." Shaw (as "Reuter"), untitled essay, 141.

79. Stoeckel, "The Wagner Festival at Bayreuth," 267. On the images seen by the first at Bayreuth audiences, see Oswald Georg Bauer, *Josef Hoffmann,* 53–117.

80. Twain, "At the Shrine of St. Wagner," 212.

81. Ibid., 225.

82. Ibid., 222 and 211.

83. Ibid., 224.

84. Ibid., 224–25.

85. Ignoring Semper's role, Köhler writes: "The theater that was built to Wagner's instructions was a recreation of the one in Riga, whose darkened, amphitheatrically rising auditorium

had impressed Wagner in 1837, the very year in which Cosima was born." Joachim Köhler, *Richard Wagner,* 539.

86. Camille Saint-Saëns, excerpt from *Harmonie et mélodie* (Paris: Calmann Lévy, 1885), in Hartford, *Bayreuth,* 60.

87. Ibid., 61.

88. On Wagner's and Brandt's apparent lack of interest in acoustic matters, see Izenour, *Theater Design,* 76.

89. Shaw, "Wagner in Bayreuth," 208.

90. "The reason for this seemingly absurd practice," Dahlhaus writes, "lies in the tradition of the eighteenth century when the conductor, seated amidst the other musicians as a *primus inter pares,* also functioned as harpsichordist or first violinist." Dahlhaus, *Nineteenth-Century Music,* 46. See also Bowen, "The Rise of Conducting," 93ff.

91. Stoeckel, "The Wagner Festival at Bayreuth," 266.

92. Wagner, quoted in Habel, "Die Idee eines Festspielhauses," 311, n.d.

93. Semper to Wagner, May 10, 1865, quoted in Mallgrave, *Gottfried Semper,* 256.

94. Semper to Wagner, November 26, 1865, quoted in Gutman, *Richard Wagner,* 376.

95. Eger, "The Bayreuth Festival and the Wagner Family," 488.

96. Shaw, "Wagner in Bayreuth," 209. "The singers and the players are easily and perfectly heard, the merest whisper of a drum-roll or a tremolo travelling clearly all over the house; and the *fortissimo* of the total vocal and instrumental force comes with admirable balance of tone, without rattle, echo, excessive localization of sound, or harsh preponderance of the shriller instruments." Ibid.

97. Peter Ilyich Tchaikovsky to Modeste Tchaikovsky, August 14, 1876, reprinted in Hartford, *Bayreuth,* 54. An Irish visitor, the composer Sir Charles Villiers Stanford, reminisced about his own visit to Bayreuth: "Beer, it is true, was in sufficient quantities, but the human being cannot exist upon it, and the complaints of the crowds at the restaurants in the town were pitiable to hear, and easy to substantiate." Stanford, *Records and Reflections* (London, 1922), reprinted in Hartford, *Bayreuth,* 105.

98. Eduard Hanslick, diary entry of August 14, 1876, reprinted in Hartford, *Bayreuth,* 73. Hanslick continued: "I only wish to state my increased conviction that a major artistic undertaking belongs in a major city." Ibid. As Ernst Hanisch writes, Hanslick "was the city man condemning the narrow-minded provincial atmosphere of the small town, the Viennese aesthete complaining at length about uncomfortable accommodations and poor food. He was the bourgeois moralist who had internalized the Victorian ideal of the family and who was confronted in the *Ring* with deception, lies, violence, brutish sensuality, and disgusting incestuous relationships." Hanisch, "The Political Influence and Appropriation of Wagner," 188.

99. Cosima Wagner, diary entry of September 9, 1876, in *Die Tagebücher,* 1: 1002.

100. Cosima Wagner, diary entry of February 26, 1877, in *Die Tagebücher,* 1: 1035.

101. "In 1876 . . . Marx contemptuously described Wagner as a 'state composer.'" Krohn, "The Revolutionary of 1848–49," 158 (no citation given).

102. Hanslick, excerpt from *Musical Criticisms, 1846–99,* translated by Henry Pleasants (1951), in Hartford, *Bayreuth,* 74.

3. Empathy Abstracted

1. The English word "empathy" was coined in 1904 in the translation of Wilhelm Wundt's *Principles of Physiological Psychology* by E. B. Titchener, Wundt's former student and

later the head of the psychology laboratory at Cornell University. Notably, contemporary German speakers use the term *Empathie,* not *Einfühlung,* to describe the generic emotional and psychological experience of empathy. Throughout this chapter I have left the term "Einfühlung" untranslated where it refers specifically to the late-nineteenth-century discourse in an effort to distinguish the concept from more amorphous understandings of empathy.

2. Seemingly a gentler model of the aesthetic response than abstraction, distraction, or estrangement, Einfühlung appears to promise a constructive theoretical approach that values emotional understanding, treasures interdisciplinarity, and allows for the possibility of bridging radically different subject positions, both within and across historical periods and geographic zones.

3. Vischer, *Über das optische Formgefühl,* 20. This translation, the phrases and sentences that surround it, and the general introductory overview of Einfühlung that they provide were first presented in "Thoroughly Modern Empathy," a lecture delivered at Columbia University, Yale University, and Johns Hopkins University in spring 2004. Along with the bulk of this chapter, they were first published in Koss, "On the Limits of Empathy," *Art Bulletin* 88, no. 1 (March 2006): 139–57. They subsequently appeared without a citation of their source in Lutz Koepnick, "Richard Wagner and Modern Empathy," chapter 2 of *Framing Attention: Windows on Modern German Culture* (Baltimore, Md.: The Johns Hopkins University Press, 2006).

4. The centrality of spectatorship made theater a natural home for the discourse of Einfühlung. Compare the following analysis of the audience's aesthetic experience made a dozen years later in France: "The public does not consciously exist at Bayreuth; all that is in me that is susceptible to responding to the call of the living drama melds itself intimately to this drama, lives in its life. The rest is completely annihilated. One retakes possession of one's self when the curtain closes." Pierre Bonnier, "L'orientation auditive," *Bulletin scientifique du département du Nord* (1885), 19, quoted in Maynard, "The Enemy Within," 427. My thanks to Debora Silverman for directing my attention to this dissertation.

5. On the link between Einfühlung and Aristotle's notion of *eleos* in the *Rhetoric,* see Kaufmann, *Tragedy and Philosophy,* 44–48; see also Herder, *Kalligone.* For a history of Einfühlung from Immanuel Kant through German Romanticism to the late nineteenth century, see Mallgrave and Ikonomou, introduction to *Empathy, Form, and Space,* 1–85; as well as Morgan, "The Enchantment of Art"; and Etlin, "Aesthetics and the Spatial Sense of Self." Brief essays on empathy theorists and related figures, from Gustav Fechner and Charles Darwin to Wilhelm Worringer, appear in Barasch, *Modern Theories of Art,* 2: 84–187.

6. Nietzsche, "Richard Wagner in Bayreuth," in *Untimely Meditations,* 239 (translation modified); Nietzsche, "Richard Wagner in Bayreuth," in *Nietzsche Werke,* 4: 61. F. T. Vischer had also known Wagner and Semper in Zurich, where he lived after 1855; for claims regarding Robert Vischer's intellectual debt to Semper, see Mallgrave, *Gottfried Semper,* 366.

7. Other important discussions of empathy include Groos, *Einleitung in die Ästhetik;* Groos, *Der ästhetische Genuss;* Volkelt, *Der Symbol-Begriff in der neuesten Ästhetik;* and Volkelt, *Ästhetische Zeitfragen.*

8. Vischer, *On the Optical Sense of Form,* 92; Vischer, *Über das optische Formgefühl,* vii. A mutual interest in the work of Schopenhauer links the empathy theorists to Freud; see Mallgrave and Ikonomou, introduction to *Empathy, Form, and Space,* 8–10.

9. Wölfflin, *Prolegomena to a Psychology of Architecture,* 157 (translation modified); Wölfflin, *Prolegomena zu einer Psychologie der Architektur,* 14. Vischer's distinctions are found

in *Über das optische Formgefühl*, 24–25. "Feeling" here describes an active, physical sensation, as in the phrase "I feel the ground beneath my feet."

10. One image that can provoke a visceral response appears on the cover of Crary, *Techniques of the Observer*. Crary's work on embodied perception in the nineteenth century denies the place of Einfühlung within this history, owing partly to a focus on French material. "The whole neo-Kantian legacy of a disinterested aesthetic perception," Crary has written elsewhere, "from Konrad Fiedler . . . to more recent 'formalisms,' has been founded on the desire to escape from bodily time and its vagaries." Crary, *Suspensions of Perception*, 46. Placing Einfühlung within this escapist camp, he calls its model viewer "constructed . . . to counter the claims of an antihumanist stimulus-response psychology or behaviorism." Ibid., 158. Einfühlung was often deeply engaged with stimulus-response psychology, however; it treated embodied, temporal perception theoretically, as opposed to empirically.

11. Vischer, *On the Optical Sense of Form*, 98; Vischer, *Über das optische Formgefühl*, 10.

12. Vischer, *On the Optical Sense of Form*, 97; Vischer, *Über das optische Formgefühl*, 8.

13. In this context, see the discussion of Adolph Menzel's *Moltke's Binoculars* (1871), *The Opera Glass* (ca. 1850), and *Lady with Opera Glasses* (ca. 1850) in relation to embodied vision in Fried, *Menzel's Realism*, 46–47, 101.

14. Wölfflin, *Prolegomena to a Psychology of Architecture*, 155; Wölfflin, *Prolegomena zu einer Psychologie der Architektur*, 22.

15. "We judge every object by analogy with our body," he asserted two years later, "and should not architecture participate in this unconscious animation? It participates in the highest possible measure." Wölfflin, *Renaissance und Barock*, 56. Compare to Vischer: "In rooms with low ceilings our whole body feels the sensation of weight and pressure. Walls that have become crooked with age offend our basic sense of physical stability." Vischer, *On the Optical Sense of Form*, 98; Vischer, *Über das optische Formgefühl*, 10.

16. Wölfflin, *Prolegomena to a Psychology of Architecture*, 177; Wölfflin, *Prolegomena zu einer Psychologie der Architektur*, 35. Further analysis of Wölfflin's dissertation appears in Mallgrave and Ikonomou, introduction to *Empathy, Form, and Space*, 39–47.

17. Schmarsow, *The Essence of Architectural Creation*, 288; Schmarsow, *Das Wesen der architektonischen Schöpfung*, 15. See also Bettina Köhler, "Architekturgeschichte als Geschichte der Raumwahrnehmung / Architecture History as the History of Spatial Experience."

18. Mitchell Schwarzer has traced the shift to a spatial understanding of architecture to an essay by the Viennese architect Hanns Auer, "The Development of Space in Architecture" (1883). Schwarzer, *German Architectural Theory and the Search for Modern Identity*, 192.

19. This disciplinary divergence is legible in Michael Podro's remark that "there is something strained about the way he [Wölfflin] yokes painting and architecture." Podro, *The Critical Historians of Art*, 98. It is also worth noting Podro's reference to "the basic and rather primitive theory of empathy." Ibid., 100.

20. Insofar as Einfühlung addresses an aesthetic response to space as well as to visual form, it has remained central to the canon of architectural theory, while fading from that of art history. Its central texts are still assigned in methods courses in doctoral programs in architecture history in the United States, for example, while generally remaining absent from their counterparts in art history.

21. See, for example, Giedion, *Space, Time, and Architecture* (1941); and Zevi, *Architecture as Space* (1948), 188–93. In the late 1920s, László Moholy-Nagy defined architecture as "the

functionally and emotionally and satisfactory arrangement of space." Moholy-Nagy, "The Concept of Space," 122.

22. Hildebrand, *The Problem of Form in the Fine Arts,* 247–48; Hildebrand, *Das Problem der Form in der bildenden Kunst,* 28–29.

23. Hildebrand, *The Problem of Form in the Fine Arts,* 239; Hildebrand, *Das Problem der Form in der bildenden Kunst,* 19.

24. Hildebrand, *The Problem of Form in the Fine Arts,* 253; Hildebrand, *Das Problem der Form in der bildenden Kunst,* 33.

25. Hildebrand, *The Problem of Form in the Fine Arts,* 250; Hildebrand, *Das Problem der Form in der bildenden Kunst,* 30.

26. On the link between relief sculpture and narrative, with reference to Hildebrand, see Krauss, *Passages in Modern Sculpture,* 12–15. On opticality and embodiment in the work of Roger Fry, see Krauss, *The Optical Unconscious,* 138ff.

27. Hildebrand, *The Problem of Form in the Fine Arts,* 227. As we have seen, these ideas were not original to Hildebrand; that same year, Schmarsow had defined architecture itself in terms of space: "Our sense of space and spatial imagination press toward spatial creation; they seek their satisfaction in art. We call this art architecture; in plain words, it is the creatress of space [*Raumgestalterin*]." Schmarsow, *The Essence of Architectural Creation,* 287; Schmarsow, *Das Wesen der architektonischen Schöpfung,* 11.

28. Hildebrand, *The Problem of Form in the Fine Arts,* 239.

29. Ibid., 244.

30. Ibid., 229.

31. Hildebrand's distinction of *Sehen* and *Schauen* is found in Hildebrand, *Das Problem der Form in der bildenden Kunst,* 42. See also Vischer: "Scanning is a much more active process than seeing, because it does not simply rely on the natural impulse to seek a relative whole; instead, our eye wanders up and down, left and right, making contact with the individual dimension." Vischer, *On the Optical Sense of Form,* 94; Vischer, *Über das optische Formgefühl,* 1–2. On the relationship of Hildebrand's and Vischer's arguments, see Mallgrave and Ikonomou, introduction to *Empathy, Form, and Space,* 36–37.

32. Such vision, Hildebrand wrote, "is certainly no purely mechanical act; it is only through experience that the imagination turns the mechanical retinal image into a spatial image, allowing us to recognize what it represents." Hildebrand, *The Problem of Form in the Fine Arts,* 236.

33. Ibid., 233.

34. Ibid., 235.

35. Ibid., 252.

36. Ibid., 253–54.

37. Ibid., 229.

38. Ibid., 243. On the German reception of French impressionism beginning in 1890, see Lothar Müller, "The Beauty of the Metropolis."

39. Fried, "Art and Objecthood," 167. Fried famously opposed minimalist objects, which harbored "a kind of latent or hidden anthropomorphism," insofar as they engaged the beholder's body over time. Ibid., 157. His essay did not mention Einfühlung, but his opposition to the concept may be inferred from his use of Brecht to argue against "theatricality" in the theater as well.

40. Greenberg, "Modernist Painting," 4: 89.

41. Ibid., 90.

42. Fiedler, *The Origins of Artistic Activity,* quoted in Dal Co, *Figures of Architecture and Thought,* 114. "In the following investigations," Fiedler explained in his book's opening pages, "'artistic activity' always refers only to the activity of the fine artist." Fiedler, "Über den Ursprung der künsterlischen Thätigkeit," 1: 111.

43. The first reference in this correspondence to the development of the artistic principles that would later appear in *The Problem of Form* is found in a letter of 1881; Hildebrand thanked Fiedler for his comments on an initial manuscript and continued to present his argument that visual art should provide the viewer with an intense perceptual experience that was grounded optically. "This desire," he declared, "this means of obtaining clarity, this method, expedient for recognition and based in the eye, shows itself most powerfully in relief." Hildebrand to Fiedler, October 9, 1881, in Jachmann, *Adolf von Hildebrands Briefwechsel mit Conrad Fiedler,* 161. As Wölfflin put it: "Without Fiedler, Hildebrand might very well not have written his *Problem of Form.*" Wölfflin, quoted in Henry Schaefer-Simmern, introduction to Fiedler, *On Judging Works of Visual Art,* xii.

44. On the overlap of Einfühlung and formalist theory in Geoffrey Scott's *The Architecture of Humanism* (1914), see Mitrovic, "Apollo's Own."

45. Fiedler to Hildebrand, August 27, 1876, in Jachmann, *Adolf von Hildebrands Briefwechsel mit Conrad Fiedler,* 65.

46. Fiedler, "Richard Wagner," 2: 272. See also Andreas Anglet, "Musikphilosophische Perspektiven der Kunsttheorie Konrad Fiedlers."

47. Rozanova, "Extracts from Articles," 148.

48. By contrast, the vertical zips of Barnett Newman might be read in relation to Einfühlung—albeit watered down, over the decades, in its transfer to the United States. On Newman's critique of Worringer's arguments (which the artist knew only through paraphrases provided by T. E. Hulme), see Barck, "Worringers Stilpsychologie im Kontext der Stilforschung," 31. For a discussion of Newman's zips with regard to the phenomenological concerns of Maurice Merleau-Ponty, see Bois, *Painting as Model,* 194–96.

49. The birth of experimental psychology within the domain of philosophy is usually taken to be the establishment of Wilhelm Wundt's laboratory in Leipzig in 1879. See Danziger, *Constructing the Subject,* 17–38; Fizer, *Psychologism and Psychoaesthetics,* 45–57; Jarzombek, *The Psychologizing of Modernity,* 37–72; Jay, "Modernism and the Specter of Psychologism"; and Leary, "The Philosophical Development of the Conception of Psychology in Germany." See also Crary, *Techniques of the Observer,* 69 and passim.

50. Lipps, "Einfühlung und ästhetischer Genuss," 108. An English translation (mistakenly dated 1905), is found in Aschenbrenner and Isenberg, *Aesthetic Theories,* 409.

51. "It is a basic fact of psychology and even more so of aesthetics that a 'sensuously given object,' strictly speaking, is an absurdity—something that does not exist and never can exist." Lipps, "Einfühlung und ästhetischer Genuss," 106.

52. Lipps, "Psychologie und Aesthetik," 111–12.

53. At the same time, those whose work had been steeped in Einfühlung had moved away from its theoretical claims. On the methodological shifts in Wölfflin's work, for example, see Warnke, "On Heinrich Wölfflin."

54. Hildebrand to Fiedler, July 24, 1892, in Sattler, *Adolf von Hildebrand und seine Welt,*

384. Hildebrand refers to a talk Helmholtz had presented at the general meeting of the Goethe Society in Weimar on July 11, 1892, published in *Deutsche Rundschau* 72: 115–32 (see also Sattler, *Adolf von Hildebrand und seine Welt,* 741 n. 232). Fiedler viewed this common ground more warily, warning his friend, "If you were ever to publish your research, people would be able to say in some instances that Helmholtz has already touched upon it." Fiedler to Hildebrand, August 6, 1892, in Sattler, *Adolf von Hildebrand und seine Welt,* 385.

55. Hildebrand to Nikolaus Kleinenberg, February 11, 1891, in Sattler, *Adolf von Hildebrand und seine Welt,* 359. See also two letters from Hildebrand to Fiedler of April 9 and 16, 1891, and one from Helmholtz to Hildebrand of December 26, 1891, in ibid., 362 and 374. The bust is now in the Academy of Sciences in Berlin.

56. Bullough, "Recent Work in Experimental Aesthetics," 93.

57. Ibid., 86. Bullough labeled these "objective," "physiological," "associative," and "character."

58. Ibid., 78.

59. Ibid.

60. Vischer, *Über das optische Formgefühl,* 26.

61. Ironically, the object is not an original work of art but a copy of a painting by Giovanni Bellini.

62. Worringer, lecture on Wölfflin, n.d., in Wilhelm Worringer Papers, Fine Arts Archive, Germanisches Museum, Nuremberg, ZR ABK 146, p. 160a/93.

63. Lipps, "Einfühlung und ästhetischer Genuss," 113.

64. For a treatment of German socioeconomic transformation between 1870 and 1918, see Ringer, *The Decline of the German Mandarins,* 42–61.

65. See Kaes, "Mass Culture and Modernity," 320; as well as Kaes, "The Debate about Cinema."

66. Panofsky, "Style and Medium in the Motion Pictures," 93–94.

67. Begun in 1905, *Abstraktion und Einfühlung* was published first as a dissertation (Neuwied, 1907) and subsequently as a book, in 1908. It did not appear in English until 1953. See Waite, "Worringer's *Abstraction and Empathy,*" esp. 16–20; Gluck, "Interpreting Primitivism, Mass Culture, and Modernism"; as well as Siegfried K. Lang, "Wilhelm Worringers *Abstraktion und Einfühlung.*" Worringer's work entered Anglophone criticism through Joseph Frank and T. E. Hulme, with its absorption into art history accomplished primarily by Rudolf Arnheim and Herbert Read. Its postwar reception was affected by Worringer's political and biographical circumstances, which may be gleaned from a lecture in 1924 concerning what he termed "the eternal cultural struggle on two fronts in the midst of which we Germans, as people of the European center, are placed." Worringer, *Deutsche Jugend und östlicher Geist,* 5; I thank Margaret Olin for sharing this text with me. See also Grebing, "Bildungsbürgerlichkeit als Lebenssinn."

68. Again following Riegl, Worringer presented the *Kunstwollen* as Riegl's critique of Semper's materialist followers. See Worringer, *Abstraktion und Einfühlung,* 42. Riegl had argued, "Technical factors surely played a role as well . . . but it was by no means the leading role that the supporters of the technical materialist theory of origin assumed. The impetus did not arise from the technique but from the particular artistic impulse." Riegl, *Problems of Style,* 30.

69. Worringer's argument overthrew the tyranny of ancient Greece and of the Renaissance, while remaining under Nietzsche's spell. (The reference here is to Butler, *The Tyranny of*

Greece over Germany.) One might argue that with *Problems of Style,* Riegl offered a theoretical justification of Jugendstil ornament while perpetuating the tyranny of Greece.

70. Ernst, review of *Abstraktion und Einfühlung,* 529. Worringer referred to "the poet Paul Ernst" in the foreword to the 1948 edition of his book; Karl Scheffler cited "the dramatist Paul Ernst, who may be described as the leader of the neoclassical school in Germany." Scheffler, "Bühnenkunst," 222.

71. According to Marvin Carlson, this neoclassicism "grew from the same roots as the sociological writings of [Georg] Simmel." Carlson, *Theories of the Theatre,* 331. Carlson's treatment of Ernst follows a discussion of Georg Lukács, who wrote on Ernst; according to Richard Sheppard, "Lukács had a long-standing friendship with Paul Ernst . . . until the latter's flirtation with the Nazis." Sheppard, "Georg Lukács, Wilhelm Worringer, and German Expressionism," 282, n. 2.

72. Ernst, review of *Abstraktion und Einfühlung,* 529.

73. Paul Stern, *Einfühlung und Association in der neueren Ästhetik* [Empathy and association in the new aesthetics]; see Worringer, *Abstraktion und Einfühlung,* 136 n. 2.

74. He had included in the bibliography appended to his dissertation the two volumes of Lipps's *Aesthetics,* published in 1903 and 1906, respectively. See Worringer, *Abstraktion und Einfühlung,* 170 n. 3. On Lipps's abandonment of psychologism following criticism from Edmund Husserl, see Fizer, *Psychologism and Psychoaesthetics,* 224 n. 18; on Worringer's productive misreading of Lipps, see Waite, "Worringer's *Abstraction and Empathy,*" 23–28.

75. Worringer, *Abstraktion und Einfühlung,* 36.

76. Ibid.

77. Lipps, "Einfühlung und ästhetischer Genuss," quoted in Worringer, *Abstraktion und Einfühlung,* 37, 40, 48, 58, 59.

78. Worringer, *Abstraktion und Einfühlung,* 40.

79. Ibid., 52.

80. Ibid., 48. The implicit link between beauty and empathy was made by Carl Jung, who argued (citing Theodor Lipps): "The form into which one cannot empathize is . . . *ugly.*" Jung, *Psychological Types,* 360 (translation modified).

81. See Worringer, *Abstraktion und Einfühlung,* 39.

82. See ibid., 9–13. For an analysis of this tale as "empathetic discourse in the crudest sense," see Waite, "Worringer's *Abstraction and Empathy,*" 30.

83. Worringer, *Abstraktion und Einfühlung,* 59.

84. Ibid., 59–60. I have translated *Entäußerung* as "estrangement" to distinguish it from Marx's concept of alienation, *Entfremdung.*

85. Lipps, quoted in ibid., 60.

86. Worringer, *Abstraktion und Einfühlung,* 60.

87. Ibid.

88. Nietzsche, "Richard Wagner in Bayreuth," in *Untimely Meditations,* 222 (translation modified); Nietzsche, "Richard Wagner in Bayreuth," in *Nietzsche Werke,* 4: 38.

89. Wagner, *The Art-Work of the Future,* 168 (translation modified); Wagner, *Das Kunstwerk der Zukunft,* 3: 135.

90. Describing an artist viewing the subject for a painting, Nietzsche referred to "that aesthetic phenomenon of detachment from personal interest with which a painter sees in a stormy landscape with thunder and lightning, or a rolling sea, only the picture of them within him,

the phenomenon of complete absorption in the things themselves." Nietzsche, "On the Uses and Disadvantages of History for Life" (1873), in *Untimely Meditations,* 91.

91. Worringer, *Abstraktion und Einfühlung,* 75–76. Introducing the reissued English edition of Worringer's book in 1997, Hilton Kramer presented the author as a proto-Greenbergian: "What remains central to *Abstraction and Empathy* is the essential distinction it makes between art that takes pleasure in creating some recognizable simulacrum of three-dimensional space . . . and art that suppresses that spatial illusion in favor of something flatter, more constricted and abstract." Kramer, introduction to Worringer, *Abstraction and Empathy,* ix.

92. See Worringer, *Abstraktion und Einfühlung,* 59, 76, and passim.

93. Ibid., 49. On spatial anxiety in architectural discourse, see Esther da Costa Meyer, "La Donna è Mobile"; as well as Vidler, *The Architectural Uncanny*; and Vidler, "Agoraphobia."

94. Worringer, *Abstraktion und Einfühlung,* 49.

95. Ibid., 50.

96. Ibid.

97. Ibid., 55–56.

98. Ibid., 81.

99. What Hildebrand had labeled "the agonizing quality of the cubic," Worringer argued, "is ultimately nothing else than a remnant of that agony and unease that governed mankind in the face of the things of the outside world in their unclear connection and interplay; it is nothing else than a final memory of the point of departure for all artistic creation, namely of the urge to abstraction." Ibid., 58. See also Worringer, review of *Gesammelte Aufsätze,* 3: 212. The task of sculpture, Hildebrand had actually written, is to offer a "visual image and thus to remove what is disturbing from the cubic form." Hildebrand, *Das Problem der Form in der bildenden Kunst,* 37; Hildebrand, *The Problem of Form in the Fine Arts,* 258.

100. Riegl, *Problems of Style,* 14. "The earliest works of art are sculptural," Riegl further explained. "Since things in nature are seen only from one side, however, relief sculpture began to satisfy the same purpose. Subsequently, two-dimensional representation was established and led to the idea of the outline. Finally, sculptural qualities were abandoned altogether and replaced by drawing." Ibid., 29.

101. "It's certainly very welcome that Dr. Wilhelm Worringer, Professor of Art History in Bern [*sic*], has undertaken to portray and to develop further the basic principles of his [Riegl's] view of art," Egon Friedell declared in a review of *Abstraction and Empathy* in 1920; Riegl's work was important, but "not in the least accessible," and Worringer helped the reader navigate "the oppressive fullness of purely archaeological detail . . . to get at the genial thoughts at the core." Friedell, "Der Sinn des Expressionismus," *Neues Wiener Journal,* June 25, 1920, quoted in Donahue, *Forms of Disruption,* 32 n. 10. Worringer was a professor at the University of Bonn from 1920 to 1928.

102. See Worringer, 78 and 106–8; and Riegl, *Problems of Style,* 51–83. For a discussion of the symbolic value of Egyptian art in the work of Riegl, Hildebrand, Worringer, and others, particularly in relation to early silent film, see Lant, "Haptical Cinema." Two decades later Worringer published *Ägyptische Kunst.*

103. On the naturalist movement in Munich at the end of the nineteenth century and its demise two decades later, see Jelavich, *Munich and Theatrical Modernism,* 26–52.

104. Worringer, *Abstraktion und Einfühlung,* 44.

105. Behrens, *Feste des Lebens und der Kunst,* 22.

106. Ernst, review of *Abstraktion und Einfühlung,* 529.

107. Worringer, *Abstraktion und Einfühlung,* 92–93. He was not averse to sexist generalizations, however, and elsewhere referred to the "feminine receptivity to the appearances of life" that dominated nineteenth-century architecture, arguing that "this feminine self-resignation is synonymous with the will to the loss of self." Worringer, "Zum Problem der modernen Architektur," 496.

108. Scheffler, *Die Frau und die Kunst,* 4.

109. Ibid., 38.

110. Worringer's engagement with contemporary art increased after the publication of *Abstraction and Empathy* in 1908. See Perkins, *Contemporary Theory of Expressionism,* 47–48.

111. Gabriele Münter to Wilhelm Worringer, January 13, 1951, Wilhelm Worringer Papers, ZR ABK 146, p. 377.

112. Werner Haftman, "Gruss an Wilhelm Worringer," *Die Neue Zeitung,* January 9, 1951, in Wilhelm Worringer Papers, ZR ABK 146, p. 278. Hans Sedlmeyer referred to *Abstraction and Empathy* as "a bestseller of art history," saying, "Even in the twenties, every educated person who wanted to speak about art had to have read it, much like—a bit earlier—Simmel's writings." Sedlmeyer (memorial speech, Ostfriedhof Crematorium, Munich, April 2, 1965), in Wilhelm Worringer Papers, ZR ABK 146, p. 486.

113. Kandinsky, *Concerning the Spiritual in Art,* 44; Kandinsky, *Über das Geistige in der Kunst,* 110. According to Peg Weiss, Kandinsky was "not likely to have seen the book [*Abstraction and Empathy*] in any case before 1909, when his own ideas . . . were already well formulated." Weiss, *Kandinsky in Munich,* 159.

114. Kandinsky, *Concerning the Spiritual in Art,* 32; Kandinsky, *Über das Geistige in der Kunst,* 75–76. Worringer's response to Kandinsky's book was polite, but distant. With reference to the artist's famous description of art as a large, upwardly moving triangle, he wrote: "Briefly formulated, this is my position with regard to your book: I am not standing at the same point, but I find myself in the same triangle." Worringer to Kandinsky, January 7, 1912, quoted in Frank, "Die Missverstandene Antithese," 75.

4. The Nietzschean Festival

1. Count Harry Kessler, quoted in Aschheim, *The Nietzsche Legacy in Germany,* 23. "For the post-1890 literate public, some sort of confrontation with Nietzsche—the man, the image, and his works—was becoming virtually obligatory." Aschheim, *The Nietzsche Legacy in Germany,* 18.

2. Nietzsche, "Richard Wagner in Bayreuth," in *Untimely Meditations,* 248.

3. Fiedler to Hildebrand, August 2, 1876, in Jachmann, *Adolf von Hildebrands Briefwechsel mit Conrad Fiedler,* 62. "Nietzsche was constantly trying to rescue Wagner from the Germans and to place him above Wagnerism, by portraying him as a Frenchman—that is, as a revolutionary and as a decadent." Hanisch, "The Political Influence and Appropriation of Wagner," 195. On the Wagner cult in late-nineteenth- and early-twentieth-century Germany, see Grund, *Zwischen den Künsten,* esp. 152ff.

4. A psychobiographical account of this relationship and its demise is found in Joachim Köhler, *Nietzsche and Wagner;* insightful analysis of Nietzsche's writings concerning Wagner may be found in Frisch, *German Modernism,* 17–28.

5. Nietzsche, *The Case of Wagner,* 167.

6. Nietzsche, *The Birth of Tragedy*, 79.

7. Ibid.

8. Ibid., 128; Nietzsche, *Die Geburt der Tragödie*, 3: 1 and 133.

9. Nordau, *Degeneration*, 199.

10. Fuchs graduated in 1888 from the gymnasium in Darmstadt, where he had been a classmate and friend of the writer Stefan George. After a year of military service, he studied for two years in Leipzig: first theology, at the insistence of his father, a Lutheran minister, and then *Germanistik*. In 1891, he moved to Munich to become an art critic in Germany's self-proclaimed *Kunststadt*, or "art city"; for five years there, he edited *Allgemeine Kunst-Chronik*, begun in 1892 and supportive of the newly formed Munich Secession movement. His essay "Vorspiel" appeared in George's own art journal, *Die Blätter für die Kunst*, in 1894. In *Allgemeine Kunst-Chronik*, his review of the Munich Secession exhibition in 1893 was followed that same year by "Divina Comedia!—Vom Zwecke der Schaubühne" and by a pseudonymously published essay in which he reported on the artistic activities in Darmstadt.

11. Fuchs, "Richard Wagner und die moderne Malerei," 113.

12. Ibid., 98.

13. Emil Fuchs, *Mein Leben*, 1: 49.

14. Fuchs, "Friedrich Nietzsche und die bildende Kunst," 33.

15. Ibid., 34.

16. Ibid.

17. Ibid., 37.

18. Ibid., 37–38.

19. Ibid., 33. The two sentences appear in Nietzsche, *Thus Spoke Zarathustra*, 141 and 303 (translation modified). Fuchs returned to the first quotation seven years later, in an essay on Peter Behrens's design for the Hamburg entry hall at the International Exhibition of Modern Decorative Arts in Turin. See Fuchs, "Die Vorhalle zum Hause der Macht und der Schönheit," 9.

20. On the early-twentieth-century German promulgation of *Sachlichkeit*, or "objectivity," as a critique of the individualism and elitism of secessionism and Jugendstil, see, for example, Pevsner, *Pioneers of Modern Design*, 32–36; Schwarzer, *German Architectural Theory and the Search for Modern Identity*, 215–60; as well as Schwartz, *The Werkbund*, esp. 23–43.

21. The founding of the Werkbund is often taken as the emblematic moment when Nietzschean ideals began to confront the realities of mass culture—when, for example, the creative individualism of Jugendstil design gave way to a machine aesthetic. This transition, of course, happened neither instantly nor solely within the realm of designed objects; rather, it occurred throughout German culture in the context of sweeping socioeconomic and political changes. In this context, see Campbell, *The German Werkbund*, 9–32; Jarzombek, "The Discourses of a Bourgeois Utopia, 1904–1908, and the Founding of the Werkbund"; Jeffries, *Politics and Culture in Wilhelmine Germany*, 101–243; Junghanns, *Der Deutsche Werkbund*, 17–27; Schwartz, *The Werkbund*, esp. 23–43; Posener, "Between Art and Industry"; and Posener, "Werkbund and Jugendstil."

22. Beyond its implicit status in Nietzsche's works, the question of the individual's relation to his social group was prominent in the German sociological and philosophical literature of the early twentieth century. Notable treatments of the theme include Simmel, "Group Expansion and the Development of Individuality"; as well as Kracauer, "The Group as Bearer of Ideas."

23. Fuchs, "Friedrich Nietzsche und die bildende Kunst," 35. The idea of art providing completion for the mundane experiences of daily life famously recurs in *The Birth of Tragedy*: "We have our highest dignity in our significance as works of art—for it is only as an *aesthetic phenomenon* that existence and the world are eternally *justified*." Nietzsche, *The Birth of Tragedy*, 62.

24. Fuchs, *Der Kaiser, die Kultur, und die Kunst*, 38. See also Krimmel, "In Schönheit Sterben."

25. The typeface had been designed in 1900 by G. Lemmen (with the assistance of Count Harry Kessler); van de Velde designed the book, title page, and ornaments and oversaw the printing process. It was published in Leipzig by Drugulin in 1908. The leather-bound book is held in the Special Collections of the Getty Research Institute, Los Angeles, no. 471. On the relationship of Nietzschean philosophy to art and architecture, see Kostka and Wohlfarth, *Nietzsche and "An Architecture of Our Minds,"* especially Neumeyer, "Nietzsche and Modern Architecture."

26. According to Wiltrud H. Steinacker, "in 1896 Fuchs was offered the post of chief editor for the Darmstadt art journal *Deutsche Kunst und Dekoration*, to be published by Alexander Koch, who had founded a publishing company carrying his name in Darmstadt in 1888. . . . It was due to this position that Fuchs took part in the planning of the Colony and its exhibition." Steinacker, "Fuchs and the Concept of the Relief Stage," 52. Lenz Prütting writes that Koch invited Fuchs "to come to Darmstadt and become the editor of his journal." Prütting, "Die Revolution des Theaters," 68. Fuchs's name, however, appears neither on the masthead of the journal nor in Randa, *Alexander Koch, Publizist und Verleger in Darmstadt*.

27. Fuchs, "Die 'Mathilden-Höhe' Einst und Jetzt," in Koch, *Grossherzog Ernst Ludwig und die Ausstellung der Künstler-Kolonie in Darmstadt von Mai bis Oktober 1901*, 115. This volume, reissued in facsimile form in 1989 as *Die Ausstellung der Darmstädter Kunstlerkolonie*, contains several essays by Fuchs and others reprinted from *Deutsche Kunst und Dekoration*.

28. On the Nietzschean qualities of the Darmstadt Artists' Colony, see Anderson, *Peter Behrens and a New Architecture for the Twentieth Century*, 45–67; as well as Buddensieg, "Das Wohnhaus als Kultbau."

29. On the founding of the Artists' Colony, see Kruft, "The Artists' Colony on the Mathildenhöhe"; as well as Bott, "Darmstadt und die Mathildenhöhe"; and Maciuika, *Before the Bauhaus*, 35–39. Behrens spent four years in Darmstadt, from November 1899 to March 1903. A concise and respectful narration of the history of the Artists' Colony, written by the grand duke's son, is found in Hessen, *Die Darmstädter Künstlerkolonie*.

30. The motto is taken from the Viennese art critic Hermann Bahr. See Kruft, "The Artists' Colony on the Mathildenhöhe," 28.

31. Behrens, *Ein Dokument Deutscher Kunst*, in Georg Fuchs Papers, Monacensia Library, Hildebrand Haus, Munich, folder L4182. Behrens wrote to Richard Dehmel, in reference to the Artists' Colony, "We will build a temple to art ourselves; it will be sacred inside." Letter of June 16, 1900, quoted in Boehe, "'Darmstadter Spiele 1901,'" 161.

32. Fuchs, "Grossherzog Ernst Ludwig und die Entstehung der Künstler-Kolonie," 17.

33. For more on the Soviet constructivist urge to bring "art into life," see Lodder, *Russian Constructivism*, 73–108; as well as Andel, "The Constructivist Entanglement." In this context, see also Rosenthal, *Nietzsche and Soviet Culture*.

34. "The 1901 exhibition attracted the attention of a vast public, but unfortunately, owing to their cost, the furnishings put on show remained inaccessible to the middle class for whom

they had been intended." Kruft, "The Artists' Colony on the Mathildenhöhe," 29. See also Hofmann, "Luxus und Widerspruch."

35. Fuchs, "Grossherzog Ernst Ludwig und die Entstehung der Künstler-Kolonie," 22.

36. Nietzsche, "On the Uses and Disadvantages of History for Life," 123.

37. Ibid., 82.

38. As Stanford Anderson has written, "The grand duke sought to preempt the greater established 'art-cities' by making his seat, Darmstadt, the prominent center of the new movement. . . . That Ernst Ludwig became the patron and apologist for a new cultural program Fuchs claimed to be a logical parallel to what Wilhelm was achieving in the realm of national material productivity and well-being." Anderson, *Peter Behrens and a New Architecture for the Twentieth Century*, 50.

39. Nietzsche, "Richard Wagner in Bayreuth," in *Untimely Meditations*, 210.

40. Ibid., 212. Wagner was "quite incapable of regarding the welfare of art as being in any way divorced from the general welfare." Ibid., 247.

41. Fuchs, "Grossherzog Ernst Ludwig und die Entstehung der Künstler-Kolonie," 20.

42. The original program of *Das Zeichen,* with Fuchs's corrections, is in the Georg Fuchs Papers, Monacensia Library, folder L4182. The text is an alteration of *Die Ankunft des Prometheus: Cantate von Georg Fuchs, Musik von Willem de Haan* (four pages of text; n.d.). The cover page originally read "Das Zeichen: Festliche Handlung von Peter Behrens, Willem de Haan und Georg Fuchs. Dargestellt am 15. Mai 1901. von Frau Kaschowska, Herrn Riechmann, Herrn Weber und dem Hoftheater-Singchore. Orchester: Einige Mitglieder der Hof-Kapelle. Drei kleinere Fanfaren-Orchester a.d. heiligen Militär-Kapellen." These words are crossed out; only the title, *Das Zeichen,* remains. Fuchs has added the words "*Festliche Dichtung* zur Eröffnung des Künstlerhauses durch S.K.H. der Großherzog Ernst Ludwig aufgeführt in Darmstadt am 15. Mai 1901." The final section of *Thus Spoke Zarathustra* was deeply influential in turn-of-the-century Germany, and Behrens himself designed a limited edition of the book that was exhibited in 1902 at the International Exhibition of Modern Decorative Arts in Turin. Prometheus appears throughout *The Birth of Tragedy*—including, visually, on the title page of the first edition. See Anderson, *Peter Behrens and a New Architecture for the Twentieth Century,* 47 and 268 n. 6.

43. The crystal symbolized "the transformation of dust to diamond, life to aesthetic perfection. It was quite precisely the *Zeichen* as Romantic symbol, simultaneously the internal totality of the work of art and the visual embodiment of nonsensuous transcendent truth." Schwartz, *The Werkbund,* 173–74. Schwartz describes the crystal's trajectory from Romantic symbol in the Darmstadt performance in 1901 to corporate symbol in Behrens's design for the Allgemeine Elektricitäts-Gesellschaft (AEG), or "General Electric Company" trademark in 1908. The crystal in Wagner's *Parsifal* would also have been an important source for Fuchs; crystals likewise play a crucial role in Worringer's *Abstraction and Empathy,* representing simultaneously geometric abstraction and the phenomena of the natural world. See also Bletter, "The Interpretation of the Glass Dream"; and Prange, *Das Kristalline als Kunstsymbol.*

44. Three years earlier, Fuchs had written approvingly of the work of Ludwig Habich in his essay "Deutsche Plastik" in *Deutsche Kunst und Dekoration*; his essay devoted to the sculptor, "Ludwig Habich," appeared in *Deutsche Kunst und Dekoration* in 1901.

45. The previous year, these same two vignettes had embellished Behrens's own essay "Die Dekoration der Bühne" in *Deutsche Kunst und Dekoration,* discussed below.

46. Fuchs, "Hermann Obrist," 323. He refers to Obrist's *Peitschenhieb* on page 324. Notably, August Endell objected to Fuchs's analysis. "By the way, I am not at all a pupil of Obrist," he explained in a letter the following year: "This is a childish statement by this G. Fuchs whom I first took to Obrist when nobody knew him. I had to use Fuchs as an intermediary, because I had no relations with the press. Both of us instructed Fuchs thoroughly. Now he acts as the discoverer of the new direction. I shall fix his wagon a little." Endell, undated letter to his cousin written between September 13 and October 15, 1897, excerpted in Buddensieg, "The Early Years of August Endell," 46.

47. Schreyl, *Joseph Maria Olbrich,* 112.

48. See Boehe, "'Darmstadter Spiele 1901.'" The main hall of the Ernst Ludwig House also contained its own stage, hidden behind a curtain. Additionally, one of Olbrich's first projects for the Artists' Colony, drawn in 1899, had been a theater studio. For a description, perspective drawing, and bibliographic references for this project, see Schreyl, *Joseph Maria Olbrich,* 65–66.

49. Ibid.

50. Lichtwark, as quoted in Ludwig Prinz von Hessen und bei Rhein, *Die Darmstädter Künstlerkolonie,* 31–32.

51. Fuchs, *Die Schaubühne der Zukunft,* 70. A frequent self-plagiarist, Fuchs had used the first sentence in a previous essay to argue against "serious literary plays." See Fuchs, "Die Schaubühne—Ein Fest des Lebens," 484.

52. "After Nietzsche became disillusioned with Wagner," Alexandre Kostka has written, "the dream of the 'New Man' was not abandoned but converted into the hopeful anticipation of a Renaissance carried out by a small elite (a 'squad of a hundred progressives')." Kostka, "Architecture of the 'New Man,'" 201. The quotation from Nietzsche is from *Untimely Meditations.*

53. Fuchs, "Die Eröffnungs-Feier vom 15 Mai 1901," 56.

54. Ibid., 60.

55. Nietzsche, fragment from 1881, in *Nietzsche Werke,* 9: 506.

56. Bruns, "Die Eröffnungs-Feier der Kunst-Ausstellung," 446.

57. Nietzsche, "On the Uses and Disadvantages of History for Life," 70.

58. Fuchs, *Die Schaubühne der Zukunft,* 70.

59. Fuchs, "Grossherzog Ernst Ludwig und die Entstehung der Künstler-Kolonie," 22.

60. Fuchs, "Die Schaubühne—Ein Fest des Lebens," 483.

61. Neumeyer, "Nietzsche and Modern Architecture," 286.

62. Fuchs, *Die Schaubühne der Zukunft,* 7. Cultural regeneration, as usual, was predicated on acknowledging the degenerate status of contemporary German culture.

63. Fuchs, "Zur künstlerischen Neugestaltung der Schau-Bühne," 204.

64. Behrens, "Die Dekoration der Bühne," 401.

65. Ibid., 405.

66. Wagner had presented the tendency to abstraction on the part of "Asiatics and Egyptians" as a foil for the naturalism of the ancient Greeks in *The Art-Work of the Future* in 1849; Riegl expanded on the theme in his 1893 book *Problems of Style.* Worringer would make similar symbolic use of Egyptian art in 1908 in *Abstraction and Empathy.*

67. Behrens, *Feste des Lebens und der Kunst,* 12–13. Further analysis of this book can be found in Posener, "Werkbund and Jugendstil," 16.

68. Behrens, *Feste des Lebens und der Kunst,* 10.

69. Ibid., 21.

70. Ibid., 17.

71. Ibid., 19.

72. Notably, before building the Artists' Theater in Munich, Max Littmann became known as the inventor of the variable proscenium, which he built at the Hoftheater in Weimar (1906–8) and which could be raised and lowered. He described this achievement in his 1908 essay "Theatertechnische Neuerung im Hoftheater in Weimar," which is cited at length in the 1929 book *Bühnentechnik der Gegenwart* by Friedrich Kranich, technical director at the time of both the Hanover State Theater and the Bayreuth Festival Theater.

73. Ten years later, Behrens was still promoting the "relief stage"; see Behrens, "On Art for the Stage."

74. According to Anderson, "Fuchs's aristocratic ideals, and the implications of those ideals for the social role and physical form of the theater, directly shaped Behrens's proposal," while Fuchs, under Behrens's influence, came to believe that performance reform would not happen without architectural reform. But Anderson's claim that "the theme of the ceremony and the specific symbol were chosen by Behrens, who used precious stones as the leitmotif of his work at the colony," ignores Fuchs's role in shaping the Darmstadt aesthetic. Anderson, *Peter Behrens and a New Architecture for the Twentieth Century,* 57 and 29. Presenting the performance of *Das Zeichen* entirely as a Behrens creation, Rosemary Haag Bletter ignores Fuchs's authorship of the play and suggests Paul Scheerbart as the source for the architect's interest in crystals. See Bletter, "The Interpretation of the Glass Dream," 31. Steinacker, meanwhile, has argued (without citing sources) that Behrens and Fuchs were unified in their approach, and together united against Olbrich's ideas about theater: "Although Behrens and Fuchs had ambitious plans for establishing a new theater at the Colony, which the former published in his *Feste des Lebens* (Celebrations of Life), these plans did not materialize. The reason for this development lay in the rivalry between Behrens and Fuchs, on the one hand, and another member of the Colony, Joseph Maria Olbrich." Steinacker, "Georg Fuchs and the Concept of the Relief Stage," 53. According to Steinacker, "Behrens was definitely the first to introduce the concept of the relief to the stage (*Feste* 17, 19), while the title of his *Feste des Lebens* (1900) may have been derived from Fuchs' earlier essay." Ibid., 46 n. 61.

75. Fuchs published two plays in 1893: *Liebe, Tragische Oper in einem Akt* and *Das Nibelungenlied, ein Festspiel.* His comedy *Till Eugenspiegel* was published in Florence and Leipzig in 1899, in Darmstadt in 1903, and in Munich and Leipzig in 1905; his tragedy *Manfred* appeared in Darmstadt in 1903 and in Munich and Leipzig in 1905. Further biographical information about Fuchs's early years is found in Steinacker, "Georg Fuchs and the Concept of the Relief Stage," 48ff.; as well as Prütting, "Die Revolution des Theaters," 15–24.

76. Fuchs, *Der Kaiser, die Kultur, und die Kunst,* 84.

77. Ibid., 10.

78. See Muthesius, *The English House.* On the cultural politics of Muthesius's work in Britain, see Maciuika, *Before the Bauhaus,* 69–103.

79. Fuchs, *Der Kaiser, die Kultur, und die Kunst,* 10.

80. Ibid., 11.

81. Ibid., 13.

82. Ibid, 13–14.

83. Ibid., 68.

84. Fuchs, *Die Schaubühne der Zukunft,* 11.

85. Nietzsche, *Human, All Too Human,* 100–101, quoted in Frisch, *German Modernism,* 20.

86. Fuchs, *Die Schaubühne der Zukunft,* 8.

87. This distinction is reiterated in Grohmann, *Das Münchener Künstlertheater in der Bewegung der Szenen- und Theaterreformen,* 6.

88. Fuchs also used the phrase in his essay "Zur Kunstgewerbe-Schule der Zukunft" in 1904.

89. Fuchs, *Die Schaubühne der Zukunft,* 40–41.

90. Ibid., 41.

91. On the retreat within modernist performance from speech in the drama and the concomitant embrace of silence (in the form of pantomime, dance, and silent film), see Segal, *Body Ascendant,* 1–126.

92. Fuchs, "Die Schaubühne—Ein Fest des Lebens," 485.

93. On Wagner's political activity at this time, see Chytry, *The Aesthetic State,* 274–80. For more on the significance of Wagnerian politics in the early years of the twentieth century, see Fritz Stern, *The Politics of Cultural Despair,* 120–23.

94. Fuchs, "Die Schaubühne—Ein Fest des Lebens," 484.

95. Fuchs, *Die Schaubühne der Zukunft,* 7.

96. Ibid., 35.

97. Ibid., 9.

98. Ibid., 6. Again, crystallization appears as a metaphoric creation narrative, evoking simultaneously the natural sciences and a geometric mental image appropriate for modern machine civilization.

99. Ibid., 22.

100. Ibid.

101. Ibid., 28.

102. In support of his claim, Fuchs cited a recent book by the theater theorist Adolphe Appia, *Die Musik und die Inscenierung* (*Music and Staging*) first published in Munich in 1899.

103. Evident here is Fuchs's theoretical distance from Brecht, who valued such jarring elements for their potential to reconfigure the spectators' perceptual faculties.

104. Fuchs, *Die Schaubühne der Zukunft,* 28–29.

105. See Meyerhold, "The Naturalistic Theater and the Theater of Mood," 31. According to Marvin Carlson, the essay was written in 1906 and first published in 1908. See Carlson, *Theories of the Theatre,* 320. In this context, see also Geldern, "Nietzschean Leaders and Followers in Soviet Mass Theater, 1917–27"; as well as Carnegy, *Wagner and the Art of the Theatre,* 213ff.

106. Fuchs, *Die Schaubühne der Zukunft,* 17.

107. Jelavich, *Munich and Theatrical Modernism,* 156.

108. According to Jelavich, the Schauspielhaus "became a home for the most advanced lyric, symbolist, and social dramas from Germany, Austria, and Scandinavia in the prewar period." Ibid., 158.

109. Fuchs, *Die Schaubühne der Zukunft,* 33.

110. Ibid., 47.

111. Ibid.

112. Ibid., 53.

113. Ibid., 85.

114. Ibid.

115. Ibid., 107–8.

116. Ibid., 51.

117. On the notion of perceptual efficiency at this time in Europe more generally, see Crary, *Suspensions of Perception*, 17 and 23.

118. Fuchs, *Die Schaubühne der Zukunft*, 101.

119. Ibid., 91.

120. Ibid., n. 42.

121. Other buildings by Littmann in Munich include the Kaufhaus Hertie department store (1904–5) and the Dresdner Bank (1906–7). For more on his work, see Wolf, *Max Littmann, 1862–1931*, an illustrated homage published on the occasion of the architect's death. On his theater projects specifically, see Schaul, *Das Prinzregententheater in München und die Reform des Theaterbaus um 1900*.

122. Fuchs, *Die Schaubühne der Zukunft*, 44.

123. See Kertz, "Die Szene im Prinzregententheater zwischen Historismus und Moderne," 86–93; as well as Schaul, *Das Prinzregententheater in München und die Reform des Theaterbaus um 1900*, 4–67. Heinrich Habel describes how Littmann reworked this model of auditorium in his Schillertheater in Berlin as well as two years later in the Munich Artists' Theater; see Habel, "Die Idee eines Festspielhauses," 315. Manfred Semper presents four theater types in his book *Theater*: one presenting opera and ballet; one for opera, ballet, and plays; one for plays only; and, last, the Wagner-theater. The example he provides of the fourth type is the Prinzregententheater. See Manfred Semper, *Theater*, 509–11.

124. Littmann was also careful to acknowledge Schinkel as a forerunner of Semper's efforts at theater reform. See Littmann, *Das Prinzregenten-Theater in München*, 3.

125. Littmann, "Theater- und Saalbauten," 245–46.

126. Cosima Wagner, July 3, 1901, Wahnfried Museum Archive, Bayreuth.

127. Fuchs, *Die Schaubühne der Zukunft*, 70–71.

5. RETHEATRICALIZING THE THEATER

1. Baedeker, *Southern Germany (Wurtemberg and Bavaria)* (1907), 195.

2. For a description of the exhibition, which ran from May 16 to October 18, 1908, see Lauterbach, "'München 1908'—Eine Ausstellung"; and Gaenßler, "Die Architektur des Münchner Ausstellungsparks."

3. Baedeker, *Süd-Deutschland* (1909), 260. Perhaps as telling of the theater's fate is the brief mention it receives in the Baedeker guide three decades later: "Artists' Theater in exhibition park, summer only." Baedeker, *Deutsches Reich* (1936), 460.

4. Muthesius, "Die Architektur auf den Ausstellungen in Darmstadt, München, und Wien," 493.

5. Ibid.

6. Ibid.

7. In a notable exception in recent scholarship, Nancy Troy has described the exhibition's importance for French designers and critics in *Modernism and the Decorative Arts in France*, 57.

8. Huret, "En Allemagne," 5, quoted in Troy, *Modernism and the Decorative Arts in France*, 57.

9. Deubner, "Decorative Art at the Munich Exhibition," 42.

10. One temporary structure on view was a small house designed by Riemerschmid for the garden city of Hellerau, near Dresden. See Lauterbach, "'München 1908'—Eine Ausstellung," 40 and 46.

11. Deubner, "Decorative Art at the Munich Exhibition," 50.

12. Ibid., 44.

13. Ibid., 43. He praised, for example, "those products of the industrial organization in which the co-operation of the artistic world of to-day has been enlisted, a co-operation which has met with striking success in many ways," in particular in the design of kitchens and bathrooms. "Three large halls are reserved for displaying the products of industry," he wrote, "and one is amazed at the wealth of imaginative and constructive energy here revealed." Ibid., 49–50.

14. Michel, "Die Ausstellung München 1908," 9 and 12.

15. Ibid., 9.

16. Ibid., 13.

17. Von Pechmann, "Die Ausstellung München 1908," 425.

18. Ibid., 425 and 426.

19. Ibid.

20. Ibid., 427. The consumer to whom German industry catered belonged, he added, "to the great mass, and in fact—and this is the decisive thing—until now not to the mass of our *Volk,* but rather to the masses of the United States, Brazil, India." Ibid. Von Pechmann blamed the low quality of mass-produced goods on the fact that they were destined for these other countries, where the public desired a certain level of tastelessness.

21. Ibid., 425.

22. Ibid., 426.

23. Ibid., 427.

24. Naumann, "Kunst und Industrie," 69, quoted in Jarzombek, "The Discourses of a Bourgeois Utopia, 1904–1908, and the Founding of the Werkbund," 133. A member of the Werkbund from the beginning, van de Velde remained committed to the artist's individualism, opposing the Werkbund endorsement of standardization most famously in his ten "counter-theses" to dispute the ten theses put forward by Muthesius at the Werkbund exhibition in Cologne in 1914. See Schwartz, *The Werkbund,* 147–49.

25. Naumann, "Kunst und Industrie," 73, quoted in Jarzombek, "The Discourses of a Bourgeois Utopia, 1904–1908, and the Founding of the Werkbund," 135 (translation modified).

26. See Mallgrave, "From Realism to *Sachlichkeit,*" 292–95. Streiter associated *Sachlichkeit* with "realism," a term he preferred to "naturalism"; his ideas thus might be seen as parallel to the rejection of naturalism in the theater by Behrens and Fuchs. On *Sachlichkeit,* see also Anderson, "*Sachlichkeit* and Modernity; or, Realist Architecture," 339–41; Anderson, introduction to Muthesius, *Style-Architecture and Building Art,* esp. 14–19; and Schwartz, "Form Follows Fetish," 48–49.

27. Muthesius, "Die Architektur auf den Ausstellungen in Darmstadt, München, und Wien," 494.

28. Craig, "The Theater in Germany, Holland, Russia, and England," 160.

29. Lux, *Das Neue Kunstgewerbe in Deutschland,* 172. Lux's book was itself designed by Behrens. In his *Prolegomena* of 1886, Heinrich Wölfflin had opposed the concepts of *Gesetzmäsigkeit* and *Regelmäsigkeit,* or "uniformity," a distinction that would become central to Wilhelm Worringer's analysis of abstraction and empathy in his book of that title.

30. See Schwartz, *The Werkbund,* 56–58.

31. Behrens, *Feste des Lebens und der Kunst,* 7.

32. Fuchs, *Deutsche Form,* 415.

33. Muthesius, "Die Bedeutung des Kunstgewerbes," 177.

34. Jarzombek, "The Discourses of a Bourgeois Utopia, 1904–1908, and the Founding of the Werkbund," 128. "The *Kunstgewerbe* claimed that the solution to the decade-long struggle to find a suitable identity for modern Germany lay . . . [within] the commitment of the educated upper middle class to capitalism on the one hand and to social responsibility through control of its own aesthetics, on the other." Ibid. See also Jarzombek, "The *Kunstgewerbe,* the *Werkbund,* and the Aesthetics of Culture in the Wilhelmine Period."

35. Lux, *Das Neue Kunstgewerbe in Deutschland,* 241.

36. Two years earlier, Fuchs had made the same assertion about the categories of art and craft. See Fuchs, "Der Schöpferische Künstler und die Kulturelle Organization."

37. Lux, *Das Neue Kunstgewerbe in Deutschland,* 211.

38. Loos, *Gentleman Prefer Blondes,* 148–49. The 1953 movie based on the novel and starring Marilyn Monroe excises the Munich chapter, an omission that testifies to, among other things, Munich's demise as an international *Kunststadt.*

39. Ibid., 148.

40. See Carter, *The New Spirit in Drama and Art,* 131. Praise for the Artists' Theater can also be found in Craig, "The Theater in Germany, Holland, Russia, and England." Photographs of the theater were printed in New York in *Theater Arts* 4, no. 1 (January 1920): 30–31 and 57–60. Further discussion of the Artists' Theater appears in Grohmann, *Das Münchener Künstlertheater in der Bewegung der Szenen- und Theaterreformen;* Gorelik, *New Theaters for Old,* 175–88; Prütting, "Die Revolution des Theaters"; Weiss, *Kandinsky in Munich,* 92–103; Jelavich, *Munich and Theatrical Modernism,* 187–208; and Steinacker, "Fuchs and the Concept of the Relief Stage."

41. According to Jelavich, Littmann introduced himself to Fuchs after hearing him lecture in 1904; the architect's designs for a theater appeared in the first edition of Fuchs's *Die Schaubühne der Zukunft,* published later that year. Jelavich, *Munich and Theatrical Modernism,* 193.

42. Sayler, "The Munich Künstler, a Pioneer Little Theater," n.p. Sayler later wrote several books on theater, including *The Russian Theatre* (New York: Brentano's, 1923) and *Inside the Moscow Art Theatre* (New York: Brentano's, 1926), and edited a collection of essays translated from the German and entitled *Max Reinhardt and His Theater* (New York: Brentano's, 1924).

43. Bredt, "Die Ausstellung als Künstlerisches Ganzes," 432.

44. Ibid. Bredt further stated that, as a result of their architectural achievements at the exhibition, "WILHELM BERTSCH's name in connection with PAUL PFANN will be famous for all time in the art historical annals of Munich." Ibid., 433.

45. Two other photographs of the Artists' Theater facade were published in 1931, the year of Littmann's death, in a book celebrating the architect's achievements. See Wolf, *Max Littmann, 1862–1931.* The marble sculpture in front of the theater is *Nymph of the Spring,* by Heinrich Düll and Georg Pezold, who were also responsible for the colored terracotta decorations around the three main doors to the theater and for the two large bronze lights that flanked these doors.

46. Craig, "The Theater in Germany, Holland, Russia, and England," 160.

47. Morin, "Design and Construction of Theaters, Part IV—The Projection Booth," 541.

48. Ibid., 542.

49. Bredt, "Die Ausstellung als Künstlerisches Ganzes," 434. Bredt believed that the facade was also architecturally noteworthy: "The *exterior* can, despite its very modest language and means, signify for Munich a pleasant small step in the emancipation from a practically sacred world of forms." Ibid.

50. Littmann, *Das Münchner Künstlertheater*, 19.

51. "During the first seasons of the 1830s a few concert sponsors began setting aside reserved seats priced only in the upper bracket, and by 1840 the practice was almost universal in all three capitals (London, Paris, Vienna). The special tickets therefore afforded people a strong sense of social distinction." William Weber, *Music and the Middle Class*, 25.

52. Littmann, *Das Münchner Künstlertheater*, 19. The same set of historical references, deriving from Fuchs himself, would be repeated by Walter Grohmann, who listed Schinkel, Semper, Wagner, and other German precursors on the first page of his book on the Artists' Theater. See Grohmann, *Das Münchener Künstlertheater in der Bewegung der Szenen- und Theaterreformen*, 3.

53. For an explanation of adjustments to the theater's design, see Jelavich, *Munich and Theatrical Modernism*, 205.

54. Gorelik, *New Theaters for Old*, 176.

55. Fuchs, *Die Schaubühne der Zukunft*, 106.

56. "The Munich naturalists stressed the fact that 'reality' was very much determined by the perceptions and interventions of the observer [and that] the social relevance of art was to be achieved not through passive observation but active engagement. . . . With reference to Zola's celebrated formulation of his naturalist credo—'a work of art is a corner of nature viewed through a temperament'—one might say that the Munich naturalists, as disciples of Wagner and Ibsen, stressed their 'temperaments.'" Jelavich, *Munich and Theatrical Modernism*, 26; see also ibid., 44–52.

57. Gorelik, *New Theaters for Old*, 175.

58. The production was directed by Albert Heine and designed by Fritz Erler, with music provided by Max Schillings. An assessment of Erler's work from 1901 appears in Mayr, "Fritz Erler, München."

59. Gorelik, *New Theaters for Old*, 177.

60. Fuchs, "Zum Spielplan des Münchener Künstlertheaters," 6. *Herr Peter Squenz* was designed by Wilhelm Schulz and directed by Fr. Basil; *Das Wundertheater* was designed by Robert Engels and directed by Fr. Basil; *Die deutschen Kleinstädter* was designed by Thomas Theodor Heine and directed by Eugen Kilian; *Die Maienkönigin* was designed by H. Buschbeck and directed by Professor Anton Fuchs; and *Das Tanzlegendchen* was designed by Hans Beatus Wieland.

61. Fuchs, "Zur künstlerischen Neugestaltung der Schau-Bühne," 204.

62. Fuchs, *Revolution in the Theater*, 151.

63. Fuchs, "Zum Spielplan des Münchener Künstlertheaters," 17.

64. Fuchs, *Revolution in the Theater*, 34.

65. Ibid., 67.

66. Ibid., 43 and 42.

67. Ibid., 39.

68. A third extant photograph shows the first scene of a production of Shakespeare's *Hamlet* designed by Fritz Erler for the summer season of 1909 or 1910. All three photographs were published to accompany Fuchs, "Das Münchener Künstler-Theater."

69. Julius Diez designed the scenery, masks, and costumes for the performance; Walter Braunfels composed the music; and Albert Heine directed. See Fuchs, "Zum Spielplan des Münchener Künstlertheaters," 5 and 17–18.

70. Joseph Rüderer adapted the play; Adolf Hengler designed the scenery, masks, and costumes; Anton Beer-Walbrunn composed the music; and Fr. Basil directed.

71. Fuchs, *Revolution in the Theater*, 126.

72. Ibid., 114–15. Demanding a figurehead to supervise the details, the dictatorship of literature produced "the tyranny of the director in the modern drama." Ibid.

73. Evidence of the persistence, ten years later, of the theoretical opposition of art and literature is found in Thomas Mann's declaration in 1918 that "the German tradition is culture, soul, freedom, art, and *not* civilization, society, voting rights, and literature." Mann, *Reflections of a Nonpolitical Man,* 17.

74. Fuchs, *Revolution in the Theater,* 126.

75. Fuchs, *Die Schaubühne der Zukunft,* 54.

76. Fuchs, *Revolution in the Theater,* 3.

77. Grohmann, *Das Münchener Künstlertheater in der Bewegung der Szenen- und Theaterreformen,* 6. Both the text and the quotations, unattributed, are reproduced from Fuchs, *Die Schaubühne der Zukunft,* 8.

78. The first was by Adolf Hildebrand; the second was written by Toni Stadler, a young Munich sculptor who announced that the Artists' Theater would present only a few dramas and comedies but that these would be presented "with fewer realities and greater effectiveness [*weniger Wirklichkeiten und mehr Wirkung*]" than was customary with the style of "brutal naturalism." Stadler, "Gedanken über die Aufgaben der Kunst auf der Bühne," 11. The third essay, by Fuchs himself, described the productions that summer in some detail; it was reprinted in Russian the following year and, two years later, in German. See Fuchs, "Myunkhenskii Khudozhestvennyi Teatr."

79. In addition to the works of Riegl, Hildebrand, and Worringer discussed in chapter 3, see also Schmarsow, "Reliefkunst."

80. Scholarship on the Artists' Theater, usually written from the point of view of either theater history or German studies, has tended to ignore the role of Hildebrand's writings as inspiration for the Artists' Theater's shallow stage. Jelavich, for example, never mentions Hildebrand in "Retheatricalized Modernism: The Künstlertheater and Its Affinities," chapter 5 of *Munich and Theatrical Modernism,* 186–235. Within an art historical context, Günter Schöne's assessment in *Apollo* may be taken as typical: "Fuchs argued the case for a 'relief' stage as the only possible form of scenic representation. He conceived of its being done by a sort of relief, somewhat in the manner of the early mosaics at Ravenna." Schöne, "The Munich Künstlertheater and Its First Season," 397. Schöne quotes the first sentence of Hildebrand's essay on the Artists' Theater but treats Hildebrand as if he were an independent art critic.

81. In Munich in 1891, for example, he had an exhibition at the Kunstverein, and several months later, he showed ten sculptures at the Glass Palace. For more on Hildebrand's artistic achievements, see Esche-Braunfels, *Adolf von Hildebrand*; and Geissler, "Die Kunsttheorien von Adolf Hildebrand, Wilhelm Trübner, und Max Liebermann," 35–39.

82. One of his more famous larger public creations is the Wittelsbach Fountain, begun in 1890 and unveiled at the center of the Lenbachplatz in Munich in 1895; other fountains include those in Jena (1893–94), Strassburg (1897–1902), Worms (1895–1914), and Cologne (1911–22). In addition to producing sculptures large and small, Hildebrand also worked as an architect; his designs for a house for himself in Munich were constructed by the office of Gabriel Seidl and completed in 1898. See Esche-Braunfels, *Adolf von Hildebrand*, 479–85. This house now contains the Monacensia Collection of the Munich State Library, which holds the archives of both Hildebrand and Fuchs.

83. Esche-Braunfels, *Adolf von Hildebrand*, 173. His status as a sculptor may be illustrated by a reference made in 1908 by Lux to "Hildebrand, who works in the shadow of the great Renaissance tradition, and who is full of its spirit and its noble emphasis on handicraft." Lux, *Das Neue Kunstgewerbe in Deutschland*, 228.

84. Hildebrand, *The Problem of Form*, in Mallgrave and Ikonomou, *Empathy, Form, and Space*, 243.

85. See Esche-Braunfels, *Adolf von Hildebrand*, 504.

86. Ibid., 501.

87. Fuchs, *Die Revolution des Theaters*, 115. Translations from this book are my own, made with the occasional guidance of the published abridged English translation.

88. Ibid., 117.

89. Ibid., 101–2.

90. See Robert Brussel, "La saison à Munich: Le Künstler-Theater," *Le Figaro*, August 18, 1908, reprinted in Fuchs, *Die Revolution des Theaters*, 236–42. Brussel's discussion of Hildebrand is on 237–38.

91. Behrens, *Feste des Lebens und der Kunst*, 19.

92. Fuchs denied that his appropriation of Hildebrand's theory of relief sculpture was entirely literal. "The 'relief stage' got its name from the fact that the visual impressions coming from it have an effect of relief," he wrote. "But they achieve this relief effect not because one has arbitrarily imposed compulsory principles of the plastic arts on the dramatic performance . . . rather, they receive them because one has allowed the drama to develop *out of itself*." Fuchs, *Die Revolution des Theaters*, 99.

93. Behrens, "On Art for the Stage," 140.

94. Ibid., 142.

95. Hildebrand, "Münchener Künstler-Theater," 71.

96. Hildebrand, *The Problem of Form*, 261.

97. Fuchs, *Die Revolution des Theaters*, 58–59. And again: "The 'work of art,' the 'art,' the 'beautiful,' is neither object nor subject, but rather is *movement*; it is a movement that arises from the contact and the interpenetration of the 'subject' with the 'object.'" Ibid., 59.

98. Ibid., 4.

99. Ibid., 99. Although the level of his familiarity with the concept is uncertain, Fuchs used the word "Einfühlung" on at least one occasion, in an unpublished typescript in the late 1930s. In reference to the appointment of a new editor in chief at the *Münchener Neueste Nachrichten* fifteen years earlier (Fritz Gerlich, the former general secretary of the German Democratic Party), he referred in passing to the need for the "most careful 'psychological Einfühlung into the mentality of the masses and that of the cultivated public,'" placing the phrase in quotation marks as if it were a known theoretical quantity. As we shall see, by the

1930s Einfühlung had come to stand for a psychologically based manipulation of the larger public, not a form of active, individual spectatorship. Fuchs, *Zur Vorgeschichte der Nazional-sozialistischen Erhebung,* 93.

100. Hildebrand, *The Problem of Form,* 247.

101. Four years after the inauguration of the Artists' Theater, Max Krüger discussed the theory of Einfühlung in relation to the theater, referring explicitly to Riegl, Lipps, Schmarsow, and Worringer—but not to Fuchs. See Krüger, *Über Bühne und bildende Kunst,* 20–26.

102. Sayler, "The Munich Künstler, a Pioneer Little Theater."

103. Muthesius, "Die Architektur auf den Ausstellungen in Darmstadt, München, und Wien," 494.

104. Hildebrand, "Münchener Künstler-Theater," 71.

105. Ibid., 72. "The artistic truth for the stage décor must lie not in achieving the most true-to-life and realistic Piazza della Signoria possible, but rather in presenting it only insofar, and as strongly, as it comes into consideration during the real dramatic experience." Ibid., 73.

106. Ibid.

107. Ibid., 74.

108. Ibid., 73. "Finding the right measure of the visual impression, so that it only supports the situation and does not draw attention to itself and detract" from the dramatic experience, Hildebrand explained, "therein lies the problem for the stage, in the realm of real drama." Ibid.

109. Ibid., 74.

110. Ibid., 74–75.

111. Ibid., 72.

112. See, for example, Hagemann, *Aufgaben des modernen Theaters*; Marsop, *Weshalb Brauchen wir die Reformbühne*; Burckhard, *Das Theater*; and Scheffler, "Das Theater."

113. Scheffler, "Bühnenkunst," 231.

114. Worringer, "Das Münchener Künstlertheater," 1709.

115. Ibid.

116. Ibid., 1710–11.

117. Ibid., 1710.

118. Ibid., 1709.

119. Ibid., 1710.

120. Hildebrand, *The Problem of Form,* 234.

121. Worringer, "Das Münchener Künstlertheater," 1710.

122. Wagner, *The Art-Work of the Future,* 109 (translation slightly modified); Wagner, *Das Kunstwerk der Zukunft,* 3: 81.

123. Worringer, "Das Münchener Künstlertheater," 1709.

124. Ibid.

125. Ibid., 1710.

126. Ibid.

127. Ibid., 1711.

128. Ibid. The actors performing on the stage of the Artists' Theater in its first season were from the court theater of Munich.

6. The Specter of Cinema

1. Hansen, "Early Cinema," 234–35.

2. Ibid., 235.

3. Kaes, "The Debate about Cinema," 9.

4. Ibid. While acknowledging "the frequent reference to cinema in the theater criticism of the time," Kaes maintains that, whereas in the United States at the time, "cinema was simply seen as a variant of the already commercialized boulevard theater," in Germany "cinema had to justify itself vis-à-vis literature—the classical medium of bourgeois (self-)representation." Ibid., 17 and 30.

5. Altenloh, *Zur Soziologie des Kino,* 29.

6. Ibid., 99.

7. Ibid., 49–50.

8. Ibid., 100.

9. Ernst, "Möglichkeiten einer Kinokunst," 45.

10. Ibid., 48.

11. Gunning, "The Cinema of Attractions," 59. Gunning characterizes the period in film after around 1907 as marked by the embrace of narrative.

12. Michel, "Wohn- und Wirtschaftsbauten auf der Ausstellung München 1908," 476.

13. Shand, *Modern Picture-Houses and Theatres,* 15.

14. Gorelik, *New Theatres for Old,* 178.

15. Nietzsche, "On the Uses and Disadvantages of History for Life," 105.

16. Fuchs, *Die Schaubühne der Zukunft,* 56.

17. Simmel, "Metropolis and Mental Life," 324. Shallow spectators were perhaps ideal for viewing the modernist painting that, as Greenberg would famously write in 1965, "oriented itself to flatness as it did to nothing else." Greenberg, "Modernist Painting," 4: 87.

18. In 1922, forty million movie tickets were bought in the United States each week, with women increasingly doing the purchasing. See Stokes, "Female Audiences of the 1920s and Early 1930s," 43.

19. On the history and significance of the gramophone, see Kittler, *Gramophone, Film, Typewriter;* Gumbrecht, "Gramophones," in *In 1926,* 108–14; and Millard, *America on Record.*

20. On photography's appearance in advertising in the 1890s, see David Phillips, "Art for Industry's Sake."

21. "As advertising matured as a profession, executives also began to recognize the advertising audience as female. . . . As the twenties unfolded, new audiences came into view, such as the massive working class female readership of Bernarr Macfadden's *True Story* magazine. But as Roland Marchand has convincingly argued, admen tended to collapse class distinctions into a composite portrait: the typical consumer was not only a 'she,' but a lazy, emotional, and stupid 'she' at that." Brown, *The Corporate Eye,* 225. See also Marchand, *Advertising the American Dream,* 52–87.

22. Münsterberg, *The Photoplay,* 99.

23. Münsterberg, "Why We Go to the Movies," *Cosmopolitan,* 60, no. 1 (December 15, 1915), reprinted in *Hugo Münsterberg on Film,* 172.

24. Münsterberg, *The Photoplay,* 63.

25. Ibid., 97. Films "*are not and ought never to be imitations of the theater. . . . To imitate the world is a mechanical process; to transform the world so that it becomes a thing of beauty is the purpose of art. The highest art may be furthest removed from reality.*" Ibid., 113 and 114–15.

26. Ibid., 132–33.

27. Ibid., 70.

28. Ibid., 91.

29. Ibid., 105.

30. Ibid., 137.

31. See Münsterberg, *Psychology and Industrial Efficiency,* 255–71.

32. "In a 1922 survey of movie theaters by *Motion Picture News,* exhibitors were asked about the musical accompaniment in their theaters. . . . Of those who answered the question, 46 percent used theater organ, 25 percent used piano only, and 29 percent had an orchestra." Sauer, "Photoplay Music," 60–61. Such categories were not mutually exclusive, as many theaters provided different kinds of accompaniment for different occasions.

33. Adorno, "The Curves of the Needle," 606.

34. Ibid., 607.

35. Münsterberg, *The Photoplay,* 111.

36. Ibid., 95.

37. Ibid., 127.

38. Ibid., 126.

39. Adorno, *In Search of Wagner,* 100.

40. Roh, *Nach-Expressionismus, Magischer Realismus,* 40. In 2002, Michael Fried made a similar claim: modern Western culture between 1840 and 1880 may be viewed within the theoretical framework of Einfühlung, he wrote, citing the following men: "Kierkegaard, Helmholtz, Ruskin, Marx, Courbet, Millet, Thoreau, Whitman, Melville, Flaubert, Baudelaire, Dickens, Wagner, Cézanne, the first decade of Eakins's activity as a painter, [and] early Hardy." Fried, *Menzel's Realism,* 253.

41. Universalizing art historical claims deriving from Einfühlung, based on personal observation, and legitimized by psychological insight have appeared most famously in the work of Rudolf Arnheim and Ernst Gombrich. See, for example, Arnheim, *Art and Visual Perception*; Arnheim, *Toward a Psychology of Art*; and Gombrich, *Art and Illusion*. See also Arnheim, "Wilhelm Worringer on Abstraction and Empathy."

42. See Vernon Lee with Clementine Anstruther-Thomson, *Beauty and Ugliness and Other Studies in Psychological Aesthetics*; Vernon Lee, *The Beautiful*; and Stein, *Zum Problem der Einfühlung* [On the problem of empathy].

43. Kracauer, *The Salaried Masses,* 94.

44. Kracauer, "The Little Shopgirls Go to the Movies," 76 and passim. On the relation of gender and attention among Weimar cinema audiences, see Petro, "Perceptions of Difference." On the early-twentieth-century cultural coding of mass culture as feminine, see Huyssen, "Mass Culture as Woman."

45. Kracauer, "The Hotel Lobby," 174–75.

46. Kracauer, "The Cult of Distraction," 324.

47. Kracauer, "The Mass Ornament," 85.

7. Bauhaus Theater of Human Dolls

1. Gropius, introduction to Schlemmer, Moholy-Nagy, and Molnár, *The Theater of the Bauhaus,* 7.

2. Gropius, "Program for the Staatliche Bauhaus in Weimar," 31. By contrast, Gropius called for instruction in a range of other subjects that he considered necessary for a complete

education in the arts. These included anatomy, garden design, contract negotiation, bookkeeping, and art history—this last, he enjoined, "not presented in the sense of a history of styles, but rather to further active understanding of historical working methods and techniques." Ibid., 32. The "Statutes of the Staatliche Bauhaus in Weimar" published in January 1921, which includes a section on the curriculum, likewise makes no mention of theater. See Wingler, *The Bauhaus,* 44–48.

3. Schlemmer had been hired in 1922 as master of form in charge of woodworking and stone sculpture but was already overseeing theater work when Schreyer quit in early 1923, during rehearsals for performances that summer during Bauhaus week. See Wingler, *The Bauhaus,* 360; as well as Toepfer, *Empire of Ecstasy,* 136–38.

4. Schlemmer, Moholy-Nagy, and Molnár, *Die Bühne im Bauhaus.* Copies of the book itself are dated 1924, when it was put together in Weimar; secondary literature on the Bauhaus generally gives a publication date of 1925, when the book was edited in Dessau. The book contained essays by Farkas Molnár, Laszló Moholy-Nagy, and Schlemmer himself, with additional images by Marcel Breuer, Kurt Schmidt, and Alexander "Xanti" Schawinsky. It gained an introduction by Gropius when it was published in 1961 in English translation as *The Theater of the Bauhaus.*

5. Schlemmer, "Mensch und Kunstfigur," 7.

6. On the contemporaneous relation of theater to sports (and boxing in particular), see Brecht, "More Good Sports"; and Gumbrecht, *In 1926,* 42–52.

7. Winckelmann, *Gedanken über die Nachahmung der griechischen Werke in der Malerei und Bildhauerkunst,* 21.

8. Schlemmer, "Mensch und Kunstfigur," 18–19.

9. Schlemmer, *Idealist der Form,* 230–31. He continued, "In all *early* cultures that were also *high* cultures—the Egyptians, the early Greeks, early Indian art—the human form is far from the naturalistic image, but thus closer to the *lapidary* symbolic form: the *idol,* the *totem,* the *doll.*" The modernist emphasis on theatricality, Rainer Nägele has argued, "radicalizes exteriority to the point where the living actors are replaced by the puppet," a creature that "radically refuses dialogue," its silence enforced by the impossibility of discerning the creature's source of speech. Nägele, *Theater, Theory, Speculation,* 27.

10. See, for example, Doherty, "'See: We Are All Neurasthenics!'"; Doherty, "Figures of the Pseudorevolution"; Fineman, "Ecce Homo Prostheticus"; Lavin, *Cut with a Kitchen Knife*; and Teitelbaum, *Montage and Modern Life.* Matthew Biro discusses Raoul Hausmann's photomontages of 1920 through the insistent anachronism of the "Weimar cyborg" in "The New Man as Cyborg"; see also Foster, *Prosthetic Gods,* 108–49.

11. "For much of the first half of this [the twentieth] century," Christopher Phillips has written, "montage served not only as an innovative artistic technique but functioned, too, as a kind of symbolic form, providing a shared visual idiom that more than any other expressed the tumultuous arrival of a fully urbanized, industrialized culture." Phillips, introduction to Teitelbaum, *Montage and Modern Life,* 22. An anonymous text in the Soviet journal *Lef,* probably by Gustav Klutsis, advocates the technique for its effectiveness: "A combination of snapshots takes the place of the composition in a graphic depiction. . . . [The] precision and documentary character of the snapshot have an impact on the viewer that a graphic depiction can never attain." [Klutsis], "Photomontage," *Lef,* no. 4 (1924): 43–44, trans. John E. Bowlt, in Christopher Phillips, *Photography in the Modern Era,* 211–12; see also Sergei Tretyakov,

"From the Editor," *Novyi Lef* 11 (1928): 41–42, in Phillips, *Photography in the Modern Era,* 270–72.

12. For an extended analysis of this image, see Lavin, *Cut with a Kitchen Knife,* 193–94.

13. On this "return to order," see Buchloh, "Figures of Authority, Ciphers of Regression."

14. "Results of the Investigation Concerning the Staatliche Bauhaus in Weimar," in Wingler, *The Bauhaus,* 42.

15. Under the directorship of Hannes Meyer (1928–30), the Bauhaus in fact encouraged leftist politics, inspiring an engagement with collective production as much as with communism.

16. See, for example, Nerdinger, *Bauhaus-Moderne im Nationalsozialismus,* esp. Droste, "Bauhaus-Maler im Nationalsozialismus."

17. Schlemmer to Gunta Stötzl, June 16, 1933, quoted in Nerdinger, "Modernisierung, Bauhaus, Nationalsozialismus," 19. "Schlemmer, who in 1934 submitted to a competition for a mosaic in the Deutsches Museum a design depicting a group marching and giving the Hitler salute to a luminous image of the Führer, wrestled for years with his position toward and within National Socialism, as his diaries (in the Bauhaus Archive) suggest." Nerdinger, "Modernisierung, Bauhaus, Nationalsozialismus," 23 n. 52. Hans Wingler told a different story in 1969: "Following his dismissal from the teaching profession, which had been decreed by the National Socialists [in 1933], he was forced to take odd jobs in order to manage." Wingler, *The Bauhaus,* 257.

18. After World War II, such diametrically opposed arguments were indeed made in East and West Germany about the Bauhaus. See Nerdinger, "Modernisierung, Bauhaus, Nationalsozialismus," 17–18. For a critique of retrospective allegations of protofascism, see Koss, "Allegorical Procedures, Apocalyptic Threats." Relevant here are Bernstein, *Foregone Conclusions*; Herf, *Reactionary Modernism*; and Lane, *Architecture and Politics in Germany.*

19. Kracauer, "Those Who Wait," 138.

20. Roh, *Nach-Expressionismus, Magischer Realismus,* 45–46.

21. Kleist, "On the Marionette Theater," 420. This essay inspired the theater impresario Edward Gordon Craig, whose own "The Actor and the Über-Marionette" appeared in 1907. Notably, Sigmund Freud wrote several pages about the tale "The Sandman" written by Hoffmann, whom he termed "the unrivalled master of the uncanny in literature." Freud, "The Uncanny" (1919), 209 and passim.

22. Walter Benjamin, "Convolute Z," 694. See also Benjamin, "Lob der Puppe"; as well as Benjamin, "Old Toys"; Benjamin, "The Cultural History of Toys"; Benjamin, "Toys and Play." For an overview and bibliography of writings on dolls, see Bell, "Puppets, Masks, and Performing Objects at the End of the Century." An excellent compendium of essays on and images of twentieth-century dolls is Müller-Tamm and Sykora, *Puppen Körper Automaten,* esp. Bredekamp, "Überlegungen zur Unausweichlichkeit der Automaten"; and Hille, "'. . . über den Grenzen, mitten in Nüchternheit.'" The literature on surrealist doll figures (in this volume and elsewhere) is extensive; see, for example, Foster, *Compulsive Beauty*; Lichtenstein, *Behind Closed Doors*; and Taylor, *Hans Bellmer.*

23. Small wooden figures made in the stage workshop after designs by Eberhard Schrammen (1923–25) may be seen in Scheper, *Oskar Schlemmer, "Das Triadische Ballett," und die Bauhausbühne,* 92–93; photographs of three marionettes by Hilde Rantzsch appeared in *Bauhaus* 1, no. 3 (1927). Moholy-Nagy—who in 1925 made a photograph entitled *Puppen*— also worked with dolls; "out of his theoretical laboratory experiments at the Bauhaus," Gropius

recalled in 1961, "Moholy later developed original stage settings for the Kroll Opera House in Berlin for the *Tales of Hoffmann* and for other operatic and theatrical performances." Gropius, introduction to Schlemmer, Moholy-Nagy, and Molnár, *The Theater of the Bauhaus,* 10.

24. Felix Klee, introduction to Paul Klee, *Paul Klee,* 21. My thanks to Stefan Jonsson for bringing these creatures to my attention.

25. Schlemmer, "Mensch und Kunstfigur," 19.

26. So, too, did cinema: Ernst Lubitsch based *Die Puppe* (1919) on Hoffmann's tales, for example; Walther Ruttmann's *Berlin, die Symphonie der Großstadt* (1927) is permeated by mannequins. James Whale's 1931 film of *Frankenstein,* based on Mary Shelley's book of 1817, assigned the inventor's name to his creation, conflating creator and creation precisely as had the ballet *Coppélia,* which reassigned to the doll the name of its inventor, Coppelius, in Hoffmann's tale "The Sandman" of 1815.

27. Moholy-Nagy, "Theater, Zirkus, Varieté," 50.

28. Kleist, "On the Marionette Theater," 416.

29. The most famous automatons, however, often proved to be elaborate hoaxes. See, for example, Sussman, "Performing the Intelligent Machine"; as well as Standage, *The Turk.*

30. La Mettrie, *Machine Man,* 9.

31. Beaune, "The Classical Age of Automata," 432. For a history of playful automatons in the context of the *Kunstkammer,* see Bredekamp, *The Lure of Antiquity and the Cult of the Machine*; see also Mazlish, *The Fourth Discontinuity,* 31–58; and Nelson, *The Secret Life of Puppets,* 47–73.

32. Beaune, "The Classical Age of Automata," 436. According to André Pieyre de Mandiargues, "The word automaton contains a contradiction, because it applies both to spontaneity of movement and to the mechanization of it. Thus we come back to the idea of ambiguity and the light it casts on the strange spell automata exercise over us." Pieyre de Mandiargues, "Les rouages de l'automate," preface to Jean Prasteau, *Les Automates* (Paris: Gründ, 1968), quoted in Beaune, "The Classical Age of Automata," 475.

33. On the "disenchantment with language and the growing appeal of nonverbal expression" characteristic of European theatrical modernism, see Segal, *Body Ascendant,* 32 and passim. For Segal, this tendency is epitomized in the work of Hugo von Hofmannsthal, whose "Letter to Lord Chandos" captured the crisis of narrative and language in 1900 and who in 1911 wrote, "Words evoke a keener sympathy, but it is at the same time figurative, intellectualized, and generalized. Music, on the other hand, evokes a fiercer sympathy, but it is vague, longingly extravagant. But the sympathy summoned by gestures is clearly all-embracing, contemporary, gratifying." Notably, the purpose of each art form here is the evocation of sympathy. Hofmannsthal, quoted in Segal, *Body Ascendant,* 43.

34. For an analysis of abstraction in Schlemmer's choreography, see Toepfer, *Empire of Ecstasy,* 138–45; on the antipsychologist impulse, see Jay, "Modernism and the Specter of Psychologism." Related (but not identical) to the emphasis on physical gestures is Brecht's theory of *Gestus,* or "gest," first articulated in print in 1930 in "The Modern Theatre Is the Epic Theatre," reprinted in *Brecht on Theatre.* More directly linked is the development of biomechanics by the Soviet director Vsevolod Meyerhold, inspired partly by the German development of theatrical modernist abstraction.

35. Schlemmer, diary entry of September 1922, in Tut Schlemmer, *The Letters and Diaries of Oskar Schlemmer,* 126.

36. Moholy-Nagy, "Theater, Zirkus, Varieté," 49.

37. Ibid.

38. "Posthumanism is the conscious response, whether with applause or regret, to the dissolution of psychological autonomy and individualism brought by technological modernization. It is a mobilization of aesthetic practices to effect a shift away from the humanist concept of subjectivity and its presumptions about originality, universality, and authority." Hays, *Modernism and the Posthumanist Subject,* 6. See also Brecht, "Neue Sachlichkeit." On *neue Sachlichkeit* and subjectivity, see Lethen, *Cool Conduct*; and McCormick, *Gender and Sexuality in Weimar Modernity,* esp. 39–58.

39. Schlemmer, "Mensch und Kunstfigur," 7. The two other signs of the age were, according to Schlemmer, mechanization and "the new possibilities given by technology and invention."

40. Schlemmer, wall text written in 1930 for the Folkwang Museum, Essen, in *Idealist der Form,* 231.

41. See the caption for plate 1 in Herzogenrath and Kraus, *Erich Consemüller,* 19. Another version of the dress, designed by Lis Beyer for Dora Fieger in 1927, is in the collection of the Stiftung Bauhaus, Dessau.

42. In this context, see Baumhoff, "Die 'moderne Frau' und ihre Stellung in der Bauhaus Avant-Garde"; and Sykora, "Die neue Frau: Ein Alltagsmythos der Zwanziger Jahre"; as well as Ray, "Bauhaus Hausfraus."

43. Kracauer, "The Mass Ornament," 76. "The hands in the factory," he noted, "correspond to the legs of the Tiller Girls." Ibid., 79. On Weimar chorus lines, see Beuth, "Die Wilde Zeit der Schönen Beine"; Gordon, "*Girls Girls Girls*"; and Ward, *Weimar Surfaces,* esp. 228–33. If the doll is the inanimate embodiment of empathy and estrangement, its animate equivalent is the prostitute, a creature of infinite fascination in Weimar culture. Chorus lines contain liminal creatures, somewhere between hired women and stage dolls.

44. Kracauer, "The Mass Ornament," 76.

45. Ibid.

46. See Plett, "The Performance Photographs of Oskar Schlemmer's Bauhaus Theater Workshop, 1923–29," 20–21; as well as Barche, "The Photographic Staging of the Image—On Stage Photography at the Bauhaus." The sculpted head reappears in the anonymous image reprinted in Schlemmer, Moholy-Nagy, and Molnár, *The Theater of the Bauhaus,* 104.

47. Rilke, "Puppen," 689. A discussion of similar themes in Rilke's writings on Auguste Rodin is found in Potts, "Dolls and Things." See also Bühler-Dietrich, "Zwischen Belebung und Mortifizierung." Schlemmer's last diary entry consists entirely of a quotation from Rilke: "To consider art not as a microcosm of the world, but rather as the world's complete transformation into magnificence." Diary entry of April 1, 1943, in *Idealist der Form,* 348.

48. Worringer, *Abstraktion und Einfühlung,* 60.

49. Gropius, introduction to Schlemmer, Moholy-Nagy, and Molnár, *The Theater of the Bauhaus,* 8 and 9–10. Acknowledging the importance of theater in the autumn of 1922, Gropius emphasized "the power of its effect on the soul of the spectator and the auditor," an effectiveness that was, in turn, "dependent on the success of the transformation of the idea into (visually and acoustically) perceivable space." Gropius, "The Work of the Bauhaus Stage," 58.

50. Benjamin, "The Work of Art in the Age of Mechanical Reproduction," 239 (translation modified).

51. Brecht named the technique of *Verfremdung* in 1936 in response to a performance he had attended in Moscow the previous year. See Brecht, "Alienation Effects in Chinese Acting." The background historical narrative here would extend from 1914, when the Russian formalist writer and critic Viktor Shklovsky proclaimed *ostranenie*, or "estrangement," the defining concept of art; through the Soviet theorists in the Lef group in the 1920s; to Brecht, who articulated the *Verfremdungseffekt* in 1936. See Mitchell, "From Shklovsky to Brecht"; and Brewster, "From Shklovsky to Brecht: A Reply"; as well as Demetz, introduction to *Brecht*, 1–15.

52. Brecht, entries for January 11 and February 1, 1941, in *Journals, 1934–1955*, 124, 131.

53. Brecht, entry for August 2, 1940, in *Journals, 1934–1955*, 81–82.

54. Brecht, entry for July 21, 1944, in *Journals, 1934–1955*, 321.

55. Brecht, entry for February 1, 1941, in *Journals, 1934–1955*, 131.

56. Moholy-Nagy, "Theater, Zirkus, Varieté," 47.

57. Benjamin, *The Origin of German Tragic Drama* (1928), quoted in Nägele, *Theater, Theory, Speculation*, 111.

58. Kracauer, "Cult of Distraction," 326. "Nobody would notice the figure at all if the crowd of spectators, who have an aesthetic relation to the ornament and do not represent anyone, were not sitting in front of it." Kracauer, "The Mass Ornament," 77. Notably, Paul de Man associated Kleist and Kracauer via the theme of distraction. "When, in the concluding lines of Kleist's text ["On the Marionette Theater"], K is said to be 'ein wenig zerstreut,' then we are to read, on the strength of all that goes before, *zerstreut* not only as distracted but also as dispersed, scattered, and dismembered." De Man, "Aesthetic Formalization in Kleist," 289.

59. "Ever since capitalism has existed, of course, within its defined boundaries rationalization has always occurred. Yet the rationalization period from 1925 to 1928 represents a particularly important chapter, which has produced the irruption of the machine and 'assembly-line' methods into the clerical departments of big firms." Kracauer, *The Salaried Masses*, 29–30.

60. Kracauer, "The Little Shopgirls Go to the Movies," 76.

61. The reference is to Huyssen, "Mass Culture as Woman."

62. By 1926, as Toepfer writes, "the dance was famous enough to spawn a gallery exhibit in Central European cities. As the piece grew older, it became shorter; once an evening-long event, it wound up featured on a program of modernist works. Finally, in 1932 the piece went to Paris as part of an international dance competition promoting the restoration of elite, high cultural glory to ballet." Toepfer, *Empire of Ecstasy*, 140. For more on the history and significance of the *Triadic Ballet*, see Maur, *Oskar Schlemmer*, 197–212; Scheper, *Oskar Schlemmer, "Das Triadische Ballett," und die Bauhausbühne*; Troy, "An Art of Reconciliation"; McCall, "Reconstructing Schlemmer's Bauhaus Dances"; and Louis and Stooss, *Oskar Schlemmer— Tanz—Theater—Bühne*.

63. "The surprising success of the debut of the Bauhaus theater in Berlin," he proudly noted in May 1929, "created the pleasant circumstance that theoretical defences and speculations are justified by the facts of practice and may be detached from these." Schlemmer, diary entry, in *Idealist der Form*, 209–10. "'Why is the public so enthusiastic? From primitivism, opposition, the emotion of contemporary culture? From a misunderstanding of the humor, from a desire for Variety shows?' So asks the well-known expert dance scholar Professor Oskar Bie." Ibid., 209.

64. Schlemmer, "The Mathematics of the Dance," *Vivos Voco* 5, nos. 8–9 (August– September 1926); translation in Wingler, *The Bauhaus*, 119.

65. Ibid.

66. Foreshadowing the exuberance of this final figure, the two men in the second-act finale ("Turkish dancers") brandish batons beyond their own rectangular frames; the hand of one man is also cut off by the column's left edge.

67. Freud, "The Uncanny," 195. See also Vidler, *The Architectural Uncanny,* esp. 3–14 and 21–26. On the link between *Unheimlichkeit,* Martin Heidegger, and the Bauhaus, see Sloterdiijk, *Critique of Cynical Reason,* 203–4.

68. Kracauer, "The Mass Ornament," 78. While the prevalence of isolated body parts in Weimar cultural representation is often attributed to the German experience of World War I, the presence of severed limbs across a spectrum of works both before and after the war demands a larger treatment of the relationship between cultural production, industrial society, and the evolving discussion of modern subjectivity. Such a project would accommodate Kracauer's association of the limbs of alienated labor with those performing cultural estrangement ("the hands in the factory correspond to the legs of the Tiller Girls"; ibid., 79); it would also engage further the theme of gender among the androgynous Weimar dolls.

69. The two paragraphs of text read as follows: "'Triadic,' derived from triad = mathematical and musical. There are 3 dancers (one female and two male, who dance individually, in pairs, or all three together); three main colors on the stage: lemon yellow, white, and black; there are 12 dances and 18 costumes altogether.

"The ballet was already begun prior to 1914. Parts of it were performed in 1916. Premiere of full ballet in 1922 in the Landestheater in Stuttgart. Repeated in Weimar and Dresden. Later (with music for mechanical organ by Paul Hindemith) in Donauschingen and in a revue in Berlin."

70. Schlemmer, diary entry of September 1922, in *Idealist der Form,* 96.

71. Gropius, "Program for the Staatliche Bauhaus in Weimar," 31.

72. That Gropius and others embraced this cultural lineage with renewed zeal in early 1919 is also unremarkable; Wagner's cultural politics, developed in the context of the 1848–49 revolution, would have appealed strongly to those of Nietzschean bent during the revolutionary early Weimar era, when socialist leanings were easily expressed as a demand for cultural unity achieved by means of revolutionary creativity.

73. Gropius, "Program for the Staatliche Bauhaus in Weimar," 31. The notion of the theater of the future and that of theater as the highest cultural symbol evokes the arguments of Behrens, *Feste des Lebens und der Kunst* (1900); and Fuchs, *Die Schaubühne der Zukunft* (1905).

74. Gropius, "Program for the Staatliche Bauhaus in Weimar," 32. Schlemmer even created his own Nietzschean aphorisms: "The world belongs to the dancer, as Nietzsche would say." Schlemmer, letter to Otto Meyer-Amden, December 28, 1919, in *Idealist der Form,* 58. The editor of this volume, Andreas Hüneke, wryly notes, "Unfortunately I have not yet been able to verify such a statement." Ibid., 374 n. 34.

75. Klee, "On the Urge for Renewal and Parties at the Bauhaus," 172.

76. The spontaneous festivities of the Weimar years became more organized in Dessau; gaining infamy as financial burdens increased, they operated as fund-raisers in the school's final year, in Berlin. See Ackermann, "Bauhaus Parties—Histrionics between Eccentric Dancing and Animal Drama."

77. One figure is Casca Schlemmer, older brother of Oskar; the other is Georg Hartmann. I am grateful to C. Raman Schlemmer for this information.

78. Nägele, *Theater, Theory, Speculation,* 3, has described the foregrounding of the body in the performances of the 1920s; citing "Brecht's gestural and epic theater, the theater of cruelty and the absurd, a theater where a clown appears and stumbles ostentatiously," he states that after the "increasing interiorization" that characterized bourgeois drama, "the body becomes visible as an obstacle; it speaks through irritation." Likewise relevant is the growing popularity of cabaret performance and theatrical revues in the 1920s; see Jelavich, *Munich and Theatrical Modernism,* 139–84.

79. "Something Metallic," *Anhalter Anzeiger,* Dessau, February 12, 1929, in Wingler, *The Bauhaus,* 157.

80. Ibid. A related discussion of the contemporaneous productions of Erwin Piscator, beyond the scope of the present book, might explore the shared effort to render the spectator a participant by combining such elements as film and slide projections into a larger theatrical event. Bauhaus performances avoided Piscator's political orientation (and Brecht's attempt to "refunction" spectators politically). Schlemmer called Piscator "very politically tendentious, but strong in this approach. Doesn't understand our thing—for him it's just play. Nevertheless he intends—said this in passing—eventually to collaborate on creating a theater school in Berlin, but very politically leftist." Schlemmer to Tut Schlemmer, April 11, 1927, in *Idealist der Form,* 170. John Willett has described Piscator, whose Berlin home was outfitted by the Bauhaus furniture workshop, as "providing the Bauhaus with its main link to the Berlin stage"; in addition to the Total Theater, he also commissioned theater settings from Moholy-Nagy in 1928. Willett, introduction to Huder, *Erwin Piscator, 1893–1966,* 1.

81. Schinkel to Carl Friedrich Zelter, October 22, 1821, quoted in Jochen Meyer, *Theaterbautheorien zwischen Kunst und Wissenschaft,* 191.

82. Moholy-Nagy, "Theater, Zirkus, Varieté," 54.

83. Molnár presented his U-Theater in Schlemmer, Moholy-Nagy, and Molnár, *Die Bühne am Bauhaus,* 57–62; Schlemmer included Weininger's Spherical Theater in his lecture "Bühne," reprinted in the same volume; and Gropius inserted a discussion and several illustrations of his Total Theater in the introduction to the book's English-language edition in 1961, Schlemmer, Moholy-Nagy, and Molnár, *The Theater of the Bauhaus,* 10–14. On the link between Gropius's theater design and Italian fascism, see Schnapp, "Border Crossings."

84. See Schlemmer, "Bühne," a lecture presented on March 16, 1927, and published in *Bauhaus* 1, no. 3 (July 10, 1927); an English translation appears in Schlemmer, Moholy-Nagy, and Molnár, *The Theater of the Bauhaus,* 81–101. For further description of the auditorium, see Scheper, *Oskar Schlemmer, "Das Triadische Ballett," und die Bauhausbühne,* 137–38.

85. Wagner, *The Art-Work of the Future,* 185 (translation modified); Wagner, *Das Kunstwerk der Zukunft,* 3: 151–52.

86. Schlemmer, "Mensch und Kunstfigur," 20.

8. Invisible Wagner

1. Sontag, "Wagner's Fluids," 9, quoted in Deathridge, "A Brief History of Wagner Research," 216.

2. Nietzsche, *The Case of Wagner,* 166. For more on Nietzsche's discussion of Wagner and decadence, see Borchmeyer, "Wagner and Nietzsche," 340–42.

3. Nietzsche, *The Case of Wagner,* 155.

4. Nietzsche, "Richard Wagner in Bayreuth," in *Nietzsche Werke*, 4: 38. A slightly different English translation is found in Nietzsche, "Richard Wagner in Bayreuth," in *Untimely Meditations*, 223.

5. Nietzsche, "Richard Wagner in Bayreuth," in *Nietzsche Werke*, 4: 38–39.

6. Both Hegel and Marx had used the terms *Entfremdung* and *Selbstentäußerung* to develop a concept of alienation; interest in alienation was provoked in 1932 by the publication of Marx's "Economic and Philosophical Manuscripts" of 1844. According to Richard Schacht, Nietzsche's participation in a discourse of alienation was both unconscious and unoriginal: "Nietzsche uses variants of the term *Entfremdung* in a few scattered passages, but only in passing, and in quite ordinary ways, which warrant no special attention." Schacht, *Alienation*, 198.

7. On the theoretical connections between Nietzsche and Brecht, see Grimm, "Verfremdung"; Grimm, "The Hidden Heritage"; and Grimm, *Brecht und Nietzsche oder Geständnisse eines Dichters*. On the link between perceptual distance and closeness, treated in the discourse of visual theory in terms of near and distant vision, see chapter 3.

8. Adorno, *In Search of Wagner*, 100.

9. Musil, *The Man without Qualities*, 66.

10. Ibid., 55. "The treacherous thing was that although such austere opinions issued from his mouth, what issued from his room, as soon as he had locked himself in, was, more and more often, the sound of Wagner's music, that is to say, a kind of music that in earlier years he had [called] the perfect example of a philistine, florid, degenerate era, and to which he himself had now become addicted as to a thickly brewed, hot, intoxicating potion." Ibid., 55–56.

11. Ibid., 74.

12. Georges Servières, "Revue musicale," *La Minerve* (1885): 261, as quoted in Maynard, "The Enemy Within," 162. On the responses in the *petits revues* in France to Wagner's works in the 1880s (in Bayreuth and elsewhere) in terms of intoxication and addiction, see Maynard, "The Enemy Within," 148–78.

13. See, for example, Maynard, "The Enemy Within," 171ff.

14. Nordau, *Degeneration*, 14.

15. Nietzsche, *The Case of Wagner*, 166.

16. Shaw, "Wagner in Bayreuth," 204.

17. Ibid., 207.

18. Cosima Wagner, diary entry of September 23, 1878, in *Die Tagebücher*, 2: 181–82. On Richard Wagner's "post-natal depression," see Carnegy, *Wagner and the Art of the Theatre*, 105–6.

19. Nietzsche, *The Case of Wagner*, 160.

20. Nordau, *Degeneration*, 194.

21. Ibid., 194–95 (translation modified).

22. Twain, "At the Shrine of St. Wagner," 212–13.

23. Adorno, *In Search of Wagner*, 30. "The methods by which Wagner blurs all dividing lines, and the monumental scale of both his subjects and his works, are inseparable from his longing to create in the 'grand style,' a longing already inherent in the masterful gesture of the conductor." Ibid., 101. Adorno wrote *Versuch über Wagner* [Essay on Wagner] in 1937–38; it was first published in German in 1952 and in English translation, as *In Search of Wagner*, in 1981.

24. Adorno, *In Search of Wagner*, 30–31 (translation modified). The German is found in Adorno, *Versuch über Wagner*, 27. For a critique of Adorno's analysis of Wagner, see Baragwanath, "Musicology and Critical Theory." For an insightful discussion of Adorno's book on

Wagner "not only as an account of the birth of fascism out of the spirit of the Gesamtkunst-werk but also as an account of the birth of the culture industry *in* the most ambitious high art of the nineteenth century," see Huyssen, "Adorno in Reverse," 35.

25. Adorno, *In Search of Wagner,* 35.

26. Ibid., 108.

27. No reference to a visit to the town of Bayreuth, or to Wagner's theater more specifi-cally, is found in Müller-Doohm, *Adorno.*

28. Adorno, *In Search of Wagner,* 82.

29. Ibid., 76.

30. Ibid., 104–5.

31. Ibid., 40.

32. Brecht, "The Modern Theater Is the Epic Theatre," 37–38.

33. A contemporaneous discussion of the link between the rise of mass culture, new modes of perception, and "efforts to render politics aesthetic" appears in Benjamin, "The Work of Art in the Age of Mechanical Reproduction," 241 and passim. Brecht's public mistrust of Einfühlung has been inherited by art historians who ignore his treatment of the concept in his journals and fail to distinguish between the Einfühlung he discussed and that of the nineteenth century.

34. Nietzsche, *The Case of Wagner,* 171. Seven years later, Georg Fuchs would label *Lohen-grin* "the first great German work of art since Goethe's *Faust.*" Fuchs, "Richard Wagner und die moderne Malerei," 113.

35. Mann, "Richard Wagner and *The Ring of the Nibelungen,*" 13; "Richard Wagner und 'Der Ring des Nibelungen,'" 161.

36. Adorno, "Wagner, Nietzsche, and Hitler" (1947), 157, quoted in Baragwanath, "Musi-cology and Critical Theory," 57. The German is found in Adorno, *Gesammelte Schriften* 19: 406.

37. Thomas Mann, journal entry of April 5, 1947, in *Im Schatten Wagners,* 196.

38. In the preface to *In Search of Wagner,* Adorno notes that the text is "intimately bound up with Max Horkheimer's essay 'Egoism and the Movement for Emancipation: towards an anthropology of the bourgeois era,' which appeared in 1936, as well as other writings emanat-ing from the Institute for Social Research during those years." Adorno, preface to *In Search of Wagner,* 9. On Adorno's writing of the text (and Walter Benjamin's initial response to it), see Müller-Doohm, *Adorno,* 237–40. Adorno's arguments should be understood in the context of a larger set of contemporaneous Frankfurt school ideas about the culture industry, the author-itarian personality, the relationship of modernism and the avant-garde, and fascism. Further analysis would address such earlier texts as "Notiz über Wagner" (1933), in which Adorno had written more positively of Wagner's music while lamenting the Wagner cult; later texts on the composer, including "Wagner, Nietzsche, and Hitler" (1947), "Wagners Aktualität" (1964), and "Wagner und Bayreuth" (1966); and related arguments in Horkheimer and Adorno, "The Cul-ture Industry" (1947), Adorno et al., *The Authoritarian Personality* (1950), and Adorno, *Aesthetic Theory.* In this context, see Karin Bauer, "Adorno's Wagner," 70ff.

39. Adorno, *In Search of Wagner,* 140.

40. As the conductor Daniel Barenboim has noted, "Bayreuth began, under Wagner, as a great experimental theater. The whole world attended the world premiere of *The Ring* in 1876. Wagner also had, for his time, absolutely the most revolutionary and progressive ideas." The five subsequent decades at the theater were stultifying, however; at the time Adorno was railing

against Bayreuth, the Gesamtkunstwerk, Wagner, and Wagnerianism, "Bayreuth was the most conservative, unthoughtful theater in the whole world." Barenboim, in Barenboim and Said, *Parallels and Paradoxes,* 92–93.

41. Adorno, *In Search of Wagner,* 104. Huyssen, meanwhile, has argued that the Gesamt-kunstwerk is "a false totality and . . . an equally false monumentality." Huyssen, "Adorno in Reverse," 39.

42. Adorno, *In Search of Wagner,* 111.

43. Ibid., 102.

44. Nordau, *Degeneration,* 195.

45. Adorno, *In Search of Wagner,* 110.

46. "The flawed nature of the whole conception of music drama is nowhere more evident than . . . in Wagner's hostility towards the division of labour on which it is agreed that the cul-ture industry is based." Ibid., 108. Equally lamentable, however, was the fact that "Wagner's intention of integrating the individual arts into the Gesamtkunstwerk ends up by achieving a division of labour unprecedented in the history of music." Ibid., 109.

47. Ibid., 49.

48. Ibid., 106. "Broken down into the smallest units, the totality is supposed to become controllable, and it must submit itself to the subject who has liberated himself from all pre-existing forms." Ibid., 49. "Wagner was an impressionist *malgré lui,*" Adorno further insisted, emphasizing the composer's lack of self-control, before tumbling further into chronological incoherence: "No comparison of Wagner with the Impressionists will be adequate unless it is remembered that the credo of universal symbolism to which all his technical achievements sub-scribe is that of Puvis de Chavannes and not Monet's." Ibid., 50.

49. Ibid., 97. "Like Nietzsche and subsequently Art Nouveau, which he anticipates in many respects," Adorno likewise declares, Wagner "would like single-handed to will an aes-thetic totality into being, casting a magic spell and with defiant unconcern about the absence of the social conditions necessary for its survival." Ibid., 101.

50. Ibid., 83.

51. Ibid., 109.

52. The chess-playing automaton built by Wolfgang de Kempelen in the late eighteenth century provides a useful precursor for understanding the magical appeal of Bayreuth in the nineteenth. For decades, crowds gathered all over Europe and the United States to watch this automaton compete against human subjects, with lengthy interpretations produced of the "trick": explanations of the magic that lurked within this machinery accompanied by detailed visual analyses. As with the sorcery in Bayreuth, the cause of fascination was both that the performance was technically advanced, mechanized, and modern and that the creation of the performance and the secrets of its trickery were invisible. Like Wagner's music, which intro-duced dissonance and chromaticism into Western composition, the performance relied for its magical effects on particular inventions beyond the comprehension of its audiences. See Sussman, "Performing the Intelligent Machine."

53. Adorno, *In Search of Wagner,* 107.

54. Ibid., 46. "Among the functions of the leitmotiv can be found, alongside the aesthetic one, a commodity-function, rather like that of an advertisement: anticipating the universal practice of mass culture later on, the music is designed to be remembered, it is intended to be forgetful." Ibid., 31.

55. See, for example, Wyss, "*Ragnarök* of Illusion," 77–78; as well as Mackintosh, *Architecture, Actor, and Audience*, 41. With Max Horkheimer, Adorno would extend his retroactively determined predictions to television, which "aims at a synthesis of radio and film" and would one day soon "derisively fulfill the Wagnerian dream of the *Gesamtkunstwerk*." Horkheimer and Adorno, "The Culture Industry," 124.

56. Or, as Jonathan Crary has argued, attention and distraction exist along a theoretical continuum, with the latter easily mobilized in the late nineteenth century and afterward to aid in the construction of passivity. See Crary, *Suspensions of Perception*, 22–23, 51, and passim.

57. Adorno, *In Search of Wagner*, 85.

58. Ibid., 87. "The phantasmagoria tends towards dream not merely as the deluded wish-fulfillment of would-be buyers, but chiefly to conceal the labor that has gone into making it. It mirrors subjectivity by confronting the subject with the product of its own labor, but in such a way that the labor that has gone into it is no longer identifiable. The dreamer encounters his own image impotently, as if it were a miracle, and is held fast in the inexorable circle of its own labor, as if it would last forever." Ibid., 91.

59. Ibid., 102. "But as a merely contingent being that usurps the status of a necessary existence, the Gesamtkunstwerk must inevitably fail." Ibid., 104.

60. Adorno, *In Search of Wagner*, 94. As Huyssen argues, in uniting the art forms the Gesamtkunstwerk, in Adorno's estimation, "is intended as a powerful protest against the fragmentation and atomization of art and life in capitalist society. But since it chooses the wrong means it can only end in failure." Huyssen, "Adorno in Reverse," 41.

61. As Huyssen has argued, Adorno's analysis of Wagner was inspired by his own historical perspective; Adorno is ultimately "a theorist of a construct [called] 'modernism' which has already digested the failure of the historical avant-garde." Huyssen, "Adorno in Reverse," 31.

62. Adorno, *In Search of Wagner*, 69; Thomas Mann, cited in ibid., 29. See also Dahlhaus, "Der Dilettant und der Banause in der Musikgeschichte"; and Dahlhaus, "The Music," 311–14.

63. Nordau, *Degeneration*, 14. Wagner's status within the larger discourse of degeneracy is as fascinating as it is inconsistent. Under the National Socialists, Isolde Vetter has written, "Wagner was now accounted among the party saints, so there could no longer be any question of seeking out psychic abnormalities. The result was that for a period of some twelve years the composer was virtually ignored as an object of psychiatric inquiry." Vetter, "Wagner and the History of Psychology," 130.

64. Adorno, *In Search of Wagner*, 29–30.

65. Ibid., 30.

66. Quoted in Adorno, *In Search of Wagner*, 28–29. Mann continues, "There is something dubious about his relations with the arts; insane though it sounds, there is something inartistic about it." Ibid. Mann's text is found in "Leiden und Grösse Richard Wagners," 96.

67. Nietzsche, "Richard Wagner in Bayreuth" (1876), quoted in Adorno, *In Search of Wagner*, 28; and in Mann, "Leiden und Grösse Richard Wagners," 41.

68. "Dilettante—1733, borrowing of the Italian *dilettante*, 'lover of music or painting,' from *dilettare* 'to delight,' from the Latin *delectare*. . . . Originally without negative connotation, 'devoted amateur,' the pejorative sense emerged in the late eighteenth century by contrast with *professional*." Dictionary.com, *Online Etymology Dictionary*, Douglas Harper, Historian, http://dictionary.reference.com/browse/dilettante.

69. Schultze-Naumburg, *Häusliche Kunstpflege,* 101–2. Schultze-Naumburg continues, "All who wish to be dilettantes and are too classy to kill time with tomfoolery should first of all tell themselves that they must learn something here too. Plain old messing around with material and tools really makes no sense for mature people, whose time is too good to kill." Ibid.

70. Ibid., 102.

71. Nordau, *Degeneration,* 195. The book was translated into English in 1895; its last German and French editions appeared in 1909; it was translated into Italian in 1925.

72. Ibid., 199.

73. Baudelaire, "Richard Wagner and *Tannhäuser* in Paris" (1861), 123.

74. Twain, "At the Shrine of St. Wagner," 222.

75. Wagner, "Introduction to *Art and Revolution,*" 24; Wagner, "Einleitung zum dritten und vierten Bände," 3: 2–3.

76. See Nike Wagner, *The Wagners,* 159–66; Hilmes, *Herrin des Hügels,* 418ff. and 426ff.; and Gottfried Wagner, *Twilight of the Wagners.* On Winifred's role in particular, see Hamann, *Winifred Wagner;* as well as Skelton, *Wagner at Bayreuth,* 137–46.

77. In this context, see Golomb and Wistrich, *Nietzsche, Godfather of Fascism?* esp. Holub, "The Elizabeth Legend." Relevant here are also Koepnick, *The Dark Mirror;* and Potter, *Most German of the Arts.*

78. Mann, "Coming to Terms with Richard Wagner," 47.

79. Greenberg, "The Case for Abstract Art" (*Saturday Evening Post,* August 1959), in *The Collected Essays and Criticism,* 4: 81.

80. Adorno, *In Search of Wagner,* 26.

81. A forceful critique of this tendency is found in Bernstein, "Backshadowing and Apocalyptic History," chapter 2 of *Foregone Conclusions,* 9–41.

82. Greenberg, "Venusberg to Nuremberg," review of *Metapolitics: From the Romantics to Hitler,* by Peter Viereck (*Partisan Review,* November–December 1941), in *The Collected Essays and Criticism,* 1: 82.

83. Michelson, "'Where Is Your Rupture?' Mass Culture and the Gesamtkunstwerk," 56.

84. Ibid., 43.

85. Ibid.

Bibliography

Archival Sources

Archive of the Library of the Performing Arts, New York Public Library, New York
Georg Fuchs Papers. Monacensia Library, Hildebrand Haus, Munich
Special Collections, Getty Research Institute, Los Angeles
Theater Museum Archive, Munich
Wahnfried Museum Archive, Bayreuth
Wilhelm Worringer Papers. Fine Arts Archive, Germanisches Museum, Nuremberg

Published Sources

Ackermann, Ute. "Bauhaus Parties—Histrionics between Eccentric Dancing and Animal Drama." In Fiedler and Feierabend, *Bauhaus,* 126–39.
Adorno, Theodor W. *Aesthetic Theory* (1970). Translated by Robert Hullot-Kentor. Edited by Gretel Adorno and Rolf Tiedemann. Minneapolis: University of Minnesota Press, 1997.
———. "The Curves of the Needle" (1928). Translated by Thomas Levin. In Kaes, Jay, and Dimendberg, *The Weimar Republic Sourcebook,* 605–6.
———. *Gesammelte Schriften.* Edited by Rolf Tiedemann and Klaus Schultz. Frankfurt am Main: Suhrkamp, 1984.
———. *In Search of Wagner.* Translated by Rodney Livingstone (1952). New York: Verso, 1991.
———. "Notiz über Wagner" (1933). In Adorno, *Gesammelte Schriften,* 18: 204–9.
———. *Versuch über Wagner.* Frankfurt am Main: Suhrkamp, 1952.
———. "Wagner, Nietzsche, and Hitler." *Kenyon Review* 9, no. 1 (1947): 147–57. Also in Adorno, *Gesammelte Schriften,* 19: 404–12.
———. "Wagner und Bayreuth" (1966). In Adorno, *Gesammelte Schriften,* 18: 210–25.
———. "Wagners Aktualität" (1964). In Adorno, *Gesammelte Schriften,* 18: 543–64.
Adorno, Theodor, Else Frenkel-Brunswik, Daniel Levinson, and Nevitt Sanford. *The Authoritarian Personality.* New York: Harper and Row, 1950.
Altenloh, Emilie. *Zur Soziologie des Kino: Die Kino-Unternehmung und die soziale Schicht ihrer Besuchenr.* Jena: Eugen Diederichs, 1914.

Andel, Jaroslav. "The Constructivist Entanglement: Art into Politics, Politics into Art." In *Art into Life: Russian Constructivism 1914–1932,* Henry Art Gallery (Seattle) exhibition catalog, 223–39. New York: Rizzoli, 1990.

Anderson, Stanford. *Peter Behrens and a New Architecture for the Twentieth Century.* Cambridge: MIT Press, 2000.

———. "*Sachlichkeit* and Modernity; or, Realist Architecture." In Mallgrave, *Otto Wagner,* 323–60.

Anger, Jenny. "Modernism at Home: The Private *Gesamtkunstwerk.*" In Ogawa and Johnson, *The Feeling of Seeing,* 211–43.

Anglet, Andreas. "Musikphilosophische Perspektiven der Kunsttheorie Konrad Fiedlers." In Majetschak, *Auge und Hand,* 329–33.

Ankum, Katherina von, ed. *Women in the Metropolis: Gender and Modernity in Weimar Culture.* Berkeley and Los Angeles: University of California Press, 1997.

Applegate, Celia, and Pamela Potter. "Germans as the 'People of Music.'" In *Music and German National Identity,* edited by Celia Applegate and Pamela Potter, 1–35. Chicago: University of Chicago Press, 2002.

Arnheim, Rudolf. *Art and Visual Perception: A Psychology of the Creative Eye.* Berkeley and Los Angeles: University of California Press, 1954.

———. *Toward a Psychology of Art: Collected Essays.* Berkeley and Los Angeles: University of California Press, 1966.

———. "Wilhelm Worringer on Abstraction and Empathy." In *New Essays on the Psychology of Art,* 50–62. Berkeley and Los Angeles: University of California Press, 1986.

Aschenbrenner, Karl, and Arnold Isenberg, eds. *Aesthetic Theories: Studies in the Philosophy of Art.* Englewood, N.J.: Prentice Hall, 1965.

Aschheim, Steven. *The Nietzsche Legacy in Germany.* Berkeley and Los Angeles: University of California Press, 1992.

Baedeker, K. *Baedeker's Southern Germany and Austria, including Hungary, Dalmatia, and Bosnia.* London: Dulau and Company, 1891.

———. *Deutsches Reich.* Leipzig: Karl Baedeker, 1936.

———. *Southern Germany (Wurtemberg and Bavaria): Handbook for Travellers.* New York: Charles Scribner's Sons, 1907.

———. *Süd-Deutschland: Handbuch für Reisende.* Leipzig: Karl Baedeker, 1909.

Baragwanath, Nicholas. "Musicology and Critical Theory: The Case of Wagner, Adorno, and Horkheimer." *Music and Letters* 87, no. 1 (2005): 52–71.

Barasch, Moshe. *Modern Theories of Art.* Vol. 2, *From Impressionism to Kandinsky.* New York: New York University Press, 1998.

Barche, Gisela. "The Photographic Staging of the Image—On Stage Photography at the Bauhaus." Translated by Michael Robinson. In Jeannine Fiedler, *Photography at the Bauhaus,* 238–53.

Barck, Karlheinz. "Worringers Stilpsychologie im Kontext der Stilforschung." In Böhringer and Söntgen, *Wilhelm Worringers Kunstgeschichte,* 23–34.

Barenboim, Daniel, and Edward W. Said. *Parallels and Paradoxes: Explorations in Music and Society.* Edited by Ara Guzelimian. New York: Pantheon, 2002.

Barish, Jonas. *The Antitheatrical Prejudice.* Berkeley and Los Angeles: University of California Press, 1981.

Baudelaire, Charles. "Enivrez-vous" (1862). In *Petits poèmes en prose (Le spleen de Paris)*. Edited by Henri Lemaître, 167–68. Paris: Garnier, 1968.

———. "Richard Wagner and *Tannhäuser* in Paris" (1861). In *The Painter of Modern Life and Other Essays*. Translated and edited by Jonathan Mayne, 111–46. New York: Phaidon, 1995.

Bauer, Karin. "Adorno's Wagner: History and the Potential of the Artwork." *Cultural Critique* 60 (Spring 2005): 68–91.

Bauer, Oswald Georg. *Josef Hoffmann: Der Bühnenbilder der ersten Bayreuther Festspiele*. Munich and Berlin: Deutscher Kunstverlag, 2008.

Bauhaus 1, no. 3 (1927).

Baumhoff, Anja. "Die 'moderne Frau' und ihre Stellung in der Bauhaus Avant-Garde." In Sykora et al., *Die Neue Frau*, 83–94.

Bayer, Herbert, Walter Gropius, and Ise Gropius, eds. *Bauhaus, 1919–1928*. New York: Museum of Modern Art, 1938.

Bayerischen Architekten- und Ingenieur-Verein, ed. *München und seine Bauten*. Munich: F. Bruckmann, 1912.

Bayreuth-Album, 1889. Berlin: Haassenstein und Vogler, 1889.

Beaune, Jean-Claude. "The Classical Age of Automata: An Impressionistic Survey from the Sixteenth to the Nineteenth Century." Translated by Ian Patterson. In Feher, *Fragments for a History of the Human Body*, 431–80.

Behrendt, Walter Curt. "Das Münchener Künstlertheater." *Neudeutsche Zeitung* 39, no. 4 (1908): 305–11.

Behrens, Peter. "Die Dekoration der Bühne." *Deutsche Kunst und Dekoration* 6 (May 1900): 401–5.

———. *Ein Dokument Deutscher Kunst: Die Ausstellung der Künster-Kolonie in Darmstadt, Zur Feier der Eröffnung, 15 Mai 1901*. Munich: F. Bruckmann, [1901].

———. *Feste des Lebens und der Kunst: Eine Betrachtung des Theaters als höchsten Kultur-Symboles*. Leipzig: Diederichs, 1900.

———. "On Art for the Stage" (1910). Translated by Howard Fitzpatrick. *Perspecta: The Yale Architectural Journal* 26 (1990): 135–42.

Bell, John. "Puppets, Masks, and Performing Objects at the End of the Century." *Drama Review* 43, no. 3 (Fall 1999): 15–27.

———, ed. *Puppets, Masks, and Performing Objects*. Cambridge: MIT Press, 2001.

Belting, Hans. *The Germans and Their Art: A Troublesome Relationship* (1993). Translated by Scott Kleager. New Haven, Conn.: Yale University Press, 1998.

Benjamin, Walter. *The Arcades Project*. Translated by Howard Eiland and Kevin McLaughlin. Cambridge, Mass.: Harvard University Press, 1999.

———. "Convolute Z." In *The Arcades Project*, 693–97.

———. "The Cultural History of Toys." In *Walter Benjamin: Selected Writings*, 2: 113–16.

———. *Gesammelte Schriften*. Vol. 3. Edited by Hell Tiedemann-Bartels. Frankfurt am Main: Suhrkamp, 1989.

———. "Lob der Puppe." *Literarische Welt*, January 10, 1930. In Benjamin, *Gesammelte Schriften*, 3: 213–18.

———. "Old Toys: The Toy Exhibition at the Märkisches Museum." In *Walter Benjamin: Selected Writings*, 2: 98–102.

———. *The Origin of German Tragic Drama.* Translated by John Osborne. New York: Verso, 1977.

———. "Toys and Play: Marginal Notes on a Monumental Work." In *Walter Benjamin: Selected Writings,* 2: 117–21.

———. *Walter Benjamin: Selected Writings.* Vol. 2, *1927–1934.* Edited by Michael W. Jennings, Howard Eiland, and Gary Smith. Translated by Rodney Livingstone. Cambridge, Mass.: Harvard University Press, 1999.

———. "The Work of Art in the Age of Mechanical Reproduction." In *Illuminations,* edited by Hannah Arendt, translated by Harry Zohn, 217–51. New York: Schocken Books, 1969.

Berg-Ganschow, Uta, and Wolfgang Jacobsen, eds. *Film . . . Stadt . . . Kino . . . Berlin.* Berlin: Argon, 1987.

Bermbach, Udo. *Der Wahn des Gesamtkunstwerkes: Richard Wagners politisch-ästhetische Utopie.* Frankfurt am Main: Fischer, 1994.

Bernstein, Michael André. *Foregone Conclusions: Against Apocalyptic History.* Berkeley and Los Angeles: University of California Press, 1994.

Beuth, Kirsten. "Die Wilde Zeit der Schönen Beine: Die inszenierte Frau als Körper-Masse." In Sykora et al., *Die Neue Frau,* 95–106.

Biro, Matthew. "The New Man as Cyborg: Figures of Technology in Weimar Visual Culture." *New German Critique* 62 (Spring–Summer 1994): 71–110.

Blackbourn, David, and Geoff Eley. *The Peculiarities of German History: Bourgeois Society and Politics in Nineteenth-Century Germany.* New York: Oxford University Press, 1984.

Bletter, Rosemarie Haag. "The Interpretation of the Glass Dream—Expressionist Architecture and the History of the Crystal Metaphor." *Journal of the Society of Architectural Historians* 40, no. 1 (March 1981): 20–43.

Boehe, Jutta. "'Darmstadter Spiele 1901': Das Theater der Darmstädter Künstler-Kolonie." In Bott, *Von Morris zum Bauhaus,* 161–81.

Böhringer, Hannes, and Beate Söntgen, eds. *Wilhelm Worringers Kunstgeschichte.* Munich: Wilhelm Fink, 2002.

Bois, Yve-Alain. *Painting as Model.* Cambridge: MIT Press, 1990.

Bois, Yve-Alain, and Rosalind E. Krauss. *Formless: A User's Guide.* Cambridge: MIT Press, 1997.

Borchmeyer, Dieter. "München—Eine Wagner-Stadt?" In Seidel, *Das Prinzregenten-Theater in München,* 224–37.

———. "The Question of Anti-Semitism." Translated by Stewart Spencer. In Müller and Wapnewski, *Wagner Handbook,* 166–85.

———. *Richard Wagner: Theory and Theatre* (1982). Translated by Stewart Spencer. Oxford: Clarendon Press, 1991.

———. "Wagner and Nietzsche." Translated by Michael Tanner. In Müller and Wapnewski, *Wagner Handbook,* 327–42.

Bott, Gerhard. "Darmstadt und die Mathildenhöhe." In Wietek, *Deutsche Künstlerkolonie und Künstlerorte,* 154–61.

———, ed. *Von Morris zum Bauhaus: Eine Kunst gegründet auf Einfachheit.* Hanau: Hans Peters, 1977.

Bowen, José Antonio. "The Rise of Conducting." In *The Cambridge Companion to Conducting,* edited by José Antonio Bowen, 93–113. New York: Cambridge University Press, 2003.

Brecht, Bertolt. "Alienation Effects in Chinese Acting." In *Brecht on Theatre,* 91–99.

———. *Brecht on Theatre: The Development of an Aesthetic.* Edited and translated by John Willett. New York: Hill and Wang, 1994.

———. *Journals, 1934–1955.* Translated by Hugh Rorrison. Edited by John Willett. New York: Routledge, 1996.

———. "The Modern Theater Is the Epic Theatre" (1930). In *Brecht on Theatre,* 33–42.

———. "More Good Sports" (1926). In Kaes, Jay, and Dimendberg, *The Weimar Republic Sourcebook,* 536–38.

———. "Neue Sachlichkeit." In *Schriften zum Theater,* vol. 1, *1918–33,* 129–30.

———. *Schriften zum Theater.* Vol. 1, *1918–33.* Frankfurt am Main: Suhrkamp, 1963.

Bredekamp, Horst. *The Lure of Antiquity and the Cult of the Machine: The Kunstkammer and the Evolution of Nature, Art, and Technology.* Translated by Allison Brown. Princeton, N.J.: Markus Wiener, 1995.

———. "A Neglected Tradition? Art History as Bildwissenschaft." *Critical Inquiry* 29 (Spring 2003): 418–28.

———. "Überlegungen zur Unausweichlichkeit der Automaten." In Müller-Tamm and Sykora, *Puppen Körper Automaten,* 94–105.

Bredt, E. W. "Die Ausstellung als Künstlerisches Ganzes." *Dekorative Kunst* 11 (July 1908): 428–49.

Brewster, Ben. "From Shklovsky to Brecht: A Reply." *Screen* 15, no. 2 (Summer 1974): 82–102.

Brown, Elspeth. *The Corporate Eye: Photography and the Rationalization of American Commercial Culture, 1884–1929.* Baltimore, Md.: The Johns Hopkins University Press, 2005.

Brückwald, Otto. "Das Bühnenfestspielhaus zu Bayreuth." *Deutsche Bau-Zeitung,* 1875, 1–2.

Bruns, Marg. "Die Eröffnungs-Feier der Kunst-Ausstellung." *Deutsche Kunst und Dekoration* 8 (June 1901): 446–48.

Buchloh, Benjamin H. D. "Figures of Authority, Ciphers of Regression: Notes on the Return of Representation in European Painting." In *Art after Modernism: Rethinking Representation,* edited by Brian Wallis, 106–35. Boston: Godine, 1984.

Buchloh, Benjamin H. D., Hal Foster, and Rosalind Krauss. *Art after 1900: Modernism, Antimodernism, Postmodernism.* Cambridge: MIT Press, 2005.

Buddensieg, Tilmann. "The Early Years of August Endell: Letters to Kurt Breysig from Munich." *Art Journal* 43 (Spring 1983): 41–49.

———. "Das Wohnhaus als Kultbau: Zum Darmstädter Haus von Peter Behrens." In Schuster, *Peter Behrens und Nürnberg,* 37–47.

Bühler-Dietrich, Annette. "Zwischen Belebung und Mortifizierung: Die Puppe im Briefwechsel zwischen Rilke und Lou Andreas-Salomé." In Kornmann, Gilleir, and Schlimmer, *Textmaschinenkörper,* 117–32.

Bullough, Edward. "'Psychical Distance' as a Factor in Art and an Aesthetic Principle." *British Journal of Psychology* 5, no. 2 (June 1912): 87–118.

———. "Recent Work in Experimental Aesthetics." *British Journal of Psychology* 12, no. 1 (1921–22): 76–99.

———. "The Relation of Aesthetics to Psychology." *British Journal of Psychology* 10, no. 1 (May 1919): 43–50.

Burckhard, Max. *Das Theater.* Frankfurt am Main: Rütten und Loening, 1907.

Burckhardt, Lucius, ed. *The Werkbund: Studies in the History and Ideology of the Deutscher Werkbund, 1907–1933.* Translated by Pearl Sanders. London: Design Council, 1980.

Butler, E. M. *The Tyranny of Greece over Germany: A Study of the Influence Exercised by Greek Art and Poetry over the Great German Writers of the Eighteenth, Nineteenth, and Twentieth Centuries*. 1935. Reprint, Boston: Beacon Press, 1958.

Campbell, Joan. *The German Werkbund: The Politics of Reform in the Applied Arts*. Princeton, N.J.: Princeton University Press, 1988.

Carlson, Marvin. *Places of Performance: The Semiotics of Theater Architecture*. Ithaca, N.Y.: Cornell University Press, 1989.

———. *Theories of the Theatre: A Historical and Critical Survey, from the Greeks to the Present*. Ithaca, N.Y.: Cornell University Press, 1993.

Carnegy, Patrick. *Wagner and the Art of the Theatre*. New Haven, Conn.: Yale University Press, 2006.

Carr, Jonathan. *The Wagner Clan: The Saga of Germany's Most Illustrious and Infamous Family*. New York: Atlantic Monthly Press, 2007.

Carter, Huntly. *The New Spirit in Drama and Art*. London: Frank Palmer, 1912.

Cheetham, Mark A. *The Rhetoric of Purity: Essentialist Theory and the Advent of Abstract Painting*. New York: Cambridge University Press, 1991.

Chytry, Joseph. *The Aesthetic State: A Quest in Modern German Thought*. Berkeley and Los Angeles: University of California Press, 1989.

Collier, Jo Leslie. *From Wagner to Murnau: The Transposition of Romanticism from Stage to Screen*. Ann Arbor, Mich.: UMI Research Press, 1988.

Compagnon, Antoine. "L'hypertexte Proustien." In Galard and Zugazagoitia, *L'oeuvre d'art totale*, 93–108.

Craig, Edward Gordon. "The Actor and the Über-Marionette" (1907). In *On the Art of the Theatre*, edited by Franc Chamberlain, 27–48. New York: Routledge, 2008.

———. "The Theater in Germany, Holland, Russia, and England." *Mask* 1, no. 8 (November 1908): 159–60 and 162–63.

Crary, Jonathan. *Suspensions of Perception: Attention, Spectacle, and Modern Culture*. Cambridge: MIT Press, 2000.

———. *Techniques of the Observer: On Vision and Modernity in the Nineteenth Century*. Cambridge: MIT Press, 1990.

Da Costa Kaufmann, Thomas. "A Gesamtkunstwerk in the Unmaking? The Kunstkammer and the Age of the Bel Composto." In *Struggle for Synthesis: A Obro de Arte Total nos Séculos XVII e XVIII / The Total Work of Art in the 17th and 18th Centuries*, edited by Luis de Moura Sobral and David Booth, 2: 389–99. Lisbon: Instituto Portugués do Património Arquitectonico, 1999.

Dahlhaus, Carl. "Der Dilettant und der Banause in der Musikgeschichte." *Archiv für Musikwissenschaft* 25, no. 3 (1968): 157–72.

———. "The Music." Translated by Alfred Clayton. In Müller and Wapnewski, *Wagner Handbook*, 297–314.

———. *Nineteenth-Century Music* (1980). Translated by J. Bradford Robinson. Berkeley and Los Angeles: University of California Press, 1989.

———. *Wagners Konzeption des musikalischen Dramas*. Regensburg: Gustav Bosse, 1971.

Dal Co, Francesco. *Figures of Architecture and Thought: German Architecture Culture, 1880–1920*. New York: St. Martin's Press, 1990.

Danziger, Stuart. *Constructing the Subject: Historical Origins of Psychological Research*. New York: Cambridge University Press, 1990.

de Man, Paul. "Aesthetic Formalization in Kleist." In *The Rhetoric of Romanticism,* 263–90. New York: Columbia University Press, 1984.

Deathridge, John. "A Brief History of Wagner Research." In Müller and Wapnewski, *Wagner Handbook,* 202–23.

———. Review of *In Search of Wagner,* by Theodor Adorno, translated by Rodney Livingstone. *19th-Century Music* 7, no. 1 (Summer 1983): 81–85.

———. *Wagner: Beyond Good and Evil.* Berkeley and Los Angeles: University of California Press, 2008.

Debord, Guy. *Society of the Spectacle* (1968). Translated by Donald Nicholson-Smith. New York: Zone Books, 1994.

Demetz, Peter. *Brecht: A Collection of Critical Essays.* Englewood Cliffs, N.J.: Prentice Hall, 1962.

Deubner, L. "Decorative Art at the Munich Exhibition." *International Studio* 36 (November 1908): 42–50.

Didi-Huberman, Georges. *L'image survivante: Histoire de l'art et temps des fantômes selon Aby Warburg.* Paris: Éditions de Minuit, 2002.

Dieckmann, Friedrich. "Vom Gesamtkunstwerk." *Bildende Kunst* 36, no. 7 (1988): 298–99.

Diers, Michael. "Warburg and the Warburgian Tradition of Cultural History." *New German Critique* 65 (Spring–Summer 1995): 59–73.

Doherty, Brigid. "Figures of the Pseudorevolution." *October* 84 (Spring 1998): 65–89.

———. "'See: We Are All Neurasthenics!' or, The Trauma of Dada Montage." *Critical Inquiry* 24 (Autumn 1997): 82–132.

Ein Dokument Deutscher Kunst, 1901–1976. 5 vols. Mathildenhöhe Kunsthalle, Hessisches Landesmuseum exhibition catalog. Darmstadt: Eduard Roether, 1977.

Dömling, Wolfgang. "Reuniting the Arts: Notes on the History of an Idea." *19th-Century Music* 18, no. 1 (Summer 1994): 3–9.

Donahue, Neil H. *Forms of Disruption: Abstraction in Modern German Prose.* Ann Arbor, Mich.: University of Michigan Press, 1993.

———, ed. *Invisible Cathedrals: The Expressionist Art History of Wilhelm Worringer.* University Park: Pennsylvania State University Press, 1995.

Droste, Magdalena. "Bauhaus-Maler im Nationalsozialismus: Anpassung, Selbstentfremdung, Verweigerung." In Nerdinger, *Bauhaus-Moderne im Nationalsozialismus,* 113–41.

Düsel, Friedrich. "Das Münchener Künstlertheater." *Westermanns Monatshefte* 104, no. 2 (September 1908): 893–901.

Eger, Manfred. "The Bayreuth Festival and the Wagner Family." Translated by Stewart Spencer. In Müller and Wapnewski, *Wagner Handbook,* 485–501.

———. "The Patronage of King Ludwig II." Translated by Stewart Spencer. In Müller and Wapnewski, *Wagner Handbook,* 317–26.

———. *Richard-Wagner-Museum, Bayreuth.* Braunschweig: Westermann, 1982.

Eggert, Klaus. "Der Begriff des Gesamtkunstwerks in Sempers Theorie." In *Gottfried Semper und die Mitte des 19. Jahrhunderts,* edited by Adolf Max Vogt, Christina Reble, and Martin Fröhlich, 122–28. Basel: Birkhäuser, 1976.

Elsaesser, Thomas, ed. *Early Cinema: Space, Frame, Narrative.* With Adam Barker. London: British Film Institute, 1990.

Ernst, Paul. "Möglichkeiten einer Kinokunst." In *Tagebuch eines Dichters,* 43–48. Munich: Albert Langen/Georg Müller, 1913.

————. Review of *Abstraktion und Einfühlung,* by Wilhelm Worringer. *Kunst und Künstler* 6 (September 1908): 529.

Esche-Braunfels, Sigrid. *Adolf von Hildebrand.* Berlin: Deutsche Verlag für Kunstwissenschaft, 1993.

Etlin, Richard A. "Aesthetics and the Spatial Sense of Self." *Journal of Aesthetics and Art Criticism* 56, no. 1 (Winter 1998): 1–19.

Feher, Michael, ed., with Ramona Naddaff and Nadia Tazi. *Fragments for a History of the Human Body.* Part 1. New York: Zone Books, 1989.

Fiedler, Conrad [Konrad]. *On Judging Works of Visual Art* (1876). Translated by Henry Schaefer-Simmern. Berkeley and Los Angeles: University of California Press, 1978.

————. "Richard Wagner." In *Schriften zur Kunst,* 2: 270–72.

————. *Schriften zur Kunst.* Edited by Gottfried Boehm. 2 vols. Munich: Wilhelm Fink, 1991.

————. "Über den Ursprung der künstlerischen Thätigkeit" (1887). In *Schriften zur Kunst,* 1: 111–220.

Fiedler, Jeannine, ed. *Photography at the Bauhaus.* Cambridge: MIT Press, 1990.

Fiedler, Jeannine, and Peter Feierabend, eds. *Bauhaus.* Translated by Translate-a-Book. Oxford. Cologne: Könemann, 1999.

Fineman, Mia. "Ecce Homo Prostheticus." *New German Critique* 76 (Winter 1999): 85–114.

Finger, Anke K. *Das Gesamtkunstwerk der Moderne.* Göttingen: Vandenhoeck und Ruprecht, 2006.

Fizer, John. *Psychologism and Psychoaesthetics: A Historical and Critical View of Their Relations.* Amsterdam: John Benjamins, 1981.

Forster-Hahn, Françoise, ed. *Imagining Modern German Culture: 1889–1910.* Washington, D.C.: National Gallery of Art, 1996.

Foster, Hal. *Compulsive Beauty.* Cambridge: MIT Press, 1993.

————. *Prosthetic Gods.* Cambridge: MIT Press, 2004.

Frank, Hilmar. "Die Missverstandene Antithese: Zur logischen Struktur von *Abstraktion und Einfühlung.*" In Böhringer and Söntgen, *Wilhelm Worringers Kunstgeschichte,* 67–80.

Freud, Sigmund. "The Uncanny" (1919). In *Writings on Art and Literature,* 193–233. Stanford, Calif.: Stanford University Press, 1997.

Fried, Michael. "Art and Objecthood" (1967). In *Art and Objecthood: Essays and Reviews,* 148–72. Chicago: University of Chicago Press, 1998.

————. *Menzel's Realism: Art and Embodiment in Nineteenth-Century Berlin.* New Haven, Conn.: Yale University Press, 2002.

Frisch, Walter. *German Modernism: Music and the Arts.* Berkeley and Los Angeles: University of California Press, 2005.

Fuchs, Emil. *Mein Leben.* 2 vols. Leipzig: Koehler und Amelang, 1957.

Fuchs, Georg. *Deutsche Form: Betrachtungen über die Berliner Jahrhundertausstellung und die Münchener Retrospektive.* Munich and Leipzig: Georg Müller, 1907.

————. "Deutsche Plastik." *Deutsche Kunst und Dekoration* 2 (April–September 1898): 395.

————. "Divina Comedia!—vom Zwecke der Schaubühne." *Allgemeine Kunst-Chronik,* 1893, 700.

————. "Die Eröffnungs-Feier vom 15 Mai 1901." In Koch, *Grossherzog Ernst Ludwig und die Ausstellung der Künstler-Kolonie in Darmstadt von Mai bis Oktober 1901,* 56–60.

———. "Friedrich Nietzsche und die bildende Kunst." *Die Kunst für Alle* 11 (November 1, 1895): 33–38; 11 (November 15, 1895): 71–73; 11 (December 15, 1895): 85–88.

———. "Grossherzog Ernst Ludwig und die Entstehung der Künstler-Kolonie." In Koch, *Grossherzog Ernst Ludwig und die Ausstellung der Künstler-Kolonie in Darmstadt von Mai bis Oktober 1901*, 17–22.

———. "Hermann Obrist." *Pan* 1, no. 5 (1896): 318–25.

———. *Der Kaiser, die Kultur, und die Kunst: Betrachtungen über die Zukunft des Deutschen Volkes aus den Papieren eines Unverantwortlichen*. Published anonymously. Munich and Leipzig: Georg Müller, 1904.

———. [Pseudonymously published]. "Kunstbrief aus Darmstadt." *Allgemeine Kunst-Chronik*, 1894, 42.

———. "Ludwig Habich." *Deutsche Kunst und Dekoration* 9 (October 1901): 1–7. In Koch, *Grossherzog Ernst Ludwig und die Ausstellung der Künstler-Kolonie in Darmstadt von Mai bis Oktober 1901*, 189–95.

———. "Die 'Mathilden-Hoehe' Einst und Jetzt" (1901). In Koch, *Grossherzog Ernst Ludwig und die Ausstellung der Künstler-Kolonie in Darmstadt von Mai bis Oktober 1901*, 115–33.

———. "Das Münchener Künstler-Theater." *Dekorative Kunst* 14 (December 1910): 138–43.

———. "Myunkhenskii Khudozhestvennyi Teatr." *Apollon*, November 1909, 47–53.

———. *Die Revolution des Theaters: Ergebnisse aus der Münchener Künstler-Theater*. Munich: Georg Müller, 1909.

———. *Revolution in the Theater: Conclusions Concerning the Munich Artists' Theatre*. Translated by Constance Connor Kuhn. Ithaca, N.Y.: Cornell University Press, 1959.

———. "Richard Wagner und die moderne Malerei." *Die Kunst für Alle* 10 (January 1, 1895): 97–98; and 10 (January 15, 1895): 113–16.

———. "Die Schaubühne—Ein Fest des Lebens." *Wiener Rundschau* 3 (November 15, 1898–December 31, 1899): 483–86.

———. *Die Schaubühne der Zukunft*. Berlin: Schuster und Loeffler, 1905.

———. "Der schöpferische Künstler und die kulturelle Organization." *Die Kunst* 14 (September 1906): 512–20.

———. "Die Vorhalle zum Hause der Macht und der Schönheit: Zur Hamburger Vorhalle von Prof. Peter Behrens." *Deutsche Kunst und Dekoration* 11 (October 1902): 1–12.

———. *Wir Zuchthausler: Erinnerungen des Zellengefangenen Nr. 2911, im Zuchthause geschrieben*. Munich: A. Langen, 1931.

———. "Zum Spielplan des Münchener Künstlertheaters." In *Münchener Künstler-Theater, Ausstellung München 1908*, 16–23.

———. "Zur Kunstgewerbe-Schule der Zukunft." *Deutsche Kunst und Dekoration* 13 (January 1904): 259–66.

———. "Zur künstlerischen Neugestaltung der Schau-Bühne." *Deutsche Kunst und Dekoration* 7 (October 1900–March 1901): 198–214.

———. *Zur Vorgeschichte der Nazionalsozialistischen Erhebung: Aufzeicherung persöhnlicher Erlebnisse aus en Jahren 1919 bis 1923*. Part 1, "Nach 1936 geschrieben." Georg Fuchs Papers, Monacensia Library, Munich, folder L4174.

Gaenßler, Michael. "Die Architektur des Münchner Ausstellungsparks." In *Vom Ausstellungspark zum Internationalen Messeplatz München, 1904 bis 1984*, 42–48.

Galard, Jean, and Julian Zugazagoitia, eds. *L'oeuvre d'art totale*. Paris: Gallimard, 2003.

Geissler, Joachim. "Die Kunsttheorien von Adolf Hildebrand, Wilhelm Trübner, und Max Liebermann: Ein Beitrag zur Geschichte der Kunstliteratur in Deutschland." Ph.D. diss., Heidelberg, 1963.

Geldern, James von. "Nietzschean Leaders and Followers in Soviet Mass Theater, 1917–27." In Rosenthal, *Nietzsche and Soviet Culture*, 127–48.

Giedion, Siegfried. *Space, Time, and Architecture: The Growth of a New Tradition*. Cambridge, Mass.: Harvard University Press, 1941.

Gluck, Mary. "Interpreting Primitivism, Mass Culture, and Modernism: The Making of Wilhelm Worringer's *Abstraction and Empathy*." *New German Critique* 80 (Spring–Summer 2000): 149–69.

Gobran, Sophie. "The Munich Festival Theater Letters." *Perspecta: The Yale Architecture Journal* 26 (1990): 47–68.

Goehr, Lydia. *The Quest for Voice: Music, Politics, and the Limits of Philosophy*. New York: Oxford University Press, 1998.

Golding, John. *Cubism*. 1959. Reprint, London: Faber and Faber, 1968.

Golomb, Jacob, and Robert S. Wistrich, eds. *Nietzsche, Godfather of Fascism? On the Uses and Abuses of a Philosophy*. Princeton, N.J.: Princeton University Press, 2002.

Gombrich, Ernst. *Art and Illusion: A Study in the Psychology of Pictorial Representation*. London: Phaidon, 1960.

Gordon, Terri. "*Girls Girls Girls*: Re-Membering the Body." In *Rhine Crossings: France and Germany in Love and War*, edited by Peter Schulman and Aminia Brueggemann, 87–118. Albany, N.Y.: State University of New York Press, 2005.

Gorelik, Mordecai. *New Theaters for Old*. 1940. Reprint, New York: E. P. Dutton, 1962.

Grand-Carteret, John. *Richard Wagner en caricatures*. Paris: Larousse, [1892].

Grebing, Helga. "Bildungsbürgerlichkeit als Lebenssinn: Soziobiographische Annäherungen an Wilhelm und Marta Worringer." In Böhringer and Söntgen, *Wilhelm Worringers Kunstgeschichte*, 204–8.

Greenberg, Clement. "The Case for Abstract Art" (1959). In *The Collected Essays and Criticism*, 4: 75–84.

———. *The Collected Essays and Criticism*. 4 vols. Edited by John O'Brian. Chicago: University of Chicago Press, 1986.

———. "Modernist Painting" (1960). In *The Collected Essays and Criticism*, 4: 85–93.

———. "The State of American Writing, 1948: A Symposium" (1948). In *The Collected Essays and Criticism*, 2: 254–58.

———. "Towards a Newer Laocoon" (1940). In *The Collected Essays and Criticism*, 1: 23–38.

———. "Venusberg to Nuremberg" (1941). Review of *Metapolitics: From the Romantics to Hitler*, by Peter Viereck. In *The Collected Essays and Criticism*, 1: 79–83.

Gregor-Dellin, Martin. *Richard Wagner: Sein Leben—Sein Werk—Sein Jahrhundert*. Munich: R. Piper, 1980.

Grimm, Reinhold. *Brecht und Nietzsche oder Geständnisse eines Dichters*. Frankfurt am Main: Suhrkamp, 1979.

———. "The Hidden Heritage: Repercussions of Nietzsche in Modern Theater and Its Theory." In *Echo and Disguise: Studies in German Comparative Literature*, 61–78. New York: Peter Lang, 1969.

———. "Verfremdung: Beiträge zu Wesen und Ursprung eines Begriffs." *Revue de Littérature Comparée*, no. 35 (1961): 207–36.

Grohmann, Walter. *Das Münchener Künstlertheater in der Bewegung der Szenen- und Theater-reformen.* Berlin: Gessellschaft für Theatergeschichte, 1935.

Groos, Karl. *Der ästhetische Genuss.* Giessen: Ricker, 1902.

———. *Einleitung in die Ästhetik.* Giessen: Ricker, 1892.

Gropius, Walter. "Program for the Staatliche Bauhaus in Weimar" (April 1919). In Wingler, *The Bauhaus,* 31–33.

———. "The Work of the Bauhaus Stage" (1922). In Wingler, *The Bauhaus,* 58.

Grund, Uta. *Zwischen den Künsten: Edward Gordon Craig und das Bildertheater um 1900.* Berlin: Akademie, 2002.

Gumbrecht, Hans Ulrich. *In 1926: Living at the Edge of Time.* Cambridge, Mass.: Harvard University Press, 1997.

Gunning, Tom. "The Cinema of Attractions: Early Film, Its Spectator, and the Avant-Garde." In Elsaesser, *Early Cinema,* 56–62.

Günther, Hans, ed. *Gesamtkunstwerk: Zwischen Synästhesie und Mythos.* Bielefeld: Aisthesis, 1994.

Gutman, Robert. *Richard Wagner: The Man, His Mind, and His Music.* New York: Time–Life, 1968.

Habel, Heinrich. *Festspielhaus und Wahnfried: Geplante und Ausgeführte Bauten Richard Wagners.* Munich: Prestel, 1985.

———. "Die Idee eines Festspielhauses." In Petzet and Petzet, *Die Richard-Wagner-Bühne König Ludwigs II,* 298–316.

Hagemann, Carl. *Aufgaben des modernen Theaters.* Berlin: Schuster und Loeffler, 1906.

Hamann, Brigitte. *Winifred Wagner: A Life at the Heart of Hitler's Bayreuth* (2002). Translated by Alan Bance. London: Granta, 2005.

Hanisch, Ernst. "The Political Influence and Appropriation of Wagner." Translated by Paul Knight. In Müller and Wapnewski, *Wagner Handbook,* 186–201.

Hansen, Miriam. "Early Cinema: Whose Public Sphere?" In Elsaesser, *Early Cinema,* 228–46.

"Harold Lloyd's New Home." *Photoplay* 21, no. 8 (July 1922): 68–69.

Hartford, Robert, ed. *Bayreuth: The Early Years; An Account of the Early Decades of the Wagner Festival as Seen by the Celebrated Visitors and Participants.* New York: Cambridge University Press, 1980.

Haxthausen, Charles W., and Heidrun Suhr, eds. *Berlin: Culture and Metropolis.* Minneapolis: University of Minnesota Press, 1990.

Hays, K. Michael. *Modernism and the Posthumanist Subject: The Architecture of Hannes Meyer and Ludwig Hilberseimer.* Cambridge: MIT Press, 1992.

Hegel, Georg Wilhelm Friedrich. *Vorlesungen über die Ästhetik III.* Vol. 15 of *Werke.* Edited by Eva Moldenhauer and Karl Markus Michel. Frankfurt am Main: Suhrkamp, 1970.

Herder, Gottfried. *Kalligone: Vom Angenehmen zum Schönen.* Leipzig: J. F. Hartkoch, 1800.

Herf, Jeffrey. *Reactionary Modernism: Technology, Culture, and Politics in Weimar and the Third Reich.* New York: Cambridge University Press, 1984.

Herrmann, Wolfgang. *Gottfried Semper: In Search of Architecture.* Cambridge: MIT Press, 1984.

Herzogenrath, Wulf, and Stefan Kraus, eds. *Erich Consemüller: Fotografien Bauhaus Dessau.* Munich: Schirmer/Mosel, 1989.

Hildebrand, Adolf [von]. "Münchener Künstler-Theater." *Münchener Neueste Nachrichten* (February 1908); repr. in *Münchener Künstler-Theater, Ausstellung München 1908,* 7–10. Munich

and Leipzig: Georg Müller, 1908; and in Adolf von Hildebrand, *Gesammelte Aufsätze*, 71–75. Strassburg: Heitz, 1909.

———. *Das Problem der Form in der bildenden Kunst.* 1893. Reprint, Baden-Baden: Heitz, 1961.

———. *The Problem of Form in the Fine Arts.* In Mallgrave and Ikonomou, *Empathy, Form, and Space*, 227–79.

Hille, Karoline. "'. . . über den Grenzen, mitten in Nüchternheit': Prothesenkörper, Maschinenherzen, Automatenhirne," in Müller-Tamm and Sykora, *Puppen Körper Automaten*, 140–59.

Hilmes, Oliver. *Herrin des Hügels: Das Leben der Cosima Wagner.* Munich: Siedler, 2007.

Hofmann, Werner. "Luxus und Widerspruch." In *Ein Dokument Deutscher Kunst, 1901–1976*, 1: 21–28.

Holub, Robert C. "The Elizabeth Legend: The Cleansing of Nietzsche and the Sullying of His Sister." In Golomb and Wistrich, *Nietzsche, Godfather of Fascism?* 215–34.

Horkheimer, Max, and Theodor Adorno. "The Culture Industry: Enlightenment as Mass Deception" (1947). In *Dialectic of Enlightenment,* translated by John Cumming, 120–67. New York: Continuum, 1993.

Huder, Walter, ed. *Erwin Piscator, 1893–1966.* Berlin: Archiv der Akademie der Künste, 1979.

Huret, Jules. "En Allemagne: Munich; Les arts décoratifs à l'exposition." *Le Figaro,* January 19, 1905, 5.

Huyssen, Andreas. "Adorno in Reverse." In *After the Great Divide: Modernism, Mass Culture, Postmodernism,* 16–43. Bloomington: University of Indiana Press, 1986.

———. "Mass Culture as Woman: Modernism's Other." In *After the Great Divide: Modernism, Mass Culture, Postmodernism,* 44–62. Bloomington: University of Indiana Press, 1986.

———. "Monumental Seduction." In "Special Issue on Richard Wagner," ed. David J. Levin and Mark M. Anderson, *New German Critique* 69 (Fall 1996): 181–200.

Iverson, Margaret. *Alois Riegl: Art History and Theory.* Cambridge: MIT Press, 1993.

Izenour, George C. *Theater Design.* New York: McGraw-Hill, 1977.

Jachmann, Günther, ed. *Adolf von Hildebrands Briefwechsel mit Conrad Fiedler.* Dresden: Wolfgang Jess, 1927.

James-Chakraborty, Kathleen. *German Architecture for a Mass Audience.* New York: Routledge, 2000.

Jameson, Fredric. "The Politics of Utopia." *New Left Review* 25 (January–February 2004): 35–54.

Jarzombek, Mark. "The Discourses of a Bourgeois Utopia, 1904–1908, and the Founding of the Werkbund." In Forster-Hahn, *Imagining Modern German Culture*, 127–45.

———. "The *Kunstgewerbe,* the *Werkbund,* and the Aesthetics of Culture in the Wilhelmine Period." *Journal of the Society of Architectural Historians* 53, no. 1 (March 1994): 7–19.

———. *The Psychologizing of Modernity: Art, Architecture, History.* New York: Cambridge University Press, 2000.

Jay, Martin. "Modernism and the Specter of Psychologism." *Modernism/Modernity* 3, no. 2 (1996): 93–111.

Jeffries, Matthew. *Politics and Culture in Wilhelmine Germany: The Case of Industrial Architecture.* Washington, D.C.: Berg, 1995.

Jelavich, Peter. *Munich and Theatrical Modernism: Politics, Playwriting, and Performance, 1890–1914.* Cambridge, Mass.: Harvard University Press, 1985.

Jones, E. Michael. *Dionysos Rising: The Birth of Cultural Revolution out of the Spirit of Music.* San Francisco: Ignatius Press, 1994.

Jullien, Adolphe. *Richard Wagner: His Life and Works.* Translated by Florence Percival Hall. Philadelphia: Theodore Presser, 1900.

Jung, C. G. *Psychological Types; or, The Psychology of Individuation* (1923). Translated by H. Godwin Baynes. London: Pantheon Books, 1964.

Junghanns, Kurt. *Der Deutsche Werkbund: Sein erstes Jahrzehnt.* Berlin: Henschelverlag, 1982.

Kaes, Anton. "The Debate about Cinema: Charting a Controversy (1909–1929)." *New German Critique* 40 (Winter 1987): 7–33.

———. "Mass Culture and Modernity: Notes toward a Social History of Early American and German Cinema." In *America and the Germans: An Assessment of a Three-Hundred-Year History,* edited by Frank Trommler and Joseph McVeigh, 2: 317–31. Philadelphia: University of Pennsylvania Press, 1985.

Kaes, Anton, Martin Jay, and Edward Dimendberg, eds. *The Weimar Republic Sourcebook.* Berkeley and Los Angeles: University of California Press, 1994.

Kaiser, Hermann. *Der Bühnenmeister Carl Brandt und Richard Wagner: Kunst der Szene in Darmstadt und Bayreuth.* Darmstadt: Eduard Roether, 1968.

Kandinsky, Wassily. *Concerning the Spiritual in Art* (1912). Translated by M. T. H. Sadler. New York: Dover, 1977.

———. *Über das Geistige in der Kunst.* 1912. Reprint Bern-Bümpliz: Benteli, 1959.

Karbaum, Michael. *Studien zur Geschichte der Bayreuther Festspiele (1876–1976).* Regensburg: Gustav Bosse, 1976.

Kaufmann, Walter. *Tragedy and Philosophy.* Princeton, N.J.: Princeton University Press, 1968.

Kertz, Peter. "Die Szene im Prinzregententheater zwischen Historismus und Moderne." In Seidel, *Das Prinzregenten-Theater in München,* 86–21.

Kittler, Friedrich A. *Gramophone, Film, Typewriter* (1986). Translated by Geoffrey Winthrop-Young and Michael Wutz. Stanford, Calif.: Stanford University Press, 1999.

Klee, Felix. "On the Urge for Renewal and Parties at the Bauhaus." In Fiedler and Feierabend, *Bauhaus,* 172–73.

Klee, Paul. *Paul Klee: Puppen, Plastiken, Reliefs, Masken, Theater.* Neuchâtel: Éditions Galerie Suisse de Paris, 1979.

Kleist, Heinrich von. "On the Marionette Theater" (1810). Translated by Roman Paska. In Feher, *Fragments for a History of the Human Body,* part 1, 415–20.

[Klutsis, Gustav]. "Photomontage." *Lef,* no. 4 (1924): 43–44. Translated by John E. Bowlt. In Christopher Phillips, *Photography in the Modern Era,* 211–12.

Koch, Alexander, ed. *Grossherzog Ernst Ludwig und die Ausstellung der Künstler-Kolonie in Darmstadt von Mai bis Oktober 1901.* Darmstadt: A. Koch, 1901. Reissued in facsimile form as *Die Ausstellung der Darmstädter Künstlerkolonie.* Stuttgart: Arnoldsche Verlaganstalt, 1989.

Koepnick, Lutz. *The Dark Mirror: German Cinema between Hitler and Hollywood.* Berkeley and Los Angeles: University of California Press, 2002.

Köhler, Bettina. "Architekturgeschichte als Geschichte der Raumwahrnehmung / Architecture History as the History of Spatial Experience." *Daidalos* 67 (March 1998): 36–43.

Köhler, Joachim. *Nietzsche and Wagner: A Lesson in Subjugation.* Translated by Ronald Taylor. New Haven, Conn.: Yale University Press, 1998.

———. *Richard Wagner: The Last of the Titans.* New Haven, Conn.: Yale University Press, 2004.

Kornmann, Eva, Anke Gilleir, and Angelika Schlimmer, eds. *Textmaschinenkörper: Genderorientierte Lektüren des Androiden.* New York: Rodopi, 2006.

Koss, Juliet. "Allegorical Procedures, Apocalyptic Threats: Early Weimar Cultural Positions." In *Issues of Performance in Politics and the Arts: Proceedings of the Third Annual German Studies Conference at Berkeley,* 101–15. Berkeley, Calif.: Berkeley Academic Press, 1997.

Kostka, Alexandre. "Architecture of the 'New Man': Nietzsche, Kessler, Beuys." In Kostka and Wohlfarth, *Nietzsche and "An Architecture of Our Minds,"* 199–231.

Kostka, Alexandre, and Irving Wohlfarth, eds. *Nietzsche and "An Architecture of Our Minds."* Los Angeles: Getty Research Institute for the History of Art and the Humanities, 1999.

Kracauer, Siegfried. "The Cult of Distraction: On Berlin's Picture Palaces" (1926). In *The Mass Ornament,* 323–28.

———. "The Group as Bearer of Ideas" (1922). In *The Mass Ornament,* 143–70.

———. "The Hotel Lobby" (1922). In *The Mass Ornament,* 173–85.

———. "The Little Shopgirls Go to the Movies" (1927). In *The Mass Ornament,* 291–304.

———. "The Mass Ornament" (1927). In *The Mass Ornament,* 75–86.

———. *The Mass Ornament: Weimar Essays.* Edited and translated by Thomas Y. Levin. Cambridge, Mass.: Harvard University Press, 1995.

———. *The Salaried Masses: Duty and Distraction in Weimar Germany* (1929). Translated by Quintin Hoare. New York: Verso, 1998.

———. "Those Who Wait" (1922). In *The Mass Ornament,* 129–40.

Kranich, Friedrich, ed. *Bühnentechnik der Gegenwart.* 2 vols. Munich and Berlin: R. Oldenbourg, 1929.

Krauss, Rosalind E. *The Optical Unconscious.* Cambridge: MIT Press, 1993.

———. *The Originality of the Avant-Garde and Other Modernist Myths.* Cambridge: MIT Press, 1985.

———. *Passages in Modern Sculpture.* Cambridge: MIT Press, 1977.

Kremer, Detlef. "Ästhetische Konzepte der 'Mythopoetik' um 1800." In Günther, *Gesamtkunstwerk,* 11–27.

Krimmel, Elizabeth. "In Schönheit Sterben: Über das Religiöse im Jugendstil." In Bott, *Von Morris zum Bauhaus,* 69–89.

Krohn, Rüdiger. "The Revolutionary of 1848–49." Translated by Paul Knight. In Müller and Wapnewski, *Wagner Handbook,* 156–65.

Kruft, Hanno-Walter. "The Artists' Colony on the Mathildenhöhe." In Burckhardt, *The Werkbund,* 25–34.

Krüger, Max. *Über Bühne und bildende Kunst.* Munich: R. Piper, 1912.

Kühnel, Jürgen. "The Prose Writings." Translated by Simon Nye. In Müller and Wapnewski, *Wagner Handbook,* 565–654.

Kunze, Stefan. *Der Kunstbegriff Richard Wagners: Voraussetzungen und Folgerungen.* Regensburg: Gustav Bosse, 1983.

La Mettrie, Julien Offrey de. *Machine Man* (1747). In *Machine Man and Other Writings,* edited and translated by Ann Thomson, 3–39. Cambridge: Cambridge University Press, 1996.

Lane, Barbara Miller. *Architecture and Politics in Germany, 1918–1945.* Cambridge, Mass.: Harvard University Press, 1968.

Lang, Karen. *Chaos and Cosmos: On the Image in Aesthetics and Art History.* Ithaca, N.Y.: Cornell University Press, 2006.

Lang, Siegfried K. "Wilhelm Worringers *Abstraktion und Einfühlung*: Entstehung und Bedeutung." In Böhringer and Söntgen, *Wilhelm Worringers Kunstgeschichte,* 81–117.

Lant, Antonia. "Haptical Cinema." *October* 74 (Fall 1995): 45–73.

Lauterbach, Burkhart. "'München 1908'—Eine Ausstellung." In *Vom Ausstellungspark zum Internationalen Messeplatz München, 1904 bis 1984,* 37–42.

Lavignac, Albert. *The Music Dramas of Richard Wagner and His Festival Theatre in Bayreuth* (1897). Translated by Esther Singleton. New York: Dodd, Mead, 1901.

Lavin, Maud. *Cut with a Kitchen Knife: The Weimar Photomontages of Hannah Höch.* New Haven, Conn.: Yale University Press, 1993.

Leary, David E. "The Philosophical Development of the Conception of Psychology in Germany." *Journal of the History of the Behavioral Sciences* 14 (1978): 113–21.

Lee, Pamela M. *Chronophobia: On Time in the Art of the Sixties.* Cambridge: MIT Press, 2004.

Lee, Vernon. *The Beautiful: An Introduction to Psychological Aesthetics.* New York: Putnam's, 1913.

———, with Clementine Anstruther-Thomson. *Beauty and Ugliness and Other Studies in Psychological Aesthetics.* New York: Lane, 1912.

Lehman, Arnold L., and Brenda Richardson, eds. *Oskar Schlemmer.* Baltimore, Md.: Baltimore Museum of Art exhibition catalog, 1986.

Lenman, Robin. "The State and the Avant-Garde in Munich, 1864–1919." In *Society and Politics in Wilhelmine Germany,* edited by Richard J. Evans, 90–111. New York: Barnes and Noble Books (Harper and Row), 1978.

Lethen, Helmut. *Cool Conduct: The Culture of Distance in Weimar Germany.* Berkeley and Los Angeles: University of California Press, 2001.

Levin, David J. "Reading Beckmesser Reading: Antisemitism and Aesthetic Practice in *The Mastersingers of Nuremberg*." In "Special Issue on Richard Wagner," edited by David J. Levin and Mark M. Anderson. *New German Critique* 69 (Fall 1996): 127–46.

Lichtenstein, Therese. *Behind Closed Doors: The Art of Hans Bellmer.* Berkeley and Los Angeles: University of California Press, 2001.

Lipps, Theodor. "Einfühlung und ästhetischer Genuss." *Die Zukunft* 54 (January 1906): 99–114. Translated as "Empathy and Aesthetic Pleasure" by Karl Aschenbrenner in Aschenbrenner and Isenberg, *Aesthetic Theories,* 403–12.

———. "Psychologie und Aesthetik." *Archiv für die gesamte Psychologie* 9 (1907): 91–116.

Lista, Marcella. *L'oeuvre d'art totale à la naissance des avant-gardes, 1908–1914.* L'Art et l'essai. Paris: Éditions CTHS, 2006.

Littmann, Max. *Das Münchner Künstlertheater.* Munich: L. Werner, 1908.

———. *Das Münchener Schauspielhaus: Denkschrift zur Feier der Eröffnung.* Edited by Jakob Heilmann and Max Littmann. Munich: E. Mühlthaler's Buch- und Kunstdruckerei, 1901.

———, ed. *Das Prinzregenten-Theater in München, erbaut vom Baugeschäft Heilmann & Littmann, G.m.b.H.: Denkschrift zur Feier der Eröffnung.* Munich: L. Werner, 1901.

———. "Theater- und Saalbauten." In Bayerischen Architekten- und Ingenieur-Verein, *München und seine Bauten,* 232–60.

Lodder, Christina. *Russian Constructivism.* New Haven, Conn.: Yale University Press, 1983.

Loos, Anita. *Gentleman Prefer Blondes: The Illuminating Diary of a Professional Lady.* New York: Boni and Liveright, 1925.

Louis, Eleonora, and Toni Stooss, eds. *Oskar Schlemmer—Tanz—Theater—Bühne.* Klagenfurt: Ritter, 1997.

Lucas, Lore. *Die Festspiel-Idee Richard Wagners: 100 Jahre Bayreuther Festspiele.* Vol. 2. Regensburg: Gustav Bosse, 1973.

Ludwig Prinz von Hessen und bei Rhein. *Die Darmstädter Künstlerkolonie.* Darmstadt: Justus von Liebig, 1950.

Lux, Joseph August. *Das Neue Kunstgewerbe in Deutschland.* Leipzig: Klinkhardt und Biermann, 1908.

Maciuika, John. *Before the Bauhaus: Architecture, Politics, and the German State, 1890–1920.* New York: Cambridge University Press, 2005.

Mackintosh, Iain. *Architecture, Actor, and Audience.* New York: Routledge, 1993.

Magee, Bryan. *The Tristan Chord: Wagner and Philosophy.* New York: Henry Holt, 2000.

Majetschak, Stefan, ed. *Auge und Hand: Konrad Fiedlers Kunsttheorie im Kontext.* Munich: Wilhelm Fink, 1997.

Mallgrave, Harry Francis. "From Realism to *Sachlichkeit*: The Polemics of Architectural Modernity in the 1890s." In Mallgrave, *Otto Wagner,* 281–321.

———. *Gottfried Semper: Architect of the Nineteenth Century.* New Haven, Conn.: Yale University Press, 1996.

———, ed. *Otto Wagner: Reflections on the Raiment of Modernity.* Santa Monica, Calif.: Getty Center for the History of Art and the Humanities, 1993.

Mallgrave, Harry Francis, and Eleftherios Ikonomou, eds. and trans. *Empathy, Form, and Space: Problems in German Aesthetics, 1873–1893.* Santa Monica, Calif.: Getty Center Publications, 1994.

Mander, Raymond, and Joe Mitchenson, eds. *The Wagner Companion.* New York: Hawthorn Books, 1977.

Mann, Thomas. "Coming to Terms with Richard Wagner" (1911). In *Pro and Contra Wagner,* translated by Allan Blunden, edited by Patrick Carnegy, 45–48. 1963. Reprint, Chicago: University of Chicago Press, 1985.

———. *Doctor Faustus: The Life of the German Composer Adrian Leverkühn as Told by a Friend* (1947). Translated by John E. Woods. New York: Vintage Books, 1997.

———. *Im Schatten Wagners: Thomas Mann über Richard Wagner; Texte und Zeugnisse, 1895–1955.* Edited and with commentary by Hans Rudolf Vaget. Frankfurt am Main: Fischer Taschenbuch, 1999.

———. "Leiden und Grösse Richard Wagners" (1933). In Mann, *Im Schatten Wagners,* 150–73.

———. *Reflections of a Nonpolitical Man* (1918). Translated by Walter D. Morris. New York: Ungar, 1983.

———. "Richard Wagner and *The Ring of the Nibelungen.*" Translated by Helen T. Lowe-Porter. *Decision* 3, nos. 1–2 (January–February 1942): 7–19.

———. "Richard Wagner und 'Der Ring des Nibelungen.'" In *Im Schatten Wagners,* 85–141.

Marchand, Roland. *Advertising the American Dream: Making Way for Modernity, 1920–1940.* Berkeley and Los Angeles: University of California Press, 1985.

Marsop, Paul. *Weshalb Brauchen wir die Reformbühne.* Munich: Georg Müller, 1907.

Marx, Karl, and Friedrich Engels. *The Communist Manifesto* (1848). Translated by Samuel Moore. New York: International Publishers, 1980.

Maur, Karin von. *Oskar Schlemmer: Der Maler. Der Wandgestalter. Der Plastiker. Der Zeichner. Der Graphiker. Der Bühnengestalter. Der Lehrer.* Stuttgart: Staatsgalerie exhibition catalog, 1977.

Maynard, Kelly Jo. "The Enemy Within: Encountering Wagner in Early Third Republic France." Ph.D. diss., University of California at Los Angeles, 2007.

Mayr, Karl. "Fritz Erler, München." *Deutsche Kunst und Dekoration* 7 (October 1900–September 1901): 273–301.

Mazlish, Bruce. *The Fourth Discontinuity: The Co-Evolution of Humans and Machines.* New Haven, Conn.: Yale University Press, 1993.

McCall, Debra. "Reconstructing Schlemmer's Bauhaus Dances: A Personal Narrative." In Lehman and Richardson, *Oskar Schlemmer,* 149–59.

McCormick, Richard W. *Gender and Sexuality in Weimar Modernity: Film, Literature, and "New Objectivity."* New York: Palgrave, 2001.

Melville, Stephen. "Notes on the Reemergence of Allegorism, the Forgetting of Modernism, the Necessity of Rhetoric, and the Conditions of Publicity in Art and Criticism." *October* 19 (Winter 1981): 55–92.

Metken, Günter. "Wagner and the Visual Arts." Translated by Simon Nye. In Müller and Wapnewski, *Wagner Handbook,* 345–72.

Meyer, Esther da Costa. "La Donna è Mobile: Agoraphobia, Women, and Urban Space." In *The Sex of Architecture,* edited by Diana Agrest et al., 141–56. New York: Abrams, 1996.

Meyer, Jochen. *Theaterbautheorien zwischen Kunst und Wissenschaft: Die Diskussion über Theaterbau im deutschsprächigen Raum in der ersten Hälfte des 19. Jahrhunderts.* Berlin: Gebrüder Mann, 1998.

Meyerhold, Vsevolod. *Meyerhold on Theatre,* edited and translated by Edward Braun. New York: Hill and Wang, 1969.

———. "The Naturalistic Theatre and the Theatre of Mood" (1906). In *Meyerhold on Theatre,* 23–24.

Michel, Wilhelm. "Die Ausstellung München 1908: Wohnungskunst und Kunstgewerbe." *Dekorative Kunst* 12 (October 1908): 9–15.

———. "Wohn- und Wirtschaftsbauten auf der Ausstellung München 1908." *Dekorative Kunst* 11 (August 1908): 473–84.

Michelson, Annette. "'Where Is Your Rupture?' Mass Culture and the Gesamtkunstwerk." *October* 56 (Spring 1991): 43–63.

Millard, Andre J. *America on Record: A History of Recorded Sound.* New York: Cambridge University Press, 1995.

Miner, Margaret. *Resonant Gaps: Between Baudelaire and Wagner.* Athens: University of Georgia Press, 1995.

Mitchell, Stanley. "From Shklovsky to Brecht: Some Preliminary Remarks towards a History of the Politicisation of Russian Formalism." *Screen* 15, no. 2 (Summer 1974): 74–81.

Mitrovic, Branko. "Apollo's Own: Geoffrey Scott and the Lost Pleasures of Architectural History." *Journal of Architectural Education* 54, no. 2 (November 2000): 95–103.

Moholy-Nagy, László. "The Concept of Space" (1925–28). In Bayer, Gropius, and Gropius, *Bauhaus, 1919–1928,* 122–24.

———. *Painting, Photography, Film.* Translated by Janet Seligman. Cambridge: MIT Press, 1969.

———. "Theater, Zirkus, Varieté." In Schlemmer, Moholy-Nagy, and Molnár, *Die Bühne im Bauhaus,* 45–56.

Morgan, David. "The Enchantment of Art: Abstraction and Empathy from German Romanticism to Expressionism." *Journal of the History of Ideas* 57, no. 2 (1996): 317–41.

Morin, Roi L. "Design and Construction of Theaters." *American Architect: The Architectural Review* 122: "Part 1," no. 2406 (November 8, 1922): 393–402; "Part II—The Stages," no. 2407 (November 22, 1922): 443–50 and 453–56; "Part III—Lighting," no. 2408 (December 6, 1922): 493–96 and 507–10; "Part IV—The Projection Booth," no. 2409 (December 20, 1922): 537–42 and 553–56.

Most, Glenn W. "Nietzsche, Wagner, et la nostalgie de l'oeuvre d'art totale." In Galard and Zugazagoitia, *L'oeuvre d'art totale,* 11–34.

Müller, Lothar. "The Beauty of the Metropolis: Toward an Aesthetic Urbanism in Turn-of-the-Century Berlin." In Haxthausen and Suhr, *Berlin,* 41–47.

Müller, Ulrich. "Wagner and Antiquity." Translated by Stewart Spencer. In Müller and Wapnewski, *Wagner Handbook,* 227–35.

Müller, Ulrich, and Peter Wapnewski, eds. *Wagner Handbook.* Cambridge, Mass.: Harvard University Press, 1992.

Müller-Doohm, Stefan. *Adorno: A Biography* (2003). Translated by Rodney Livingstone. London: Polity Press, 2005.

Müller-Tamm, Pia, and Katharina Sykora, eds. *Puppen Körper Automaten: Phantasmen der Moderne.* Düsseldorf Kunstsammlung Nordrhein-Westfalen exhibition catalog. Cologne: Oktagon, 1999.

Münchener Künstler-Theater, Ausstellung München 1908. Edited by the Verein Münchener Künstler-Theater. Munich and Leipzig: Georg Müller, 1908.

Münsterberg, Hugo. *Hugo Münsterberg on Film: The Photoplay: A Psychological Study, and Other Writings.* Edited by Allan Langdale. New York: Routledge, 2002.

———. *The Photoplay: A Psychological Study.* In *Hugo Münsterberg on Film,* 45–163.

———. *Psychology and Industrial Efficiency* (1913). Reprint, Bristol: Thoemmes Press, 1999.

Musil, Robert. *The Man without Qualities* (1930). Translated by Eithne Wilkins and Ernst Kaiser. New York: Perigree Books, 1980.

Muthesius, Hermann. "Die Architektur auf den Ausstellungen in Darmstadt, München, und Wien." *Kunst und Künstler* 6 (September 1908): 491–95.

———. "Die Bedeutung des Kunstgewerbes: Eröffnungsrede zu den Vorlesungen über modernes Kunstgewerbe an der Handelshochschule in Berlin." *Dekorative Kunst* 10 (February 1907): 177–92.

———. *The English House* (1904–5). Translated by Janet Seligman. New York: Rizzoli, 1987.

———. *Style-Architecture and Building Art* (1902). Translated by Stanford Anderson. Santa Monica, Calif.: Getty Research Center for the History of Art and the Humanities, 1994.

Nägele, Rainer. *Theater, Theory, Speculation: Walter Benjamin and the Scenes of Modernity.* Baltimore, Md.: The Johns Hopkins University Press, 1991.

Naumann, Friedrich. "Kunst und Industrie." *Kunstwart* 20, no. 2 (1906): 69–73.

Nelson, Victoria. *The Secret Life of Puppets.* Cambridge, Mass.: Harvard University Press, 2001.

Nerdinger, Winfried, ed. *Bauhaus-Moderne im Nationalsozialismus: Zwischen Anbiederung und Verfolgung.* With the Bauhaus-Archiv, Berlin. Munich: Prestel, 1993.

———. "Modernisierung, Bauhaus, Nationalsozialismus." In Nerdinger, *Bauhaus-Moderne im Nationalsozialismus,* 9–23.

Nerdinger, Winfried, and Werner Oechslin, eds. *Gottfried Semper, 1803–1879: Architektur und Wissenschaft.* Architekturmuseum der TU München exhibition catalog. New York: Prestel, 2003.

Neubauer, John. *The Emancipation of Music from Language: Departure from Mimesis in Eighteenth-Century Aesthetics.* New Haven, Conn.: Yale University Press, 1986.

Neumann, Alfred R. "The Earliest Use of the Term 'Gesamtkunstwerk.'" *Philological Quarterly* 35 (1956): 192–93.

Neumeyer, Fritz. "Nietzsche and Modern Architecture." In Kostka and Wohlfarth, *Nietzsche and "An Architecture of Our Minds,"* 285–309.

New German Critique 69 (Fall 1996). "Special Issue on Wagner." Edited by David J. Levin and Mark M. Anderson.

Newman, Ernest. *The Life of Richard Wagner.* Vol. 3, *1859–1866.* New York: Alfred A. Knopf, 1941.

Nietzsche, Friedrich. *The Birth of Tragedy* (1872). In *The Birth of Tragedy and The Case of Wagner,* translated by Walter Kaufmann, 15–146. New York: Vintage Books, 1967.

———. *The Case of Wagner* (1888). In *The Birth of Tragedy and The Case of Wagner,* translated by Walter Kaufmann, 153–92. New York: Vintage Books, 1967.

———. *Die Geburt der Tragödie.* In *Nietzsche Werke,* 3: 5–152.

———. *Human, All Too Human* (1886). Translated by R. J. Hollingdale. Cambridge: Cambridge University Press, 1996.

———. *Nietzsche Werke: Kritische Gesamtausgabe.* Edited by Giorgio Colli and Mazzino Montinari. 15 vols. Berlin: Walter de Gruyter, 1967–88.

———. "On the Uses and Disadvantages of History for Life" (1873). In Nietzsche, *Untimely Meditations,* 59–123.

———. "Richard Wagner in Bayreuth" (1876). In *Nietzsche Werke,* 4: 3–82.

———. "Richard Wagner in Bayreuth" (1876). In Nietzsche, *Untimely Meditations,* 195–254.

———. "Schopenhauer as Educator" (1874). In Nietzsche, *Untimely Meditations,* 125–94.

———. *Thus Spoke Zarathustra* (1885). Translated by R. J. Hollingdale. New York: Penguin, 1969.

———. *Untimely Meditations.* Translated by R. J. Hollingdale. Edited by Daniel Breazeale. New York: Cambridge University Press, 1997.

Nordau, Max. *Degeneration* (1892). Lincoln: University of Nebraska Press, 1993.

———. *Entartung.* Berlin: C. Duncker, 1893.

Ogawa, David, and Deborah Johnson, eds. *The Feeling of Seeing: Modernism, Postmodernism, and Beyond; A Festschrift for Kermit Swiler Champa.* New York: Peter Lang, 2005.

Opelt, Franz-Peter. *Richard Wagner: Revolutionär oder Staatsmusikant?* Frankfurt am Main: Peter Lang, 1987.

L'Opéra de Paris construit par M. Charles Garnier: Architecture, sculpture, décorative: Extérieur et intérieur. Photographs by Charles Marville. Paris: E. Bigot, ca. 1876.

Panofsky, Erwin. "Style and Medium in the Motion Pictures." In *Three Essays on Style,* edited by Irving Lavin, 93–122. Cambridge: MIT Press, 1995.

Perkins, Geoffrey. *Contemporary Theory of Expressionism.* Frankfurt am Main: Herbert Lang, 1974.

Petro, Patrice. "Perceptions of Difference: Woman as Spectator and Spectacle." In Ankum, *Women in the Metropolis,* 41–66.

Petzet, Detta, and Michael Petzet, eds. *Die Richard-Wagner-Bühne König Ludwigs II.* Munich: Prestel, 1970.

Pevsner, Niklaus. *Pioneers of Modern Design: From William Morris to Walter Gropius.* 1936. Reprint, New York: Penguin, 1987.

Phillips, Christopher, ed. *Photography in the Modern Era: European Documents and Critical Writings, 1913–1940.* New York: Metropolitan Museum of Art, 1989.

Phillips, David Clayton. "Art for Industry's Sake: Halftone Technology, Mass Photography, and the Social Transformation of American Print Culture, 1880–1920." Ph.D. diss., Yale University, 1996.

Pinotti, Andrea. *Il corpo dello stile: Storia dell'arte come storia dell'estetica a partire da Semper, Riegl, Wölfflin.* Palermo: Centro Internazionale Studi di Estetica, 1998.

Plett, Nicole Bronowski. "The Performance Photographs of Oskar Schlemmer's Bauhaus Theater Workshop, 1923–29." M.A. thesis, University of New Mexico, 1989.

Podro, Michael. *The Critical Historians of Art.* New Haven, Conn.: Yale University Press, 1982.

Posener, Julius. "Between Art and Industry—the Deutscher Werkbund." In Burckhardt, *The Werkbund,* 7–15.

———. "Werkbund and Jugendstil." In Burckhardt, *The Werkbund,* 16–24.

Potter, Pamela M. *Most German of the Arts: Musicology and Society from the Weimar Republic to the End of Hitler's Reich.* New Haven, Conn.: Yale University Press, 1998.

Potts, Alex. "Dolls and Things: The Reification and Disintegration of Sculpture in Rodin and Rilke." In *Sight and Insight: Essays on Art and Culture in Honor of E. H. Gombrich at 85,* edited by John Onians, 355–78. London: Phaidon, 1994.

Prange, Regine. *Das Kristalline als Kunstsymbol: Bruno Taut und Paul Klee.* New York: Georg Olms, 1991.

Presner, Todd Samuel. *Mobile Modernity: Germans, Jews, Trains.* New York: Columbia University Press, 2007.

Prütting, Lenz. "Die Revolution des Theaters: Studien über Georg Fuchs." Ph.D. diss., University of Munich, 1971.

Randa, Sigrid. *Alexander Koch, Publizist und Verleger in Darmstadt: Reformen der Kunst und des Lebens um 1900.* Worms: Wernersche Verlagsgesellschaft, 1990.

Ray, Katerina Rüedi. "Bauhaus Hausfraus: Gender Formation in Design Education." *Journal of Architectural Education* 55, no. 2 (November 2001): 73–80.

Reinhart, Hartmut. "Wagner and Schopenhauer." Translated by Erika and Martin Swales. In Müller and Wapnewski, *Wagner Handbook,* 287–96.

Riegl, Aloïs. *Problems of Style: Foundations for a History of Ornament* (1893). Translated by Evelyn Kain. Princeton, N.J.: Princeton University Press, 1992.

Rilke, Rainer Maria. Auguste Rodin (1907). Leipzig: Insel [1919].

———. "Puppen: Zu den Wachspuppen von Lotte Pritzel" (1914). In *Schriften zur Literatur und Kunst,* edited by Horst Nalewski, 4: 685–92. Frankfurt am Main: Insel, 1996.

Ringer, Fritz K. *The Decline of the German Mandarins: The German Academic Community, 1890–1933.* London: Wesleyan University Press, 1990.

Roh, Franz. *Nach-Expressionismus, Magischer Realismus: Probleme der neuesten Europäischen Malerei.* Leipzig: Klinkhardt und Biermann, 1925.

Rose, Margaret A. *Marx's Lost Aesthetic: Karl Marx and the Visual Arts.* New York: Cambridge University Press, 1984.

Rose, Paul Lawrence. *Wagner: Race and Revolution.* New Haven, Conn.: Yale University Press, 1992.

Rosenthal, Bernice Glatzer, ed. *Nietzsche and Soviet Culture.* New York: Cambridge University Press, 1994.

Roth, Eugen. *Der Glaspalast in München: Glanz und Ende, 1854–1931.* Munich: Süddeutscher, 1971.

Rozanova, Olga. "Extracts from Articles" (1918). In *Russian Art of the Avant-Garde: Theory and Criticism,* edited and translated by John E. Bowlt, 148. New York: Thames and Hudson, 1988.

Sandqvist, Tom. *Dada East: The Romanians of Cabaret Voltaire.* Cambridge: MIT Press, 2006.

Sattler, Bernhard, ed. *Adolf von Hildebrand und seine Welt: Briefe und Erinnerungen.* Munich: Georg D. W. Callwey, 1962.

Sauer, Rodney. "Photoplay Music: A Reusable Repertory for Silent Film Scoring, 1914–1929." *American Music Research Center Journal* 8–9 (1998–99): 55–76.

Sayler, Oliver M. "The Munich Künstler, a Pioneer Little Theater." *Indianapolis News,* February 20, 1915, n.p.

Schacht, Richard. *Alienation.* London: George Allen and Unwin, 1970.

Schaul, Bernd-Peter. *Das Prinzregententheater in München und die Reform des Theaterbaus um 1900: Max Littmann als Theaterarchitekt.* Munich: Bayerisches Landesamt für Denkmalpflege, 1987.

Scheffler, Karl. "Bühnenkunst." In "Special issue on *Bühnenkunst,*" edited by Karl Scheffler. *Kunst und Künstler* 5 (March 1907): 217–44.

———. *Die Frau und die Kunst.* Berlin: Julius Bard, 1908.

———. "Das Theater." In *Moderne Kultur: Ein Handbuch der Lebensbildung und des guten Geschmacks,* edited by Eduard Heyk, 2: 405–23. Stuttgart: Deutsche Verlags-Anhalt, 1907.

Scheler, Max. *The Nature of Sympathy* (1912). Translated by Peter Heath. London: Routledge and Kegan Paul, 1954.

Schelling, Friedrich Wilhelm Joseph. *Philosophie der Kunst.* Darmstadt: Wissenschaftliche Buchgesellschaft, 1974.

Scheper, Dirk. *Oskar Schlemmer, "Das Triadische Ballett," und die Bauhausbühne.* Berlin: Schriftenreihe der Akademie der Künste, 1988.

Schivelbusch, Wolfgang. *The Railway Journey: Trains and Travel in the Nineteenth Century.* 1977. Reprint, Berkeley and Los Angeles: University of California Press, 1986.

Schlemmer, Oskar. *Idealist der Form; Briefe, Tagebücher, Schriften 1912–1943.* Edited by Andreas Hüneke. Leipzig: Reclam, 1990.

———. "Mensch und Kunstfigur." In Schlemmer, Moholy-Nagy, and Molnár, *Die Bühne im Bauhaus,* 7–21.

Schlemmer, Oskar, Laszló Moholy-Nagy, and Farkas Molnár. *Die Bühne im Bauhaus.* Munich: Albert Langen, 1925.

———. *The Theater of the Bauhaus* (1925). Edited by Walter Gropius. Translated by Arthur S. Wensinger. Middletown, Conn.: Wesleyan University Press, 1961.

Schlemmer, Tut, ed. *The Letters and Diaries of Oskar Schlemmer.* Translated by Krishna Winston. Middletown, Conn.: Wesleyan University Press, 1972.

Schmarsow, August. *The Essence of Architectural Creation* (1893). In Mallgrave and Ikonomou, *Empathy, Form, and Space,* 281–97.

———. "Reliefkunst." In *Grundbegriffe der Kunstwissenschaft: Ab Übergang vom Altertum zum Mittelalter,* 263–78. 1905. Reprint, Berlin: Gebrüder Mann, 1998.

———. *Das Wesen der architektonischen Schöpfung.* Leipzig: Karl W. Hiersemann, 1894.

Schnapp, Jeffrey T. "Border Crossings: Italian/German Peregrinations of the *Theater of Totality.*" *Critical Inquiry* 21 (Autumn 1994): 80–123.

Schöne, Günter. "The Munich Künstlertheater and Its First Season." *Apollo* 94, no. 117 (November 1971): 396–401.

Schorske, Carl E. "The Quest for the Grail: Wagner and Morris" (1967). In *Thinking with History: Explorations in the Passage to Modernism,* 90–104. Princeton, N.J.: Princeton University Press, 1998.

Schrader, Susanne. *Architektur der barocken Hoftheater in Deutschland.* Munich: Scaneg, 1988.

Schreyl, Karl Heinz. *Joseph Maria Olbrich: Die Zeichnungen in der Kunstbibliothek Berlin, Kritischer Katalog.* Berlin: Gebrüder Mann, 1972.

Schultze-Naumburg, Paul. *Häusliche Kunstpflege.* 1898. Reprint, Jena: Eugen Diederichs, 1906.

Schulze, Hagen. *The Course of German Nationalism: From Frederick the Great to Bismarck, 1763–1867.* Translated by Sarah Hanbury-Tenison. New York: Cambridge University Press, 1991.

Schuster, Peter-Klaus, ed. *Peter Behrens und Nürnberg: Geschmackswandel in Deutschland; Historismus, Jugendstil, und die Anfange der Industrieform.* Germanisches Nationalmuseum, Nuremberg, exhibition catalog. Munich: Prestel, 1980.

Schwartz, Frederic J. *Blind Spots: Critical Theory and the History of Art in Twentieth-Century Germany.* New Haven, Conn.: Yale University Press, 2005.

———. "Form Follows Fetish: Adolf Behne and the Problem of *Sachlichkeit.*" *Oxford Art Journal* 21, no. 2 (1998): 45–77.

———. *The Werkbund: Design Theory and Mass Culture before the First World War.* New Haven, Conn.: Yale University Press, 1996.

Schwarzer, Mitchell. *German Architectural Theory and the Search for Modern Identity.* New York: Cambridge University Press, 1995.

Segal, Harold B. *Body Ascendant: Modernism and the Physical Imperative.* Baltimore, Md.: The Johns Hopkins University Press, 1998.

Seidel, Klaus Jürgen, ed. *Das Prinzregenten-Theater in München.* Nuremberg: Drei W. Druck and Verlag J. Schoierer KG, 1984.

Semper, Gottfried. *The Four Elements of Architecture and Other Writings.* Translated by Harry Francis Mallgrave and Wolfgang Herman. New York: Cambridge University Press, 1988.

Semper, Manfred, ed. *Das Münchener Festspielhaus: Gottfried Semper und Richard Wagner.* Hamburg: Conrad H. A. Kloß, 1906.

———. *Theater.* Stuttgart: A. Kröner, 1904.

Shand, P. Morton. *Modern Picture-Houses and Theatres.* Philadelphia: J. B. Lippincott, 1930.

Shaw, George Bernard. "Wagner as Revolutionist" (1898). In *The Perfect Wagnerite: A Commentary on the Niblung's Ring,* 21–25. 1898. Reprint, Whitefish, Montana: Kessinger Publishing, 2004.

———. "Wagner in Bayreuth." *English Illustrated Magazine* 73 (October 1889): 49–57. In Mander and Mitchenson, *The Wagner Companion,* 203–15.

———— [Reuter, pseud.]. Untitled essay. *Hawk,* August 13, 1889. In Hartford, *Bayreuth,* 139–48.

Sheppard, Richard. "Georg Lukács, Wilhelm Worringer, and German Expressionism." *Journal of European Studies* 25 (1995): 241–82.

Simmel, Georg. "Group Expansion and the Development of Individuality" (1908). Translated by R. P. Albares. In *On Individuality and Social Forms,* edited by Donald N. Levine, 251–93. Chicago: University of Chicago Press, 1971.

————. "Metropolis and Mental Life" (1903). Translated by Edward A. Shils. In *On Individuality and Social Forms,* edited by Donald N. Levine, 324–39. Chicago: University of Chicago Press, 1971.

Skelton, Geoffrey. *Wagner at Bayreuth: Experiment and Tradition.* New York: George Brazilier, 1965.

Sloterdiijk, Peter. *Critique of Cynical Reason.* Translated by Michael Eldred. Minneapolis: University of Minnesota Press, 1987.

Smith, Matthew Wilson. *The Total Work of Art: From Bayreuth to Cyberspace.* New York: Routledge, 2007.

Sontag, Susan. "Wagner's Fluids." *London Review of Books* 9, no. 22 (December 10, 1987): 8–9.

Spotts, Frederick. *Bayreuth: A History of the Wagner Festival.* New Haven, Conn.: Yale University Press, 1994.

Stadler, Toni. "Gedanken über die Aufgaben der Kunst auf der Bühne." In *Münchener Künstler-Theater, Ausstellung München 1908,* 11–15.

Standage, Tom. *The Turk: The Life and Times of the Famous Eighteenth-Century Chess-Playing Machine.* New York: Walker, 2002.

Stein, Edith. *Zum Problem der Einfühlung.* Halle: Buchdruckerei des Waisenhauses, 1917.

Steinacker, Wiltrud H. "Georg Fuchs and the Concept of the Relief Stage." Ph.D. diss., University of Toronto, 1995.

Steinberg, Michael P. "Music Drama and the End of History." In "Special Issue on Richard Wagner," edited by David J. Levin and Mark M. Anderson. *New German Critique* 69 (Fall 1996): 163–80.

Stern, Fritz. *The Politics of Cultural Despair: A Study in the Rise of Germanic Ideology.* New York: Doubleday, 1965.

Stern, Paul. *Einfühlung und Association in der neueren Ästhetik: Ein Beitrag zur Psychologischen Analyse der ästhetischen Anschauung.* Hamburg: Leopold Voss, 1898.

Stoeckel, Gustave J. "The Wagner Festival at Bayreuth." *New Englander* 36, no. 139 (1877): 258–93.

Stokes, Melvyn. "Female Audiences of the 1920s and Early 1930s." In *Identifying Hollywood's Audiences: Cultural Identity at the Movies,* edited by Melvyn Stokes and Richard Maltby, 42–60. Berkeley and Los Angeles: University of California Press, 1999.

Stokes, Melvyn, and Richard Maltby, eds. *Identifying Hollywood's Audiences: Cultural Identity at the Movies.* Berkeley and Los Angeles: University of California Press, 1999.

Sussman, Mark. "Performing the Intelligent Machine: Deception and Enchantment in the Life of the Automaton Chess Player." In Bell, *Puppets, Masks, and Performing Objects,* 71–84.

Sykora, Katharina. "Die neue Frau: Ein Alltagsmythos der Zwanziger Jahre." In Sykora et al., *Die Neue Frau,* 9–24.

Sykora, Katharina, Annette Dorgerloh, Doris Noell-Rumpeltes, and Ada Raev, eds. *Die Neue Frau: Herausforderung für die Bildmedien der Zwanziger Jahre.* Marburg: Jonas, 1993.

Taylor, Sue. *Hans Bellmer: The Anatomy of Anxiety.* Cambridge: MIT Press, 2002.

Teitelbaum, Matthew, ed. *Montage and Modern Life: 1919–1942.* Institute for Contemporary Art, Boston, exhibition catalog. Cambridge: MIT Press, 1992.

Thomä, Dieter. *Totalität und Mitleid: Richard Wagner, Sergej Eisentstein, und unsere ethisch-ästhetische Moderne.* Frankfurt: Suhrkamp, 2006.

Toepfer, Karl. *Empire of Ecstasy: Nudity and Movement in German Body Culture 1910–1935.* Berkeley and Los Angeles: University of California Press, 1994.

Tretyakov, Sergei. "From the Editor: European Documents and Critical Writings, 1913–1940." *Novyi Lef* 11 (1928): 41–42. Translated by John E. Bowlt. In Christopher Phillips, *Photography in the Modern Era,* 270–72.

Trevelyan, George Macaulay. *British History in the Nineteenth Century (1782–1901).* New York: Longmans, Green, 1922.

Troy, Nancy. "An Art of Reconciliation: Oskar Schlemmer's Work for the Theater." In Lehman and Richardson, *Oskar Schlemmer,* 127–47.

———. *Modernism and the Decorative Arts in France: Art Nouveau to Le Corbusier.* New Haven, Conn.: Yale University Press, 1991.

Twain, Mark. "At the Shrine of St. Wagner" (1891). In *What Is Man? and Other Essays,* 209–27. New York: Harper and Bros., 1917.

Vetter, Isolde. "Wagner and the History of Psychology." Translated by Stewart Spencer. In Müller and Wapnewski, *Wagner Handbook,* 118–55.

Vidler, Anthony. "Agoraphobia: Psychopathologies of Urban Space." In Vidler, *Warped Space,* 25–50.

———. *The Architectural Uncanny: Essays in the Modern Unhomely.* Cambridge: MIT Press, 1992.

———. *Warped Space: Art, Architecture, and Anxiety in Modern Culture.* Cambridge: MIT Press, 2000.

Vischer, Robert. *On the Optical Sense of Form* (1873). In Mallgrave and Ikonomou, *Empathy, Form, and Space,* 89–123.

———. *Über das optische Formgefühl: Ein Beitrag zur Aesthetik.* Leipzig: Credner, 1873.

Volkelt, Johannes. *Ästhetische Zeitfragen.* Munich: Beck, 1895.

———. *Der Symbol-Begriff in der neuesten Ästhetik.* Jena: Dufft, 1876.

Vom Ausstellungspark zum Internationalen Messeplatz München, 1904 bis 1984. Edited by the Münchner Messe- und Ausstellungsgesellschaft and the Münchner Stadtmuseum. Munich: Peter Winkler, 1984.

von Pechmann, Günther. "Die Ausstellung München 1908." *Dekorative Kunst* 11 (July 1908): 425–27.

Wagner, Cosima. *Die Tagebücher.* Edited by Martin Gregor-Dellin and Dietrich Mack. 2 vols. Munich: R. Piper, 1977.

Wagner, Gottfried. *Twilight of the Wagners: The Unveiling of a Family's Legacy.* Translated by Della Couling. New York: Picador, 1997.

Wagner, Nike. *The Wagners: The Dramas of a Musical Dynasty.* Translated by Ewald Osers and Michael Downes. Princeton, N.J.: Princeton University Press, 1998.

Wagner, Richard. *Art and Politics.* Translated by William Ashton Ellis. 1895. Reprint, Lincoln: University of Nebraska Press, 1995.

———. *Art and Revolution* (1849). In *Richard Wagner's Prose Works,* vol. 1, *The Art-Work of the Future and Other Works* (translation first published in 1893), 30–68.

———. *The Art-Work of the Future* (1849). In *Richard Wagner's Prose Works,* vol. 1, *The Art-Work of the Future and Other Works* (translation first published in 1893), 69–214.

———. "Autobiographical Sketch" (1842). In *Richard Wagner's Prose Works,* vol. 1, *The Art-Work of the Future and Other Works* (translation first published in 1893), 1–20.

———. "Autobiographische Skizze" (1842). In Wagner, *Sämtliche Schriften und Dichtungen,* 1: 4–19.

———. *Das Braune Buch: Tagebuchaufzeichnungen, 1865–1882.* Edited by Joachim Bergfeld. Zurich: Atlantis, 1975.

———. "A Communication to My Friends" (1851). In *Richard Wagner's Prose Works,* vol. 1, *The Art-Work of the Future and Other Works* (translation first published in 1893), 267–392.

———. *The Diary of Richard Wagner, 1865–1882: The Brown Book.* Translated by George Bird. Edited by Joachim Bergfeld. New York: Cambridge University Press, 1980.

———. "Einleitung zum dritten und vierten Bände" (1872). In Wagner, *Sämtliche Schriften und Dichtungen,* 3: 1–7.

———. "Introduction to *Art and Revolution*" (1872). In *Richard Wagner's Prose Works,* vol. 1, *The Art-Work of the Future and Other Works* (translation first published in 1893), 21–29.

———. "Judaism in Music" (1850). In *Richard Wagner's Prose Works,* vol. 3, *Judaism in Music and Other Essays* (translation first published in 1894), 75–122.

———. "Das Judenthum in der Musik" (1850). In Wagner, *Sämtliche Schriften und Dichtungen,* 5: 66–85.

———. *Die Kunst und die Revolution* (1849). In Wagner, *Sämtliche Schriften und Dichtungen,* 3: 8–41.

———. *Kunst und Revolution: Auswahl aus seinen politischen Schriften.* Introduction by Gustav Steinbömer. Potsdam: Alfred Protte, 1935.

———. *Das Kunstwerk der Zukunft* (1849). In Wagner, *Sämtliche Schriften und Dichtungen,* 3: 42–177.

———. *Mein Leben.* Edited by Martin Gregor-Dellin. Munich: List, 1963.

———. "Eine Mittheilung an meine Freunde" (1851). In Wagner, *Sämtliche Schriften und Dichtungen,* 4: 230–344.

———. "A Music-School for Munich" (1865). In *Richard Wagner's Prose Works,* vol. 4, *Art and Politics* (translation first published in 1895), 171–224.

———. *My Life.* Authorized translation of *Mein Leben.* Munich: F. Bruckmann, 1911; London: Constable, 1911.

———. *Opera and Drama* (1851). Translated by William Ashton Ellis. Lincoln and London: University of Nebraska Press, 1995.

———. *Richard Wagner: Sämtliche Briefe.* Vol. 3 (1975) and vol. 5 (1993). Edited by Gertrud Strobel and Werner Wolf for the Richard-Wagner-Stiftung, Bayreuth. Leipzig: Deutscher Verlag für Musik, 1967–2003.

———. *Richard Wagner: Werke, Schriften, und Briefe.* Digitale Bibliothek, vol. 107. Edited by Sven Friedrich. CD-ROM. Berlin: Directmedia, 2004.

———. *Richard Wagner's Prose Works.* 8 vols. Translated and edited by William Ashton Ellis. Lincoln: University of Nebraska Press, 1993.

———. *Sämtliche Schriften und Dichtungen.* 12 vols. Leipzig: Breitkopf und Härtel, [1911].

———. *Selected Letters of Richard Wagner.* Translated and edited by Stewart Spencer and Barry Millington. New York: W. W. Norton, 1987.

Waite, Geoffrey C. W. "Worringer's *Abstraction and Empathy*: Remarks on Its Reception and the Rhetoric of Criticism." In Donahue, *Invisible Cathedrals,* 13–40.

Ward, Janet. *Weimar Surfaces: Urban Visual Culture in 1920s Germany.* Berkeley and Los Angeles: University of California Press, 2001.

Warnke, Martin. "On Heinrich Wölfflin." *Representations* 27 (1983): 172–87.

Weber, Carl Maria von. *Writings on Music.* Edited by John Warrack. Translated by Martin Cooper. New York: Cambridge University Press, 1981.

Weber, William. *Music and the Middle Class: The Social Structure of Concert Life in London, Paris, and Vienna.* New York: Holmes and Meier, 1975.

Weiner, Marc A. "Reading the Ideal." In "Special Issue on Richard Wagner," edited by David J. Levin and Mark M. Anderson. *New German Critique* 69 (Fall 1996): 53–83.

Weiss, Peg. *Kandinsky in Munich: The Formative Jugendstil Years.* Princeton, N.J.: Princeton University Press, 1979.

Welchman, John C. "After the Wagnerian Bouillabaisse: Critical Theory and the Dada and Surrealist Word-Image." In *The Dada and Surrealist Word-Image,* edited by Judi Freeman, Los Angeles County Museum of Art exhibition catalog, 57–95. Cambridge: MIT Press, 1989.

Wietek, Gerhard, ed. *Deutsche Künstlerkolonie und Künstlerorte.* Munich: Karl Thiemig, 1976.

Williamson, George S. *The Longing for Myth in Germany: Religion and Aesthetic Culture from Romanticism to Nietzsche.* Chicago: University of Chicago Press, 2004.

Wilts, Bettina. *Zeit, Raum, und Licht: Vom Bauhaustheater zur Gegenwart.* Weimar: Verlag und Datenbank für Geisteswissenschaften, 2004.

Winckelmann, Johann Joachim. *Gedanken über die Nachahmung der griechischen Werke in der Malerei und Bildhauerkunst.* Dresden: Im Verlag der Waltherischen Handlung, 1756.

Wingler, Hans M., ed. *The Bauhaus: Weimar, Dessau, Berlin, Chicago.* Translated by Wolfgang Jabs and Basil Gilbert. Cambridge: MIT Press, 1969.

Wolf, Georg Jacob. *Max Littmann, 1862–1931.* Munich: Knorr und Hirth, 1931.

Wölfflin, Heinrich. *Prolegomena to a Psychology of Architecture* (1886). In Mallgrave and Ikonomou, *Empathy, Form, and Space,* 149–90.

———. *Prolegomena zu einer Psychologie der Architektur* (1886). Reprint, Berlin: Gebrüder Mann, 1999.

———. *Renaissance and Baroque* (1888). Translated by Kathrin Simon. Ithaca, N.Y.: Cornell University Press, 1984.

———. *Renaissance und Barock* (1888). Reprint, Munich: F. Bruckmann, 1907.

Worringer, Wilhelm. *Abstraction and Empathy: A Contribution to the Psychology of Style* (1908). Translated by Michael Bullock. With an introduction by Hilton Kramer. Chicago: Elephant Paperbacks, 1997.

———. *Abstraktion und Einfühlung: Ein Beitrag zur Stilpsychologie.* 1908. Reprint, Amsterdam: Verlag der Kunst, 1996.

———. *Ägyptische Kunst: Probleme ihrer Wertung.* Munich: R. Piper, 1927.

———. "Die Ausstellung München 1908." *Masken* 4 (September 7, 1908): 19–24.

———. *Deutsche Jugend und östlicher Geist.* Bonn: Friedrich Cohen, 1924.

———. *Formprobleme der Gothik.* Munich: R. Piper, 1920.

———. "Das Münchener Künstlertheater." *Die Neue Rundschau* 19 (July–December 1908): 1709–11.

———. Review of *Gesammelte Aufsätze* (Strasbourg: Heitz und Mündel, 1909), by Adolf Hildebrand. *Monatshefte für Kunstwissenschaft* 3 (1910): 212.

———. "Zum Problem der modernen Architektur." *Neudeutsche Bauzeitung* 7, no. 37 (1911): 496–98, 500.

Wyss, Beat. "*Ragnarök* of Illusion: Richard Wagner's 'Mystical Abyss' at Bayreuth." *October* 54 (Fall 1990): 57–78.

Zevi, Bruno. *Architecture as Space: How to Look at Architecture*. 1948. Reprint, New York: Horizon Press, 1957.

Zugazagoitia, Julian. "Archéologie d'une notion, persistance d'une passion." In Galard and Zugazagoitia, *L'oeuvre d'art totale*, 67–92.

Index

Juliet Koss is associate professor and chair of art history at Scripps College in Claremont, California.